Approaches
to Art
in Education

Approaches to Art in Education

LAURA H. CHAPMAN

 HARCOURT BRACE JOVANOVICH, INC.

New York San Diego Chicago San Francisco Atlanta

Preface

Approaches to Art in Education deals with art instruction in the preschool through the junior high. It is intended as a text for classroom and art instructors, but it is also recommended for principals, members of school boards, parents, and other interested citizens whose vision and support are vital for lively and successful school art programs.

A total rethinking of the purposes of art education is necessary to develop such art programs. Art education must be recognized as an essential subject within the total school curriculum—not an educational frill. Art education must foster a more comprehensive understanding of the importance of art in the lives of children. Simply providing art materials to children so that they may occupy themselves on a rainy day or discovering and training those few children who show artistic promise does not constitute art education.

One of the main themes in this volume is that no single approach to art can adequately represent to children the diversity inherent in art. For this reason, art programs should be eclectic; they should reflect major traditions of artistic thought and practice in Western culture as well as cross-cultural insights drawn from anthropology.

Children should experience art by both creating it and responding to it. These modes of encounter are interdependent. Creative work can enhance children's ability to respond sensitively to two- and three-dimensional forms. And a well-developed sense of perception is necessary for creating expressive works of art.

Children's art experiences must extend beyond the traditional confines of "school" art. Art is a dynamic, multifaceted enterprise. Above all else, it is a means of giving form to feelings and ideas, and of enriching our vision of the world. The world of art encompasses the traditional fine and studio arts as well as the fields of architecture; film, television, and photography; graphic and product design. It includes those masterworks treasured by critics and connoisseurs, but it also spans the wide range of cultural symbols and artifacts essential to everyday life. Art education should reveal to children the relationship between these forms of art and the children's own artistic endeavors.

Finally, a methodology of art education cannot be discovered simply by reading a book. Instructors *develop* methods best suited to their own personalities and to the dynamics operating in a particular classroom at a given moment. Because the process of learning how to teach requires on-the-job experience, this book concentrates on *what* to teach and *why* it is worth teaching.

Among those persons who have been most instrumental in shaping my views on the practice of art education, I wish to acknowledge the early and profound role played by Helen Donnell;

Al Hurwitz, Coordinator of Visual and Related Arts, Newton Public Schools; Jean Johnson, Kean College of New Jersey; Betty Kowalchuk; Jo Kowalchuk; Sara Maddox; and Patricia A. Renick, University of Cincinnati.

Without holding them responsible for the use I have made of their contributions, I wish to acknowledge my professional debts to Marylou Kuhn, The Florida State University; Marion J. Hay; Frederick M. Logan, University of Wisconsin; June King McFee, University of Oregon; Vincent Lanier, University of Oregon; Edmund B. Feldman, The University of Georgia; and the late Manuel Barkan for showing me the importance of attending to philosophy as a tool for thinking, the history of art education, cultural anthropology, the sociology of art, art criticism, and the virtues and hazards of eclecticism.

I wish to thank all the instructors and supervisors who provided many of the illustrations and thus offer evidence that both the quality and variety of art experiences presented in this text are within reach of instructors and children. Special thanks are given to Evan, Lucy, and Sarah Kern for permission to use Sarah's drawings of horses. Created over a span of fifteen years, these drawings are of special interest in light of Sarah's desire to become a veterinarian specializing in equine medicine. Eleese V. Brown kindly provided the photographs of children's clay figures, which illustrate untutored growth in using a three-dimensional medium. I am pleased that Georgie Ann Grosse permitted the use of her photographs of the superb teaching materials she has developed.

Patterson B. Williams of the Philadelphia Museum of Art and Bonnie Baskin of the University Art Museum, University of California, Berkeley, provided many of the photographs illustrating the vitality of educational programs in museums.

Valuable manuscript criticism was provided by Al Hurwitz; Hilda P. Lewis, San Francisco State University; Jerry Tollifson, State Supervisor of Art Education, Ohio Department of Education; Gene Mittler, Indiana University; D. Jack Davis, North Texas State University; and Ivan E. Johnson, The Florida State University.

Among those who have contributed to the production of the book, I wish to thank Nina Gunzenhauser for persistent and patient editorial support; Irene Pavitt and Betty Gerstein for detailed yet judicious editing; Kay Ellen Ziff for pictorial searches; Lucile Jenss for deciphering my handwriting, discreetly correcting spelling errors, and efficiently typing several drafts of the manuscript; Judith A. Wittlin for multipurpose dependability; and Patricia A. Renick, who, better than anyone, comprehends the ironic circumstances under which this book has been written.

LAURA H. CHAPMAN

Contents

II

Children's artistic development

III

Suggested activities

IV

Program planning and evaluation

Approaches
to Art
in Education

foundations
for art
education

A perspective on art education

1

It has been estimated that 85 percent of the nation's youth receive no instruction in art beyond the age of thirteen or fourteen.[1] Thus it is essential that we achieve excellence in the quality of art education available to youngsters during the elementary and junior high years. In their preadolescent years, children form basic attitudes toward a number of experiences, including those in art. The quality of art education available in schools can determine whether children will cherish art as a vital part of their lives.

It is important to note that in our society the school is the only institution officially responsible for educating children in art. Teachers are thus in a key position to influence the way this generation feels about art and how it perceives its nature.[2] The challenge is to provide art experiences that are intellectually sound, personally rewarding to children, and relevant to their lives. Your role as a teacher will be to mediate the child's education in and through art.

The need for art education

Problems arise because the art teacher is not the only mediator of the child's experiences in art. The dominant values in our culture are still

reflected in the quest for wealth, success, and upward social mobility. Within this scheme of values, art is often treated as little more than a leisure-time pursuit, a decorative addition to life, or a symbol of wealth and social sophistication. The deeper satisfactions of art are poorly understood and largely unrealized.[3]

Values operating in the larger society influence children. From the earliest years of their lives, they are educated through visual forms at home, in stores, and in the neighborhood. Far more of the children we teach are familiar with plaster figurines made in Hong Kong than with bronze sculptures made by skilled artists. Far more will live in tract housing, sterile apartments, or squalid tenements than in homes designed by architects. For better or worse, we cannot ignore the child's experience outside of school. It is, in itself, an educational force to be reckoned with.

As children grow older they are attracted to products that superficially resemble art—craft kits, coloring books, numbered painting sets, and plastic models. From products such as these, children acquire concepts of art that are quite different from those they encounter in school or in museums and galleries. Television, comic books, and movies also influence the child's understanding of what is worth doing, having, and seeking (Figure 1-1).

In making these observations it would be unfair to imply that everyone in our society is indifferent to art. A substantial number of people go to museums and galleries. Many people are interested in collecting original works of art because they enjoy owning objects that are visually stimulating. The popularity of art as a hobby reflects a widespread desire to "have a hand" in making things. There is a growing awareness that the quality of life is influenced by the way we shape our everyday environment.

Nevertheless, the child in today's world is bombarded—by the mass media, advertising, consumer products, and the environment—with countless ready-made self-images and values. In contrast, there are relatively few opportunities for the child to express *how* his or her particular life feels, to discover *what* its special meanings are, or to comprehend *why* it is like no other person's life. Art education can acquaint children with more subtle forms of feeling and more precise images of the human spirit than they are likely to discover on their own. Through instruction in art, the child can acquire the know-how to explore the deeper meanings of visual forms.

Historical concerns and contemporary practice

If children could discover the power of visual forms by unguided experience alone, there would be little need for art instruction in school.

1-1 (*left*) Children's tastes and sensitivities are influenced by visual forms in the everyday environment.

1-2 (*below*) Walter Smith, *Teacher's Manual of Freehand Drawing and Designing* (1876). Children once were asked to copy images like these.

The kind of influence the school *should* have is the central problem in art education. We can gain a perspective on this problem through a brief review of the history of art education in this country and of the practices that have left a mark on the contemporary teaching of art.[4]

1870–1920:
The beginning of art education

ART AS SKILL IN DRAWING. In the early 1870s, a group of industrialists in Massachusetts pressured the state legislature to make drawing a required subject in school. The manufacturers recognized that skilled draftsmen and designers would be needed if American products were to compete favorably in an expanding world market. Walter Smith, an Englishman, was brought to this country to develop the first required course in art and to train teachers in its use.[5] Smith's course, like others of this period, was offered as a prescribed series of exercises in copy work. It reflected a belief that skill in drawing and design could be mastered through imitation, drill, and practice.

In Smith's program of drawing, the first task to be mastered was drawing a straight line without a ruler (Figure 1-2). Later tasks required a mastery of line and shadow to represent objects and space. The familiar expression "I can't draw a straight line with a ruler" illustrates that skill

in making accurate drawings is still a popular adult standard for judging artistic ability. Indeed, children acquire this concept early because it is so pervasive among adults. Accuracy in drawing is certainly a narrow view of art. When we equate art with representation, we deny any value to works that have exaggerated forms, omitted or simplified parts, imaginative shapes, or idealized subjects. One of the major problems that art educators still face is the popular acceptance of the representational concept of art to the exclusion of all others.

By today's standards for art education, the materials from Walter Smith's program seem very restrictive. Copy work is generally discouraged now because we value originality more highly than imitation in children's art. Nevertheless, the legacy of Smith's era may be found in step-by-step books and exact how-to-do-it instructions that severely restrict children's opportunities to make artistic decisions on their own. Coloring books and worksheets to trace or copy also prevent children from expressing their own feelings and ideas. Materials of the kind shown in Figure 1-3 often add insult to injury by presenting stereotyped and poorly drawn images for children to copy, fabricate, or study.

ART FOR CULTURAL REFINEMENT. Around the turn of the century, art appreciation was introduced into school programs (Figure 1-4).

1-3 Images for children to copy or color are often stereotyped, and their use restricts opportunities for children to make artistic decisions.

1-4 At the turn of the century, picture-study programs emphasized moral lessons and introduced children to European high culture (Sir Henry Raeburn, *A Boy and Rabbit*).

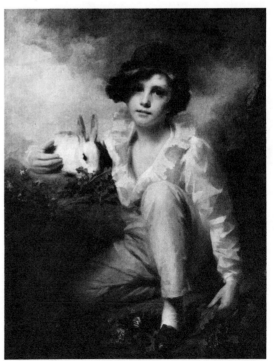

1-5 (*left*) Contemporary teaching aids for art appreciation are varied and colorful, and they invite personal responses from children.

1-6 (*opposite, left*) Early manual-training classes in the crafts emphasized skill more than originality (c. 1900).

1-7 (*opposite, right*) Craftwork is now regarded as an opportunity for original design and individual expression.

Graded "picture study" texts became available. These texts emphasized the virtues of hard work, piety, and loyalty as portrayed in the subject matter of "famous" paintings or in the artists' lives. Artists were often viewed in terms of two stereotypes: the inspired genius or the suffering hero. An appreciation of art was considered one of the finer things in life—a form of culture especially important for young ladies who wanted to become "properly" refined and part of the social elite.[6] Thus, through an ingenious blend of Puritan and aristocratic values, children received lessons in "moral character" and became familiar with "masterpieces" of art, principally from the Renaissance and the nineteenth-century romantic period in Europe.

Attitudes from the past are still apparent in our society. An appreciation of art is often regarded as a luxury or frill to be enjoyed primarily by wealthy socialites, especially women. Many newspapers, for example, report community art events in the section on society, women, or entertainment. Judgments about the life of artists are frequently based on the same two stereotypes: the inspired genius whose talent is beyond comprehension, or the suffering hero who creates art in spite of personal hardship. The validity of these and other cultural stereotypes about art can and should be examined with children.[7]

Contemporary approaches to art appreciation are varied. In general, children are encour-

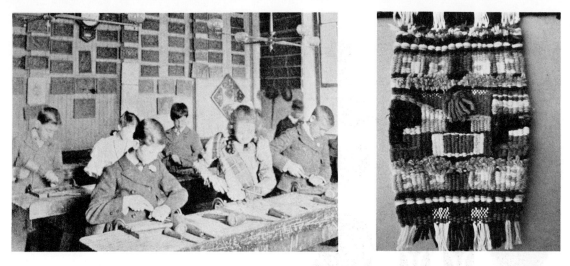

aged to discover individual meanings in works of art. They are engaged in the process of looking at a work and formulating a critical judgment about its significance. Teachers try to acquaint children with community artists and their work as well as with works in local museums and galleries. Although original works are best for teaching art appreciation, substitutes like slides, prints, and reproductions are convenient for immediate classroom use. Most art teachers rely on resources like those in Figure 1-5 to teach art appreciation.

ART AS CRAFT AND FOLK TRADITION. In the decades preceding and following 1900, the largest wave of immigration in our history occurred. Faced with increasing numbers of children who spoke little or no English, many schools offered special programs that would teach a useful trade, provide nonverbal success to children, and draw on the ethnic traditions of the immigrants. Vocational skills were developed by manual training in the crafts of wood, metal, leather, and clay (Figure 1-6). Cooking, sewing, weaving, and embroidery were introduced as well.[8] In the early part of this century, the crafts were approached in the spirit of extending the immigrants' traditional pride and vocational interest in well-made handcrafted items.

In time, manual training in the traditional crafts evolved into industrial arts (for boys) and home economics (for girls). As presently taught,

these subjects still emphasize the practical and vocational aspects of woodworking, sewing, and other crafts. Within art programs, however, the crafts now have a different status: they are treated as opportunities for individual design and expression (Figure 1-7). Programs are no longer based on sexist stereotypes, such as sewing for girls and woodworking for boys.

In spite of these changes, the attitude persists that art is primarily a manual skill. This bias is reflected in the common assumption that children who do not succeed academically are likely to be good at working with their hands. Further, this attitude implies that art is not intellectually demanding, that only academic achievement leads to success, and that nonacademic endeavors are second-rate activities.[9] At best, this view perpetuates the concept of an elite class of intellectuals whom society should revere above other. At worst, it causes people to judge themselves and others as "superior" or "inferior" by an extremely narrow standard of human potential.

Art activities based on folk traditions and ethnic holidays are another legacy of the turn-of-the-century immigration period (Figure 1-8). In spite of the American melting-pot image, various holiday symbols and art forms—turkeys, tulip borders, shamrocks, black cats, and Easter bunnies—have survived to the present. Unfortunately, these and similar motifs have become so commercialized that few of us understand

1-8 Many holiday images can be traced to folk traditions celebrated by immigrants.

1-9 A creative approach to holidays: children decorated envelopes for Valentine's Day cookies they baked.

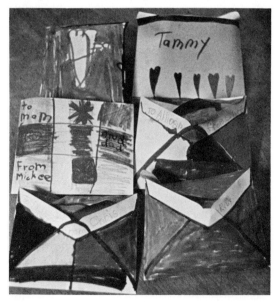

their original meanings. Although children rarely learn about the origins of these traditional holiday symbols, their meanings should be explored in the classroom.[10] In contemporary art programs children are encouraged to develop their own visual symbols to express their feelings about holidays and traditions (Figure 1-9).

Within the last decade the need for positive recognition of minority groups has led to a rediscovery of the ethnic diversity of our society. Because ethnic identity is established partially through distinct visual forms, some art programs now offer concentrated studies in Mexican-American, Appalachian, American-Indian, and Afro-American arts. Children also learn about art forms and symbols created in other cultures.

1920–1940:
The progressive movement

ART AS SELF-EXPRESSION. Prior to the early 1920s, children's art was widely regarded as a clumsy and immature version of adult art. Adult art, in turn, was valued if it echoed the great achievements of the old masters. Both of these concepts were challenged in the decades following the First World War.

The New York Armory Show of 1913 was the first large and widely publicized exhibition of modern art ever held in America. The new

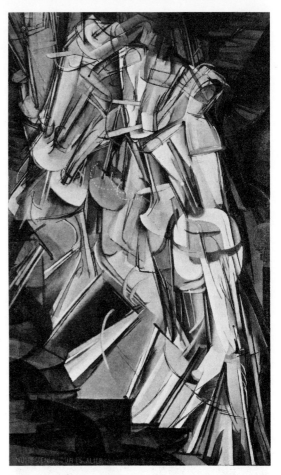

1-10 (*right*) Marcel Duchamp's *Nude Descending a Staircase No. 2* (1912) was exhibited in the New York Armory Show of 1913. The concept of art as self-expression was strengthened by the varied styles developed by early-twentieth-century artists.

styles of art, as in Figure 1-10, demonstrated that the artist's creative energy could turn inward to the subconscious, explore pure visual form and structure, and transform our sense of time, space, and motion. It was soon obvious to many scholars, artists, and teachers that art could no longer be defined exclusively in terms of skillful representation, Renaissance perspective, and classical proportions. By 1920, alert art teachers were aware that nothing short of an artistic revolution had occurred in Europe, and they could see its growing influence on American artists.[11]

The newer forms of expression being explored in the world of art, together with trends in educational theory, helped to shape the concept of art as self-expression. In the early decades of this century, John Dewey, an American philosopher and educator, articulated a view of education that was as revolutionary for its time as the innovations that were redefining the nature of art. In Dewey's view, children should be treated as active learners whose creative energies center on themselves and their world. The traditional concept of the child as "a miniature but imperfect adult" had supported a host of practices that Dewey and his followers rejected—namely, rote learning of ready-made facts, drill and recitation of text materials, and the imposition of arbitrary rules by adults. According to Dewey, active inquiry, sharing of effort, and experience in decision-making were natural and

1-11 (*below*) One of the most important legacies of the Progressive Education Movement is the belief that children can produce works that are creative, self-expressive, beautifully designed, and therefore authentic as art.

1-12 An example of correlated art from 1936.

1-13 Several functions of art are integrated in this activity—self-expression, communication, and a celebration of spring.

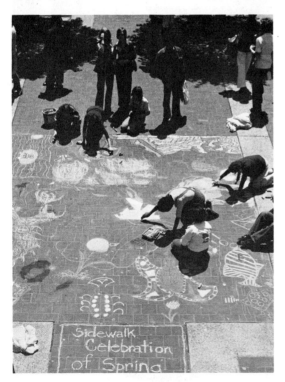

effective means to nurture learning.[12] In 1920, educators who supported the principles of John Dewey's educational philosophy formed the Progressive Education Association. Through this organization, Dewey's ideas were tested and translated into classroom practices. Traditional subject areas, including art, were reinterpreted (Figure 1-11).

Art teachers who supported Dewey's tenets soon discovered that recent developments in the world of art were compatible with the new philosophy of education.[13] Educators began to recognize that the child's self-expression in art had its own kind of integrity; it had an authenticity that did not depend on traditional notions of skillful representation. Self-expression was not only a natural mode of behavior for children but was fundamental to their ultimate maturity. Thus, the child's artistic effort, at that time regarded by many teachers as a crude attempt at representation, was recognized by the "progressives" as a genuine form of art. "Child art" was discovered.[14]

The concept of creative self-expression was radical for its time. It was so radical that it was not widely accepted until the years following the Second World War, when, as a nation, we were more conscious of the need to protect and nurture individual expression. Today, the work of children is widely valued as legitimate art and admired for characteristics that distinguish it

A PERSPECTIVE ON ART EDUCATION

1-14 Units of study from the 1930s Owatonna Project are still excellent models for developing units on art in everyday life.

from adult art. The concept of art as creative self-expression is no longer a new idea; it has been thoroughly assimilated into the philosophy of contemporary art education. It is discussed in less romantic and naive terms than in the 1920s. We recognize now that the "self" of the child is complex and that authentic expression through art is rarely achieved without active, sympathetic, and structured guidance from adults.

INTEGRATED AND CORRELATED ART. In Dewey's philosophy of education, the school is a microcosm of everyday life. It functions as a small community facing its own problems and finding solutions through cooperative effort and democratic procedures. In progressive schools of the 1920s and 1930s, group activities were popular. Small groups of children worked on parts of a large problem that interested everyone. Teachers developed a number of activities in order to help children clarify their ideas and communicate the results of their efforts in solving problems of common concern. Among the means of communication were murals, puppet shows, table-top models, charts, displays, and bulletin boards. These activities were integral to the problem-solving process: they served as a method of correlating the ideas of the group and reporting them to a larger audience.[15] This use of art-related activities was termed correlated, or integrated, art (Figure 1-12). If activities were

correlated, children could more readily achieve a personal integration of their experiences.

Art educators today are generally skeptical of activities that use art materials merely to illustrate, chart, or graphically represent other subjects. For example, art educators would disapprove of a social-studies lesson on the Southwest Indians that included copying pictures of Indians or using art media to duplicate Indian designs. Such activities are uncreative, time-consuming, and do not, in themselves, help children grasp the underlying relevance of Indian art to their own lives. However, children might well learn about the visual symbols Indians use to express such important events as rainfall and good harvests. Children might then invent their own symbols to represent an important event in their own lives (Figure 1-13). In relating art to other subjects, sensitive teachers give priority to expressive parallels such as these; they do not use art merely to reinforce factual knowledge.

ART IN EVERYDAY LIVING. During the depression of the 1930s, nothing seemed more important than the routine of day-to-day life, doing useful things, and getting a job. Art teachers were forced to find free, inexpensive, or discarded materials for school activities. Because new household items were costly, children were encouraged to make decorative yet practical items to brighten their homes. Art teachers also

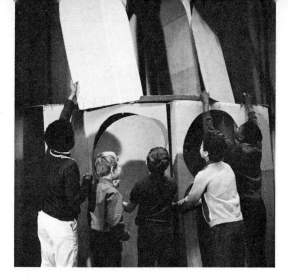

1-15 (*left*) Architecture—the most neglected art form in school programs—is here introduced as a creative problem-solving activity.

1-16 (*opposite, left*) National priorities often influence art education theory and practice. The impact of the Second World War is evident in these titles of articles from *School Arts Magazine* (1943–1944).

1-17 (*opposite, right*) Following the Second World War, there was a sense of urgency about art education and a commitment to it as a humanizing and healing force.

acquainted students with vocational possibilities in art and emphasized skills in applied design for advertising, interiors, and crafts (Figure 1-14). In effect, the social and practical aspects of art were given more attention than the creative, self-expressive ones.[16]

The concept of art in everyday life was the basis for an unusual experimental program during the 1930s. With the aid of a grant from the Carnegie Corporation, the small town of Owatonna, Minnesota, became a center for total community involvement in art. The five-year program centered on artistic decisions in daily life—in city planning, architecture and interior design, landscaping, clothing, utensils, advertising, and recreation. Special teaching units on art in daily living[17] were introduced in the schools. This comprehensive community program offered the public numerous exhibitions and lectures on art while providing individual residents, business executives, and city officials with consultations on artistic decisions.

The spirit of the Owatonna Project can be found in contemporary art education. Environmental design, architecture, advertising, and other arts of daily living are essential considerations in a comprehensive art program. Problems of designing spaces for living, working, playing, and traveling are considered in relation to the school and the neighborhood.[18] Some teachers provide space and materials for children to create mini-environments that express a mood (Figure 1-15). Although children are still encouraged to make useful objects, they are taught to consider how the design of an object can be tailored to suit a specific purpose, person, or location. Art teachers also help children become aware of the ways that their everyday purchases may be influenced by advertising and package design.

1940–1960:
Mid-century developments

EXPERIMENTATION WITH MATERIALS. As a result of Hitler's rise to power in the early 1930s, many refugees fled to America. Among them were teachers at the Bauhaus, a German school of design that sought to merge the skill of the individual artisan with the requirements of mass production. According to the Bauhaus philosophy of education, it is important for the artist to explore qualities of materials and to experiment with different forms that might be suited to mass production.

American teachers of art who were trained by refugee Bauhaus teachers (or their students) found, in the Bauhaus emphasis on experimentation, an approach to art that seemed in accord with Dewey's emphasis on creative activity for children and the experimental method in learn-

ing.[19] By the mid-1940s, experimentation with materials had virtually become a doctrine in art education, and few art teachers questioned the value of this means of involving children in creative art activities.

By the early 1950s, however, it became apparent to some art educators that teachers had lost sight of the meaning of experimentation as a systematic inquiry into the nature of materials. In practice, it had come to mean little more than improvisation with media, and the more media the better. Although children were indeed inspired by opportunities to explore art materials, teachers too often accepted the superficial manipulation of materials as a genuine experiment or creative effort.

Today, most art teachers recognize that the expressive possibilities of a material are not limited to those that can be discovered by improvisation. Indeed, when the Bauhaus philosophy is practiced seriously, children's experiments with art media are quite deliberate and in the spirit of scientific experimentation:[20] their discoveries lead to greater control in achieving their expressive intent. Ideally, children are conscious of the decisions they make in designing their work and can apply their discoveries to new situations.

ART EDUCATION DURING THE SECOND WORLD WAR. During the Second World War, the nation's activities were concentrated on victory. In publications and at conferences, art educators stressed the freedom of expression enjoyed by citizens of a democracy, condemned the censorship imposed on people living under a totalitarian form of government, and advocated the development of well-rounded personalities as a remedy to future wars.[21] In schools, however, children made stereotyped posters for the war effort and they mass-produced patriotic mementos and decorative items for organizations like the USO and the Red Cross (Figure 1-16). Since art materials were in short supply, art teachers exchanged recipes for paste, paint, and modeling materials and found ingenious ways to use all sorts of scraps. Although rationalized by the same theme—patriotism—theory and practice were often at odds with each other.

Present-day teachers may find the extreme patriotism of the early 1940s somewhat strange. Whatever our judgment of that period, it is important to recognize that schools are social institutions, that they are influenced by national priorities and social problems. Because art forms are an effective means of communicating ideas and beliefs, they are often used for political or social ends. Today, art teachers are exploring ways to help children understand both the use and abuse of visual forms in shaping the attitudes of people. Advertising, product design, and visual symbols of various groups are examined as transmitters of social values and beliefs.

1-18 (*left*) The literature of art education reflects a strong interest in creativity.

1-19 (*right*) The academic emphasis of the early 1960s led to renewed interest in curriculum development.

ART AS A DEVELOPMENTAL ACTIVITY. After the Second World War, and largely as a consequence of that experience, the literature of art education considered the humanizing potentials of art (Figure 1-17). Making the world "safe for peace" seemed to depend on developing human creative capacities through freedom of expression.[22] The coercive influence of authority was recognized. Art activities were viewed as broadly therapeutic—a means for children to give expression to their experiences in a creative manner, free from the possible coercive influence of adult standards. Art educators believed that the intellectual, emotional, physical, and creative processes involved in producing art would help the child achieve an integrated, well-rounded personality. Thus, in the postwar years, the dominant theme in art education became human development through creative self-expression.

Today, this philosophy of art education is called the developmental point of view; in the process of giving visual form to experiences, the child's whole being is active. Ideally, there is such a complete integration of thought with feeling and of purpose with effective action that the process of creating art contributes to the development of personal maturity.

Contemporary art educators do not reject the developmental perspective, but they believe that children can benefit from studying works of art that have been created by adults. Exposure to adult art can become a satisfying experience if children gain a personal knowledge of how art is created, what it can express, and how it pervades everyday life. Through their comprehension of art, children become sensitive to the varieties of human experience that can be captured in visual form. Many art educators recognize the complementary relationship of education *through* art and education *in* art.

ART AND CREATIVE BEHAVIOR. In the late 1950s, the space race began, and interest in the relationship between artistic and general creativity reached a peak.[23] At that time, Russian technological achievements in space spurred Congress to fund educational programs in mathematics, science, and foreign languages in order to catch up with the Soviet Union in producing creative scientists and engineers. In the interests of strengthening the position of the art curriculum, some art educators believed it important to relate artistic creativity to the development of a general creativity in life, especially in mathematics and the sciences. Numerous publications justifying the development of creativity through art were issued (Figure 1-18). Although this justification of art education is still pervasive, it is not totally adequate.

Many educators assume that creativity is a desirable characteristic to nurture, that creative

behavior is always manifested in socially worth-
while ways. We might call this the fallacy of
creativity as a moral good. History teaches us
that creative behavior can serve morally offen-
sive ends as well. Both Einstein and Hitler, for
example, could be counted among the most
creative people of this century.

The problem of defining creativity is not
simple. One can hardly compare the traits and
performance of Michelangelo or Picasso with
those of elementary school children. In addition,
there is little evidence of the existence of a
general creativity trait that carries into every
aspect of life. Instead, creativity in each field of
endeavor seems to hinge as much on a sound
command of knowledge as it does on flexibility
and openness.[24] In short, there is no firm basis
for claiming that artistic creativity contributes
to a more general pattern of creative behavior.

1960 to the present

ART AS A BODY OF KNOWLEDGE. The first
Russian achievements in space led to many
changes in American education. In 1958, Con-
gress passed the National Defense Education
Act to encourage curriculum reform in mathe-
matics, science, and foreign languages. Academic
excellence became the keynote of education in
the 1960s (Figure 1-19). In response to the new

concern for educational achievement, art educa-
tors began to reexamine the academic status of
art and to view it as a body of knowledge that
should be transmitted to children. Efforts cen-
tered on the identification of key concepts and
fundamental behavior that would foster an un-
derstanding of the nature of art.[25]

In contemporary educational thought, art is
defined both as a body of knowledge and as a
developmental activity. Children are introduced
to basic concepts in art and to methods of in-
quiry that permit them to learn about the sub-
ject of art. At the same time, art educators are
committed to art experiences as a means of
nurturing personal maturity. The processes of
creating art and of responding to visual forms
develop the child's identity and openness to
experience. It is worth repeating that personal
development *through* art is as important as
learning *about* art.

ART AND THE SOCIAL ORDER. During the
1960s, the civil-rights movement focused atten-
tion on minority groups and the problems of
living in urban areas. Questions were raised
about the quality of life one could hope for in
an abused, polluted environment. These and
other social issues have caused art educators to
reassess the bearing of art on social problems.[26]
(Figure 1-20). Environmental awareness is now
an essential aspect of school art programs.

1-20 The social turmoil of the 1960s raised questions about the relevance of art education to urban and minority children. The social and communicative functions of art are now essential considerations in teaching art.

Almost every new program in the last decade can be considered a contemporary variation on earlier ideas.[27] Newer environmental-awareness programs, for example, although less ambitious than the Owatonna Project, are in the spirit of that earlier attempt at integrating art into everyday life. The concept of emphasizing career education in art was in evidence in Walter Smith's time, in the early manual-training programs, and in the years of the depression. Current interest in ethnic-arts programs are an effort to reverse the melting-pot trend that began in the early decades of this century. Recent interdisciplinary studies linking the arts or relating art to science have their roots in earlier concepts of correlated and integrated art. Other parallels have been pointed out in the discussion of each period, and even more could be noted in a more detailed treatment of historical developments in art education. However, it is time to summarize and determine which of history's many lessons is most important to us in the present.

Summary

The history of art education in the public schools is marked by shifts in theory and in practice. At various times, art programs have been dominated by one of three overriding concerns: developing the well-rounded child through art, promoting the knowledge and appreciation of art as a subject, and fostering the ability to relate art to daily living. In general, art educators have shown greater interest in children as creators of art than as appreciators of visual forms. The highly personal and creative nature of art has received more attention than the influence of art on society. The time is ripe for a fusion of these three concerns: personal fulfillment through art; appreciation of the artistic heritage; awareness of the role of art in society.

The historical comparisons reveal that it is not difficult for art educators to indoctrinate children with a particular view of society and the proper role of art within it. Indeed, at no time have we been so aware of the stereotypes—social, racial, sexual, vocational—that past educational practices and narrow concepts of art have helped to create. If it is easy to endorse a single doctrine of art education, it is also hazardous. What we need is a concept of art education that will help children to appreciate the artistry in varied life styles and to wisely shape their own. This is one of the main challenges facing art education in this decade.

A rationale for teaching art

The recommendations in this book are not the simple sum of historical ideas and contemporary

Functions of General Education	Purposes of Art Education
Encourages personal fulfillment	Encourages personal fulfillment through art experience
Transmits the cultural heritage	Transmits an appreciation of the artistic heritage
Develops social consciousness in youth	Develops an awareness of the role of art in society

practice. Although an effort has been made to account for the best of the past and present, the proposals developed in this text are necessarily selective. If some of the ideas seem controversial to you, so much the better. Through discussions, debate, and further study of these points, you should be able to clarify your own reasons for teaching art. The basic rationale for this book is outlined here to familiarize you with ideas that are developed in greater detail throughout the text.

Purposes of art education

In a democratic society, the power to determine the quality of life is shared by all the people, not just one person or a self-appointed few. The need for enlightened citizens leads to three primary responsibilities of general public education and, by implication, of art education. General education provides for *personal fulfillment*, nurtures *social consciousness*, and transmits the

cultural heritage to each generation. In practice, we say that school programs should be planned in relation to the *child*, the *subjects* that comprise the cultural heritage, and *society*.

Three major purposes of art education stem from the personal, social, and historical responsibilities of general education. School art programs encourage personal fulfillment by helping children respond to their immediate world and express its significance to them in visual form. Through studies of the artistic heritage, children learn that art is related to cultural endeavors of the past and present. By studying the role of art in society, children can begin to appreciate art as a way of encountering life and not view it as simply an esoteric frill. This rationale for school art education is outlined above.

PERSONAL FULFILLMENT THROUGH ART. When children use art as a means of expression and as a way of responding to life, it becomes a source of personal fulfillment. Learning to per-

ceive expressive forms is just as important as learning to create them. The two modes of art experience are dynamically interrelated; both are essentially creative processes. Children's perceptual awareness and expressive powers have to be cultivated so that children can clarify their feelings and make sense of the booming, buzzing confusion of raw experience. The educational task is to develop children's independence in creating art and in fully perceiving the world.

APPRECIATION OF THE ARTISTIC HERITAGE. The artistic heritage is broadly defined as organized knowledge about art as well as specific works that have been created by artists, designers, architects, and artisans of the past and present. When children's lives and artistic efforts are related to the artistic heritage, the entire experience is personalized, and children are helped to value the work of others. At the same time, their encounters with the artistic heritage confirm the authenticity of their own creative efforts.

AWARENESS OF ART IN SOCIETY. Children should understand that the visual forms they create help them express their own identities as well as their membership in groups. Visual forms also mark important events in their lives. In the same way, tools and spaces for living reflect people's expressive and physical needs in everyday life. The color, shape, and arrangement of objects in stores and in advertisements have a profound effect on behavior. We should help children become aware of the many ways visual forms can shape and express the feelings of people of all cultures.

The need for planning

If we grant that these purposes are important, we must make an effort to plan activities that will meet them. A totally casual and improvised educational program is inadequate. Precisely because the child's attitudes are well developed by early adolescence, each purpose must be met in a substantial way during the elementary and junior high years. The necessity for a planned art program is increased by the unhappy fact that few children receive any education in art beyond the junior high years. This book suggests how these purposes of art education can be fulfilled.

Notes

[1]Hazel Davis, project director, *Music and Art in the Public Schools*, Research Monograph 1963-M3 (Washington, D.C.: National Education Association, 1963), p. 57.

[2]See Associated Council of the Arts, *Americans and the Arts: Highlights from a Survey of Public Opinion* (New York: Publishing Center for Cultural Resources, 1974).

[3]Ibid. Also of value as a survey of attitudes toward art in our culture is the double issue ("Capitalism, Culture, and Education") of *The Journal of Aesthetic Education* 6 (1972).

[4]For a more detailed account of the history of art education, see Frederick M. Logan, *Growth of Art in American Schools* (New York: Harper & Row, 1955).

[5]Walter Smith, *Freehand Drawing and Designing* (Boston: James R. Osgood, 1873).

[6]Robert J. Saunders, "A History of the Teaching of Art Appreciation in the Public Schools," in *Improving the Teaching of Art Appreciation*, U.S. Office of Education Cooperative Research Project V-006 (Columbus: Ohio State University Press, 1966), pp. 1–47.

[7]For an excellent photographic essay on stereotypes, see John Berger, *Ways of Seeing* (New York: Viking Press, 1972).

[8]Saunders, "History of the Teaching of Art Appreciation."

[9]For a discussion of forms of excellence, see John W. Gardner, *Excellence: Can We Be Equal and Excellent Too?* (New York: Harper & Row, 1961).

[10]Information on traditional symbols can be found in encyclopedias and in the books listed in the Suggested Readings for Chapter 17.

[11]Oliver W. Larkin, *Art and Life in America* (New York: Holt, Rinehart and Winston, 1960), pp. 360–67.

[12]One of the most readable accounts of Dewey's philosophy is found in John Dewey, *The Child and the*

Curriculum (Chicago: University of Chicago Press, 1902).

[13]Gertrude Hartman, ed., *Creative Expression Through Art* (Washington, D.C.: Progressive Education Association, n.d. [ca. 1926]).

[14]Recognition of children's work as true art was also promoted by the aesthetic theory of significant form, the emergence of Gestalt psychology, and, indirectly, by the writings of Freud. See Chapters 3 and 4.

[15]For an example of this philosophy, see Leon Loyal Winslow, *The Integrated School Art Program* (New York: McGraw-Hill, 1939).

[16]For an overview of the status of art in the prewar years, see G. M. Whipple, ed., *Art in American Life and Education*, Fortieth Yearbook of the National Society for the Study of Education (Bloomington, Ill.: Public School Publishing, 1941).

[17]Melvin Haggarty, *The Owatonna Art Education Project* (Minneapolis: University of Minnesota Press, 1936).

[18]For exemplary curriculum materials, see Group for Environmental Education, *Our Man-Made Environment: Book Seven* (Philadelphia: GEE, 1971).

[19]The method is described in John Dewey, *How We Think* (New York: D.C., Heath, 1910), p. 72.

[20]For a description of the analytic character of the Bauhaus program, see Gillian Naylor, *The Bauhaus* (London: E. P. Dutton, 1968), pp. 76–132.

[21]Hellmut Lehmann-Haupt, *Art Under A Dictatorship* (New York: Oxford University Press, 1954), and "Art Education and the War," in *Art Education Today*, Fine Arts Staff, Teachers College, Columbia University (New York: Teachers College Press, 1943).

[22]Eastern Arts Association, *Art Education for One World: Yearbook 1946* (Kutztown, Pa.: Kutztown State Teachers College, 1946) and *Art Education in a Free Soci-ety: Yearbook 1947* (Kutztown, Pa.: Kutztown State Teachers College, 1947). Also National Art Education Association, *Art Education and Human Values: Yearbook 1953* (Kutztown, Pa.: Kutztown State Teachers College, 1953) and *Art: A Frontier for Freedom: Yearbook 1955* (Kutztown, Pa.: Kutztown State Teachers College, 1955).

[23]The literature on creativity is voluminous. For an orientation to this topic, see Lambert W. Brittain, ed., *Creativity and Art Education* (Washington, D.C.: National Art Education Association, 1964).

[24]Frank Barron, "The Creative Personality: Akin to Madness," *Psychology Today* 6 (1972):43–85.

[25]Edward L. Mattil, project director, *A Seminar in Art Education for Research and Curriculum Development*, U.S. Office of Education Cooperative Research Project V-002 (University Park: Pennsylvania State University Press, 1966).

[26]June King McFee, "Society, Art, and Education," in Mattil, *A Seminar in Art Education*, pp. 122–40.

[27]Al Hurwitz, *Programs of Promise: Art in the Schools* (New York: Harcourt Brace Jovanovich, 1972).

Suggested Readings

Eisner, Elliot. *Educating Artistic Vision*. New York: Macmillan, 1972. Chapter 3.

Logan, Frederick M. *The Growth of Art in American Schools*. New York: Harper & Row, 1955.

———. "Up Date '75, Growth of American Art Education." *Studies in Art Education* 17 (1975): 7–16.

MacDonald, Stuart. *The History and Philosophy of Art Education*. London: University of London Press, 1970.

Basic concepts in art

Virtually all our artistic perceptions, actions, and observations are channeled through a few basic concepts: *art form*, varieties of art products and how they function; *medium*, the means through which a work is created; *design*, the plan within a work of art; *subject matter*, the meanings conveyed through a work; *style*, a family resemblance in a group of works.

These concepts are fundamental; they are tools for your own understanding of art and for communicating art to children. The concepts are basic because they direct our attention to important features in art, and they make the communication of those features more efficient. In addition to orienting you to terms that are commonly used and distinctions that are frequently made in discussions about art, the concepts can serve as points of departure for appreci-

ating art, creating it, and planning art experiences for children.

Art forms and their functions

Efforts to classify art forms are never entirely satisfactory. New forms of art often challenge traditional categories and defy tidy classification. Nevertheless, some of the common distinctions are noted below.

Classification schemes

Art forms are frequently classified by dimension and sensory appeal. The *three-dimensional arts*

include products with height, width, and depth, while *two-dimensional* forms are essentially flat and depend on visual illusions for a sense of depth and volume. The *visual arts* are composed of forms that appeal primarily to the eye, while the *spatial arts* include objects that appeal to the kinesthetic and tactile senses. *Plastic arts* are created by shaping substances like stone, metal, or wood. In the *graphic arts,* surfaces are marked, printed, or designed. All of these categories are *descriptive*—that is, they divide art forms into broad groups without implying value judgments.

Many classification schemes are *honorific.* They categorize forms according to merit or to acceptability to a particular social or economic class. For example, many art historians distinguish the *fine,* or *major, arts* of painting, sculpture, and architecture from the *applied,* or *minor, arts,* such as crafts, drawing, printmaking, and graphic and product design. The judgmental classification stems from the ancient Greek belief that truly important art forms are intellectually and spiritually imposing, not merely utilitarian.[1] This belief, which is deeply imbedded in Western thought, perpetuates an aristocratic attitude toward forms of art that have popular appeal or that contribute to the artistic quality of everyday life. The Greek concept of the superiority of the fine arts also provides the rationale for the use of such terms as "primitive art" or "folk art" to disparage works that seem to be untutored or naive.

Today, there is both growing appreciation of the scope of human artistry and serious criticism of classification systems that are biased toward Western values.[2] *Tribal art* forms like totems, amulets, ceremonial containers, and body adornments are no longer prejudged as "primitive" in the derogatory sense. Similarly, the *folk arts,* once regarded as naive and amateur, are now appreciated for their immediate relevance to everyday life and their preservation of local or ethnic artistic traditions.

The *popular,* or *mass, arts* include forms that are mass-produced for large audiences, such as comic books, movies, television, fashion, advertising, and product design. Popular art is viewed as either a "watered-down" version of fine art in which professionally trained commercial artists are usually responsible for its design, or as a "souped-up" version of folk art in which the goal is to appeal directly to many people and maintain a wide circulation. Whatever our judgment of its merit, popular art is unique in that it attempts to reconcile the unschooled taste attributed to ordinary people with the sophisticated discernment ascribed to art experts. In this sense popular art reflects a democratization of art.

As you can see, the task of classifying art forms is not easy, nor has it always been carried

out in a purely descriptive way. It is important to be aware of the Western cultural bias that underlies some of the most familiar classification schemes, such as "fine" versus "applied" art. Indeed, many cultures have no word at all for art. Instead, the concept of art is conveyed by referring to specific objects and events that are important in everyday life and that are admired because they are fashioned with attention to their use and meaning.

Specific art forms

It would be an impossibility to list every object or event that might be regarded as art or as part of the artistry in living. At the same time, we must have some way of mapping out the scope of forms we believe children should encounter as part of their education in art. In the context of teaching art to children we will consider, in Chapters 11 through 17, the following forms of art: drawing and painting; printmaking and graphic design; photography, film, and television; sculpture; crafts and product design; architecture and environmental design; ceremonial and holiday arts.

Each of these art forms can be understood as a vehicle for children's personal expression as well as a means of acquainting children with their artistic heritage and the social aspects of art. Brief descriptions of some of the characteristics of these art forms are provided here.

Drawing and *painting* involve similar processes. Drawing is usually more linear than painting and less dependent on color. In both processes, a coloring agent is applied to a surface with a tool. Some coloring agents are pigments, dyes, colored clays, chalk, or powdered glass. In order to make it workable, the coloring agent is usually mixed with a binder, or adhesive, such as wax, linseed oil, gum arabic, or egg yolk. Painting and drawing media can be applied to a wide range of surfaces, such as paper, cloth or canvas, wood, metal, or plaster. Drawings may be finished works of art or preparatory sketches (Figure 2-1).

A *mural* is a large painting made for a particular architectural space. A *miniature* is a small painting, historically associated with illuminated manuscripts and small portrait keepsakes that were often decorated with precious stones and used as jewelry. An *easel painting* is of moderate size, portable, and usually done on canvas stretched on a wooden frame. Some compositions are painted on two panels—diptychs—or on three panels—triptychs. Multiple panels like these were first used as altarpieces. Since the mid-1960s, artists have experimented with three-dimensional surfaces to develop paintings that often resemble polychrome (many-colored) relief sculpture.

2-1 Albrecht Dürer, *Self-Portrait at 13,* silverpoint (1484).

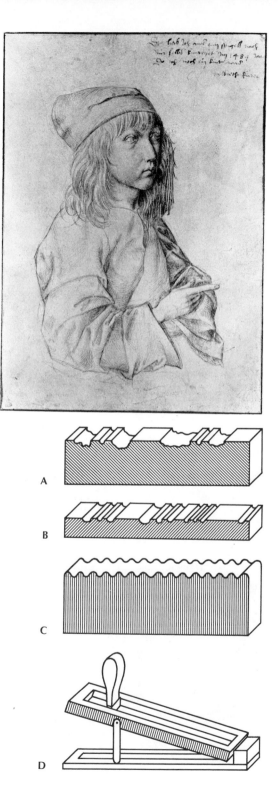

2-2 Basic printing processes.
A Relief (Woodcut)
B Intaglio (Etching)
C Planography (Lithography)
D Stencil (Serigraphy)

Printmaking and *graphic design* are related art forms in that both are concerned with the reproduction of images. A *print* is made by transferring an image from one surface to another, usually in a way that permits duplication of the original. Basic printing processes are illustrated in Figure 2-2. In *relief* printing, the image to be printed is raised from a background. In the *intaglio* process, the image to be printed is below the surface. The ink is forced into grooves, and excess ink on the surface is wiped away. The image is transferred by applying pressure to the plate so that the ink is drawn from the channels. In *stencil* printing, the image is cut into a protective sheet. Ink is applied through these cut-out shapes to the surface underneath. In *planographic* printing, the image is transferred by a resist process. The drawing is done in a greasy medium that attracts oil-based ink, but on a surface that is chemically treated so that it repels excess ink. Examples of prints made by each process are shown in Figure 2-3.

When it is the artist's intent to make a print using a particular duplicating process, the result is considered an original work of art in multiple form. (In contrast, a *reproduction* is a printed copy of a work that was originally executed in another medium, such as paint.) An *artist's proof* is a trial print made during the preparation of the printing surface. The total number of prints that will be made is called an

2-3 Examples of print qualities.

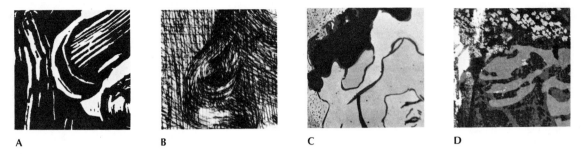

A B C D

A Käthe Kollwitz, detail of *The Mothers,* woodcut (1935).

B Pablo Picasso, detail of *Head of a Woman,* etching (1905).

C Henri de Toulouse-Lautrec, detail of *Jane Avril,* lithograph (1893).

D Mary Corita, detail of *Angel,* serigraph.

2-4 *1976 Annual Report,* General Electric Company.

edition. Since the original surface on which the image appears undergoes subtle wear and tear as each print is made, prints made later in an edition may differ from earlier ones. Thus, the place of a particular print in an edition is shown on the print. The number 8/50 indicates the eighth print in an edition of fifty. In a *limited edition,* because the printing surface is defaced after a specific number of prints are made, the existing prints are thought to be worth more.

Graphic design encompasses a wide range of two-dimensional images used in advertising, publications, and signs as well as the repetitive designs found in continuous surfaces like wallpaper, wrapping paper, and fabric. A *layout* is a preliminary composition showing the basic idea and major elements of the final work. The art of designing (or selecting) and organizing letter forms appropriate to a purpose is called *typography.* *Illustration* is the art of visually clarifying and communicating an idea, mood, or story. In the skill called *drafting,* parts of a complex process are visually coded so that others can carry out construction. The artistry in graphic design lies in the creation of images that effectively communicate to a specific audience (Figure 2-4).

Photography, film, and *television* are twentieth-century art forms. A photograph is produced by exposing light to a light-sensitive surface and making the image permanent by chemical treatment. The camera permits the

2-5 (*left*) Ansel Adams, *Death Valley National Park.*

2-6 (*below*) Charlie Chaplin in *The Pawnshop* (1916).

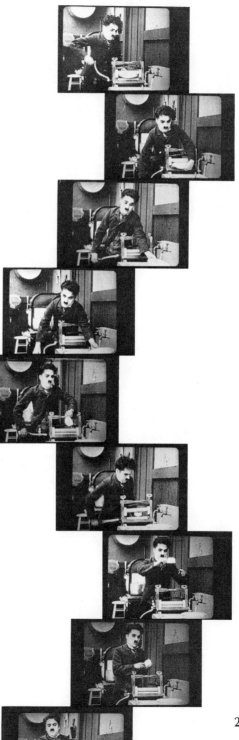

photographer to frame and focus selected images and to control the amount of light captured on the light-sensitive film. The artistry in photography involves choosing the decisive moment to snap the picture, chemically developing the print, and cropping (trimming) and mounting the final photograph (Figure 2-5).

Cinematography is an art form based on multiple sequences of images that seem to move. The illusion of movement is created by a visual afterimage effect. Physiologically, the eye retains an image for a moment after the picture is no longer being received by the retina (Figure 2-6). Different techniques can be used to create the illusion of being in two places at once (parallel editing), experiencing the past in the present (flashback), perceiving many things at the same time (montage), leaving one situation (fade out) and arriving at another (fade in), or of being either a spectator or a participant in an event (distance and angle shots).

Television images are created by electronic impulses broadcast through the air. Unlike film, television can transmit images of live events from anywhere in the world. In addition, the images come to us in the home, a radically different context from a darkened theater, where attention is virtually guaranteed. Home viewing makes television a more intimate form of art than film or theater. Nevertheless, because television is usually competing for our attention in a space that is animated by other activities, its

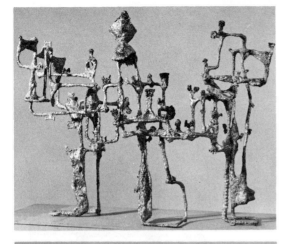

A

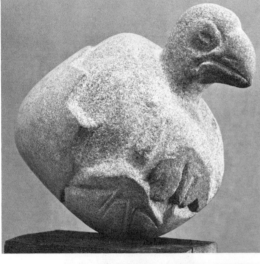

B

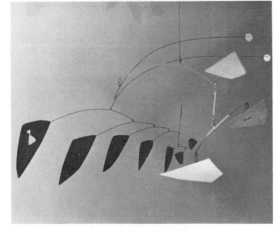

C

2-7 Varieties of sculpture.
A Ibram Lassaw, *Procession,* welded (1955–56).
B John Flannagan, *Triumph of the Egg, I,* carved (1937).
C Alexander Calder, *Two White Dots in the Air,* assembled (1958).

dominant modes of presentation are based on contrasts in sound and on movement and size of image.

Sculpture is a three-dimensional art form. A *free-standing* form is designed to be seen from all sides, while *relief* sculpture is planned with one view in mind and is usually mounted on a wall or placed in a niche. In low-relief, or bas-relief, sculpture, the raised surfaces extending from the background are less extreme than in high-relief sculpture. A sculpture painted in varied colors is called *polychrome* sculpture. Forms in *mobile,* or *kinetic,* sculpture actually move in space, with activation provided by air, water, heat, gravity, magnetic fields, chemical action, or electricity. Sculpture may be as small as a piece of jewelry or, like Mount Rushmore, as large as a mountain. Varieties of sculpture are shown in Figure 2-7.

The basic processes for creating sculpture are carving, casting, and constructing and assembling. Carving is a subtractive process; it involves cutting away or removing parts of the medium. Because it is often difficult—or impossible—to replace parts that are cut away, the carver usually works from a plan or preliminary idea. Casting is an indirect process by which one or more permanent works are reproduced from a less permanent model. Any material that can solidify from the liquid state, such as molten metal, watery clay called slip, plaster, and molten glass,

BASIC CONCEPTS IN ART

is poured into a mold and allowed to harden. The sculpture, which in hardening has assumed the shape of the mold, is then removed from the mold. In assembling or constructing a sculpture, the artist selects and groups materials to create a new form. The methods of fabrication are usually evident in joints that are welded, nailed, sewn, glued, or bolted.

Crafts and *product design* are related forms of art, since both originated in the need to create tools and utensils for daily living. Crafts are objects made by hand, usually for everyday use. The fabrication process is under the direct control of the craftsworker, who is often highly skilled in a particular medium. Crafts are usually defined by medium and process. *Ceramics* refers to the art of making clay objects heated at high temperatures. *Textiles* include fiber-made products that are woven, printed, dyed, and stitched. *Enameling* is the process of heating ground colored glass to fuse it with metal. Metal- and woodworking, leather crafts, glassmaking, stained glass, and mosaics are also counted among the crafts.

The product designer plans and creates models of objects intended for mass production: furniture, appliances, housewares, industrial equipment and hardware, tools, containers, and means of transportation fall within the province of product design. To ensure that an item will function properly and can be mass produced,

2-8 Handmade and mass-produced tools.
A Millers Falls plane (1957).
B Early American hand plane.

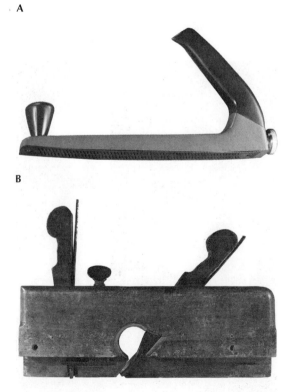

A

B

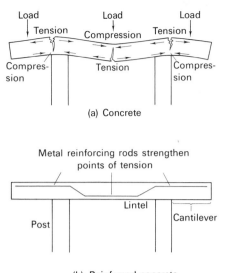

(b) Reinforced concrete

Post and lintel construction.

2-10 (*this and opposite page*) Structural principles in architecture.

2-9 Skidmore, Owings, and Merrill, *Lever House* New York (1950–52).

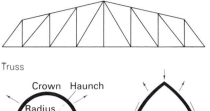

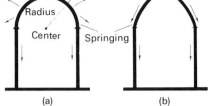

The dynamics of arches.

product designers frequently work with engineers. Sometimes, extensive consumer research is carried out with mock-ups, models, or full-scale test versions before a product design is decided on. Handcrafted and mass-produced forms of the same tool are shown in Figure 2-8.

Architecture and *environmental design* are concerned with the quality of the spaces in which we live, work, and play (Figure 2-9). Architecture is a functional art form experienced from the inside and outside both visually and spatially. Architectural forms are determined, in part, by the site on which they are built, the characteristics of available materials, and their intended physical and psychological functions. Principles of construction are complex, dealing with the effects of stress, tension, and gravitational pull on massive, heavy forms that span open spaces. Examples of common solutions to structural problems are shown in Figure 2-10.

Interior design enhances the physical and psychological activity that occurs within a space. The designer's primary tasks are to choose and arrange ready-made objects to suit the needs and life style of the client, taking into account the basic activities that occur in the space as well as preferences for formality or casualness, privacy or openness.

Specialists in community, urban, or environmental design integrate natural and constructed environments to accommodate different life styles. The interdependence of services

BASIC CONCEPTS IN ART

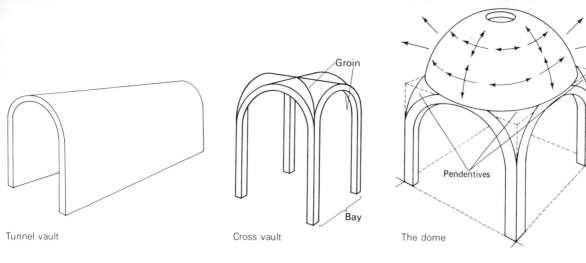

Tunnel vault Cross vault The dome

and activities in a metropolitan area makes some form of planning essential. Community planning may be as comprehensive as developing a new town or as localized as revitalizing a neighborhood. In coordinating change, urban planners try to anticipate patterns of growth. Land use, basic services, physical structures, and systems of transportation and communication are among the factors that are considered.

Geodesic dome

Ceremonial and *holiday arts* enhance the celebration of special private and public events. Birthdays, anniversaries, holy days, initiations, graduations, weddings, and funerals are among the occasions marked by the presence of artifacts that have been especially chosen, created, or arranged for the event (Figure 2-11). Costumes or uniforms, flags and bunting, certificates, trophies, jewelry, containers, and utensils can add a ceremonial dimension to an event. Some of the arts of body adornment—masks, tatoos, decorative body scars, jewelry, body and face makeup, hair styling, hats and crowns—are practically universal and are frequently used in ceremonial ways. Fashion and costume design are professional fields devoted to the art of body adornment.

2-11 The meaning of ceremonies is enhanced by visual forms: a Navaho ceremony makes use of sand painting.

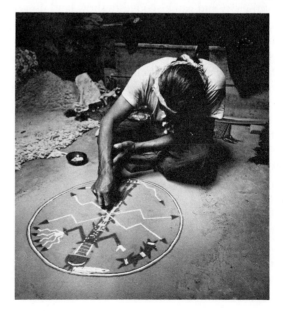

Functions of art forms

Art forms have always served a variety of functions—personal, social, physical, political,

religious, educational, and economic. Although art forms can be made to function as people choose, there are three major relationships between the character of an art form and its function in human activity.

First, each art form offers distinct possibilities for expressing an idea or solving a problem. Consider the assignment of portraying a city. A painting can capture the mood of the city, especially through color. A movie may document the changes in the city at different times of day and the sequence of spatial experiences the city affords. A map gives an overall sense of the shape of the city and can be coded to show land use. A table-top architectural model can show the patterns of vertical density created by buildings. The choice of an appropriate art form is essential in achieving a particular expressive or communicative purpose.

Second, a variety of art forms sometimes serves the same basic need or function. Consider the different art forms that can be used to express national identity: flags, official seals, stamps, currency, civic buildings and monuments, uniforms for government employees, and so on. Within a ceremonial context, the particular character of each art form may actually be less important than the combined effect of related forms. For example, a birthday celebration may be noted by a variety of art forms, including a decorated cake, candles, unusual hats, and gifts in special wrappings.

Third, the particular function of an art form is often determined by the context in which it is experienced. A chalice designed to function in an inspiring religious ceremony may lose its religious connotation when displayed in an art museum, but it may still be aesthetically inspiring. Similarly, a flag freely waving on a pole acquires a different symbolic meaning when it is draped over a casket at a funeral service. In short, neither the function of art forms nor their particular characteristics can be understood apart from the uses people make of them.

Medium

Medium, the singular form of *media*, refers to the means by which a work of art is created. When Marshall McLuhan says, "The medium is the message," he is reminding us that materials like cloth, stone, wood, and metal seem to command our senses in particular ways.[3] Discussions of media usually involve references to the materials, tools, and techniques of the artist, as well as to the symbolism of the materials and processes used.

Materials

The sensuous qualities of materials such as clay, paint, metal, and wood are of great interest to

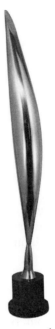

the artist. For example, the artist who works in wood will be keenly aware of the grain, density, color, texture, and odor of particular kinds of wood. Artists are also aware of the possibilities and limitations of materials. In shaping wood, the artist must pay close attention to the direction and density of the grain and the degree of force required to cut it. A material becomes a medium when the artist singles out particular qualities of the material to shape and develop. Ceramic clay can be a medium for expression in two- or three-dimensional form; it can be finished so it is smooth or rough, shiny or dull. Particular choices among qualities transform a material into a medium for expression (Figure 2-12).

2-12 All materials have a range of potentials as *media* of expression, as seen in these two bronze sculptures. (*above*) Constantin Brancusi, *Bird in Space* (1925). (*below*) Alberto Giacometti, *Man Pointing* (1947).

Tools, equipment, services

Although most artists are very exacting about the tools they use, they are skilled at adjusting their work habits when the right equipment is not available. One of the most versatile tools is the human hand, and it can be used alone to shape many materials. Hand-held tools are sufficient for much work. Equipment such as printing presses, potter's wheels, kilns, and looms permit an artist to create forms that are not possible with the hand alone. In some fields of art, the services of technicians are necessary: architects and product designers work with engi-

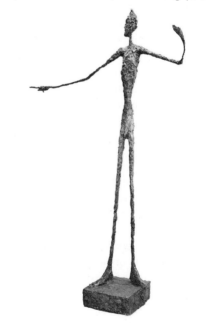

neers; graphic designers depend on typesetters and printers. Technical services are as essential to the designer as a loom is to the weaver.

Techniques

There are two general types of artistic techniques: conventional and personal. A conventional technique is a relatively standard method of achieving a known effect. For example, a wash, which is a thin coat of very diluted paint, is a conventional technique in watercolor painting. A personal technique is the artist's individual way of using a medium. It is analogous to the unique quality in each person's handwriting. Anyone can learn a conventional technique, but a personal technique cannot be taught.

Symbolism

Every material has subtle personal and cultural meanings—connotations—to which artists are sensitive. Some materials seem to be warm, others cold, still others rugged or temporary or garish or rare. These connotations influence our response to a work of art. For example, even someone who is not a Christian would probably respond differently to a crucifix fashioned of wood, or of iron or leather or paper or plastic or neon or gold and precious gems.

For the creator of art, the expressive power of a medium often stems from connections between qualities of the material and life itself. For the woodworker or stonecutter, for example, the raw material may seem to have a life of its own, almost as if it were communicating with the artist while it is being shaped. Often a piece of wood or a block of stone seems to have a unique personal history; at the same time it seems to speak of all human experiences with wood or stone. To the extent that viewers can see and feel connections of this kind, the medium holds affective power for them.

Design: visual structure

The word *design* is both a verb and a noun. As a verb, *design* means "to plan in relation to a goal or purpose." As a noun, *design* refers to the organization, arrangement, or composition of a work. Thus, we can consider design as either a process or as the result of a process.[4] The prime concern of the designer is to plan a work so that viewer responses are influenced by the perception of qualities and relationships portrayed.

Qualities of line, color, shape, texture, and value (light and dark) are treated as the most important visual phenomena, or elements, that the artist organizes and the viewer perceives. By planning the relationships among particular

qualities of line, color, and so on, the artist can sustain the viewer's attention. The affective power of art stems, in part, from our ability to project human meaning onto inanimate lines, colors, and shapes. Sometimes visual and tactile qualities echo personal and cultural experiences of which we are scarcely conscious.[5] In some cases, visual and tactile qualities actually generate physiological activity in the eye and body.[6] Our responses to line, color, shape, and related phenomena are governed by the fact that we are active, upright creatures who, in spite of our individuality, think, feel, and see in fundamentally similar ways.

Visual and tactile phenomena

LINE. We usually think of line as a record made by the moving point of a pencil, pen, or other tool. When we look at a line, we can imaginatively re-create the actions and feelings that might have produced it. We speak of lines as hesitant or bold, nervous or lyrical, almost as if they had real life and personality. The correspondence between what we see and how we feel or think extends to other qualities of line as well. We can group lines to evoke a sensation of texture, to suggest light and shadow, and to indicate form. If we place lines so that they converge, we create the illusion of depth. We can overlap lines to portray transparency in a

form. *Implied lines* also have expressive power: the contour of an object can be seen as simply a line or as an outline of an object in silhouette. The overall movement within a form may be only linear. We can suggest a form through a series of points or edges that may not be connected but are aligned in some way. The "personality" of these implied lines can be planned to influence the viewer's response.

Lines have personal and cultural associations. Many people think of curved lines as gentle and organic, while straight lines seem to have active and mechanical associations. Zigzags and S curves appear aggressive and energetic, especially if they are condensed. Broad lines seem strong and forceful; narrow lines, wiry or delicate. Vertical lines suggest an upward striving or strength. Diagonals set up tensions, while horizontals remind us of things at rest.

Lines can be used to communicate specific, coded meanings. Alphabets, street markers, maps, diagrams, blueprints, musical and mathematical signs—all are symbol systems based on the graphic power of line. *Calligraphy* is a form of elaborate handwriting expressing a delight in the beauty of lines. While it usually appears on diplomas and other documents, calligraphy can also be found as decoration on automobiles, camper vans, and delivery trucks. The ornamental use of line is evidenced in wrought-iron work, architectural details, textile and carpet design, and wallpaper. Cartoons and caricatures gain

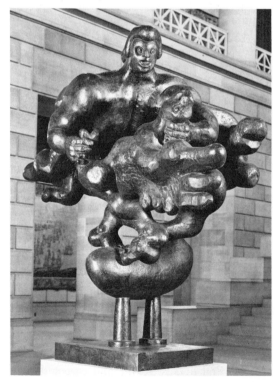

2-14 (*below*) Jacques Lipchitz, *Prometheus Strangling the Vulture II* (1945–53).

2-13 (*left*) Margaret Bourke-White, *Contour Plowing, Walsh, Colorado* (1954).

2-15 (*opposite, left*) The "Modulor" system of proportion developed by the architect Le Corbusier shows the versatility of well-planned shapes.

2-16 (*opposite, right*) Georges-Pierre Seurat, *At the "Concert Européen"* (c. 1887): a dramatic use of value contrasts.

their expressive power from the versatility of simple lines (Figure 2-13).

SHAPE AND VOLUME. Shape indicates length and width; volume, length, width, and height. The relationship of shape to volume is reflected in the difference between a circle and a sphere, or a square and a cube. The general term *form* refers to shape or volume. The functions and connotations of shapes and volumes are similar to those of line.

The shape or volume to which our attention is normally drawn is called positive space, or *figure*. The surrounding area is called negative space, or *ground*. If we deliberately focus our attention on the negative space, we can see that its presence, outline, and action are just as important as the positive form. Artists often shift their attention back and forth between the figure and the ground in order to study the visual clarity, interest, and dynamics of their forms.

The open or closed character of shapes and volumes can also be used expressively. Shapes may appear to be solid and opaque; volumes, impenetrable and blocklike. Volumes and shapes can appear to be transparent and open. Action and movement can be suggested through rhythmic overlapping of planes or irregular edges. Shapes and volumes seem organic and dynamic if they have continuous surfaces and

BASIC CONCEPTS IN ART

curves, geometric and static if they have defined edges and angles (Figure 2-14).

PROPORTION, SCALE, SIZE. Like other visual phenomena, size is relative; it is experienced as a continuum. Our sense of scale and proportion is usually determined by our own size (Figure 2–15). We tend to perceive things as life-size, miniature, or monumental. In pictorial work, the relative dimensions of an image are influenced by the shape and size of the background. Depth can be suggested either by varying the size of a recognizable shape like a person or by placing the shape higher or lower in the background. We can change proportional relationships to suggest that something is near or far, isolated or confined. By exaggerating the size of a part or by placing it higher than others, we can suggest its relative importance psychologically and hence, expressively.

VALUE. Value is the relative lightness or darkness given to a surface by the amount of light reflected from it. Extreme contrasts in light and dark areas tend to make objects more visible, easily recognizable, and dramatic. Gradual shifts from light to dark provide clues to the relative solidity and distance of objects. Varying the degree of lightness of the background influences—by contrast—the apparent darkness of

any element in it. Highlights and shadows, actual or implied, are important elements in suggesting texture and volume in a form. Direct light accentuates a form by creating highlights, while light reflected from one surface to another has a more subduing effect (Figure 2-16). A form is defined indirectly by cast shadows, which suggest the direction of the source of the light.

TEXTURE. Texture refers both to the actual surface of a material—that is, its tendency to be smooth or rough, soft or hard, one color or variegated—and to the visual illusion of texture. Actual and visual texture may interact and complement each other, as in thick brush strokes that echo the edge of a form. By varying textural detail, the artist can make some surfaces dominant and others subordinate. Textures can be mechanically spaced to suggest a definite pattern, or graduated to suggest depth or form.

COLOR. Color is surely one of the most exciting and complex of visual phenomena. We shall examine some of the elementary aspects of color: its basic properties, the principles of mixing it in paint, and its symbolic use.

If a red dye is applied to several different kinds of paper, it will vary slightly in color from

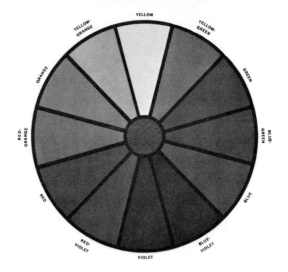

2-17 The color wheel is a convenient aid in understanding color relationships.

one surface to another. Similarly, reds in yarn, watercolor, clay, or neon light offer distinct qualities for our perception even though they share the attribute of redness. The common trait by which we identify a color is called its *hue*.

The color wheel is a convenient device for illustrating the fundamentals of mixing color (Figure 2-17). The *primary* colors of pigment are red, yellow, and blue, so called because other colors are mixed from them. (Primary colors of light are yellow, red, and green). Orange, green, and purple are *secondary* colors; they are mixed from adjacent primaries. *Intermediate* colors can be mixed by altering the proportions of primary or secondary colors. Colors opposite each other on the wheel are called *complementaries*. Mixed together, they contain the three primaries, and, by altering their proportions, one can produce various browns, grays, and neutral tones. Placed side by side, complementaries vibrate, intensifying each other. A light color, or *tint*, is created by adding white to a color or by diluting a color with a vehicle (water, oil, wax) to give it transparency. A dark color, or *shade*, is made by adding a complement or black.

Personal associations and cultural traditions influence the symbolic connotations of colors. Red, yellow, and orange are called warm colors because they remind us of warm things, such as the sun and fire. Blue, green, and purple are called cool colors because they remind us of cool

things, such as ice, water, and shade. Overcoming color stereotypes is often difficult. Water and sky are not always blue; grass is not always green. Only recently have crayon companies stopped manufacturing a color they termed "flesh," which was light red-orange and clearly reflected a bias. Color coding, as in traffic signals, brand names, and uniforms, is an important means of standardizing recognition responses.

Organization or structure

When artists plan such features of a work as placement, size, and color, they make very subtle judgments about relationships among these components. Like novelists, poets, composers, and choreographers, artists must determine which parts of their work will be dominant and which subordinate. They decide where contrasts and tensions are needed, where incidental counterpoints to a major theme will energize response, where continuity is desirable. Taken together, these judgments give structure to a work and influence the overall response of the viewer. Two guiding principles for organizing a work are unity and variety.

UNITY. One of the relationships most people seek by nature is unity—that is, a feeling of coherence, equilibrium, order, and wholeness.

38

Visual and spatial order give us a feeling of psychological order. A sense of unity can be achieved in many ways: through the choice of similar shapes, colors, or other characteristics of forms; through the placement of the same—or different—forms in close proximity; through the planning of continuity in the feeling of movement. *Closure* is the tendency of the eye to complete a form that is only partially visible. Edges that seem to extend beyond their actual boundaries imply a complete or closed form. A symmetrical arrangement of elements that are approximately equal in psychological importance suggests equilibrium. Any systematic repetition of colors, lines, shapes, or volumes creates a predictable rhythm and thus unity in composition.

VARIETY. Totally unified works are likely to bore us; variety within unity sustains our interest. In order to create interest in a work, we can vary its visual and spatial qualities: separating shapes and colors allows us to see them as distinct entities; interrupting a dominant motion or rhythm gains the viewer's attention. Ambiguity and exaggeration invite extra participation and increase interest, since tension is heightened when forms are juxtaposed contrary to our normal expectations.

If unity and variety are judiciously used as guiding principles for creating a work, viewers are not likely to be easily bored *or* fully satisfied by a quick encounter with it; they will probably want to return to the work again and again. However, the formal relationships of unity and variety in line, texture, color, and the other visual phenomena do not, in themselves, give art its expressive aspect. Rather, *it is our capacity to perceive such phenomena as connections with life that gives them evocative power.* It is for this reason that so much of art education is ultimately concerned with life itself. To see a work and feel it as "peaceful" or "angry," we must first know something of peacefulness and anger.

Subject matter and expressive content

If life is important to our understanding of art forms, media, and design, and is enhanced by our understanding of them, it is surely essential to the overall meaning of any work. *Subject matter* refers to the actual or implied content presented in or through a work of art, which may have several levels of meaning.

Recognizable things and events

Many works of art are based on images from ordinary experience: still lifes, portraits, inte-

2-18 Four interpretations of cities.

A John Marin, *Lower Manhattan* (1920).

riors, city scenes, and landscapes. Scenes of everyday activities are depicted realistically in a form of painting called *genre painting*. Natural elements, such as plants, animals, weather, the seasons, and time of day, are often treated in such works of art. Some familiar images refer to historical events, myths, legends, or political and religious themes.

Symbols

A *symbol* is an image that stands for something else. Conventional symbols have a definite meaning within a particular culture. In the Christian faith the cross and the halo symbolize divinity. The skull and crossbones represents danger or death. In American culture, certain trademarks for products and company logos have become conventional symbols. Unconventional symbols may embody associations that are unique to a particular artist, or they may be so remote from our experience that a cultural or historical explanation is essential to their interpretation.

Themes and interpretations

The experienced viewer can recognize such recurrent themes as birth, marriage, death, victory, defeat, and love, and can also detect an artist's particular attitude toward a subject (Figure 2-18). The artist's approach might be factual, spiritual, critical, whimsical, or analytical. Artists have depicted woman, for example, as mother, as saint, as harlot, and as sex object. Similarly, the theme of death has been treated both as an agonizing physical experience and as a calm, spiritual conclusion to life. Sometimes subjects are dealt with allegorically—that is, an artist portrays some situation—historical, mythical, or fanciful—in order to represent abstract ideas, such as truth, purity, time, and innocence.

Expressive content

Expressive content refers to our "best guess" about the significance of a work at each of the preceding levels of meaning. Because these different meanings are also shaped by the artist's use of media and by the visual organization of the work, we have to consider the interrelatedness of subject, medium, and visual structure. Expressive content may evoke a feeling that the work has affected us in a distinct way that cannot be fully conveyed in words. The expressive content we discover in a work depends on the features the work presents to us, and our skill in perceiving and interpreting their meaning. Detecting the expressive content in a work

B Charles Sheeler, *City Interior* (1936).

is not only the conclusion but also the reward of a full act of creative perception.

Style

The word *style* comes from the Latin *stilus*, a sharp, pointed tool used by the ancients for writing on clay tablets. In art, *style* refers to a family resemblance among works by virtue of their common features. The individual style, which makes an artist's work different from that of any other artist, is called an *idiom*.

Most of us are acquainted with "period" styles used by art historians. Texts on art history are usually organized to show stylistic trends, from the ancient arts of Egypt to the classical traditions of Greece and Rome, to medieval and Renaissance art, and so on through the twentieth century. Other approaches to style are based on a family resemblance apparent in works produced by a particular culture or in a specific geographic region.

Although chronological, cultural, and geographic definitions of style are valuable, they presuppose a detailed knowledge of historical facts that the nonspecialist does not necessarily possess. Moreover, stylistic similarities can be identified in works that are distant in time and space. For these reasons, it is preferable to regard styles as different ways of comprehending life

and making sense of the realities of human experience.[7]

Expressionistic works

Expressionistic works of art reflect an emotional interpretation of reality. Images are usually symbolic records of feelings that the artist has tried to capture in a direct, energetic manner. Sometimes shocking, often sentimental or romanticized, this style expresses the reality of our personal feelings about nature and the human condition. Expressionistic works of art often exaggerate the size, color, and linear movement of forms as if to force a response that is as intense as the feeling the artist sought to express (Figure 2-18a).

Realistic works

Realistic works demonstrate the artist's interest in careful observation of the external world—including people, nature, and the constructed environment—and often present a precise and detailed inventory of sense qualities and psychological relationships. Some works are based on systematic observation of recurrent patterns and forces in nature. The artist's creative strategy seems to prove the reality of our perception of outer events (Figure 2-18b).

C Piet Mondrian, *Broadway Boogie Woogie* (1942–43).

Formalistic works

Formalistic works of art reflect a concern for absolute, ideal, or essential forms that lie beyond the surface appearance of things. There is often a clarity, intensity, or simplicity to forms that echoes the formulas in mathematics and logic. Formalism is most often associated with the compact, geometric, and measured relationships of classical Greek and Roman art, but similar qualities are also present in tribal art forms and in contemporary works. This style seems to express the reality of our desire for an intellectually perfect order not found simply in the appearance of things (Figure 2-18c).

Fantastic works

Fantastic works of art arise from our ability to dream impossible dreams, to envision heaven and hell, to conjure up images and structures never seen or thought about before. Throughout history, people have created art forms in order to cope with the mysterious, capricious, and paradoxical events thrust on them by nature, their friends and foes, and even their own minds. Fantastic works of art record the reality of our imaginative capacities (Figure 2-19d).

Summary

An understanding of key concepts in art is essential for teachers. Virtually everything we do, say, or think about art can be partially explained by a few basic concepts and related terms that define the concepts.

A *medium* is the means through which the artist creates a work. Every work exhibits a plan, *design,* or visual composition. Even if a work does represent an obvious *subject,* we can examine the work to discover its *expressive content.* Any object can be considered an *art form* when we consider it in the context of its expressive function. A *style* is a family resemblance that we can discern in a group of art works.

There are many technical aspects of art that are beyond the scope of this book. Although the art teacher has a clear advantage over the classroom teacher in specialized areas of art, no teacher is completely knowledgeable about all aspects of art. Many of the problems that arise in teaching art are solved on the spot by the combined ingenuity of the teacher and students. Your college preparation should enable you to pursue your own self-education in the technical aspects of art. An understanding of the basic concepts can help you locate this information more efficiently.

D Peter Blume, *The Eternal City* (1937).

Notes

[1] James L. Jarrett, *The Quest for Beauty* (Englewood Cliffs, N.J.: Prentice-Hall, 1957), pp. 9–26.

[2] Alvin Toffler, *The Culture Consumers* (New York: Random House, Vintage Books, 1964), pp. 211–31.

[3] Marshall McLuhan and Quentin Fiore, *The Medium is the Message: An Inventory of Effects* (New York: Bantam Books, 1967).

[4] For a more detailed discussion of design as a process, see Lawrence Halprin, *The RSVP Cycles: Creative Processes in the Human Environment* (New York: George Braziller, 1970), and Robert H. McKim, *Experiences in Visual Thinking* (Monterey, Calif.: Brooks/Cole, 1972).

[5] Adelbert Ames, "Sensations, Their Nature and Origin," *Transformations* 1 (1950), and Paul Klee, *Pedagogical Sketchbook* (New York: Praeger, 1953).

[6] Rudolph Arnheim, *Art and Visual Perception* (Berkeley: University of California Press, 1954), and Kurt Koffka, *Principles of Gestalt Psychology* (New York: Harcourt Brace Jovanovich, 1935).

[7] This conception of style may be found in Edmund Feldman, *Varieties of Visual Experience: Art as Image and Idea*, 2nd ed. (Englewood Cliffs, N.J.: Prentice-Hall, 1972). See also Leonard Freedman, ed., *Looking at Modern Painting* (New York: W. W. Norton, 1957), and Christopher Jencks, *Architecture 2000: Predictions and Methods* (New York: Praeger, 1971).

Suggested Readings

Arnheim, Rudolph. *Art and Visual Perception: A Psychology of the Creative Eye.* Berkeley: University of California Press, 1971.

Faulkner, Ray, and Ziegfeld, Edwin. *Art Today.* 5th ed. New York: Holt, Rinehart and Winston, 1969.

Feldman, Edmund. *Varieties of Visual Experience: Art as Image and Idea.* 2nd ed. Englewood Cliffs, N.J.: Prentice-Hall, 1972.

Lowry, Bates. *The Visual Experience: An Introduction to Art.* New York: Abrams, 1961.

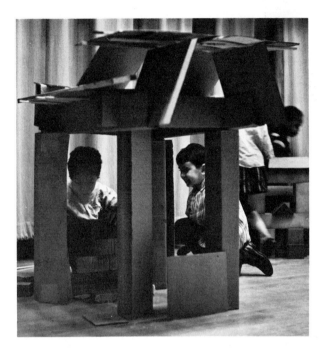

Understanding the artistic process

3

In order to guide children in creating works of art, you must have some knowledge of the artistic process. The best foundation for understanding the artistic process is personal experience in creating art. There is, of course, a substantial difference between teaching art and creating art. Teaching art involves arranging conditions so that children are motivated to learn about and create art. Therefore, the art teacher must become familiar with ways of thinking about art that extend beyond personal preferences and experience.

This chapter presents a synthesis of theory and research about the practice of art, and is organized to help you understand similarities and differences among artists in the way they work and recognize parallels in the way children may be engaged in creating art.

Stages in the artistic process

A number of theorists have identified general phases, steps, or stages in the artistic process. Although the theorists differ in their terminology, they agree, to a remarkable extent, on the characteristics of the process.[1] Phases in the artistic process do not occur in a definite sequence; they are interchanged, repeated, and

fused in the artist's unique way in order to achieve an individual method of creating art.

Inception of an idea

At some point early in the process, artists develop an idea, a sense of purpose, or a tentative direction for their work, although quite often they cannot state this intention verbally. Some artists reach this stage through the slow process of incubating ideas; others deliberately search for inspiration; still others receive inspiration in a sudden flash of insight or illumination. The most important feature of this stage is the motivation or intention to make art.

Because children usually enjoy art, it is easy for teachers to assume that motivation will somehow take care of itself. However, teaching art is not simply a matter of passing out materials and letting children get to work. Without adequate guidance and inspiration, many children will flounder, become discouraged, or resort to "formula" art that others have praised in the past. Thus, one of the aims of art education is to help children learn to generate their own ideas for artistic self-expression.

Elaboration and refinement

The artist's initial idea usually is incomplete; it has to be developed for expression in visual form. In this phase of the process, the artist may elaborate on the basic idea, refine it by making systematic visual studies of it, or totally revise it. Even when the artist appears to work spontaneously, thoughts and feelings are being transformed into organized activity.

Although teaching conditions often favor the creation of "instant art"—completed in a total of forty to sixty minutes—the stage of elaboration and refinement is quite important for children. If this phase is aborted, children (like adults) will typically create works that are merely decorative motifs or thoughtless media exercises. Because the natural desire to achieve a quick result is magnified in our society by the high value placed on achieving instant success, it is our educational task to engage children in reflective thought about their work—that is, to help them learn to extend and refine their ideas in order to capture the meaning of those ideas in visual form.

Execution in a medium

The realization of any work depends on the artist's use of a medium. Some artists develop ideas by working directly with their chosen medium from the beginning of the process. Others prefer to make preliminary models or sketches in one medium and then create the final work in a more permanent medium. Clearly, the choice of

medium and art form can make a difference in the amount and type of preparation by the artist. A large sculpture of cast metal usually requires more planning than a small, hand-crafted sculpture in clay.

A major concern in teaching children is to help them recognize media as *means* of expression. Children can become so fascinated with the process of manipulating materials that they forget about using the medium for personal expression. As a consequence, children create products but do not understand what they mean or whether they should be valued. Expressive art results when children's desire to use a medium is fused with a need to share thoughts and feelings in concrete form.

Approaches to creating art

Artists approach their work in many ways. In the remainder of this chapter, we will reexamine each phase of the artistic process to illustrate how artists differ in their sources of inspiration leading to the inception of an idea, in their means of elaborating on ideas, and in their ways of using media. The analysis is organized to show that many of the concerns and methods of work of adult artists can be used by children— provided, of course, that the techniques are adapted to the interests and abilities of children.

Sources of inspiration

It is impossible to list every source to which artists have turned for inspiration. Any attempt would probably end up as an inventory of the universe. However, for the purpose of teaching art, we can identify several broad patterns of inspiration. Among these are nature and the constructed environment, inner feelings and fantasy, broad themes and forms of order, and everyday life.

NATURAL AND CONSTRUCTED ENVIRON-MENTS. Whether viewed with innocent awe or with the analytic eye of the scientist, nature and the constructed environment have long been universal sources of inspiration for art (Figure 3-1). Prehistoric peoples created images in order to explain the natural forces in their lives. Many artists have expressed the brutality of nature; others have captured the grandeur of land, sea, and sky. The dynamic forms in trees, spider webs, shells, and honeycombs have served as models for architectural structures. The organic qualities and inherent beauty of wood, clay, and fibers often find expression in the products of craftsworkers and designers.

Some contemporary artists have approached nature in the spirit of science, delighting in careful observation and orderly visual experiments. The Impressionists, for example,

3-1 An unknown photographer captured Henri de Toulouse-Lautrec at work in the garden of his Montmartre studio.

investigated minute changes in the appearance of an object when it is seen under different lighting conditions. Other artists have studied color interactions, optical illusions, and the qualities of actual or implied motion. Still others have reexamined the fundamental elements of fire, air, water, and earth, both as sources of inspiration and as media for expression.

Many historians, philosophers, and critics have commented on nature as a source of art. Both George Berkeley, an eighteenth-century philosopher, and John Ruskin, a nineteenth-century art critic, believed that artists should try to see the world with an "innocent eye"—without preconceived ideas—so that they can depict what is actually visible.[2] The art historian E. H. Gombrich offers a fascinating account of the artist's search for techniques to capture an illusion of the real world in pictorial form. According to Gombrich, representational art never duplicates every detail seen by the artist; rather, it creates illusions—through suggestions of color, form, space, and light—that give the observer a sense of perceiving every detail.[3]

Exploring the relationship of art to science, artist-teachers Laszlo Moholy-Nagy[4] and Gyorgy Kepes[5] have shown that science and technology have given artists a new vision of natural phenomena. Microscopes, telescopes, X-rays, and other photographic instruments and techniques reveal structural relationships in nature. Preservation of the natural environment has become a major concern in urban design and architecture. The American architect Frank Lloyd Wright was one of the most influential proponents of the integration of architecture into the natural landscape.[6] Similar environmental concerns were expressed by the nineteenth-century industrial designer William Morris, who deplored the effects of industrialization on the quality of life and advocated a return to nature both as a source of design and as a standard of beauty in manufactured goods.[7]

Children, too, can find inspiration for their own art by observing the natural and constructed environment and by learning to interpret what they see in a personal way, not merely recording visual facts, but capturing their feelings about the world (Figure 3-2).

INNER FEELINGS AND IMAGINATION. Inspiration for art may come from the very real world of subjective experience. Many artists have expressed the mystery, fear, ecstasy, or irony of their inner existence through images that transcend any objective view of the world (Figure 3-3). The urge to go beyond ordinary experience is expressed in works that deal with imagined realities, spiritual revelations, exotic places, and impossible situations. Compositions based on dreams and fantasies often contain haunting visual metaphors—comic, eerie, poetic, or threatening—that speak of experiences

3-2 Inspiration for art can come from observing nature. Grade 8.

3-3 *Space City 1990,* Lockheed Missiles and Space Company. The orbiting, wheel-shaped satellite will contain many areas for living and working.

we have had but never fully comprehended. In confronting the life of their innermost feelings, artists celebrate or condemn the paradox, humor, and tragedy of human existence.

Visions of alternative life styles have led many artists to create works that challenge the norms, customs, and unquestioned beliefs of their times. Some have created satirical images to criticize polite society. Others serve as prophets who foresee life as it might be and offer proposals for the future. For example, Buckminster Fuller, engineer and architect, has pioneered the art of forecasting the influence of technology on the form and essence of life in the next century.[8] Visionary architects and designers are proposing satellite communities as a practical solution to the problem of housing people in an overpopulated world.

Although subjective experience has long been the source of artistic inspiration in many cultures, it is only recently that theories have emerged about the artist's inner life and imagination. Two contributors to theories of the artistic imagination are Sigmund Freud[9] and the existential philosopher Jean-Paul Sartre,[10] who theorize that the artist's quest for individual identity is pursued at the cost of loneliness and isolation. By creating their own images of reality, artists extend themselves beyond the limits of their physical circumstances: they transcend the problems of mere existence and challenge

UNDERSTANDING THE ARTISTIC PROCESS

3-4 *City of the Future.* Grade 6.

the status quo. Imaginative art invites us to comprehend *this* world by conjuring up images of alternative worlds.

Fantasy, imagination, and the inner life of feeling are certainly valid motivational sources of children's art. Obviously, children do not have the depth of experience that adult artists can draw on for their work, but children can create valid images to express their vivid and active imaginations (Figure 3-4). It is precisely because our culture so often ridicules fantasy and inhibits genuine expression of private feelings that teachers must nurture children's creative imaginations.

3-5 Victor Vasarely, *YMPO* (1970).

QUEST FOR ORDER. In all cultures and in all periods, art has reflected the strange power of the mind that seems to delight in order for its own sake. The human mind is unique in its capacity to conceptualize universal forms or ideas from particular objects or events. Long before Plato explained art as a quest for the underlying idea of an object—as conceived by the mind[11]—artists had discerned that surface appearances can hide the essential and true form of things. The urge to create "perfect and true" forms of order is still apparent in the work of contemporary artists who are attracted to the logic of geometric forms, mathematical proportions, and structural principles for creating art (Figure 3-5).

Nonobjective art is the ultimate expression of pure form. Stripped of all worldly associations, it exhibits the sheer sensuous beauty of color, line, and shape. In *minimal art*, the artist attempts to reduce our attention to the simple, essential forms and colors that make up the work, so that we focus on the work as a single entity without reference to ideas beyond it. If you have ever been conscious of a transcendent universal order—perhaps through meditation—you are familiar with the kind of intellectual reverberation minimal art can evoke. *Conceptual art* is related to Plato's philosophy of art in that the material form of the work is of less interest to the artist than the original concept. Often the work of art consists of little more than a plan or notation—sometimes in words or graphs—of the object or event. By creating works that do not derive meaning from their forms, artists celebrate the conceptual over the material. Thus, by freeing their works from materialistic values, artists restore the "idea" of art to a central position.

Through the subject matter of their work, many artists allude to universal human experiences or relationships—life and death, love and hate, joy and despair, victory and defeat have inspired artists of all cultures. Our relationships to others, to nature, and to a supreme being are constantly reexamined and expressed in portraits, landscapes, allegories, and works based on myth and legend.

The classical interest in ideal forms that developed in ancient Greece can be found in more recent formalistic theories of art. Writing in 1913, the aesthetician Clive Bell defined art as "significant form." According to Bell, a work of art attracts our attention and stirs our emotions by virtue of relationships among such formal qualities as colors, lines, and shapes *irrespective of the subject matter* portrayed in the work.[12] A different perspective on our capacity to respond to pure form is offered by Kurt Koffka, a pioneer of Gestalt psychology, who speaks of a universal attraction to "good gestalts"—forms that are so precisely arranged that a change in one part alters the whole.[13] Within the design fields today, there is a great interest in formal analysis of environmental problems. The architect Christopher Alexander, for example, has developed a method of environmental analysis that attempts to free designers from cultural biases in order that they be able to produce rational or pure designs with universal applications.[14]

Theoretical explanations of apparently universal themes, symbols, and images in art can be found in the writings of Carl Jung and Susanne Langer. Jung, building on Freudian concepts, proposed that art stems from a "collective unconscious." Certain visual motifs appear in many cultures because they symbolize "thought-forms" common to all humanity.[15] Birds, for example, often symbolize a spirit capable of moving freely between heaven and earth. In Langer's view, the

3-6 Children enjoy creating orderly arrangements of shapes. Grade 5.

arts serve as a universal means for people to articulate nondiscursive experience—the feeling side of life—in much the same way that language permits them to organize thought, or discursive, experience.[16]

It is obvious that the concepts of formal order and of universal ideas are complex and abstract, and therefore difficult for children to grasp. Nevertheless, even young children share with adults an interest in creating ordered relationships among shapes, colors, and lines—if only for the pure delight of seeing the ordered outcome (Figure 3-6). Like adults, children are sensitive to love, hate, joy, sorrow, and other emotions that recur in different guises in their own and others' lives. When properly translated into the child's realm of experience, activities based on broad themes and the desire to create visual order can be effective sources of inspiration for art.

ORDINARY EXPERIENCE. Our fundamental requirements of food, clothing, shelter, and systems of communication account for the development of many artifacts that civilize life. Through the artistry involved in tending to our everyday needs, we come to know the difference between feeding ourselves and dining, between occupying a shelter and experiencing architecture, between wearing clothes and adorning our bodies. Visual communications remind us of our

3-7 An example of typographical design by William Morris (1894).

3-8 Hooked, stitched, and appliquéd pillow. Grade 5.

religious and political beliefs, our national and ethnic identities, our social and occupational statuses. Our need to share ideas and living space with others is a fundamental source for the arts of product design, graphic design, and architecture.

Subject matter drawn from ordinary life also offers many opportunities for the creation of art. Both historical and contemporary artists have been challenged to transform an inconsequential or habitual event into something extraordinary and memorable: Pieter Bruegel the Elder and Ben Shahn portrayed people at work and at play; Jan Vermeer and Vincent van Gogh depicted quiet interiors; and Jean-Baptiste Chardin and Tom Wesselmann elevated simple still-life arrangements into statements about life. Art becomes a form of communication when people use visual means to celebrate and share their experiences (Figure 3-7). In exaggerated degree, the concept of art as communication can lead to the use of visual forms for persuasion or propaganda.

In many cultures, the social importance of art overshadows the contribution of any individual artist. If we find this idea strange it is probably because we live in a society that claims to have great respect for individuality and personal expression. Although we tend to value art as an individual quest for meaning, anthropologists like Margaret Mead remind us that many art forms have their roots in the requirements of social living—especially the need to communicate beliefs.[17]

John Dewey spoke of art as a form of communication that requires an appreciative audience for its completion. According to Dewey, art is properly viewed as an experience that builds a sense of communion and communication among people by intensifying, prolonging, and deepening the satisfaction we derive from ordinary events.[18] Leo Tolstoy, the Russian novelist and reformer, called the power of art "infectious" and advocated its use to inspire religious feelings in ordinary people, specifically toward the ends of brotherhood, equality, and love.[19] The concept of art as communication acquires political meaning in the writings of Karl Marx, who viewed art as a reflection of social realities and a means of informing the common people of their duties to the state.[20]

Experiences in the daily life of every child offer numerous opportunities for creating art. Inspiration may come from events in the home or at school or from activities with friends and relatives. In addition to communicating their experiences through visual forms (and thereby displaying them in a public arena), children may also be made aware of the concept of sharing as a basic human value by creating functional and life-enriching objects for themselves or for others (Figure 3-8).

3-9 Albrecht Dürer, *Four Heads* (1513–15).

Means of elaborating ideas

Art rarely occurs spontaneously; most artists search for appropriate visual qualities to capture their expressive intent. In this sense, artistic activity involves problem solving. The several problem-solving methods we shall discuss— observing and making visual studies, changing habits of work, exploring meanings and symbolism, and considering purposes and means—are of particular value in the education of artists and are suitable for the art education of children.

OBSERVING AND MAKING VISUAL STUDIES. It is self-evident that artists cultivate their observational powers. They study visual phenomena in great detail. Many artists make sketches to record their observations and to test the clarity of their vision. Artists can explore the expressive meaning of an idea in an immediate way by making sketches that vary in color, line, shape, texture, and proportion, or that exaggerate or omit certain parts of the subject (Figure 3-9). Visual studies are not restricted to sketches in two dimensions; studies can be done with clay or wire or any flexible medium that permits rapid visualization and adaptation of ideas. Architects, sculptors, and craftworkers, for example, have comparable methods of studying forms and test-

ing possibilities for the design of a work—small three-dimensional models and layouts and plans. In architecture and the other design fields, artists sometimes create preliminary models and plans to determine whether a proposal will meet the aesthetic needs of the client and still be technically sound, financially feasible, and environmentally acceptable.

Not surprisingly, a number of researchers have observed that artists characteristically have well-developed powers of observation, particular skill in representing the external world, and a facility for adapting ideas to the givens of a situation. After conducting research throughout the 1930s, Norman Meier concluded that artists excel in manual skill, visual memory, and ability to adapt new or familiar materials to solve specific problems.[21] J. P. Guilford has noted that artists can adapt familiar materials to unfamiliar problems, a skill he calls "adaptive flexibility."[22] Investigations by Frank Barron[23] and by Irvin Child[24] also indicate that artists are able to see and organize more visual information than people with little or no artistic training.

When children begin to create works based on observation or recall, they should be introduced to the use of sketches, models, and related means to explore, clarify, and test their ideas. These traditional tools of observation and planning are as valid for the child as for the adult artist. Simple forms of sketching can be

3-10 *Eyeglasses.* Grade 6.

introduced as early as the first grade. The ability to capture an idea or a feeling in visual form is rarely so fully developed in children that they cannot benefit from learning to make preliminary visual studies (Figure 3-10).

CHANGING HABITS OF WORK. Most artists develop a style or method of working that they prefer over others. Occasionally this chosen style proves to be a handicap rather than an advantage; the development of an idea may call for the modification of the artist's customary mode of thinking and acting (Figure 3-11). The value of learning to "shift gears" is widely acknowledged. Artists—adult and child alike—should be encouraged to view the following conventional patterns of work as starting points—that is, basic approaches to be consciously selected or put aside in order to develop a fresh solution to a problem when necessary.

Convergent and Divergent Methods. Studies by Louis Thurstone[25] and J. P. Guilford[26] indicate that some artists use the *convergent* technique—that is, their method leads directly from the germ of an idea to its execution in a medium—with only a few stops along the way. The artist is aware of elements that need to be organized, and synthesizes them in a single-minded manner. All of the effort is directed toward a predetermined end.

Artists who prefer the *divergent* method of work explore several directions of production by recombining similar elements and creating several tentative variations on a theme before deciding on a particular direction. This method capitalizes on serendipitous events—fortunate discoveries made accidentally. An artist who prefers to work divergently may find it helpful, on occasion, to work in a more direct, convergent way. Similarly, an artist who normally works in a convergent manner can sometimes make better progress by working divergently.

Spontaneous and Deliberate Approaches. Kenneth Beittel and R. C. Burkhart[27] have studied methods of work among beginning adult artists. Students who use the *spontaneous* approach have a predetermined goal—such as making a vase—and vary their procedures, perhaps by trying coil, slab, or pinch methods, until they find a satisfactory technique. Students who use the *deliberate* method of work have a definite procedure they wish to use, such as the coil method, and are willing to change their goals in order to use it. The subtle distinctions in methods of working suggest that artists who are willing to rearrange the priorities of their procedures or goals are able to get a fresh perspective on their work.

Visual and Haptic Orientations. Viktor Lowenfeld[28] has noted that an artist's preferred method of working may stem from a basic per-

UNDERSTANDING THE ARTISTIC PROCESS

3-11 Four stages in the creation of Henri Matisse's *Lady in Blue*.

A February 26, 1937.
B March 10, 1937.
C March 25, 1937.
D The finished painting.

ceptual orientation to the world. *Visually minded* artists, who take the perspective of the observer, rely on visual clues to create their work. In contrast, *haptically minded* artists, who respond to situations as participants, rely on their inner feelings and on kinesthetic clues. By intentionally shifting their customary way of perceiving, artists can achieve a more effective resolution to an immediate problem.

Like adults, children can acquire mental habits and attitudes that may prevent them from exploring ideas and discovering appropriate visual solutions to expressive problems. Art teachers should first help children become conscious of their preferred work methods and then show them the possible advantages of alternative approaches. Such flexibility is almost always an asset in creative endeavors.

EXPLORING MEANINGS AND SYMBOLISM. The artist often finds that the meaning of an initial idea or feeling must be examined and reinterpreted. Consider, for example, the general concept of expressing love. An artist might ask many questions about love: Am I interested in expressing the fury and passion of love, or its tenderness and security? Does love exclude hate? What love–hate relationships have I experienced? What have novelists, playwrights, and poets said about love? How have other

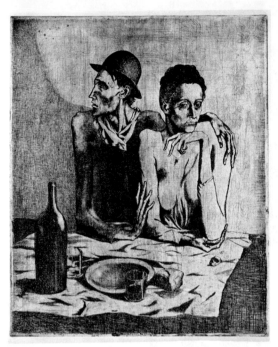

3-12 Pablo Picasso, *The Frugal Repast* (1904).

3-13 A seventh-grade boy addresses the theme *A Night in Jail.*

artists treated the subject? Through associations such as these the artist explores subtle connotations of an idea and arrives at a personal understanding of its meaning (Figure 3–12).

Similar explorations might be made in the process of designing functional objects: What form might a chair take if we conceive of it as a throne? a nest? a womb? a support? a restraint? Can ceramic pots have personalities? Are some pots elegant, quiet, well-mannered? Are others arrogant, rude, aggressive? These and similar imaginative elaborations on an idea play an important role in the development of works of art.

Accounts of the creative process often refer to the artist's ability to engage in imaginative or contemplative play, even when the artist does not have an immediate purpose. Psychologists such as Carl Rogers[29] and A. H. Maslow[30] characterize creative people as open to experience, able to take risks, and willing to tolerate ambiguity. Lawrence Kubie[31] suggests that subliminal or preconscious learning may account for the ease with which artists make spontaneous associations. Frank Barron[32] notes that artists are sometimes viewed as childlike because they retain a receptivity to nonrational experience. J. P. Guilford[33] describes the artist's ability to develop a number of different ideas from a single theme or problem as "spontaneous flexibility."

UNDERSTANDING THE ARTISTIC PROCESS

3-14 Bruce Moore and George Thompson, *The Queen's Cup* (1957). Presented to Queen Elizabeth II and the Duke of Edinburgh on a State Visit to the United States by President and Mrs. Eisenhower.

Even though many children are highly imaginative, they can benefit from learning to explore their ideas in order to discover the precise nuances of thought and feeling they wish to express. The conventional response, the stereotyped image, and the unexamined cliché are substitutes for reflection and speculation. When children learn to make rich mental and sensory associations, they can more clearly identify those unique qualities of their ideas or feelings that might be expressed in visual form (Figure 3-13).

CONSIDERING PURPOSES AND MEANS. The use of the general term *artist* to describe people involved in different kinds of creative processes tends to minimize the important distinctions among them. The intended function of a work and the medium it is to be executed in both have a definite influence on how the artist creates the work. An architect or a designer, for example, is not totally free to pursue a private vision in the same way that a painter or sculptor may be. The architect and the designer have to be more "other-directed" than the studio artist because their work is conditioned by the needs of a client as well as by factors like economy and safety.

Artists often explore directions for their work by considering relationships between means and ends. For example, a client might ask a graphic designer to create a poster to announce a community event. The graphic designer knows that the poster must provide essential information in a form that the intended audience can readily understand; otherwise the poster will not serve its purpose. Nevertheless, the designer (unlike the poster artist) will want to know whether the client wishes to sponsor a poster or to communicate information. If the latter intent is more important, a number of means other than posters might be more effective—postcards, leaflets, or advertisements in newspapers, magazines, and on television. The designer's choice of means should be governed by the purpose the work will serve.

Craftsworkers and studio artists must make comparable decisions. Ceramics, wall hangings, and jewelry can be designed without regard to the context in which they are to be used, or they can be custom made—that is, designed for a specific setting or occasion (Figure 3-14). Custom-made items invite intimate and ceremonial responses. Multipurpose items, designed for no particular situation, are treated more casually and flexibly. By examining relationships between means and ends, artists can clarify their ideas and determine their goals.

Rudolph Arnheim[34] has noted that artists are skilled in visual thinking; they can imagine a particular goal in terms of the means for achieving it. For example, a painter who works in an

3-15 (*left*) Stitched and appliquéd vest. Grade 6.

3-16 (*right*) Bronze Ife Head, Court Dignitary, Yoruba tribe, Nigeria (c. fourteenth century).

abstract manner can envision how a human figure might look as a study in color and shape. According to David Ecker[35], the overall style of an artist's work results from the artist's seeking an "end-in-view" and establishing component qualities (means) necessary to achieve it. Many artists specialize in one art form or medium and work within a particular stylistic context; their purposes and means are fairly well defined by these preferences.

Children must be taught to consider relationships between *what* they want to say and *how* they want to say it. These considerations are especially important in the upper elementary grades, when many children become aware of the difference between their ability to come up with ideas and their ability to express them visually. Attention to purposes and means is also vital in most activities that treat the crafts and the "public" arts of architecture, graphic design, and product design (Figure 3-15).

Approaches to using media

Each artist has a distinct way of using media for expressive ends. In spite of the variety inherent in personal approaches to media, artists are sensitive to the values of controlling media, adapting media to ideas and ideas to media, selecting a medium for its symbolic qualities, and experimenting with media.

CONTROL. The ability to control any medium comes from practice in using it. Control is linked to the concepts of skill, craftsmanship, and mastery (Figure 3-16). Harry Broudy[36] has noted that mastery involves not only dexterity in manipulation but sound judgment as well. Some measures of growth in manipulative skill are decreases in time and effort required to perform a task, reduction of errors in the process of work, and increases in speed in making appropriate decisions to overcome obstacles.

By extending Broudy's analysis of mastery we can identify several levels of skill in using a medium:

1. trial and error, leading to easy recognition of errors and means of eliminating them
2. elimination of error by practice; gradual increase in speed with a corresponding reduction of error, effort, and conscious decision-making when faced with a single task
3. ability to classify familiar obstacles and respond to them with known types of solutions; gradual increase in ability to handle ordinary problems with increasing speed, fewer errors, and less conscious decision-making
4. ability to identify unusual problems, classify types of solutions through conscious effort, and solve problems efficiently; gradual increase in ability to overcome ordinary and unusual problems with no apparent effort (Notice that superior skill seems effortless)

UNDERSTANDING THE ARTISTIC PROCESS

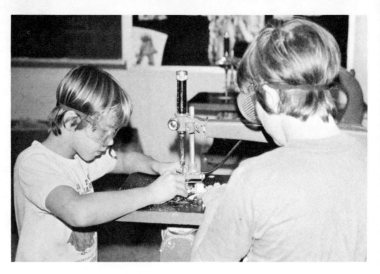

3-17 These fifth graders have learned to use work-saving tools.

From the preceding analysis we can see that control and mastery, far from being a simple matter of eye–hand coordination, require thought, judgment, and problem solving.

To develop control in using media, it is important to avoid shifting from one medium to another, since that will inhibit the growth of skills. If children are to achieve expressive mastery of a medium, they must have repeated opportunities to work with the same medium to produce different objects—for example, to use clay to make sculpture, containers, and jewelry, or to use watercolor to create both large and small paintings with different expressive qualities (Figure 3-17).

ADAPTATION. The ability to adapt materials to ideas and ideas to materials is an important artistic skill. Suppose that an artist wants to express the delicacy of a spider, a flower, or a dancer, using clay as the medium. An experienced artist will anticipate the way to overcome the technical problems of making thin parts, of supporting the parts, and of preventing them from breaking. In this instance, the artist could easily overcome the bulky quality of the medium by modifying his or her technique.

However, an artist may find that an initial idea or feeling must be altered to suit a preferred way of using a medium. In the previous example, the artist might choose to work with the bulky, organic quality of clay rather than with its potential for thinness and delicacy, creating a form to express the massiveness, weight, and thick convolutions of growing flowers, a dancer in repose, or a spider in death. The initial idea undergoes modification to suit the preferred use of a medium.

When a medium offers little resistance to being shaped, an artist may allow ideas to develop during the process of work. When a medium does not lend itself to easy adaptation, artists either plan their work in detail or hope they can succeed without a full plan. Many works are created from unforeseen qualities that inspire new ideas and enable artists to salvage apparent failures.

In order to become confident in visual expression, children have to acquire flexibility in using media. Like adults, children can benefit from developing their ability to modify an idea to suit their choice of media or to change their customary way of using a medium to express an idea. Only rarely is adherence to a single idea or to a single procedure an asset for children.

SELECTION. The problem of choosing a medium appropriate to an idea is especially important in the design fields and architecture, but it is also significant in the traditional studio fields of painting, sculpture, and the crafts. Suppose a sculptor is commissioned to create a public

3-18 Is this permanent playground congenial to children's sense of touch?

monument on the theme of law and order. Would the sculpture connote law and order if it were made of plastic? of glass? of stone and stainless steel? of rugged, unpainted wood? If the sculptor is sensitive to the symbolism of materials, the medium selected will contribute to the meaning of the composition.

These examples will further illustrate the importance of choosing media. Is there a qualitative difference in the feeling we have when sitting on a park bench made of poured concrete? of wood slats bolted together? of cast fiberglass? of welded metal strips? Which material would you choose for a park adjoining a playground for toddlers? for a large commercial amusement park? for a park used by campers who like to rough it? Questions such as these are central in the design fields and architecture, where opportunities to choose and arrange materials do not depend solely on the artist's own skill in shaping them (Figure 3-18).

Too often children are prevented from making choices among media because teachers find it easier to provide a single medium for all children in a class. In addition, many of the media that children use in school have symbolic meanings that are largely restricted to school experience; colored construction paper, wax crayons, finger paints, toothpicks, and soda straws are rarely the chosen media of adult artists. Further, the artistic process, as typically defined in school programs, does not extend to selecting materials for the purpose of designing interiors, architectural structures, or urban environments.

In short, typical patterns of instruction in school often prevent children from becoming adept at choosing a medium for the symbolic meanings inherent in it. Fewer, but higher-quality, media ought to be available to children. The range should afford opportunities for two- and three-dimensional expression. In every instance, the cultural, personal, and historical connotations of media should be explored with children, who can easily grasp the meaning of such expressions as "clear as crystal," "heart of gold," and "nerves of steel," even though they may never work directly with crystal, gold, or steel.

EXPERIMENTATION. There are two basic purposes for experiments with media. The first is to solve specific expressive problems. In this case, artists who are seeking a particular visual effect deliberately try out various means of achieving it. For example, a painter might vary the brush strokes and the proportions of colors in order to discover those qualities of paint that will express coolness, dryness, or brittleness. The second purpose of experimentation is to develop a repertoire of techniques and their effects for future applications. In this instance, artists play with a

UNDERSTANDING THE ARTISTIC PROCESS

3-19 *Oil Derricks.* Grade 5. An effective use of unconventional media.

TABLE 3-1

THE ARTISTIC PROCESS: PHASES AND APPROACHES

Phases	Approaches
Inception of an Idea	Nature and the constructed environment
	Inner feelings, imagination
	Quest for order, universal themes
	Ordinary experience
Elaboration and Refinement	Observation, visual studies
	Change of work habits
	Exploration of meanings, symbolism
	Consideration of purposes, means
Execution in a Medium	Control
	Adaptation
	Selection
	Experimentation

material in order to discover whether its possibilities and limitations are suited to their styles of work or expressive interests.

Art teachers often encourage children to experiment with media. While experimentation does have a place in the development of skills, it must be purposeful. Otherwise, children may assume that anything goes if you call it "just an experiment." While teachers should encourage children to experiment with media, they should also point out to them the application of their experiments in solving expressive problems (Figure 3-19).

Summary

Artists may define their creative problems in open-ended terms or within well-defined limits. The variety of approaches artists use can be

traced to their sources of ideas, their methods of elaborating ideas, and their uses of media. Each of these phases of the artistic process includes four major points of variation in specific procedures. These are summarized in Table 3-1.

If education about and by means of the artistic process is to be personally valuable and intellectually sound, then activities for children should be designed around these several approaches to art. The approaches serve both as starting points for children's own creative art expression and as links for building children's awareness of the way artists go about their work.

Notes

[1] Brewster Ghiselin, ed., *The Creative Process* (New York: New American Library, Mentor Books, 1955).

[2] George Berkeley, "New Theory of Vision," in Edwin G. Boring, *Sensation and Perception in the History of Experimental Psychology* (New York and London: Appleton-Century-Crofts, 1942), Chapter 3, and John Ruskin, *Lectures on Art* (New York: Maynard and Merrill, 1893).

[3] E. H. Gombrich, *Art and Illusion: A Study in the Psychology of Pictorial Presentation*, 2nd ed. (New York: Pantheon Books, 1961).

[4] Laszlo Moholy-Nagy, *Vision in Motion* (Chicago: Paul Theobald, 1947).

[5] Gyorgy Kepes, *The Language of Vision* (Chicago: Paul Theobald, 1944).

[6] Frank Lloyd Wright, *The Future of Architecture* (New York: New American Library, Mentor Books, 1963).

[7] William Morris, *The Aims of Art* (London: The Commonweal, 1887).

[8] R. Buckminster Fuller, *Operating Manual for Spaceship Earth* (New York: Simon & Schuster, Pocket Books, 1970).

[9] Sigmund Freud, *Civilization and Its Discontents*, trans. Joan Riviere (London: Hogarth Press, 1930), pp. 25–39.

[10] Jean-Paul Sartre, "Introduction to *Les Temps Modernes*," in Eugen Weber, ed., *Paths to the Present: Aspects of European Thought from Romanticism to Existentialism* (New York: Dodd, Mead, 1967), pp. 432–41.

[11] Plato, "The Republic," Book 10, in Eric H. Warmington and Philip G. Rouse, eds., *Great Dialogues of Plato* (New York: New American Library, Mentor Books, 1956), pp. 393–422.

[12] Clive Bell, *Art* (1913; reprint ed., New York: G. P. Putnam, Capricorn Books, 1959), pp. 16–17.

[13] Kurt Koffka, "Problems in the Psychology of Art," in *Art: A Bryn Mawr Symposium* (Bryn Mawr, Pa.: Bryn Mawr College, 1940), pp. 230–50.

[14] Christopher Alexander, *Notes on the Synthesis of Form* (New York: Oxford University Press, 1964).

[15] Carl Jung, "On the Relation of Analytical Psychology to Poetic Art," in H. G. Baynes and C. F. Baynes, trans., *Contributions to Analytical Psychology* (London: Routledge & Kegan Paul, 1928), pp. 157–61, 240–49.

[16] Susanne Langer, *Philosophy in a New Key* (New York: New American Library, 1948), pp. 30–31.

[17] Margaret Mead, Speech given at the National Art Education Association Conference, Chicago, April 12, 1974.

[18] John Dewey, *Art as Experience* (New York: Minton, Balch, 1934), pp. 73–74.

UNDERSTANDING THE ARTISTIC PROCESS

[19]Leo Tolstoy, *What Is Art?* (New York: Thomas Y. Crowell, 1899).

[20]Karl Marx and Friedrich Engels, *The Communist Manifesto*, trans. Samuel Moore, (Chicago: Henry Regnery, 1954).

[21]Norman C. Meier, ed., "Studies in the Psychology of Art, III," *Psychological Monographs* 51 (1939):140-58.

[22]J. P. Guilford, "Creative Abilities in the Arts," in Elliot W. Eisner and David W. Ecker, eds., *Readings in Art Education* (Waltham, Mass.: Blaisdell, 1966), pp. 283-91.

[23]Frank Barron, "Artistic Perception as a Factor in Personality Style," *Journal of Psychology* 33 (1952):199-203.

[24]Irvin L. Child, "Personality Correlates of Esthetic Judgment in College Students," *Journal of Personality* 33 (1965):476-511.

[25]Louis Leon Thurstone, *Factoral Study of Perception* (Chicago: University of Chicago Press, 1944).

[26]Guilford, "Creative Abilities in the Arts."

[27]Kenneth R. Beittel and R. C. Burkhart, "Strategies of Spontaneous, Divergent, and Academic Art Students," *Studies in Art Education* 5 (1963):20-41.

[28]Viktor Lowenfeld, *The Nature of Creative Activity* (London: Routledge & Kegan Paul, 1939).

[29]Carl R. Rogers, "Toward a Theory of Creativity," *Review of General Semantics* 11 (1954):249-60.

[30]A. H. Maslow, "Creativity in Self-Actualizing People," in H. Anderson, ed., *Creativity and Its Cultivation* (New York: Harper & Row, 1959), pp. 55-68.

[31]Lawrence S. Kubie, *Neurotic Distortion of the Creative Process* (Lawrence: University of Kansas Press, 1961).

[32]Frank Barron, *Creative Person and Creative Process* (New York: Holt, Rinehart and Winston, 1969).

[33]Guilford, "Creative Abilities in the Arts."

[34]Rudolph Arnheim, *Art and Visual Perception* (Berkeley: University of California Press, 1954), pp. 155-212.

[35]David W. Ecker, "The Artistic Process as Qualitative Problem Solving," *The Journal of Aesthetics and Art Criticism* 21 (1963):283-90.

[36]Harry S. Broudy, "Mastery," in B. O. Smith and Robert H. Ennis, eds., *Language and Concepts in Education* (Chicago: Rand McNally, 1961), pp. 72-85.

Suggested Readings

Ghiselin, Brewster, ed. *The Creative Process.* New York: New American Library, Mentor Books, 1955.

Herbert, Robert L. *Modern Artists on Art: Ten Unabridged Essays.* Englewood Cliffs, N.J.: Prentice-Hall, 1964.

Miller, Henry. *To Paint Is to Love Again.* Alhambra, Calif.: Cambria Books, 1960.

Naylor, Gillian. *The Bauhaus.* London: Studio Vista, 1968.

Shahn, Ben. *The Shape of Content.* Cambridge, Mass.: Harvard University Press, 1957.

Perceiving and responding to visual forms

The ability to see visual forms is a natural endowment of those blessed with vision. Perceptual skills are essential for a number of tasks, including reading, writing, and scientific observation. However, the ability to respond to works of art and to the visual environment is not simply a matter of decoding symbols and of noting the observable properties of things. It is a predisposition, cultivated by instruction, to search for expressive meaning in visual forms.

The process of responding to visual forms is as complex and demanding as is the process of creating art. Clearly, no visual form is created in the absence of perceptual processes. Nevertheless, the ability to respond to visual forms is not merely an adjunct to artistic activity; it is an active, creative process in its own right. Developing perceptual abilities is worthy of the same attention and educational time that, in the past, have been reserved for creating art.

Psychologists, art critics, philosophers, and historians of art have studied the nature of perception and the special skills involved in responding to visual forms. The following survey of research, theory, and practice will acquaint you with basic information to help you stimulate children's creative and critical responses to visual forms and introduce children to the artistic heritage as a source for discovering meanings in works of art.

Obstacles to full response

In order to respond to visual forms, we have to overcome conditions that prevent us from fully exercising our perceptual powers. Among the more common obstacles to active perception are the development of perceptual constancies and of stereotypes and preconceptions; lack of background information; and poor conditions for responding to art.

Perceptual constancies

The tendency to perceive the general features of an object rather than its specific qualities is referred to as *perceptual constancy*.[1] We usually see things as units, or wholes, "averaging" the sizes, shapes, details, and colors of objects into an overall impression; thus we perceive only a fraction of all the sensory information available to us. Perceptual constancies are formed during infancy and are firmly established by early childhood. They accommodate our need for constant points of reference as we move through space, avoid obstacles, and reach destinations. Consider the potential for disaster on a freeway if drivers were suddenly distracted by the changing profiles and sizes of cars and the shapes of cast shadows on the road.

Although perceptual constancies are important for routine activities, they can prevent us

from seeing many of the visual nuances that help to shape our feelings. We may quickly examine a landscape painting, for example, and notice little more than green trees, a blue sky, and a few flowers. If we study the painting longer, we become aware of variations in colors, values, and brush strokes (Figure 4-1); we begin to see and feel more subtle qualities, such as "hot shimmering agitation" or "cool quietness and peace." Thus, in an artistic context, our ability to overcome perceptual constancies is essential to fresh, vital awareness.

Stereotypes

Stereotypes simplify our thoughts and feelings in the same way that perceptual constancies simplify our responses to sensory stimuli. A *stereotype* is the frequent, almost mechanical repetition of an idea, an image, a form of speech, or an attitude that encourages us to prejudge things as good or bad, pleasant or irritating, sensible or inane. We usually become aware of our stereotypes when we are challenged by new experiences.[2]

In responding to art and to the visual environment, we must often suspend judgment, tolerate ambiguity, and put aside familiar associations. For example, if we have "overlearned" that bright yellows, reds, and oranges are warm, happy colors, we can miss their power to suggest

4-1 Vincent van Gogh, *The Starry Night* (1889).

4-2 Honoré Daumier, *Connoisseurs* (1862–64).

darkness, death, and damnation. If we are accustomed to seeing Jesus portrayed as a blond, blue-eyed Anglo-Saxon, we may not be sufficiently tolerant of other images of him to explore their possible significance. It is important to engage in perceptual activities with as few prejudices (prejudgments) as possible.

Lack of background information

From the preceding discussion of stereotypes, we might conclude that any prior knowledge about art can interfere with direct perception. Although intellectual comprehension can become a substitute for direct perception, the risk is minimized if we use our knowledge to enhance our responses. Like anything else, art experience can be enriched by curiosity, effort, and study.

Background information is most readily grasped when it is organized around our interests. If we wished to learn about the relationship of a particular style to the social and intellectual history of its time and place, we might seek out relevant texts and museum tours. If we wished to learn how the accomplishments of individual artists reflect their personal struggles and social milieus, we might visit several museums to see the artists' works and read biographies of their lives. Studies of a single art form, such as architecture or ceramics, can make us aware of the problems artists face in using materials and de-

PERCEIVING AND RESPONDING TO VISUAL FORMS

signing structures to express personal or social values.

Poor conditions for responding to art

The physical and psychological settings in which we view art can determine which properties of a form will be available to our perception. The physical setting is important because we cannot fully perceive a work of art if we view it from an improper angle, under poor lighting conditions, or from an inappropriate distance. (Whenever possible, original works, not reproductions or slides, should be studied.) Slides and reproductions vary in quality and differ in color, scale, and detail from original works. Architecture and the larger visual environment should be studied "on location" so that those qualities that shape our movements, define the space we occupy, and produce a sense of scale can be directly experienced.

The psychological setting in which we respond to art is also important (Figure 4-2). Many people feel restrained or threatened in museums and galleries; they are intimidated by the presence of guards and works of art. By learning more about museums and galleries—why they exist and how they operate—and by visiting these institutions as often as possible, people can overcome their fears. If we are apprehensive about saying the right thing, our perception of art may be selective and incomplete. In order to respond to a work openly and honestly, we must be psychologically prepared to do so.

Critical phases in responding to art

Just as the process of creating art hinges on several critical stages, so too does response to visual forms fall into basic phases: perceiving obvious and subtle qualities, interpreting perceived qualities as sources of feeling and meaning, and judging the significance of our experience. For each of these phases, several techniques can be used to enhance the range and depth of our own responses as teachers, as well as the responses of children.

Perceiving obvious and subtle qualities

Ordinarily, we stop examining something as soon as we recognize it. We can expand our perceptual capacity by making a conscious effort to experience both the subtle and the obvious qualities of things. In this section we will examine four approaches to sharpening perception: discriminating basic properties of things, building multisensory associations, exploring symbol-

4-3 Montessori-type materials sharpen children's discrimination of visual qualities.

ism and connotations, and becoming aware of contexts.

DISCRIMINATING BASIC PROPERTIES. Most of our perceptual distinctions are based on memory traces that form a continuum of sensation. For example, we recognize light green in relation to a range of greens—from very dark to very light; we see or feel something as "rough" because we have also had some experience with things that are "smooth." We are able to make sensory discriminations like these both when they are immediately presented to us as contrasts and gradations and when they have been assimilated into our memory so that we can draw on them for additional comparisons.

Our ability to make sensory discriminations can be developed through highly structured perceptual activities (Figure 4-3). It is helpful to practice matching and sorting into sets objects that have been "controlled" for isolated qualities. For example, if we wanted to sharpen our sensitivity to texture, we might obtain different kinds of white paper and cut them into squares. By controlling the size, shape, and color of the papers, we can, while sorting them, focus our attention on subtle differences in texture. Similarly, we can become sensitive to varieties of "red" by assembling a collection of red objects or by looking selectively for red in the environment. Comparable exercises in perception can

be invented to suit a range of phenomena. We can learn to perceive the varied qualities of a particular material, such as wood or metal, paper or clay. We can study the variety of objects made by a specific process, such as weaving or carving. We might look for differences in trees, utility poles, chimneys, and other natural or manufactured forms. Practice in selective perception within categories like those listed in Table 4-1 will sharpen basic sensory discriminations.

Maria Montessori, who specialized in early-childhood education, was one of the first educators to recognize the value of structuring phenomena in order to facilitate discrimination of their basic properties.[3] Jerome Bruner, a psychologist interested in education, has reported that subjects have little difficulty identifying the dominant attributes in an array of visual forms if the number of irrelevant attributes is reduced, if examples are presented in an ordered arrangement rather than randomly, and if the pace of the sorting activity is flexible—that is, adjusted to the individual.[4] These principles are commonly used in the activities planned for young children in Montessori programs, but they are equally valuable for teaching perceptual discrimination to people of all ages.

DEVELOPING MULTISENSORY ASSOCIATIONS. By communicating thoughts and feelings, our language is a good indicator of the ways

TABLE 4-1
WORDS THAT REFER TO SENSORY CONTINUA

TASTE
bitter-sweet bland-juicy sweet-sour

SMELL
acrid-sweet pungent-mild spicy-bland

SOUND
loud-soft natural-artificial shrill-mellow
close-distant changing-stable complex-simple
high pitched-low pitched

TOUCH (Surface)
soft-hard rough-smooth regular-irregular
hot-cold porous-nonporous wet-dry

TIME (Sensation of)
expanding-contracting continuous-interrupted
real-unreal long-short linear-circular

MOTION
opening-closing advancing-retreating
rising-sinking twisting-straight floating-thrusting
free-flowing-restrained sudden-sustained
motionless-energetic strong-weak
centralized-dispersed rhythmic-random fast-slow

SPACE
deep-shallow empty-filled extended-enclosed
narrow-wide vast-small open-closed
convergent-divergent

VOLUME/MASS
big-small bulky-delicate empty-filled
heavy-light solid-open stable-unstable

ENERGY/TENSION
active-passive stable-unstable strong-weak
static-dynamic directed-free

SHAPE/FORM
concave-convex geometric-biomorphic
transparent-opaque simple-complex
curvilinear-angular

SIZE
changing-stable large-small
proportional-exaggerated tall-short

LIGHT
artificial-natural bright-dim direct-indirect
lighted-shaded bright-dull night-day
reflected-absorbed

COLOR
bright-dull light-dark opaque-transparent
pure-mixed warm-cool advancing-receding

LINE
narrow-wide jagged-smooth dark-light
straight-zigzag convergent-divergent
straight-curved

POSITION
near-far up-down left-right central-peripheral
juxtaposed-overlapped

that many of our perceptions are based on multisensory associations—the linking of sight with sound, of sound with motion, and so on. We speak of "loud" colors, "active" lines, "energetic" shapes, and "heavy" textures. We make these and similar associations because sensory experiences are rarely limited to only sight or hearing or touch.

We can enhance our perceptual awareness by making a conscious effort to build multisensory associations. One method is to attend to the wholeness of a moment from the "inside out." For example, we might try something as simple as sitting on the front steps and perceiving the sensations of the warm sunlight on our skin, the weight of our body and feet on the steps, the odors permeating the space, the rhythm of our breathing, the shine of our shoes in the sunlight, and so on. Quiet moments of sensory openness and awareness are especially valuable when our lives have become frantic and task-oriented.

We can also try a multisensory approach in isolating and understanding visual relationships. If I want to *see* a tree, I might try to become more conscious of myself *as if I were* a tree, expending my energy to support my branches and limbs. The form experienced and the energy within my body help me to *see* the central thrust of the tree trunk, the points of stress in

4-4 Leonardo da Vinci or Cesare da Sesto, *Tree*.

4-5 (*opposite*) Pablo Picasso, *Guernica* (1937).

the branches, and the volumes created by radiating limbs and clumps of leaves. Try this yourself. Become the tree in Figure 4-4.

It is equally valuable to learn to comprehend relationships between actions in one sensory mode and their effects in another. For example, musical rhythms can be echoed in body motions. Body motions, in turn, can be recorded as visible marks on paper or as traffic patterns left in a sawdust-covered floor. Similarly, if I vary the amount of *physical* pressure on a pencil as I draw, I see the *visual* evidence of the pressure changes being recorded in a lighter or darker line. When I look at a pencil drawing, I can better imagine the kinesthetic activity that created the effect that I see.

Experimental evidence shows that when energy and attention are restricted to or locked into one sensory mode, they will be released in another sensory mode, either directly or vicariously. Werner and Wapner[5] have theorized that any perceptual event involves a dynamic interplay between external stimulations and internal changes in muscular tension. The transfer of energy from one sensory mode to another may account for the astronaut's ability to function without feeling the force of gravity or having other sensory cues that we normally rely on to perceive depth, distance, and vertical–horizontal planes. Intersensory energy transfer also seems to account for our desire to physically tap out a rhythm we hear, our ability to see static objects as if they were moving, and our tendency to be physically exhausted after watching a film.

EXPLORING SYMBOLISM AND CONNOTATIONS. Perceptual response is also influenced by the symbolic meaning one can decipher in visual forms. By exploring the symbolism in and connotations of visual forms, we can become more conscious of the assumptions we make about the meanings of things we perceive.

Symbolism might center on the material from which a thing is made. Sterling silver and chromium are shiny and similar in color, but they have quite different connotations; so, too, do fresh flowers and plastic flowers. Symbolism might be traced to colors, lines, and shapes. Consider the referents we have for "red, white, and blue" and for "stars and stripes." The symbolic power of any visual form stems from our prior experience with the same or similar forms. We can heighten our own and children's perception by exploring sources of symbolism in the forms we see—sources based in childhood experiences, in family events, in religious rituals, in local and national traditions. How many symbolic elements can you identify in Figure 4-5?

The role of personal and cultural association in perception has been studied in some detail. Experiments by Adelbert Ames[6] have demonstrated that we assign familiar attributes to ambiguous stimuli. A number of researchers

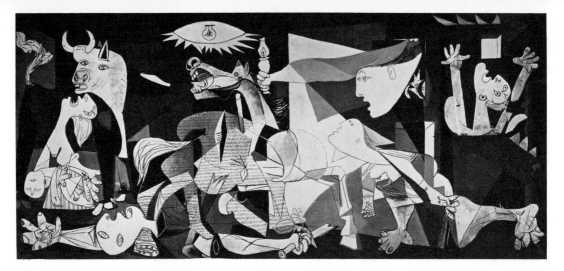

have observed that we perceive highly valued objects as larger in size or as more frequently present than less-valued objects. In interpreting Rorschach inkblots, for example, Samoans mention white spaces far more frequently than do residents of the United States.[7] In Samoan culture, the symbolism of white is especially rich and varied.

BECOMING AWARE OF CONTEXTS. *Contexts*—the background features of a situation—are important because they determine the relative importance of the things we perceive. Often we ignore the larger contexts in which objects are perceived. We become conscious of time, for example, when we have too little or too much of it on our hands. We are largely unaware of weather, spaces, lighting conditions, temperature, furniture arrangements, and the like unless they intrude on our senses in an unusual way.

Precisely because background features can influence our perception, we have to become skilled in identifying them. The scale of our awareness may be extended in *time*, so that we perceive "now" as a moment within an hour, an afternoon, a day, a week, or a year. We can become aware of *spatial* contexts that are relatively near to us and confined, or extremely distant and expansive; that are crowded and active or open and passive. We can become sensitive to *social* contexts ranging from inti-macy and informality to the utmost "distance" and formality.

In *The Image*,[8] Kenneth Boulding outlined a provocative list of dimensions that, in his view, explain how we construct an image of ourselves. The list, summarized here, suggests some of the contexts in which we might view our relationships with other things, events, and people.

1. *Space.* Think of your relative location in a room, neighborhood, city, state, nation, on the planet earth, in the galaxy. Consider your relative position next to the earth, under the sky, and within three-dimensional boundaries.

2. *Time.* Do you think of time as linear (chronological), as do most people in Western culture? In some non-Western cultures, time is circular (seasonal) and is endlessly repeated. In all cultures, sequential times of life—birth, childhood, maturity, old age, death, life after death, rebirth—are contexts for understanding events.

3. *Stability of relationships.* Do you believe in the predictability of events or in their capriciousness? Do you assume that your destiny is under your personal control or that it is preordained in some way?

4. *Value.* Consider the relative worth to you of material and of nonmaterial things (good health, life, religion). Also think about the relative value you normally assign to objectivity or subjectivity, to pleasure or to pain.

4-6 What shapes and forms do you see in the inkblot?

5. *Reality.* What is the degree of your belief in the "truth" of sensory experience, of dreams, of universal truths. Do you ordinarily believe that others share in the same reality you do?

When we become aware of the contexts that govern our perceptions, we can comprehend that, ordinarily, *what we are likely to see* is largely determined by *what we assume to be important* (Figure 4-6). Activities that help children attend to the background features of their environment can sharpen their perception and self-understanding.

Interpreting perceived qualities as sources of feeling and meaning

Perception cannot be reduced to sensory experience alone. In full perception, we organize our impressions so that we can understand what they mean. Full response depends on our ability to interpret the things we see, hear, touch, smell, taste, and do *as sources of our feelings.* Unless we can interpret the meaning of our perceptual experience, it has but momentary significance. When we examine our experience, we can better appreciate the value of heightened awareness. Our efforts to interpret experience are aided by an adequate vocabulary to describe our perceptions, a balance between objectivity and subjectivity, a willingness to speculate on alternative

meanings, and an attempt to synthesize our impressions.

BUILDING A VOCABULARY TO DESCRIBE PERCEPTIONS. While language plays an important role in the way we interpret our experience, language itself derives from our perceptions; our use of language reflects the nuances of our perceptions and the relative importance of specific experiences in our lives.[9] Eskimos, for example, have more words to describe different kinds of snow than we have. Whereas in west Africa, qualities of line are defined in relation to travel by foot along village pathways, in our culture qualities of line and shape are described by adjectives that refer to personality types— bold, hesitant, active, nervous, lazy.

Thomas Munro, an aesthetician and a pioneer in museum-based art education, has noted that a rich vocabulary for color, line, and other sensory qualities can help us discover clues to the expressive meanings of things we see.[10] Consider, for example, the words we might use to describe *neon red.* It *glows* and *glares*; it is *bright* and *sharp*; it is a *uniform electronic red*, not a *naturally varied red*; it is *red-in-a-tube.* Try to imagine the sense of love conveyed by a sculpture presenting neon lips. Would it be a compassionate or a cruel statement about love? intimate or remote? public or private? mechanical

PERCEIVING AND RESPONDING TO VISUAL FORMS

4-7 Robert Indiana, *Love* (1966).

or personalized? Describe the shape and placement of the letters in Robert Indiana's *Love* (Figure 4-7). What is the sense of love the work seems to convey? Do the visual qualities of this work have any influence on its message? A well-developed vocabulary of specific nouns, verbs, adjectives, and adverbs is essential to comprehending art and teaching it.

EMPATHIZING AND MAINTAINING PSYCHIC DISTANCE. *Empathy* is the projection of one's own personality into a situation. As a consequence, we personify the situation; we endow external, inanimate things with our own feelings. According to Vernon Lee, the aesthetician who expanded on this concept, empathy involves the unconscious projection of our feelings onto the object so that we think of the object as if *it* actually had *our* feelings.[11] Our language reflects the ease with which we assign human attributes to objects. We look at leaves blowing in the wind and say they are "dancing"; we say that a skyscraper is "straining" toward the sky.

The experience of empathy can be so intense that we fail to distinguish our feelings from the visual forms that trigger them. The aesthetician Edward Bullough called such a reaction "underdistancing,"[12] a state in which we cannot fully experience a work because we have no sense of our own identity. "Overdistancing,"

the opposite response, occurs when we are so objective or self-conscious that we are unable to let the work influence us at all. Neither of these extremes is ideal, for adults or children. Some works, such as those in Figures 4-8 and 4-9, require that we make a conscious effort to establish the proper degree of psychic distance—that is, a balance between total objectivity and total subjectivity. From this middle ground we are best prepared to interpret our experience—to grasp how and why each work has significance for us. Since our culture encourages children to be objective, cool, and sophisticated, it is essential to cultivate personal identification and empathy in order to seek a balanced stance in responding to art.

SPECULATING. We can rarely interpret the meaning of something by merely "adding up the visual evidence." If our perception of a work has been fairly comprehensive, we will have some clues to its possible meanings. *Speculating* is the process of mentally or imaginatively examining those clues in order to formulate good guesses about the significance of a visual form.

It is sometimes useful to envision how a form would look if all its dominant features were transformed into their opposites. Would the significance of the work be the same if the work were larger or smaller than it is? if the values were heightened (intensified) or subdued (softened)? if the materials were different?

4-8 David Alfaro Siqueiros, *Echo of a Scream* (1937).

4-9 Donald Judd, Untitled (1966).

When we consider possibilities such as these we expand our awareness of specific qualities that carry expressive meaning. Speculation may focus as well on the origin of the work within a time, place, and culture; on the purposes served by the work; or on the possible intention of the artist.[13] We might gain further insight if we compared the work with other forms of the same type. In every case, speculation is aimed at discovering possible explanations for what we see in the work and how we feel about what we see.

SYNTHESIZING. A *synthesis* is a drawing together of the discoveries we have made while examining a visual form. According to Dewey, our impressions should be integrated in a way that leaves us with a feeling of completeness about our response.[14] If we feel that something quite commonplace and obvious is really extraordinary and special, or if we feel that something apparently extraordinary and unusual is mysteriously universal, we have experienced this fusion of impressions. If we try to explain our response, we usually discover a poetic analogy or metaphor that approximates the feeling-tone of our experience. If you are unable to synthesize your impressions, it is helpful to ask questions such as these: What thoughts or feelings are most dominant, and why? What connections exist between what I see or feel and any other experience I have had?

PERCEIVING AND RESPONDING TO VISUAL FORMS

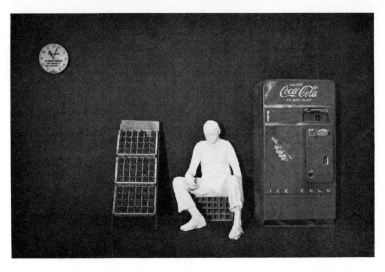

4-10 George Segal, detail of *The Gas Station* (1963).

Although words can never fully capture the totality of our response to a work, the effort to verbalize our impressions is valuable precisely because it reminds us that the significance of a visual form cannot be reduced to words. The process of synthesizing is also important because it forces us to reflect on the recurrent or pervasive qualities of a work and on the overriding theme or mood created by their presence (Figure 4-10). Children, in particular, benefit from learning to synthesize their impressions. The process gives coherence and clarity to their experience of a work.

Judging the significance of perceptual experience

The ability to make decisions about the value of experience is an essential characteristic of maturity. Our response to visual forms is incomplete unless we have tried to determine the significance of our experience. This section treats the difference between personal preference and critical judgment and reviews broad patterns of thought about criteria for judging art.

PERSONAL PREFERENCE VERSUS CRITICAL JUDGMENT. A *personal preference* is something we like regardless of our judgment of its value or significance in a larger context. Com-

pletely egocentric people regard their personal preferences as the only possible criteria for judgment and only acknowledge the value of something if they personally like it.

Unlike a personal preference, a *critical judgment* is based on our carefully observing the facts of a situation (*perceiving*), analyzing facts and relationships among facts in order to discover their implications (*interpreting*), and stating criteria and offering reasons for our decisions about a particular art experience (*judging*).

A *criterion* is a standard by which something is judged. The most difficult problem, of course, is determining the criteria by which we *should* judge our experiences with works of art. There are several guidelines for judgment. First, the criteria we use should not automatically exclude the informed opinions of scholars. It is often helpful to be acquainted with major concepts of art in Western culture and the criteria for judgment related to them.[15]

Second, we should use criteria that allow us to recognize different forms of excellence in art. Just as it is imprecise to judge apples as "poor" because they do not taste like oranges, so it is unfair to decide that all nonobjective paintings are without merit because they do not represent reality. When we learn to value different types of excellence, we find more to appreciate in art.

Third, criteria for judgments should be appropriate to the work in question. This is another version of the apple–orange principle. Ap-

ples come in different sizes, colors, and degrees of sweetness. If we are examining a small, green apple, we should not judge it by the same criteria we would use to judge a large, red apple. We expect little, green apples to be sour, not sweet, to be good for cooking, not for eating raw. Similarly, if we are looking at a work of art that has rugged forms, irregular textures, and muted colors apparently drawn from nature, it is inappropriate to judge it as "poor" because it does not portray other qualities that one can find in nature, such as precision, regularity, and bright colors. It is appropriate, however, to ask whether the rugged forms, irregular textures, and muted colors are so skillfully presented that we are convinced of their naturalness.

Finally, we should be prepared to consider or formulate new criteria for judging art. In twentieth-century architecture and product design, a common criterion for judgment has been "form follows function"—that is, human needs and purposes should determine the form of structures. Nevertheless, many innovations in design have come from artists who have created forms without initial regard for the functions they might serve. Buckminster Fuller's geodesic dome seems to be a form in search of a purpose. The dome can be adapted to serve as a dwelling, an aviary, or an exposition hall. Many contemporary products are specifically designed to serve multiple functions. For example, many preschool classrooms have modular forms that can be used as tables, chairs, storage units, or giant building blocks. Thus, an emerging criterion for judging useful structures is "maximum flexibility in functions from a single form."

With these guidelines in mind, let us briefly review some of the criteria associated with major concepts of art in Western culture.

CONCEPTS AND CRITERIA FOR JUDGING ART. For the purpose of comparison and contrast, criteria for several major philosophical positions are presented in parallel form and center on judgments about the design, subject matter, use of materials, and function of art forms.

Representational Accuracy and Organic Form. A respect for nature is the basis for philosophies[16] that emphasize accuracy and natural form as major criteria for judging art.

The *design* of a work of art should exhibit a dynamic integration of visual elements into an organic whole. The work should express the natural perfection we find in organic forms and the principle of unity-in-variety found everywhere in nature. We should get the impression that no part of the work could be otherwise placed, that the plan, thought, or purpose is carried out without apparent effort.

The *subject* of the work is usually of less importance than the manner in which the subject is treated. If a subject is represented, it should be treated directly—that is, as if it were

accessible to our vision. Indeed, the work should, in some sense be a mirror of external realities. Images of war and destruction should be presented as frankly as subjects about springtime and youth. Nonobjective works should echo the forms, motions, and growth patterns found in nature.

Materials should be handled in a manner that seems effortless. The natural properties of the materials should be respected and revealed rather than contrived or disguised. The medium should be used unobtrusively to enhance the overall mood, visual relationships, and functions of the work.

Finally, if the work is decorative or useful, it should fulfill those *functions* as efficiently as possible without excessive ornamentation. The objects within the work should seem to be a natural part of the environment in which they are placed, seen, or used. As in nature, the form of the work should look as if it were the direct result of its function: form follows function. For example, any object intended to move swiftly should have smooth-flowing surfaces.

Formal Restraint and Moral Value. A respect for our intellectual capacities undergirds those philosophies that emphasize formal restraint and moral value—the good, the true, the beautiful—as major criteria for judging art.[17]

The *design* of a work is successful if the design appears to be consistent and logically developed. The work should seem to be constructed "architecturally"—that is, with a sense of deliberate spacing and measured relationships in lines, planes, colors, and proportions. The work should express a kind of order that, far from echoing nature and being organic, seems to be intentionally patterned by the will of the artist.

The *subject* matter of a work, if there is one, should be idealized; it should convey meanings through expressions, symbols, and themes that are held in high regard by people of refined taste. It should inspire people to better conduct and more considered attitudes. In order to provide satisfaction to the intellect, the work should be "difficult"; it should withstand repeated scrutiny, and challenge us to discover fresh meanings even when we have encountered it numerous times.

The *materials* in a work of art should be handled in a way that obviously seems to have been contrived by the "mind" of the artist. The artist's technique work should appear to have been consciously developed, as if the artist wished to exhibit the fact that precise judgments were made about all the obvious and subtle transitions in the work. We should feel that there is nothing superfluous in the choice of materials or their particular use in enhancing the total form and meaning of the work.

Finally, an artifact that serves an ordinary *function* qualifies as "art" only if its form—considered in its own right, apart from its utility—is

4-11 **A** Amedeo Modigliani, *Head.*

B Portrait bust of a Roman (first century B.C.).

C (*opposite, left*) Donatello, detail of *Mary Magdalen* (c. 1454).

D (*opposite, right*) Frank Gallo, *Head of a Fighter* (1965).

B

A

elegant, restrained, and arrests our attention. The object should seem to have been made for and introduced into the environment in order to make living more gracious and refined. The function of art, in short, is to harmonize our desire for efficiency with our need for visual forms that dignify our life.

Expressiveness and Originality. A respect for individuality and the potency of our inner life is the focus of systems of thought[18] in which expressiveness and originality are major criteria for judging art.

The *design* or composition should not be based on rules or formulas but should be unique to the artist or to the work. The arrangement of parts should hold our attention through unexpected forms of balance, startling colors, dramatic contrasts, or other means that intensify our perception, thought, and feeling.

The *subject* of a work should appear to be of compelling personal concern to the artist. It should be treated in a way that invites us to search our own experience in an effort to find a rapport with the artist's own feelings and outlook. Ordinary subjects should be made to seem extraordinary. Works dealing with social themes should cause us to question our traditional ideas.

The artist's use of *materials*, rather than being shaped by conventional techniques, should seem to flow directly from a total involvement in creating the work. A work showing

PERCEIVING AND RESPONDING TO VISUAL FORMS

C D

originality should not merely be an attempt at novelty but should reflect a genuine effort by the artist to capture personal ideas or feelings.

Works intended to serve a *function* should cause us to alter our typical habits of response. They should offer relief, amusement, or opportunities for us to reflect on some aspect of life that we might otherwise overlook or prefer to ignore. A work might be valued because it performs an unusual function or because of its originality, such as a sculpture that makes music.

Utility and Communication. Some philosophies emphasize the instrumental values of art,[19] placing major criteria for judgment on its usefulness in our lives and its power to communicate to many people.

The *design* of the object should provide us with essential clues to the meaning of the work. For example, sharp, angular, and twisting shapes would be an inappropriate means of expressing tranquility. At the same time, the composition of the work should be intriguing enough so that we have to restructure our experience in some way in order to accommodate what we see.

The *subject* of the work cannot be completely divorced from social experience and still serve as a means for the artist to communicate with an audience. However, a work is unsuccessful if the subject matter is so common or is treated so matter-of-factly that it provides no fresh insights. The subject or theme should

sustain our interest and create a desire to discover the interpretation the artist has given it.

The *materials* of the work should be used in an unobtrusive manner. We should not become so aware of technique that we feel as if the artist is deliberately trying to manipulate our perception and response. If our attention is too forcefully drawn to the medium, the artist has failed to integrate means (medium) of communication with goals (intentions).

Since the *function* of art is ultimately social, any useful or decorative object should help to draw people together and to foster communication. Buildings, utensils, and furnishings that are very elaborate can so dominate our attention as "things" that we cannot regard them as humanizing our daily experience.

These four sets of criteria—representational accuracy, formal restraint, expressiveness, and utility—are not exhaustive, nor are they mutually exclusive. However, they do introduce us to a range of qualities and values essential to judging art. As you can see in Figure 4-11, some works of art will meet all the criteria listed under one of the concepts of art; others will not; and still others will combine particular values from two or more of these concepts. Indeed, many twentieth-century works are intentionally designed to cross categories of criteria; they make visible the contradiction, ambiguity, and paradox of life today.

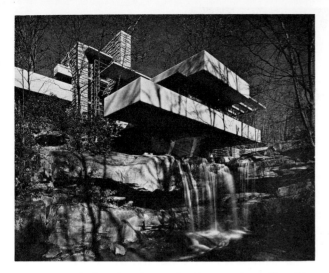

4-12 Frank Lloyd Wright, *Falling Water* (Kaufmann House, Bear Run, Pennsylvania [1936–39]). The view from below the falls.

Whatever the work, the criteria outlined in this section are not absolute or infallible. Taken together, they merely illustrate some of the forms of value that we may find in art. They are but tools to aid independent thought and critical judgment.[20]

Methods of criticizing art

It is important for children to understand both the process of arriving at a critical judgment and the role of criteria within the process. When children become aware of criteria by which art can be judged, they are, at the same time, learning about some of the qualities that many people appreciate in art. We cannot teach children to appreciate art; we can teach them a critical process through which they can develop, test, and refine their own artistic judgments.

Several methods for developing your own skill and confidence in criticizing art are outlined in the remainder of this chapter. Each of the methods—inductive, deductive, empathic, and interactive—is outlined. Following the description of each method is an example of its application, formulated to illustrate how different criteria lead to different judgments about the merit of a single work of art—in this case, the Kaufmann House ("Falling Water"), designed by Frank Lloyd Wright (Figure 4-12).

The inductive approach

Some critics favor an *inductive* approach to examining works of art[21]—that is, gathering visual "facts" in a manner similar to that of Sherlock Holmes's partner, Dr. Watson. The general procedure involves compiling an inventory or counting visual elements in the work; describing relationships among those visual elements; and, when we are confident that we have fully perceived the work, summarizing our impressions in a manner that captures the essence of what we have seen, even though words are never fully adequate to the task. It is important to avoid emotional reactions or premature judgments.

In the view of some theorists, a full visual inventory of a work of art can be made in the manner suggested below. No further judgments of significance or merit need to be made, but they can be if one wishes to. Whether we choose to use words or to perceive the work, the following procedure will be helpful.[22]

1. Perceive (describe) basic characteristics of the work.
 A. Elementary parts: bluish gray, ovals, darks.
 B. Complex areas: cluster of deep grooves, patterns of grain.

2. Perceive (describe) relationships between parts.

PERCEIVING AND RESPONDING TO VISUAL FORMS

A. Elementary areas: this area is lighter than that.
B. Complex parts: the left side is smoother than the right.
C. Recurrent small-scale relationships: blue is repeated.

3. Perceive (describe) regional and overall qualities.
 A. Nonhuman aspects: planes are continuous.
 B. Human qualities: vigorous, brooding, joyful.

4. Perceive (interpret) aspects as they relate to experience.
 A. What is depicted or portrayed: boat, horse, person.
 B. What is suggested: bones like a dinosaur, lines like a leaf.

5. Interpret and summarize the recurrent ideas, themes, qualities to characterize the expressive meaning or import of the work.

6. Judge the work by citing criteria and offering evidence to support the judgment.

Example: The Inductive Approach

Basic character-istics This house ("Falling Water," Figure 4-15) presents a number of horizontal planes of similar proportions but different sizes. The planes intersect to create large, light-colored volumes that contrast with the dark, recessed spaces in between.

Relationships between parts The top and bottom slabs of concrete intersect to form a horizontal cross. These horizontal planes are repeated on a smaller scale in the eaves and balconies. The rectangular proportions are repeated within the vertical chimney core, in the natural stone masonry, and in the natural formation of rocks.

Regional and overall qualities The crosslike intersection of forms is repeated in a series of setbacks toward the chimney. The center of gravity seems to be deep within the hillside. The main slabs seem to be thrusting into space, but they also seem strong, firmly rooted, and capable of bearing their own weight.

Interpre-tation in light of experience This is a photograph of the Kaufmann House at Bear Run, Pennsylvania. It is called "Falling Water." The residence was rather obviously designed for this particular location; it echoes the basic

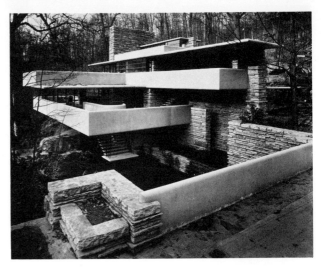

The view from the bridge.

structure of natural rock formations in the waterfall. At the same time, the thrusts and counterpoint of the balconies augment and dramatize the energy field created by the cliff and the rushing water.

summary of main theme

Throughout the residence we feel the dynamic interplay between the supporting weight and strength of the rockbed and the outward thrust into space of the shelflike balconies. The forces of energy inherent in the waterfall are echoed in the form of the house.

General criteria

In view of the apparent concern for nature as an integral part of this residential design, we could say that the most appropriate criteria for judgment are related to the idea of organic form. Accordingly, we might make the following critical judgments:

Specific criterion

DESIGN: Residential architecture should have an organic quality in its design. The major forms in this house echo the caves, boulders, and "steps" in a waterfall. Natural stone from the surrounding area has been used in the chimney.

Evidence showing how work meets criterion

Judgment based on evidence

The asymmetrical arrangement of volumes contributes to the feeling of organic, rather than mechanical, or purely rational, form. The house is well designed because it reflects the serious attention paid by the architect to organic form in many aspects of its plan.

Judgment

SUBJECT: Wright's interpretation of a residential retreat for his client, a department-store magnate, seems generally appropriate. The house mirrors the prestige of the property, the architect, and the client in a luxurious and quietly dramatic manner (scale, setting, attention to detail).

Evidence

Implied criterion and evidence

MATERIALS: The waterfall, heavy boulders, and surrounding landscape have been respected, revealed, and integrated into the design of the house. The smooth surfaces of the reinforced concrete slabs are unnatural and too imposing. They give a technological arrogance to the structure, which seems out of place with other, more organic uses of materials.

Contra-dictory evidence

Judgment

Judgment

FUNCTION: The overall purpose of integrating the house into the

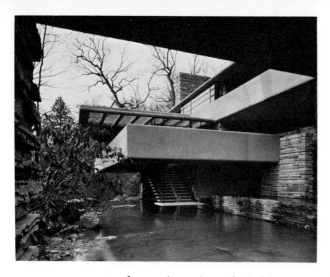

The quiet pond.

Implied criterion

Evidence

natural setting is admirably served. However, there are flaws that hinder efficient living within the structure. Short handrails, narrow halls, and low ceilings make visitors feel uncomfortable and prevent full enjoyment of the residence.

Summary and judgment

In summary, the merit of this residence stems from the architect's concept of designing a house that fits into the natural landscape in its plan, location, and use of materials.

The deductive approach

Another method of examining a work of art might be called the Sherlock Holmes approach. Holmes became famous for his ability to solve a crime by developing a theory that permitted him to deduce who had committed it. He then looked for *only* those facts that would nail the suspect.

This procedure involves choosing definite criteria for judging a work of art (refer to the four sets of criteria outlined earlier for examples); examining the work to see if it presents visual "facts" that do or do not meet each standard; and deciding whether the work is (or is not) "satisfactory" in terms of the standards.[23]

Many people regard the deductive approach as unnatural and restrictive. They argue that if we follow the rules of evidence, we must maintain a distance between our personal feelings and our intellectual performance. On the contrary, this approach can enhance our involvement with a work of art, especially if we are willing to put it on trial, so to speak, more than one time and with different standards each time. This approach also lends itself to a debate format that can prove to be interesting and enlightening. The basic procedure is summarized below.

1. Decide on the criteria you will use.

2. Examine the work to identify evidence that specific features do or do not meet the criteria.

3. Decide on the degree to which the criteria have been met.

Example: The Deductive Approach

To illustrate how the choice of criteria can influence judgments, this example of the deductive approach is developed around the general standards of formal restraint and moral value. The work is the same as before, Wright's "Falling Water."

Criteria

Evidence

Judgment

DESIGN: The design criteria for residential architecture are internal consistency among parts and overall logic among parts. Since the house is built around a module (a standard unit, varied in size), it meets the first criterion quite well. In addition, virtually every aspect of the house employs the rectangular module. Floor plan, details, and the many structural slabs—all repeat the module in a vertical or horizontal orientation. The house, therefore, also meets the second criterion for design.

Criteria

Evidence

Judgment

SUBJECT: The subject, or expressive content, of a residence should reveal fresh meanings to us over a span of time and should represent values that are cherished by civilized people. The residents are most likely to discover new meanings in the environment from the variety of angles and locations from which the natural surroundings might be observed. In general, the house would seem to encourage contemplation and retreat from the stresses of modern living. Thus, according to the two standards for expressive content in residential architecture, the house

is satisfactory. However, the house might have been more elegant and enduring as a source of intellectual delight had the architect been less flamboyant in using the site. There is really no "retreat" from the presence of the waterfall.

Criterion

Evidence

MATERIALS: In architecture, materials should be handled so that we are aware of the judgment and taste of the architect. There is an obvious "rock-shelf" metaphor in the total house. The smooth concrete with rounded edges, the inset glass, and the partially enclosed water pools all reflect constructed, not natural, forms of order. But the architect's logic has not been carried out in a consistent manner. For example, the interior walls are of rugged stone, and the furnishings, also designed by the architect, are also too obviously tied to their natural sources. The "rock-shelf" metaphor becomes banal when applied to the shelving built into the interiors. Similarly, tree trunks that serve as tables are a gimmick unworthy of the subtle logic exhibited in other parts of the house, mainly in the

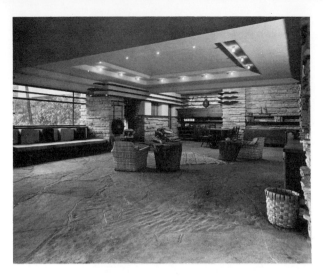

The living room.

Judgment use of concrete and glass. Therefore, in its material aspects, the house is not entirely satisfactory.

Criterion FUNCTION: Residential architecture should meet the functional standard of elegant restraint in daily living. It should reflect a life style based on dignity and grace in family and social events. The integration of the house and its natural environment would seem to *Evidence* encourage a casual and leisurely life style, but still allow for contemplation. It is difficult to imagine exuberance in or around the *Judgment* residence. For these reasons, the house is at least moderately successful in terms of function.

The empathic approach

When we *empathize* with a work of art we attribute feelings and capacities to it as if it had life and vitality. We *see* a line, but we *feel* as if it is moving, active, and rhythmic, we *see* a painting of a tree, but we *feel* as if it is lonely or brooding. Analogies such as these help us experience art, especially if we try to avoid (or postpone) judgments like "it's ugly" or "it's beautiful."

When we examine a work of art, some of the following techniques are helpful to develop empathy and involvement.[24]

1. Do not overlook the obvious. Obvious features may be overlooked even by people who are highly trained in art. If the painting shows a boat, call it a boat; do not reduce the boat to "interesting lines and colors."

2. However, do not overlook purely visual qualities. Notice lighter and darker areas, shifts in color, relative sizes, and so on.

3. Use analogies and metaphors to relate what you see to what you feel. Project yourself into the work as if you were a poet trying to capture the mood or feeling of the work.

4. Use your own experience and knowledge. Compare what you see to feelings you have had, places you have been, discoveries from your own studio work.

5. Be persistent. Do not be afraid to dwell on one aspect of the work; try to understand why you keep returning to it.

6. By all means, get physically and imaginatively involved—as if you were the work or were in it. Act out what you see; use arm and body motions; grimace, grin, whisper, shout. If you are shy, imagine doing these things.

7. Judge the work if you want to.

Example: The Empathic Approach

Do not overlook the obvious
The photographs show a house built over and around a waterfall. The rectangular slabs serve both as platforms for viewing the surrounding landscape and as structural units for supporting the ceilings and floors of the house.

Do not overlook visual qualities
The overall effect is created by horizontal volumes broken by light planes and dark hollows of space. Several spaces have been contrived to direct the flow of water into pools and streams in and around the house.

Use analogies and metaphors
There are probably many places within and around the house where you can be alone and fully alert to the sounds and movement of the water. At the same time, there is an air of status to the residence that seems to invite personal interaction of a restrained, formal nature. The house is like a rugged, informal American version of the traditional Japanese estate with formal gardens.

Use your experience and knowledge
The total effect is dramatic, to say the least. Even though the house was built more than forty years ago, it seems quite modern. Many people would associate the structure and site with great wealth. There is something quite exclusive about the residence.

Do not be afraid to dwell on one aspect
The one thing that seems oppressive is the idea of day-to-day living on top of water and being surrounded by its sound. On a rainy day, the house would seem dark, damp, and cavelike.

Get involved— as if you were the work or were in it
There is also the question of psychological comfort in relation to the decks and the special pond. Looking down at the waterfall from the top deck would be a bit scary. The sunlight seems to be closed out of the house itself; it is only on the decks that warmth and expansiveness can be felt.

General criterion
If criteria based on the expressiveness of a work were applied to the Kaufmann House, judgments of the residence might be as follows:

Fusion of implied criteria, evidence, and judgments
DESIGN: There is little that is ordinary about the residence. Strong contrasts in the use of materials, in the symmetrical arrangement of volumes, and in the site itself build a feeling of dynamic poise

and suggest a latent restive power in the overall form.

Fusion of implied criteria, evidence, and judgments SUBJECT: The concept of a house built above a waterfall, rather than on property adjoining the waterfall, shows the originality of Wright's interpretation of residential architecture—fusing the structure of the house with its environment. There is also a strange primitive reference here, in spite of the modern look of the house; the architect seems bent on forcing a reunion of people with nature.

Fusion of implied criteria, evidence, and judgments MATERIALS: At the time this house was built, the potentials of reinforced concrete for residential architecture were not often exploited; Wright's dramatic use of that material in the Kaufmann House was original. The architect also designed the furniture. The sofa and chairs represent the first use of foam-rubber cushions in furniture. The glass windows are set directly into the stone walls without a frame—another structural innovation.

Fusion of implied criteria, evidence, and judgments FUNCTION: It seems obvious that the house invites a change of pace and a revised outlook on life. Imperfections in its efficiency are of minor importance.

The interactive approach

The interactive approach is also inductive, but unlike the purely descriptive approach, it is a means of seeking, through discussion and debate, *group* agreement about the most likely meaning of a work. The discussion is based on the same steps that were cited for the inductive approach. After the group has exhausted the inductive approach, several people try to formulate a hypothesis about the meaning of the work. They point out features that seem to confirm the appropriateness of their guess, and they encourage others to question each hypothesis. If necessary, the group may conduct research. Through the insights of participants, a process of fusion or funding usually occurs—that is, separate impressions lead to conclusions about the meaning of the work. Quite often there will be a consensus within the group on the meaning of the work.[25]

Although this approach may seem too analytical, the insights of different people can often enrich our own understanding. Moreover, a work of art is "good" if it *does* resist our efforts to

analyze it and if our experience of the work has not been destroyed by the analysis.[26] The procedure is summarized below.

1. Select a moderator and clarify the roles.

2. Draw as many people as possible into the process of describing the work. (Use the inductive outline to guide descriptions.)

3. When people seem to run out of descriptions, call for guesses or hypotheses.

4. Move to a group discussion of the hypotheses until one or two interpretations seem, by group consensus, to approach the possible meaning of the work.

Example: The Interactive Approach

Focus on description, not prejudgment

MODERATOR: Let's see if as a group we can discover some things about this house that we might overlook if each of us viewed it alone. Let's begin by describing what we see; try to avoid loaded terms like "beautiful," "ugly," and such. Who will begin?

Descriptions

BILL: Well, it's a house close to a waterfall. The water is coming out of the bottom of the house. There's a concrete thing that juts out. It looks heavy, as if it was hard to build.

MODERATOR: O.K. That's good. What else?

JOAN: Like the concrete is smooth?

MODERATOR: Right, good, let's keep going.

TOM: The windows are set in metal; they go up next to that deck. Those big slabs or cliffs of concrete—one goes this way and the other one crosses it.

JILL: Yeah, and there are these little ledges you see here, eaves I guess, only there isn't any roof to them.

Loaded observation

TED: I'll bet it's noisy there, and damp.

MODERATOR: Oops—is that loaded?

TED: Well, yes, but I can't get away from this feeling that it would be like living in a fish bowl or a cave.

[After additional discussion and analysis]

Set stage for hypotheses

MODERATOR: O.K., let's shift gears and see if we can come up with some ideas about the aim of the architect. Who has a guess or hypothesis?

PERCEIVING AND RESPONDING TO VISUAL FORMS

BILL: I think he was just trying to build a house.

MODERATOR: Is this one like a tract house in the suburbs?

BILL: No, but you won't find a waterfall in many suburbs, either.

MODERATOR: Well, did the waterfall influence what he did?

MARY: The whole house repeats what the waterfall does, only it is constructed, not a natural form.

MODERATOR: How so?

MARY: Ledges, hollows, concrete boulders, steps, ponds, even the chimney is kind of treelike.

JIM: I don't see it. If he wanted to do that, it wouldn't look so modernistic.

ANN: To me, it's kind of American-Oriental. That's weird, I know, but it's like an American version of a temple set in a naturalistic garden–landscape, like those you see in Japan. But it's American because of the materials and the melodrama.

MODERATOR: O.K., good. Does anyone think the architect failed to account for the waterfall?

EVERYONE: No.

MODERATOR: Well, that's at least one thing we can agree on. Let's round up some other examples of Japanese architecture and explore that hypothesis further.

[Subsequent discussion leads the group to conclude that Hypothesis 2, in elaborated form, is one of several satisfactory ones.]

Because these examples have been written to show the *logical* structure of critical thought, they may seem to deny that we have any personal involvement in the process of judgment. It is important to remember, however, that what we hope to develop is neither a retreat to personal preference nor a blind acceptance of prejudgments by others; what we hope to develop is skill in making critical judgments. Our personal involvement is expressed in the feeling of confidence we obtain from mastering this process and thus being free of the compulsion to accept any ready-made judgment as if it were an edict. Indeed, with sufficient practice, we can approach any object or event and determine the degree and type of significance it holds for us.

In teaching children to examine works of art and objects in the environment, we most frequently commit the error of handing children narrow, ready-made judgments of merit. We do this when we say something as simple as "This is a famous painting. . . ." If we value independ-

TABLE 4-2
PERCEPTUAL RESPONSE: PHASES AND APPROACHES

Perceiving Obvious and Subtle Qualities	Discriminating basic properties
	Building multisensory associations
	Exploring symbolism and connotations
	Becoming aware of contexts
Interpreting Qualities as Sources of Feeling	Building a vocabulary
	Developing empathy and psychic distance
	Speculating
	Synthesizing
	Criteria
Judging the Significance of Perceptual Experience	Representational accuracy, organic form
	Formal restraint, moral value
	Expressiveness, originality
	Communication, utility
	Methods
	Inductive
	Deductive
	Empathic
	Interactive

ent judgments, we should avoid these and similar value-laden claims. Instead, we should nurture skills in perceiving the visual evidence in the work, in interpreting the possible meanings of the work, and in judging the kind and degree of value the work might hold for ourselves and others.

Summary

Full perception requires a conscious effort to overcome our customary habits of seeing things and responding to them. The quality of our response to visual forms hinges on our ability to perceive, interpret, and judge the significance of our experience. A knowledge of varied concepts of art and of criteria for judging visual forms is a point of departure for developing personal and independent judgments of merit. Several methods can be used to develop skills in perceiving, interpreting, and criticizing art. Table 4-2 summarizes these points.

Notes

[1] Kurt Koffka, *Principles of Gestalt Psychology* (New York: Harcourt Brace Jovanovich, 1935), pp. 493–506.

[2] Carl I. Hovland, Irving L. Janis, and Harold H. Kelley, *Communication and Persuasion* (New Haven, Conn.: Yale University Press, 1953).

[3] E. M. Standing, *Maria Montessori: Her Life and Work* (New York: New American Library, 1962).

[4] Jerome Bruner, Jacqueline J. Goodnow, and George A. Austin, *A Study in Thinking* (New York: John Wiley, 1956), pp. 81–90.

[5] H. Werner and S. Wapner, "Toward A General Theory of Perception," *Psychological Review* 59 (1952):324–38.

6 Adelbert Ames, *Some Observations Concerned with the Origin and Nature of Our Sensations* (Hanover, N.H.: Hanover Institute, 1946).

7 P. H. Cook, "The Application of the Rorschach Test to a Samoan Group," *Rorschach Research Exchange* 6 (1942):51–60.

8 Kenneth Boulding, *The Image* (Ann Arbor: University of Michigan Press, 1961), pp. 47–56.

9 C. E. Osgood, "Semantic Differential Techniques in the Comparative Study of Culture," in L. A. Jakobovits and M. S. Miron, eds., *Readings in the Psychology of Language* (Englewood Cliffs, N.J.: Prentice-Hall, 1967), pp. 371–97.

10 For an excellent sampling of Thomas Munro's views on art education, see G. M. Whipple, ed., *Art in American Life and Education,* Fortieth Yearbook of the National Society for the Study of Education (Bloomington, Ill.: Public School Publishing, 1941).

11 Vernon Lee, *The Beautiful* (Cambridge: Cambridge University Press, 1913), Chapters 8–11.

12 Edward Bullough, "'Psychical Distance' as a Factor in Art and an Aesthetic Principle," *British Journal of Psychology* 5 (1912–13):87–118.

13 Henry Aiken, "The Aesthetic Relevance of the Artist's Intentions," *The Journal of Philosophy* 52 (1955):733–53.

14 John Dewey, *Art as Experience* (New York: Minton, Balch, 1934).

15 For a systematic review of such concepts, see Stephen C. Pepper, *The Basis of Criticism in the Arts* (Cambridge, Mass.: Harvard University Press, 1945), and Monroe C. Beardsley, *Aesthetics: Problems in the Philosophy of Criticism* (New York: Harcourt Brace Jovanovich, 1958).

16 Eugen Weber, ed., *Paths to the Present: Aspects of European Thought from Romanticism to Existentialism* (New York: Dodd, Mead, 1967), Chapter 2.

17 Morris Weitz, *Problems in Aesthetics* (New York: Macmillan, 1959), pp. 5–37, 76–92.

18 Weber, *Paths to the Present,* Chapter 3.

19 Beardsley, *Aesthetics,* pp. 539–47, 557–91.

20 Weitz, *Problems in Aesthetics,* pp. 145–56.

21 E. F. Kaelin, "Aesthetic Education: A Role for Aesthetics Proper," *Journal of Aesthetic Education* 2 (1958):51–66.

22 Monroe C. Beardsley, "The Categories of Painting Criticism," in Ralph Smith, ed., *Aesthetics and Criticism in Art Education* (Chicago: Rand McNally, 1966), pp. 489–90.

23 B. O. Smith, "The Logic of Teaching in the Arts," *Teachers College Record* 43 (1961):176–83.

24 Frank Sibley, "Aesthetic Concepts," in Ralph Smith, ed., *Aesthetics and Criticism,* pp. 332–42.

25 Edmund Feldman, *Becoming Human Through Art* (Englewood Cliffs, N.J.: Prentice-Hall, 1970), pp. 196–204.

26 Evan James Kern, "Three Dimensions of Experience: A Curriculum Model for Art Education" (Ph.D. diss., Ohio State University, 1969), pp. 65–92.

Suggested Readings

Boulding, Kenneth. *The Image.* Ann Arbor: University of Michigan Press, 1961.

Feldman, Edmund. *Becoming Human Through Art.* Englewood Cliffs, N.J.: Prentice-Hall, 1970.

Freedman, Leonard. *Looking at Modern Painting.* New York: W. W. Norton, 1961.

Pepper, Stephen C. *The Basis of Criticism in the Arts.* Cambridge, Mass.: Harvard University Press, 1945.

Taylor, Joshua C. *Learning to Look: A Handbook for the Visual Arts.* Chicago: University of Chicago Press, 1957.

Understanding the role of art in contemporary society

5

The preceding chapters dealt with the process of creating art and responding to visual forms from the standpoint of individual participation. This chapter examines similar processes but in the larger context of sociocultural groups.

The children we teach live in a world of ready-made goods and structures. Thus, it is easy for children (and for adults) to forget that our environment is not simply given to us but is created by human effort. When children understand *why* people create objects and images, then they can see their environment not just as a physical entity but as a large-scale expression of human needs. All of us are, in some respects, like *every* other person, like *some* other people, and like *no* other person. We must, therefore, attend to those dimensions of our selfhood that are visibly shared with others in order to fully understand our own uniqueness. Nowhere are those common dimensions more clearly apparent than in the contemporary visual environment and in artifacts created by people whose lives often seem quite different from our own.

The first part of this chapter examines how cultural and social forces influence the creation of artifacts; the second part illustrates how our perception of artifacts is influenced by cultural values. The term *artifact* refers to any object that is intentionally shaped or selected to serve a human purpose.

Social expression through art

Relationships between individual and social artistic expression can be seen in the origin of art forms within a culture, the way people use visual qualities to express their beliefs, and the role of media in social expression.

Sources of art forms in society

The artifacts in any society originate from several sources: the physical need for food, clothing, and shelter; the quest for individual and group identity; and the desire to celebrate important life events.[1]

THE NEED FOR UTENSILS AND SPACES FOR LIVING. Many art forms develop out of the need to create structures for living, working, and

playing. Architecture has evolved as a specialized response to the basic necessity of shelter. Fashion design is a refined extension of our need for clothing. In order to shape any environment, people also need tools and containers. Today, most household and commercial goods are designed for mass production by experts in the fields of graphic and industrial design.

In any culture where physical survival is an ever-present concern, people revere objects that help sustain life. In many African tribes the main cooking pot for a home is created with ritualistic care and is not used until it is dedicated to the proper life spirit. The pot is sacred because it gives physical and spiritual nourishment to the family. When survival is at stake, the manner in which any life-sustaining object is created, acquired, cared for, and disposed of is just as important as the actual purpose the object serves.[2]

Because our standard of living is relatively high, we seldom think of everyday objects as life-sustaining; we view them as life-enriching. We are largely consumers of available products, not creators of unique objects. We have so little personal investment in the process of creating objects that we fail to see that many of them originated from a need for physical survival; objects become psychologically obsolete before they are physically useless (Figure 5-1). Unlike people who live in a culture based on survival, we create tons of litter and junk from useful

5-1 George Gardner, a junkyard in rural New York (1977).

5-2 Notice the visual clues to group identity in this Anglican Congress procession.

objects that we no longer care about. In spite of efforts to salvage and recycle materials, solutions to the problem of waste in our culture cannot be found in technology and engineering alone[3]: a fundamental reeducation of attitudes is required. We must teach ourselves and our children not only to understand the motivations that lead people to create objects but also to cherish things that truly express our beliefs and aspirations.

THE NEED FOR GROUP IDENTITY. Our self-image is shaped, in part, by its visible relationship to the selves of others.[4] A number of art forms establish or maintain the identity of groups—national, social, political, religious, and occupational. Among these forms are flags, stamps, currency, official seals, emblems, insignia, and jewelry. Visually coordinated ceremonies, special motifs, and symbols are the means by which we both establish a sense of community—of commonality and communication—with others (Figure 5-2) and express our individual patterns of living.

In addition to these small and portable signs of group membership, a wide range of buildings and living spaces is specifically designed to facilitate and enhance group activity. Town halls, churches, schools, factories, parks, the city itself—all express our overlapping affiliations with others. Such forms remind us that

UNDERSTANDING THE ROLE OF ART IN CONTEMPORARY SOCIETY

5-3 Collecting and arranging ready-made objects encourages individual expression.

our personal history is linked with the history of others. If children are unable to read their environment for signs of time, place, and belonging, their sense of personal identity is diminished.

THE NEED FOR INDIVIDUAL IDENTITY. In almost every culture, the need for individual identity is as strong as the need for group identity. We can assert our individuality through the arts of body adornment (hair styles, clothing, makeup, and jewelry) and by creating or owning unique objects. Within our culture individuality is often shown by customizing mass-produced objects like cars, bicycles, motorcycles, and clothes. We create a steady market for initialed stationery, jewelry, and housewares because our personal signature and initials signify our individuality. The current renaissance in handcrafts and the popularity of do-it-yourself projects demonstrate that many people who live in a largely standardized and mass-produced environment want to affirm their individual creative powers.[5]

By tradition, most of the art activities offered in schools are aimed at individual expression. We seem to forget that children, like adults, can express their individuality not only by creating art but also by acquiring, arranging, and modifying mass-produced goods (Figure 5-3).

THE NEED TO MARK IMPORTANT LIFE EVENTS. Many artifacts are created for circumstances that profoundly affect the survival and destiny of people. Visual forms help people commemorate such important times in their lives as birth, maturity, marriage, old age, and death.

In traditional societies, art forms express the joys of good harvests, fertility, health, and victory, and they mediate the fears of famine, barrenness, disease, and defeat. Amulets, masks, ritual drums, and sculpture may serve these purposes. Modern societies also use visual forms to celebrate important life events (Figure 5-4). Greeting cards, souvenirs, and gifts are mementos that help us recall milestones in our lives, places we have been, and people we care about. Diplomas, special clothing, and ceremonies help mark our "rites of passage" from one level of accomplishment to another, from one stage of life to the next.

All of us have a desire to know who we are, to remember places we have been, and to recall events that have been important to us. This motivation for creating artifacts is so fundamental that it is easy for us to overlook it completely, especially in teaching children. We should nurture sensitivity to the values people express when they create, arrange, and exchange visual forms. From this perspective, holidays and special school events need not be regarded as trivial opportunities for learning, if we can help

5-4 The greeting-card industry is supported by our desire to celebrate important life events.

5-5 Simple and elaborate forms have different connotations.

5-6 (*opposite*) An aluminum Plantation House, gas station, restaurant, and gift shop. What are the visual clues to some of the value contradictions?

children clarify and acknowledge the values they wish to express on such occasions.

Uses of visual qualities to express social values

The visual qualities of artifacts often express people's values and beliefs. When any culture undergoes change, there are corresponding changes in the visual qualities of the forms the culture produces. Artifacts may show greater complexity or simplicity; traditional visual symbols may acquire new meanings; "original" objects may be mass produced; older forms may be revived.

SIMPLE AND ELABORATE FORMS. Values are often expressed in the kind and amount of elaboration given to artifacts[6] (Figure 5-5). The visual qualities typically found in simple forms are large, strong, but tightly organized shapes; little surface decoration; and subdued patterns of movement. Simple forms usually express the social values of restraint, stately dignity, and permanence. They also suggest efficiency and cleanliness.

Elaborate forms activate our senses in a different way. Surfaces are rich in decorative detail; size relationships are exaggerated. Patterns of visual and kinesthetic movement are

created by many shifts in direction, so that we feel a gathering of our own energies as we examine the form. Qualities such as these express emotional or physical energy; they allude to wealth and a quest for ecstasy or power. They are also linked to a desire for sensuous experience and the showmanship of overstatement.

In our society many people express their desire for social status by acquiring elaborate furnishings and decorative items. Even in the absence of genuine power and wealth, people can still express these aspirations by acquiring low-cost versions of items they consider status-giving. Many elaborately decorated items can be manufactured at very low cost because ornamental surfaces can be used to hide ill-fitting joints, unfinished edges, and poorly engineered parts. Although it is easy to judge many popular art forms as tasteless and poorly crafted, it is important for children to understand the human aspirations that these forms fulfill.

CONTRADICTORY RELATIONSHIPS. Visual contradictions will be apparent in artifacts when new values are not fully integrated with older ones. Artifacts may keep the same basic form but be decorated in a new way, or the decoration may remain but be attached to new forms (Figure 5-6). Sometimes people maintain older forms (like train stations) but put them to new uses (converting them into recreation centers).

Consider, as an example of contradictory values, the popularity of brand-new Early American furniture, finished in Formica. The style of the furniture encourages the owner to feel in touch with the American heritage. At the same time, the surface of the furniture is new and damage-resistant. The furniture speaks of the American heritage only through its surface form, not through its underlying meaning. Unlike an antique, the new furniture does not embody a real history of care that would account for its survival to the present. Moreover, because the newer furniture is intentionally designed to take abuse, it invites an attitude of carelessness that contradicts what the visual form seems to assert—namely, a devoted interest in preserving objects from the past.

Contradictions of this kind pervade the popular taste of our time. On the one hand, they express our interest in trying to accommodate the past to the present; on the other hand, they reflect a subtle kind of self-deception in which our values are superficially displayed but are not actually reconciled.[7] Both children and adults need to become more conscious of the way ordinary objects express values, even if those values, when examined, are not the values we might wish to affirm.

SYMBOLISM. When similar themes occur in different cultures, related symbols are often used

TABLE 5-1

UNIVERSAL THEMES IN ART

Ideas	Imagery and Symbols
Duality: male–female, good–evil, human–animal	Androgynous creatures, part human and part animal; witches, monsters, wild beasts subdued by more passive creatures
Transcendence of ordinary experience	Birds, winged horses, flying dragons, angels; amphibious creatures like mermaids, alligators, turtles, snakes, lizards; superheroes like Hercules, Apollo, Mercury, Tarzan, Superman
Totality of self, natural forces, spirits, time and place	Circle, mandala (interlocking circle and square), all-seeing eye, objects made of stone and other permanent materials

Chart is based on an analysis of themes and examples presented in Carl Jung, *Man and His Symbols* (New York: Dell, 1964).

to express them.[8] Strength and power are frequently symbolized by creatures that are powerful, tenacious, or cocky. In our culture, for example, the most common symbols for collegiate athletic teams are tigers, wildcats, bears, and cougars. Other examples of themes and symbols are noted in Table 5-1.

The symbolism found in mass media and in the environment reveals the dominant concerns of our culture. The good life is often envisioned as a proper blend of youth, security, freedom, material wealth and status, personal attractiveness, and self-image, we seem to fear their opposites—old age, insecurity, lack of freedom, poverty and failure, unattractiveness, and lack of identity.

Various symbols express these themes. In advertising, youth and freedom may be symbolized by placing a product in a natural or exotic environment where innocence might be rediscovered. The sea—symbolizing a new life, cleanliness, and adventure—helps to sell personal products. The pirate, knight, and cowboy are common visual metaphors for virility; women's products are sold through varied images of femininity—woman as sex siren, goddess of beauty, serene madonna, perfect hostess, earth mother. Our physical and psychological needs for secu-

UNDERSTANDING THE ROLE OF ART IN CONTEMPORARY SOCIETY

rity are reflected in the environments we construct. High fences, wire grates and silver strips on windows, and uniformed security guards are both real and symbolic expressions of our need to feel safe. Whether subtle or obvious, the symbolism in cultural artifacts is a potent means of social expression.

The visual environment in which children grow up is loaded with symbolic meaning (Figure 5-7). The messages communicated to children through advertising, product design, community planning, films, and television are sometimes contradictory and often false. But symbols are too rarely examined within the art program. When we teach children about symbolic meanings of artifacts—in our own and in other cultures—we must be willing to talk with children about *life,* not just art.

PROTOTYPES AND VARIATIONS. In many societies, we can find structures that are so original, expressive, and widely revered that people want to imitate them. Recently built "Greek temples," new "Roman pantheons," modern "Gothic cathedrals," and variants of "American skyscrapers" can be found in many parts of the world (Figure 5-8). Variations like these offer a real or vicarious opportunity for people to express an affinity with the values represented in the prototype building.

5-7 A form like this communicates messages about the "good life."

5-8 What is the prototype for this Midwestern American church?

Through mass production, images of prototypes can be widely circulated and used for a variety of purposes. Consider the expressive use of a Mona Lisa image on shopping bags, wrapping paper, or in cosmetic advertisements. In reproduced form, the image is "democratized"; it no longer enjoys the aura of preciousness that surrounds the original work. The inherent expressiveness of the painting becomes less important to us than the fact that we have already seen the image in prints and reproductions. Ironically, we begin to value the original because it confirms the authenticity of our reproduction.[9] When images are widely circulated, they become part of the general visual language in the larger environment and acquire new expressive meanings.

When elements from different prototypes are combined in a single form to express competing cultural values, the result is an *eclectic* form. Where else but in America could we find gasoline stations that look like English cottages, Chinese temples, or Spanish haciendas? Eclecticism is characteristic of American culture, perhaps because we are a nation of immigrants and we are relatively young as a distinct culture. "Western" and "colonial" themes are popular sources of design in houses, shopping centers, furniture, clothing, and decorative items. The West and Colonial America probably thrive as stylistic prototypes because many people still identify with the spirit of ruggedness and independence represented by these styles.

The large-scale creative processes that cause any environment to have a particular look and feel are neither so complex nor so abstract that children cannot grasp them, provided that the examples we draw on are tied to the existing interests of children or are treated so that new interests are generated.

Uses of media to express social values

Anthropologists have long recognized that a culture can be radically altered by new tools and materials. When Marshall McLuhan says "the medium is the message," he reminds us that tools, materials, and technologies can have a profound influence on life styles.

CONTROL OF MEDIA. In almost every culture, rare materials or those obtained through great effort are reserved for the powerful; they symbolize status. In this respect, a tiger-tooth necklace is not much different from one made of diamonds. The ability to acquire, keep, or share certain materials is not just a measure of personal status; it may also be a symbol of national

prestige. Wars have been fought to gain control of materials like diamonds, gold, silver, and silk.

Social values can be reinforced or changed by controlling the use of a medium or a technique. In the Soviet Union, for example, artists are issued a supply of materials for their work. In exchange for the materials, the artists must fully account for their use of them. The ideological content of their work must be approved before they are given additional materials. Because the state controls the artist's source of materials and the conditions for using them, the state also controls the images people are permitted to see.

Teachers in our public schools often unwittingly use the same system for distributing supplies. Perhaps you recall getting nice white paper to draw on, but only after your idea was approved by the teacher. Control can be subtle or obvious. For example, if you were forbidden to use any paper items for a day, how many products would you have to do without?

ADAPTATION OF MEDIA. Our fascination with a carefree existence is evident in the materials from which many everyday objects are made. Such materials invite us to treat things roughly and carelessly. Some objects—such as toys, watches, and suitcases—are specifically designed and advertised to be indestructible, or

nearly so. Some advertisements even dare us to test the "rugged" construction and "tough" materials of a product by trying to destroy it.

A rough, destructive attitude toward things is reinforced by the preponderance of disposable goods. We smash paper cups without blinking an eye, squash aluminum cans to test our strength, throw away plastic glasses, forks, and spoons after using them once. The existence of items advertised as care-free, self-cleaning, and unbreakable contributes to our belief that objects do not need any special treatment to retain their utility.

In a world of crushproof, disposable, replaceable, and care-free objects, children can fail to learn the value of preserving things and handling them with a delicate touch and gentle motions. In principle, care-free items leave all of us free to care more about human relationships and the quality of life. One wonders, however, whether a careless attitude developed in the context of *things* can be contained and restricted to things alone, or whether it may not extend to people as well. Childhood is a prime time to build a sensitivity to the relationship between our conduct and the objects and spaces in our environment.

SELECTION OF MEDIA. Social concerns are expressed in choices of media. Fluorescent colors

5-9 Elliot Erwitt, *Highways* (1968). Extensive environmental changes can be brought about by innovations in media and technology.

appeal to teenagers because the colors have an intensity, contrast, and visual vibration that heightens and complements the energy of youth. Glitter dust and rhinestones echo the sparkling beauty of diamonds; spray paint in gold and silver is a popular item, not only because it is inexpensive but also because it shows a desire to own things of real silver and gold.

A particular medium can have contradictory connotations. Glazed brick is frequently used for the interior of school buildings because it is easy to clean and does not need to be repainted. At the same time, this material creates a hard, cold, glaring surface that magnifies sound and conveys the sterility of a hospital, the impersonal uniformity of a prison. The physical characteristics of glazed brick contradict the idea of teaching and learning within a warm, friendly environment.

INNOVATIONS IN MEDIA. When media are introduced into a society or culture, radical changes are bound to occur. The introduction of metal axes into a culture previously dependent on shells and stones for cutting materials allows new forms of art and architecture to develop. The invention of printing made it possible to share thoughts and pictures with a large number of people. Many immigrants adopted speech

patterns and etiquette by watching the "talking movies."[10] Television has profoundly altered our sense of time, space, and reality, not only by locating worldwide events in our living rooms but also by developing program formats with as many as twelve one-minute commercials punctuating a thirty-minute broadcast period.

Innovations in media have altered the course of art and architecture. Oil paint, for example, permitted artists to use multiple layers of paint. The rich shading created a new kind of "photographic" illusion that had not been possible with other painting media. Reinforced concrete, steel, and glass offered new structural possibilities for architects and engineers (Figure 5-9). Telescopes, microscopes, X-rays, and similar mechanical extensions of the eye gave artists a new understanding of the activity, scale, and form of things that previously could not be seen by the naked eye alone.

We need to help children understand that our environment is marked by a number of contradictions, ironies, and ambiguities. In this respect our environment echoes the imperfect accommodation we have made to the pace of change in many aspects of our lives. In other ways, however, the visual forms that pervade our lives serve the same stabilizing functions that cultural artifacts have always served—to envision, to celebrate, and to control the human condition.

5-10 One hundred percent pure plastic flowers.

Patterns of response to the visual environment

There is an intimate relationship between the way people live and the way they perceive, interpret, and judge their visual environment. On the scale of a culture or a subculture, patterns of response to visual forms are inseparable from life styles.

Ways of perceiving the visual environment

Our visual environment is so complex and value-laden that we cannot easily perceive it as a whole. For this reason, it is helpful to examine our visual environment selectively in terms of media and art forms, subjects and symbolism, design and style, and the purposes and contexts associated with artifacts.

MEDIA AND ART FORMS. Our perception of any environment is conditioned by the dominant materials and forms within it. Americans are said to be a visually oriented people; the "appearance" of things is very important to us. Even if we ignore the "look-but-don't-touch" admonitions of the middle class, there are few cultural incentives for us to make distinctions in the texture, resilience, weight, and temperature of things. Almost all the products that we use in daily life are packaged or designed for visual appeal, thus minimizing other modes of sensory exploration. We cannot smell coffee sealed in a can; we cannot feel cloth enclosed in a plastic bag. Consequently, our ability to distinguish real from imitation materials is poorly developed.

Surface appearances can be misleading. Through modern technology, compressed wood can be made to look like ceramic tile, asphalt tile to look like brick, paper to look like cloth, and plastic to look like almost anything (Figure 5-10). Imitative techniques are so highly developed that people sometimes touch flower arrangements to see whether the flowers are real. Products are labeled so consumers will know that they are "genuine leather," "solid brass," "authentic handcarved wood," or even "fake fur." Extending this idea, one manufacturer assures us that his plastic tablecloths are "100 percent pure virgin vinyl plastic."

Critics of contemporary life have dubbed our environment "plasticland." The label suggests a relationship between the qualities of plastic as a material and the quality of life we live. Plastic is synthetic; it easily imitates the colors, textures, and forms of many other things. Plastic items are inexpensive to replace. We tolerate an imitation world, critics imply, be-

5-11 Whimsy and history are combined in many environmental forms.

5-12 Stylistic discontinuity is common in the contemporary environment.

cause we have become "imitation" human beings; we are easily impressed by surface appearances, and we tend to regard other people as replaceable objects. Cultural conditioning of perception is so pervasive and so subtle that neither we nor the children we teach are even aware of it. And if we are unresponsive to the conditioning of our senses, then we can hardly judge the positive or negative influence of conditioning on our lives.

SUBJECTS AND SYMBOLISM. Explicit symbolism is based on our immediate experience and thus is always more readily perceived than implicit symbolism. The skull and crossbones—symbolizing poison, danger, and death—is quite explicit. When black Americans adopt African hair styles and clothing, they refer to their ancestral heritage explicitly. Implicit symbolism is an equally important transmitter of social beliefs. For example, many older schools were built to resemble medieval monasteries or "temples" of scholarship. Newer schools often resemble factories; they visually reflect a belief that education is preparation for the world of work. We echo this philosophy when we speak of *industrious* students, school *work* and learning *tasks*.

When visual symbols are shifted from one social context to another, they undergo subtle transformations in meaning.[11] The castle in medieval society protected residents from invaders

UNDERSTANDING THE ROLE OF ART IN CONTEMPORARY SOCIETY

and indicated the wealth, power, and benevolence of the noble family that occupied it. At the turn of this century, many homes were built with turrets and towers to express the same idea—namely, that "a man's home is his castle." Today, this castle metaphor has acquired a note of fantasy, not only in Disneyland but in restaurants where the king of hamburgerland entices us to visit his glistening white castle and enjoy a royal feast. Children, no less than adults, can easily miss the wit, poetry, and history reflected in our contemporary environment if they fail to perceive the delightful irony and pretentiousness of such visual metaphors (Figure 5-11).

DESIGN AND STYLE. As a culture, we are quick to notice "styling" in automobiles, appliances, home furnishings, and clothing. Because we buy such products and make personal stylistic choices among them, our perception of them is fairly astute. We are less skilled in discerning larger relationships within our living spaces and environment. In the Midwest, for example, many older brick homes were modernized by the replacement of wood or brick porch columns with wrought iron porch supports. The owner considered the new detail attractive and characteristic of newer homes, but seemed unaware of the discrepancy between the apparent weight of the porch roof and the flowery openness of the new supports. Examples of this kind are evidence of an inability to perceive those relationships among parts that give coherence to the overall form.

The uncontrolled growth of large urban centers has created an environment that is difficult for us to see and comprehend as a stylistic whole (Figure 5-12). Suburban tract developments and national chains of stores and motels do offer some visual coherence within the larger environment. Nevertheless, people who live in predictable environments often seek out places in which perceptual activity is stimulated—such as the downtown districts in many cities, with the rich interplay of new and old forms, or the suburban shopping centers, with their multilevel malls and complex entry–exit points.

PURPOSES AND CONTEXTS. In any culture heavily bound by tradition and authority, people have little difficulty perceiving the purposes of artifacts and the appropriate contexts for their use. Ritual and ceremonial objects are treated specially. Socially important objects are carefully displayed, handled, maintained, and stored. Anyone unable to realize that certain artifacts require special treatment is considered "different," "an outsider," or "crude." Thus, a person wishing to attract attention or to publicize an issue may intentionally alter the context in which an artifact is perceived, thereby producing a visual contradiction. A flag displayed

on the seat of one's pants is one example; a pair of pants hoisted on a flagpole is another. We can see contextual "dislocations" like these as morally offensive or as simple pranks, depending on the degree to which we value a particular visual form.

Our ability to determine our priorities can be eroded by continual exposure to conflicting visual information. What happens to the serious meaning of a televised documentary on poverty when the program is interspersed with commercials for deodorants and antacid preparations? Do we perceive the irony? Do we believe children should? It is not yet possible to predict the specific messages that people receive from the mass media; it is evident, however, that when advertisers spend as much as $120,000. per minute for a television commercial, an effect on the viewer is expected.[12]

When we teach children to "read" the visual environment as a system of communication, we show them that literacy extends beyond books and blackboards. It includes the ability to decipher meanings that are presented in visual forms.

Ways of interpreting the visual environment

People tend to interpret objects as possessing a distinct function in life, as signaling individual-ity or representing group membership, or as marking important events. We have treated these themes earlier in the chapter as cultural reasons for the creation of art. We return to them now as bases for the interpretation of the environment. The relationship and overlap are intentional. On the scale of daily living, many apparently trivial artifacts make sense to us as part of artistry in living, not as singularly precious items to be revered for all time as great works of art. Our educational task is to help children interpret simple, ordinary things in terms of the human needs they satisfy.

TOOLS, UTENSILS, AND SPACES. The expression "a house is not a home" points up the difference between the physical structure of a residence and the feeling-tone within it. In a house, a chair is little more than a piece of furniture to sit on. In a home, a chair has a history of associations. We remember how it was acquired, who prefers to sit in it, how it has aged, and the care it has received. Similarly, we obtain some things as gifts; others we purchase; and still others we borrow, trade for, or rent. If a family heirloom is left to us in a will, the implications for its use and care are far more complex than for a similar item purchased on impulse. The meaning we can ascribe to an object is only partially determined by the object's visual prop-

5-13 Traditional structures suggest continuity in the midst of change.

erties and utility. Our interpretation often depends on the intimacy of the circumstances in which we acquire the object.

The real or threatened disposal of an object reveals the degree of genuine feeling we have for it. In many cultures, formal ceremonies preceed the use of any natural resource for a human need. If a tree is cut down to make a house or a canoe, the sacrifice of the tree is noted in prayer. Similarly, the kind and degree of effort we channel into the preservation of open spaces or historical buildings shows the importance we attach to such things (Figure 5-13). (Often it is very little.) Nevertheless, the physical care we give to material things ultimately affects the way we are able to care about each other. Each generation, it seems, must relearn this lesson; and the more affluent the time, the more difficult the lesson is to learn.

EXPRESSIONS OF GROUP MEMBERSHIP. When people have a comprehensive system of belief, they tend to interpret a wide range of artifacts in terms of that system. During the Middle Ages, religion played such an important role in people's lives that all their efforts were undertaken in the spirit of serving God, and virtually every artifact could be interpreted as fulfilling a religious purpose. In a totalitarian government, a wide range of artifacts is used to further the interests of the state. Within our culture, some religious groups have definite rules for interpreting artifacts as good, neutral, or evil; as sacred, secular, or profane.

People who have special interests usually present elaborate interpretations of particular artifacts. Experts on comic books, old films, custom-built cars, and other popular art forms can offer subtle explanations of these forms. Comparable skills are found in the field of traditional fine arts, where experts in art history may specialize in interpreting a single art form or historical period. Thus, intense interests are not always generalized.[13]

The more permanent a group is, the more it can embellish the meaning of cultural artifacts. Folklore and repeated use of artifacts keep their meaning alive within a group. In a highly mobile society, there are relatively few permanent groups to which people feel they belong. Consequently, the rich cultural meanings of many artifacts are now poorly understood. Current efforts by American Indians, Afro-Americans, Spanish-speaking groups and people from Appalachia to revive their heritages center, in part, on reinterpreting the expressive power of the artifacts of their respective cultures.

EXPRESSIONS OF INDIVIDUALITY. We interpret the individuality of cultural artifacts by

the frame of reference we have for uniformity. In many towns, residents can point out certain buildings that are unconventional, eccentric, bizarre, or exotic by community standards. Perhaps your home town had a house made of sand-filled bottles and cement, or maybe it had a futuristic, custom-designed residence. Such artifacts become topics of conversation because they are unusual. The larger the number of digressions from the norm, the more apparently "individual" an expression is.

Notice, however, that our own sense of cultural history stems from the fact that we can recognize prototypes, landmarks, exemplars, or innovations that give visible form to new patterns of human achievement because of the magnitude of their departure from previous traditions. What one generation may ridicule another may cherish. Idiosyncratic forms—whether local or national, trivial or profound—speak of self-reliance and personal freedom.

IMPORTANT LIFE EVENTS. When social values change, people interpret the same kind of event in different ways. In paintings, tapestries, and triumphal arches, war is depicted as a gentlemanly sport and an aristocratic pursuit, as a religious crusade against the forces of evil, as the protest of ordinary people against injustice, as

the nakedly brutal destruction of human life, as a computerized operation yielding printouts of "body counts." Art forms in may cultures are a means for people to interpret the meaning of life through their concept of death. Interpretations of life events, by both creator and audience, vary with time, place, and dominant cultural values.[14]

If an artifact is closely tied to the central ideology of a group, its preferred interpretation is usually codified by rules and rituals. Since people do not take ideological matters lightly, national flags, religious artifacts, political emblems, and other images symbolizing the beliefs of a group are interpreted in rather explicit ways. Members of secret societies are carefully instructed in the meanings of artifacts that play a central role in the affairs of the group. Governments employ experts in protocol to help insure that nonverbal "insults" are avoided in affairs of state, such as formal dinners, exchanges of gifts, and parades.

From these examples we can see that although artistic considerations do play an important role in interpreting cultural artifacts, aesthetic values are not the *only* basis for such understanding.[15] A cultural perspective on art is valuable because it tempers our tendency to emphasize children's individual responses to fine art while neglecting the larger systems of value that condition attitudes toward art.

(*opposite*) People attach different values to permanent and to disposable or temporary forms.

(*right*) What values and needs were evidently *not* met by these new apartment buildings?

Ways of judging the visual environment

There is a direct relationship between visual forms and social values; indeed, a judgment of one implies a judgment of the other. When we judge cultural artifacts we should acknowledge that different values can be expressed and reflected in visual forms; similarly, when we judge life styles we should be tolerant of modes of living that differ from our own.

THE VALUES OF PERMANENT AND TEMPORARY FORMS. Because the degree of permanence people seek in their lives differs from person to person, from culture to culture, and from generation to generation, there is wide variation in the values people attach to relatively permanent and temporary artifacts (Figure 5-14). It is, therefore, not a simple matter to make judgments about the degree of permanence that people should seek in their lives.

Whether by choice or of necessity, many people in our society live a nomadic life; they have relatively few permanent artifacts. A wide range of goods and services facilitates this life style: rental services offer people temporary living quarters, furniture, and transportation; many items can be purchased at low cost and sold or

thrown away on moving day. Alternatively, a person can purchase a mobile home and achieve the freedom to live almost anywhere for as long as he or she wishes.[16]

In a transient society such as ours, permanence may be defined less in terms of *our* location than in terms of the larger geographic area within which we move. We feel "permanence" when we encounter the familiar design of national chains of motels, service stations, and restaurants, as well as well-known trademarks and signs. People who move from place to place often treasure a few items that they place in the new environment to make them feel at home and to give continuity to their lives.

We usually express our most important ideas and traditions in relatively permanent structures and artifacts. However, when we no longer believe in the values represented through permanent structures, we lose our desire to maintain the structures. Thus, efforts to preserve or renovate old buildings are most likely to succeed in communities in which residents have rich and positive memories of the "lives" of the buildings. Although permanent structures can become white elephants or empty monuments to the past, they can also embue a community with a sense of continuity in the midst of change. Moreover, any decision to destroy evidence of cultural tradition is irrevocable; we can never reconstruct, even through clever replicas, the authentic living history that many perma-

nent structures embody. We diminish our opportunity for self-understanding when we destroy the forms that represent our past.

THE VALUES OF TRADITIONAL AND INNOVATIVE FORMS.

Some people prefer to build their lives around traditional forms; others want to have things that are up-to-date, stylish, or novel (Figure 5-15). A life style based on tradition offers different rewards from a life style centered on the new.

Traditions have to be protected and renewed if their value is to be appreciated in the present. In the last decade, there has been a growing interest in nostalgic items, in antiques, old-fashioned clothes, handcrafts, and organic gardening. People are interested in rediscovering traditions that have nearly been lost, because traditions provide a feeling of identity and meaning in the midst of an anonymous and perennially novel environment.

Nevertheless, we value innovations so highly in our society that merely putting the words *new* or *improved* on the label of a product will virtually guarantee an increase in sales.[17] The desire to be up-to-date and to have the latest available goods and services is characteristic of a life style that invests the present with a feeling that the future is already here. If it is true that many innovations have little staying

power, it is probably because we have not envisioned a future that has emotional meaning and ideological depth. As a consequence, we are neither profoundly pleased nor displeased with forms that embody our expectations. The "firsts" within our personal history are usually memorable because of the anticipation surrounding them.

To the extent that we value tradition-bearing structures, we seek a meaningful link with the past. Many of the structures in our environment appear to preserve tradition but do not require us to adopt behavior appropriate to the tradition. At the very least, we should be *conscious* of the discrepancy between appearance and behavior and make children aware of it as well. Only then can we determine in what aspects of our lives we truly wish to foresake tradition and the forms that express it. Only then can we consciously create traditions—including, if we wish, "the tradition of the new."[18]

THE VALUES OF SINGLE-PURPOSE AND MULTIPURPOSE FORMS. When people are very interested in an activity, they value specialized equipment, tools, and spaces for carrying on that activity. Photography buffs, for example, are soon up to their ears in cameras, lenses, and enlargers. In contrast, because people who are less devoted to an activity are often willing to

improvise and are less concerned with precision they are more likely to want only a few basic, multipurpose items. Thus, a life style built around multipurpose forms is structured differently from a life style centered on single-purpose forms (Figure 5-16).

Multipurpose structures have the advantage of accommodating a variety of human activities without requiring people to invest a great deal of their time getting ready for each activity. Many schools have a large multipurpose room that serves as gymnasium, cafeteria, theater, and meeting room. However, what happens to our appreciation of the finer points of dining when we play fast-moving games in the same space in which we eat? Are there visual clues to remind us of the difference between throwing a ball and throwing food? In order to focus on a specific activity in a multipurpose room, such as watching a theatrical performance, children must overcome their associations of the space as a place to eat and to play. Appropriate behavior for a theater audience must be structured from the "inside out" because the physical environment and visual form of the multipurpose room do not, in themselves, reinforce or complement any particular pattern of behavior.

Community decisions about building specialized or multipurpose structures are never without social consequences. Until recently, citizens from all walks of life in a midwestern city attended the summer opera held in a grand-

5-17 (*opposite*) Which of these two communities seems more inviting?

5-16 Which form appears to be more specialized in function? (*above*) Platform bed (1973). (*below*) Queen Anne bed (1735–50).

stand theater at the local zoo. Families combined a night at the opera with a preperformance visit to the zoo and a picnic dinner on the grounds. Performances at the zoo were discontinued when the opera house downtown was renovated. Now the opera is patronized largely by the upper middle class, and fewer families attend performances. The new opera house is ideal for more professional performances, but the less professional (specialized) conditions at the zoo attracted people of more ages and from a wider range of socioeconomic backgrounds. Since the city could not support operatic performances at two locations, this aesthetic decision involved a trade-off between access to the opera and the quality of opera available. If you lived in this city, what would your reaction have been to this?

If we believe that our lives require more focus, order, and discipline, we can nurture that pattern of behavior through specialized structures. By the same token, we can seek out and create multipurpose forms if we believe that our lives require greater openness, flexibility, and casualness.

THE VALUES OF UNIFORMITY AND DIVERSITY. People also differ in the degree to which they seek uniformity and diversity in their lives.

These qualities of life can be supported and enhanced through the design of the larger environment and of the artifacts within it.

It has been estimated that about 80 percent of the constructed environment has been designed "unself-consciously"—that is, without the direct influence of architects and professionals in environmental design.[19] In unself-conscious design, individuals or small groups use the resources available and work without reference to a centralized plan, to build places for living and working that suit their own immediate needs. As a result, the environment they create is composed of fairly autonomous parts that can be altered with little difficulty. Most cities have developed in this way, and thus can be rich, diverse, and flexible precisely because they were not built around a comprehensive plan.

Today, life in metropolitan centers is so complex and services are so interrelated that small changes in the environment rarely meet people's needs. Improvements in mass transportation, pollution control, and urban renewal, for example, require vast resources and cannot be made as rapidly as small changes. In order to make any extensive environmental improvement, some person or some group must have a concept of the future needs and desires of the many people who will be affected by the change. The question facing citizens and planners is how to maintain personal freedom and diversity while providing goods and services for many people. Answers are complicated by the fact that our society is organized for mass production.

Inherent in mass production are possibilities for building either greater uniformity or greater diversity into the environment and into people's lives. Mass production is based on the principle of duplicating identical units; the unit can be as small as a window or as large as a suburb. Uniformity of style results because critical decisions about the form of each unit are delegated to a relatively small number of experts in design, engineering, and marketing. In many large-scale projects, prefabricated and modular units speed up the construction and reduce the costs, making the use of these units economically attractive. Aesthetically, prefabricated units also reduce the visual chaos of an unplanned environment. However, when they are used unimaginatively, prefabricated units create a uniform, sterile environment (Figure 5-17).

Mass-produced units need not be used mechanically. The availability of a wide range of ready-made units to people, including professional designers, facilitates both choice among the units and the creation of more individualized environments for living. Ready-made units can be combined, added to existing structures, and adapted to create new forms and to serve new purposes. Viewed in this way, mass produc-

TABLE 5-2
SOCIAL EXPRESSION THROUGH ART

Sources of Art Forms in Society	The need for tools and spaces
	The need for group identity
	The need for individual identity
	The need to mark important life events
Uses of Visual Qualities	Simple and elaborate forms
to Express Social Beliefs	Altered visual relationships
	Symbolism
	Prototypes and variations
Uses of Media	Control
to Express Social Values and Beliefs	Adaptation
	Selection
	Innovation

PATTERNS OF RESPONSE TO THE VISUAL ENVIRONMENT

Ways of Perceiving	Media and art forms
	Subjects and symbolism
	Design and style
	Purposes and contexts
Ways of Interpreting	Tools and spaces
	Expressions of group membership
	Expressions of individuality
	Important life events
Ways of Judging	Permanent and temporary forms
	Traditional and innovative forms
	Single-purpose and multipurpose forms
	Uniformity and diversity in forms

tion need not prevent the development of responsive and personalized environments.

Neither extreme—sterile uniformity or chaotic diversity—is entirely satisfying. Ideally, the environment should be designed to accommodate the plurality of expectations within our society.[20] The environment is not merely a physical entity but a *system of communication.* If people are to create a sensible and meaningful environment, citizens must be conscious of the power of visual forms to support and enhance values. The task of citizens and professionals in design is to articulate forms, functions, and images so that there is an interplay of meanings that can be discerned by people from all walks of life.[21]

In any extended view of environmental design, we inevitably confront relationships between aesthetic judgments and human aspirations. Today's children are tomorrow's citizens. As taxpayers and decision-makers, they will, either by choice or by default, re-create the environment. As human beings, children deserve an educational program that prepares them to feel some personal and direct control over the shape of their world and what it says about being human.

Summary

Many of the artifacts produced in a society may seem to be little more than cultural doodads; nevertheless, visual forms serve as important means of maintaining, transmitting, and transforming people's values and beliefs. The human environment is not simply a neutral background for living; it is a significant educational force in its own right.

The social dimensions of art are complex but can be understood in terms of large-scale processes that are, in some ways, parallel to the processes of individual creativity and perception (Table 5-2). Nevertheless, the role of art in a society or a culture cannot be reduced to purely aesthetic considerations. The life styles that people create for themselves are reflected in and altered by the art forms they choose and make. Whenever we judge the contemporary environment, we render judgment on ourselves.

Notes

[1] Melville Jean Herskovits, *Man and His Works* (New York: Alfred A. Knopf, 1948).

[2] Ruth Benedict, *Patterns of Culture* (New York: New American Library, Mentor Books, 1934), pp. 59–61, 196–240.

[3] Paul Swatek, *The User's Guide to the Protection of the Environment* (New York: Ballantine Books, 1970).

[4] Anselm Strauss, ed., *The Social Psychology of George Herbert Mead* (Chicago: University of Chicago Press, 1956), pp. 212–94.

[5] Bernard Rosenberg and David Manning White, eds., *Mass Culture* (Glencoe, Ill.: Free Press, 1960).

[6] Kenneth Boulding, *The Image* (Ann Arbor: University of Michigan Press, 1961), pp. 132–47.

[7] Gillo Dorfles, *Kitsch: The World of Bad Taste* (New York: Universe Books, 1969).

[8] Carl Jung, *Man and His Symbols* (New York: Dell, 1964).

[9] John Berger, *Ways of Seeing* (New York: Viking Press, 1973), pp. 20–23.

[10] Reuel Denney, *The Astonished Muse: Popular Culture in America* (New York: Grosset & Dunlap, Universal Library, 1964), pp. 249–53.

[11] Lewis Mumford, *The Human Prospect* (Boston: Beacon Press, 1955), p. 212.

[12] Bryan Wilson Key, *Subliminal Seduction* (New York: New American Library, 1972).

[13] Alvin Toffler, *The Culture Consumers* (New York: Random House, Vintage Books, 1964), pp. 211–31.

[14] Boulding, *The Image*, pp. 164–75.

[15] Otto Kleppner, *Advertising Procedure*, 5th ed. (Englewood Cliffs, N.J.: Prentice-Hall, 1966).

[16] Vance Packard, *A Nation of Strangers* (New York: Simon & Schuster, Pocket Books, 1972).

[17] Vance Packard, *The Hidden Persuaders* (New York: Simon & Schuster, Pocket Books, 1957).

[18] Harold Rosenberg, *The Tradition of the New* (New York: Grove Press, 1961).

[19] Charles Jencks, *Architecture 2000: Predictions and Methods* (New York: Praeger, 1971).

[20] Stanford Anderson, *Planning for Diversity and Choice* (Cambridge, Mass.: M.I.T. Press, 1968).

[21] Robert Venturi, *Complexity and Contradiction in Architecture* (New York: Museum of Modern Art, 1966).

Suggested Readings

Berger, John. *Ways of Seeing*. New York: Viking Press, 1973.

Dorfles, Gillo. *Kitsch: The World of Bad Taste*. New York: Universe Books, 1969.

Hall, E. T. *The Silent Language*. Garden City, N.Y.: Doubleday, 1959.

Herskovits, Melville Jean. *Man and His Works*. New York: Alfred A. Knopf, 1948.

Lynes, Russell. *The Tastemakers*. New York: Harper & Row, 1954.

McLuhan, Marshall. *Understanding Media: The Extensions of Man*. New York: New American Library, 1964.

Mumford, Lewis. *Technics and Civilization*. New York: Harcourt Brace Jovanovich, 1963.

Venturi, Robert. *Complexity and Contradiction in Architecture*. New York: Museum of Modern Art, 1966.

A curriculum framework for art education

In the preceding chapters we have examined different ways of understanding the nature of art. This chapter summarizes those ideas and translates them into a curriculum framework for art education.

A curriculum is a written statement outlining educational goals and the means of achieving them. It is not intended to give a detailed picture of classroom activities; rather, it is designed to present a philosophy of art education, goals for instruction, and content to be included in the program. In principle, a curriculum is a document that can be examined by anyone who wants to know *what* is being taught and *why*.

As you read this chapter, keep in mind that it illustrates the reasoning process involved in preparing a curriculum. Even if you do not fully accept the aims and content as outlined, you might find the form of the discussion useful in developing your own curriculum.

A basic philosophy of education

Goals for American education should reflect the fact that we live in a democracy. Whatever deficiencies we might see in the operation of our society, few of us would quarrel with the human values a democracy is intended to nurture. More than any other form of government, a democracy requires that its citizens be knowledgeable, humane, and imaginative in their pursuit of a satisfying life.

If these qualities are to be nurtured and exercised wisely, citizens must be broadly educated, not merely trained in a narrow, technical sense. As an institution, the public school plays a major role in meeting the need for general education. The three major functions of general education are to develop each child's ability to find personal fulfillment in life, to transmit the cultural heritage, and to extend the social consciousness of children and youth.

The purposes of art education coincide with the broader responsibilities of general education. School art programs facilitate the child's quest for personal fulfillment through art experiences based on the child's immediate life and world. Studies of the artistic heritage provide children with a knowledge of art as a significant form of human achievement. Awareness of the role of art in society is essential if children are to make informed aesthetic decisions about their environment. In other words, the child's encounter with art should be personally meaningful, authentic as "art," and relevant to life.

Ideally, education teaches children how to become independent when they leave the protected environments of the home and the school. Children's experiences in school should inspire and enable them to continue their own education into adulthood, and the educational goals of an art program should nurture those behaviors most essential to independent lifelong learning in art. In short, goals should focus on learning to learn *about* art and *through* art.

Major goals of art education

What goals are likely to promote long-term, self-directed inquiry in art? Art makes sense to children when they experience it as a basic form of expression and as a response to life. The two modes of experience—expression and response—are interdependent. Both are essential considerations in charting goals for personal fulfillment, for studies of the artistic heritage, and for studies of the social aspects of art.

Personal fulfillment through art

In order to find personal fulfillment through art, children need to learn how their lives can be enriched by their own efforts to create art and respond to visual forms.

Children enjoy manipulating art materials, and even without guidance they may produce works that have expressive power. Nevertheless, mere activity and chance successes are poor measures of learning. If, as the saying goes, "one picture is worth a thousand words," one truly creative experience in art is worth a thousand

A CURRICULUM FRAMEWORK FOR ART EDUCATION

aimless experiments with art media. Although we may experience the personal pride and the surge of inner strength that come from shaping forms that express something about ourselves, *genuine self-expression is not easy*. Who among us has not been exasperated at one time or another by our inability to communicate what we feel, see, know, and imagine?

Art has the potential for making feelings and ideas vivid; but to function expressively, an art form must be created so that it captures the precise feeling and imagery of our experience. Only then can art give substance to feelings that might otherwise remain undefined, unclear, and unexplored. Few children are such natural artists that they can easily express themselves without a supportive environment. In order to achieve personal fulfillment through creating art, children need sensitive adult guidance in mastering the following pivotal moves in the artistic process: the creation of ideas for personal expression, the discovery of visual qualities to express ideas and feelings, and the use of media to convey an expressive intent.

In daily life, we "look at" much more than we truly "see," "feel," and "experience." If we are sensitive to our aesthetic responses, however, we realize that we are "moved" by something because our senses are fully activated. At such moments of realization, we experience a kind of insight so uncommon and so exact that we are in awe of our own powers of perception. Through such experiences we discover that we possess an extraordinary perceptual capacity that we can call on, test, and enjoy, not only for its own sake but also to extend our understanding of ourselves and others.

Consider, for example, this interior monologue in response to Edward Hopper's painting *House by the Railroad* (p. 117). "At first glance, I see it as a painting of a fairly ordinary old house. But as I examine it (and myself), the painting begins to speak to me of isolated houses, of houses built grandly and solidly, of houses that retain an air of dignity in spite of 'progress.' The window-eyes seem to command a vast, empty domain broken only by the cutting line of the rail tracks. I see the house as a brooding presence that will endure, holding its own melancholy watch long after I have gone. But maybe too, I am the one presence that will remain, pressing forward along the rails while the house and the moment fade, sink, and move past me, vanishing into the thin air and harsh glare of a vast open space."

Responding to visual forms can be an active, creative process when we allow what we see to give shape to our feelings and ideas. Perceptual awareness can become a mode of response to life that is personally fulfilling to children if they have guidance in perceiving obvious and subtle sensory qualities, in interpreting the

meanings of perceptual experiences, and in deciding on the significance of these experiences.

Understanding the artistic heritage

The artistic heritage is a significant part of the general cultural heritage. It includes the work of artists, architects, designers, and craftsworkers of both the past and the present, as well as the contributions of people who preserve and interpret works of art—collectors, curators, scholars, and teachers. No part of the artistic heritage can have personal meaning for children unless it connects with their own lives. The connections must be explicit, focused on process and not on disembodied facts, such as a chronology of names, dates, and titles of works.

The connecting links can be made when we realize that children and adult artists confront many of the same problems in trying to achieve expression in visual form. Irrespective of the media or art forms in which they work, artists and children develop ideas from their own life experiences, interpret the ideas in visual form, and use media to capture their own expressive intent. When these relationships are made apparent, children have not only a personal basis for comprehending the work artists do but also a good reason to believe that their own efforts are authentic as art. Thus, goals for this aspect of the artistic heritage are parallel to the goals for

personal expression—that is, learning how artists create ideas for their work, how they use visual qualities for expression, and how they use media.

Children can also study the artistic heritage from the viewpoint of people who have developed special skills in responding to art. Scholars, teachers, collectors, and curators of art give us insight into the process of perceiving art, interpreting its meanings, and judging its significance. By becoming acquainted with the way experts use their skills, children can begin to appreciate that full response to art is a creative and problem-solving activity not only for themselves but also for experts. Accordingly, educational goals are learning how experts perceive and describe art, how they examine works of art, and how they judge works of art.

Understanding the role
of art in society

As we have seen, a society or culture is identified, in part, by the visual forms it creates. Children can and should become aware of visual forms as powerful means of social expression, not only in our own society but in other cultures as well. Illustrations of the social aspects of art can be based on children's immediate environment as well as on cultural groups less familiar to them. Goals for this aspect of art education are

A CURRICULUM FRAMEWORK FOR ART EDUCATION

learning how art forms originate in a society, how visual qualities express social values, and how media are used to express social values.

Even though we are not always conscious of doing so, we are constantly responding to visual forms in our environment. People who are totally unaware of the manner in which they are affected by visual forms are vulnerable to control by perceptual forces they cannot understand, judge, or change. Such people are, in effect, perceptually illiterate. Because children are often unable to integrate what they see with what they feel and know, they need guidance in learning how they themselves and other people perceive visual forms in their environment, interpret visual forms as social expressions, and make judgments about visual forms in society. By studying how people respond to visual forms both in our society and in other cultures, children can gain insight into their own habits of response.

Expression and response are interdependent ways of experiencing art. Whether our educational aims are personal fulfillment, an understanding of the artistic heritage, or a knowledge of art in society, we should focus on the basic human processes involved: generating ideas, refining them, using media; perceiving, interpreting, and judging art forms. From the curriculum framework presented in Table 6-1, you can see that the proposed goals for art education are based on the "pivotal moves" for expression and response discussed in Chapters 3 and 4 and extended in Chapter 5. The goals are deliberately stated in roughly parallel form to emphasize points of continuity from the child's own explorations in art, to the work of professionals in art, to the social aspects of art.[1]

Approaches to study

Art deals with human feelings, beliefs, and conduct. Studies in art—like those in the humanities—are loaded with implications about the ideal life and the values people hold. If we treat art as if it were only a matter of learning facts and mastering techniques, we deny its value-laden character. In the public schools of this country, at least, subjects that center on human values are taught in a comparative manner. Social studies, history, politics and economics are taught so that children can appreciate the different viewpoints from which people construct their lives.

As teachers, we should clearly emphasize that *art can also be understood and experienced in different ways.* In the past, art programs too often have been based on the formalist view of art dominant in Western culture—a view that separates art from life, makes art an aristocratic affair, and perpetuates a marginal place for art in the school and in society. Instead of reflecting a

TABLE 6-1
A CURRICULUM FRAMEWORK FOR ART EDUCATION

Functions of General Education	Purposes of Art Education
Facilitation of personal fulfillment	Personal response and expression in art
Transmission of the cultural heritage	Awareness of the artistic heritage
Development of social consciousness	Awareness of role of art in society

GOAL: PERSONAL EXPRESSION AND RESPONSE

Children should learn different ways to:

generate their own ideas for personal expression through art
refine and modify their ideas for visual expression
use media to convey their own expressive intent

perceive obvious and subtle qualities
interpret the meaning of what they perceive
decide on the significance of their experiences

GOAL: AWARENESS OF THE ARTISTIC HERITAGE

Children should learn how members of the artistic community:

generate ideas for their work	perceive and describe art
use visual qualities for expression	examine works of art
use media and tools	judge works of art

GOAL: AWARENESS OF ART IN SOCIETY

Children should learn how people in our own culture and in others:

originate art forms	perceive visual forms in their environment
use visual qualities to express their beliefs	interpret visual forms as social expressions
use media to express social values	judge visual forms in society

single, narrow concept of art, art programs should offer avenues of study that encourage children to probe various ways that art can challenge and reward the human spirit.

The term *study* is used deliberately. It suggests a search for understanding and experience, not merely by trial and error, but with guidance. If the ideas reviewed in previous chapters reflect some of the major paths along which present knowledge about art has developed, similar paths are a point of departure for children to use in their own search for art experience. *In other words, approaches to study should reflect not only different concepts of art within Western culture but also cross-cultural concepts drawn from anthropology.*

A curriculum framework for art education

The following curriculum framework illustrates how the concepts introduced in earlier chapters can serve as approaches to study. Obviously, developmental factors must be taken into account when we teach children, and subsequent chapters will acquaint you with appropriate methods of teaching children at different levels of maturity. For the present, general relationships between goals and approaches to study will be presented.

Expression in art

INCEPTION OF IDEAS FOR ART. In teaching art to children, we should note similarities among children's own experiences as a source of artistic inspiration, the sources that artists draw on for inspiration, and the genesis of art forms in social life.

Goal: Learning to generate ideas for expression through art.

The importance of this goal is illustrated by the classic situation of a child who says, "I don't know what to do or make." When children are unable to create ideas for art, they often resort to copying. Sometimes they rely on a formula that has been successful in the past. Stereotypes and clichés in children's art reveal that guidance in generating ideas is needed. The problem is not just that children lack motivation but that they do not understand that part of the artistic process *does* involve a struggle to find ideas and that varied sources in their experience can be tapped for inspiration.

Approaches to Study

Observing. Children can learn to generate ideas by careful observation of their natural and con-

structed environment. Subjects are abundant—people, places, inanimate objects, plants, animals, weather, the seasons, and special events.

Imagining. Imagination is the ability to form images in the mind, especially of things that are not "real" in ordinary life. Fantastic, futuristic, weird, mysterious, and dreamlike events can be a source of inspiration for art.

Contemplating. Broad themes can serve as a source of motivation for art. Children can learn to express their personal feelings about such concepts as love, peace, and beauty as well as hate, war, and ugliness.

Inventing. "Necessity," it is said, "is the mother of invention." Ideas can come from problems and needs in everyday life, such as wanting to make a present for someone special.

Goal: Learning how artists generate ideas for their work.

Relationships between children's sources of ideas and the sources to which artists turn can be pointed out during studio activities or through exhibits and field trips. As we have seen, some artists address themselves to nature and the environment. Broad themes, such as poverty and wealth or love and hate, inspire other artists. Architects and designers are challenged by the sometimes conflicting needs of their clients and by practical considerations. Craftsworkers may develop ideas from nature and from the broad traditions of their craft. When it is feasible, articulate local artists should be invited to the classroom or visited in their studios. Indirect contact with artists can be arranged through the use of films, taped interviews, biographies of artists, and collections of original works.

Approaches to Study

Nature and the Environment. Children should examine works of art that show nature, people, and the constructed environment as sources of inspiration for art. When possible, a variety of art forms should be made available for study.

Fantasy and Imagination. Experiences organized by this approach can help children notice the variety of ways in which artists have explored the world of the mind. Examples in jewelry, painting, and even architecture and graphic design should be sought.

Broad Themes. Holidays and special events during the school year provide excellent opportunities to examine works based on broad themes. Social-studies topics can create interest in studying works dealing with pollution, mass production or history.

Needs of Daily Living. Children can become aware of the fact that every useful object in their

environment was designed or planned by someone. They should come to regard the need or desire for such items as a potential source of inspiration for artists, craftsworkers, and architects.

Goal: *Learning how art forms originate in society.*

The social origins of art can be seen in the human urge to elaborate on tools, utensils, and spaces for living. In order to survive, a society must also provide avenues for group and individual expression. In addition, many art forms originated in and developed from rituals and ceremonies that marked important events in life.

Approaches to Study

Tools and Spaces for Living. Children can study other cultures to become aware of both the ways in which people create tools and spaces and the reasons why people seek to elaborate on the basic forms of their creations. Children can also examine or suggest improvements in spaces within their own environment.

Expressions of Individuality. Children can use their own experiences to identify visual clues to individuality, particularly in their own art work but also in things they see at home, in school, and in the neighborhood.

Expressions of Group Membership. Children can notice how uniforms, emblems and insignia, trademarks, and other visual motifs are used to identify people's occupations, authority, or interests. In studying other cultures, children may look for symbols that express similar concerns.

Expressions of Important Events. Birthdays, marriage and funeral ceremonies, and similar events of ritual significance are the sources of many art forms. Children can learn to consider how important events in their own lives are marked as "special" by visual forms.

VISUAL QUALITIES THAT CAPTURE IDEAS. Efforts by children to give their own ideas and feelings visual form should be the touchstone for examining how artists go about their work and how they solve comparable problems. The visual qualities of art forms in various cultures can be studied as examples of large-scale variations in the quest for appropriate visual qualities to express ideas and beliefs.

Goal: *Learning to refine and modify ideas for visual expression.*

Children can become more independent in art if they are encouraged to solve problems and to refine their ideas without adult guidance at every step in the process. A child who stops

working and says, "It doesn't look right," usually has a mental picture of something he or she wants to show or make that does not match the child's actual work. Problems of this kind lead to the familiar syndrome of "starting over and over again" in an effort to solve a problem. While many teachers value spontaneity in children's art, research suggests that by the age of five, most children (80 percent) have some idea in mind before they begin working with media.[2] Thus, even first graders may need help in searching for visual qualities that will capture their feelings and ideas.

Approaches to Study

Making Visual Studies. Children can learn to make sketches and small models to anticipate how a work might look if certain parts were omitted, exaggerated, and so on. This approach encourages flexibility not only in visualizing ideas but also in exploring the qualities of design that will best convey the expressive intent of those ideas.

Changing Habits of Work. Sometimes it is helpful to change our customary way of working in order to make progress. Children should learn that changing their physical posture, angle of vision, or preferred method of working is often helpful in gaining a fresh perspective on their work.

Exploring Meanings. Obvious symbols and their meanings can be reexamined with the child to determine if genuine feelings are involved in the child's interpretation of them. Children might discover that loving a toy is not the same as loving a person, or that a heart-shaped symbol is not the only way to express the idea of love.

Considering Purposes. If children have a clear sense of purpose, they are more willing to search for appropriate visual qualities. Like adults, children can forget the aim of their activity; sometimes the initial purpose of expression is modified in the process of work, and children should be made aware of this change.

Goal: Learning how artists use visual qualities for expression.

As we have seen, artists use various methods to visualize, refine, and modify their ideas. Sketches and models are especially useful in helping children grasp the way artists explore different possibilities for the scale, imagery, and details of an idea. A comparison of works based on the same subject or problem can reveal the varied interpretations of different artists. Artists may be invited to talk to the class, or visits to museums and galleries can be scheduled to acquaint children with the ways in which artists refine and modify their ideas.

Approaches to Study

Sketches and Models. By exhibiting artists' preliminary sketches, you can help children appreciate the fact that artists work at clarifying their ideas. You might also present a series of works by a single artist in order to illustrate methods of exploring ideas visually.

Comparing Methods of Working. When possible, arrange field trips or visiting-artist programs and show films of artists at work so that children can see the actual development of a work and appreciate the fact that the basic outlooks and strategies of artists are varied.

Comparing Works with the Same Theme. Subtle differences in the way artists interpret the same subject also become apparent when, for example, children examine a series of self-portraits by van Gogh or study the ways in which artists have depicted horses.

Comparing Solutions to Problems in Daily Living. Children can begin to see that even ordinary objects like chairs, houses, and street lights differ in "personality," and that designers offer a variety of solutions to the same human needs.

Goal: ***Learning how cultural groups use visual qualities to express their beliefs.***

Children should learn that when there are radical changes in the beliefs and values of people, there are usually corresponding alterations in the style of the visual forms people produce. Within any culture, innovations in technology, changes in leadership, or shifts in economic opportunities tend to simplify some aspects of the culture while making other characteristics more complex. Today, the rate of change in our environment is intensified by our mobility and our instant access through television, to important events around the world. In every culture, there are quite specific visual clues that express social problems and values.

Approaches to Study.

Comparing Simple and Elaborate Forms. In some cultures, a simple form has greater value than an elaborate form; in other cultures, the reverse is true. Children can learn to compare, for example, the values people may attach to a simple vase as opposed to a vase that is highly ornamented.

Comparing Older and Newer Forms. Surprising parallels in human concerns can be discovered by radical comparisons. The launch pads at the Kennedy Space Center have been termed "modern pyramids"; high-rise apartments are called "cliff dwellings." What are the bases for these analogies?

Comparing Symbolism in Different Cultures. Cross-cultural comparisons often provide a fresh

viewpoint on the symbolism in our own culture. Comparisons can center on meanings of specific images as well as on colors, shapes, lines, and forms.

Comparing Prototypes and Eclectic Forms. Children can learn that original or one-of-a-kind objects are highly valued in some cultures but are regarded as inferior in others. Older children can grasp the fact that eclectic forms may express contradictory values.

USES OF MEDIA. Parallels and comparisons can be made among the child's use of artistic media in school, the artist's use of media in all periods and cultures, and the importance of media in the larger visual environment.

Goal: *Learning to use media to convey an expressive intent.*

In teaching children to use media, a balance between exploration and control is desirable. A medium becomes a means of expression when children are sensitive to the medium's properties, when children feel confident that they can control the medium, and when children are able to choose the appropriate medium for their purposes. Children do need guidance in learning to use materials, tools, and equipment so that they can achieve personal expression in

visual form. Although the supply closet may dictate which materials are available to children, a good art program is not defined by the number and novelty of media but by the quality of thought and sensitivity brought to each medium.

Approaches to Study

Developing Control. Control is not necessarily synonymous with neatness. It takes control to create a watercolor that is clear and not overworked. It takes control to produce a rough surface texture in clay. Children enjoy the feeling of competence that comes with practice in using media, tools, and equipment.

Adapting Media to Ideas and Ideas to Media. Children can learn that their initial ideas may change as they begin to work in their chosen medium. For example, while creating a collage depicting a city, a child may discover a scrap of paper shaped like a boat and decide instead to portray a seascape.

Selecting Appropriate Media. The very choice of a medium is an important part of the artistic process. At a simple level, a child can understand that chalk might show the soft furriness of a kitten but that cut paper would be a good choice to show a rough, scrappy alley cat.

Experimenting. Children can learn that experimenting with a medium will help them discover

A CURRICULUM FRAMEWORK FOR ART EDUCATION

how it can be used expressively. Accidental discoveries should always be carefully examined so that children can intentionally re-create those effects later if they want to.

Goal: *Learning how artists use media and tools.*

Artists have a kind of love affair with their materials. Since most artists concentrate on one or two media during their careers, they acquire a detailed understanding of the technical problems in using those media. Because the media artists use are often different from those available to children, it is essential for children to see original works of art and to watch demonstrations by artists.

Approaches to Study

Direct and Indirect Uses of Media. Children can become sensitive to direct and indirect ways of using media. Some media and processes are inherently more complicated and less direct. Casting in bronze, for example, is an indirect process; modeling in clay is a more direct process.

Varieties of Media. Different kinds of media, as well as varieties within a given medium, should be noted. For example, different kinds of paint used by artists include encaustic (wax), oil, and watercolor.

Symbolism in Media. By comparing cups made from silver, fine porcelain, paper, and glass, for instance, children can note the symbolic value of materials. Artists select materials for sculpture, crafts, architecture, and other art forms, in part, by considering their symbolic value.

Inventions in Media and Processes. Children in the fourth and fifth grades normally study inventions. Their attention can certainly be drawn to inventions that have had an impact on the world of art—printing, concrete and steel construction, photography, and mass-production techniques.

Goal: *Learning how cultural groups use media to express social values.*

The materials, tools, and technologies available in a society obviously play a role in the artifacts that society can produce. Whatever the material resources of a culture, the manner in which people use materials can either reinforce or change social beliefs and values. Children can learn that people do attach value to the way media are used.

Approaches to Study

Control. Children can learn how the use of media can be controlled to reinforce traditions and to ensure status. Examples can be centered

on a typical medium in children's experience. Ask children what they would do if they were forbidden to use metal products for a day.

Adaptation. In any culture, readily available and highly versatile materials are the most likely to be adapted to various uses. Indians of the Southwest, for example, use clay for a wide range of artifacts and structures.

Selection. The symbolism of materials sometimes determines their value to people. Choices of media are often, though not entirely, influenced by economic considerations. Children can become skilled in noting how some media are used to imitate qualities of other media, and they can examine the reasons why people may prefer one or another variation.

Innovation. In our culture, *new* has come to mean "better." The value placed on innovations has not always been so high, nor is it universal. Children can reflect on the extent to which they are impressed by new media. The social impact of innovations in media can be studied in the upper grades.

Response to visual forms

PERCEPTUAL AWARENESS. Children should become aware of the distinct value of their personal perceptions and they should learn the skills required for selective viewing of acknowledged works of art and of cultural artifacts. They should also be aware that adults trained in art can provide them with insights.

*Goal: **Learning to perceive obvious and subtle qualities.***

When children discover both the obvious and the subtle qualities of things they see, touch, taste, smell, hear and handle, perception becomes an active and creative process. Perceptual awareness extends beyond simple recognition of lines, shapes, colors, and other visual qualities to associations and feelings linked to the context of our immediate and past experiences. A rose in a garden is not the same as a rose in a flower shop; a rose in a vase is somehow different if we know it is for a funeral or for a mother or for a lover. Children are far more capable of discriminating subtle visual, spacial, and tactual qualities than we may think.

Approaches to Study

Discriminating Basic Phenomena. Various qualities of line, shape, color, and materials can easily be noted by most children by the second grade. Skills can be developed by matching and sorting activities. Concentrate on selected visual

A CURRICULUM FRAMEWORK FOR ART EDUCATION

phenomena as well as on varied media, styles, art forms, and natural objects.

Building Multisensory Associations. Children enjoy learning to associate sights with sounds, motions with marks on paper. Children should learn why a line can seem active, why colors can seem to be loud. Multisensory awareness of a single object or situation is equally important.

Exploring Symbolism. Symbolism and systems of visual coding in the environment should be pointed out. Color and shape, for example, serve as a visual code in traffic signs. More subtle examples can be found by noting personal and shared associations children have for colors, shapes, materials, art forms, and natural objects.

Becoming Aware of Contexts. Changes in moods and feelings come from shifts in weather, from the arrangement of furniture in a room, and from other backgrounds of our experience. There is a difference, for example, between *measured* time and space and the psychological *feeling* of time and space; sometimes a walk down one block can feel like a five-mile hike.

Goal: *Learning how experts perceive and describe art.*

The rich and precise language of experts who devote their lives to the study of art can provide children with insights into art. The key concepts introduced in Chapter 2 are distinctions frequently used by art critics, art historians, museum personnel, and art teachers. A number of teaching materials and local resources make it possible for children to appreciate how experts look at and talk about art.

Approaches to Study

Art Forms and Media. Articulate local artists, museum personnel, films, and books are resources for teaching children what experts see and describe when they focus on media and art forms.

Design and Style. Resources in the form of films, slide sets, and reading materials for understanding design and style are also available. Local artists, art critics, and museum personnel, as well as parents with art training, might serve as experts on design and style.

Subjects and Symbolism. Symbols associated with particular holidays and national events are often treated in standard encyclopedias for children. Art books organized around a single subject are also available. Some of these are noted in the bibliography at the end of this book.

Purposes and contexts. In addition to the resources already noted, teachers will find that

local advertisers, designers, manufacturers, architects, and representatives of civic groups may be willing to talk to children about the purpose of their work and the contexts in which it is used.

Goal: *Learning how people perceive visual forms in their environment.*

The arts of a culture or a society are difficult to examine because they are so numerous and, in some cases, alien to our own experience. Children's immediate environments, although more familiar, are often the most difficult for them to see. Children can perceive complex visual fields if they have a definite frame of reference to guide their own observations and if they have the opportunity to compare their perceptions with those of other people. In order to structure children's experiences in perceiving and comparing perceptions of visual forms, the following approaches to study are recommended.

Approaches to Study

Art Forms and Media. Children can learn to perceive the varieties of art forms and media (both common and rare) that are present in their own environment. Activities correlated with social studies can help them understand that in other cultures people might peceive art forms and media in ways that we do not.

Design and Style. Contrasts and comparisons are useful in learning to perceive qualities of design and style. Grouping and sorting activities can help children notice specific qualities as well as general patterns.

Subjects and Symbolism. The subjects and symbols within a culture or an environment can be observed in a variety of art forms. Older children can learn to look for, and compare their perceptions of, advertising appeals based on images of a happy life, on the testimony of current idols in sports and entertainment, and on other visual metaphors.

Purposes and Contexts. Information about the beliefs, resources, and habits of living of other cultures can help children appreciate the artifacts produced in other cultures. In their immediate environment, children can become sensitive to the character of visual forms during various cycles of human activity (working, playing, resting), at different times of day, and in various weather conditions.

INTERPRETIVE SKILLS. In addition to developing children's personal skills in interpreting art, we should help them understand the skills that professionals bring to the same task of examining art. Cross-cultural comparisons should focus on the human needs that art forms satisfy.

Goal: Learning to interpret the meaning of perceptions.

Young children tend to be satisfied with sensory experience for its own sake, especially if the stimulus is new or dramatic. Nevertheless, there is a reflective and imaginative side to their perception that adults sometimes mistake for daydreaming. Personal meanings are shaped by the depth of feeling and scope of imagination that we bring to our experience. For children, sheer familiarity with things is important. A picture of an elephant has more meaning to children if they have seen an elephant. Speculation and empathy also play a part in making sense out of experiences. Imagine that you are grass trying to grow at the corner of a city block. How would you feel? What would you see? What would you want people to notice about you?

Approaches to Study

Recognizing and Naming. As children become skilled in recognizing and naming what they see and feel, they are better able to interpret their experiences. Encourage children to talk about their perceptions. Vocabulary development, with an emphasis on adjectives and adverbs, is important.

Empathizing. Children can begin to empathize with things they see by trying to personify them. This involves noting, for example, how features of a rock make us feel as if it were strong. Analogies and metaphors are useful verbal tools to interpret relationships between feelings and things.

Speculating. First glances can be misleading; practice in speculating on several possible meanings of an experience develops an open-minded attitude toward things. Speculation is essential when children express either absolute certainty or extreme uncertainty about what they have seen.

Synthesizing. Complex perceptual experiences—such as visiting a museum, looking at a film, or studying a painting—can leave children with unrelated impressions. Encourage children to sort out their impressions by finding a pattern in them. The pattern might be sequential, thematic, or spatial.

Goal: Learning how experts interpret works of art.

As early as the first or second grade, children are introduced to the process of gathering data, developing hypotheses, and explaining phenomena. These basic steps in reasoning, which are commonly taught in science and social-studies classes, are also useful in demonstrating that when experts examine a work of art critically, they may interpret its significance from a particular vantage point. Some experts

interpret works of art in relation to a specific time and culture, others in relation to the artist's life. Each interpretive stance is analogus to a hypothesis that determines the facts one considers and the explanation one formulates. Approaches to study should illustrate some of the most common avenues for interpreting works of art.

Approaches to Study

Time and Culture. Chronological accounts of art are poorly grasped by children. However, by the third or fourth grade, children can understand that experts may interpret works of art as reflections of a particular time and culture—for example, ancient Egypt, the Middle Ages, or the Mayan civilization.

The Artist's Life. Introduce children to biographies of artists. Help them notice how experts who interpret works in relation to artists' lives can illuminate aspects of the artists' works that otherwise might have little meaning for us.

An Artistic Problem. Some experts show us how a work is distinctive relative to other works that deal with the same artistic problem. A work might be interpreted as a unique solution to such problems as capturing motion, portraying childhood, or communicating information.

An Occasion for Personal Response. In Chapter 4, several methods of interpreting a work of art

without reference to other works or to the artist's life were presented. The treatment of a work as an occasion for personal response can best be demonstrated by teachers and guest critics who, in this case, must be experts in guiding children's responses.

Goal: *Learning how people interpret visual forms as social expressions.*

As children gain more experience in the world, they can become more astute in noting how visual forms express social beliefs, conditions, and aspirations. Even first graders are keen interpreters of visual clues to social status, authority, and individual differences. Children should become sensitive to the basic human needs that a variety of visual forms may satisfy. Older children can benefit from comparing their interpretations of artifacts with interpretations offered by people of different ages and economic status.

Approaches to Study

Varieties of Tools and Spaces for Living. Children can become aware that a variety of tools and containers are suitable to the different needs and preferences of people. Children's interpretations of dwellings, signs, lampposts, and the like can be compared with interpretations others might offer.

Varieties of Individual Expression. Even though many artifacts in the contemporary environment are mass produced and uniform, children should become aware of visual clues to individuality within their environment. They can explore the ways people may show their individuality when they add to, alter, or combine ready-made products or create handcrafted and personalized items.

Expressions of Group Membership. Children are exposed to many images that convey the idea of group membership. When children learn to interpret artifacts as signs of group membership, they can better understand how, through particular group affiliations, people can also express their individuality.

Expressions of Important Events. Children can become aware of the ways in which people in their own community express important life events. Festivals, parades, holidays, and other events that are important to children can be examined to discover the values that are communicated by visual means.

JUDGING ART. A broad perspective on the problem of judging art should be nurtured. Children's judgments about their own experiences, their own artwork, and their own environment should be related to historical criteria for judging art in Western culture, as well as to

criteria that function more generally to shape different life styles within our own and other cultures.

Goal: Learning to judge the significance of experience.

Expanding our sensitivity and imaginative powers is not an end in itself, but a means to achieve a sense of ourselves-in-touch-with-life. For children, no less than adults, life is raw and warm, lusty and quiet—a process of discovering things to give ourselves to and things to leave behind. The ability to make decisions about the worth of experience is especially important in a time when children are bombarded with so many new, exciting, and often bizarre images of life. Learning to weigh and judge the relative importance of our experience is vital to maturity. It is much easier to accept the opinions and judgments of others than to formulate our own.

Approaches to Study

Asking: What Did I Learn? When children learn to ask this question they often discover that an experience made them aware of something they did not know before. An experience might also be important because it shows children they already knew more than they thought. Receiving confirmation that our present knowl-

edge is correct is just as vital to our feeling of competence as the acquisition of new knowledge.

Asking: What Was Special? The sheer novelty of an experience may not make it truly memorable or important. Children can begin to sense that an experience may be special or extraordinary for more subtle reasons—for its beauty, solemnness, or humor.

Asking: How Did I Feel? How Do I Feel? Children can learn to reflect on their experience during and after an event. At a circus, for example, we may feel happy, tense, even fearful. Afterward we may feel let down, but proud and happy to have been there. Self-awareness comes with an appreciation of contrasting feelings—the flow of emotionality in life.

Asking: Can I Use the Knowledge Gained from the Experience? The practical application of knowledge gained from an experience is both a common and an important test of the significance of an experience. Older children are inclined to ask about "the use" of experience, but the question should be asked by people of all ages. Notice that learning something new does *not* lead directly to thinking about the uses of this knowledge.

Goal: Learning how experts judge works of art.

Children should learn that experts do not always agree on the importance or the merit of works of art. Differences in judgment arise from the varying standards used to evaluate a work. If children learn that judgments about art can be *relative,* they are more likely to be open minded about unfamiliar styles of art. At minimum, children should become familiar with simple versions of major criteria for judgment within Western culture.

Approaches to Study

Accuracy and Natural Beauty. Children can easily understand some of the criteria associated with representational art. The concept of organic form can be introduced in the upper grades and be related to studies of structures that occur in nature.

Imagination and Originality. The idea that art need not be "real" is easily grasped by young children. Older children tend to acquire and use conventional adult criteria for judging representational art. Unless children become aware of other criteria, their appreciative skills will be limited.

Ordered Arrangement and Lessons Learned. Children can understand that some experts believe art should be inspiring and should teach us about our better qualities. The idea of formal order is difficult for children to grasp, as it is for many adults. Analogies with beautiful arrangements in daily life can be helpful.

Usefulness in Daily Life. Children have little difficulty recognizing that art can be used to solve problems of daily living. The more subtle criteria linked with this viewpoint can be explored with children in the upper grades.

Goal: *Learning how judgments can be made about visual forms in society.*

As a cultural group, Americans are often said to place little value on art. Nevertheless, the enormous range of commercial products gives every person some opportunity to express aesthetic choices. In this sense, artistic decision-making is an integral part of our culture. Patterns of taste and judgment are so closely tied to life styles that the acceptance of a particular pattern of taste implies the acceptance of the corresponding life style. Judgments about the value of art in society should not be imposed on children; however, children should become familiar with some of the standards people do use in making judgments.

Approaches to Study

Permanent and Temporary Forms. Children can explore the advantages of permanent and temporary forms as they influence life styles. For example, some people want an environment they can leave behind easily. Some people do not believe material goods are important. Others feel that if things are worth having, they should last a long time.

Innovation and Tradition. Children can reflect on reasons why many people like to have new things but want them to appear old. Children can consider why some people keep family heirlooms and collect antiques, while other people like to have the latest models of everything.

Specialized and Multipurpose Forms. Children can examine why some people like to acquire highly specialized items and tend to be fascinated with gadgets and others seem to prefer a few items that can serve a variety of purposes. Older children can consider the problems faced by architects and planners if they have to decide, for example, whether to design a stadium for a single sport or for varied public gatherings.

Uniformity and Diversity. Children can seek explanations for the fact that some people are attracted to planned communities, color coordinated environments, and other arrangements

that make them feel as if things go together, while other people acquire and keep objects that have individual meaning, even if the objects do not make a coherent visual environment.

Summary

The goals and approaches to study outlined here do not in themselves constitute an art program. In order to develop such a program, we need to think about relationships among goals, the scope and rhythm of instruction within a year and from one year to the next, and variations in the circumstances under which teachers work. These matters will be discussed in Chapter 18.

The purposes of art education parallel the functions of general education in a democracy. Goals for instruction in art are based on two principles: (1) helping children continue their self-education in art, and (2) developing children's understanding of relationships among their own artistic endeavors, the work of professionals in art, and the social impact of visual forms. Expression and response are interrelated and equally important modes of experiencing art. Approaches to study should reflect major concepts of art in Western culture, as well as cross-cultural concepts of art drawn from anthropology. Individual school programs in art should be planned with due attention to continuity and variety in experiences as well as to the practical problems teachers face.

Notes

[1] This rationale was first presented by the author in an address before the Ohio Art Education Association, Columbus, Ohio, November 1969.

[2] Evidence from a study by H. Kind Hetzer cited in Jean Piaget, *The Child's Conception of Space* (London: Routledge & Kegan Paul, 1956), p. 62.

Suggested Readings

Other ideas for curricula for art education may be found in the following books.

Barkan, Manual; Chapman, Laura H.; and Kern, Evan J., eds. *Guidelines: Curriculum Development for Aesthetic Education.* St. Ann, Mo.: Cemrel, 1970.

Eisner, Elliot W. *Educating Artistic Vision.* New York: Macmillan, 1972. Chapter 6.

Feldman, Edmund. *Becoming Human Through Art.* Englewood Cliffs, N.J.: Prentice-Hall, 1970. Chapter 7.

Hubbard, Guy, and Rouse, Mary. *Art 1–6: Meaning, Method and Media.* Westchester, Ill.: Benefic Press, 1972.

Lansing, Kenneth. *Art, Artists, and Art Education.* New York: McGraw-Hill, 1969.

McFee, June K. *Preparation for Art.* 2nd ed. Belmont, Calif.: Wadsworth, 1970.

A CURRICULUM FRAMEWORK FOR ART EDUCATION

children's artistic development

The preschool years: ages 3–5

Drawings by Sarah Kern.

A First drawing. 1 year.

B 1 year, 8 months.

C *Balloons.* 2 years, 4 months.

D 2 years, 9 months.

E F

G

E *Boy.* 3 years, 8 months.

F *Cowboy Feeding Horse.* 4 years, 3 months.

G *Cowboy, Tree, Horse, House.* 4 years, 1 month.

H 4 years, 10 months.

I *Horse.* 5 years, 1 month.

I

The child's first encounter with a planned learning environment often occurs in a day-care center, preschool, or kindergarten. Educators have different opinions about the proper function of these early experiences. Some educators regard them as preparation for first grade; others view preschool and kindergarten as an extension of the child's social environment and feel that formal learning should not be expected. In spite of the variety of opinion about early childhood education, the preschool years are widely recognized as vital to the child's development.

Personal fulfillment through art

First experiences in creating art and in responding to visual forms should be rich, varied, and appropriate to the child's level of development. Although it is an axiom that the teacher must begin with the child—that is, at the child's level—it is also the teacher's responsibility to extend and refine the child's skills, attitudes, and understanding. Accordingly, our discussion not only presents relevant developmental information for engaging children in art but also suggests general methods of enhancing the quality of that engagement.

Guiding the artistic process

An exploratory stage of marking surfaces with scribblelike patterns is typical of children's first encounters with drawing and painting media (Figure 7-1). Around the age of three, children begin to associate lines and shapes with tangible objects; a transition from "marking" to "drawing" occurs (Figure 7-2). Nevertheless, until children reach the age of four or five, their work is determined by tactual and kinesthetic activity more than by vision; their compositions reflect motor activity and a part-by-part thought process without regard for adult notions of visual or logical coherence.[1] Because children develop each part of their work as it occurs to them, size relationships are largely determined by the scale of the children's motor activity, by the nature of the medium, and by the sequence in which parts of the work are created. Children may exaggerate size relationships in order to show parts of the work that are of special importance to them (Figure 7-3). Color choices are governed as much by personal preference and children's access to new or easily reached colors as they are by children's expressive intent or perception of the external world. Local color—blue sky, green grass—is gradually apparent but is probably introduced to please adults rather than out of any intrinsic desire for accurate representation.

7-1 (*opposite, left*) Tempera painting by a two-year-old.

7-2 (*opposite, right*) *Girl with Pants On.* Pencil drawing by a three-year-old.

7-3 *Horse.* Pencil drawing by a three-year-old.

7-4 Pencil drawing by a four-year-old.

Around the age of four or five, youngsters become consciously aware that lines and shapes can stand for people, animals, and objects. They begin to offer a narrative account of what they are showing in their work (Figure 7-4). Children should be encouraged to talk about their work because verbalizing reinforces their awareness that visual forms are related to life experiences. Gradually, children will elaborate their visual symbols and verbal accounts to include more complex events and activities.

The *early expressive* stage of development is the period during which children formulate ideas for expression *before* they begin to work and are therefore conscious of the need to discover visual means to communicate what they have in mind. About 30 percent of all four-year-olds and about 80 percent of all five-year-olds have something in mind before they begin to create a work.[2]

As children become more aware of their own work, they begin to look for models of performance in peers, adults, or their own previous work. They may ask adults to draw things for them, or wait until another child begins work and then imitate his or her approach, or say, "I can't do it." In general, copying and other forms of dependence on external models should be discouraged. However, when children copy or repeat images from their *own* earlier work, they are sometimes trying to master a skill or perfect

7-5 (*left*) The imagery in children's work is related to their experiences.

7-6 (*opposite, left*) *Lion.* Kindergarten.

7-7 (*opposite, center*) *A Happy Person.* Kindergarten.

7-8 (*opposite, right*) Self-portrait by a four-year-old.

an image, and they enjoy the sense of accomplishment that comes with repeated, self-imposed practice. When they are tired of repeating themselves or are satisfied with their efforts, they will move on to something different.

Children entering the early expressive stage are beginning to capture the most important features of their personal experience (Figure 7-5). The imagery of a child's work becomes very personal and detailed when the child's perceptions, feelings, and thoughts are energized by direct experiences. Sensitive questioning by the teacher to elicit an imaginary reenactment of an experience is an important means of motivating children. After playing on the swings, for example, children can be asked to imagine the experience and to recall details as they act it out again. Can you feel the seat of the swing? Are you gripping the ropes tightly? Can you feel the *whoosh* of the up-and-down motion? Feelings about any past experience must be revitalized so that children can more readily express themselves artistically.

While the child's interest in manipulating materials often coincides with a train of thought that leads to image making, the child's sensitivity to the range of personal experiences to express in art should be expanded through direct motivation. Particular topics are so numerous that they cannot all be listed. Possibilities for expression in two- or three-dimensional form, based

on the child's observation and recall of familiar situations, include "Playing on the slide," "A rainy day," "My teacher," "Our pet mouse."

Most preschoolers have vivid imaginations (Figure 7-6). Children become so immersed in an activity that they cannot separate real from imaginary events. Their daydreams are built around imaginary companions, happy celebrations, and conquering heroes; they enjoy stories based on situations that could happen, but they also want a clear distinction between the plausible and the fantastic. They like the exaggerated humor of slapstick comedy.[3] At the preschool level, storybooks can be effective in motivating children; however, it is always better to read a story to children without sharing the pictures in the book with them until the children have had an opportunity to express their own ideas and feelings about the story.

Imaginary themes are of particular importance because they enable children to express their feelings in a slightly disguised form that is free from conventional judgment. Pretending activities—be a giant; feel how tall you are, see how tiny the chairs are, lift your big foot—heighten children's imagination and encourage readiness for expression. Wish-fulfilling themes like "If I were a giant I'd . . ." or "If I were rich I'd . . ." are appropriate, as are suggestions like "The cake that flew" or "I caught a rainbow and took it home." Books such as the following are valuable in motivating the imagination: *The*

Dragon in the Clock Box, by M. Jean Crain, a story about a dragon's egg in an empty box, seen only by Joshua; *Custard the Dragon*, by Ogden Nash, the classic story of a cowardly dragon; *Where the Wild Things Are*, by Maurice Sendak, about an imaginary trip by a boy who has been sent to his room for misbehaving.

Preschool children are in the process of forming basic attitudes about the value of human life, standards of right and wrong, and ways of coping with their feelings. The child's emerging sense of right and wrong is not based on reason or on moral principle; it is based on deference to physical power and on the market value of fairness in the home and the neighborhood. The child values human life according to a person's ability to provide for the child's immediate needs and according to a person's possession of the attributes and objects that the child admires.[4] In general, anything that moves, has a useful purpose, or can be acted on is thought to be "alive."[5] Death is viewed as "going away," a change in residence.[6] The child's emotional well-being and self-image are determined largely by the value adults in the child's environment place on human life, by the love and affection the child receives as an individual, and by a day-to-day balance between routine and novel experiences.

Broad themes—"things that make me happy," "I was proud when I . . . ," "The silliest thing I ever did"—provide opportunities for children to express their feelings and clarify their emerging values (Figure 7-7). Books such as the following are also appropriate: *That Mean Man*, by Liesel Moak Skorpen, a story about a man and his family who are mean and messy; *Sam*, by Ann Herbert Scott, about a boy whose family ignores him until . . . , *The Dead Bird*, by Margaret Wise Brown, a narrative treating death in a way that children can understand; *Moving Away*, by Alice R. Viklund, an excellent treatment of an experience many preschoolers have had or will have.

Daily activities also provide occasions to create art (Figure 7-8). Artistic decisions are involved in arranging books, toys, and furniture, as well as in cleaning things up and putting them away. Topics like "Setting the table" or "Putting on my shoes," and themes about creative gift giving—"A gift of help," "A gift from nature," "A surprise gift"—can serve as motivation for art expression.

Regardless of the theme or subject, preschool children are usually spontaneous in the way they create art. In general, children's perception and thinking tend to be governed by particulars; children usually focus on one thing at a time and overestimate its importance. Children also have difficulty in mentally retracing their actions. Consequently, they usually have to start over again if they encounter a problem.[7] Although their attention span is relatively short, young children should be made aware of art as a

7-9 *Snow Scene.* Grade 1.

thoughtful process. Several forms of guidance are appropriate for this age level.

In order to refine and extend children's means of visual expression, teachers should encourage children to create a set of drawings, paintings, or sculptures on the same or related themes. For example, a related set of drawings might be developed showing a smiling face, a frowning face, a scary face, a crying face; or a barking dog, a sleeping dog, a furry dog; or a windy day, a sunny day, a snowy day (Figure 7-9).

Open-ended questions can begin to make children aware of the relationships between meanings they wish to express and visual images that might capture those meanings. For example, as children work on clay containers, you might ask a child: If you were a cup, would you want to be plain or fancy? thick or thin? tall or short? for milk or for juice? While children are using tempera paint, you might ask: If you were going to show a happy day, what colors would you choose? what might you show? what would be happening? Questions such as the following build an awareness of causes and effects and encourage reflection while nurturing personal discovery: How did you make this happen? Could you do it again? Can you figure out another way to do that?

Preschool children enjoy the process of discovering that media can be used to create images and objects. It is important to remember that since the visual and motor development of preschoolers is incomplete, there are some visual and motor operations that children cannot perform well or for sustained periods.

Because the physical development of the eye is not complete, preschool children are normally farsighted. Sustained, detailed work at a close range is difficult and often produces eye fatigue. As children approach the age of five or six, a preference for using the right or left hand emerges. (Although 90 percent of all children will be right-handed, teachers must be sensitive to left-handed children, who may need individual demonstrations and extra guidance in learning to use media.[8]) Fine muscles in the arm, wrist, and hand are not yet fully developed, and thus the child has difficulty sustaining delicate movements. However, most children can learn to make body, arm, and hand motions that vary in effort (fast–slow), contrast (vigorous–light), position, (high–low, extended–closed), and direction (right–left, forward–back).[9] Problems in eye–hand coordination may become apparent in image reversals and in difficulties in controlling the direction and degree of hand or arm movements as children use tools and media.

We have noted that preschoolers have little interest in controlling media for the sake of visual precision; instead, they strive for kinesthetic and tactual control through repeated mo-

7-10 Kindergartener making a paraffin print.

tions. They are usually happy if the amount and placement of a medium are logically or psychologically appropriate at the moment. Nevertheless, preschool children benefit from direct and systematic guidance that will enable them to associate their physical manipulation of media with the visual qualities in their work.

Specific activities for developing skills in using media are suggested in later chapters. Most children, by the age of five, can learn to use drawing and painting media to create recognizable and expressive images, and can learn to cut basic shapes and to anticipate the amount of glue needed to paste paper to paper. They can use ready-made shapes and stamps to produce prints, and they can make crayon rubbings and monoprints (Figure 7-10).

In three-dimensional work, skills are more clearly related to physical strength and motor control (Figure 7-11). Nevertheless, with instruction and easy access to materials, preschool children can learn to pinch, pull, roll, and make textures in clay. Although the immediate tactual appeal of clay usually takes precedence over an interest in making finished products, preschool children can be encouraged to form sculpture and simple containers. Hand tools—saws, hammers, sanding blocks, vices—can be used effectively. Children can assemble metal sculpture from ready-made parts joined together by magnets, and can draw on and press light metal foil to make low-relief sculpture. Sand and plasticene casts in plaster can be made with adult supervision. Preschool children can also be taught simple loom weaving, knot tying, and stitching.

With the help of adults, preschoolers can learn to aim a camera and snap a picture if the camera is mounted on a tripod or otherwise firmly supported. Occasionally, several children can work together for extended periods (an hour or more) with little or no intervention by an adult. For the most part, effective cooperation on large-group activities, such as murals or puppet shows, is short-lived unless adults structure and pace these projects.

It is important for children to feel as if they are in control of the media that they are using. Competence can be nurtured in several ways. While children are working, ask them questions like: If glue won't hold, what would work? If you want bright colors of paint, would it help to clean your brush? Encourage children to try different methods of joining and cutting materials. Help them learn to vary the speed, pressure, and direction of movement in their use of tools or media. Demonstrations and suggestions while children are using a medium may help them to achieve the specific quality they want. For example, if a paintbrush is too wide to create details, show the child the advantages of using both wide and narrow brushes for painting.

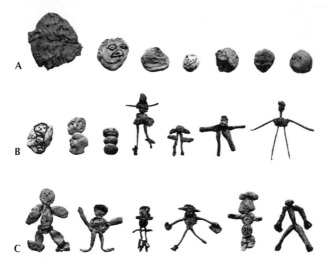

7-13 Montessori-type materials are especially valuable aids for teaching visual discrimination. (*opposite, left*) Felt strips for shape recognition. (*opposite, right*) Montessori templates.

7-11 Typical clay figures made by children who have not had instruction in using the medium.
A 3 years **B** 4 years **C** 5 years

7-12 An easel allows children to use large movements and to see their work at eye level.

It is important that teachers encourage flexibility in children's thinking about art techniques and in children's use of motor skills. Flexibility can be nurtured by arranging activities so that children may work on the floor, at easels, or outdoors (Figure 7-12). Techniques such as providing different amounts of clay, or various sizes, colors, and shapes of paper on which to paint and encouraging children to examine their works from far away and close up are relatively unobtrusive ways to sustain flexibility.

Nurturing response to visual experiences

The preschool years are a critical time in the child's perceptual development. In addition to forming the basis for conceptual development, perceptual experiences are the source of feeling and emotive meaning. Children's ability to make sense of the many stimuli in the environment is nurtured through activities enabling the children to perceive, to interpret, and to judge the significance of their experiences.

Most preschool and kindergarten programs in mathematics and science emphasize perceptual activities that are also relevant to concepts in art. Early mathematics lessons, for example, stress skills in identifying colors, shapes, sizes, textures, and weights. Children are taught to compare amounts, sizes, and lengths of things.

THE PRESCHOOL YEARS: AGES 3-5

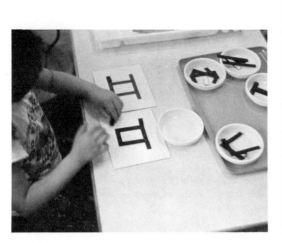

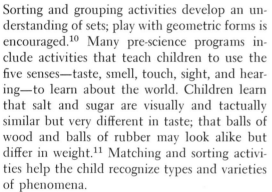

Sorting and grouping activities develop an understanding of sets; play with geometric forms is encouraged.[10] Many pre-science programs include activities that teach children to use the five senses—taste, smell, touch, sight, and hearing—to learn about the world. Children learn that salt and sugar are visually and tactually similar but very different in taste; that balls of wood and balls of rubber may look alike but differ in weight.[11] Matching and sorting activities help the child recognize types and varieties of phenomena.

Classroom teachers should note that many of the games, exercises, and experiments that are commonly used in pre-science and pre-mathematics instruction are directly relevant to artistic awareness as well. Art teachers, in turn, should become more alert to preschool and kindergarten materials suitable for visual-tactual learning. Montessori-type materials, in particular, are excellent models for art and classroom teachers to use in developing their own special collections of materials relevant to art (Figure 7-13). Such collections of objects and images should be arranged into groups to facilitate recognition of varied qualities of line, color, shape, texture, forms of balance and order, and so on.

When the child's sensorium is active, perception is at its peak and experience has a memorable quality. For example, sitting quietly and watching for the slightest sound or movement can sharpen auditory and visual perception. Expressing one mode of sensory perception in another mode also stimulates perceptual awareness (Figure 7-14). Musical rhythms can be translated into body movements; body movements can be translated into graphic form with large crayons or paintbrushes. Notice the sounds made by tapping objects made of different materials. Such multisensory experiences add depth to the child's perception of objects and events.

Occasionally rearrange the furniture in the classroom so that children become more aware of spaces that they use but may no longer see. Invite children to notice minor changes in some part of the room. Dramatic changes in weather also provide an opportunity to teach children to observe the background features of their environment.

Vocabulary development is the key to comprehending the meaning of perceptual experience. Prior to entering first grade, the child has a meaningful vocabulary ranging from two thousand to ten thousand words.[12] Vocabulary development is more rapid when words are associated with concrete objects rather than with photographs of objects. Encourage children to use correct names like *scissors* and *paint* when they are working with such materials. Adjectives and adverbs permit children to talk about qualitative differences in things they see. In the preschool years, children can begin to use adjectives like *fuzzy*, *warm*, *soft*, and *cuddly* to express sensuous and emotional reactions. With

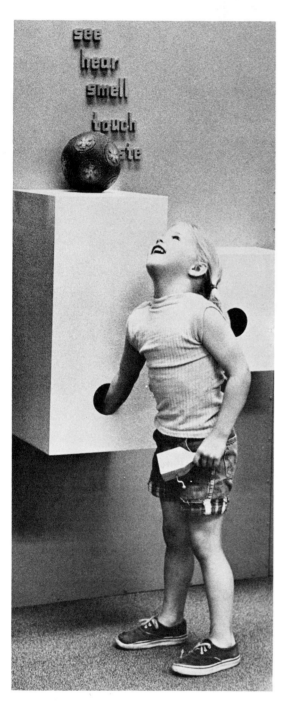

7-14 (*left*) Learning to identify shapes and surfaces by touching them.

7-15 (*opposite, left*) Costumes and mirrors help children become more aware of their feelings.

7-16 (*opposite, right*) Quiet moments provide an opportunity for gathering impressions and for reflecting on experience.

extended opportunities to work with clay, children can learn to use terms like *dig, pat, flatten, pound, pull, punch, roll, rub, smooth, squish,* and *twist.*[13] Above all, the teacher's own accurate use of a rich and descriptive art vocabulary is important. Baby talk should be avoided.

Empathy is a strong mode of response among preschool children. Indeed, it is often so intense that children lose their own sense of identity and become the thing they are seeing, feeling, or talking about. A number of activities can be designed to retain children's empathic power while building their capacity to keep their own identities. You might provide children with hand puppets or old hats and costumes and encourage them to dress up and play-act in front of a mirror (Figure 7-15). Mime activities or "instant replay" situations—in which one child attempts to make a mirror image of another child's motions—are helpful. Techniques for developing empathy may be found in books on creative dramatics and improvisational theater.[14]

About 70 percent of the questions asked by preschool children begin with "Why."[15] Teachers should invite children to ask and answer "Why" and "How" and "What if" questions about their own experiences or imaginary situations. Children might imagine that they are an insect or an animal and dramatize how that animal might go to sleep, wake up, play with friends, or eat dinner. On neighborhood walks, ask children to speculate on how a crack in the

THE PRESCHOOL YEARS: AGES 3–5

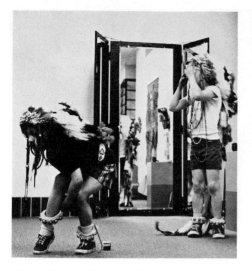

sidewalk got there or how a sign was put into place or what it would be like to walk down a street on which every building was pink, or purple. Questions that begin with "How" and "Why" invite more extended verbal responses than questions that begin with "What is it" or "Is that a." Allow ample time for children to respond to questions.

Preschool children also need guidance in synthesizing their impressions of an event or an experience. Many "reading readiness" activities are designed to help children learn procedural and temporal relationships. For example, show children how to place picture cards in a left-to-right sequence in order to create a coherent visual story. Provide other visual models of orderly thought by organizing displays that show part-to-whole or whole-to-part relationships. Oral reviews of an experience, focusing on what came first, next, and so on, can also accomplish this purpose. The ability to synthesize experience is developed by show-and-tell sessions and through periodic discussions of activities that children have just completed. Preschool children can effectively participate in group discussions lasting from ten to twenty minutes.

We live in a time and a culture that make it difficult for children to judge the value of their experiences. Children, like adults, can easily be conditioned to accept momentary pleasures as the essence of life. Children need to become acquainted with values other than those of he-donism and materialism, which are pervasive in the culture at large.

We should help children value learning itself as one of the rewards of daily experience. This can be done by noticing occasions when a child teaches *you* something new or by sharing something you have learned and showing your delight in that new skill or knowledge. In addition, overtly display your pride in each child's discoveries. Encourage children to teach and to learn from each other in a spirit of sharing. At natural transition points during the day, explicitly state what you think children have learned and compliment them on their overall performance.

Children need opportunities to "be"—to look quietly out of a window or to sit passively in a swing and absorb the view. They have to learn that such experiences are neither wasted time nor idle daydreaming but part of the joy of living (Figure 7-16). In order to encourage children to value the special qualities of each experience, we must develop in them an ability to recognize their own uniqueness. We teach children to value themselves in subtle but important ways—by using their names, by communicating our love for them, by insisting that others not demean them, by cherishing each one of them for the special way that they inhabit our lives.

A sense of the relative value of experience also comes with time and reflection. The young

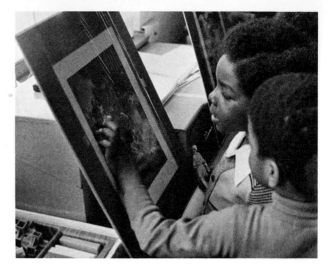

7-17 Preschool children have a keen interest in looking at and discussing works of art.

child's sense of time and place is increased by the routine of activities in the home and in the preschool environment.[16] Even the young child can learn that experiences are important precisely because their meanings can be reexamined, altered, or reaffirmed over time. For example, before children look at a familiar picture or hear a familiar story, poem, or musical selection, ask them what they like about it. After they see or listen to it, ask them to share anything new they may have discovered in the experience.

In teaching, we should note occasions in which children are using their prior experience to accomplish a particular activity. When children encounter a problem in carrying out a task, ask them to think of other things they have learned that might help them solve the problem. These and other explicit comments demonstrate to children the practical value of learning.

Introducing children to the artistic heritage

Since most preschool children have no knowledge of the work artists do or of the outcome of artists' efforts, they should be given as many opportunities as possible to see works of art, to visit museums and galleries, and to meet local artists, craftsworkers, designers, and architects.

Reproductions and some original works of art are essential for every preschool environment (Figure 7-17). The manner in which a young child encounters a work of art is just as important as the quality of the work itself; in every case, adults play a vital role in determining what children notice about a particular work and how children feel about the very process of encountering works of art.

The child's untutored sense of beauty and order is influenced by images in the home and in the mass media. Visual preferences become apparent at an early age. They are expressed as likes and dislikes, usually for objects with vivid colors, real or implied motion, and recognizable subject matter.[17] Young children do not distinguish between the beauty of an object, their preference for it, and their potential ownership of it. Responses to manufactured objects are primarily kinesthetic and visual, not tactual. However, children respond to natural forms tactually and kinesthetically more than visually.[18] (These patterns of response are typical for children who have *not* had any systematic exposure to works of art or to discussions about art.)

Children's encounters with works of art should be planned so that relationships between children's own artistic efforts and the efforts of adult artists are apparent. *Comparisons should center on similarities in the process of creating art. The adult artist's product should never be*

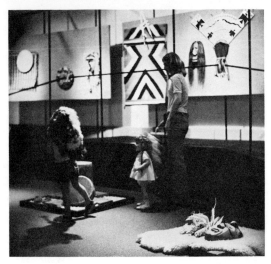

7-18 A museum exhibition designed for children. Dayton Living Art Center, Dayton, Ohio.

held up as a standard for young children to emulate or copy.

Collections of art should be organized thematically so that children can become familiar with common sources of inspiration. The broad categories of people, places, things, and nature are useful at this level of instruction. Each category might be further subdivided. For example, works based on nature might be grouped in collections that reflect the artist's interest in plants, birds, animals, landscapes, or the seasons. Collections should not be restricted to paintings, drawings, and sculpture but should include examples of the crafts, prints, architectural models, and other art forms.

Plan brief weekly or biweekly demonstrations and talks by articulate local artists *who enjoy children.* Several times during the year, invite a guest artist or craftsworker to set up a temporary studio within the preschool room and to work there daily for one or two weeks. Teachers in rural communities or small towns with relatively few artists should plan a film program for supplementary introduction to the work artists do.

Short visits to a local art museum or artist's studio are also important means of developing receptivity to the artistic heritage. During such trips, children should be permitted to examine works at their own eye level and from close and medium distances. (Unless the museum is de-signed for children, the very small child may have to be lifted up to the eye level of an adult.) In a museum or an artist's studio, no child should be left unattended or be permitted to touch any object unless the child is specifically invited to do so by the museum attendant or artist (Figure 7-18). A short visit, while the children's full attention has not yet been exhausted, is vital; very young children cannot remain in tow for long periods, nor can they comprehend the reasons for the "don't touch" and "don't run" rules.

Teachers and guest artists who have had little experience leading discussions often wonder how they can keep young children actively involved in a "looking and seeing" activity. The following dialogues illustrate several techniques for helping children see and think about the work of artists.

Some discussions can focus on works of art that show the artist's interest in nature, imagination, and everyday life as a source of inspiration. In the following example,[19] the work is a nonobjective sculpture by a local artist.

TEACHER: How would you like to go on a trip without even leaving the room? Today we are going to do that. We are going on a trip to see what we can discover with our eyes. This was made by an artist. It's called sculpture. Can you say that word?

7-19 These children are actively engaged in seeing, thinking about, and describing a work of art.

CHILDREN: Sculpture.

TEACHER: The sculpture is small, and you are very big. To go on our trip, we'll need to get smaller. I'm going to give you a magic stick that will make you small enough to go on our trip. I'll get small too, and we will all go together. Ready? Can you feel yourself getting smaller and smaller? Do you see the sculpture getting larger and larger? That's small enough now. Let's see, where can we crawl up on the sculpture?

CHILDREN: Where it touches the floor. Yeah. I can do that. Me too. There's another place. It's too high.

TEACHER: Let's try. Follow me. (*Teacher narrates physical actions that might be carried out as the children pretend to climb up on the sculpture and begin to walk along its "valleys," "hills," and "cliffs."*) You're doing fine. Look overhead. See that beautiful arch? Do you hear how quiet it is? Touch the walls with your eyes. Are the walls smooth here? Let's go down this hill and see what's around the corner. It's light here. See the shadow made by the arch? Does it make a curvy shape? Can you show me that curvy shape with your hand? Good! (*Teacher continues leading imaginary walk.*)

CHILDREN: I'm scared. I want to go home. It's not scary. It's pretty.

TEACHER: Amy, hold Mike's hand. Let's see. Where shall we get down?

MIKE: The same place we got up. There it is.

TEACHER: O.K. Good. Whew! Is everybody back? Hold your magic stick tight while we grow back. Ready? Feel yourself getting bigger, growing taller. See how small the sculpture is getting. You are good travelers!

Afterward, the teacher encourages children to help each other look at other works of art and to take imaginary trips into them. The teacher points out that artists often create things because they want to share their make-believe" with others. Notice that the *method* of engaging children in the perceptual experience is itself imaginative.

Works of art that show different interpretations of the same theme can be examined (Figure 7-19). Here is an example of a discussion about works portraying clowns and the circus.

TEACHER: Have you ever been to a circus or seen one on TV?

CHILDREN: Yes. They have animals. Yeah. Clowns. Horses.

TEACHER: Good, a circus is fun. Clowns do silly things to make people laugh. Do you see a painting of a clown here? Sarah, can you point to it? Good. Look at this painting carefully. Pretend you are the clown. Let

7-20 An architectural model is the focal point of this preschool lesson.

your body show how he's sitting. Now, look at his face and make your face look like his. Do you feel happy now?

CHILDREN: No.

TEACHER: Is he doing something funny?

CHILDREN: No. He's resting.

TEACHER: Are the colors bright and happy?

CHILDREN: No. Yes. No. No. He looks dirty. His face is blue.

TEACHER: His clothes do have dull colors, don't they? He has blue around the eyes. Is a clown funny if he looks sad and isn't doing anything silly? If he's not painted with bright colors?

CHILDREN: No.

TEACHER: Why would an artist paint a picture of a clown that's not funny?

CHILDREN: Maybe he didn't like him. Is he sick? He's going to cry. Sad. His mother's gone.

TEACHER: Do you think the clown looks happy or sad?

CHILDREN: Sad!

TEACHER: Is it hard to be funny all the time? If you were a clown and didn't feel good or were sleepy or tired would it be hard to be funny and make people laugh?

CHILDREN: Yes.

TEACHER: Sometimes artists show us things we don't usually think about. Clowns are funny, but they are real people too, just like we are. They can be sad inside even though

they have a smile painted on their face. Have you ever smiled with your face when you weren't smiling inside?

The teacher turns the children's attention to other examples of work based on the circus theme, helping children see similarities and differences in the moods of the people depicted.

Because preschool children cannot yet see tools and spaces as forms of art, an awareness of the design and importance of everyday objects and spaces should be nurtured (Figure 7-20). Here is a sample dialogue about the design of spoons.

TEACHER: See what we have to look at today. Spoons. What do you think about them? What do you see?

CHILDREN: They're pretty. That's the big one. It's shiny.

TEACHER: Close your eyes now. I'm going to put one of these in your hands. Keep your eyes closed and tell me how it feels. Is it cold or warm? (*Children reply. Teacher continues with questions and waits for answers.*) Is it heavy or light? Is it smooth or bumpy? Feel the edges. Are they curvy or flat? Open your eyes and look carefully at the spoon you have. What do we use these for?

CHILDREN: Cereal. Cooking. Eating. Stirring.

TEACHER: That's right. What is this part for? (*Points to handle.*)

CHILDREN: Holding it. You put your hand there.

TEACHER: And what is this part for? (*Points to bowl of spoon.*)

CHILDREN: Cereal. Soup. Holding stuff.

TEACHER: Look at the edge and bottom. Is it curled up and deep, or is it flat and kind of straight?

CHILDREN: Flat. Curved.

TEACHER: They are different, aren't they? Some are made to hold a lot, some aren't. If you have one that's kind of flat, you'd have to slow down and eat carefully—like someone at a special dinner with company. What about this one?

CHILDREN: You can eat faster. You don't mind your manners. You spill things.

TEACHER: Do you mean you can hurry and that makes you spill?

CHILD: Yes.

TEACHER: Spoons are planned by artists. Did you know that? The artist who plans a spoon can make it to eat with, or stir with, or mix things with. The artist plans it so it's fancy or plain. What other things are planned like spoons are?

The teacher briefly points out that chairs, tables, coats, and even shoes are designed by artists. The teacher invites children to help each other look for things that are planned to be plain or fancy, to be easily used or carefully handled.

The purposeful character of an artist's work can best be understood by seeing an artist at work or by talking to an artist. In the following illustration, a local weaver has been invited to visit a preschool class.

WEAVER: I like to weave. Weaving is how cloth is made. Sometimes I make cloth on a loom like this one (4-harness, table-top). Sometimes I make cloth by knotting and braiding.

TEACHER: Mr. Smith will show us how he makes these beautiful things. Can you show him you are ready? Thank you.

WEAVER: I know you've used these (*holds up wood frame for weaving jersey loops*). This is called a loom. Can you say that? (*Children say* loom.) This loom (*points to table-top loom*) does the same thing. A loom holds some of the yarn in place so you can weave other yarn across it. If you gather around me, I'll show you. (*Children watch while weaver demonstrates, explains what he's doing, and answers children's questions.*)

TIM: Is that how you do that? (*Points to freeform wall hanging.*)

WEAVER: No, that's made a different way. Why don't we move back to the circle and I'll show you how that's done. (*Children move back to circle.*)

TEACHER: I think we're ready now.

WEAVER: This is made to hang on a wall. It's made without a loom. I began with this loop and tied yarns to it. Then I made lots and lots of knots to make it bunch up here, and left a few threads there to make this curve go up to this other big knotty part. (*Demonstrates knots.*)

CHILDREN: That's hard. Boy. It's like tying things. Your shoes.

WEAVER: It takes practice to tie a shoelace, and it takes practice to tie knots like this. I like to tie knots like these because I can make cloth look round and like it's moving. If I want to make something flatter and straighter, I use this loom. It's nice to be able to do both. One is like playing tag. The other is more like listening to quiet music.

The demonstration is concluded with the classroom teacher and the weaver inviting the children to touch the work carefully and to look at it closely. Simple looms and yarns are then placed in a prominent place for children to use if they wish.

The preschool child should have opportunities to become acquainted with the range of media that artists use. In addition to live demonstrations by artists, touchable examples are appropriate means of building familiarity with media. Small paintings or samplers of encaustic,

egg tempera, oil, watercolor, and fresco might be designed by parents or staff from local museums or college art departments. Local craftsworkers or members of trade unions might make puzzles or samplers to acquaint children with varieties of metal, wood, ceramics, stone, fabric, and paper.

It is important for preschool children to hear adults talk about art in a clear, concrete manner appropriate to the children's level of understanding. In addition to hearing adults discuss art, children should participate with adults in the process of looking at a work, allowing it to shape their feelings, and discovering how it is made. Short, focused, and repeated encounters with single works of art are better than unstructured and prolonged encounters with many works. When the same work is reexamined from time to time, with the object of discovering new aspects, children can begin to appreciate that looking at a work of art is a process of exploration and discovery, not a one-time, all-or-nothing experience.

Elaborate on the child's emerging preferences and perceptions by helping the child notice moods or feelings portrayed in a work—for example, that a dog looks tired and old or that a person looks quiet and peaceful. Examine various art forms—jewelry, ceramics, and product design—to determine their function and use (Figure 7-21). Help the child notice how the object makes a person feel about it or want to use it. For example, a cut-glass vase may make a

person want to hold it carefully and put it where light can shine through it. Thus you can build on the child's untutored responses and nurture an awareness that perception, thought, and feeling enter into the appreciation of art.

It is neither essential nor desirable to plan specific lessons to introduce young children to the concepts of medium, style, and design or to acquaint children formally with methods of interpreting and judging art. Children's personal preferences should be pointed out to them. The fact that each child may like a work for different reasons is as important as the fact that ten children may like ten totally different works of art. It is often possible to conclude an encounter with works of art by noting such individual differences in taste and perception; for example, a teacher might say: "Mary seems to like the bright colors in this one, and Tom noticed the great clouds in this work. It's nice to have different ways of looking at things." A child whose preferences have been respected will be able to develop more critical and systematic judgments of art later on.

Developing an awareness of art in society

One of the purposes of the preschool program is to introduce children to the process of learning within a group setting. Basic skills in listening, sharing ideas, getting along in a group, and assuming responsibility are emphasized. Children visit zoos, parks, and construction sites to learn about the larger environment. Some programs introduce children to civil servants such as police and firefighters, and teach children to distinguish between the family unit and "other people." Both the purpose and the nature of such activities are relevant to the child's ultimate understanding of art as a form of sociocultural expression.

Television and the world of commerce also influence children's understanding of "other people." By the age of three, most children spend an hour a day watching television. By the age of six, most children watch television for four hours a day.[20] Although many of the programs children watch are cartoon fantasies, the action of the characters and the standards depicted in the intervening commercials teach children one version of what their own culture values.

Young children quickly learn that items have status and exchange value. Before the first grade, many children learn to make simple purchases, can tell the worth of coins, and have an understanding that money buys things that are nice to own.[21] While preschoolers have a vague sense that people work, they tend to believe that people hold jobs because they like to do certain things during the day.[22]

7-22 Birthdays provide an opportunity for self-expression.

In short, the young child is not totally naive about the world outside of the home, friends, and family. But because the preschool child does not have an intellectual understanding of social groups and abstract ideas of time and place, it is best to use informal approaches to the social aspects of art.

Like most of us, children take many things for granted. In order to teach children how cultural artifacts fulfill people's physical and psychological needs for safety, comfort, and security, you might, for a short period, remove from the classroom every portable object made of a particular material—paper or clay or plastic or metal. When children begin to notice that something is missing, ask them to name what it is and how it is used. Then return each item with great care to its place, pointing out that we can sometimes forget how important ordinary things are.

It is crucial for preschool children to become aware of their individuality. Comment on qualities in each child's work that make it unique, and assure the children that they are personally responsible for the fact that their work is unique. Write each child's name on every work he or she creates, even if the child is unable to read the name. Provide a special place for each child's own possessions. Notice things that each child can do independently.

Preschool children have a well-developed sense of the importance of birthdays and holidays, especially those that are celebrated in the home or at a church or synagogue (Figure 7-22). They are skilled in devising imaginary celebrations on the spur of the moment. Birthdays of children in the class; a celebration for a beautiful rainbow; "firsts," like learning to print one's name; birthdays of guppies, hamsters, or other animals—all are occasions for artful celebration. Help children understand that the most important part of a special event is the feelings of people. Encourage children to notice how special feelings and special objects often go together. For example, on a beautiful, windy day, hang streamers and balloons in the playground; play music, choreograph dances, or hold a parade to celebrate the beautiful, windy day.

Informal situations are appropriate to teach preschool children the feelings that can be expressed in simple and elaborate forms, special symbols, and other variations in cultural artifacts. At snack time, serve cookies and milk in fancy glasses and plates, and place fresh flowers on the table. Point out the way our "best manners" seem to go with flowers and our fanciest plates and glasses. Acquaint children with cross-cultural symbols by collecting and displaying images of the sun, trees, birds, and so on from various cultures and by talking about the moods the different images evoke. Does this bird look strong? gentle? helpful?

Children should be exposed to numerous examples of artifacts from other cultures. Col-

lect artifacts made from the same material by people in different cultures—a papier-mâché *piñata* from Mexico, a paper necklace from Appalachia, a paper cutout decoration from a Slavic country. Point out the ways different people use the same material. As a complement to this approach, collect artifacts made from one material abundant in a single culture—from Mexico; a tin lamp, a tin cookie cutter, a tin decorative mirror, a tin toy.

Preschoolers need to develop their own sense of self. At this age, it is sufficient that children gain an intuitive understanding that people differ in their responses to visual forms. This kind of learning takes place naturally in the course of everyday life; it also underlies some of the informal activities suggested in this chapter. Formal instruction to nurture an understanding of how others see, interpret, and judge cultural artifacts is unnecessary.

Notes

[1] For an excellent critical review of theories of artistic development in children, see Elliot W. Eisner, *Educating Artistic Vision* (New York: Macmillan, 1972).

[2] This data, from a study by H. Kind Hetzer, is reported in Jean Piaget, *The Child's Conception of Space* (London: Routledge & Kegan Paul, 1956), p. 62.

[3] A. F. Roberts and D. M. Johnson, "Some Factors Related to the Perception of Funniness in the Humor Situation," *Journal of Social Psychology* 46 (1957):57–63.

[4] Lawrence Kohlberg, "The Child as Moral Philosopher," in *Readings in Psychology Today* (Del Mar, Calif.: CRM Books, 1969), pp. 181–86.

[5] Jean Piaget, *The Child's Conception of the World* (Patterson, N.J.: Littlefield, Adams, 1960).

[6] M. H. Nagy, "The Child's Theories Concerning Death," *Journal of Genetic Psychology* 73 (1948):3–27.

[7] Jean Piaget and Barbel Inhelder, *The Psychology of the Child* (New York: Basic Books, 1969), pp. 51–91, 92–128, 130–51.

[8] L. B. Ames and F. L. Ilg, "Developmental Trends in Writing Behavior," *Journal of Genetic Psychology* 79 (1951):28–46.

[9] Joan Russell, *Creative Dance in the Elementary School* (London: Macdonald & Evans, 1965).

[10] Howard F. Fehr and Jo McKeeby, *The Teaching of Mathematics in the Elementary School* (Reading, Mass.: Addison-Wesley, 1967).

[11] James J. Gallagher and Paul D. Hurd, *New Directions in Elementary Science* (Belmont, Calif.: Wadsworth, 1968).

[12] Albert Harris, *How to Increase Reading Ability* (New York: David McKay, 1961).

[13] Nancy Douglas and Julia B. Schwartz, "Increasing Awareness of Art Ideas of Young Children Through Guided Experiences with Ceramics," *Studies in Art Education* 8 (1967):7.

[14] One of the best of these books is Viola Spolin, *Improvisation for the Theater* (Evanston, Ill.: Northwestern University Press, 1963).

[15] K. Yamamoto, "Development of the Ability to Ask Questions Under Specific Testing Conditions," *Journal of Genetic Psychology* 101 (1962):83–90.

[16] N. C. Bradley, "The Growth of the Knowledge of Time in Children of School Age," *British Journal of Psychology* 38 (1947):67–68.

[17] D. P. Ausubel et al., "Prestige Suggestions in Children's Art Preferences," *Journal of Genetic Psychology* 89 (1956):85–93.

[18] Laura H. Chapman, "Responses to the 'You Name It' Show (Unpublished report for the Taft Museum staff, Cincinnati, Ohio, 1972).

[19] Adapted from a lesson given to a kindergarten class by Jan Harbolt while she was student teaching.

[20] Data from Joan Beck, "T.V. Violence May Be Linked to Disturbances on Campus," *Cincinnati Enquirer,* June 2, 1970, p. 4.

[21] A. L. Strauss, "The Development and Transformation of Monetary Meanings in the Child," *American Sociological Review* 17 (1952):275–86.

[22] E. Ginzberg et al., *Occupational Choice* (New York: Columbia University Press, 1951).

Suggested Readings

These readings cover material presented in Chapters 7 through 10 of this book. For information on specific aspects of children's development, see the notes at the end of each chapter.

Gardner, Howard. *The Arts and Human Development: A Psychological Study of the Artistic Process.* New York: John Wiley, 1973.

Gardner, Howard; Winner, Ellen; and Kircher, Mary. "Children's Conceptions of the Arts." *Journal of Aesthetic Education* 9 (1975):60–77.

Harris, Dale B. *Children's Drawings as Measures of Intellectual Maturity.* New York: Harcourt Brace Jovanovich, 1963.

Kellogg, Rhoda. *Analyzing Children's Art.* Palo Alto, Calif.: National Press, 1969.

Lark-Horovitz, Betty; Lewis, Hilda Present; and Luca, Mark. *Understanding Children's Art for Better Teaching.* 2nd ed. Columbus, Ohio: Charles E. Merrill, 1973.

Lowenfeld, Viktor, and Brittain, W. Lambert. *Creative and Mental Growth.* 5th ed. New York: Macmillan, 1970.

The early elementary years: grades 1–3

Drawings by Sarah Kern.

A *Cowboy on Horse.* 6 years, 3 months.

B 6 years, 8 months.

C 7 years, 2 months.

B

C

D 8 years.

E 8 years, 8 months.

F 8 years, 11 months.

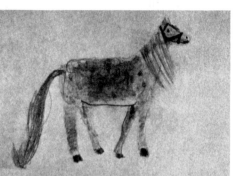

D

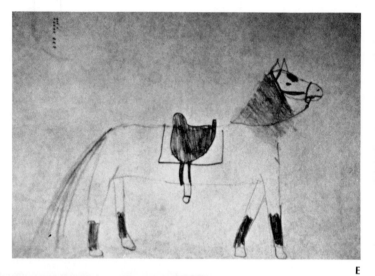

E

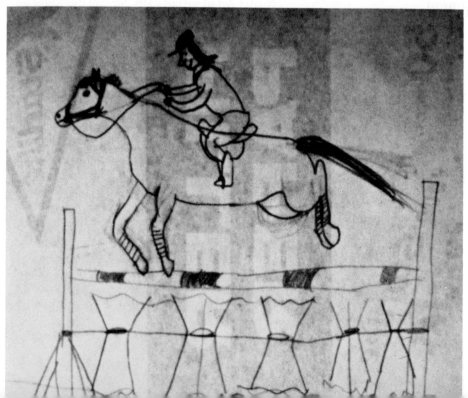

F

8-1 *Playing Jump Rope.* Grade 2.

Most youngsters believe that anything is possible. When we consider the remarkable accomplishments of children during their first years in school—learning to read, to communicate through marks on paper, to interact with many people in a strange environment—the child's belief in his or her own power seems warranted. Indeed, one of the primary risks in teaching children of this age is underestimating what they are able to and want to learn.

Personal fulfillment through art

During their first years in school, children undergo a remarkable period of growth in their ability to give visual forms to things they see and feel. Most children approach art with an air of confidence and unrestrained enthusiasm. These positive attitudes should be channeled into the process of acquiring skills and knowledge that will sustain children's interest in art in the later elementary grades and, indeed, throughout their lives.

Guiding the artistic process

In the early elementary grades, children seem to prefer drawing people, simple landscapes, ani-

mals, and objects like boats, trains, and cars. Many second and third graders create works showing complex actions and events. In pictorial work, symbols representing people, houses, and trees are often placed along one or more base lines. This arrangement retains the visual clarity of each part (Figure 8-1). By the end of the third grade, children begin to use overlapping shapes to show near and far space (Figure 8-2).

During the early elementary years, children continue to develop their work by a part-by-part thought process; however, they now show greater detail within parts. Size relationships are often determined by the desire to retain a clear image, to fill an empty space, or to express an emotionally important aspect of an experience (Figure 8-3). Relative sizes are shown when children strive to show logical or functional relationships—for example, a door is drawn big enough for a person to walk through (Figure 8-4). Color choices are often related to stereotyped notions of the proper colors for things—blue sky, green grass. With instruction, children can learn to mix colors and will begin to show an interest in more subtle uses of color to portray the weather, the seasons, and moods.

Although youngsters at this age have a vivid imagination and a keen interest in the world around them, they need guidance in order to give visual form to their experience. Left on their own, children will create images that are little more than stereotyped references to their

166

own experiences and that are lacking in detail, conceptual clarity, and expressive content. The desire to create art is directly related to the vividness and intensity of children's personal imagery. Imagery, in turn, is more vivid when children encounter a situation that fully activates their vision, feeling, imagination, or sense of purpose.

Careful observation of the natural and constructed environment is an important way for children to develop a sense of their own identity and to comprehend their relationship to the larger environment in which they live (Figure 8-5). Topics for artwork might include people engaged in active or passive activities, such as "Sitting in my favorite chair" or "Playing on the jungle gym"; places, with an emphasis on times of day, the seasons, the weather, or action, such as "Seeing a parade" or "A rainy day"; and things, such as "The school bus" or "Bikes." Animals, insects, birds, fish, flowers, and trees also fascinate children of this age. Arrange trips into the neighborhood and, if possible, trips to a zoo, and bring live animals into the classroom to offer children rich opportunities for creating art.

Children in the early elementary grades enjoy using imaginary themes and situations for artistic inspiration (Figure 8-6). They like riddles and delight in stories that offer absurd explanations for familiar things.[1] Their daydreams still have conquering-hero themes. Poems and stories continue to be valuable sources of motivation,

8-2 (*above, left*) *Playing Baseball.* Grade 3.

8-3 (*above, right*) Size relationships are sometimes determined by the sequence in which parts of a work are developed and by the need to retain visual clarity.

8-4 (*below*) *Children and Barking Dogs.* Grade 2.

Thomas
John Paolini

8-5 (*below*) A third grader drew this house from direct observation.

8-6 (*right*) *Castles and Dinosaurs.* Grade 3.

8-7 (*opposite, left*) *Fight Pollution.* Grade 3.

8-8 (*opposite, right*) Life drawing. Grade 3.

but children should create their own images before seeing illustrations in the books. Literary sources like *The Dong with a Luminous Nose*, by Edward Lear, *The Adventures of Isabel*, by Ogden Nash, or *The Jungle Books*, by Rudyard Kipling, are appropriate. Adaptations from sources like these can easily be developed: "How the (*television*) got its (*antennae*)," "Two million, two hundred thousand (*pillows, ants*)."

Themes for personal expression can draw on the child's emerging concepts of right and wrong, of weakness and strength, of love and hate. In the early elementary grades, children are still forming basic attitudes about themselves and others. Children's ideas of right and wrong are based on their immediate desires and on patterns of conduct allowed by adults. The value children place on human life is shaped by the empathy and affection they see others display.[2] In general, "life" is associated with anything that can move on its own; for this reason, not only people and animals are thought to be alive but also the sun, the moon, and rivers.[3] Children think of death as a person "who comes and takes you away."[4] Art activities based on fables, riddles, stories, and proverbs often provide a non-threatening way for children to reflect on the delicate balance of positive and negative forces in their lives. Opposite moods and actions can be explored. Contrasts in feelings like selfish–generous, kind–cruel, naughty–nice can inspire personal images for art. "What

THE EARLY ELEMENTARY YEARS: GRADES 1–3

if" themes are also fruitful: What if the world were full of happiness? of sadness?

During the early elementary years, children take on more responsibility for their personal appearance and their immediate environment. (Figure 8-7). They are interested in decorating for celebrations, and they enjoy giving and receiving gifts. Take advantage of everyday events and special circumstances for personal expression. For example, if a classmate is in the hospital, what might make him or her feel better? greeting cards? a photograph of the class? handmade comic books? If children are excited about Halloween, how might their excitement be expressed? a parade? a hall mural? mask making?

Children's sensitivity to experiences that can be expressed in visual form does not always keep pace with children's skills in shaping materials. In order to build flexibility and increase children's sensitivity to details, the teacher should encourage children to make visual studies based on careful observation and recall. In the first grade, related sets of works, differing in size, color, shape, or mood, can be created: a tall building, a short building; a building with many windows, one with few windows. Beginning in the second grade, children can be introduced to the idea of making sketches from life. Short sessions (two to three minutes) with a posed model can be undertaken (Figure 8-8). Drawings from still-life arrangements can be made outdoors or indoors.

In every instance, children should be guided to express their personal viewpoints and feelings about what they see. Simple forms of overlap, color subtleties, significant details, patterns of movement, and underlying shapes can be pointed out, but interpretive seeing should be emphasized. Representational accuracy is not only beyond the conceptual grasp of most early elementary children but it is also a false premise for nurturing personal expression.

In the early grades, children show increased understanding of simple cause–effect relationships. They learn to group similar things without seeing concrete examples; they learn to retrace their actions mentally in order to discover errors or to reproduce a prior achievement. They can combine two ideas to find a third: "If I do x and I do y, then z happens."[5] All of these emerging skills can be tapped to make children more confident in anticipating problems in artistic expression.

Indeed, children in the early elementary grades enjoy the process of solving problems and sharing their discoveries with others. When children begin to work, the teacher should talk with the children about what they want to do and why they want to do it. As the children work, the teacher should comment on effects they are achieving and the ways in which they are achieving them. If children seem to be creating images that are little more than visual notations, the teacher should help children explore several

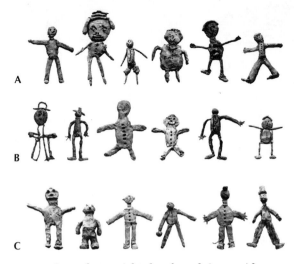

A

B

C

8-9 (*left*) Typical clay figures made by children who have not had instruction in using the medium.
A 6 years
B 7 years
C 8 years

8-10 (*opposite, left*) Skills in manipulating any medium are improved by frequent opportunities to use it.

8-11 (*opposite, center*) Learning to appliqué fabric.

8-12 (*opposite, right*) Photograms. Grade 3.

meanings that might be found in an idea or topic. For example, when children draw animals, help them think about what animals look like, where and how they sleep, what they do in bad weather, how they move when they are young and frisky, how they move when they are old and tired.

Physiologically, normal children have few limitations of vision or of fine-muscle control: the eye is fully developed by the age of six, thus enabling visual coordination. Although most schools have programs to detect visual problems, the typical letter-chart examination (the Snellen test) is not sufficient as a screening technique. Teachers should refer youngsters to a physician if image reversals, excessive squinting, or inattentiveness persists. Eye infections of any kind should be treated promptly.[6]

By the age of seven, most children have a clearly established pattern of left or right dominance of eye–hand coordination. Only about 20 percent have no clear preferences. "Mixed" dominance is evidenced in a confusion of left with right and in image reversals.[7]

During the early elementary years, children gain skills in controlling the scale, direction, force, and speed of their hand, arm, and body movements. Children can produce straight, wavy, curved, and twisted paths while drawing, using clay, or creating dances.[8] Most children make the shift from printing to cursive writing between the second and third grade. This shift

reflects their growing command of smooth, continuous hand and finger motions. Letter forms with reversed loops are the most troublesome for the beginner.[9] Because fine muscles are usually developed by age six, poor coordination often is due not to slow physiological development but to lack of practice in manipulating or shaping materials. The major physiological considerations in selecting media are the child's lack of strength, short stature, light body weight, and inability to maintain any stressful hand or body position.

Given a supportive environment and appropriate instruction, children in the early elementary grades can learn to control the amount of paint they put on a brush, to mix colors, and to use varied brush strokes to create specific effects. They can begin to anticipate proper amounts of glue and to plan an efficient sequence for gluing parts together. Skills in the use of printing processes are limited only by the bounds of physical strength and by safety considerations.

In three-dimensional work, skills are still limited by the degree of physical strength and by the number of factors that children must consider simultaneously (Figure 8-9). In working with clay, children can be introduced to basic processes of modeling by hand and, with proper tutoring, can begin to make clay cylinders on a potter's wheel. They can learn to improve the consistency of clay while they are working (Fig-

THE EARLY ELEMENTARY YEARS: GRADES 1–3

ure 8-10). With sufficient practice, children can fashion clay to show movement. (Untutored sculptural work in clay often tends to be frontal and cubic, with little diagonal movement.) Instruction in the proper use of hand tools for woodworking—chisels, saws, hammers, clamps, drills—should be provided so that children can use them safely and skillfully. Metalworking can be introduced; children can learn to bend sheet metal and wire and to model soft metal foil. In plaster casting, children can learn to anticipate the elevations and placement of parts before the work is cast. In carving soft stone and plaster, children have difficulty visualizing the form "in-the-round"—thus, surface carving is typical of beginning efforts. Weaving, stitching, and simple macramé can be undertaken, provided that the scale of the work is small enough for children to see their progress (Figure 8-11).

With instruction and practice, children can learn to use a box camera to take photographs and to achieve good framing of their chosen subjects. Children do require guidance in order to become selective about what they photograph. Simple film animation can be undertaken. In any group activity, children work most effectively if labor is divided and if an overall concept of the final product is established first (Figure 8-12).

In order to gain some mastery in working with a medium, children must be able to use it frequently and for sustained periods of time (Figure 8-13). For example, encourage children to work on a single painting for two or three hours (over several days) in order to refine it. Teach them efficient techniques for obtaining, handling, and putting materials away, but be sure that the mechanics of gaining access to a medium do not overshadow the importance of the medium's creative application.

As children become increasingly familiar with qualities of media, they should become more selective in their choice of media. If children have worked with chalk and wax crayon, they can begin to understand that the shiny quality of wax crayons might show the bright reflections of rain on city streets, while chalk might show the steamy fog rising from hot streets after a brief shower.

Many third graders begin to show uncertainty in using media, possibly because of their growing consciousness of the "right" way to perform many tasks. When children express dissatisfaction with their work, their desire to create art may be curtailed. It is often helpful to encourage children to see a problem as if it were an opportunity. For example, if a clay container begins to sag and get out of shape, study the shape and see if it might suggest a new direction for work. Experimentation can also be helpful if it is aimed at the development of skills. Although children intuitively use the trial and error method to solve problems, their skills are not necessarily improved by this method be-

8-13 Silkscreening. Grade 1.

cause children have no recollection of the cause-effect relationships that led to success. Experiments involving only a few variables appeal to children and contribute to skill development because cause-effect relationships can be clearly traced. For example, in order to gain skill in mixing paint, children might vary the amount of white added to a color and study the different tints that result.

Nurturing response to visual experiences

Perceptual skills and sensitive responses are essential to the process of creating visually expressive forms. Nevertheless, art experience is not limited to creating works; it can be the outcome of seeing, interpreting, and judging a wide range of objects and events. All of the methods treated in this section apply to studio activity; however, the methods can also be employed to heighten aesthetic response for its own sake.

During their first several years in school, children are involved in making very fine visual, tactual, kinesthetic, and auditory discriminations. Many of the perceptual skills children normally learn in science, mathematics, and reading are also applicable to art.

Close observation and accurate description are the hallmarks of early science education.

Children are taught to observe motion, light, shadow, the effects of heat, and changes in the seasons and the weather. They are taught to describe things by their physical properties—color, length, width, volume.[10]

In mathematics, children learn to count, match, sort, and place things in subsets. By the time they have reached the third grade, children are likely to have been introduced to problems in measuring time, speed, distance, and volume. Basic geometric shapes and concepts of straightness, roundness, angularity and parallelism are introduced in many early elementary mathematics programs (Figure 8-14).[11]

In addition to learning skills in science and mathematics, children are learning to read, to recognize and decipher the meaning of single-letter forms and complex combinations of them. The initial process of learning to make sense of shapes, lines, and clusters of marks is basically the same whether the child is beginning to read words or beginning to "read" visual imagery.

Aesthetic perception, however, is not simply a matter of decoding symbols with fixed meanings. *Aesthetic* pertains to "perception based on feeling and sensation." Aesthetic perception is particularized in the moment, not generalized for all instances. It is connotative, as is poetry, not denotative, as is prose. Thus, from the viewpoint of aesthetic perception, practice in reading for fixed meanings can build concep-

8-14 This aid teaches children to distinguish between actual form and the illusion of form.

tual rigidity and can actually prevent children from seeing, feeling, and understanding the uniqueness of things. For this reason, the perceptual skills that children normally learn from reading, science, and mathematics have to be complemented with experiences that stimulate multisensory awareness and that promote a sensitivity to expressive meanings and to contexts.

Multisensory associations can be developed by moving from one sense to another to take in an event or an object, first through vision, then touch, then hearing, and so on. Associations can also be developed by receiving information in one sensory mode—hearing—and then by giving it form in another mode—body movement. Dancing to music is a common example of transforming musical rhythms into rhythmic body motions. "Blind" drawing, based on feeling an object one cannot see, involves touch, sight, and movement. Children can also learn to reduce large body movements to progressively smaller ones, first limited to the arm, then to the hand and fingers, and finally to the finger tips.

Projective techniques also heighten aesthetic perception. For example, while children are looking at a tree, have them "become" the tree. Here is a sample narrative: "Close your eyes and smell the bark and leaves; feel where the branches and twigs meet; notice the leaves moving gently. Can you make your fingers and hands move like the leaves? Can you show with your body how strong the trunk is? How the roots go down? How the branches extend out? Close your eyes and pretend you really *are* this tree."

Symbolic associations are also vital to full perception. Following an experience like the one just described, children might listen to poems that personify trees and to program music that deals with tree and forest imagery. Children might create their own poems, sounds, and dances that express the moods and feelings of young and tender trees, of old and wise trees, and so on. These activities nurture an empathic relationship with trees. They help children to see reasons for looking at trees, for caring about trees, and for learning more about them.

We can add to our tree example one further form of perception: attending to contexts and purposes. Trees are not static. They change over time, as we do. Our perception of trees changes with the changes we see in them and the changes we feel in ourselves. Seasonal changes are an obvious point of comparison, but the weather, too, is important; so, also, are the angles from which we see trees, and the relative importance of trees at the moment we see them. If we are late for school, we might pass many trees without noticing them at all. Our experience of a tree is quite different if we are embraced in its branches, just low enough to feel safe and protected but high enough to feel triumphantly tall.

8-15 This vocabulary-development game is keyed to abstract lines, shapes, and patterns.

Children's thought processes and vocabulary levels are important considerations in nurturing interpretive skills. Speech and thought help children articulate their impressions and discover what those impressions mean (Figure 8-15). In the early elementary grades, children may have vocabularies ranging from five thousand to seventeen thousand words.[12] Children begin to understand that different words, such as *kiss, love, hug, dear,* and *warm,* have a common connotation. Children can associate sensed qualities like sweet, hard, cold, and deep with qualities related to people and to feelings. Children can also use several words for the same thing: *push, shove; smooth, silky.* They can combine words to make subtle distinctions: *brownish gray, bluish green.*[13] These emerging skills in the metaphorical use of words should be put to work in the context of art. Vocabulary development is most efficient and meaningful when it is related to what children see, feel, and think.

We have noted that perceptual and interpretive skills are enhanced by empathic relationships with people, places, and things. At this age, children still experience such intense emotional involvement that their own sense of identity is temporarily lost. For this reason, empathy must be tempered with some psychological distance. Puppets, masks, and role playing are excellent vehicles for children to use in talking about highly emotional experiences, since they can articulate feelings through these once-removed channels that they might not express directly.

Although many school activities are aimed at mastery of "right" answers, children have to learn that many experiences cannot be understood or enjoyed in simple "right and wrong" terms. Speculative interpretations can be encouraged by asking children to imagine *how* something came into being; *what* about it is different or special; *why* anyone might want to pay attention to it; *when* it matters most to them; *what if* the object or event were larger, smaller, younger, older. The child's own spontaneous questions are a natural point of departure for discussions of this kind. During this age span, about 80 percent of the questions children ask begin with "Why."[14]

Coherent thinking is essential if children are to interpret their experiences. Skills in synthesizing impressions are developed in the early elementary grades. Children can engage in activities that involve them in reporting on an experience by describing each event in sequence, by referring to spatial relationships, by noting simple logical relationships like "*x* and *y* combine to produce *z*," by reporting a general impression and then noting details (whole to part), or by relating details to one another in order to create an overall impression (part to whole).[15]

The process of judging the significance of experiences should not be ignored. Children

continue to need adult models who demonstrate that learning is to be valued in its own right. The teacher's own curiosity, delight, and willingness to share personal discoveries with children is as important as overt displays of pleasure in the child's discoveries and progress. Whenever children have discovered something, encourage them to share what they have learned with at least one other person.

The special, self-contained character of certain experiences should be noted. Quite often, the wholeness of a time and place is grasped in memory and cherished precisely because it is in vivid contrast with the humdrum of everyday life. An experience may be memorable because of its beauty, sadness, humor, solemnness, or strangeness. Even ordinary events can be inexplicably poignant and difficult to forget. When special moments occur, they should be recognized, honored, and shared. Teachers are the prime model for enhancing the child's sensitivity to this way of judging experiences. Share examples of your own memorable experiences, and encourage children to talk about their own special moments.

At this age, children can begin to realize that part of growing up means that your feelings about things change. To help children reevaluate experiences ask them: How do you feel about this? How did you once feel about this? Reexamination of experiences can also be encouraged by comparing expectations for an event with its actual outcome. Before an event, ask children to describe what they think it may be like; afterward, ask them to describe their experience. Were all expectations fulfilled? some? Did unexpected things occur?

These approaches to teaching and learning are not often followed in the context of art. Indeed, we have hardly spoken of "art" at all in the preceding discussion. The omission is deliberate; it is intended to illustrate that the subject matter of art always touches on life itself. Our discussion has centered on skills and attitudes that hold the promise of transforming the very process of living into an art—making life, like art, palpable, vivid, and intelligible.

Developing an awareness of the artistic heritage

Children who have not had any experience in looking at or talking about works of art have little or no understanding of the work artists do. Consequently, such children can benefit from the activities recommended for the preschool years. Beginning in second grade, however, children should become much more involved in discovering visual clues to the expressive mean-

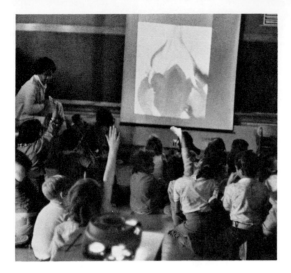

8-16 (*left*) These first graders are enthralled by the work of Georgia O'Keefe.

8-17 (*opposite, left*) Improvisational techniques encourage children to feel what they see.

8-18 (*opposite, right*) Puzzles are useful in building an awareness of visual qualities in sections of a work.

ing of works of art. Even if children have not had the benefit of any prior instruction in looking at art or in talking about it, they have by this time developed personal preferences and a concept of beauty.

The child's sense of beauty is influenced by images in the home, the school, the neighborhood, and the mass media.[16] Preferences develop rapidly; they are definite, but more subtle than one might guess. To the child, a general like or dislike is clearly different from a judgment of beauty or a desire to own an object. The child is now attracted to beauty in manufactured objects more than in natural objects. Vivid colors and motion are still important considerations in preferences. Responses to manufactured objects are primarily tactual and visual; natural forms are perceived kinesthetically and visually.[17]

Children's preferences should be accommodated and explored, but not to the point of limiting children's horizons. If children see only what they like, their interests and appreciations are not expanded but are merely reinforced. First and second graders can become intrigued with medieval art, particularly illuminated manuscripts. Third graders can become fascinated with the hidden figures, demons, dragons, and symbolic hand positions in Chinese painting. Second graders are delighted to learn the difference between an original work and a reproduction of it.

Many teachers are reluctant to engage children in the process of looking at works of art either because teachers view the process as a passive, talky activity or because they are fearful of imposing their own perceptions and judgments on children. The first reservation can be overcome by using teaching techniques that make the process active and inquiry-centered. Some of these techniques are presented later in this chapter; others appear in Chapters 11 through 17. The second objection to exposing children to works of art in the classroom is common but unjustified. If school programs do not offer children informed and sensitive inquiry into the nature of art, children will still acquire tastes, but from the untempered influences of the mass media, advertising, peer groups, and the neighborhood. If we wish children to make informed and independent judgment of art, we must provide them with tools and methods for doing so.

What we call the artistic heritage is really many artistic heritages, one born of another, sometimes merging, sometimes dividing. What we normally regard as the artistic heritage is works of art in museums and art history documented in books. Only rarely do we, as adults, consider contemporary art as part of the artistic heritage. No heritage truly exists for us until *we* discover its relevance to us now. Any heritage must be rediscovered and reevaluated by each generation to gain personal significance.

176

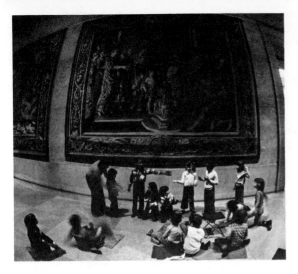

The child's study of the artistic heritage should not consist in learning predigested facts about great works of art. Nothing is more irrelevant to art appreciation than learning the names, nationalities, and birth dates of artists, or the titles and dates of works. The more information we assume children must have before they can encounter a work of art, the more difficult we make it for them to enjoy and appreciate art. The more hurdles we put up, the more we confine art experience to the specialist and the connoisseur.[18]

Clearly, many of the methods of engaging children in responding to their everyday visual experiences can be used to teach them how to look at works of art. Similarly, the child's framework for understanding the way artists work is the child's own studio work. Live demonstrations, films, field trips, thematically organized collections of art, and focused encounters with individual works of art are also essential means for children to experience the artistic heritage.

As early as the first grade, children can effectively participate in group discussions about works of art for half an hour or more (Figure 8-16). Many of the discussion formats introduced in Chapter 7 are suitable for the first grade. In general, the keys to a successful discussion are: (1) arousing children's curiosity; (2) posing "Why," "How," and "What if" questions; (3) summarizing what has been discovered; (4) noting parallels between children's ob-

servations about the work and children's everyday experiences; (5) praising astute observations and clarifying unclear responses; and (6) providing a model of enjoyment, discovery, and questioning by the tone of your voice and the tempo of the discussion.

Children's encounters with works of art can be animated by building anticipation, curiosity, and active participation in viewing art. A few of the techniques are presented here; others are presented in subsequent chapters treating specific art forms.

Improvisation. Children at this age are able to project themselves into the space portrayed in paintings, to imagine themselves as figurative sculpture, and to act out the major stresses and the movements in containers, furniture, and architecture. Activities that encourage responsive looking and personal identification with expressive themes strengthen children's appreciation of the action and mood of works of art (Figure 8-17).

Eyewitness. Show children a work of art for about one minute. Then put the work away. Ask the children to describe everything they can remember seeing in the work. Tape-record their responses by holding the microphone close to each child while the child comments on the work. After you have tape-recorded the information, display the work of art again as you play back the tape. The children can compare what they reported with the original work.

8-19 Children should be encouraged to read about art and artists.

Hidden Figures. Children enjoy hidden-figure puzzles, which can be created with simple visual or verbal clues for children to discover (Figure 8-18). Each child (or every two children) is provided with a clue sheet, a reproduction of a work of art covered with acetate, a grease marker, and tissue. The child searches for the figures that are described or visually shown on the clue sheet and marks the location of the clue on the acetate covering.

I Spy. Provide each child with a spyglass made by rolling $8\frac{1}{2} \times 11$-inch paper and taping it to form a tube (1 inch in diameter, $8\frac{1}{2}$ inches long). Have children gather near a work of art so that they can "spy" it from a distance of ten to fourteen feet. As you describe parts of the work, the children move their spyglasses around the work until they find the part you are describing. When they find it, they should call out, "I spy!" After several rounds, children can take turns leading the search.

Caboodles. Caboodles[19] are collections of images and objects packaged in kits for children to examine without adult supervision. The kits are intended to trigger curiosity and to invite children to find relationships among the objects. For example, one kit might have materials organized around images of the sea:

6 reproductions of paintings dealing with the sea
3 seashells (1 large)
1 sealed jar of seaweed
2 replicas of sculpture—1 fish, 1 whale
1 vial of brine
1 small fishnet
1 tape recording of sea sounds, music, and poems about the sea
1 book of photographs of the sea
2 photographs of sea images in architecture
3 woodcuts of sea images

Children in the early elementary grades should be introduced to "stories" about art. Children at this age are fascinated by things and events removed from their own experience, and they enjoy hearing explanations of the origin and symbolism of works of art. Children can reflect on a discussion or "story" about art and characterize what the speaker seemed to think and feel about the work. By the second grade, children understand that experts may offer more than one explanation if they do not know the reason for something. Children should be acquainted with the fact that some people like to study works of art and write about them in order to help us see and think about works of art in a new way.

Encourage children to examine books about art (Figure 8-19). Read to them from art books. Help them notice not just the conclusions offered by the writer but also the writer's enthusiasm in sharing his or her thoughts. As children gain skill in reading, direct them to books about art or about the lives of artists. An

8-20 An easily made inflatable structure demonstrates how space can be enclosed and how different spaces can be created by a membrane.

early awareness that people write about art can enhance children's interest in this important channel for learning more about the subject.

Just as young children understand that people do not always agree about judgments of merit, so they should realize that judgments about art can differ. Specifically, young children can begin to learn that people may value works of art because they are skillfully made or are related to nature, because they are original and imaginative, or because they are carefully planned or inspiring.

Children's responsiveness to works of art can be no richer than their response to life itself, and, reciprocally, children's perception of works of art should intensify and make vivid their responses to everyday life. In order to aid children in developing this dual responsiveness, the teacher must be alert to children's experiences that can be examined through works of art. If children are excited about a forthcoming holiday, seek examples of works that bear on the holiday theme. At every opportunity, make connections between art and life.

Developing an awareness of art in society

When children enter the first grade, they embark on an intensive socialization process. For children who have not attended preschool or

8-21 Examining graphic art.

8-22 These first and second graders are discovering the symbolic and functional meanings of hats.

kindergarten, adjusting to the social mores of life in school is particularly demanding. Much of the first year is spent in learning to get along with other people.

Social-studies programs in the early grades are usually organized to expand the child's frame of reference for understanding social groups. In the first grade, the social environment of the home is contrasted with that of the school. In the second grade, children study their neighborhood or community, while in the third grade, the city, town, or county is examined as a social unit. Forms of transportation, communication, shelter, and public service are noted (Figure 8-20).[20]

In some third-grade programs, children study geographic influences on the lives of such people as Eskimos, North Africans, the Swiss, the Japanese, and Peruvians. The art forms of cultural groups should be introduced to children and related to other aspects of these people's lives. The visual forms through which each group expresses its values and beliefs can be compared with similar forms or beliefs in the lives of children. For example, the desert dweller's life is influenced by the scarcity of water in his environment. You might compare the design of containers for carrying liquids in North Africa and in the child's own environment.

Other opportunities to link social studies and art are numerous. Children's understanding of shelter can be expanded to include architecture, which, unlike shelter, meets the psychological needs of people as well as their physical needs. Letters, signs, and images should be noted as systems of communication that complement speech (Figure 8-21). Product or industrial designers plan contemporary forms of transportation, urban or community planners guide the overall design of many communities. Activities that illustrate the relationship of art to social studies should be introduced in the early grades.

Out-of-school activities—as well as school-related experiences—socialize children in the early elementary grades. The pervasive influence of television has been noted in Chapter 7. In the course of a year, most children see from fifteen to thirty thousand television commercials. But even without the informal education provided by television, children become aware of the economic and social value of goods. They know that money can buy special toys and clothes that may have prestige value in their peer group. They are aware of the cost of goods relative to their own access to money.[21] They know that money can be earned, stolen, or received as a gift. Children on welfare are conscious that money comes from a source that differs from that of money earned from a job. Children's emerging awareness of the monetary value of products should be tempered with an

180

8-23 A third grade class learns to identify the functions of different types of buildings within a community.

understanding that society and the products in it can also be judged by their human meanings and purposes.

Late in the first grade, youngsters begin to develop an intellectual understanding of social groups and how they function. They know that rules can sometimes be drawn up to fit particular occasions and that violation of fixed rules is likely to result in disapproval or punishment.[22] Sensitivity to rules and to just (or unjust) applications of them is very marked in the third grade, when children are becoming less dependent on adults to arbitrate disputes but have not yet developed patterns of trust among their peers. Children's awareness of social groups gives them an ability to appreciate how the beliefs of social groups may be expressed in such visual forms as uniforms, insignia, and public buildings.[23]

At about the midpoint of the second grade, most children can begin to describe things from the viewpoint of another person; they can begin to analyze and describe events that are not immediately present in their environment. At this age, children are able to project themselves mentally into another space or role and to characterize what they might see and think from that vantage point.[24] These abilities also enable children to study cultural artifacts more objectively.

Given the importance of this period for the child's self-image and eventual maturity, it is important for teachers to help children understand their own responses to events and objects in their own milieu. Help them notice comparable responses among adults and the consequences of certain patterns of response. For example, there are many opportunities to note visual forms that express children's individuality—children's own artwork; their names and signatures; their ability to think about, see, arrange, and value things in their own way. At the same time, point out that adults also express their individuality, often through means that are similar to those of children (Figure 8-22).

Implicit in any understanding of individuality is some frame of reference for understanding similarities and differences among members of a group and among different groups. Within the neighborhood, for example, children might identify the place almost everyone likes to play, particular places some children like but others dislike, as well as special, private places that are favorites of each child. Explorations of this kind can be expanded to help children understand why, for example, communities are planned to provide certain services for all people; specialized services for some people; and certain services, as needed or wanted, for specific individuals (Figure 8-23). Many of the mathematical exercises that introduce children to sets and subsets can also be applied to studying sets and subsets

of visual forms in the environment, thereby building the child's awareness of overlapping signs of group affiliation.

In guiding the young child to see, think about, and judge the visual environment, the teacher should point out the human needs that particular forms satisfy and should explore other ways in which the same needs might be fulfilled. For example, candy wrappers are useful because they identify the product and keep the food clean. But candy wrappers also create problems: when they are carelessly disposed of, they create litter. Explore the ways in which environmental problems like this might be solved.

Many of the children we are teaching today are growing up in a milieu that is far less protected and gentle than the society of even a decade ago. Because so many of the child's concepts and attitudes are subtly conditioned by visual forms, we owe it to children (and to ourselves) to nurture an early understanding of the social importance of art. If we ignore the profound influence of television and mass marketing on children's lives, if we pretend that children are innocent of any knowledge of social manipulation, we will inevitably fail to help them learn how to shape their own lives.

Notes

[1] A. F. Roberts and D. M. Johnson, "Some Factors Related to the Perception of Funniness in the Humor Situation," *Journal of Social Psychology* 46 (1957):57–63.

[2] Lawrence Kohlberg, "The Child as Moral Philosopher," in *Readings in Psychology Today* (Del Mar, Calif.: CRM Books, 1969), pp. 181–86.

[3] Jean Piaget, *The Child's Conception of the World* (Paterson, N.J.: Littlefield, Adams, 1960).

[4] M. H. Nagy, "The Child's Theories Concerning Death," *Journal of Genetic Psychology* 73 (1948):3–27.

[5] Jean Piaget and Barbel Inhelder, *The Psychology of the Child* (New York: Basic Books, 1969), pp. 51–91, 92–128, 130–51.

[6] *Estimated Statistics on Blindness and Vision Problems* (New York: National Society for the Prevention of Blindness, 1966).

[7] Albert Harris, *How to Increase Reading Ability* (New York: David McKay, 1961), pp. 236–55.

[8] Joan Russell, *Creative Dance in the Elementary School* (London: Macdonald & Evans, 1965).

[9] L. B. Ames and F. L. Ilg, "Developmental Trends in Writing Behavior," *Journal of Genetic Psychology* 79 (1951):28–46.

[10] James J. Gallagher and Paul D. Hurd, *New Directions in Elementary Science* (Belmont, Calif.: Wadsworth, 1968).

[11] Howard F. Fehr and Jo McKeeby, *The Teaching of Mathematics in the Elementary School* (Reading, Mass.: Addison-Wesley, 1967).

[12] Harris, *Reading Ability.*

[13] James A. Smith, *Creative Teaching of Reading and Literature in the Elementary School* (Boston: Allyn & Bacon, 1967).

[14] K. Yamamoto, "Development of the Ability to Ask Questions Under Specific Testing Conditions," *Journal of Genetic Psychology* 101 (1962):83–90.

[15] Piaget and Inhelder, *Psychology of the Child.*

[16] D. P. Ausubel et al., "Prestige Suggestions in Children's Art Preferences," *Journal of Genetic Psychology* 89 (1956):85–93.

[17] Laura H. Chapman, "Responses to the 'You Name It' Show" (Unpublished report for the Taft Museum staff, Cincinnati, Ohio, 1972).

[18] For a more extended discussion, see Edmund Feldman, *Becoming Human Through Art* (Englewood Cliffs, N.J.: Prentice-Hall, 1970), pp. 22–28.

[19] Gilbert A. Clark, "Art Kits and Caboodles: Alternative Learning Materials for Education in the Arts," *Art Education* 28 (1975):27–30.

[20] John S. Gibson, *New Frontiers in the Social Studies: Action and Analysis* (New York: Citation Press, 1967).

[21] A. L. Strauss, "The Development and Transformation of Monetary Meanings in the Child," *American Sociological Review* 17 (1952):275–86.

[22] Kohlberg, "The Child as Moral Philosopher."

[23] Robert D. Hess and Judith V. Torney, *The Development of Political Attitudes in Children* (Garden City, N.Y.: Doubleday, Anchor Books, 1967), pp. 171–74, 294.

[24] Piaget and Inhelder, *Psychology of the Child.*

Drawings by Sarah Kern.

A 9 years, 8 months.

B 9 years, 9 months.

C 10 years, 4 months.

D 10 years, 5 months.

E 11 years.

F 11 years.

A

B

C

D

E

F

185

9-1 (*left*) *In Front of My House.* Grade 4.

9-2 (*opposite, left*) *Street Scene.* Grade 4.

9-3 (*opposite, right*) Figure drawing. Grade 5.

Many school districts are establishing "middle schools" to accommodate the special needs of children as they make the transition from childhood to early adolescence. Middle schools typically encompass grades four through eight, although some begin with grade five. In more traditional systems, children attend elementary school until grade six and then junior high school for grades seven through nine. Regardless of the organizational pattern of schools, the years preceding adolescence—roughly spanning the fourth through the sixth grade—are quite distinct from early childhood and early adolescence.

Personal fulfillment through art

During the preadolescent years, children make a gradual shift from dependence on adults for approval toward greater reliance on themselves and dependence on their peers for approval. Children begin to judge themselves and others by more critical standards. They are testing and refining their survival skills in a larger and less protected environment than that of early childhood, and they will emerge from these later years of childhood with a fairly well-developed self-image.

Guiding the artistic process

In the upper elementary grades, the untutored pictorial work of children is usually detailed and topically related to their immediate experience (Figure 9-1). Given the pervasive cultural stereotypes about roles and sex, it is not unusual for boys to portray cars, machinery, and he-men and for girls to draw landscapes, flowers, and pretty girls.

Some children begin to plan the overall composition of their work in advance, working from the whole to parts. Many children continue part-to-part development of their work. The desire to represent space and time leads to ingenious compositional devices, including "X-ray" images and multiple baselines[1] (Figure 9-2). By the sixth grade, children are beginning to use overlap, diminishing size, converging lines, and atmospheric effects to create the illusion of depth.

Color choices become more subtle and expressive, especially when children have had prior instruction in color mixing. By the sixth grade, many children are interested in showing light and shadow and in creating moods with color. Qualities of line and texture frequently echo characteristics of the child's handwriting. Diagonals are used more confidently to express motion, size relationships are gradually defined, and proportions are grasped more firmly. Children

THE PREADOLESCENT YEARS: GRADES 4–6

still tend to overestimate or underestimate the size of complex details and the shape of outer contours (Figure 9-3).

What may be termed a "crisis of confidence" in self-expression often occurs in the later elementary grades. Because children of this age are more self-critical than younger children, they are quick to judge their own efforts as "good" or "bad." Children begin to perceive themselves and each other as talented or untalented in art. Their lack of confidence is usually apparent in such behavior as starting over and over again, hiding work in progress, copying, and throwing away completed work. Many of these actions continue into the junior high years. Behavior of this kind need not occur too frequently if children feel that they are making progress in art.

The "crisis of confidence" in creating art that some children experience occurs when their ideas and concepts outstrip their skills in creating visual forms. Intense, selective observation is one way to restore confidence and to overcome deficiencies that stem from substituting a general concept or idea for direct perception. Topics and situations like "Crowds of people," "Treasures in the vacant lot," "Shadows on buildings," "Unexpected colors I see," or "Looking out the window" intrigue youngsters of this age and help satisfy their desire to create representational art (Figure 9-4). Beginning in the fourth grade,

9-4 (*top, left*) *View Out the Window.* Grade 6.

9-5 (*center, left*) *Dragon.* Grade 6.

9-6 (*bottom, left*) Spider mask. Grade 6.

many children develop intense interests in birds, fish, horses, sports, cars, bikes, and planes. These interests often provide inspiration for art and encourage children to make expressive images that are also rich in detail.

In the upper elementary grades, many children become fascinated with monsters, mysteries, science-fiction themes, and prehistoric beings, especially dinosaurs (Figure 9-5). Children's imaginative work is often macabre and sometimes satirical. Humorous characters with super-human powers are effective points of departure for art—"The freeze-dried man," "Tall Tillie the Terrible." Encourage children to imagine creatures that combine parts of people and machines or parts of machines and animals. Develop imaginative themes in connection with sculpture and the crafts, not just drawing and painting.

Children of this age begin to raise questions about their own rights and responsibilities as well as those of others. They are searching for models to emulate and are attracted to heroes and heroines in their own peer group as well as in the mass media. The child's basic system of values is beginning to take shape, but it is still open to change. Developmental studies offer the teacher information on preadolescent concepts of justice, human worth, and life.

Since children's sense of right and wrong is based on an appeal to rules that are fixed by

9-7 (*top, right*) *Humanity Mural.*
Grade 6.

9-8 (*center, right*) Figure drawing.
Grade 4.

9-9 (*bottom, right*) Letters cut from pine
wood. Grade 6.

parents, teachers, and peers, children usually conform to rules in order to avoid censure by friends, authorities, or a majority of their peers.[2] The child understands majority rule as a political principle but does not appreciate the political importance of minority criticism. Children from low-income groups begin to feel that they cannot influence "the system."[3] The value of human life is based on the value given to it by others in the child's milieu, as reflected in empathy and in affection toward others. In general, "life" is believed to be a characteristic of things (plants, animals, and humans) that move or grow on their own, without being acted on by people.[4] Death is associated with old age, illness, accidents, and murder.[5]

Themes that focus on human feelings, values, and actions encourage children to express and clarify their emerging concepts of fairness, power, life, and death. Through topics based on legends, myths, and "What if" or incomplete stories, children can reflect on positive and negative forces in their own lives in a way that is nonthreatening to them. Creating works that show contrasts in moods or concepts—such as right and wrong, beautiful and ugly, love and hate—can also be an effective means of value clarification (Figure 9-6).

Children at this level are skilled in making useful objects; they also have a keen sense of ceremony and enjoy devising ways to change or

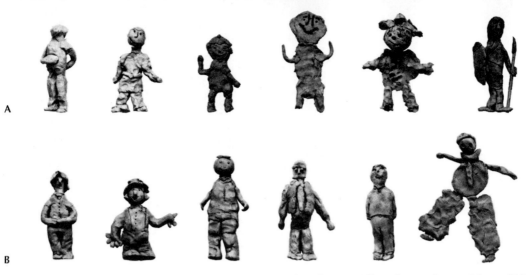

A

B

improve their environment. Group projects that give each youngster a clear and important role in the total effort are very effective: mural- and model-making, film and television production, and room redesign (Figure 9-7).

In pictorial work, preadolescents tend to be fascinated with detail; they have a relatively poor command of larger patterns and relationships in their work. Some activities should tap and strengthen their strong interest in detail; others should focus on overall compositional skills. Contour and gesture drawing, together with sustained life drawing (ten minutes or more) can be introduced at this level (Figure 9-8). Selective studies of size, shape, color, and spatial relationships can also be introduced. These studies need not be limited to drawing and painting but can be extended to other art forms, such as sculpture and the crafts. The studies should *not* be based on pure abstract design but on subjects directly observed or on expressive themes. These image-centered bases for design are more readily understood and more useful to youngsters than concentration on the abstract "elements and principles" of design.

Preadolescents are able to understand subtle and complex nuances of feelings and ideas and are able to grasp relationships between a visual quality (a "lazy" line) and the idea of such a quality (a lazy afternoon or a lazy person). This sensitivity should be tapped to the fullest,

thereby providing the student with a solid basis for understanding the expressive power of lines, colors, shapes, and, as a byproduct, for evolving a more expressive approach to design.

During these years, children begin to develop individual styles of working. Some prefer to work from part to part; others, from whole to parts. Some children like to plan their work; others work more spontaneously. In order to strengthen children's individual styles of work while preserving their flexibility and potential for growth, the teacher should provide opportunities for students to work on one theme or topic in several media, both two- and three-dimensional. Children should also try working on one theme or topic in a single medium, perhaps first on a very large and then a very small scale, or the reverse.

Many children are attracted to clichés, motifs, and images found in comic books, television, films, and sports. In creating art, children may rely on stereotypes of pretty girls and muscle men, of horses and dogs, of faces and clothes. Such stereotypes should be explored for more subtle and particular variations in meaning. It is often useful to introduce children to poems and descriptive passages from stories to help them develop personal and detailed imagery. Questions that probe for meanings might include: *Who* is like this? *Where* did this symbol come from? *Why* is it appealing? *How* is it used?

9-10 Typical clay figures made by children who have not had instruction in using the medium.
A 9 years **B** 10 years **C** 11 years

C

Preadolescents are very interested in cause-and-effect relationships; they are able to analyze why their work is successful or why it is not. They are delighted by situations that call for creative problem solving and practical decision making. Before children begin working, ask them to indicate what they hope to create or accomplish. As they are working, help them define problems they are having and encourage them to consider ways of solving them. After students have completed their work, help them see it as part of a larger pattern of growth and understanding.

The child's ability to make expressive use of media may be limited by abnormalities in eye–hand coordination. Teachers should be aware of the fact that about 25 percent of all preadolescents still have visual problems that were undetected in the early elementary grades and that can influence school performance.[6] Visual-screening programs should be continued, and teachers should be alert to possible problems. Colorblindness, which rarely occurs in females, may be present in 4 percent to 8 percent of males.[7]

By the age of nine, about 8 percent to 10 percent of all children have not yet achieved a dominant pattern of eye–hand coordination. Left-handed children tire easily when they must use right-handed tools while learning new skills involving subtle motions.[8] Handwriting and sig-

natures become highly individualized. Children are more aware of body symmetry and the beauty of simultaneous movement of left and right sides. They can control the duration, timing, effort, speed, and direction of simple and complex body movements. They can make sudden changes in motion or can create smooth, sustained gestures with their hands, arms, and bodies.[9]

Improved physical strength and stamina enable children to work in less resilient media and to undertake more complex processes (Figure 9-9). With sufficient guidance and practice, children can use a wide range of hand tools and can safely operate a band saw, a drill press, and a belt sander. In sculptural work of clay, wood, or plaster, the child begins to think "three dimensionally" and achieves more continuous movements in all sides of the modeled form (Figure 9-10). Soft soldering in metal can be managed in stages, so that parts of a larger piece can be assembled from smaller sections. Weaving, stitchery, macramé, and other work with fiber is restricted more by impatience than by lack of skill.

In photography, children can anticipate the angle and framing of still shots. With ample instruction and practice, children can learn to use adjustable cameras, to develop black and white film, and to use an enlarger to make prints. Children can plan, film, and edit 8mm

movies, including animated films. For successful group activities, a general procedure or structure should be established first. Within that basic framework, children are usually able to work out specific problems on their own. Occasionally, adults may be asked to help settle disputes.

Since there is a strong perfectionist impulse in the preadolescent, every child should be encouraged to become a "master" of one medium. The perfectionist drive should be directed by providing specific instruction in the skills and craft of using media. Help children learn to find shortcuts and to recognize skills that must be perfected by practice. Hallmarks of careful work and means of achieving it should be noted (Figure 9-11).

Preadolescents can make conscious choices among materials. They can make comparisons between the idea they want to express and the qualities of the available materials: "Chalk can be fuzzy and bright like the early morning is foggy and bright." Encourage children to make associations of this kind so that they can make sensitive choices of media.

Preadolescents are fascinated by scientific experiments in which variables are carefully controlled in order to discover causes and effects. In art, experiments with media should be approached in the same spirit; they should not be occasions for thoughtless trial and error. In the upper elementary grades, children can become more proficient in simultaneously controlling

several variables in their work[10]—for example, choice of color, amount of color on the brush, and size of the area they wish to paint. Selective uses of media are also apparent (Figure 9-12). For example, in choosing adhesives or glues, the child begins to consider the strength of the adhesive as compared with the weight and porosity of the materials to be fastened. Activities should be designed to lead children toward an intentional use of the experimental method in working with media.

Nurturing response to visual experiences

Children at this age have a strong interest in collecting objects that delight the eye or that appeal to the touch. They are skilled in observing details of their environment and are fascinated by their own ability to see fine points and nuances that others may overlook.

Although preadolescents are skilled in making basic visual and tactile discriminations, they still need practice in testing and refining their perceptivity. Both details and larger patterns should be the focus of activities. Natural and manufactured forms can be the object of study (Figure 9-13). Things like color variations, textured surfaces, patterns revealed in shells, crystal structures, and stairways, should be examined. Optical illusions are particularly fascinating.

THE PREADOLESCENT YEARS: GRADES 4–6

9-11 (*opposite, left*) *Bird.* Grade 5.

9-12 (*opposite, right*) Ceramic container. Grade 4.

9-13 (*right*) The shapes of a telephone pole seen from different angles.

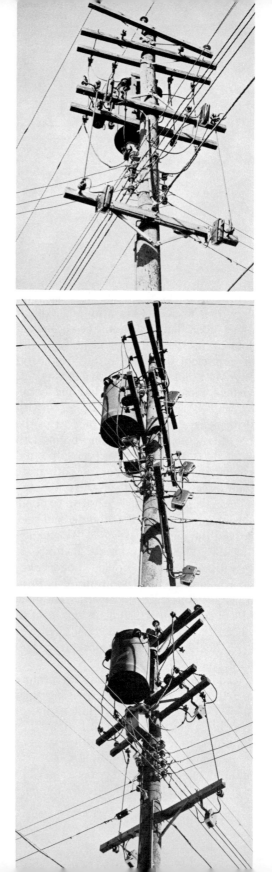

Children in the upper elementary grades can benefit from making multisensory associations that are more subtle and complex than those they have previously experienced. Children's physical growth leads to greater muscle control and to an increased ability to create smooth, continuous motions. Improvisational techniques that correlate sight with sound, sound with touch, touch with kinesthetic response (lifting, moving) are enjoyed. Tape recordings of "found" sounds like those of dogs barking, trucks roaring, and birds chirping, can be translated into physical movements and then captured in graphic form.

During these years children have a keen interest in symbolism, secret codes, and disguised or hidden meanings. It is an excellent time to develop their skills in perceiving the symbolism of such things as colors, shapes, lines and specific motifs.

The preadolescent is consciously aware of physical contexts and of the fact that changes in them can influence the feelings and behavior of people. To sharpen this awareness, the teacher might encourage the preadolescent to notice that many ordinary things we perceive—the dreariness of an overcast day, the energy of children during recess, the sounds of traffic horns signaling frustration—are worthy of attention as factors that influence thoughts, feelings, and actions.

In the upper elementary grades, children are aware of the value of words in expressing

ideas. In addition to expanding their basic vo- cabulary, preadolescents are acquiring skill in using metaphors and analogies. The vocabulary of children in the upper elementary grades ranges from eight thousand to thirty thousand words.[11] Most children enjoy using swearwords and delight in secret language like pig Latin. "Why" and "What" questions are asked with equal frequency, each about 30 percent of the time. Other dominant questions begin with "How" and "Is it."[12] If there is pacing to build suspense and curiosity, children can participate in group discussions for forty to fifty minutes.

Children are increasingly sensitive to oppo- sites like fragile–strong, order–disorder and they understand the meaning of words like *redesign* and *recycle*. They can associate qualities of things with qualities of people; "Loud colors and loud people are alike; you notice both of them first."[13] References to qualities are more varied and subtle. In art, students can learn to use adjectives and adverbs to describe character- istics of line, color, shape, movement, and human feelings.

Preadolescents are beginning to acquire adult patterns of response in expressing their emotions. Although they are still capable of experiencing strong empathic relationships, they are less willing to reveal and share the extent of their emotional involvement unless they are caught up in role playing or they have agreed to do so in advance. They need sensitive response and interaction with an adult who will help them reflect on the feelings they are expressing.

Preadolescents develop excellent skills in synthesizing their impressions and in drawing conclusions; they can learn to use various princi- ples to organize their impressions into a coher- ent summary. In science, for example, they learn to formulate hypotheses, to make inferences, to control variables, and to explain results of exper- iments.[14] Children can also cite specific exam- ples to illustrate a general idea and can entertain an idea hypothetically—without having to be- lieve that it is true. They can recognize the fallacy of "appeal to authority" advertising, and they are aware of the role of missing data in broad statistical claims.[15]

It is doubtful that any time is more impor- tant than the preadolescent years for learning to judge the worth and significance of experience. Immediate judgments are often made on the basis of peer opinion and expedience. At the same time, children are uncertain enough of their own judgments that they will often seek out adults whom they trust in order to find out whether something was right or wrong, true or false.

Upper elementary children can begin to use the criterion "What did I learn?" to judge their experiences. They can learn to do so without adult prompting on every occasion. When the child is able to use this criterion, the process of problem solving becomes more efficient. Teach-

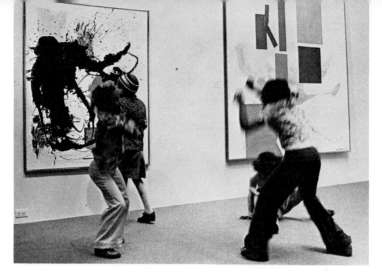

9-14 Children enact the energy that they see in a painting by Hans Hofmann.

ers should encourage children to ask themselves this question at the conclusion of *any* experience or art activity.

Preadolescents also benefit from opportunities to appreciate the value of experiences that are unusual, ambiguous, or controversial. Because peer-group pressure is strong, children are easily led to change their own judgments about the value of an experience in order to be accepted by their peers. Help children see the humor, strangeness, elegance, sadness—the individual character—of certain moments in life and to make personal judgments about the significance of those moments.

In the upper elementary grades, children become more conscious of their personal history. Help them examine differences between their response to situations in early childhood and their feelings about similar situations now. They can become concious of the fact that their feelings about an experience may differ during it, immediately after it, and much later. Comparing "before," "after," and "right now" impressions makes children aware of the value of reexamining their experiences.

In the upper elementary grades, children begin to ask whether they really must do something that appears to have little or no value to them. In other words, they begin to judge the value of experience by its utility. Teachers should point out the applicability of school lessons to life situations outside of school.

Developing an awareness of the artistic heritage

Children in the upper elementary grades have a strong interest in looking at works of art and in seeing "expert" performances in art. They are conscious of mastery as a criterion for judgment and they want to know, from a technical point of view, how works are created. Children also enjoy looking at works of art when the process is active, filled with suspense, and intellectually demanding (Figure 9-14).

Children's untutored sense of beauty is still influenced by peer-group preferences and by the taste of adults with whom they identify.[16] The child's judgments of beauty are clearly separate from the desire to own an object and from other forms of personal preference. Children respond visually and tactually to ready-made forms, and primarily kinesthetically and tactually to natural forms.[17]

The child's sense of time is oriented around events and activities more than around people, places, and facts about things. Concepts of time about history are weak, but broad distinctions between "now" and "very long ago" can be made.[18] A living sense of the artistic heritage cannot be built from factual surveys of works of art arranged in chronological order, but rather from personal contact with artists and from an understanding of their concerns and methods of

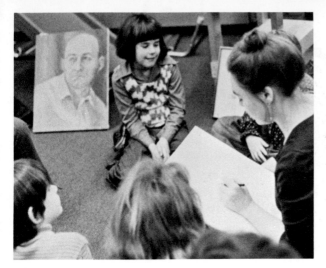

9-15 (*left*) A portrait artist at work.

9-16 (*opposite, left*) Assuming the pose of figures in a large painting.

9-17 (*opposite, right*) A vocabulary game for art in which felt shapes are arranged to illustrate words or in which arrangements are described verbally.

work. As was recommended for the earlier grades, articulate artists who enjoy children should be invited to the school to show their work and to share their ideas with youngsters. Short-term encounters with artists who work in varied media and art forms expand the child's understanding of the scope of art (Figure 9-15).

A number of engaging formats can be used to enliven the process of viewing and discussing works of art. Some of these are noted below; others are presented in subsequent chapters treating specific art forms. Techniques that were recommended for the lower elementary grades will also be appropriate for children with little prior experience in artistic perception (Figure 9-16).

Trading Post. Obtain from a museum, bookstore, or gift shop many small postcard prints of different subjects, styles, and art forms. Distribute two or three to each child. Ask children to notice any similarities among their prints and to find another person in the class who has prints that have something in common with their own. These sets of children look at their combined "collections" and decide which two prints are least like the others. They then trade the dissimilar prints with students who have prints that resemble them. At the end of the trading period, children describe similarities in the works they have collected.

Concentration. Provide two or three children with a tape recorder and at least three prints that closely resemble each other—all portraits, all landscapes, all geometric abstractions, all Gothic cathedrals. Each print is numbered. Ask the children to put any two prints side by side and to decide how they differ. They record their observations on the tape recorder. The first child begins by stating those qualities he or she sees in print 1 but not in print 2. The next child notes those qualities he or she finds in print 2 but not in print 3. The next child continues, comparing print 3 with print 1. Children then listen to the playback and verify their initial observations.

Travel the Maze. Obtain duplicate postcard reproductions for every two children. Cover the prints with acetate and provide each child with a grease pencil and a tissue. One child draws a maze through a print, starting at one side and ending at another (or top to bottom). This child then tries to describe the path to his or her team member, who, without seeing the maze drawn by the first child, attempts to duplicate the path. Afterward, they compare the paths they have drawn, erase the grease marks, and switch roles.

Treasure Hunt. The "treasures" are predetermined features of a work that are sketched on cards and placed in a box at the front of the room. One child chooses a card and becomes the leader of the treasure hunt; only that child knows what the treasure is. Classmates are asked to guess the treasure by pointing out and naming features of the work that they think could be

196

the treasure. The leader answers either, "Yes, that's it," "No, that's not it," or "You're close; try again." After several sessions like this, children can make up their own treasure cards for other works of art.

Match Game. If you can obtain three prints of the same work, cut two of them into small *duplicate*, squares. Place one set of squares in a box at the front of the room, and distribute the other set of squares to the class. One child draws a chip from the box and describes it as fully as possible, but does not show it to the class. When a member of the class is quite certain that he or she has the duplicate square, that child comes to the front and checks to see if it is a match. If the chips match, both children show exactly where that section of the work may be found and then place their chips in an extra box. The child who got the match based on the description draws a fresh chip, and the game continues.

Discussions of works of art are very effective when children are formally introduced to methods of perceiving, interpreting, and judging works. Initially, "rule-governed" discussions (using any of the four methods suggested in Chapter 4) help children of this age focus on the content and meaning of a work and teach them to keep track of each set of discoveries they make. Initial discussions are aided by the use of duplicate sets of "clue" or "action" cards that

ask children to tell about the colors, lines, and subjects they see, to state what mood or feeling is shown, to act out major movements or positions of figurative elements (Figure 9-17). After several practice sessions with "clue" cards and each of the four methods, children begin to see that they can discuss a work of art thoughtfully *without* having to rigidly rely on any one of the methods.

Preadolescents are able to appreciate things from another person's point of view, so they can begin to recognize the skills involved in the written and oral reports on art presented by experts. They enjoy imaginative role playing in which they are "art experts." They respond well to guests who are articulate about art. Children in the upper elementary grades can begin to distinguish among statements that refer to what people see, statements that reveal how people feel, and statements that refer to a judgment someone has made.

Color coded "flash cards" like those shown in Figure 9-18, can increase children's awareness of the form of critical discussions about works of art. As you read a segment of criticism about a work, pause at appropriate points and ask the children to flash the card that corresponds to the critical comment they just heard. As a variation, members of the class might volunteer their own observations and see if their classmates can identify whether the statement referred to something visible in the work, to a feeling about

LOOK
TELL
DESCRIBE

SEEK
FIND
ANALYZE

THINK
CONNECT
INTERPRET

JUDGE

ORDER REALITY FANTASY EMOTION

9-18 (*left*) Flash cards help children become conscious of the function of different statements they make about art.

9-19 (*opposite, left*) The visual environment in many communities provides material for teaching children the role of art in society.

9-20 (*opposite, right*) The bold motifs, words, and colors of soap boxes can serve as teaching materials for art.

the work, or to a judgment about the merit of the work.

Upper elementary children are fascinated by mysteries, puzzles, and intellectual or technical problems that experts have not fully resolved. They are also able to recognize relationships between facts and possible conclusions drawn from them. For this reason children become interested in comparing what different experts may say about the same work.

Preadolescents are highly sensitive to the process of making judgments. They understand the concepts of "fair" or "unfair," and they realize that people who give reasons for their judgments are sharing their thought processes. At this level, many children begin to value art that is based on nature and that reflects skill in representing the world. The primacy they give to this kind of art may prevent them from recognizing that other values may also be found in art, so it is important to emphasize imagination, originality, and other criteria for judging art (see Chapter 4).

Developing an awareness of art in society

We have noted that children in the upper elementary grades are beginning to gain independence from adults and seek affiliations with their peers. At an intuitive level, preadolescents begin to experience many of the social processes that they will continue to experience throughout their adult lives, for example, the fact that a group of people can often accomplish things that an individual cannot. This social awakening of the child is a natural point of reference for studies of the role of art in social groups.

Social-studies programs in the upper elementary grades are varied, but children usually study American states and geographic regions in the fourth grade and American history in the fifth grade. Many fourth- and fifth-grade programs acquaint children with American political leaders, inventors, and world explorers. Children often study the growth of this nation from frontier times through the Industrial Revolution. Ancient History is typically introduced in the sixth grade; topics focus on the agriculture, industry, and culture of ancient Egypt, Mesopotamia, Greece, and Europe.[19] All these and related studies of social or cultural groups are logical points of departure for introducing children to the ways in which people use visual forms to express their beliefs.

When children are studying Colonial America, for example, they might well examine the tools, furniture, and forms of shelter of colonists and compare them with similar products available to people after the Industrial Revolution. Authentic imagery and symbolism from Early American life might be compared with

198

contemporary versions (Figure 9-19). Similar relationships can be noted in the architecture of ancient Greece and neoclassical architecture in the community.

In addition to these logical points of connection between social studies and art, the child's out-of-school experiences should be brought into play in order to build an awareness of the social aspects of art (Figure 9-20). Most preadolescents still spend an average of four hours a day watching television. For children from low-income families, five to seven hours a day is more typical.[20] Most children become more critical of television commercials and more skeptical about the truth of what they see in commercials and dramatic programs (Figure 9-21). Children are also fascinated with the technical aspects of television and want to learn how certain visual effects are produced.

Television and mass merchandising make children increasingly conscious of the economic and prestige value of certain products. Many children equate success in life with being rich enough to buy anything they want.[21] Many children are also aware that money can be used to bribe and manage people. Children whose families are on welfare become very conscious of peers who are and are not supported in this way. Similarly, children from affluent families begin to compare their relative economic status by noting "how many" or "how much" their peers

have.[22] The materialistic values that children are developing should be tempered with an appreciation of the human meanings expressed through or reflected in material forms.

The preadolescent child has a well-developed understanding of the way social groups function. Most parents of preadolescents allow their children some freedom to be with friends and to structure their own activities. Patterns of trust and distrust are developed, and disputes are frequently settled without depending on adults to arbitrate differences. Children learn that cooperation can be fostered by majority rule. This period in the child's life, aptly called the "gang age,"[23] is an excellent time to help children understand how their perception and use of visual forms can contribute to a feeling of group membership.

There are many ways to teach preadolescents about the social aspects of art. Many children of this age recognize the importance of certain life events. Religious training, extended family relationships, and the mass media influence the particular events that children consider significant. Within their own peer groups, children may develop rituals and ceremonies that function as "initiations" and "graduations" into a group. Upper elementary youngsters can understand that people differ in the ways they commemorate important events. Children can become skilled in examining artifacts in order to interpret the events they help make memorable.

Activities that involve "decoding" visual symbolism in their own environment intrigue children of this age (Figure 9-22). They enjoy discovering how trademarks, brand names, color and shape coding, and other visual codes are used to convey meaning. Comparisons between visual symbols used in our culture and Egyptian hieroglyphics are fascinating to them.

Because children of this age are beginning to try out or adopt some forms of behavior that can shape their responses as adults, it is impor-

tant to treat their reactions to the social aspects of art reflectively and with as much candor as possible. If children from radically different neighborhoods are in the same classes, have them describe features of their neighborhoods that they admire or dislike. Explore how these features got there and what might become of them through human effort or through lack of caring. In short, teach children to critically examine the consequences of the way people treat their natural and constructed environments.

Notes

[1] For a detailed discussion of the reasons children use these devices, see Viktor Lowenfeld and W. Lambert Brittain, *Creative and Mental Growth* 5th ed. (New York: Macmillan, 1970).

[2] Lawrence Kohlberg, "The Child as Moral Philosopher," in *Readings in Psychology Today* (Del Mar, Calif.: CRM Books, 1969), pp. 181–86.

[3] Robert D. Hess and Judith V. Torney, *The Development of Political Attitudes in Children* (Garden City, N.Y.: Doubleday, Anchor Books, 1967).

[4] Jean Piaget, *The Child's Conception of the World* (Paterson, N.J.: Littlefield, Adams, 1960).

[5] M. H. Nagy, "The Child's Theories Concerning Death," *Journal of Genetic Psychology* 73 (1948): 3–27.

[6] Patricia A. Renick, "The Prevalence of Corrective Lenses Among Black and White Junior High School Students," *American Journal of Optometry and Archives of American Academy of Optometry* 49 (1972):942–44.

[7] *Estimated Statistics on Blindness and Visual Problems* (New York: National Society for the Prevention of Blindness, 1966).

[8] Albert Harris, *How to Increase Reading Ability* (New York: David McKay, 1961).

[9] Joan Russell, *Creative Dance in the Elementary School* (London: Macdonald & Evans, 1965).

[10] James J. Gallagher and Paul D. Hurd, *New Directions in Elementary Science* (Belmont, Calif.: Wadsworth, 1968).

[11] Harris, *Reading Ability.*

[12] K. Yamamoto, "Development of the Ability to Ask Questions Under Specific Testing Conditions," *Journal of Genetic Psychology* 101 (1962):83–90.

[13] James A. Smith, *Creative Teaching of Reading and Literature in the Elementary School* (Boston: Allyn & Bacon, 1967).

[14] Gallagher and Hurd, *Elementary Science.*

[15] Willavene Wolf, *Critical Reading Ability of Elementary School Children*, U.S. Office of Education Project 5-1040 (Columbus: Ohio State University Research Foundation, 1967), pp. 108–09, 137–65.

[16] D. P. Ausubel et al., "Prestige Suggestions in Children's Art Preferences," *Journal of Genetic Psychology* 89 (1956):85–93.

9-21 (*opposite, left*) Children reveal their sensitivity to graphic design and the psychological aspects of packaging. Grade 4.

9-22 (*opposite, right*) Comic-book art is one of the art forms whose images children enjoy decoding in order to discover how visual symbolism creates meaning.

[17] Laura H. Chapman, "Responses to the 'You Name It' Show" (Unpublished report for the Taft Museum staff, Cincinnati, Ohio, 1972).

[18] N. C. Bradley, "The Growth of the Knowledge of Time in Children of School Age," *British Journal of Psychology* 38 (1947): 67–68.

[19] John S. Gibson, *New Frontiers in the Social Studies: Action and Analysis* (New York: Citation Press, 1967).

[20] Data from Joan Beck, "T.V. Violence May Be Linked to Disturbances on Campus," *Cincinnati Enquirer*, June 2, 1970, p. 4.

[21] A. L. Strauss, "The Development and Transformation of Monetary Meanings in the Child," *American Sociological Review* 17 (1952): 275–86.

[22] G. Jahoda, "Development of the Perception of Social Differences in Children from 6 to 10," *British Journal of Psychology* 50 (1959): 159–75.

[23] Viktor Lowenfeld, *Creative and Mental Growth* (New York: Macmillan, 1947).

Drawings by Sarah Kern.

A 12 years.

B 13 years.

C 13 years.

D 14 years, 4 months.

A

B

The junior high years: grades 7-9

C

D

Most children receive their last formal instruction in art in the seventh or eighth grade; that is, during the last years of middle school or in early junior high school. This chapter examines characteristics of the early adolescent and teaching methods that are suitable for most youngsters in the age range of twelve to fifteen.

Personal fulfillment through art

In our culture, early adolescence is a time of self-doubt and inconsistent behavior. The transition from childhood to adulthood is agonizing, prolonged, and borderless; it is made without benefit of those formal rites of passage that are found in many cultural groups. In the adolescent, emotional intensity, physical energy, and social awareness are delicately balanced against apathy, fatigue, and personal loneliness. While art offers no panacea for the many and varied problems of growing up, it is one of the few subjects in which students can be actively encouraged to clarify and express their own feelings, thoughts, and perceptions. The challenge in teaching early adolescents is to accommodate their urgent desire to be grown up while accounting for the fact that their growth is far from complete.

Guiding the artistic process

Adolescents often create romanticized images of their current heroes and heroines and their most intense personal interests. Their social commentaries on poverty, loneliness, and popularity can be highly expressive and poignant (Figure 10-1). In pictorial work, adolescents try to create appropriate compositions for the thematic content they are expressing. Many young adolescents can integrate figurative elements with the background and interrelate parts of a work visually, logically, or psychologically. They can also omit or exaggerate certain elements in order to achieve an expressive aim (Figure 10-2).

Adolescents consciously use color for dramatic effect or accurate representation. Moods, atmospheric effects, and linear perspective fascinate youngsters at this age. Linear qualities are related to styles of handwriting, but new habits of using line and texture can still be developed. A personal style of creating art becomes more apparent, especially among those students who have had continual opportunities to work in media of their choice.

The crisis of confidence that many youngsters experience in the late elementary grades often continues into the junior high years. In order to feel confident in their ability to create art, adolescents require patient and sensitive guidance in generating ideas, refining them, and using media.

10-1 (*top, left*) A sensitive handling of watercolor. Grade 7.

10-2 (*bottom, left*) Scratchboard drawing. Grade 8.

Adolescents have a keen interest in creating representational art based on direct observation and memory. Any topic related to nature and the environment can be an impetus for creating a wide range of art forms, not just paintings and drawings. A topic like "The hangout" or "Babysitting" might be developed into a sculpture, painting, or print. The appeal of any subject will depend on the adolescent's ability to identify with it. Many students are interested in topics that involve people, including self-portraits (Figure 10-3); places like downtown or the movies; and things like machinery, junk, or natural forms. Themes like "A rainy night in town," "Early morning fog," and "Before the storm" invite youngsters to experiment with color and value for expressive ends.

Junior high youngsters are also attracted to imaginative themes that challenge their intellect and raise questions about unfamiliar forms of life. While adolescents are likely to view monster themes as juvenile, they are intrigued by science-fiction stories and myths. Varied media and art forms are vehicles for developing ideas based on imagination and fantasy (Figure 10-4). Explore options such as androgenous creatures (part human, part animal), nightmares and "good" dreams, and satires based on myths—the Cyclops reincarnated as the school principal or the Medusa as a waitress.

At this time in their lives, youngsters are testing and crystallizing their basic system of

10-3 (left) Self-Portrait. Grade 8. (right) Portrait of Creacie. Grade 8.

values. They are increasingly conscious of their own values and are beginning to understand that value systems influence "how the world works." Most children understand abstract concepts of justice and honesty, but their conduct tends to be guided by personal opinion rather than by a fixed moral code. The early adolescent tends to value human life as a "right" to which a person is entitled only if that person contributes to the family or community welfare; life is not yet an inherent right for everyone.[1] Most youngsters now understand the biological concept of life and attribute life to plants and animals only, not to inanimate objects.[2] Youngsters begin to sense the finality of death. A belief in life after death is especially strong among youngsters who have had religious training.[3]

Although adolescents have fairly stable concepts about human values, their emotional lives oscillate between optimism and cynicism, ecstasy and despair, confidence and fearfulness. Themes based on opposites like love and hate, innocence and guilt, success and failure may inspire personal exploration of issues that affect the adolescent. For students who enjoy the challenge of translating concrete experiences into nonobjective form, themes contrasting abstract forms of order and pervasive moods may provide an impetus for art: quiet-noisy, violent-calm, light-heavy, elegant-garish.

Junior high students also have a keen interest in making useful and decorative objects for

10-4 Ceramic mask. Grade 8.

themselves and for others. Opportunities for individual or group expression may be found in occasions like personal or school-wide celebrations, gift exchanges, or special projects for the young, aged, or handicapped (Figure 10-5). It is essential to avoid clichés and stereotypes in celebrating important events, exchanging gifts, or planning community-oriented projects. For example, if school symbols and colors are part of a ceremony, the expressive problem is not drawing the school symbol or choosing the colors for the event. Rather, the problem is twofold: deciding on the art forms in which the school symbol will be embodied (banners, supergraphics, slides, table decorations) and determining how these forms can be orchestrated to create a mood (solemn, poignant, energetic, humorous) suited to the particular occasion.

Although they are easily discouraged and embarrassed by shortcomings that they see in their work, adolescents are still willing to put forth their best effort in order to become competent in art, provided that they see improvement in their work. The adolescent's continued growth and flexibility is just as important as the self-confidence gained by using a familiar method of work. Plan activities that involve selective changes in habits of working. If students are confident in a particular subject matter, like cars or people, encourage them to express these subjects in different media. A series

of studies might be made of a single person, place, or thing with intentional variations in color, value, figure-ground relationships, proportions, or details (Figure 10-6). In drawing, introduce students to gesture and contour skills; in painting, contrast direct methods, such as wash, with indirect methods, such as scumbling and glazing.

Imaginative play with ideas can be encouraged by inverting ordinary relationships and seeking uncommon juxtapositions. For example, students might try to imagine hard things as soft, tall things as short, or gravity-bound things as airborne. Attribute-listing is another way of imagining variations. If the initial idea for a work of art is "A picnic," the student might list several alternatives under such column headings as *who* might be at a picnic, *where* and *when* it could be held, *what* might be present, and *why* it is being held. The student can imagine a wider range of possibilities for "picnics" than might initially have been called to mind by checking one or more of the attributes in each column.

Explore the connotations of images or symbols that are currently popular with adolescents (Figure 10-7). For example, analyze the Snoopy character in the Peanuts comic strip. Find analogies for Snoopy-like behavior (clowning, arrogance, philosophizing) among real people, or among animals other than dogs. Use similar

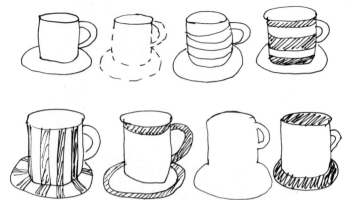

10-5 (*opposite, left*) The scale model of a movable circus wagon designed by eighth graders for the school library.
(*opposite, right*) The full-sized circus wagon.

10-6 (*top, right*) Studies of a cup. Grade 7.

10-7 (*center, right*) Aries zodiak motif. Grade 8.

10-8 (*bottom, right*) Silver rings. Grades 7 and 8.

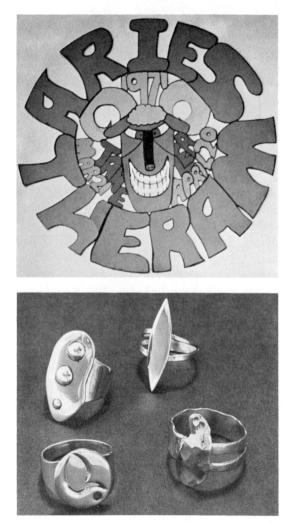

techniques to probe other feelings and ideas that students seek to express in visual form. Understanding of the symbolism of a medium can be developed in a comparable way. Ask for references to the symbolism of specific materials in myths, poetry, and songs. Symbolism for the medium of paper, for example, can be noted in the lyrics of "I'd Rather Have a Paper Doll," and of Dionne Warwick's "Papier Mâché."

Adolescents require guidance in noticing relationships among *what* they are doing, *how* they are approaching their work, and *why* they are seeking a particular goal. Before students begin work, ask them questions like: What do you want to express? Is your work designed for a specific person or place? As students work, help them explore the relationship between why they are creating a work and how their choices of things like medium, color, and size can forward their aims. After any work is completed, engage students in a discussion of their efforts. Focus on relationships between their methods of working and the effectiveness of the result.

The preadolescent's desire for perfection continues into adolescence. If they have not developed their skills in at least one medium, adolescents will be attracted to superficial techniques that permit them to hedge on skill while probing for an accidental success. Paradoxically, adolescents who perceive themselves as clumsy or unskilled can be motivated by complex tech-

PERSONAL FULFILLMENT THROUGH ART

10-9 (*left*) Use of professional equipment improves the artistic performance of the early adolescent.

10-10 (*opposite, left*) A clay whistle shaped like a lion. Grade 8.

nical processes, such as silversmithing, batik, rya weaving, or welded sculpture (Figure 10-8). Every student should work with a single medium long enough to feel some command of it.

Teachers should be aware of eye–hand coordination problems that may influence how students use media. Adolescents suffer from eye problems that are typical of the adult population: farsightedness makes close work difficult; astigmatism blurs and distorts images; poor fusion reduces depth perception and increases focusing time; reflex failures make it difficult to sustain attention or follow the path of a moving object.[4] Teachers should refer students who may have uncorrected eye problems to the school nurse or counselor, or to a physician.

If hand dominance has not been firmly established by this time, a student may have poor coordination in both hands. Most left-handed children have developed ambidextrous skills for dining, shaking hands, and using some tools. Fancy variations in handwriting are one means of testing and extending fine-muscle control. Most children in normal health can make subtle motions with their whole bodies and with parts of their bodies. Among these are the *dab*, or darting motion; the whiplike *slash*; the *weightless touch* like a caress or tickle; the *flick*, as in a fast scattering gesture; the smooth-flowing *glide*; the firm and sudden *thrust*; and differences in *pressure* caused by variations in muscular tension.[5]

Adolescents who have had effective prior instruction can simultaneously control the direction of movement, value, texture, color, and placement as they manipulate familiar media to create two-dimensional art forms. Only a few of these variables can be controlled at the same time if the medium is new to the student. Most students can use at least one drawing or painting medium well enough to create expressive works. Adolescents can begin to achieve expressive relationships in particular printing processes (Figure 10-9). Print registrations can be anticipated in multicolored work.

In three-dimensional work, skills are determined by patience and persistence more than by muscle control. With practice, adolescents can learn to throw clay on a wheel and to control both the size and the shape of forms. Clay sculpture can be well proportioned and highly expressive (Figure 10-10). Both hand tools and power equipment can be used effectively in wood- and metalworking. Metal casting, braising, welding, enameling, and related processes can be learned. Plaster can be carved or used by the additive method with an armature, but free-flowing forms are still difficult to achieve. In weaving and stitchery, complex patterns can be executed if they are planned (Figure 10-11). Combined techniques like batik and stitchery or ceramic clay and wood can be managed.

Adolescents can work effectively on film-production teams and can cooperatively plan

scripts, lighting, sound effects, and other technical matters. With instruction, they can learn the fundamentals of photography and darkroom procedures. Effective cooperation and expressive results can also be achieved when adolescents work on ceremonies, special school events, and community projects.

10-11 A pillow with an eagle motif. Grade 7.

Nurturing response to visual experiences

For the adolescent who finds little personal satisfaction in creating art, the chief benefit of studying art may well be a lifelong pursuit of opportunities for heightened perceptual awareness. Although perceptual skills are essential in creating art, one need not create art to enjoy one's powers of perception.

One of the most effective ways to review basic perceptual discriminations is through studying advertising and product design, two fields in which visual and plastic qualities are fairly obvious. The adolescent enjoys discovering how artists who work in commercial fields "manipulate" the viewer's behavior by the way they use symbols, line, color, shape, and surface texture. Adolescents can still enjoy matching and sorting games, puzzles, and mechanical devices that selectively feature optical, kinesthetic, and tactual phenomena (Figure 10-12). Art teachers will find science and industrial-arts teachers

10-12 This simple aid is designed to heighten youngsters' awareness of viewpoints.

helpful in locating resources like optical illusions, moiré patterns, prisms, and examples of natural structure in plants, animals, and minerals.

The junior high school curriculum is more heavily tied to abstract reasoning than to sensory experience. Art teachers should seek out opportunities to team-teach, a good way to promote multisensory awareness. Most physical-education teachers can contribute ideas based on their knowledge of kinesthetics and dance. English teachers might help invent dramatic situations to involve students in seeing, tasting, listening, smelling, moving, and touching. The expertise of music teachers can be tapped to interrelate sounds with visual, spatial, kinesthetic, and tactual phenomena.

Popular icons in the adolescent's environment are useful in demonstrating that many images have several levels of symbolic meaning (Figure 10-13). Adolescents enjoy examining images and environments in modified Jungian terms—noticing, for example, whether something is designed to appeal to the "parent" in us, to the "child," the "adult," or the "clown-trickster." Students might collect magazine advertisements for a single product and sort them to show similarities in the symbolism used to sell the product.

Adolescents can benefit from activities that make them aware of the contexts influencing human behavior. Examples can focus on subtle forms of interpersonal communication—body language, seating and traffic patterns—and large-scale symbolic means of communication—wearing jeans or having a certain hair style in order to avoid being conspicuous. Occasionally, you might invite two or three students to observe and record such things as your own traffic pattern in the room or how often things are dropped on the floor. Make sure the students share their data with the class.

Adolescents are still learning to interpret their personal experiences—that is, to discover patterns of meaning in the variety of things they see, think, and feel. Art educators have not paid enough attention to the positive value of language as a medium of thought and expression (Figure 10-14). Language serves to abstract perceptual experience in much the same way that any medium of expression does, including painting, sculpture, and drawing. What art educators want to avoid is not the rich poetic imagery of language based on perception, but the typical use of language in academic subjects—namely, to communicate factual information and concepts with denotive meanings.

The adolescent has acquired a meaningful vocabulary of approximately ten to thirty thousand words but may not use it well or to its limit because of lack of incentive to do so.[6] Adolescents who punctuate every sentence with "It's like," or "You know," are not really trying to understand what their immediate experience *is*

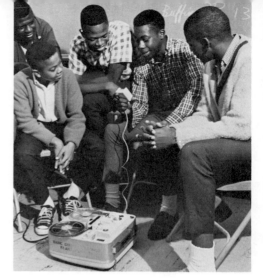

10-13 (*opposite*) Adolescents find levels of symbolic meaning in popular icons.

10-14 (*right*) Discussions of art are enhanced by the use of a tape recorder.

and *means*, but are dismissing it from further attention by cataloging it. When adolescents do not use an effective vocabulary to characterize what they feel, see, and think, they cannot reflect on an experience or clarify its meaning through discussion, dialogue, or reading. Their understanding of themselves is limited by their inability to communicate with the selves of others.

The art teacher's own speech and vocabulary should be a model for heightening students' perception and should create a desire on the students' part for effective communication. Nothing kills perceptual awareness as rapidly as the repeated use of vacuous statements like "That works" or "That's nice" or "My, how interesting." Art teachers might well collaborate with teachers of English to improve the adolescent's understanding of the poetic and expressive power of words. Haiku poetry is a popular and useful example of the analogy between visual images and word images, but other forms of poetry and prose are rich in possibilities.

In literature and English classes, adolescents learn to use similes and metaphors; they learn to associate detailed sense experiences with abstract ideas (as in haiku poetry) and to create categories for apparently dissimilar things. They also organize ideas to reflect different levels of meaning. In creative writing, for example, they may recast the same experience in several forms: narrative, dialogue, monologue, and essay.[7] In

art, skills such as these can be applied to the process of interpreting works of art or visual experiences. For example, using principles like consistency and coherence, adolescents' oral or written accounts of a work of art would cite features that seemed odd or inappropriate to the dominant mood or purpose of the work. Psychological, sequential, or spatial relationships might also serve as principles for organizing interpretive accounts. Students also enjoy making audio- and video-taped interviews of themselves or others as they discuss their artwork or visual experiences.

Adolescents are often reluctant to express their empathic relationships with people, places, and things. Peer-group pressure to conform is strong and being "grown-up" is often equated with cool indifference or outright ridicule of anything unconventional. Empathic responses to people are developed from experiences that call for personal identification with another. In general, adults do not pay enough attention to adolescents' desire to feel useful, competent, and needed. As a consequence, adolescents often act as if they were useless, incompetent, and indifferent.

Empathy for others begins with self-respect. You might arrange for students to engage in a community-service project for the elderly, handicapped, or very young. Assign each student the job of reporting his or her experience through words, pictorial works, photographs, or

audio tape. You might ask students to imagine they are in the room of a person who is dying. Have them compare the thoughts and feelings of the person who is dying, the attending physician, the clergyman, the mother, the lawyer, the lifelong friend.

In addition to nurturing interpersonal relationships based on empathy, the teacher should encourage the adolescent to establish empathic relationships with *things*—not on the superficial level of wanting to acquire them, but on a level of comprehending how things have origins, histories, and destinies. For example, automobiles are an extraordinary product of people's collective efforts. How do cars die? How are they buried? Do we mourn their loss? If so, why? If not, why not? You might invite students to find an ordinary object, such as a pencil, a book, or a shoe, and narrate the personal history of that object from 7 A.M. to 7 P.M., accounting for where the object has been; for how the object felt; for its bumps, scrapes, adventures, and so on (Figure 10-15).

Adolescents enjoy speculative thinking when it does not lead to personal embarrassment. Most of their questions center on "Why" and "How." Speculative "play" with images and ideas can increase students' recognition of the assumptions that they make about ordinary experiences. Invite students to write down or to visually express three scenarios for the life they might be leading in ten years—one "good," one

"bad," one "average." Have them decide how they can best portray a life style—through possessions, through jobs, through leisure activities. In a different vein, ask students to imagine ideas, actions, or feelings that are usually considered weird, funny, or crazy. Then have students consider the same ideas in another light, such as serious or appropriate, like holding a funeral service for the day's collection of garbage, or putting bandages on "wounded" furniture.

Although prejudices, that is, patterns of prejudgment, are well developed by adolescence, most adolescents are still open to change because few of them have developed elaborate systems to rationalize and strengthen their judgments.

Adolescents will not generally acknowledge that learning to learn is valuable. In order to understand and use this criterion for judging experiences, adolescents must first feel the sense of pride and delight in learning something just for the sake of learning it. The prime time for building a positive attitude toward learning is early in the year, when attitudes about school are being reactivated. Whatever the subject— art, baseball, swimming—overtly display your admiration of student expertise in that field (Figure 10-16). You might ask students to keep a notebook describing what they have learned from each art activity. Before an activity, students might write down questions they hope to answer by completing the activity.

10-15 (*opposite, left*) In the hands of skilled and imaginative teachers, even bottles of nail polish can serve as an impetus to thinking about art.

10-16 (*opposite, right*) *Fuzzy.* Grade 8. The interests of the adolescent often provide a basis for a discussion of the relationship of art to life.

10-17 (*right*) The perfectionist drive is merged with a strong interest in "useful" drawing. Grade 8.

Many adolescents are mature enough to understand that life is enriched by special experiences, both positive and negative. Adolescents can begin to make conscious use of this criterion in reflecting on the value of an experience. They will need help in recognizing, for example, that one of the values in being lonely is the contrast it provides with having companionship. You might ask students to keep a record of special moments in their lives and to use their notes for creating art.

Adolescents can appreciate that experiences may or may not be valued at the time that they occur. You can build awareness of the continuity and flow of experience in many ways. Have students devise a color code for their feelings about each day in the art room: red = a great day, bright pink = a good day, pale pink = a so-so day, maroon = a bad day. Ask them to chart their feelings over a period of several weeks and see what relationships they find between their color scale and their sense of progress in art. Find other points of comparison and help students notice whether they feel the same or differently about the underlying experience.

The practical criterion for judging experience is the most pervasive in our culture. When adolescents question the value of education, adults answer with a future-oriented, practical justification. Adolescents are aware of the value of being able to use their experience in the present and future; they need practice in recog-

nizing that the criterion of practical worth is but one way to judge events. Youngsters should know in advance when the purpose of an art activity is immediately tied to a practical application. For example, if architectural drawings are introduced, the student should learn about the utility of knowing how to make a scale drawing (Figure 10-17).

Developing an awareness of the artistic heritage

One of the most important considerations in encouraging an awareness of the artistic heritage is the selection of works of art that will represent the heritage. Broad criteria for selecting works are implicit in the general curriculum framework presented in Chapter 6. Further suggestions may be found in subsequent chapters, which deal with specific art forms. To those guidelines and suggestions can be added several points of particular importance in teaching the early adolescent.

In selecting works of art for adolescents to examine, we should not underestimate the adolescent's ability to decipher expressive meanings that "touch" their emerging adulthood. The early adolescent is not a naive child living in a cocoon (Figure 10-18). In their daydreams, adolescents often cast themselves in the role of the

10-18 Jacob Lawrence, *Tombstones* (1942).

10-19 Willem de Kooning, *Woman, I* (1950–52).

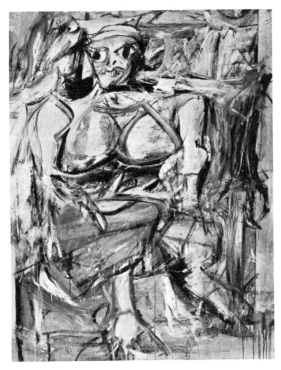

"suffering" hero or heroine. Their sexual awareness is acute and often based on overt experimentation, sometimes with members of the opposite sex.[8] Human physiology and sex education are included in many school programs. By the age of fourteen, many students have attended parental-guidance-rated movies. Television viewing time still averages four hours a day and is rarely restricted to the "family hour." Given that there will be no major change in television programming, the average student will have seen and heard, by the age of fourteen, more than three thousand detailed, fictional accounts of murder, rape, disaster, and other forms of violence, as well as countless true accounts of violence presented in news reports.[9]

Adolescents are not socially and economically naive. They know that jobs produce income and that money can be illegally obtained in many ways. Money is linked with independence and success. Youngsters who have been on welfare tend to develop strong attitudes of acceptance or rejection of welfare for themselves as adults. Adolescents who have had some money of their own to spend are keenly aware of standards of quality in products.[10] By the ninth grade, most children have a sense of the importance of aptitude and capacity as factors in choosing a vocation. Vocational preferences are determined by personal interest and social status.[11] The trend toward early vocational choice (euphemistically called "career education")

magnifies the adolescent's consciousness of the link between career, status, education, and money.

Taken together, these social, economic, and vocational concerns dominating the adolescent's life would seem to make art little more than a refuge from the world, little more than a frill. Indeed, art will inevitably seem to be a frill unless teachers become more aware of those images in art that have the potential for making a vital connection with the existential condition of the adolescent. Further, the teacher must help the student see, feel, and think about the connection. If works of art could speak for themselves, as many teachers are fond of saying, there would be little need for art education. Within the boundaries of current legal rulings and of any formally adopted school codes bearing on the selection of instructional materials, teachers should feel free to show images that address the social, ethical, political, and economic issues that confront adolescents. The teacher is equally obliged, on request, to justify the choice of instructional aids on educational grounds (Figure 10-19).

Studies of works of art should be related to adolescents' own studio work whenever possible. If adolescents' studio experiences are not narrowly conceived or superficial in content, it will be possible to point out analogies between their own idea sources and the sources to which artists have turned. This kind of connection not only builds students' readiness to look at any work of art in terms of its possible origin and expressive intent, but also helps students understand that their own search for ideas is a legitimate part of the artistic process. Several levels of comparison can usually be explored: theme, subject matter, and interpretation.

Suppose that a student is working on the theme of sports; the subject matter is football, and the student's interpretation emphasizes the power and violence inherent in the game. In this example, historical parallels could easily be drawn. The theme of sports can be traced to the art of many cultures—pre-Columbian, Egyptian, Greek. Although football is a modern sport, it can be viewed as an extension of the ancient gladiator contests and the medieval tournaments among knights. The structures architects have created for spectator sports might be pointed out—among them the classic Roman Colosseum, the contemporary Sports Plaza in Rome by Nervi and Vitellozzi, and the extravagant superdomes in Houston and New Orleans. Other interpretations of power and violence need not be limited to the narrow subject of football. They might reveal power and violence in nature, in city life, in psychological relationships among people.

Similar patterns of analogy should be drawn when students are learning about the methods by which artists give visual form to their ideas. Because methods of work are conditioned by the

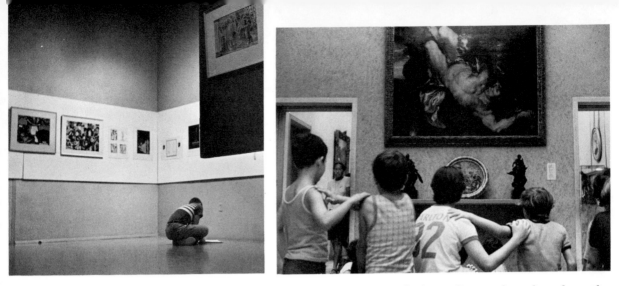

artist's media and purposes, it is important to contrast the relative privacy enjoyed by studio artists with the more public nature of the architect's or the designer's work.

Adolescents are interested in the technical problems artists encounter in using media. They are able to make extremely subtle distinctions in judging varieties of media, in recognizing direct and indirect uses of a medium, and in reasoning out the symbolic meaning in certain uses of media (Figure 10-20). In order to make these distinctions, however, adolescents must see original works of art and demonstrations, live or on film, of the physical and mental processes involved in creating art. It is of no great importance for adolescents to learn technical terms like *cloisonné* and *impasto;* however, adults usually underestimate even this kind of capacity in adolescents, who, on their own, may well have mastered the nuances of meaning and vocabulary necessary to speak intelligently with an expert in automobile repair, electronics, swimming, gymnastics, or any of many areas in which students have a special interest.

Through discussion and example, adolescents should learn that experts pay attention to the nature of the art form and the medium from which it is fashioned. Focus discussions on the character of the art form—that is, its dimensionality, its appeal to tactual, visual, kinesthetic, or spatial sensations. References to media should center on sensuous qualities, on the proc-

esses by which media are shaped, and on the symbolism inherent in the choice or use of the medium. Structured dialogue between the teacher and student will sharpen the adolescent's ability to see and talk about these aspects of art.

In the junior high years, students can learn to find symbolic meanings that are not apparent at first glance. In addition to dialogue and inquiry with the art teacher, students should listen to articulate artists and museum personnel speak about symbolic meanings. Discuss levels of meaning as seen in subject matter, themes, interpretations, symbolism, and expressive content. Discuss nonobjective and functional works in relation to the moods, feelings, and ideas they seem to evoke (Figure 10-21).

Discussions of design should reveal the processes involved in perceiving the plan in a work of art, and the physical and experiential bases of design. Do not use categorical phrases like "It's a design" (What kind? For what purpose?), "It has balance" (What kind? Why?), "It has texture" (Everything does. What kind? How do we know?). In other words, use specific adjectives and adverbs to heighten perception of qualities of line, shape, color, and balance (Figure 10-22). Emphasize the physical and experiential basis of design by noting how the eye and body respond to irregularity and regularity in line, the associations we make between certain colors and life experiences, and so on.

216

10-20 (*opposite, left*) A note-taking session in a gallery provides insight into artists' work.

10-21 (*opposite, right*) These youngsters are exploring the visual and physical aspects of muscle tension in Rubens' *Prometheus*.

10-22 (*right*) In this game, which helps structure observation and discussion of selected aspects of a work of art, the cubes can be rolled like dice or placed in a row to determine the order in which topics are discussed.

Discuss style in relation to family resemblances in works of art. Point out the relationship between style in art and general styles of seeing, thinking, feeling, and acting. Teaching stylistic labels like Impressionism, Analytical Cubism, and Baroque is not as important as helping students perceive the qualities and outlooks that lead people to recognize that some works are similar and to give a name to the similarity. Adolescents should be invited to learn traditional stylistic terms *only* after having made the perceptual associations that underlie the terms.

When you and your students talk about the purposes and contexts for art, focus on the probable intent of the artist who created the work. Even though we can never be sure about the artist's intent, nothing prevents us from making inferences about it and enjoying the speculative process. While guessing at the artist's intent, however, limit yourself to visual and historical evidence; do not make unwarranted observations like "He let his paint drip; he must have been drunk." In addition, compare the context in which the work is experienced now with the ways that it might originally have been perceived or used.

Adolescents are able to mentally project themselves into the role of "art expert" and to appreciate the kind of work historians, curators, and critics do. Adolescents should become familiar with the thought processes involved in scholarly inquiries, not merely the conclusions produced by such studies. When adolescents read about or discuss art, they should be able to recognize the difference between descriptive statements and judgments of merit or value. This skill can be developed by making use of the adolescent's familiarity with television detective programs, in which descriptive evidence serves as the basis for judgments by the jury. Given practice in making this fundamental distinction between descriptions and value judgments, adolescents can learn to employ any of the several methods of criticizing art outlined in Chapter 4.

Natural beauty, craftsmanship, and representational skill as values that many people seek in art are among the criteria that adolescents have little difficulty understanding. Junior high students can also understand that imagination and originality are especially important criteria for judging much contemporary art. The idea of formal beauty can be grasped by making analogies to "good form" in everyday activities. Adolescents can also appreciate that issues of censorship in art often center on the value people place on the particular lessons and ideas that may be communicated through art.

In order to awaken adolescents' interest in studying written art criticism, you might have students compare the judgments made by two or more critics discussing the same exhibit or work of art. You might ask students to make a list of words they use to judge cafeteria food,

clothes, or the performance of entertainers or athletes. Have them try to match the meaning of those words with the words critics employ to judge works of art. Students might write a review of an exhibit that parallels a published one, but comes to a different conclusion about the merit or significance of the exhibit.

Newspaper reviews of local exhibits, descriptions of works of art in art books, and commentaries on art in magazines are resources for analyzing the process of criticism and the criteria by which works are judged. Classic examples of the results of controversial judgments, such as reactions to the New York Armory Show of 1913, or to the court case involving James Whistler and John Ruskin, offer opportunities for students to understand that art criticism is not a passive, inconsequential activity. For example, you might compile a set of resources on the Ruskin-Whistler libel suit and have students reenact the main lines of the arguments for the plaintiff and the defendant. Afterward, ask students to speculate on the outcome of the Ruskin-Whistler case if Ruskin had held Whistler's views on art and Whistler had held Ruskin's views. Students might compare critical reviews published after the death of Pablo Picasso with those published after the death of Thomas Hart Benton. What qualities do critics admire in each artist? You might develop a collection of "letters to the editor" that deals with art exhibits or art criticism. Analyze the letters to discover

the issues that make people want to publish their views.

Developing an awareness of art in society

Most young people are permitted to choose and buy items for their bedrooms, school activities, and personal interests. For the adolescent, having the "right" hair style, clothing, bike, notebook, means that the form and style of these everyday items must be fashioned in a particular way. This desire for conformity is the basis for examining artifacts from our own and other cultures that meet the same human need for acceptance but from quite different views of "rightness." Adolescents can retain some degree of objectivity when they examine their environment if they interpret artifacts in terms of the broad human purposes they serve (Figure 10-23). At the same time, they are made aware of nuances in particular forms that make people want to acquire, create, or use them.

Interpreting artifacts as signs of group membership can be facilitated in many ways. Students might try to list identical things that at least ten students in the class have in their possession. After recording the lists, see how many of the predictions are confirmed—tennis shoes, blue jeans, a nickel, something with a school

10-23 (*opposite*) Both forms provide transportation, but the more subtle functions and meanings bear examination.

10-24 These cups have similar forms and serve the same function, but differences in medium and surface affect the way we respond to them.

emblem. Discuss the relationship between the frequently found items and forms of group membership the objects define.

Signs of individuality can be examined through comparable activities. Invite a graphic artist or a product designer to explain to the class the many visual formats a company may use in order to establish its own identity in the minds of customers, for example, Goodyear, Goodrich; Coke, Pepsi. You might ask students to find out which community buildings their peers (or others) regard as most unusual, outstanding, or different from others. Find out why people think the buildings are exceptional and which buildings are most frequently cited.

By early adolescence, many youngsters have participated in public or religious ceremonies of some kind. Whether the event is as significant as a bar mitzvah or as short-lived as a pep rally, the adolescent is able to comprehend why people need to commemorate peak moments in their lives. You might invite students to create a display or mural on "Milestones in life" based on experiences many students have had in common. Parallels can be noted between these personal experiences of students and ceremonial arts in our own and in other cultures.

Adolescents should learn how the beliefs, values, and expectations of people can influence their perception of media, art forms, design, style, symbolism, and the purposes of art. It is valuable to nurture a perceptual and interpretive style analogous to that of a cultural historian or an anthropologist who looks at particular things in terms of functional patterns; that is, how artifacts, events, and behaviors serve basic human needs.

In order to focus attention on media and art forms, invite students to collect and display labels that tell consumers whether a product is "imitation" or "genuine." Make a separate display of labels that are contradictory, such as "genuine imitation leather." Collect and display small objects that people throw away but that could be used again if saved and cared for.

Adaptations of media can be examined in everyday objects. You might ask students to collect and display examples of "disposable" artifacts. Make similar displays of packages and items that are advertised as carefree. Contrast the values that might account for the popularity of such items with the values people might place on nondisposable versions (Figure 10-24).

Awareness of design and style can be developed by many activities. You might invite students to create three displays using photographs from magazines. One display should present artifacts that are embellished with elaborate decoration; one should display artifacts that are unadorned; the third display should present items that are moderately embellished. All displays should have comparable items—three types of such things as silverware, chairs, and record-album covers.

A

B

10-25 Comparisons such as this stimulate lively discussions of the role of art in society.
A *The Discus Thrower,* Roman copy after Myron (fifth century B.C.).
B Advertisement for Landlubber trousers.

At this age, youngsters can distinguish the difference between general, or universal, symbols and particular variations of them. In addition to noting familiar symbols in the school and in the everyday environment, students can examine the symbolism in artifacts from other cultures, and they can search for parallel symbols in contemporary media and advertising. You might invite to the classroom a person well versed in cultural anthropology to discuss cross-cultural symbols. Ask the guest speaker to draw parallels to symbols in the contemporary environment. Students might enjoy the challenge of designing visual symbols for "food," "water," and "transportation" that could be used anywhere in the world. Students might research the subjects and symbolism of particular importance to specific minority groups: Mexicans, Orientals, Puerto Ricans, blacks, Indians, and so forth. Ask the school librarian to assist students in locating appropriate reference materials.

Plan activities to focus on purposes and contexts of art. For example, invite students to create collages or sculptural forms from ready-made objects based on the idea of contextual dislocations—an elegant dinner served in a garbage dump, a skyscraper in the middle of a Cape Cod housing row. Ask students to discuss occasions in which, in their opinion, inappropriate attitudes or actions were displayed. Have them identify the context that made them feel the action was inappropriate.

Junior high students are able to understand that cultural changes are often reflected in the degree of detail found in artifacts. They can also understand why judgments of a form's simplicity or elaborateness are relative. Examples can be drawn from the student's own life. Compare the design of record covers for classical and hard-rock music, and discuss the possible relationship between the album design and the kind of music on the record. Contrasts between "old" and "new" versions of a single form should focus on relationships between the beliefs of people and the design of the form. For example, you might visit two banks, two churches, or two factories that reflect dramatic contrasts in "new" and "old." Discuss the different concepts of finance, worship, and work that each building reflects.

The adolescent is an astute observer of prototypes and eclectic forms, especially as they are presented in fads, fashions, and merchandising (Figure 10-25). Virtually every community has examples of neoclassical architecture; modified English, Swiss, or Italian villas; or Western, Colonial, or Southern antebellum architecture. You might ask students to photograph, sketch, or cut out photographs of buildings that differ in style and then make the pictures into jigsaw puzzles or a humorous collage of a building that might satisfy everybody's taste. Obtain photographs of "funny cars" or buildings that are shaped like the product they sell, or collect containers in the form of people, animals, and the like. Discuss the combination of ideas and beliefs that is communicated by such forms.

Topics such as planned obsolescence, subliminal advertising, and censorship are means of building awareness of the social importance of media. For example, discuss the issue of censorship and the uses of art for propaganda, using case materials from medieval Europe, Nazi Germany, Soviet Russia, and Communist China. Invite a person who is familiar with local zoning laws and construction codes to discuss the ways that legal regulations influence the forms and materials used in buildings, as well as their locations. If possible, the discussion should occur during or prior to a site visit.

Adolescents are on the threshold of achieving full responsibility for shaping their own lives and environments. At the same time, they lack the legal, political, and economic power to make immediate and permanent changes in their lives and environments. For this reason, their engagement with the issue of judging cultural artifacts must necessarily emphasize speculation on possible solutions. Action-oriented community projects, if well planned and endorsed by residents, can also be effective as learning experiences.

Many value questions hinge on whether people want a life planned around permanent or temporary things and relationships. Invite students to collect items that are designed for temporary use. Find photographs or actual examples

10-26 The ecology of the urban environment can be studied on site by children who live in a metropolitan area.

of more permanent versions of the same items. Discuss the relative advantages and problems associated with each version. You might learn which buildings in the neighborhood or community are the oldest. Visit them and find out why they have not been torn down. Ask someone who is in the business of demolishing buildings to talk with students about the reasons for tearing them down, the average life span of different types of structures, and the fate of the materials from demolition sites (Figure 10-26).

Contrast the values that people place on tradition and on innovation. Ask students to collect examples of advertisements that try to appeal to people who want to have "traditional" things that are also new and easy to care for. Discuss why people want objects that combine new and old. Have students explain the traditions observed in their families or communities, identify artifacts that go with the traditions, and imagine how they would feel if they celebrated the traditional event without the artifacts.

Compare multipurpose and special-purpose objects as they affect behavior. Collect examples of specialized household gadgets like egg slicers, apple corers, potato peelers, and identify the special problems each gadget is designed to solve. Compare the effectiveness of the gadget with that of general tools that can do the same job, in this example, a kitchen knife. Identify community structures that have been designed

222

for special purposes, and consider how those purposes might be met (or not met) in quite different structures—for example, worship in a church, worship in a football stadium, worship in a drive-in movie.

Finally, draw attention to issues that center on uniformity and diversity. Visit a factory organized around assembly lines. Have students discuss the advantages and disadvantages of the assembly line in terms of things like worker satisfaction, product quality, and rate of production. Compare the advantages and disadvantages of living in a totally planned community by visiting local developments, by talking with developers, and by interviewing residents and business executives.

When introducing adolescents to problems in judging cultural artifacts, note both positive and negative values that people may find in the same object or environment. The relationship of life styles to choices of artifacts should be treated in a comparative manner so that students can appreciate the different values that underlie such choices.

Notes

[1] Lawrence Kohlberg, "The Child as Moral Philosopher," in *Readings in Psychology Today* (Del Mar, Calif.: CRM Books, 1969), pp. 181–86.

[2] Jean Piaget, *The Child's Conception of the World* (Paterson, N.J.: Littlefield, Adams, 1960).

[3] M. H. Nagy, "The Child's Theories Concerning Death," *Journal of Genetic Psychology* 73 (1948):3–27.

[4] Albert Harris, *How to Increase Reading Ability* (New York: David McKay, 1961).

[5] Joan Russell, *Creative Dance in the Elementary School* (London: Macdonald & Evans, 1965).

[6] Albert Harris, *Reading Ability*.

[7] James A. Moffett, *A Student Centered Language Arts Curriculum, Grades K-13* (Boston: Houghton Mifflin, 1968).

[8] W. R. Reevy, "Child Sexuality," in the *Encyclopedia of Sexual Behavior* (Englewood Cliffs, N.J.: Hawthorn, 1961), pp. 258–67.

[9] Data from Joan Beck, "T.V. Violence May Be Linked to Disturbances on Campus," *Cincinnati Enquirer*, June 2, 1970, p. 4.

[10] A. L. Strauss, "The Development and Transformation of Monetary Meanings in the Child," *American Sociological Review* 17 (1952):275–86.

[11] E. Ginzberg et al., *Occupational Choice* (New York: Columbia University Press, 1951).

suggested
activities

Drawing and painting

11

This chapter offers suggestions for engaging children and youth in the activities of drawing and painting, which will serve both as a means of personal expression and as art forms to be studied and enjoyed. This chapter, as well as those that follow, is organized to highlight the special problems involved in teaching children at different levels of maturity. Prior instruction in art and general progress in school will alter the age and grade at which children will benefit from some of the activities and forms of guidance recommended in these chapters.

Personal expression

Children's first experiences in drawing usually occur when adults provide them with paper and crayons, pencils, or felt-tip markers. Many children enter kindergarten and first grade with no

prior experience in painting, probably because parents consider it a messy activity and do not understand its potential value to young children.

Media and processes

As soon as children are able to grasp a brush or to hold a crayon or broad felt-tip pen, they should be encouraged to make marks on paper. Initial experiences with a brush and tempera paint should be limited to one color. Later, one brush can be provided for each of several colors (Figure 11-1). Over a period of several months, acquaint the very young child with many hues, both pure and mixed, as well as pastels and shades.

Large quantities of inexpensive paper in different shapes and sizes should be available to children in the exploratory stage of develop-

ment. In addition to using manila paper and newsprint, children can draw and paint on old IBM printouts, butcher paper, rolls of adding-machine tape, and cardboard (Figure 11-2). Outdoors, they can use large pieces of chalk (1 × 4-inch lecture size) to draw on the sidewalk, or they can dip brushes in clear water to create sidewalk paintings. When the child's interest in one set of arrangements begins to wane, revitalize interest by changing the medium, the surface, the tool, or the scale of activity (Figure 11-3).

When the child enters preschool, the most essential consideration is providing easy access to materials. Children gain confidence and control by knowing how to obtain and use media and tools and by being able to complete their projects without adult supervision at every stage of the process. Open shelving, related arrangement of materials, and a clear set of rules for using materials are the secret to orderly, but well-used, classrooms.

For drawing, provide large and small wax crayons, soft (HB) pencils, water-based felt markers, and large lecturer's chalk (the latter to be used primarily outside for drawing on the sidewalk or on washable walls). Virtually any kind of paper can be used for drawing. In general, paper that has a slight tooth, or texture, is best for crayon and chalk.

For painting, tempera, or poster paint, is the most versatile and the least expensive me-dium, especially when it is purchased in powdered form and mixed in half-pint milk cartons with water and a small amount of liquid starch. At least one low double easel with a tray for holding paint containers should be available in every classroom. Chalk and Cray-Pas (a blend of chalk and wax) may be used to enhance dry tempera paintings or to create painterly drawings. Finger paint is of some value for the very young child who is seeking motor and kinesthetic pleasure. But it is not recommended as a major drawing or painting medium for children who have learned to make simple visual symbols, primarily because the kinesthetic and tactual appeal of finger paint overpowers the child's attention to its visual qualities.

After the kindergarten years, soft pencil, vine and compressed charcoal, and pen and ink are essential drawing media for every grade. Although wax crayon, Cray-Pas, chalk, and colored felt markers are commonly used for drawing activities in schools, these media are most appropriate to use in a painterly fashion or in elaborating on paintings, thereby taking advantage of the wide selection of color. Children should study how differences in the pressure, speed, and direction of their physical movements can influence the visual qualities produced in all the graphic media (Figure 11-4).

By the middle of their second year in school, most children can make a transition from liquid tempera paint to acrylic tube paint. The

11-1 (*left*) A simple easel arrangement for painting.

11-2 (*below*) Large-scale paintings on cardboard can be made indoors or outdoors.

major objections to acrylic paint, neither of which are educationally sound, are cost and clean-up. Unlike tempera paint, acrylics do not run. They are easily mixed in small quantities and allow children to rework or repaint areas of their paintings after they have dried. Tempera paints are flat, fluid, and fixed in a decorative color range that is frustrating to many adult artists. We should not expect beginners to be any less frustrated by the same qualities. Acrylics, like tempera, can be cleaned up with soap and water (but most easily, before the paint has thoroughly dried). If acrylics cannot be obtained, liquid tempera paints can be used. They should be thickened with a small amount of white glue and wheat paste to make them more workable.

Children should do almost all of their tempera or acrylic paintings on a vertical or slanted easellike surface, so that they can see their work at close range and from a distance (Figure 11-5). A vertical surface also encourages rhythmic coordination of shoulder, arm, and hand muscles. When a mixing palette is directly below the surface on which the child is painting, the child can make efficient motions from the supply of paint to the surface on which he or she is working. A small amount of acrylic paint can be dispensed from tubes each day and kept in a low, covered cake pan on a side table.

In teaching children to use tempera or acrylics, focus on efficient methods of mixing

DRAWING AND PAINTING

analogous colors, tints, shades, and intermediate hues, both on a palette and directly on the painting. The size and shape of the painting surface should be selected to suit the idea to be expressed as well as the child's preference for expansive or detailed work. Because fine materials encourage serious work, prestretched canvas, masonite primed with latex or gesso, and heavy white paper with a slight tooth are recommended as surfaces for tempera and acrylic work. Newsprint, manila, and cardboard may be used for quick studies.

In addition to working with acrylics or thickened tempera, children in the third and fourth grades can be introduced to encaustic and watercolor painting. Encaustic painting (in modified form) can be arranged by fitting a metal tray or muffin tin into an empty gallon can heated with either a 25- or a 40-watt bulb, depending on the thickness of the metal tray (Figure 11-6). Old wax crayons can be used as pigments. Paraffin and dry tempera can be mixed, preferably with one part refined beeswax added to ten parts paraffin. (The beeswax, which can be obtained at a drugstore, is desirable but not essential.) Paintings should be made with bristle brushes on cardboard or masonite. Brushes can be cleaned by heating them directly on the palette and wiping them with terry cloth. Make transparent glazes by adding more paraffin and beeswax. Encaustic painting is recommended because it encourages rich development

11-3 (*above, left*) A four-year-old gets acquainted with the action and effect of paintbrushes by painting with water on a blackboard.

11-4 (*above, right*) A vigorous graphic account of an exciting event. Grade 1.

11-5 An efficient and effective arrangement for painting.

11-6 Equipment for encaustic painting is easily made.
A A one-gallon can with the side removed.
B A 25- or 40-watt light bulb for heat.
C A muffin tin placed in the open side of the can.

of color and surface textures. It has a glow rivalling oil paint and exceeding acrylic.

Watercolor painting will be preferred by some youngsters and merely tolerated by others. Basic instruction should be given in taping the paper to a board. Demonstrate effects created by such techniques as wash, stipple, spatter, and dry brush. Of equal importance is instruction on the "background to foreground" method of developing the painting and on the value of working on several paintings at one time.

Every child in a self-contained classroom should be able to paint at least once a week. This can be arranged if two double easels are available, or if table space is set aside for four children. Four children can "reserve" the easel or table for part of the morning; four can work in the afternoon. Thus, at least forty "scheduled" opportunities for painting exist during a single week. Similar arrangements in an art room can provide continual opportunities for children to paint.

By the middle elementary grades, most children show a greater command of drawing media than painting media. Many teachers introduce children to "mixed media" to compensate for this lack of skill and to sustain interest in pictorial expression (Figure 11-7). Among the applications of mixed media are: drawings in wax crayon covered with thin paint to create a "crayon resist"; collages, to which details are added with paint; compositions consisting of a painted background that establishes a general mood, with details in crayon or cut paper; and crayon "etchings."

Rather than engaging children solely in mixed-media work, nurture a more complete understanding of the expressive potential of specific drawing and painting media. Beginning in the fourth or fifth grade, children's commitment to their work is directly related to their perception of the media they are using. In the eyes of the preadolescent, wax crayons are for young children with coloring books. Transformed into encaustic paints or developed into painterly surfaces with a shellac finish, wax crayons are no longer "kid stuff." Mixed media should be used when they are appropriate to an expressive purpose, but they should not become a substitute for developing students' skills.

Both acrylics and oil paint should be available to the junior high student. Adolescents can learn to stretch a canvas and to prepare the ground with gesso. Canvas size should not be restricted arbitrarily; it should be determined by the expressive intent and the preferences of youngsters. Oil paints can be mixed with a drier to permit day-to-day work. Basic techniques in direct painting, impasto, scumbling, and glazing should be taught. Encaustic paintings should be done on gesso-covered masonite. Some students will prefer watercolor, tempera, or egg tempera to oil, acrylic, or encaustic.

DRAWING AND PAINTING

11-7 Still life, collage. Grade 6.

Drawing media should also be varied enough so that adolescents can make choices suited to their preferences and expressive intents. Pencils, Conté crayon, vine and compressed charcoal, ink with pen or brush are suitable. Colored pencils, Cray-Pas, pastel, felt-tip pens, and wax crayons should be available for drawings in color or for color studies for painting. Paper of varied sizes and grades of quality should be accessible. Inexpensive paper like newsprint, manila, and white butcher or shelf paper should be used for studies; better grades of paper should be used for finished drawings. Collage, crayon resist, tempera resist, and tissue collage should be introduced as options, but should not be relied on as shortcuts in creating works with expressive power. Too often, these techniques are used to produce attractive but merely decorative works.

Motivation

Most children who enter kindergarten have learned to make symbolic references to people, animals, and other objects through drawing or painting. At this time, children can benefit from informal motivation. Motivational activities should be based on the several approaches recommended in Chapter 6: nature and the constructed environment, imagination, broad

themes, and everyday experiences. Pictorial work based on universal themes, memory, and imagination can be encouraged from the beginning of the first school year. Drawing and painting from life should be reserved for the end of the first year, when children's self-confidence is generally stronger.

Effective motivational activities are short, rich in ideational and sensory detail, and related to the child's experience. In order to translate their experiences into visual form, young children must see relationships between the motivational topic and the expressive potential of drawing and painting media.

Suppose that the source of inspiration is "A rainy day." Invite children to notice details like the color of the sky, the puddles of water, the splash of drops, the pattern of drops on the window, and the "music" of the raindrops. Following this, ask the children to show how the rain "falls," "splashes," "drips," and "puddles," first by having them make total body movements to show "falling," "splashing," and so on, then arm movements alone, then finger motions. After this kind of kinesthetic warmup, encourage the children to draw or paint something about a rainy day. Children will often create graphic images that reflect one or more of the patterns of motion executed during the warmup activity because a clear relationship has been established between the child's personal aware-

11-8 (*top, left*) *Children in the Rain.* Grade 1.

11-9 (*center, left*) *Cats, Cats, Cats.* Grade 3.

11-10 (*bottom, left*) Visual studies of houses and trees. Kindergarten.

ness of "rain" and a potential graphic expression of it (Figure 11-8).

In addition to physically reenacting the experience to be expressed, children may rehearse what they want to draw or paint before they actually begin to work. They might pretend they are drawing on large (or small) pieces of paper and show how they would move their arms "to make the man tall," "the dog short," or "the boy happy." Such rehearsals prepare children to capture significant features of their ideas in drawings or paintings.

In pencil and crayon drawing, the clarity and expressiveness of the image is directly related to the linear qualities produced by varying the pressure, speed, and direction of hand movements. In drawing from life, memory, or imagination, motivations should focus on the linearity of the subject: the flow of lines in tree trunks; the straight, even edges of houses; the pattern of lines in cat fur (Figure 11-9). Colored drawings in wax crayon or felt pen are most appropriate for imaginative works, in which the pure color of these media often complements the child's stylized and decorative treatment of the subject.

Paint, chalk, and Cray-Pas invite painterly development of images—that is, images with blended colors, large areas, and superimposed linear or textural detail. These media are suitable for naturalistic work as well as for subtle

DRAWING AND PAINTING

expressions of mood through color. Motivational activities involving these painterly media should focus on the shape, color, and moods of the subject: the shades of green and the shapes of trees in a forest; the way gray colors and gray feelings seem to go together on a rainy day; the bright patches of color in a flower garden.

Children in the third, fourth, and fifth years of school are easily discouraged when they are not able to meet their own standards of excellence. They complain that they "can't do it" or that they "don't know what to do." Beginning in the third grade, children should learn that "getting ideas" is an important part of the artistic process. They can begin to keep an idea book, incorporating sketches of and written notes about things they see, think about, and feel that might be developed into works of art.

Young adolescents are also highly critical of their ability to draw and paint and are eager to build skills that approximate adult levels of competence. Idea or source books for paintings, drawings, and other forms of art are valuable at this level as well. Idea books might include newspaper clippings or magazine reports on topics of interest to adolescents, short, written observations, concise sketches of things they see, doodles and "mind wanderings" that might inspire imaginative works.

At every grade level, the connotations of ideas should be explored with children. A theme like "The city" should be examined to build the child's visual imagery and emotional identification with such features of city life as the rush of traffic, the height of buildings, the crowds at street corners, and so on. Imaginative themes like "The boat that flew" should be explored in the same way, so that children can visualize significant details and personal identification with the idea can occur.

Guidance

Preschoolers who are learning to make symbols can begin to create visual studies through drawing and painting. For example, have them make a series of paintings on precut, proportioned paper showing a tall house, a short house, a fat tree, a skinny tree, and so on (Figure 11-10). Use long strips of paper to encourage sequential drawings of separate events that make up a whole experience, such as going to the store, being at the store, buying candy, and coming home.

Encourage children to extend their initial drawings and paintings by imaginative projection. If the child's picture shows only a house, ask if there are trees close by, if it is next to other houses, if anyone lives in the house. Questions based on "make-believe" can also help children elaborate their ideas: If you were a bird, what

color would you want to be? Where would you sleep? Where would you fly?

Build the child's appreciation of visual qualities that refer to actions, moods, and things. Point out symbolic relationships that children can readily grasp: a wiggly line that is like a person wiggling, a greenish blue color that is like a cool swimming pool, an oval shape that is like a cloud, a stippled texture that is like gravel. Nurture flexibility in the work habits of the preschool child. Provide opportunities for children to work on surfaces that vary in color, shape, and size; to work at an easel, on the floor, at a table, or outdoors; to use different tools for drawing and painting.

Beginning in the first grade, children can be introduced to drawing and painting by having them observe still-life arrangements, nearby landscapes, and posed models in the classroom. Still-life arrangements should be visually intriguing, thematically organized, and coordinated to dramatize color relationships, linear qualities, light and shadow, or other very specific features. Outside visits should also be structured so that students can examine the environment selectively: for the linear quality of television antennae and telephone poles; the patterns and textures in wood and brick structures; the shapes of windows; the overlapping outlines of buildings and trees (Figure 11-11).

Figure-drawing and -painting should be approached as learning experiences in seeing and interpreting the action and mood of a figure, not as opportunities for applying formulas for "stick" or "sausage" people. An understanding of proportions should be built through physical comparisons like these: Have students place a hand over their faces and compare the size of the hand and the face. Notice that elbows can dig into the waist. Observe that eyes are parallel to the tops of the ears when seen from a front view, but that eyes seem to "move" up or down from ear level when the head is rotated up or down.

With posed models, it is important to pace the time for drawing between quick "gesture" drawings (one to two minutes) and between more sustained poses (eight to ten minutes) (Figure 11-12). For quick gesture studies, it is helpful to place bright contact-paper dots on major joints of the model and to focus attention on the relationships among them. Bright tape can also be placed on the clothing of the model to show directional changes in the backbone, shoulder, hips, arms, and legs. Silhouette drawing can be an effective warmup for contour and value studies. Costumed models and group poses that emphasize moods and actions help retain interest and encourage interpretive drawing.

In both drawing and painting, encourage children to refine and elaborate their initial ideas. Visual studies of the same topic from different vantage points are appropriate; for ex-

11-11 Drawing from observation. Grade 7.
(*opposite, left*) The scene.
(*opposite, right*) The drawing.

ample, a bird's-eye view contrasted with an ant's view, the same subject at night and during the day.

A simple way to develop students' visual memory is as follows: Prepare a series of slides with simple shapes, textures, and lines. Flash the slides on a screen at very short intervals ($\frac{1}{10}$ of one second). Students quickly draw each image in turn, using soft chalk and one sheet of newsprint for each slide. More complex slide images can be introduced later.[1]

Having children make serial or comic-book drawings is an effective means of introducing them to compositional problems. Children should consider whether to repeat a background and alter the size of the figures, or to repeat the figures and shift elements in the background. Compositional sensitivity is also nurtured by making the same basic drawing fit into a long, narrow format; a tall, skinny format; horizontal and vertical rectangles; and so on.

As early as the first grade, children can benefit from exploring how different feelings can be evoked by changes in the size, color, and position of parts of their work. Third graders can learn to alter proportions of sky and land and to portray the relative size of objects in scenes from nature. Many third graders can learn to show space by overlapping shapes and by using color to create atmospheric effects.

An awareness of angles of vision, size, and position relationships improves the child's abil-

11-12 Figure-drawing. Grade 5.
(*above*) The model.
(*below*) The drawing.

ity to make expressive use of space in pictorial works. Provide hand-sized objects for children to draw from the top, side, front, back, bottom, and intermediate views. Have them extend these same observational skills to larger objects and to the environment. The importance of size and position can be learned by making "flip books" of a simple figure that becomes progressively larger (or smaller) from the back page to the front. Left-to-right and top-to-bottom changes in position can also be illustrated by the flip-book method.

Ideational depth—the establishment of a distinct mental image of an object or a scene—can be nurtured by encouraging children to explore their own and others' feelings about things. For example, a landscape of the city at night can be developed to reflect its inviting diamondlike brilliance or its forbidding dark alleys and cavernlike towers (Figure 11-13). A still life of old musical instruments can accentuate the feeling of age and lack of use or can convey a sense of usefulness and quiet grace. Projecting oneself into the object—feeling as if one were the city or a musical instrument—can expand the child's sense of expressive possibilities. It is also helpful to imagine how others—rich, poor, old, young —might feel about the idea, object, or topic.

The adolescent is able to create paintings and drawings that capture several levels of expressive meaning, not just surface appearances. It is important to encourage this potential depth of perception through discussions that probe for multiple meanings and personal identification with subjects. Some students might make a series of paintings or drawings on the same subject, each study emphasizing different interpretations of the subject. The same landscape, for example, might be developed to express peacefulness, violence, gaiety, or grandeur. Interpretations might be based on humor and satire or could reflect a factual or persuasive treatment. Shifts in size, in figure–ground relationships, in position, in value, and in color should be explored as means of enhancing the expressive power of the subject.

The interplay between the adolescent's creative work and the artistic heritage should be immediate and instructive. A student who is fascinated with drawing muscle men, for example, should have extended opportunities to draw muscles, to study anatomy books, to examine works of Leonardo da Vinci, Michelangelo, Rodin, Baskin, and other masters of expression through the human form. There is little harm in students' copying images from such masters, if they remember that the copies are tools for learning and are not to be presented as original art or finished work. Virtually every person who becomes seriously involved in studying art feels a need, at some time, to test and refine his or her skills by copying other artists. Visual studies that abstract, attempt to duplicate, or otherwise borrow from a master, can be educative, but they

11-13 Two paintings of a city.
(*opposite, left*) Grade 2.
(*opposite, right*) Grade 7.

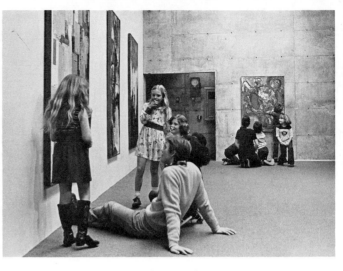

11-14 (*right*) Learning to look at,
talk about, and enjoy paintings.

should never become substitutes for personal expression, nor should they be honored above less skillful but totally individual efforts by students.

Every aspect of art instruction for the early adolescent should be based on an explicit interrelationship between student growth and ways that adult artists approach their work. Remind youngsters that developing proficiency in art, as in many things, often requires practice, warmups, mental preparation, overcoming habits that are not productive, resting, total attention, and physical energy. The two chief obstacles to intense adolescent involvement in art are treating school art as if it were different from any other kind of art, and treating adolescents as if they were children.

The artistic heritage

Every school should have a permanent gallery space, either within the school or near it, to serve as a learning laboratory for seeing art, understanding the practical problems involved in exhibiting work, and becoming familiar with the role of the audience in the artistic life of a community (Figure 11-14). If the gallery space is properly designed and the concept of its management sufficiently planned, it can be staffed by students and parent volunteers so that stu-

dents and the art teacher are free to use it as a teaching-learning arena as easily as they use the conventional studio classroom.

The gallery should be regarded as a learning laboratory for art that is of equal importance to understanding and enjoying art as the conventional studio laboratory is to nurturing personal performance in the role of artist. Learning of this kind necessarily involves direct teaching, student research, and dialogue with members of the artistic community who are professionally involved in enjoying, exhibiting, and collecting works of art. In some communities, short apprenticeship programs might be developed to acquaint the older student with procedures for operating galleries or museums. Students and teachers could modify these procedures and roles to accommodate their own needs and resources.

Original paintings and drawings in a variety of styles and media should be available for children in every grade to examine. In addition, children should meet local drafters and painters, visit their studios, and make short trips to museums to see drawings and paintings. In all cases, it is essential for children to talk with articulate members of the artistic community who enjoy sharing their knowledge with children.

Visits to museums should be planned with a definite focus, so that children examine paintings and drawings for a specific educational rea-

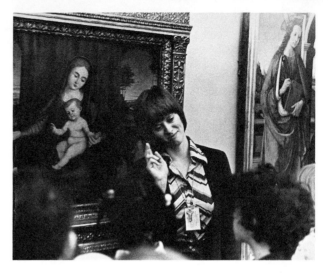

11-15 Third graders learn the language of gesture during a tour of the Philadelphia Museum of Art.

son—to study thematic or stylistic similarities or technical and compositional devices. Class discussions of reproductions and slides may also be focused in this way. It is important to remember that neither the scale nor the technical aspects of paintings and drawings are adequately presented in slides and reproductions.

Children should have the opportunity to see short demonstrations by adults of painting techniques in oil or acrylics, encaustic, egg tempera, fresco, and watercolor. They should also observe adult demonstrations of silverpoint, pencil, brush and ink, and charcoal drawing. Children should examine original paintings and drawings in different media at close range so that they can detect differences in the materials and techniques used to create them. It is helpful to obtain small duplicate samplers of these original forms of drawing and painting. Invite children to match the samplers with original works of art in the same medium.

Here are some specific points to remember in acquainting very young children with painting and drawing by adult artists.

If the work is representational, engage children in looking at the subject matter. Have them imaginatively enter landscapes, physically assume the poses and expressions of people depicted in portraits, become a mouse looking at all parts of a still life.

Ask questions to draw the child's attention to visual qualities and to encourage sensory identification: Is it a warm or a cool day? What do you see that tells you so? Is it a bumpy road or a smooth one? How can you tell? Do the clothes feel tight and heavy or loose and light? Is this book new or has it been used a lot?

Ask questions that focus on the medium: Do you think the artist pressed down hard or lightly with the pencil here? What happens when you press hard? Can you pretend you have a brush in your hand and make a stroke like this one? Can you find any yellow in this green tree? Why do you think the artist put it there?

While looking at representational and nonobjective works, build personal identification with the activity the artist might have used to create the lines, colors, shapes, and patterns of movement in the work (Figure 11-15). Have children physically reenact those gestures and relate their actions to life experiences: "Let's take a big fat brush of red paint [imaginary]. Is it full of paint? Are you ready? O.K., let's push it up like this, now fast and hard this way to the side, now slow and easy to the bottom and gently lift it away. Good."

Draw parallels between qualities in the paintings and drawings of artists and qualities that children have displayed in their work: Have you ever made paint look like this? Have you ever made lines like this in your own drawings? Do you have a favorite animal you like to paint?

Discussions of paintings and drawings with middle and late elementary students should be

11-16 Puzzles made from postcards and other reproductions can be used to heighten children's awareness of figurative elements, color, value, or other qualities. (Jackson Pollock, *Reflection of the Big Dipper* [1946]).

structured to encourage positive attitudes toward the process of creative and critical thinking about art. Interest can be sustained by many of the role-playing and gamelike formats noted in Chapters 7 through 10. Here are some additional examples:

Treasure Hunt. The treasure is found when students have discovered some feature of the work. For example, have them look for the major compositional structure—triangular, circular, L-shaped, oval—in paintings or drawings that do have an obvious major compositional theme. Provide children with an assortment of clue cards with schematic drawings of compositional themes. They hold up their clue card if they think it is appropriate to the work and point out relationships to convince the class that they have the clue and have found the treasure.

Puzzles. Duplicate reproductions are required. One is cut up into puzzlelike segments. The segments might be cut along edges of figures or into more abstract shapes that are determined by color boundaries, textured areas, or light and dark patterns. Children work in small groups and place puzzle pieces on top of the corresponding parts of the other print. They may also assemble puzzle parts on their own without looking at the duplicate print (Figure 11-16).

Match Game. Obtain duplicate sets of small prints that are closely related in subject and style (for example, works by Vasarely). Pass

11-17 This "Behind the Door" game evokes preschool children's curiosity and visual recall.

out one set to members of the class. One child, at the front of the room, names colors and shapes in the duplicate print. When a class member feels that he or she has the same print, that student calls "match" and shows the print. If it is a match, the student comes to the front and describes the next print in the stack. If it is not a match, the game continues. Children who have completed their match and description take their prints to their desk for further study.

Clue. Three children examine one nonobjective or surrealistic work. Each child is cast in the role of a detective in search of clues that will solve a mystery. The mystery is solved when the three detectives examining the work agree that it seems to express a particular mood or feeling, and when they can point out visual qualities (clues) to support their claim.

Behind the Door. To prepare for this activity, make coverings for eight to ten reproductions as shown in Figure 11-17. Align the paper coverings on each reproduction so that the flaps, when open, show identifying details underneath. Pass the uncovered prints out to groups of students and have them study the prints for three or four minutes. Collect the prints and tape the paper over them. Explain that the point of the game is for each group to tell the rest of the class what should be behind each door on the basis of what they have seen and what they remember from their study period. Students on one team

take turns calling for members of another team to tell what is behind each door. Team members confer before reporting. The door is opened to check the accuracy of the report. After one or two warmup rounds, have teams trade reproductions. Reduce the competitive aspects of this game by encouraging hints and by making a composite class score on all reproductions.[2]

Sound for Sight. Some members of the class are supplied with simple rhythm-band instruments. A leader points to a part of a painting and asks students to make a sound (loud or soft, one or several) that seems to go with that part of the painting. Class listens. The leader points to other parts of the painting, and the players echo the visual qualities they see.

In one variation of *Sound for Sight,* each instrument is labeled with an artistic term or is coded with a color, shape, line, or value. Instruments are sounded only when the designated colors, shapes, or values are pointed out. Orchestral and chord effects can be produced by the way the instruments are coded. Further variations can be tried by assigning other qualities to instruments, for example, foreground, middle ground, background; quiet, active, energetic.[3]

Descriptive Theater. One student works behind a screen or box that prevents him or her from seeing a reproduction that will be described by another student. The reporter may not refer directly to the subject of the print, but

DRAWING AND PAINTING

must try to give the transcriber a description that is clear enough for the transcriber to make a drawing of the reproduction. Interest in this game is built by using a toy telephone or tin cans connected with string or a microphone for the reporter and headphones for the transcriber. Transcriber and reporter shift roles when interest wanes or after a fixed period of time. Students build verbal skills very rapidly and are intensely interested in comparing their blind drawings with the actual reproductions.[4]

Television Producer. Arrange a block of time for students to use video-tape equipment. Have them work in teams of two or three to produce a two-minute tape that provides the viewer with a fresh look at a painting or drawing. Close-ups, pans, and narration should reveal features of the work that might be overlooked by many people. As an alternative, provide students with a tape recorder and slides of paintings. Have them discover thematic or other similarities in the slides and "produce" a two- to three-minute show with taped narration that can be shared with the rest of the class.

Words and Pictures. Invite students to write poems that fit the mood or idea they find in a work of art. Type their poems and display them next to the work.

In order to strengthen students' awareness of the relationship between individual studio work and studies of the artistic heritage, have children in the upper grades continue to discuss their *own* drawings and paintings. At the beginning of the school year, discussions of children s work are best conducted with individuals and small groups, primarily because these arrangements permit more detailed observations, and can set the tone for constructive large-group discussions later in the year.

Discussions should focus on observable qualities in the drawing or painting, on feelings and ideas engendered by what can be seen, on methods used to create specific effects, and on the positive value that children find in their work. Help children notice that different works can be successful in different ways. Help them perceive qualities of line, color, and value that contribute to the expressiveness of their work. Encourage them to report on the methods they used to achieve those qualities. Occasionally invite each child to examine a series of drawings or paintings he or she has made and to point out which of the several works seems to be most successful.

Adolescents' studio experiences should always have a direct and continuous relationship with their studies of the artistic heritage. The integrity of adolescents' approach to art is enhanced by knowing that their own efforts are analogous to the efforts of adults who are intensely committed to art. Such parallels should

not be limited just to studio experiences, but should extend to the process of looking at works of art.

Adolescents who have not had substantial experience in observing and talking about works of art should be engaged in activities similar to those suggested for the elementary grades. After warmup activities suitable for younger students, adolescents can benefit from direct approaches to art criticism. The several methods of examining a work of art introduced in Chapter 4 are appropriate for discussions about the adolescent's own work as well as about the work of adults. In addition, activities like the following build interest in the process of making judgments:

Divide the class into four groups and provide each group with a different criterion, such as the artist's use of a medium, for judging one aspect of a work. Have each group judge the relative merit of a painting using the criterion assigned to it. Contrast the judgments of each group and invite each group to justify its criticism by citing visual evidence in the work.

Invite youngsters to work in independent groups to prepare an audio-tape or a video-tape critique of the same work of art. Have each group use a different concept of art to judge the work (see Chapter 4). Compare the judgments by playing back the reports.

Find two paintings or drawings with the same theme but different interpretations. Have the class identify one or several criteria by which to judge both works. Contrast the judgments that result when the same set of criteria is applied to both works.

Identify three works that fall into the broad stylistic categories of realism, formalism, and fantasy. Ask students to select one work and to identify a concept of art that would probably lead to a negative judgment of the merit of the work. Then ask them to identify a concept of art more likely to produce a positive judgment of that work. Discuss the relationship of one's concept of art to the judgments one is likely to make about a work.

Discuss methods and criteria for judging good form in swimming, skating, or dining. Compare these examples with approaches to judging art. Make similar comparisons regarding judgments in art and moral or ethical judgments.

Interested adolescents should be invited to publish an art newspaper to report on such things as art events they have seen, works that have been created by their own classmates or by other classes, and demonstrations by visiting artists. Students can arrange for typing, duplicating, and distributing the newspaper (which can be a dittoed publication). Students might have a short apprenticeship with high school students who are involved in newspaper production or with the art critic of a local newspaper.

Extended chronological surveys of art are more likely to bore than to enlighten most stu-

11-18 Art is found in many unlikely places.

dents. While teachers should take advantage of clear opportunities to correlate art with social studies (and this should be done in all grades), there is little point in teaching a chronology of art for it's own sake. It is valuable, enjoyable, and ultimately helpful to teach adolescents chronological relationships through many short surveys, each focused on a theme, technical problem, or medium. Names, dates, and titles of works might be mentioned, but should not interfere with the central purpose of studies of the artistic heritage, namely understanding how the work of artists—past and present—informs our thought, moves our spirit, and delights our eye.

Art in society

Art is not only a means of individual expression but also a sociocultural phenomenon. The curriculum of every grade offers many logical points of connection between art and social studies. At the same time, the child's immediate environment should be drawn on to illustrate the pervasiveness of visual forms and their influence on daily life.

In the early elementary grades, children are introduced to community helpers and to concepts of a neighborhood, city, and county or region. Among community helpers are painters, drafters, illustrators, and other commercial artists who create images that inform, inspire, and enrich our lives. Graphic and painted images within the neighborhood should be examined and reasons for their existence discussed. Children can visit local buildings with outdoor murals (Figure 11-18) or with exceptional uses of drawings and paintings in the interior space. Among other possibilities, children can develop an extended concept of drawing and painting by encounters with illustrators of children's books, architectural drafters, and local product or graphic designers. The skills of local sign and house painters are also worthy of attention. A local art supply store might be visited to examine drawing and painting materials.

In the middle and upper elementary grades, children usually study geographic influences on cultural groups, such as the Eskimo and desert peoples, and the growth of the United States as a nation. In connection with these studies, there are many opportunities to emphasize the artistic achievements of cultures here and abroad, past and present. Much of what we know about any country comes to us in visual form. Drawings and paintings, in particular, are important means of preserving legends, myths, and technical information about the lives of people. Here are some suggested activities for expanding the child's understanding:

Obtain a traveling exhibit or slides of paintings and drawings by past and present artists in the state. The state arts council or a state

11-19 (*right, opposite left, and opposite right*) The merchandising of art and art images is an issue that bears critical examination with youngsters.

department of education specialist in art should be able to provide information on how to obtain exhibits or slides. If either agency cannot help, inform them of your belief that they should be able to offer this kind of service. Find out about the museums in the state: the notable collections they have and how these collections were acquired.

Arrange museum visits, films, or slide showings for the specific purpose of focusing on drawings and paintings by American artists. Arrange comparable visits or shows when studying other cultures or countries—Japan, Egypt, Greece, medieval Europe, and so on. Find out why paintings and drawings produced in different places at a given time often have similar themes, compositions, and techniques.

Study the effect that inventions like printing, the camera, oil paint, and synthetic paints have had on painting and drawing. Find out how paints and other graphic media could be made from natural resources in the community, or how such media might be produced in a preindustrial culture.

Examine the framed paintings and drawings sold in local dime stores and large discount stores (Figure 11-19). Use checklists and tally marks to record subjects, colors, media, and sizes of works that are most heavily stocked. If possible, ask the store manager or buyer which works sell best and why. Try to determine whether any of the subjects or styles have been borrowed

from other cultural groups, for example, toreador paintings on velvet based on Mexican bullfight posters. Try to contrast borrowed elements with original works from other cultures.

Adolescents should learn the difference between Western concepts of art and concepts of art in other cultures. As a learning laboratory, the gallery can not only serve as an example of how people in our society collect, display, and care for works of art, but it can also provide a context for understanding that in other societies a work of art is not necessarily an object of great permanence, nor even one that can be collected.[5]

Paintings and drawings on the human body or on buildings or on natural forms like trees and rocks are not physically available for display, purchase, and reinstallation in galleries and museums. Similarly, paintings and drawings that are integral to ceremonies or that have been duplicated many times acquire a totally different status from one-of-a-kind work created strictly for personal expression. In many cultures, paintings and drawings serve as graphic reminders of an idea or a person or a procedure, but are not of major importance in themselves. Activities like the following can teach youngsters the difference between the predominantly Western concept of "gallery and museum art" and an alternative view in which art is integral to public property, ceremonies, and the daily beat of life:

Grade 1

Grade 1

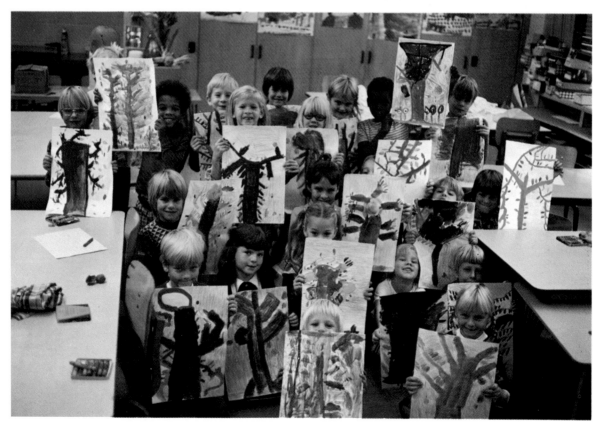

Grade 1

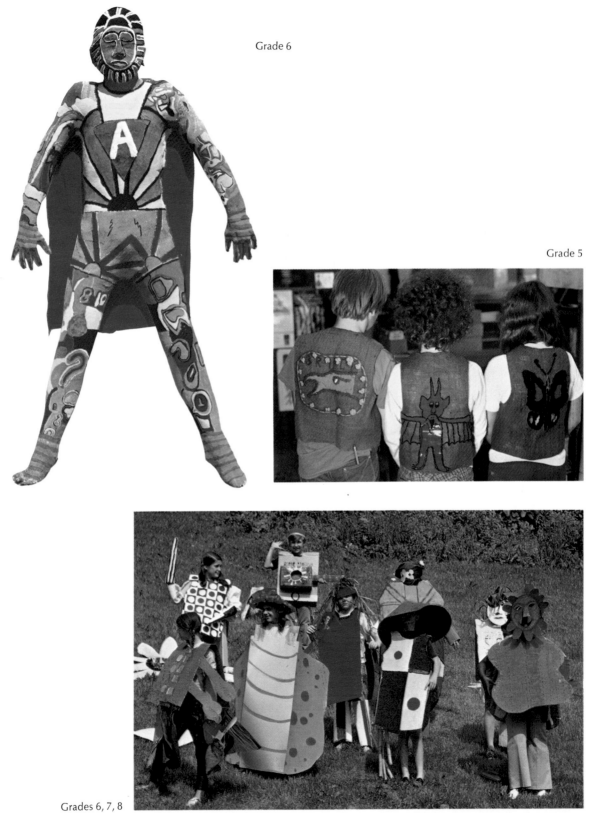

Grade 6

Grade 5

Grades 6, 7, 8

Grade 7

Grade 4

Grade 3

Preschool

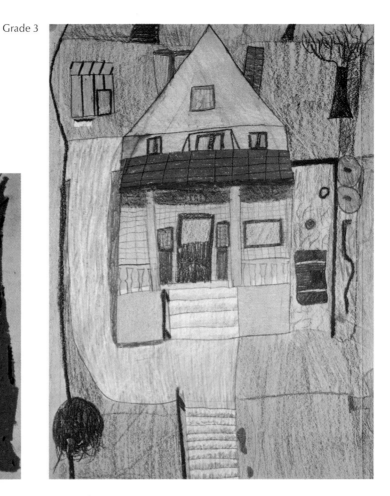

Grade 3

Grade 3

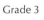

Grade 4

Grade 6

Grade 6

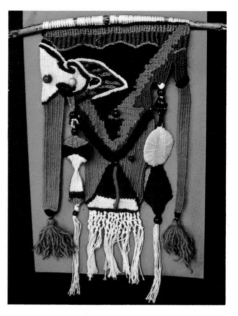

Grade 8

Grade 5

Grade 6

Grade 7

Grade 5

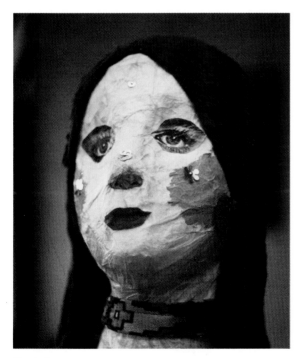

Grade 6

Grade 7

Grade 4

Grade 8

Grade 5

Grade 6

Have students study examples of rock, tree bark, and body painting in other cultures. Afterward, have them identify approximations of these forms of expression in their own environment—graffiti on water towers and walls, carvings on trees, theatrical and street makeup, tattoos. Compare and contrast the motivations behind the tribal and contemporary forms.

Find an expanse of asphalt and obtain permission for students to draw on it with chalk (large, lecturer's size); a beach or an empty sandlot would also do if drawings are made with sticks. Establish a theme for the drawings and let students decide to work alone or in groups. After the work is completed, discuss their feelings about the work and the fact that it is temporary and will be washed away by the first rain.

Invite students who are interested in music or dance to create drawings based on a code that can be used to direct the class in singing or dancing. Have these students examine aboriginal art forms or musical scores by John Cage (in a local museum or library) to get ideas for visual means of symbolizing tones, choruses, and changes in rhythm. After they have worked out the code, students should teach it to the class so that they can execute the song or dance.

If students live near a river, lake, or ocean, have them carefully choose two rocks and create drawings on them: on one rock they can draw something that would be good luck to them, on the other something that would be bad luck.

Have them design an appropriate ceremony with chants, music, dance, and a ritualized method of disposing of the rocks in or near the water. Discuss the relationship of this experience to the historical concept of drawings' having magical power—in Egyptian culture, in biblical times, in pre-Columbian culture, and among tribal peoples of the past and present. Modify this activity to suit your own geographic setting.

Obtain permission for the children to paint a mural at some public site. Establish a theme and have students make sketches of the total compositional structure with attention to color, size, and shape relationships. Discuss positive aspects in the sketches and invite one or two students to develop the final overall composition. After the composition is established, have all students participate in enlarging on portions of the mural in greater detail through scale drawings, then in transposing the enlargement directly onto the wall. After the work is completed, have students discuss their feelings about the collaborative effort and continuous public display of the work. Contrast these observations with their feelings about individually created smaller paintings.

Find a public site and approach the mural-making problem with much less planning and formality, working from a beginning made by one or two students and gradually expanding the effort by having other students join in. After the mural is completed, have the students com-

pare their feelings about the two murals—the one planned, the other spontaneous—both as products and as personal experiences.

Activities such as these are intended to confront the adolescent with the paradox of a culture that values individual works of art highly enough to institutionalize access to them but that, at the same time, limits access to art by the nature of the institutions it creates—namely, profit-making galleries and bank vaults called museums. The paradox is analogous to that of zoos, which provide public access to otherwise endangered animals, but which dislocate the animals from their natural habitat in order to put them on display. Just as we would regret the sudden disappearance of zoos, we might also regret the sudden disappearance of museums and galleries. We value the presence of both institutions as guardians of treasures; at the same time we can work for those conditions that, in the one case, restore animals to their natural surroundings and in the other, reinstate art as an accessible part of the mainstream of life.

In addition to discussions that contrast the museum-gallery treatment of paintings and drawings with the status of these same art forms in other cultural contexts, students should be engaged in activities that build their consciousness of the reasons that people in our culture produce, acquire, display, and preserve paintings and drawings. Mini-research problems might center on topics like these:

1. Why people say they like to draw and paint, and what they do with their paintings and drawings.
2. Why people purchase drawings and paintings, and what they do with them after buying them.
3. What people say they would be willing to pay for a painting, for example, the *Mona Lisa*, if they had all the money in the world. What people say they would do with the painting after acquiring it.
4. Why people buy paint-by-number sets and whether they consider their ability to follow the instructions carefully a sign of talent in art (Figure 11-20).
5. Which paintings or drawings are displayed in neighborhood banks, churches, restaurants, and businesses (Figure 11-21). Why the owner or manager displays them, and whether the works of art seem to be noticed by people who enter the buildings.
6. What proportion of the Sunday newspaper and the evening news on television is devoted to cultural activities in general and to the visual arts in particular. Compare this proportion with the coverage given to sports in general and to a particular sport that is in season, such as baseball.

In the past, questions such as these have not been treated directly (if they have been treated at all) within the process of art educa-

11-20 (*opposite, left*) Art can be discussed as a popular commodity and as a form of entertainment.

11-21 (*opposite, right*) Art is often an ingredient in advertising.

tion of youth. At the same time, it is clear that these issues are not treated in any other part of the school curriculum. Such neglect may well reinforce the pervasive cultural attitude that art is little more than a matter of doing one's own thing, and that it is of little consequence to the lives of people. Although comparable questions and issues may be raised about any art form, such problems are featured in this chapter primarily because many people tend to think of museums, galleries, and "art" in terms of drawing and painting.

Notes

[1] A more sophisticated version of this method can be found in Hoyt Sherman, *Drawing by Seeing* (New York: Hinds, Hayden and Eldredge, 1947).

[2] This technique was developed by Jan Harbolt, as a student teacher in my class.

[3] These techniques were first introduced to me by Ed Jocomo, Professor of Art Education, Alma College, Alma, Michigan.

[4] This technique was developed by Lindy Demyan, while she was a student art teacher, for presentation at an Ohio Art Education Association conference.

[5] I am indebted to Dr. Sylvanus Amenuke of Ghana for making me aware of the value of cross-cultural comparisons in understanding one's own culture.

Suggested Readings

Baigell, Matthew. *A History of American Painting*, New York: Praeger, 1971.

Barr, Alfred H. *What Is Modern Painting?* New York: Museum of Modern Art, 1966.

Gore, Frederick. *Painting: Some Basic Principles*. New York: Reinhold, 1965.

Greenberg, Pearl. *Children's Experiences in Art: Drawing and Painting*. New York: Reinhold, 1966.

Hutter, Heribert. *Drawing: History and Technique*. New York: McGraw-Hill, 1968.

Linderman, Marlene M. *Art in the Elementary School: Drawing and Painting for the Classroom*. Dubuque, Ia.: Brown, 1974.

McDarrah, Fred W. *The Artist's World*. New York: E. P. Dutton, 1961.

Nicolaides, Kimon. *The Natural Way to Draw*. New York and Boston: Houghton Mifflin, 1941.

Printmaking and graphic design

This chapter suggests methods for engaging children in printmaking and graphic design, both as avenues for personal expression and as art forms to comprehend and enjoy. *Prints* are original works of art in multiple form. Graphic design is included in this chapter because its historical beginning coincides with the invention of printing. In addition to working with printed images, contemporary graphic designers may use film, television, and dimensional forms to visualize information and to communicate ideas. Even though the graphic designer uses a variety of media, there is a fundamental relationship between the multiple images in fine prints and the multiple images of contemporary graphic design.

Personal expression

The child's first encounter with printed images occurs in the home and the environment. The child is fascinated by handprints on towels, footprints in sand and snow, and tire tracks in mud or on wet pavement. The young child may have seen clerks use rubber stamps or may have played with stamp pads and toy printing sets. Printed images in the form of books, posters, newspapers, signs, and package labels are abundant in almost every home and neighborhood. All of these memories and experiences can be drawn on to help children become sensitive to the expressive potential of printing processes.

Media and processes

Prior to being able to develop expressive prints, the young child must learn that images can be captured and duplicated by printing processes.

For children in kindergarten and the early part of first grade, the most basic printing experiences entail the simple transfer of an image from one surface to another. Chalk or crayon rubbings; mono-prints made from finger paints, tempera paints, or water-based ink; carbon-paper drawings; simple stencils; styrofoam-plate prints; and printing with found objects are suitable media and processes for the beginner (Figure 12-1). Although potato, fruit, and vegetable prints are often recommended for children, the idea of food as an expendable commodity for printmaking reflects a lack of concern about food in a world in which hunger is a serious problem.

Beginning in the latter part of first grade, children should be introduced to printing processes that more closely approximate the printing methods employed by adult artists (Figure 12-2). First graders can learn to make woodcuts. They should be provided with large planks of soft wood (at least 1-foot square) firmly secured on a low table. Sharp wood chisels and adequate supervision while learning basic rules for cutting not only help assure the children's development of skills but are essential for safety. Linoleum cuts, while generally less satisfying as prints, can be substituted for woodcuts in order to develop techniques.

In terms of ability, nothing prevents young children from making dry-point engravings and etchings in the latter part of the first and second grades. The expense of a printing press, plates, and the mess inherent in the processes are the chief objections to acquainting children with these procedures. These objections are not educationally sound. A printing press suitable for early experiences costs less than a slide projector. With new or used dental tools, small plastic plates can be engraved. Soft- or hard-ground etchings can be made on metal plates if an adult supervises the preparation of the plates with wax and the use of the acid bath. Since these processess require one-to-one or small-group guidance, they cannot be managed effectively with a total class. For this reason, classroom teachers should seek out community volunteers who are interested in art to supervise experiences of this kind. A volunteer available only four hours a week could effectively supervise two or three children an hour, making it possible for each child to complete a print within several weeks.

The quality of ink from which woodcut and intaglio prints are made should approximate the qualities that experienced printmakers value. Water-based inks, which are practical in terms of cleanup, should be of the best available quality; they should not be watery. Ink must be suffi-

ciently tacky to grip the paper and stiff enough so that, when compressed by hand-rubbing (or the press), it spreads out and makes full contact with the surface of the paper. Oil-based inks are usually far superior to water-based inks. Cleanup of oil-based ink requires turpentine or mineral spirits followed by soap and water. Tempera paint is never satisfactory for final prints but may be useful for quick stencil or scrap print studies.

Silkscreen processes can be introduced in the first or second grade (Figure 12-3). The most satisfactory prints are made with the proper equipment—that is, a hinged board and screens made of silk or the new synthetic substitutes. To block out the screen, children may draw on it with wax crayon. The drawing is then heated with a warm (not hot) iron to fill in the pinpoint holes and to block out areas that will not be printed with ink. A wax emulsion called *tusche* can also be used to block the screen. Silkscreen inks should have the consistency of a smooth, freshly made pudding so that, when pulled across the screen, the ink is pressed through the silk threads but does not run underneath them. Acrylic inks give fine prints and can be cleaned up with water.

While newsprint is satisfactory for trial prints, any final edition of prints should be made on papers that are appropriate both to the printing process and to the child's expressive intent. Colored papers might be suitable in some cases, but should not be used just for the sake of novelty. For intaglio prints (made with a press and oil-based ink) Rives paper or heavy (at least 20-pound) white bond paper is appropriate. The paper should be completely damp (not wet) before printing, so that it presses into the plate and picks up the ink in the grooves. Bond paper is also suitable for silkscreen and found-object prints. Wood or linoleum cuts should be done on a sturdy, tissuelike, absorbent paper like Japanese rice or mulberry paper.

Final prints should be planned as an "edition"—signed, numbered, and put into a simple portfolio. If selected prints are to be matted, the teacher or another qualified adult should do this. The child, however, should observe the matting process and should be given appropriate explanations about the use of a hinged mat (to let the print breathe and to keep it from buckling) and paper tape (it can be removed later without hurting the print). Through the care that we show in handling children's work, we provide a model for valuing not only completed objects of art but also the feelings and effort that have gone into their creation. Beginning in the third or fourth grade, children can learn to sign, number, and mat their own work (Figure 12-4). Some children may wish to create a suite of related prints and put them into a folio or bind them into a book.

12-1 A figurative cardboard print. Kindergarten.
(*opposite, left*) The plate.
(*opposite, right*) The print.

12-2 (*right*) Woodcut. Grade 1.

All of these traditional processes should be introduced on a tutorial basis; they do not lend themselves to large-group instruction. Because many teachers must work with large groups, little time, and small budgets, a number of special shortcut variations on printing have been developed for school programs. Nevertheless, part of the satisfaction found in printmaking rests in the *labor* of creating the print: seeing the image emerge, inking the plate, printing, pulling the print, placing it carefully to be dried, cleaning up the hands, reinking, and so forth. The making of a print is a ritualistic and reflective process. Shortcuts deny this inner experience of craftsmanship in favor of instant results and clever effects. If possible, teachers should provide full-fledged printing activities for children and regard such things as mono-prints, inner-tube prints, and cardboard prints only as preliminary means of developing familiarity with the process of printing.

By the fourth or fifth grade, children should be able to use their technical knowledge of printing to develop more expressive works. Children can now learn to manage for themselves many of the stages of printing supervised by an adult in the primary grades—preparing their own plates for etching and handling them safely in the acid bath, using woodcutting and engraving tools safely, preparing and cleaning silkscreens, using the printing press, and handling fresh

12-3 (*below*) Two second graders make silkscreen prints.

12-4 (*bottom*) A fourth grader has learned about the tradition of signing prints.

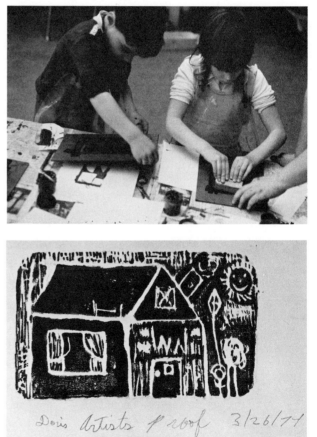

12-5 A junior high student enjoys the scale and complexity of multicolor silkscreening.

prints carefully to avoid smudging (Figure 12-5). Clearly, children who have not had prior experiences in these processes of printmaking should not be expected to have these skills.

Children in the upper elementary grades can be introduced to inexpensive mechanical printing processes—spirit duplication, mimeograph, and offset lithography from photo-ready copy. Spirit-duplicating machines or mimeograph printers are available in almost every school.

Plates for spirit duplication (ditto masters) are now available in several colors. After removing the tissue interleaf, children may draw directly on the ditto master, a paper that, when pressed to the waxy ink backing, becomes a printing plate. For trial printing, it is helpful to cut a ditto master into fourths or eighths, providing each child with a sampler. The smaller, trial pieces can then be taped together again so that the sheet can be run through the ditto machine. Children should observe the prints being made on the machine. Older children may produce multicolored prints by using several ditto masters, each of a different color.

Mimeographs are less suited to direct freehand drawing because the plate is made of dense, waxy fibers that must be separated so that the ink can pass through them. When drawings are made with plastic templates, rulers, and other mechanical aids the results are highly effective (Figure 12-6). Practice trials in mimeo-

graph printing can also be made by cutting a full stencil into smaller pieces for each child. The parts can be carefully taped together again so the mimeograph can be printed on the machine.

Offset photo lithography is a fairly inexpensive process, especially if children work on a relatively small scale and several works are printed from the same plate and cut apart later to make individual prints. Offset printing equipment is available in many high school industrial arts departments, vocational schools, and school district offices. Almost every community has numerous offset printers. Parents may be helpful in making arrangements for printing. Most teachers will have little difficulty locating a printing shop in which student work can be done "at cost" or free.

A photo offset plate is a lightweight metal plate, usually zinc, that, like photographic paper, is sensitive to light. The child's original artwork can be done on regular paper or drawn directly on thin sheets of glass or plastic film. Artwork done on regular paper must be photographed to create a film negative. The photographic negative, plastic film, or thin glass is placed on top of the light-sensitive offset plate, which is then exposed to an arc light. Where light passes through the transparent glass, plastic, or negative, the emulsion on the offset plate hardens and, when developed, will attract water but resist the oil-based printing ink. Where light does not pass through the glass, plastic, or nega-

PRINTMAKING AND GRAPHIC DESIGN

12-6 Children's skills in graphic design can be developed by their use of some of the precision tools used by graphic designers.

12-7 Woodcut. Grade 3.

tive, the emulsion on the offset plate will, when developed, soften and be receptive to printing ink but resistant to water. The printing press feeds the paper through the printing mechanism with the correct proportion of water and ink.

The preparation of work for photo offset printing is the major point of creative and expressive effort. Fine-pen drawings, as well as coarser drawings in chalk or pencil, are well suited to this process. Mechanically perfect tones, textural effects, and lettering can be obtained with ready-made dry transfer sheets that are pressed onto the glass, plastic film, or paper. As in the case of other mechanical printing processes, children should be present to see the presses operating and the run of their own prints being made.

Motivation

Beginning in kindergarten, ideational motivation for printmaking should be based on observation, imagination, personal feelings, and the desire to communicate with others.

Observation of the natural and constructed environment is often the first impetus for beginning experiences in printmaking. The delicate veins and organic shapes of leaves, the subtle contours of a feather, the rugged textures of tree bark, the geometric shape of bottle caps, or the rhythmic lines in combs may suggest ideas for

12-8 (*right*) Stencil print. Grade 8.

12-9 (*opposite, left*) Sensitivity to the beauty and expressive power of letter forms can be developed through the use of teaching aids.

12-10 (*opposite, right*) The overhead projector is useful in helping children plan the light and dark areas of relief prints.

pictorial development (Figure 12-7). Small objects may be collected and examined in detail, even under a magnifying glass or microscope, to develop imagery and sketches for prints. Beginning in the second or third grade, children might use viewfinders to select, frame, and sketch compositions that can be developed into prints.

Fantasy and imagination may be the source of ideas for prints. By combining the printed impressions of various objects—a leaf, tin can rim, scrap of wood, or fork—children might create a landscape, an animal, or an imaginary person. Wood scraps with irregular shapes may be informally printed in several colors so that children can discover imaginative figures to develop more systematically into a final print. Imaginative concepts may be portrayed by combining two or three features from unrelated objects—for example, machines that exhibit human behavior, animals that are humanlike, plants that can move or fly. Natural formations such as clouds, cracks in dried earth, and tangles of vines often suggest imaginative figures (Figure 12-8).

Poems, stories, and broad themes may inspire narrative and pictorial prints. Prints combining poems and illustrations are of special interest to older children. Friendship, loyalty, happiness, anger, curiosity, and similar themes can be explored as possibilities; hobbies and special interests, heroes and heroines, family events, may provide an occasion for children to develop personal ideas for prints. Older children enjoy developing serial prints—comic-book style—in order to express humor or a series of related events.

The desire to share a thought or message with many people may be the point of departure for designing printed greeting cards, notes, invitations, announcements, posters, and the like. Because prints for mass communication usually combine words and images, the design or choice of letter forms—typography—is an important aspect of information-giving prints. Children can begin to learn to achieve graphic clarity with letter forms by creating words, phrases, and sentences with rubber-stamp sets, an old typewriter, or precut letter forms (Figure 12-9). Older children can learn to combine typographical lines with illustrations in order to produce clear and communicative publications, including class books or a portfolio of story prints for younger children. Dry-transfer lettering is especially useful in developing photo-ready copy for offset printing.

It is important to distinguish between printmaking as an expressive art form and printing processes that merely enhance the appearance of a surface or add to the expressiveness of another art form. For example, there is little expressive value in printing an "all over repeat" design on paper unless the paper is to be used expressively (for wrapping a gift) and the design is part of that expressive intent (conveying love,

sympathy, or respect). Similarly, there is little point in making a linoleum block with one's initials on it unless, first, the letter forms are designed to fit one's own self-image and, second, the block is used for the expressive purpose of asserting one's individual identity—for example, printing the block on objects to mark them as one's own, or printing the block on sheets of paper and then fastening the printed labels to objects in order to identify them as one's own. Whatever the particular motivation for printmaking, children should be conscious of an expressive purpose as the basis of their activity.

Guidance

Children's ability to translate an idea or feeling into printed form depends on their skill in planning appropriate contrasts in line, shape, texture, and, in some cases, color. Visual expression also requires attention to the specific characteristics of each printing process. Planning for the reversal of images is very important in printmaking. Activities like the following will help children plan for specific visual qualities in their prints and thereby achieve expressiveness in their work.

Find unusual patterns of weathered wood, concrete surfaces, bark, brick, and the like. Have children press slabs of plasticene clay onto the surfaces to make impressions of them. Using the clay slabs as temporary printing plates, the children brush them lightly with tempera paint and press them gently on paper to see how the raised surfaces catch the ink.

Provide examples of weathered wood scraps. Have children make rubbings that reveal the grain of the wood; have them study the grain patterns in the rubbings to see if the patterns suggest an idea that might be more fully developed with just a small amount of additional drawing and then carving. Afterward, children transfer the drawing to the wood scrap, carve, and print it.

Place small natural or manufactured objects on an overhead projector. Tack black construction paper to a wall and project the images onto the paper. Have children use white chalk to outline and fill in the silhouette of the objects. After they complete the basic shapes, have the children take their white-on-black drawings to their seats and add further details in the white area with black chalk. This activity builds sensitivity to an overall shape and to details within it.[1]

Darken the room. Pose a model or set up a still-life arrangement in front of a strong light from a slide or overhead projector so that shadows are cast on a clear expanse of wall or a projection screen. Have students imagine that the light area is to be cut away with a chisel, leaving only the black area in place. Project and study other forms that have open textures, such

12-11 (*left*) Linoleum print. Grade 6.

12-12 (*opposite, left*) Linoleum print. Grade 7.

12-13 (*opposite, right*) Watching a printmaker pull a print.

as woven placemats, baskets, lacy fabrics, fern leaves, or vines. This activity develops perception of figure-ground relationships in planning woodcuts, linoleum cuts, or stencils (Figure 12-10).

Have students make crayon rubbings of surface textures that they find in the classroom. Provide them with black crayons or black chalk and 4-inch square sheets of newsprint for this purpose. Have students select the most and the least regular patterns they have found and transfer them onto 1-inch square linoleum or wood blocks or plastic engraving plates. This exercise is designed to build sensitivity to texture in printmaking.

Provide students with black paper. Have them make linear drawings with a white china marking pencil as if every white line were to be carved directly into a wood or linoleum block. As an alternative, provide students with 2-inch square commercial scratchboard (a clay-coated cardboard). Cover it with India ink. Have them plan a small composition, imagining that the white scratch marks they are making will be carved in wood or linoleum or engraved into plastic.

Supply students with tracing paper to make sketches for prints. Have them develop a pencil drawing that they would like to translate into an etching, an engraving, or a woodcut. After the drawing is completed, have the students study it from the reverse direction and make any changes

that they may want. When the drawing looks good from both sides, have them transfer it to plastic, metal, or wood and print it.

Provide small test plates so that children can become familiar with the relationship between linear sketches in pencil and the quality of line that can be achieved with etching, engraving, or woodcutting. Preliminary tryouts of this kind permit the child to test the clarity of the image in printed form before the final plate is created.

Encourage children to consider the various qualities of the different printing processes in choosing the most appropriate process to express their initial ideas. For example, the soft furry edges of dry point might be selected for those ideas and images in which softness and furriness are desirable characteristics. Similarly, woodcuts are well suited to rugged cubic forms in which the textural qualities of the idea are important (Figure 12-11). Engravings are suited to ideas in which sharp angular lines have expressive power.

In order to be expressive and visually clear, some designs may require colored inks, colored papers, or multiple plates for different colors. Multicolor prints are most easily managed in wood or linoleum cuts and silkscreen. Explore the appropriateness of a multicolored print with the child.

Provide children with small blocks of soft wood that might be combined to create a print. One shape might be fishlike; another might look

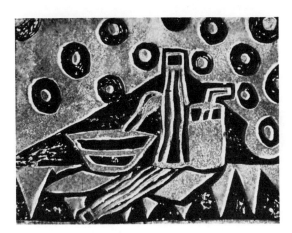

like part of a house. Have children elaborate on such images by carving details into the blocks. The blocks may then be printed in separate colors on a single sheet. Printing one block on top of another—overprinting—can be explored. In all multicolored prints, the colors are clearest and most easily mixed if lighter colors are printed first (Figure 12-12).

A related method of introducing children to multicolored prints is based on the principle of progressive carving. Children begin by carving large basic shapes in linoleum or wood and then making five or six prints. After cleaning the ink from the block, they find selected areas in the block to remove by additional and more linear or textural carving. They overprint their "new" block on the first prints they made using a different color ink and taking care to register the edges properly. The result is a two-color print. Three- and four-color prints can be made by extending this process.

Provide each student with a pad of three sheets of tracing paper interleafed with two pieces of carbon paper. Have them develop a drawing to be translated into a three-color print. After they have made the full drawing on the top sheet, have them separate the pad and use one colored pencil on each of the two other sheets to determine final color relationships. Each paper, with its own color, then represents a plate to be prepared and printed with its own color ink. From these forms of practice, children

begin to understand the principles of color mixing and plate registration, and they can develop individual methods of working.

The artistic heritage

In the early elementary grades, children should have the opportunity to see the processes by which experienced printmakers create relief, intaglio, planographic, and stencil (silkscreen) prints. Live demonstrations are ideal because they fully reveal the sounds, odors, small patterns of movement, and overall choreography of the printing process (Figure 12-13). Children's knowledge of the technical processes of hand printing also helps them distinguish prints from drawings, paintings, and photographs.

In the middle and upper elementary grades, children can become familiar with the development of prints from playing cards and book illustrations (in the 1500s) to volumes of bound prints and individual prints published in numbered editions. Children should learn that the invention of printing processes made it possible for people to know about things that were not in their own immediate environment. The "duplicate picture" was a major source of information long before it became a means of expressing the individual personality of the artist.

In addition to explaining the general development of fine prints, compare the techniques

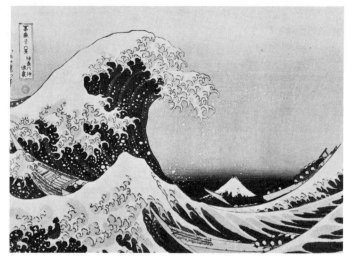

12-14 (*right*) Katsushika Hokusai, *The Great Wave at Kanagawa* (1823–29).

12-15 (*opposite, left*) Samples of effects produced by different processes can be used for recognition games.
A Lithograph. **B** Woodcut. **C** Etching.
D Photo silkscreen.

12-16 (*opposite, right*) Children watch a demonstration of the photo silkscreen process.

employed by printmakers who work in different print processes—relief, intaglio, serigraphic, and planographic. Compare the work of several artists in order to discover how each artist exploits the same basic process for personal expression. Organize works according to subject or theme so that children can discover parallels between their own sources of ideas and the sources to which artists have turned for their ideas.

In the late elementary grades and the junior high years, children should become reacquainted with the four major processes by which prints are created, and they should learn to make accurate estimates of the methods by which finished prints were produced. They should be introduced to the work of such major printmakers in Western culture as Dürer, Rembrandt, Daumier, Goya, and Blake, as well as to the contributions of Japanese printmakers to the art of colored woodcuts. Students should become familiar with work by artists such as Hirosige, Hokusai, and Utamaro (Figure 12-14).

Discussions of prints should focus on the physical sensations of creating the print, on the visual characteristics of the print that make it expressive, and on the ways that the artist may have achieved those characteristics.

Focus on qualities in wood and linoleum cuts that may have been created by incising, plowing, chipping, or wiggling the tool. Contrast clean, sharp, precise edges with fuzzy, featherlike edges. Notice the little diamond or oval shapes

that have been removed to make valleys where the ink does not reach and the paper shows through.

Comparable observations can be encouraged in discussing intaglio prints. Point out the soft edges in dry point, which show the artist's "handwriting" and permit light, airy effects or velvety shadows. Compare these qualities with the high contrast and crisp detail in engravings.[2]

Lithographs combine the qualities of drawing and painting. Painterly qualities are achieved by the use of tusche, a thin, inky grease applied with a brush. Tonal qualities are achieved by the use of greasy pencils or crayons. The grain of the stone and the texture of the paper can be controlled so that the overall print is very soft and subdued or built around high contrasts and bold strokes. Tonal contrasts and gradations, together with a sense of how they were achieved, should be emphasized in discussing lithographs.

Serigraphs, or silkscreen prints, were first used in the United States to produce posters and placards. The serigraph is based on stencil processes that were used during the Renaissance to add color to playing cards and religious images. Color vibrations are the hallmark of serigraphs. Color interactions are achieved by the progressive overlapping of colors as each color run is made. Because a silkscreen can be masked with cutout film, crayon, or brush, the shapes and textures in serigraphs may be highly geometric and hard-edged (from film) or much like

PRINTMAKING AND GRAPHIC DESIGN

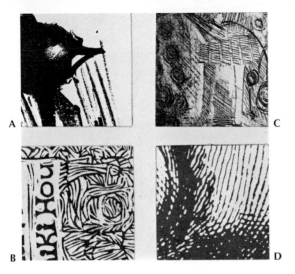

A

B

C

D

crayon or chalk drawings (from crayon) or quite painterly (from tusche). Photo silkscreens are easily recognizable by the regular transformation of edges and by the progressive amount of detail added with each color screen.

Discussions of printmaking should also emphasize the relationship of the mood or feeling of the image to the technical achievements in the work. A sharp image with much fine, realistic detail is the result of careful planning and development of the plate and of equal care in inking and printing the plate. A feeling of mystery, hidden figures, and soft vagueness is the result of a different kind of planning, frequently based on careful observation of accidental effects created by the medium or the process.

In addition to making children aware of the sensuous and expressive qualities of prints through live demonstrations and discussions, try activities like the following:

Obtain discarded proofs and plates from various hand-printing processes. The printmaking department of a nearby college is a good source. Cut the proofs into small samplers for children to examine and use for matching and sorting games (Figure 12-15). Place the original printing plates in paper bags. (Plates from which woodcuts, etchings, and engravings have been made are suitable.) Have children close their eyes and concentrate on touching the surface in order to guess the kind of image that is on the plate.

Obtain small magnifying lenses (five-power) for children to detect the patterns of ink, highlights, and grooves in original prints. If possible, get the plates from which the prints were made.

Obtain duplicate samples of white papers used for a wide range of hand-printing processes. Cut these into 2-inch squares. Have children match them or sort them into ordered arrays from smooth to rough, lightweight to heavyweight, and pure white to slightly gray or cream colored.

Invite children to find out how paper can be made by hand. Have them obtain rags, screen wire, blotting blankets, and weights to make their own pieces of paper. If possible, arrange for children to see a local craftsworker demonstrate hand papermaking processes.

Invite the curator of prints at a nearby museum to talk about the reasons people collect prints and to show children how prints are stored, handled, and displayed. This might be done through a classroom visit or a museum trip. A local printmaker or print collector might be well qualified to lead a comparable session (Figure 12-16).

Art in society

The distinction between fine handmade prints and mass-produced versions is not difficult for children to understand if they are able to see

12-17 (*left*) Children watch a press operate at a printing plant.

12-18 (*opposite, left*) These international road signs are examples of the graphic designer's skill in nonverbal communication. (*opposite, right*) A third grade class learns about the work of the graphic designer.

and hear the mechanical, uniform, rapid, and automatic means of printing for mass audiences through visits to printing plants and contrast that process with the painstaking effort of the individual printmaker. Since in mass communication through printed media, the artist's conception and design are less closely tied to the physical execution of the work, an understanding of the social importance of mass-production printing depends on a knowledge of the role of artists who are called graphic designers.

The child should become conscious of the extent to which people rely on printed matter for information and visual images that persuade, inspire, and imaginatively transport them to other times and places, both real and fanciful. Here are some examples of activities to develop this understanding:

After students have gone home for the day, remove all printed images from the classroom. On the following day, have students determine what is missing and where, within the room, it belongs. Continue this "restoration" until all printed items are back in place.

Visit a printing plant to see the stages through which a printed publication goes, from the making of plates, through the actual printing process, to the trimming, binding, and packing for shipment (Figure 12-17).

Provide small magnifying lenses (five-power) for children to examine the patterns of ink in newspaper photographs, stamps, colored magazine advertisements, dollar bills, textbook illustrations, or other fine engravings and etchings. Have them make comparative studies of the grain and texture of the paper on which the different images are printed.

Obtain samples of printed cloth, woven cloth, and dyed cloth. Invite children to determine which of the swatches have been printed; have them explain how they can tell the difference between printed fabric and woven fabric. Contrast wood, stone, brick, and tile designs printed on Formica or contact paper with real samples of wood, stone, brick, and tile.

Visit the studio of a local graphic designer or invite a graphic designer to the classroom. Ask the designer to describe to the class the nature of his or her work and to share specific examples that would be interesting to children. Invite the graphic designer to show the class how layouts are prepared for printing in black-and-white and color.

Find page layouts of newspaper advertisements for stores that sell inexpensive clothes or appliances. Compare these layouts with similar ones from stores that are normally more expensive. Cut out page layouts for advertisements from grocery stores; decide which is most and least easily read and why.

Collect examples of contemporary graphic design from Japan, Germany, China, the Soviet

Union, and the Scandinavian nations. Invite children to identify symbolic components that they can understand even though they are not able to read the language (Figure 12-18).

Acquaint children with pictographs and hieroglyphics as systems of visual communication in China, Japan, ancient Egypt, and among American Indians and aboriginal tribes. Invite children to invent their own system of pictographs and use them to tell a story.

Select a single letter such as *p* or *g*, and have children cut out numerous examples of the letter from old magazines. After they have assembled a collection, the children sort the examples into upper- and lower-case versions and then sort them further into look-alike groups—serif or sans-serif, italic or standard, bold or thin, stretched out or condensed. Help them understand that each letter form has been created by an artist and that each shape of the same letter seems to have its own personality.

Provide precut cardboard letter forms or lettering stencils for children to place on background papers and trace around to make word pictures. Letter forms might be arranged to take the shape of an animal, a person, or an object. The letters might spell out brief poems that are illustrated with pictorial elements in pencil, crayon, ink, or watercolor.

Reserve a bulletin board for children to use as an area for developing their skills in graphic design. Show them how to put up papers or pictures so that they align vertically and horizontally. Obtain large precut letters for them to tack into place for titles. If possible, place a typewriter at their disposal (a used one is satisfactory) so that they can type smaller captions. Encourage them to test the readability of the overall bulletin board from near and far distances.

Obtain several sheets of Prestype, a dry transfer material for professional lettering that is used in commercial art studios. Demonstrate how to achieve proper alignment and spacing of letters. (An overhead projector serves well for this purpose.) Have students create a personal letterhead and execute photo-ready copy for it with the dry transfer material. If possible, arrange for students to have their letterhead stationery printed in a nearby vocational school or a local printing company.

Have children save their cereal boxes and bring them to school. When there are ten or twelve examples, display them and invite children to notice similarities and differences in the designers' choice of colors, size and style of letters, images on the box, and placement of the trademark. Discuss why the appearance of a package is important to the manufacturer as well as to the consumer (Figure 12-19).

Visit a gas station and list all the products and objects on which the logo of the company

12-19 (*top, left*) The graphic appeal of cereal boxes is carefully researched and planned.
(*center, left*) A preschool lesson on graphic design.

12-20 (*bottom, left*) The elegant lines of a familiar logo were carefully fashioned for grace and continuity in line and shape.

appears. Notice that the company colors are used in the building, uniforms, and pumps to reinforce their visibility to the customer. Point out that graphic designers are employed to do this kind of work.

Have students imagine themselves as adults who own companies, service organizations, or stores. After deciding on the products or services that they will sell and on their business philosophy, have students design a logo and make sketches to show the variety of places they would display it.

Examine signs that major manufacturers of soft drinks provide for small businesses. Compare the amount of space taken to advertise the soft drink with the amount of area reserved for the name of the store or firm. Ask students to count the number of times they see the logo or brand name of a particular soft drink between their home and the school. Have them consider reasons for the frequency with which they see the logo or brand name (Figure 12-20).

Ask the manager of a fast-food restaurant to provide you with all of the disposable plastic and paper goods with printing on them that a customer who ordered every item on the menu would receive. Display these items and discuss the graphic designer's role in creating them and the advantages and disadvantages of having so many disposable products with printed messages on them.

PRINTMAKING AND GRAPHIC DESIGN

Notes

[1] This technique was developed by Georgie Gross for a Montessori program in Cincinnati, Ohio.

[2] For a more detailed discussion of qualities in prints, see William M. Ivins, Jr., *How Prints Look* (Boston: Beacon Press, 1943).

Suggested Readings

Andrews, Michael F. *Creative Printmaking*. Englewood Cliffs, N.J.: Prentice-Hall, 1963.

Bayer, Herbert. *Visual Communication*. New York: Reinhold, 1967.

Cataldo, John W. *Graphic Design and Visual Communication*. Scranton, Pa.: International Textbook, 1966.

Heller, Jules. *Printmaking Today*. New York: Holt, Rinehart and Winston, 1958.

Ivins, William M., Jr. *Prints and Visual Communication*. New York: Holt, Rinehart and Winston, 1958.

Peterdi, Gabor. *Printmaking*. New York: Macmillan, 1961.

Zigrosser, Carl. *Book of Fine Prints*. New York: Crown, 1956.

Photography, film, and television

13

The arts of still photography, film making, and television production are important avenues for personal expression. They are new media that have attracted the interest and talent of many twentieth-century artists. Clearly, they are also public and commercial art forms that have a profound effect on the child's sense of time, place, reality, and personal identity.

Personal expression

Although children see photographs, movies, and television from a very early age, their opportunities for personal expression in these media are usually limited to those offered in school.

Media and processes

Virtually every school system has (or should have) equipment for acquainting children with

the expressive potential of photography, film making, and television. All of these art forms can be meaningfully explored by children, beginning in the first grade.

For still photography, inexpensive cameras and enlargers might be purchased from local resale shops or from camera shops that accept trade-ins. In addition to cameras, you will need a darkroom for printing black-and-white photos from film negatives. (Children should not develop their own film negatives because images can be irretrievably lost at this stage.) After the film has been developed, children should create their own photographic prints (Figure 13-1). If a darkroom is not available in the school, the nearest janitor's closet can be converted into a makeshift darkroom (Figure 13-2). Film, papers, and chemicals for printing photographs can be purchased like any other art supplies.

Several types of cameras are appropriate for still photography. A simple box camera is suitable for children in the first, second, and third grades, who are just learning the rudiments of

264

framing and of choosing subjects. Young children can use Polaroid cameras effectively if adults help them pull the film so that developing can occur properly. Polaroid cameras should be used to document day-to-day activities, even when children are not using the cameras creatively to make their own photographs.

Beginning in the fourth or fifth grade, children can use cameras that have adjustable settings for speed, aperture, and focus. These features give children greater creative control in shooting a photograph. Because cameras with adjustable controls are costly (beginning at about $50.), it is best for the school to purchase four or five of them for general use and to check them out to individual classrooms as needed. Scheduling can be arranged as desired. Over a two- or three-week period, every child in a classroom can enjoy two or three full mornings or afternoons of picture taking; after introduction and practice, children might simply sign up for a round of picture taking when the time feels right. When children have learned the rudiments of controlling the focus, aperture, and speed of a still camera, they can apply this knowledge to movie cameras and video cameras as well.

There are several basic considerations in using any camera, including movie and video cameras. First, the camera must be held steady with the hands or supported on a tripod, so that light entering the camera can be clearly registered on the film. For movies or television work, smooth, continuous motions with the camera are facilitated by using a tripod or by supporting the camera firmly with the hands, holding the arms and elbows close to the body.

Second, the image must be fully framed within the viewfinder so that feet, heads, or other important features of the photograph are not cut off in the final print. To include more space around a subject, you must move away from it. In close-up work, the center of the camera lens must be pointing at the center of the part of the subject you wish to photograph.

Third, the image must be sharply focused. Simple box cameras will blur anything within three or four feet of the camera. Cameras with range finders or adjustable focusing systems allow you to adjust the sharpness of the image by looking in the viewfinder while you turn the focusing ring or knob.

Fourth, the film must be made for the camera and selected for the kind of work you wish to do. Film is made with emulsions that differ in sensitivity to light. The speed of the film in capturing light is noted by a number (ASA 125, ASA 400). The higher the number, the more light sensitive the film and the easier to register an image in dim light. Color film is also made for daylight (outdoors) or for tungsten light (indoors). The color balance of prints, slides, or movies is distorted if the wrong film is used. Color film for prints or slide transparencies

13-1 (*top, left*) A pinhole camera photograph. Grade 4.

13-2 (*center, left*) A simple darkroom arrangement. (*bottom, left*) Equipment for enlarging photographs.

13-3 (*opposite*) The diaphragm opening of a camera can be opened or closed, like the human eye, to control the amount of light that strikes the film.

is also available. Since it is costly to make a slide transparency into a print (or vice versa), it is important to purchase the film to suit your purpose.

Fifth, when children are using cameras with adjustable settings, they will need to understand the advantages of being able to control the speed of the shutter (registered in fractions of a second), the size of the diaphragm opening (f-stop), and the focus of the lens. If you wish to photograph a person riding a bike, for example, you may want to capture the motion clearly. If the shutter remains open too long ($\frac{1}{30}$ or even $\frac{1}{125}$ of a second), the camera sees a blur. At the speed of $\frac{1}{500}$ of a second, however, the shutter remains open such a short time that a clear image can be registered.

The size of the diaphragm opening regulates the amount of light that hits the film. The iris diaphragm of the camera works like the human eye. If you are in bright light, your pupil contracts to reduce the amount of light entering the eye. If you are in dim light, your pupil opens wide to let in all the available light. Just as your own eye adjusts itself to different lighting conditions, you should adjust the camera aperture, closing it to a narrow circle (f/16, f/11) in very bright light and opening it wider (f/2, f/2.8) in dim light (Figure 13-3).

If you want a given amount of light to enter the camera, you can alter either the duration of the exposure or the setting of the aperture. A

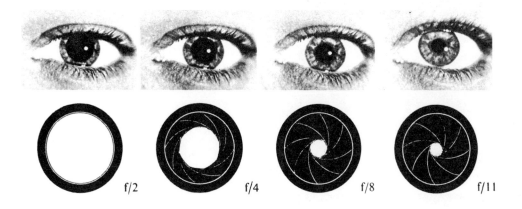

f/2 f/4 f/8 f/11

setting of $\frac{1}{125}$ at f/8 admits the same amount of light into the camera as a setting of $\frac{1}{250}$ at f/2.6 or $\frac{1}{60}$ at f/11. If you set the camera at one speed, you might shoot a static object in bright light at f/11; in dim light you might retain that same speed and open the aperture to f/5.6. Thus, the trade-offs between speed and f-stop are determined by the subject you wish to photograph and the ASA rating of your film. If the trade-offs are not judged properly, your photographic negative will be overexposed, underexposed, or blurred.

Finally, the setting of the f-stop also determines the depth of field—that is, how much of what the camera sees is actually in focus. If the aperture is closed down (f/8, f/11), the focus of all parts of the image will be sharper (like far-sighted vision) than if it is opened up (f/2, f/2.8). If you want to blur a background and focus sharply on only part of the subject (like nearsighted vision), set the f-stop closer to the f/2, f/2.8 range. On many cameras you will find a depth-of-field scale that will tell you, for every f-stop, how many feet of sharp image you will have with the combination of focus and diaphragm opening you are using. You will notice that the depth of field decreases when you are shooting close-ups, so focusing is very important.

Introduce students to still photography without a camera. Photograms can be made by arranging objects on a piece of clean glass, slipping a sheet of photographic printing paper (which is light sensitive) underneath the glass, exposing the paper to a bright light for about half a minute (bright sunlight or a 100-watt bulb), and quickly developing the print by the standard process for developing black-and-white prints (Figure 13-4).

Movies, both live action and animated, are usually developed by commercial laboratories, so that film, tripod, and camera, as well as editing and projection equipment, are the major investments (Figure 13-5). New or used tripods and Super 8mm cameras can be purchased locally if they are not already owned by the school. Because many teaching resources are available in Super 8mm format, projection equipment is probably available in the school or from a district audio-visual center. Editing equipment is relatively inexpensive, and if the cost of several units can be borne by the school district, the units can be checked out to various schools as needed.

Animated movies can be made without a camera by drawing directly on Super 8mm or standard 16mm film. Exposed film normally thrown away by film processors or television stations can be soaked overnight in a strong solution of laundry bleach (75 percent bleach, 25 percent water) to remove the emulsion and leave a clear film on which children can draw. Drawings in soft pencil can be made on the film if it is first "frosted" by rubbing it with steel wool or a hard typewriter eraser. Any felt-tip pen

13-4 (*top, left*) Photogram. Grade 4.
(*center, left*) Photogram from a drawing made on glass. Grade 6.

13-5 (*bottom, left*) These junior high students are making an animated film.

13-6 (*opposite, left*) Sections of a hand-drawn animated film made by seventh and eighth graders.

13-7 (*opposite, right*) Animation sequences by junior high school students.

or liquid ink designed for acetate is also satisfactory for drawing on film. Countdown leader film is valuable as a device to help children plan the location of their drawings within frames (Figure 13-6). Sections of countdown leader are placed under the transparent film so that sprocket holes are matched.

Animated films are best made by drawing within each frame of the film. For 16mm or Super 8mm film, an image must be redrawn at least twelve times in order to be seen on the screen. The frames of 16mm film are larger, so whereas one minute of Super 8mm film is twenty feet long, one minute of 16mm film is thirty-six feet long. In order to retain the attention of students, concentrate on very simple images and movements. For initial efforts, children can work on a hallway or classroom floor. Assign each child a three- to seven-foot section of the film to work on. Longer films can be made by developing a story plot and subdividing the film into events on which children can work independently. The final film is made by splicing the separate sections in the proper order. Proper splicing technique is essential for a smooth-running film.

Other forms of film animation can be done with a Super 8mm camera mounted on a tripod. A series of drawings, cutouts, or other items is placed on a table and photographed by using the single-frame button on the camera (Figure

PHOTOGRAPHY, FILM, AND TELEVISION

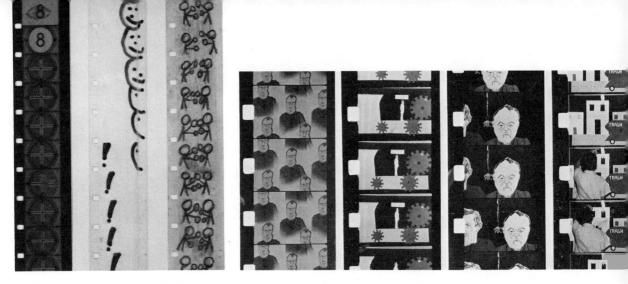

13-7). In order to create a feeling of continuous movement, the characters, items, or backgrounds are photographed for two to four frames, moved about a quarter of an inch, photographed for two to four frames, moved again, photographed again for two to four frames, and so on. Fairly continuous movement can also be obtained by drawing three or four versions of those elements that change shape. For example, a mouth might be drawn in four positions. Each mouth is cut out and placed on the face, filmed for four to six frames, and removed. The next mouth is put on the face and filmed for four to six frames, and so on. In this way a person can seem to talk, shout, or scream.

For most work of this kind, the camera can be about eighteen inches away from the table. The animation format must be horizontal in order to match the proportions of the frames on film. Paper about 11 × 14 inches is appropriate for the background of most work. A larger, black paper covering the entire surface of the table can reduce the audience's awareness of any small errors in the placement of backgrounds or camera movements.

Titles and credits on a film are much like a frame on a picture; they make it a finished work. Titles can be filmed while they are being written on a blackboard, or they can be shot as animations with letters of cut paper. The separate letters are gradually moved into place to form words. Children need only a few examples of possibilities in order to devise imaginative ways of making effective titles.

Sound effects for films can be made on a tape recorder, preferably with acetate audiotape, and played simultaneously with the film. The easiest way to synchronize sound with the film is to show the film and introduce voice or sound effects to fit the images. Because film projectors make noise when they are running, the film projector should be placed in a separate room or in a cabinet with a glass door through which the images can be projected while the sound track is being recorded.

To achieve synchronization with the film track, try the "flash-clap" method. Mark the beginning of the sound track by having a student give the title of the film and clap his or her hands once in front of the tape recorder microphone. Rewind the tape so that the clap is exactly centered on the recording head. Now mark the beginning of the film by scratching through one frame on the leader of the film just before the title frames start. This will give a clear flash of light when the film starts. The flash of light is a signal to turn on the tape recorder. This method assures fairly good synchronization. Voice, music, or other sound effects can be brought into play as the film is shown. If mistakes in creating the sound track are made, both the film projector and the tape recorder must be

rewound to the point of error. Both machines are then turned on simultaneously to assure a reasonable match between the picture and sound.

Magnetic sound stripes can be added to Super 8mm film in a processing lab. The lab can transfer a tape-recorded sound track directly onto the film so that it is always perfectly synchronized when played on a magnetic movie projector. If a magnetic projector is available in the school, the processing lab can put a blank magnetic stripe on the film. You can then use the magnetic movie projector to transfer the audio tape onto the film, saving the lab fee for synchronization. To do this, scratch one frame of the leader film just before the title frame. Put your tape on the recorder and connect the output line of the tape recorder to the recording (input) plug on the magnetic movie projector. Start the tape recorder when the clear-flash signal is shown on the screen. After the film and tape are finished, turn off the tape recorder. You should be able to rewind the film, start the projector, and hear the sound coming directly from the projector. The sound will be on the film every time you show it.

A number of special effects for film animation can be obtained by filming through a clear tray of water, by slowly panning across a mural-like drawing, by adjusting the aperture of the camera to make transitions—fading in or fading out—and by using plasticene clay to make the primary figures for animation. Technical details for achieving these effects may be found in the excellent resources noted in the bibliography at the end of this book.

Videotape equipment suitable for children and other amateurs is manufactured by several companies (Figure 13-8). Videotape appropriate for school use is ½-inch wide and available at reasonable prices for black-and-white recording. Like audiotape, videotape can be erased and used again. For creating moving images, videotape has the distinct advantages of having integral sound and being instantly available for playback and editing. However, for children, videotape is best suited to studio or indoor work rather than to outdoor work. If adults assist in setting aperture and speed controls, even young children can learn to focus and track subjects.

Detailed instructions for operating videotape machines are included with the equipment. Instructions vary with the manufacturer. In order to feel comfortable with the videotape camera, recording unit, and playback monitors, arrange for the school or district audio-visual expert to familiarize you with them. A proper orientation will test your skill in connecting all units, in basic camera techniques, and in trouble-shooting—solving common problems that can occur when you or children use the equipment. Because videotape equipment is costly (about $2000 for a good unit) and expensive to repair, children using such equipment should

PHOTOGRAPHY, FILM, AND TELEVISION

13-8 Although television equipment is often available in schools, its creative use is too rarely explored.
(*opposite, left*) Learning to frame and track an image.
(*opposite, right*) Learning to compose actions for the camera.

A

always have adequate adult supervision, perhaps in the form of a "technical director."

Motivation

Given cameras and the opportunity to shoot film, most children want to take pictures of their friends and family, their immediate environment, their pets, and their favorite possessions. They will also see photographic potential in anything that they regard as so beautiful or special that it deserves to have its picture taken (Figure 13-9).

In still photography, encourage children to take portraits, still lifes, landscapes, and details of surfaces that they see every day. Point out possibilities for photographing classmates while they are playing at recess, eating lunch, standing in line, waiting for a bus, or walking home. Help them see opportunities for photographing the same subject under various lighting conditions, at different times of day, or during different weather conditions. Time-lapse photography is especially appealing to children who are interested in science. This technique involves photographing a slow process by exposing single frames at widely spaced intervals and then projecting the developed film at regular speed to show the entire process greatly speeded up. As children develop interest in a particular subject, have them strive for interpretive photographs

13-9 Simple photographic methods can be effective.
A Pinhole photograph. Grade 6.
B Photogram. Grade 5.

B

13-10 (*left*) Documenting a single event is an instructive exercise in composition.

13-11 (*opposite, left*) Cropping a photograph can improve its composition.

13-12 (*opposite, right*) Pages from flip books, an effective warm-up exercise for film animation.

that capture subtleties in texture, gesture, and scale.

Explore the imaginative potential of still photography. Encourage children to develop a selective eye (Figure 13-10). Help them notice uncommon juxtapositions of images that make people do a double take. Show them how to look at inanimate objects like fire hydrants, plumbing connections, and door fixtures and imagine them as people or animals. Double exposures and prints combining parts of different negatives are also techniques for creating unusual and fanciful prints. Both videotape and film also are excellent avenues for imaginative expression. Animated films, in particular, invite children to create monster stories, tales of absurd adventure, and their own versions of myths and legends. Character and plot development are important in imaginative works. Encourage children to show the motivations of each character through appropriate gestures, words, and relationships with other characters.

Photo essays, documentary films, and videotapes based on broad topics encourage children to record their observations and express their feelings. Among themes that may press children to identify their emotions are friendship, love, contentment; loneliness, fear, pity. As children consider these and related ideas, help them explore various meanings and manifestations of their topics. Any form of documentation is of necessity selective; it is never a com-

PHOTOGRAPHY, FILM, AND TELEVISION

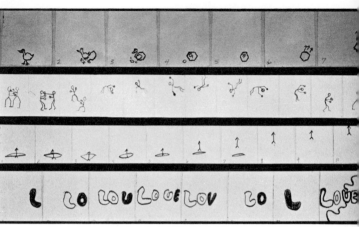

plete record of all that happened. In the junior high grades, documentary work might cover such issues as racism, poverty, and pollution.

Guidance

To practice still photography, children can make visual studies of a subject in order to sharpen their eye and achieve more expressive final prints. The same subject can be photographed from various angles and distances with different lighting effects and depth-of-field settings. In the darkroom, children can investigate how final prints can be manipulated by different exposure times, by dodging (covering part of the print while it is in the enlarger in order to make that area lighter in the final print) or burning in (using a stencil to increase the light hitting part of the print in order to make that area darker in the final print), and by cropping (using part of the negative for the final print as shown in Figure 13-11). Although effective photographs do not require the use of unusual technical devices, children sometimes gain a new perspective on possibilities by exploring double exposures, prints made from cutouts of several negatives, or examples of intentional violations of normal rules for lighting, angles, aperture, and speed settings.

Flip books are an excellent introduction to the technique of animated filmmaking. From a large 3 × 5-inch pad, tear off bound units of about twenty pages. Cut these into 1½ × 5-inch pads and staple them in the middle. Children draw a simple image on the last sheet in the pad. They flip down the next sheet so that they can see the first drawing underneath, and they make slight changes in position, size, or shape as they redraw the image on each preceding page. After completing the pad, children thumb through the pages quickly and study the motion (Figure 13-12).

Story boards are commonly used in professional film making and in video productions. They are also a useful planning technique for children. The major events in an episode are identified, drawn on small pieces of paper (4 × 6 inches), and briefly described verbally. The story board makes it possible to visualize the flow of action in a film or video production. Quite often the overall dramatic effect can be improved by rearranging the sequence of events or by introducing new elements.

Event and camera analysis in film and video work can be facilitated by making story boards or comic-strip drawings of a simple action like waking up and getting out of bed. In one frame of the strip, we see a person in a bedroom (establishing shot). In progressive frames, we see him on the bed (medium shot), rubbing his eyes (close-up), stretching his arms overhead (medium shot), and sliding his feet into slippers (close-up).

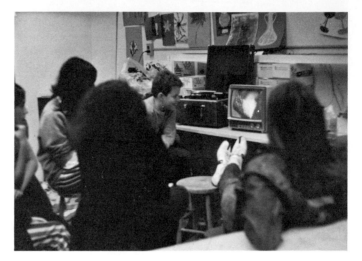

13-13 The playback of a videotape provides an opportunity for reflection on the objective image.

Children can record everyday incidents in notebooks and sketches, referring to them as possible sources of ideas for short films, videotapes, and photo essays. Details in language, dress, and interaction of figures can be noted with simple words and sketches. These notes can then be reconstructed as scenes and shots for a script; an informal script offers opportunities for improvisation and character development. A series of notes like the following might be sufficient for many situations:

Bedroom—man sleeping.

Alarm clock rings.

Man wakes, yawns, gets up.

Focus on feet.

Track with camera as he goes to window.

In general, the character motivation and imagery in children's fictional films and videotapes are strengthened by dramatic action. Fictional films and videotapes should be theatrical in the sense that they act on the viewer through plot and character development. The elements of a plot—establishing a time and place for the action, presenting an initial incident, showing actions that build toward a climax and actions that lead to a conclusion—should control the flow of the film. The characters, even if totally fanciful, should have evident motives for what they do and for how they interact with each other. When children are creating fictional works in film and videotape, they are necessarily involved in learning about theater, drama, and literature.

Encourage children to explore thematic subtleties in their work. For example, two film or video dramas might deal with different treatments of the cops-and-robbers theme. One theme may be that a logical mind (detective) can overcome physical force (robber), while the other theme may be that a logical mind (robber) cannot resist the strong bond of family ties (detective turns out to be long-lost brother of robber).

Acting for film or videotape and posing for photographs is an art in itself. Children should try to avoid overacting (unless that is what the script calls for), and they should learn to feel at ease in front of a camera (Figure 13-13). In order to look at a camera unself-consciously, it is helpful to think of it as a mirror or as a friend or as an enemy—or to pretend it is not there at all. Working in front of an unloaded camera builds familiarity with its presence and reduces camera-shy reactions. Since children are inclined to equate acting with overstatement, they usually need to work on slight changes in body gesture, facial expression, and voice pattern.

Because character identification is essential for effective acting, children should be encouraged to be themselves and to show how they feel when they are tired, angry, surprised. In scripts with totally fictional characters, children should

act the parts that they feel most comfortable with. However, it is important to avoid role-stereotyping. The class clown should have opportunities to play straight parts.

While shooting film and videotape, encourage children to explore symbolic meanings and emotional reactions that can be evoked in the viewer by such techniques as foreshadowing (showing an event or an object or a person that later becomes very important to the plot), juxtaposition (showing two apparently unrelated events, which are then woven to define a character or to reveal the plot), contrast (shifting between tense or between mysterious episodes and episodes that bring comic relief). Encourage children to try various formats for editing. They might try to edit material to make the viewers feel as if they were in two places at the same time (parallel editing), seeing the earlier history of a person or place (flashback), perceiving many things at the same time (montage), leaving one place (fade out) and arriving somewhere else (fade in).

In film making, the importance of sound effects can be studied by exploring how the same film takes on different meanings with different sound tracks. In video work, children can record a voice track on the videotape and play different kinds of tape-recorded background music as an overlay each time the videotape is shown. Audio studies of inflections can be instructive. Tape a child saying a simple line like "I didn't want that coat," but changing the emphasis on each word each time the sentence is said: "*I* didn't want . . . , I *didn't* want . . . , I didn't *want*" and so on.

Encourage children to examine the ways in which the camera can be used (in documentary photography, film, or television) to relate the most important aspects of an event. Discuss the differences in viewpoint one might show by taking the stance of a participant or of an observer of the event. Encourage children to notice the variety of ways that the camera can represent an event. Taking photographs to show definite stages in the development of a product, an activity, or an environment may inspire some children to pursue other forms of documentary work.

The artistic heritage

Photography is a relatively young art with a fascinating history. Children enjoy looking at photographs simply for the sake of recognizing familiar images or learning about people, places, and things. The history of photographic technology can be introduced around the fourth grade, when children are studying inventions. It is important that children understand the effect of photography on art and that they view photography as an art form in its own right.

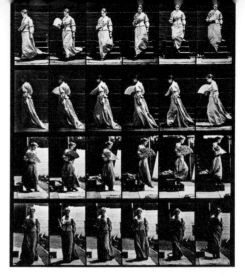

13-14 Eadweard Muybridge, Woman with a Fan.

Photography influenced art by providing a more accurate and more rapid means of capturing real images than any other medium (Figure 13-14). Soon after photography was invented, it became obvious that the camera could make artists' representational work seem little more than a poor shadow of the photograph's full detail. Thus, the development of photography caused artists, critics, and scholars of art to question the traditional criterion of "skill in representation" as a fundamental requirement for quality in art.

In response, artists began searching for images and forms of expression that were beyond the technical reach of the camera. If the camera could perfectly render any form from a fixed vantage point, then the artist could break up form into units of color and show the same form from several viewpoints at one time. If the camera could show objective reality, then the artist could express the inner life of dreams, fantasy, and emotion. Critics and scholars found good reason—because of both the invention of photography and the new work of artists—to redefine the nature of art and to respond more positively to abstract and nonrepresentational work.

Although many museums and galleries now collect and exhibit photographs, widespread acceptance of photography as art has occurred within only the last two decades. Acknowledgment of photography as an art form in its own right has taken time because photography *is*

representational and because the points at which the artistry is evident are easily confused with the mechanical and scientific principles involved in capturing the image.

The artistry of photography lies in the selective eye of the photographer—the ability to single out a moment, frame it, and technically control the camera to capture the essence of that moment. The timeliness of judgment is as critical as the photographer's attention to technical matters. Some photographers aim to capture an image fully and perfectly on the film negative so that the print can be developed by a straightforward, unmanipulated process. Other photographers consider darkroom technique and manipulation of the printing process to be an essential part of the artistry of making a photographic print. They are interested in building a fine photograph by dodging, burning in, cropping, using overlays and other techniques that suit their expressive intent.

Although photographs are usually small in scale and intimate, some photographers are challenging this traditional format. Utilizing the full technology of photography, artists are creating photo murals, developing prints on three-dimensional surfaces, working with holograms, and exploring the frontiers of computer-enhanced photography from satellites.

Moving pictures developed from the technology of still photography (Figure 13-15). In 1872, Eadweard Muybridge photographed with

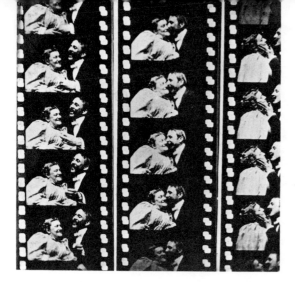

multiple cameras the motion of a running horse. Shown in quick succession, the horses seemed to move. By 1902, the motion-picture camera, invented by Thomas Edison, together with contributions to film technology by George Eastman, permitted photography of multiple images. *The Great Train Robbery* (1903) was one of the first films to make dramatic use of the medium. Talking movies, technically achieved in 1910, gave film makers unparalleled freedom to show real life and to create on film a time-space capsule for temporary escape from the real world. With Walt Disney's pioneering work in film animation in the late 1920s, film options for escape, fantasy, satire, and humor were further expanded.

Children should have the opportunity to see films of historical, artistic, and social significance. Film rentals or loans can be arranged through many public libraries or through the district audio-visual center. Lengthy films might be shown after school or in the early evening in a publicized film festival to which parents may be invited. A synopsis of the film, mention of its length, and a brief commentary on its significance should be included in the film program. Teachers should never show films that they have not previewed personally.

Television is so much a part of our lives that it is difficult to realize that commercial telecasts have been in existence for only a little more than three decades (since 1941), and that televi-

13-15 Thomas Alva Edison, excerpts from *The Kiss* and *The Great Train Robbery* (1903).

13-16 Nam June Paik, *TV Garden* (1974).

sion did not flourish until the end of the Second World War. Color television dates from the mid-1950s and satellite transmission from the late 1960s.

If today's children take television in stride, it does not necessarily follow that they comprehend the extent of its influence on their lives. Although programming on commercial channels is varied, the amount of time children view television, the intimacy of the medium, and the number of duplicate shows within a genre all make the experience of television a Gestalt that children undergo but do not really see or hear or evaluate. In the presence of a television set, real life is discontinuous: it surrounds the act of viewing television and occasionally interrupts it. But real life can also be made to disappear for extended periods simply by looking into the magic tube.

Video artists are using many of the techniques developed for commercial television in order to express the contextual importance of this medium in our lives; they demonstrate how the medium works its magic on us. For example, imagine a dark room with a garden of plastic plants flowering with images from a dozen color television sets placed at different angles, each set broadcasting a different program (Figure 13-16). This actual work is a timely, if satirical, comment on the age-old quest for a perfect "Garden of Delights." Consider another example. A miniature television set shows an endless parade of

marching soldiers, synchronized with an endless printed and audio message saying, "March, march, march, . . ." To reach the set, the viewer must, in fact, march, march, march up to it, stepping regularly on or between evenly spaced boards leading up to the image. Are there dangers in our magnetic attraction to television, as this artist suggests?

In these examples, the potential or real influence of television on our lives is both the content and the medium of the video artist's statement. Other uses of the medium reveal its potential as a mirror of life—not the well-framed, perfectly safe, always concluded, invariably entertaining picture of life that we find on commercial television, but slices of life that show the inconclusiveness, the discontinuity, and the extended periods of boredom of day-to-day existence. For example, in contrast to our response to the selective use of instant replay on commercial television, what would our reaction be to a replay of an entire day in our lives, or to a replay of a videotape depicting ourselves looking at a television camera, while we sit in an empty room. Is television really audience oriented? Such explorations of the medium reveal that the contemporary video artist views television from a perspective unlike that of the commercial television producer or director.

Under ideal conditions, children should have the opportunity to talk directly with local photographers, film makers, and video artists

13-17 A third grade class learns about the work of photographer Lewis Hine.

and to see their work. Photographers are more numerous in most communities than film makers and video artists; however, for the limited purpose of acquainting children with film and video technology, teachers may find commercial film makers or local television stations that are willing to invite school groups to visit their studio facilities.

In order to acquaint children with the artistic dimensions of these art forms, activities should focus on personal identification with images in the work, on discerning how composition and lighting (or color) heighten the feeling in the work, on interpreting ideational or symbolic content in the work, and on reading the work to assume the standpoint of the artist who created it.

Engage children in exercises to heighten sensitivity to the imagery and technical qualities in a work of still photography.

Invite children to envision themselves as the artist who took the photograph. Ask them to see the photograph as if they were looking through the viewfinder of a camera. Have them imagine the thoughts of the photographer while setting the angle and distance of the camera from the subject. Ask them to consider where the sources of light seem to be and why the photographer would be concerned with the lighting.

Provide each child with a simple viewfinder or cardboard tube through which he or she can examine sections of a photograph as if the child were the photographer inspecting the work in detail. When the child finds a part of the work that is especially interesting, invite him or her to describe it in detail so that other students can find the same section.

Hand out ten or twelve 1-inch square pieces of paper with a hole punched through the center of each piece. Have children place the paper squares on top of the photograph and see if they can find different shades of gray, ranging from very light to very dark, within the circle of each square. Have them move the squares around to find areas in which lights and darks are concentrated.

When the subject matter of the photograph is a portrait, still life, or landscape, have children enter into the frame of the photograph and imagine themselves in the setting being photographed, feeling the light and shadow fall across them and noticing how surface textures are revealed or hidden by the light. Invite children to personally identify with the subject matter, imagery, and space of the work (Figure 13-17).

In order to appreciate photography, film, and television as art forms, children have to consider relationships among the illusions created in these media, the techniques by which the illusions are created, and the way in which human experience is characterized.

Invite children to consider why, when we look at a photograph or watch a film or a television program, we feel as if we are looking at something that has really occurred or at something that is actually happening as we watch it. Encourage children to reason out those aspects of a film or a television broadcast that contribute to our feeling that events portrayed are really taking place while we are watching the film or program. Is it because the time, place, and events *are* real, and the camera has merely recorded them? Is it because the time, place, and events are not real, but the camera, acting, and location make us feel *as if* they are real? What makes an animated film or television cartoon lifelike? Is it the similarity to real life? Or is it the fact that we are actually seeing the images even though fanciful characters are portrayed? Or does the world created for cartoon characters seem to be real for the characters?

Ask children whether they feel as if they are physically present in the scene as they look at a photograph or watch a film or a television program. Are they just there with their minds—that is, involved mentally with the action and the feelings of characters but not physically in the space that is on film? Can you enter into the action more easily watching a film in a dark theater or watching television at home or in school?

Have children compare their experience of space and time in their dreams and their experience of space and time in watching films or television. In dreams, for example, can you see things even if you are not at the scene? Can you also do this when watching a film? In dreams, can you know that people are different from you, but, at the same time, can you seem to feel, think, and see things just as they do? Does this happen when you watch television or films? Can you plan a dream, or does it just happen to you? Can you plan what you see on television or in a film once you are watching it? Are you more in control of your thoughts when you are dreaming or when you are seeing a film?

Invite children to identify specific techniques and to describe the sensations that these techniques suggest: slow motion (weightlessness, lightheartedness, unreality); fast motion (comedy, satire, superhuman power); zooming in, tilting, turning, or jarring the camera (dizziness, crashing, confusion, shock); intercutting (rapid motion, seeing the same thing from different angles, locations, time frames); dissolves (change in action or location).[1]

Help children notice that film or video sound may parallel and reinforce what is being seen or it may be used as a contrast to what is being seen or it may build anticipation and curiosity about future events. Obtain a short sound film and show it as a silent movie; follow this showing with one that includes the sound. Have children watch television for short periods with sound and without sound, and have them

13-18 NBC control room, New York City.

listen to video broadcasts without seeing the picture. How clear are the images we get from sound alone?

Ask children to make judgments about the human conduct portrayed in films and television programs. Judgments might be guided by questions like the following: Do people you know really behave this way? If so, why? Suppose everybody acted the way this person did? Do you think this person's behavior was right or wrong? Why was it right? Why was it wrong? Do you think it is right or wrong to create a film or a television program that shows people doing evil things? In the upper elementary grades, such questions can be the basis for more formalized student debates.

Art in society

In the business of commercial film making and video production, tasks and roles in the total production are well defined. Typical roles in producing films are briefly described here. In television, many of the same tasks are performed but the people have slightly different titles (Figure 13-18).

The *producer* is responsible for the whole film or broadcast, including the idea of making and financing it, choosing the key people to work on it, and arranging for its showing. The producer delegates work to one or more *produc-tion* or *unit managers,* who keep track of money and make all arrangements for the director, the cast, and the crew. The *writer* creates an original script, adapts a story, or prepares the narration for a documentary film.

The *director* works on the creative side of the film or broadcast. The director works with the camera crew, the actors, the set and costume designers, and the editors to make sure that the expressive theme is captured on film or tape. The *assistant director* sees that everything is ready when filming begins. The person in charge of *continuity* is concerned with recording the details of each film segment by scene, shot, and take so that they can be edited later.

The *cinematographer* composes the camera movement and lighting of each take so that the director's interpretation is captured on the film. In large productions, additional specialists operate the camera and control lens and focus changes; in small productions, the cinematographer does all the camera work. Assistants help load film and carry equipment. Occasionally assistants will change focus and exposure settings.

The *art director* has overall responsibility for the appearance of everything that is filmed—the titles, the costumes, the set. The *set designer, costume designer,* and *makeup artist* usually work under the art director.

The technical crew includes a *sound director,* who makes sure microphones and recording

equipment are properly placed and working, and a *lighting director*, who supervises the work of *electricians*, or *gaffers*. A person responsible for props (properties) makes sure small objects are in place. Anything that needs to be moved on a set is handled by *stagehands*, or *grips*.

The *film editor* splices finished film into a sequence that expresses the idea or theme of the film. If a director works from a loosely structured script, the film editor's decisions may be as important as those of the director.

It is instructive, as an exercise, to watch the credits in several films or television broadcasts. Inventory both the number of people involved in the production and the number of roles or job classifications that are listed.

There are many ways to develop children's awareness of the social and commercial aspects of photography, film, and television:

Provide children with old magazines. Have them cut out all photographs from either every odd- or every even-numbered page and classify them into two broad categories, documentary and advertising. Have children create subcategories to show patterns in the use of photographs. Discuss the proportion of photographs used for documentary reporting or for advertising, and whether color photographs are used more frequently for one category than for the other.

From various magazines collect photographic images that are used to sell a single product. Compare the images, settings, clothing, and other kinds of audience appeal that an advertiser uses to sell that particular product to a variety of people. Discuss the importance of photographs in molding our opinions about desirable dress, jobs, activities, and products.

If the school is in or near a city, take children on a walk to look for photographic images. Point out places in which photographic images can be found (stores, banks, school), how they are presented (framed; printed on posters, packages, or billboards), and what they are used for (to honor a person, to sell a product, to record an event).

Study newspaper advertisements for films. Count the number of films that are in each of the rating-code categories. Cut out the advertisements and put them in a display according to the amount of space each occupied in the newspaper. Determine whether the larger advertisements are for films of a particular type. If the community is large, the same film might be seen in several locations. Rearrange the advertisements on a map to show in how many theaters the same movie is being shown. Discuss the relationship of film advertising and distribution to box-office sales.

Ask children if they have ever seen bloopers in a film or on television. For example, in a Western film, a cowboy is shot by an arrow and falls off his horse, but in the attack scene that follows, all the Indians have rifles; or a character

13-19 The attraction of the "flicks" is as strong today as it was in 1910.

is shot in the back but appears later, for no apparent reason, with his arm in a sling; or one car pursuing another car miraculously loses and regains its hubcaps several times in different scenes in the chase. Ask children to imagine how bloopers like these can occur.

Discuss the commercial aspects of the film and television industries (Figure 13-19). What is the difference between films and television as business and as art? What is the relationship of showmanship and entertainment to art? Ask children to find out whether it costs more to produce a film than to print, distribute, and show it. (More money is usually spent on production, primarily because union rules rigidly define tasks that can and cannot be performed by every member of the production crew.) Invite comparable investigation of financing prime-time television shows—for example, the cost of a single program ($150,000), who pays for it (advertisers), the amount of viewers that a program must attract in order to stay on prime time (20 million), how program ratings are determined (Nielsen's sample of twelve hundred homes).

Have the children create three or four one-minute commercials for an imaginary product. Make each commercial different. One might be a soft sell, another a hard sell; one might show people using the product, another might focus on details of the product itself. After the commercials have been made, use the advantages of the videotape machine—playback and holding

images—to study segments of the commercials, noting such things as camera techniques, sound and pacing. (Use the same advantages of film projection equipment—rewind and still settings—to study films for camera techniques, sound, and plot and character development.)

Collect duplicate copies of television program listings from a local newspaper. Have children color-code in red (lightly) the time blocks of three of their favorite programs. Have them color-code in blue the time blocks of three programs that they dislike. Cut out the time blocks and paste them on paper to create a graph showing how many children prefer and dislike the same programs. Discuss characteristics of the programs children like and dislike.

Invite children to name the products advertised on their favorite television show. Ask them if the products are things that they can use, or if the products are more often used by adults. If the products are things that they would like to have, ask children to figure out why the advertisements make them think the products desirable. Ask them if they have ever gotten something they saw on television that was not as much fun or as good as it seemed to be in the television commercial.

Beginning around the fourth grade, children can analyze the psychological appeal of advertisements on television and in magazines. Invite them to collect examples of magazine advertisements based on "appeal to authority,"

the word-magic of "statistics," "keeping up with the Joneses," and similar techniques. As an alternative, see if you can obtain permission to make videotapes of commercials produced in your community for local audiences. Develop a collection of tapes. Play back the commercials and invite children to identify the forms of appeal presented in them.

Note

[1] For an excellent overview of film aesthetics, see F. E. Sparshott, "Basic Film Aesthetics," *The Journal of Aesthetic Education* 5 (1971). This entire issue is devoted to problems in teaching film.

Suggested Readings

Anderson, Yvonne. *Make Your Own Animated Movies: Yellow Ball Workshop Film Techniques.* Boston: Little, Brown, 1970.

Arnheim, Rudolph. *Film as Art.* Berkeley: University of California Press, 1957.

Doing the Media: A Portfolio of Activities and Resources. New York: Center for Understanding Media, 1973.

Editors of Time-Life Books. *Time-Life Library of Photography.* 17 vols. New York: Time, 1970–72.

Jacobs, Lewis. *The Emergence of Film as Art.* New York: Hopkinson & Blake, 1969.

Johnson, Nicholas. *How to Talk Back to Your Television Set.* New York: Bantam Books, 1970.

Mayer, Martin. *About Television.* New York: Harper & Row, 1974.

Newhall, Beaumont. *The History of Photography.* New York: Museum of Modern Art, 1964.

Sculpture

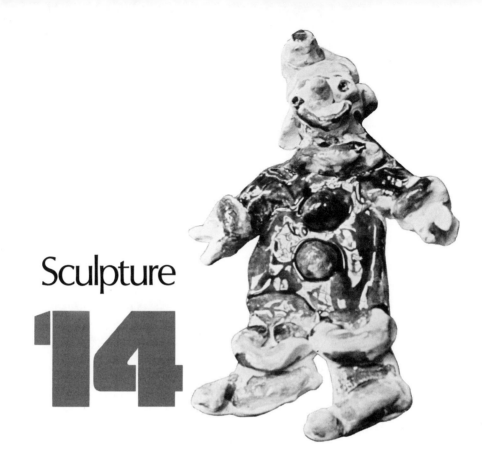

14

This chapter suggests methods of developing children's understanding of sculpture. The processes discussed here are primarily modeling soft materials and assembling forms into three-dimensional structures. Simple forms of casting are also presented.

Personal expression

For very young children, sculpture is a refined product of learning to shape pliable substances and to assemble forms in space. Children's initial sensitivity to sculptural form is probably influenced by tactual, spatial, and kinesthetic explorations within the home, and by active play that promotes controlled use of large and small muscles.

Preschool children usually develop their first sculptural forms in the context of play, assigning objects such names as "chair," "basket," "table," "baby," or "car." In using soft modeling materials like clay or play dough, children may create miniature environments that serve as stage sets for imaginary events with actors and props. In assembling structures out of wood, building blocks, or boxes, children often make a toy or create an environment in which dimensional forms are first treated as props for imaginative play and are then refined into objects that are enjoyed for their own qualities. More formal guidance in developing ideas for sculpture should begin when children show an interest in refining these play objects, environments, and props without regard to their immediate use for play. Children usually make this transition late in kindergarten or in first grade.

Media and processes

MODELING. Very young children are attracted to soft, easily shaped materials that retain a definite shape (Figure 14-1). Among these are plasticene, an oil-based clay; ceramic, or earth, clay; clean, wet sand; commercial substances like play dough; and homemade clay of cornstarch mixed with salt.

Except for preschool use, ceramic clay is preferable to plasticene clay, play dough, and other modeling materials. Ceramic clay is a more permanent medium, and the earlier children learn to use it, the more control they will develop, and thus the more satisfaction they will find in working with it. Because ceramic clay has water in it, it dries out when it is exposed to air. The dry clay is brittle and easily broken unless it is fired at a high temperature in a kiln to alter its molecular composition.

Ceramic clay should be available for independent use on a daily basis. A sculptor's turntable with a shelf for clay-working tools can be made from an old swivel-base kitchen or office chair. The turntable should be located in a corner close to drying shelves, clay storage, and the wedging board. A crock, one-quarter filled with water, can be used to mix dry clay powder into moist clay and to restore dried clay to a workable state.

Children should be taught how to recycle used clay by placing it in a crock with water and wedging and kneading the clay to remove bubbles. A parent or high school student volunteer might rework and wedge the clay on a weekly basis; this arrangement provides a fresh supply of clay for children to use and permits them to observe the process by which the clay is made workable. A wedging board and plaster drying bats should be available for the adult to use in the classroom. By the end of the second grade, some children will make effective use of the wedging board on their own, with little adult help. In the middle and upper elementary grades, several children will generally show great interest in clay and learn the consistency it must have to be workable. These children might take turns being clay experts who monitor the clay corner and help other children work effectively while the teacher is occupied with the rest of the class. The clay experts might offer assistance on a daily basis before or after school or for a short time during the day.

Children should also be shown how to restore the moisture in the clay while they are shaping it by adding a small amount of water and kneading the clay. They should always work on a cloth-covered board, 6-inch square or larger, so that the work can be easily removed from the table and studied or exhibited. Tools for carving and embossing clay can be purchased or made from dowels and tongue depressors. Cookie cutters and similar dies with simple shapes can be used for slab construction. A frame for slab con-

14-1 (*top, right*) Clay has an immediate responsiveness that children appreciate.

14-2 (*bottom, right*) A whimsical ceramic container shaped like an ice cream sundae. Grade 4.

struction will enable children to achieve an even thickness when they roll out the clay.

Teach children how to develop surface textures in clay; how to roll out, cut, and join slabs; and how to prevent thin parts from breaking off by moistening the thin areas slightly while the thicker parts dry. Children should learn that clay is made permanent by firing it in a kiln. If a child's work is especially well made, expressive, or beautifully arranged, it should be fired. Children should understand that artists do not fire every work they create but choose only those objects worth keeping. Children should evaluate their own pieces prior to determining which should be fired.

When color will heighten the existing form, mood, or clarity of the sculpture, premixed englobes (colored clay and minerals) can be applied with a brush, allowed to dry, and completely covered with transparent glaze (matte or glossy) (Figure 14-2). It is best for an adult to assist the child in applying this final coat of glaze by pouring it over the piece or by dipping the piece into a large container of glaze. The transparent glaze is necessary to seal the underpainting glazes and to waterproof objects painted with englobe. (Note that transparent glaze looks milky and opaque until it is fired.) Most classroom teachers will need the assistance of an art specialist to refine their skills in managing the processes of firing, glazing, and refiring children's work.

Even though most forms of metal are extremely difficult for children to shape, metal foils and soft wire are two of the more manageable materials that can be used for modeling. Flat rolls of foil in copper or aluminum (36-gauge) can be cut and fashioned into low-relief sculptures by using hardwood tools to depress the surface from both sides (Figure 14-3). For beginning efforts, the foil should be small (about 4-inch square). The edges of foil must first be folded down twice or taped to prevent cuts on the hand.

Ideally, the metal foil is shaped on a pitch block, which both supports the metal and yields to the pressure being applied to it. Simple pitch blocks can be made by putting a half-inch layer of plasticene on an old floor tile, in a shallow tray, or on a piece of rubber mat. The latter is ideal because it will not skid across the table. Two substitutes for pitch blocks are a thick layer of newspaper and a folded pad of cloth. Unlike the pitch blocks, these surfaces do not support the metal surfaces that have already been raised. Without this support, raised surfaces are more vulnerable to accidental crushing. Children who are attracted to this form of sculpture should try larger works and can be shown how to hold tools and tap them gently with a lightweight hammer to add depth to the form. Extensive pressing and hammering should be avoided because they harden the metal and make it brittle. Finished work should be mounted on a block of wood or other suitable base.

Soft wire is of primary value as a medium for making three-dimensional sketches (Figure 14-4). Children should not use it unless the ends are bent, taped, or covered with plasticene or corks in order to prevent children from poking themselves. The more wire is bent and twisted, the harder and more brittle it becomes. Unless stovepipe wire or very narrow-gauge wire from telephone cables is used, this material can be extremely frustrating for children. In addition, it is difficult for young children, with their relatively undeveloped muscles, to attach wire to wire, which requires either a sharp, twisting pressure with fingers or pliers, or soldering, a complex process best introduced in the later grades. In general, quick three-dimensional studies in plasticene clay are more satisfactory than comparable efforts in wire.

ASSEMBLING. Blocks of different sizes and shapes are a versatile medium for assembling sculpture. Blocks may be of wood, plastic, cloth, or foam rubber. Commercially made toys with blocks or interlocking parts are numerous and should be made available in the kindergarten and early elementary grades. Children can also assemble sculptural forms from styrofoam shapes that can be connected with small ($\frac{1}{8}$- to $\frac{1}{4}$-inch)

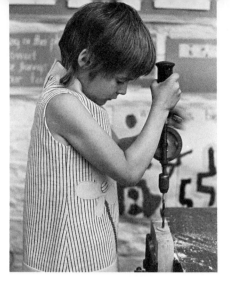

14-3 (*opposite, left*) A low-relief sculpture in aluminum foil. Grade 3.

14-4 (*opposite, right*) A direct linear expression in wire. Grade 4.

14-5 (*right*) Learning to use a brace and bit.

dowels or from painted cardboard or plastic boxes. Joining assorted metal shapes with magnets both permits young children to assemble sculptural forms quickly and introduces children to metal as a medium for sculpture.

Wood sculpture, both full round and relief, can be created by children of all ages. A large supply of precut soft wood scraps should be available, together with an accessible tool panel and a worktable equipped with two large carpenter's clamps. Free scrap wood can usually be obtained from a local lumberyard. Dowels, spools, spindles from chairs and bannisters, and curved wood scraps should also be collected from homes, junkyards, and furniture-making shops.

If the classroom is not equipped with hand tools, the school should have at least one portable tool rack that can be shared by every five or six classroom teachers. Trace silhouettes of tools on the tool rack so that students can see where tools should be returned. If the classroom does not have a carpenter's table, one can be improvised from a heavy table. Secondhand tools, including carpenter's vices and clamps, can often be purchased at auctions or from dealers who specialize in selling used tools and equipment.

Teach basic safety rules for using all tools and equipment, and demonstrate which movements are most effective with which tools. Contrast clumsy technique with efficient ways of handling tools. For example, dramatize the frustration of trying to saw wood with short, choppy strokes and with the saw blade twisted and vibrating; contrast this with slow and easy cuts that glide straight through the wood.

Whether cut by the child or precut, wood can be assembled with white glue, nails, screws, nuts and bolts, or dowels. If they plan to use bolts or dowels, children must use a brace and bit to drill holes just large enough to insert the bolt or dowel in the wood. Preschool children can learn to put wood in a vise, to saw with two hands, to use a hammer and nails, and to drill holes with a brace and bit (Figure 14-5). They have difficulty using a standard hand drill and screwdriver, but they can assemble wood by using glue and clamps. They can learn to use a sanding block or sheet sandpaper to smooth wood. Although they are not yet skilled in painting three-dimensional forms, they enjoy doing so. Thick tempera paint can be used to paint wood sculpture, but an adult should coat the work with white shellac or lacquer after the tempera dries to make the tempera waterproof.

Older children who have had ample practice in using saws, hammers, clamps, and drills can be shown how to use planes, squares, and other specialized woodworking tools. Most fifth graders can effectively use a power drill and band saw with adult supervision. They can also finish wood with varnish, wax, enamel, or latex

paint and learn to use masking tape for hard-edge effects with spray paint finishes.

Although children are attracted to mobile and kinetic sculpture, their level of engagement is often limited to a superficial curiosity about the mechanics of making the form move, or a fascination with optical tricks and decorative effects. Explain to children that mobile and kinetic sculpture become expressive when they are based on an understanding of the different meanings of motion, energy, and time in a technologically advanced society.

Air currents and their relationship to kinetic and mobile sculpture can be introduced in the preschool and primary grades. Children can hook simple cardboard forms to suspended framing systems made of dowels and pegs or wires, and these mobiles can be hung where air currents will move them. Larger versions can be created on a windy day by tying balloons, streamers, lightweight paper shapes, and painted cardboard boxes to playground equipment or to low trees.

In the middle elementary grades, when children are studying inventions, simple mechanical mobiles can be made. Battery-operated motors combined with springs, levers, weights, and simple systems of wiring can be used to create forms that move and even illuminate themselves with electric lights.

In the upper elementary and junior high school years, children should be encouraged to identify natural or mechanical principles of motion that might be illustrated by shaping materials. For example, inflated forms might be created to reveal air currents outside the building, or systems of falling weights and springs might be coordinated to reveal the reciprocal motions of contraction and expansion, lifting and falling.

CARVING. Carving in wood should not be undertaken until the upper elementary grades, but carving of bricklike clay, plaster mixed with vermiculite, and soap or sandstone can be introduced in the first and second grades. Indeed, one of the major advantages of introducing carving at this time is the child's ability to imagine that there is a figure or form inside the block of material that is waiting to be uncovered so that people can see it.

Early successes in carving are important. Children should be encouraged to envision roly-poly figures, bulky animal forms, or faces with particular expressions so that they can avoid carving thin parts that may break off. Children are more satisfied by their first carving experiences if they use professional tools that are specifically designed for sculpture, such as straight and curved rasps and knives. Inexpensive versions are table knives, heavy plastic dinner knives, screen wires, or dragon skin (thin sheets of metal punctured like a fine grater)

14-6 A carved plaster head. Grade 7.

rolled into small cylinders and taped on the edges. Working in a shallow cardboard box or tray makes cleanup easier.

Initially, children should work on small, very soft blocks that they can hold tightly in one hand while they use the other hand for carving. They should be encouraged to imagine how their figure looks from the top (as if a bird were seeing it), front, back, and sides. They should rotate the block frequently so that they can avoid the beginner's trap of merely drawing on each side of the block. Larger blocks should be undertaken after children have demonstrated good control in smaller works (Figure 14-6).

CASTING. An easy way to introduce children to casting is as follows: Place wet sand or plasticene in the bottom of a box. Children carefully press natural or constructed objects into the sand or clay to leave an impression. They watch while an adult mixes plaster and pours it into the box. After the plaster is set, the box is torn away and the clay or sand is gently removed, leaving the more permanent low-relief sculpture in plaster. For the first experience, use small boxes (about 4 inches × 4 inches × 2 inches) and fill them with sand or clay to a depth of approximately ½ inch. When casting, fill the shallow boxes to the brim with plaster. After several trials, children can begin to develop thematic and expressive low-relief sculpture.

Working with press molds is also an excellent way to introduce children to casting. Small precast slabs of plaster, about ¾-inch thick and 4-inch square, should be provided for experiments. The plaster slabs are carved in reverse with small tools like hairpins, paper clips, or old dental tools. Moist ceramic clay is then pressed firmly into the carving, lifted out, and trimmed. This positive, or raised, form is a small low-relief ceramic sculpture. After several trials, children will begin to anticipate that deeply carved areas will be the most elevated in the final form.

In the upper elementary grades, children can make small relief sculpture by casting metal into carved plaster molds. Scrap lead or pewter can be melted in a metal pan on a hot plate, carefully poured into a dry plaster mold, and quickly covered with another flat slab (of wood or plaster) to create a flat surface on the back and force the metal into the mold. When the metal is cool, it can be removed from the mold.

Regardless of the medium or process, finished sculpture should be mounted on an appropriate base; few pieces are effective as complete works without a base. The base also helps establish that the work is sculpture, not merely a decorative statue or figurine. Children can fashion their own bases from wood scraps. Although epoxy glue is the most permanent way to attach a work to a base, it is toxic until it hardens and so should be mixed and applied by an adult. White glue is also satisfactory.

In general, media and processes of greater complexity and scale can be undertaken in the upper elementary and junior high grades. For example, wood and stone carving can be managed if these materials are soft and if students use professional tools. Larger sizes of relief casting with lead or pewter can be attempted. With careful instruction, initial supervision, and good equipment, both soldering and brazing can be mastered, permitting students to create freestanding works from metal.

Adolescents can design and execute works in mixed media—clay and wood, wood and metal, metal and stone—but mixed-media sculpture is most successful when one of the materials functions primarily as a base or background for the other. Of much greater importance than these technical possibilities is the appropriate choice and use of media for expression. Indeed, the more options for working in complex processes, the greater the need for preliminary studies and careful selection of the medium and process.

Large works can be undertaken by the early adolescent (Figure 14-7). Although they may encounter some difficulty in executing large works, adolescents are usually sufficiently motivated to tolerate some struggle in completing them. The size of ceramic works is generally limited by the size of the kiln, which may be about 18 × 18 × 18 inches. This apparent limitation can be overcome by composing a larger work and executing it in sections.

For works assembled indoors, the upper limits of size are determined by the size of doors through which the work must be moved and by storage or traffic limitations. Early adolescents can work effectively on wood or stone carvings of two or three feet in major dimensions. Comparable sizes are appropriate for soldered or brazed metalworks as well as for castings in clay or plaster. Working outdoors, limits in scale are determined primarily by physical prowess and by the ultimate destination of the work—that is, whether it must be moved or will become a permanent part of the school environment.

Although paper is an inexpensive and popular medium for school sculpture, few professional sculptors, past or present, have chosen paper as a major medium for expression. Indeed, paper sculpture is most frequently associated with folk art involving ceremonies and celebrations or with temporary commercial displays in stores. In both cases, paper sculpture is used decoratively to enhance the expressiveness of an environment or an event.

The overwhelming reliance on paper as a sculptural medium in schools reinforces a decorative rather than an expressive concept of sculpture. Although paper has much to commend it as a decorative medium, both two- and three-dimensionally, it also can miseducate children

when it is treated as a major sculptural medium. Ironically, many classroom and art teachers who have learned to make such things as paper or papier-mâché animals and masks have done so without benefit of any historical or contemporary perspective on this medium. A corrective step is to distinguish the value of paper in decorative and ceremonial contexts from its lack of merit as a major expressive sculptural medium.

Motivation

In the latter part of kindergarten and in the primary grades, teachers should expand children's understanding of subjects and themes that they might express in sculptural form. Among these topics are people, animals, and plants, as well as objects and environments, both real and imaginary. Discussions will intensify children's imagery. For example, if a child begins making a figure in clay, ask if the figure is an adult or a baby, if it is happy or sad, if it is a brother or sister or friend. Kinesthetic and emotional identification with a theme can be nurtured through role playing. For example, invite children to become a plant that is just beginning to come up out of the ground. Have them become seeds that are growing, pressing up through the warm earth, seeing the light, stretching up, slowly unfolding their leaves, and

gradually pushing out each petal to become flowers. Use similar imagery to build kinesthetic awareness of other things, events, and processes.

Throughout the elementary and junior high grades, children's motivation for creating sculpture is still closely related to the tactual appeal of materials and the physical activity required to shape them. However, when children do start to work with an initial idea or an expressive purpose, it guides their activity; their interest in using sculptural media does not vanish at the first sign of difficulty in shaping materials. For this reason, vivid and active ideational motivation should be provided.

Ideas based on nature and the constructed environment should be explored so that the sculptural qualities of the forms are made apparent to children. Observable forms like plants, animals, buildings, machines, and people have characteristic profiles that permit us to recognize them at a glance. However, the clarity of a sculptural form is not determined by a single profile or viewpoint but by the multiplication of profiles or views. For this reason, observations must be made from all angles—above, below, left, right, front, back, and so on. Similarly, the natural and industrial processes through which forms are created can suggest ideas to be captured in sculpture. Consider plants and other organic forms that are created by stresses and tensions as they grow and are nourished by in-

14-8 A surrealistic ceramic sculpture. Grade 8.

ternal systems of circulation that provide nutrients to vital parts. Also consider machines that are composed of interlocking parts and buildings that are made by stacking and bracing smaller units. Observation of these structural systems may suggest images and ideas for development into sculpture.

Imagination and fantasy are also sources to which the child may be directed for sculptural ideas (Figure 14-8). Fantasy animals like dragons, griffins, and unicorns appeal to young children. Prehistoric creatures like dinosaurs also hold the interest of children well into the third or fourth grade. Combinations of natural and machinelike forms can inspire works. Inverted relationships in texture, position, proportion, and color may also be explored as sources for ideas for imaginary sculpture: a miniature elephant on the back of a tiger, a person sleeping in a stalk of celery, a purple cow.

Broad themes that invite sculptural development include emotional relationships between parents and child, mother animal and baby animal, and families of people and animals. The emotional relationships might take many forms: loving, nurturing, protecting or fighting, jealousy, isolation. Older children may enjoy creating sculpture based on memories of moments of triumph or special pride, or occasions of bitter disappointment and humility. Older children are also interested in social com-

mentary and satire as a means of expressing their opinions about growing up and their keen understanding of injustice and contradiction in adult behavior. At the opposite extreme, inspiration for sculpture may derive from children's idealized conceptions of manhood, womanhood, success, beauty, and honor. It is essential to probe the child's personal feelings and concepts in order to generate imagery appropriate to a sculptural expression of the child's attitude (Figure 14-9).

Expressive possibilities may also arise from everyday life. Sculptural gifts and mementos might be created to celebrate special events. The desire to make some part of the environment more attractive can lead to sculptural activities that range from redesigning door handles, to making three-dimensional signs or markers for the home and school, to producing sculpture especially for the blind, to creating playground sculpture for a nearby nursery school.

Ideational depth, developed by engaging in dialogue with children to clarify their feelings and thoughts about a topic, builds competence in expression. Baseball, for example, is not simply a game with players standing still at various places on the field. It is an emotion-laden experience for both players and spectators. If a child is interested in expressing something about baseball, encourage him or her to consider such

SCULPTURE

14-9 *My Summer,* assemblage. Grade 6.

things as the frustration, anxiety, and fatigue of players; the grace of skilled competitors; the exhilaration of winning; the inherent quietness of some parts of the game. The intensity of the child's identification with a feeling or an idea is vital to translating that conception into sculptural form.

Guidance

Growth in sculptural expression generally occurs at a less rapid pace than growth in painting and drawing, primarily because sculpture requires simultaneous attention to all three dimensions of a work, and the technical aspects of the medium are inherently more difficult to master. Thus, children need guidance in translating their initial ideas into perceptions and feelings that are particularly conducive to sculptural expression, and in seeing sculptural qualities during the process of creating their forms.

Encourage personal identification with patterns of movement, angular shifts, points of stress and tension, overall gestures, and subtle turns that make us feel as if we actually were the work. For example, have the children act out a physical activity, such as lifting a heavy rock, rolling a huge ball, or pushing a broom. At some point in the action, when you say "freeze" or "statue," the children should become very still.

Ask them to listen to their muscles talk to them, saying, "I'm in your arm, I'm pushing": "I'm in your leg, I'm pulling": "I'm just resting": "I'm beginning to wobble, I've got to rest."

A sensitivity to action can be fostered by close physical imitation of one person's movements by another person who is the mirror. After demonstrating the technique, divide the class into partners and designate the mirrors. At the beginning, briefly describe some actions that might be done by one partner, such as "going to sleep," "brushing teeth," "hitting a baseball," "looking for something lost in the grass." After the children practice both roles, have them invent their own actions and act them out in very, very slow motion (as they have seen on television). Help them notice shifts in position, the flow of movement, and parts of their body that are "working hard" or just "going along for the ride."

The mechanical-toy activity is designed to develop sensitivity to separate parts of the body and the directions in which they move. One child pretends to be the inventor; the other, the mechanical toy. The toy can move only if the inventor explains how and which parts of the body to move. For example, the inventor might say, "Pull your knee straight up, bend your body at the waist—no, not to the side, straight down." Each inventor poses the model for the class to see. Children alternate roles. Help them notice both the angles formed

by body parts and the body joints that create the angles.

Sculptural forms are also defined in large measure by patterns of light and shadow. Examine works under controlled lighting conditions. Darken the room and look at the sculpture under spotlights and from different angles. Some works might be placed in a dark corner of the room and lighted from each side to study highlights and shadows. In a room with the lights off, even a flashlight provides enough contrast to reveal the way edges and hollows catch light, making the form visible. A portable floodlight or a special lighted turntable is even more effective. Notice shapes formed by shadows within the structure and on the floor and walls. Take several black-and-white photographs of especially complex, beautifully arranged, or thematically clear works so that children can see their work in a new way. Examining a work in a mirror will often reveal parts that may need further development or rearrangement.

At every opportunity, encourage children to view their sculptural forms from all sides. A small object can be placed on a turntable and examined with the child to see how it looks at eye level, from each side, and from the top. Small sculptural forms should be created on a board so that they can be moved to a safe location and reexamined later. Larger works, typically assembled from wood blocks and other ready-made forms, should also be examined and refined. Offer specific comments on height, balance, theme, and depth (ins and outs or hills and valleys) to draw children's attention to their intuitively developed arrangements.

Tentative visual studies, sketches, and models can be made of plasticene clay, wood scraps, soft wire, and small, ready-made geometric forms like those found in commercial games. Thematic explorations might focus on dimensions (tallness, flatness), on forms (twisting, round), on moods (happy, sad). Quick three-dimensional sketches in plasticene or other soft materials have value in resolving all sides of a work simultaneously. They also permit the child to study the clarity of light and shadow as indications of form.

In addition to these activities, explore the moods, activities, and personalities of subjects that children wish to develop sculpturally. For example, dogs are sometimes mean and fussy, sometimes playful and happy; they assume different positions when they eat, sleep, dig a hole, or chase a ball; some are tall and sleek, others are round and woolly. Whatever the topic, help children build detailed visual images and develop emotional identifications that can be translated into sculptural form.

In using clay or in carving soft materials, the early adolescent can apply the concept "form follows line" in order to develop smooth, con-

14-10 Form follows line (or edge) is an axiom for planning highlights and shadows on smooth, continuous surfaces.

tinuous curves and edges like those found in the work of many twentieth-century sculptors, as well as in the design of appliances, airplanes, and automobiles. A form is developed by carving distinct geometric planes so that the edges of planes form a straight or curved line. The convex or concave surface is then rounded (by carving or adding clay) so that there are even transitions up to the line, or edge, that marks the beginning of the new plane. Lines or edges catch the maximum amount of light (or shadow). The regularity of the convex or concave form can be monitored by a system of grid lines temporarily cut into, drawn on, or taped over the form. Bumps and valleys in grid lines reveal irregularities that should be removed (Figure 14-10). Small three-dimensional sketches using this principle not only enhance the form of an initial idea but also suggest new ideas for sculpture.[1]

Especially in the late elementary years, children should learn to become more aware of the symbolic connotations of media and forming processes; they should be more selective in their choices of media and processes to express their ideas. Consider this example: a cubic or geometric concept like a city, buildings, or machinery might be captured in clay by using the slab method of construction; in wood by assembling cubelike scraps; in metal by soldering sheets and rods; in casting by finding cubic forms to impress into the mold. Of all these materials, clay is the least cubic connotatively and in its natural state. A clay city, building, or machine would probably have rounded edges and a soft, hand-shaped look that would contradict the rectangularity normally expected in such images. The contradiction between medium and idea may be conscious, or it may be neither intended nor perceived by the child, in which case, the contradiction should be pointed out.

Develop in children an appreciation of the value of reflecting on completed work and thinking about what they have learned. Ask children what made the experience of creating a particular sculpture so special; ask whether it might be interesting to try something similar again, changing it slightly in some way. Draw parallels between the media, techniques, thought processes, and themes that children are using and those that adult artists use.

As children use media, guide them to see and talk about the sculptural qualities that they create—for example, point out the roundness or boxiness of the forms and the light playing on inside and outside spaces. At the same time, build their skills in perceiving whether the form is massive or light, open or solid and closed, angular or curved, textured in a regular pattern or an irregular pattern, composed of continuous, smooth-flowing surfaces or interrupted by sharply defined planes. Relate these qualities to the clarity of the form and the expressive intent.

The artistic heritage

Since the scale, the location, and the sensuous quality of sculptural materials are important to the expressive power of a work, it is essential for children to see real sculpture, not just slides and photographs. Sculptural forms of metal, wood, stone, and other materials should be available in the classroom for children to see and touch. In addition, obtain duplicate samples of varieties of wood, metal, stone, and other media, making sure that the samples are of the same size and shape. Encourage children to match and sort them by sight and by touch according to texture, weight, temperature, and color.

Children should see live or filmed demonstrations of sculptors working with various media and processes. Articulate local sculptors should be invited to talk with youngsters about their work. Ideally, some films or demonstrations should center on a single medium and the different processes that can be used to shape it, such as wheel throwing, hand-building, or casting clay. Other demonstrations should center on a single process and should show how the artist's techniques, tools, and thought processes are altered by the medium. (Carving wood, for example, is not the same as carving stone.)

The principle of organized collections—thematic, stylistic, by medium, by process, by cultural group, and so on—should be used to plan museum trips or classroom exhibits. The overall visual similarity within such a collection of works forces attention to subtle differences among the works.

Occasionally, exhibits based on contrasts are instructive: works with organic, freeflowing surfaces might be displayed next to angular works; representational works might be contrasted with nonobjective works. To heighten awareness, however, contrasts should be fairly obvious and identifiable, not multiplied to the point of appearing to be a random selection. Excellent in-scale replicas of sculpture are available from museum gift shops. In communities with meager civic resources in the visual arts, the school system should provide compensatory funds, not only to purchase such replicas but to build a collection of original works by local and state artists.

Try to arrange short visits to studios of local sculptors and to nearby museums and galleries. Before children visit a museum or gallery, provide guidelines for proper conduct. In virtually every museum and gallery, visitors are not permitted to touch any work of art. Frequent handling of any surface will contribute to rapid erosion and to the accumulation of dirt. Even gentle contact abrades a surface, and the natural oil on people's hands, multiplied over and over, can irrevocably stain any work.

Some museums have exhibition areas for children or hold special exhibits that permit

14-11 (*top, right*) Children make their own sculptural pattern by rotating the balls.

14-12 (*bottom, right*) Second grade children identify with the sculpture *Diana* during a visit to the Philadelphia Museum of Art.

touching (Figure 14-11); nevertheless, unsupervised children can thoughtlessly abuse works. Museum personnel emphasize the concept of touching with one's eyes, not one's hands. Some museums also have specially trained docents, who lead children (through improvisational techniques) to feel sculpture without touching it. Indeed, many of the techniques suggested in this book for active modes of responding to art are based on the pioneering work of art educators who work in museums.

Museum and gallery rules do not always apply to works in public places, such as shopping centers, parks, and civic plazas. To an increasing degree, sculptors are commissioned to create large sculptural works that invite people to climb on, sit on, walk through, or manipulate parts. Of necessity, such works are made of rugged materials like stone, concrete, or steel and are built to support the extra weight. Even so, the works are not designed to be carved on, written on, or otherwise abused. Children should be guided to recognize and understand the limits of these open invitations to touch, feel, and climb on sculpture. At no time should a child be permitted to abuse the surfaces of public sculpture.

The child's sensitivity to sculpture comes from kinesthetic identification with three-dimensional form—patterns of movement in and through space, frozen gestures and the points of tension and weight that they produce,

Switches for
Top Row of
Fluorescent Lights

Turntable Switch

Switches for Bottom Row
of Fluorescent Lights

a sense of volume contrasted with open cavities, and a feeling that energy is straining to be released but has been temporarily arrested. It is important that such physical sensations be experienced while children are looking at sculpture.

In the preschool and early elementary grades, try activities like these:

Introduce children to the terms *sculpture* and *sculptor* as well as to the names of the materials and tools that are used for sculpture. In discussions about sculptural works, use the appropriate adjectives and adverbs to describe surfaces, moods, and positions.

When the theme or form of the work is appropriate, have children act out the major patterns of movement within the work by crossing their arms, reaching high, bending their knees, turning their head to the side, and so on (Figure 14-12). Have the children move around the form and show the movements they see from each major vantage point. Examine the work from the front, back, and sides. If the work is small and low enough, examine it from the top as well.

Collect and display small sculptural forms or objects from nature, such as nuts, shells, tree roots, rocks, fossils, and weathered bones. Have children place these objects on an overhead projector and look at the profiles of the forms from different positions. (The projector should be about three feet from a wall to ensure clear projection of the silhouette.)

Obtain a set of basic three-dimensional geometric forms, and paint them white. Ask a parent to make a turntable box (1-RPM or ½-RPM motor) with different light sources (Figure 14-13). Have children arrange the forms on the turntable and look at the shadows and highlights as the turntable rotates. Place a small sculpture on the turntable platform. Invite children to light the sculpture from different angles and to notice which sources of light enhance the sculpture.[2]

Obtain a sculpture on which tape or colored contact-paper dots can be attached temporarily. After placing the dots or tape on major lines or angles, draw children's attention to the patterns of movement, edges, and points at which angles turn abruptly.

In the middle and upper elementary grades, the historical developments of sculpture should be introduced to children either in the context of their own studio work or in relation to social studies and history. For example, many children approach carving by working selectively on front, profile, and back views, much as the ancient Egyptians, Assyrians, and Greeks did. Similarly, in making clay figures, children often use coils in the same way that they are used in pre-Columbian art. In addition to drawing parallels in techniques and processes, note similarities between the design qualities and themes that children use and those that have been of interest to artists of the past and present.

14-13 (*opposite, left*) A light box with a turntable is useful for studying sculptural forms. Each switch turns on a fluorescent light built into the top and bottom of the box. The center switch turns on the turntable, salvaged from an old record player.

14-14 (*opposite, right*) Don Flavin, *Neon Construction* (1965).

14-15 (*right*) Robert Smithson, *Spiral Jetty* (1970).

The early adolescent should learn the potential scope of sculpture and sculptural processes in the twentieth and twenty-first centuries (Figure 14-14). One way to approach the contemporary directions of sculpture is to see and talk about sculptural qualities in objects and environments not specifically designed as sculpture. Contrasts in scale, for example, reveal that sculptural forms can be as small as a piece of jewelry or as large as an entire mountain. The urban landscape can be seen as a sculpture having vertical density, horizontal spread, and crosscuts into landforms made by roads and freeways. It is a polychrome sculpture, kinetic and expressive; it acquires different patterns of color in various seasons, motions that vary with times of day, and moods that are influenced by weather and periods of celebration and tragedy.

Slow but definite sculptural processes can be seen in the rounded edges and bowl-shaped indentations on old stairways, in the erosion of land, in the shapes of vapor trails slowly transformed into clouds, in the dispersion of a crowd at a stadium after a ball game. Such observations not only enrich children's own expressive repertory but prepare them to understand more fully the kind of vision from which many contemporary sculptures are being created.

Kinetic and mobile sculpture are specific twentieth-century developments in sculpture that adolescents should comprehend. Sculptural forms may be set in motion by diverse sources of energy—natural, mechanical, or electronic. Artists are experimenting with wind, water, heated air, solar energy, gravity, erosion, and tidal changes both as means of activating sculpture and as sculptural processes (Figure 14-15). At the opposite extreme, computer-generated sculpture, remote-controlled mobile sculpture, and complex lighting systems are also being explored as means of expressing the essence of a technological society.

Although these directions illustrating some of the current interests of sculptors may, in the end, prove to be short-lived, artists are highly sensitive to the pulse of life in our environment. Developments in art may be reactions against, new interpretations of, or commentaries about this environment. Some contemporary sculptors are unifying sculpture and nature through such structures as earthworks; others interpret our technological society by using technology to create new forms of art. Some create satirical, bitter, or humorous commentaries on our apparent inability to integrate the present with the past, nature with technology, or the present with a worthwhile future. In other words, our personal understanding of much contemporary sculpture is highly dependent on a fairly comprehensive grasp of the feeling-tone of life in this century. Thoughtful discussions of life and art must be part of each activity.

In the upper elementary and junior high grades, children who are especially interested in

14-16 Evolution of Patricia A. Renick's fiberglass and steel *Stegowagenvolkssaurus* (1974).
A Styrofoam "buck" (rough form).
B Clay stage (automotive modeler's clay).
C Finished work.

A

B

C

sculpture should have short apprenticeships with local sculptors or curators of sculpture collections in nearby museums.[3] Preadolescents who have any exceptionally strong interests are capable of devoting much of their attention to a mastery of factual details about their chosen subject and the skills associated with it. Even if the interests are not sustained through later adolescence and adulthood, youngsters appreciate the rewards of feeling competent in some particular endeavor.

Adolescents should continue to see original sculpture, both in the process of being created and in completed form (Figure 14-16); the same principles for developing collections and arranging museum trips are appropriate. Adolescents' rapid growth—in independence, experience, and the ability to deal with complex concepts—will even permit them to obtain fresh insight by examining the same or related forms on many occasions. Teachers need not be preoccupied with constantly providing new experiences; the children are sufficiently "new" from year to year that some repetition is not only appropriate but probably essential for steady and coherent growth.

Since adolescents respect competence in any field and are quick to emulate those whose performance they view as expert, the teacher should assume an active and exemplary role in discussions of sculpture. Although some of the

14-17 Sculptural forms enrich the exterior of many older buildings.

role-playing activities appropriate for earlier grades are suitable for introducing the adolescent to basic terms, tools, and concepts, the adolescent is self-conscious in talking about art and quickly becomes skeptical of any role-playing activity that is not clearly related to real life. Straightforward and candid discussions of sculpture, of how adolescents view it, and of the meaning it has for them should be the operating rule. At this age, children tend to be harsh judges of their own work and of the work of their peers. In order to encourage thoughtful judgments, point out to children the basis on which they should make judgments. In relation to sculpture, the general methods and specific criteria presented in Chapter 4 can be brought into play in helping youngsters judge their own and others' work, both as products and as learning experiences.

Art in society

Children should examine sculpture created by the cultural groups that they learn about in history and social studies, and they should study the influence of climate, geography, and beliefs on the themes expressed and the purposes served by sculpture in these cultures. Examples of sculptural forms from non-Western and folk cultures should be obtained and selectively displayed on different occasions to feature similarities in media, subjects or themes, and styles.

In the middle and late elementary years, artistic achievements should be approached in a social context. Sculptural artifacts, both masterpieces and vernacular forms, should be studied in light of the prevailing beliefs and values of the people who created them. Moreover, art teachers and classroom teachers with a strong background in social studies should collaborate to develop resources to make sure that children not only see appropriate examples of sculpture but are also actively involved in comparing sculpture in terms of purposes, media, subjects and symbols, and overall stylistic character.

Children should also be made aware of the sculptural forms in their community—commemorative statuary, fountain sculpture in parks, relief sculpture on public buildings (Figure 14-17). Point out the beauty and visual interest that sculptors add to a community through their work. Invite children to notice sculptural details in buildings on their own block, at school, and in nearby stores. Discuss the reasons that people like to have sculpture as part of their buildings, parks, or homes. Give comparable attention to particular sculptors who live in the city and state.

Sculptural forms created during major periods of national growth can be noted when those

YOU'RE LOVABLE...WEIRD, MAYBE BUT LOVABLE

WORLD'S GREATEST GRANDPA

14-18 (*left*) Sculptural forms like these have great popular appeal.

14-19 (*opposite*) Two examples of sculpture in the environment.
A Fiberglass replica of Michelangelo's *David* in a shopping mall.
B Replica of the head of *David* for sale in the decorator shop of a department store.

periods are being studied. Children should become conscious of sculptural forms as sources of information about important leaders and events. Abraham Lincoln, for example, is remembered partly through the many sculptural images artists have made of him, ranging from the low-relief sculpture on pennies to the monumental statue in the Lincoln Memorial.

Useful objects that are sculptural in form can also be pointed out. Industrial sculptors are often employed to create attractive and useful forms for tools, appliances, and automobiles. Visits to a foundry, stone carver, ceramic factory, or furniture-manufacturing company should be arranged to acquaint children with the sources of materials and the industrial processes used to shape sculptural forms.

Decorative figurines, statues, and knick-knacks should be studied, not only to examine the basis of their popularity, but also to contrast them with one-of-a-kind museum works and artifacts in non-Western cultures. Commercial figurines of dogs and horses, for example, might be compared with interpretations of dogs and horses in China, the Near East, and ancient Greece and Rome.

Many children are intensely interested in collecting figurines, statues, miniatures, and plastic models. While their interest in collecting is usually focused on a particular subject—horses, cars, planes—there are several ways to relate this interest to art.

First, museums house objects that people have collected but that they no longer want to keep just for themselves. Within an art museum, you will often find the name of the person whose collection you are seeing. Parallels between the child's interest in collecting things and the functions of museums can be noted: proper care of the items, effective display, and wanting to share one's collection with others but not wanting the objects damaged.

Second, many of the three-dimensional items that children collect are designed by sculptors who work for industry. However, the items are rarely handmade; they are made by machines, usually by a process of molding or casting. Children can examine items in their collections for evidence of fine workmanship in the artist's design, as well as for evidence of quality control in the manufacturing process. Plaster and plastic figurines with rough mold lines, bubbles, and poorly registered color patterns can be compared with more carefully made examples.

Third, the subjects and sentiments expressed in particular items can be examined (Figure 14-18). Are troll figures really funny? Are they also somewhat sad? Why? If Frankenstein figures and cartoon monsters are really scary, why do people want to collect them? Are horses always as wild and free or gentle and unbridled as they often appear to be in popular china, plastic, or glass figurines? When you play with

A B

small models of combat soldiers, who is in command of the war? What are the differences between real war and play war? How are toy dolls like sculpture; how are they different?

Further sensitivity to sculptural forms in daily life can be developed through activities like the following:

Collect photographs of sculptural monuments to famous people of the past and present. Small three-dimensional portrait busts and coins with portraits might be added to the collection. Invite students to identify one of their own heroes or heroines and to design a commemorative coin or sculpture to honor that person.

Examine trophies, loving cups, and other examples of awards that have sculptural qualities. Invite students to identify an important activity for which awards are not normally given; have them design a trophy that might be awarded for outstanding performance in that activity.

In a cemetery, have children examine historical and contemporary examples of sculptural tombs and grave markers. Ask students to speculate on the values and beliefs of people as they seem to be evident in the form of sepulchers from a given period. After such speculation, have the students do research to see how accurate they were in their speculations about the values of the period.

Visit an outlet for secondhand goods. Examine the sculptural forms—plaques, figurines,

statues, figurative planters—that people recycle. Alternatively, develop a collection of such objects for classroom display. Ask students to speculate on how the objects might have been acquired and why people might have decided to give them away.

Compare the process of carving plaster or stone from a block and the process of carving styrofoam required by hobby kits containing plastic figures encased in styrofoam blocks.

Identify sculptural forms that serve as advertisements for local merchants—road signs with three-dimensional figures, window displays, mannequins, and even replicas of well-known works of art (Figure 14-19).

Obtain examples of bottles for soft drinks, and paint them with white enamel. Have students examine the silhouettes and surfaces. Analyze the forms to see if they are easy or difficult to grip because of contours or surface textures. Are some brands recognizable merely by the shape of the bottle?

Examine historical and contemporary examples of jukeboxes and vending machines. Ask students to notice changes in the overall form, materials, and style of the equipment and to account for the changes.

Visit a store and look for as many examples of sculpture as can be found—for example, custom hood ornaments for cars. Have students list each item they see according to the medium, subject, and function it seems to have. Have

them make tallies to show the most and least common media, subjects, and functions. As a follow-up activity, have students do comparable research in the sculpture galleries of a local museum. Discuss reasons for any similarities or differences in the lists compiled from visits to the two environments.

Notes

[1] I am grateful to Ron Martin, freelance industrial sculptor, Detroit, Michigan, for an understanding of this technique.

[2] This technique was developed by Victor D'Amico while he served as the educational director for The Museum of Modern Art, New York.

[3] This concept was developed by Patricia A. Renick in an unpublished paper, "The Child as Apprentice," The Ohio State University, 1967.

Suggested Readings

Andrews, Michael. *Sculpture and Ideas*. Englewood Cliffs, N.J.: Prentice-Hall, 1965.

Kultermann, Udo. *The New Sculpture: Environments and Assemblages*. New York: Praeger, 1968.

Read, Herbert. *A Concise History of Modern Sculpture*. New York: Praeger, 1964.

Stuppeck, Jules. *The Creation of Sculpture*. New York: Holt, 1952.

Crafts and product design

While traditions of handcraft—embroidery, whittling, furniture making, quilting, smithing —once were transmitted from one generation to the next, children today are consumers of mass-produced products. Contrasts and comparisons between the crafts and product design can heighten the child's understanding of both of them. Although the Industrial Revolution began two hundred years ago, it is still a crucial factor in understanding both the work of the craftsworker and the artistry of product design.

Personal expression

Children's first experience in making hand-crafted objects occurs when they improvise toys, transforming a tin can into a drum, a stick into a horse, a scrap of paper or cloth into a doll. Sometimes children find treasures—shells, rocks,

feathers, polished glass—that they keep, trade, or give as gifts. These natural urges to treasure beautiful forms and to shape useful objects are the basis for craft and product-design experiences.

Media and processes

The artistry of the handcrafted object lies in the care with which it is fashioned and in the meaning put into the process of creating it. This orientation to crafts requires that teachers themselves appreciate the skills involved in the various crafts and become knowledgeable in the special techniques they introduce to children. This chapter deals with a few of the media and processes for crafts. For a more detailed treatment of a particular craft, consult the books listed in the Suggested Readings at the end of this chapter.

Woodworking is not limited to sculpture. Creating handmade containers, utensils, simple furniture, and toys requires an understanding of techniques for crafting wood that goes beyond that needed to carve and assemble wood for sculpture (Figure 15-1).

Children in the early elementary grades can be given a small block of softwood (white pine, basswood, spruce, redwood), sandpaper, and rasps. Children should be encouraged to shape the wood into something that is smooth to touch and nice to hold. Several pieces of sandpaper, from coarse to fine grain, should be used to smooth the wood. Over a period of several weeks, alternating with other activities, children should be able to fashion superbly smooth hand-sized articles. When children have achieved a very smooth surface, show them how to use paste wax to make the grain stand out and give the surface a glow.

In order to build well-crafted toys, utensils, and simple furniture, children should be taught how to cut and join pieces of wood (Figure 15-2). Obtain a miter box with saw, a square, a brace and bit, a corner brace (a picture-frame brace), strong glue, and a sanding block. Show children how to make a simple *butt joint* by using the square to mark off a straight line across a thin ($\frac{1}{2} \times$ 1-inch) board. Teach them how to place the board on the miter box and use smooth, even strokes to cut the wood. Show children how to apply glue to the joints with a

small piece of cardboard or brush so that it does not run all over. Show them how to place the wood in a corner brace with an extra block of wood so that the surface is not damaged by the presence of the brace. After the glue is dry, show them how to finish the joint with a sanding block. *Mitered joints* can be made by the same procedure, except that the wood is cut at a 45-degree angle rather than a 90-degree angle.

Pegged joints can be made by placing two boards together in a table vice. (Be sure to guard the wood against pressure marks from the vice.) Use a $\frac{1}{4}$-inch or $\frac{1}{2}$-inch bit to drill through both boards. A $\frac{1}{4}$-inch or $\frac{1}{2}$-inch dowel, covered with a thin coat of glue, is then driven into the joint to peg it. The dowel is carefully trimmed with a saw and sanded flush with both surfaces. The critical stages in crafting the joint are measuring the point where the hole is to be placed and holding the brace and bit in a true line (so that it does not rock back and forth) while drilling (Figure 15-3).

Comparable exercises can be planned for wood carving. These exercises in shaping wood are designed to introduce children to a standard of perfection in workmanship that is an essential part of the tradition of crafting objects from wood. Place a soft board against a brace and, using a ruler, mark off two lines that are slightly farther apart than the width of the curved chisel to be used. Make sure the lines are parallel and clearly visible. Have the children chisel out the

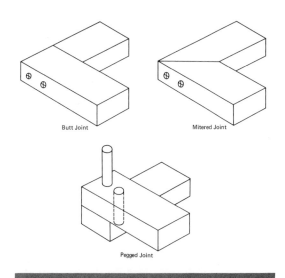

Butt Joint

Mitered Joint

Pegged Joint

wood between the lines in order to make a smooth, even trough. When they have finished, show them how to wrap sandpaper around a dowel and finish the groove. For greater challenges, have children use a compass to draw curved channel marks to carve. After carving, have them sand the grooves with sandpaper wrapped around the rounded end of a dowel.

Chip carving is also an excellent introduction to more complex forms of surface carving in wood. In chip carving, the shape of the chisel blade is used with maximum efficiency to release chips of wood from the surface of a board. The depth of the cut and the angle at which the blade of the chisel is held are carefully planned so that, with three or four cuts of the chisel, a perfect incised design is made. Chip-carving skills can be flexibly applied to curved surfaces and are useful in making sculpture and prints.

Clay, like wood, is not limited to sculpture, but has a very long tradition as a medium for handcrafted objects (Figure 15-4).

The *pinched pot* is a classic introduction to working in clay (Figure 15-5). Children can fairly easily learn to control the thickness of the walls and lip (top edge) of the container. Children should be told, in advance, that they will not keep the pots they are going to make, at least not initially.

The pinched pot is started with a round ball of clay. If the clay is not perfectly round, the pot will be difficult to form. While hands

15-6 (*opposite, left*) *Cat*, metal repoussé. Grade 8.

15-7 (*opposite, right*) Third graders learning to stitch and appliqué.

support and turn the outside of the clay ball, the thumbs press slowly and firmly into the top of the ball to open and hollow it. The skill lies in rotating the ball at an even rate while feeling the inside of the form for bumps that can be pressed away with the thumbs. When children believe they have made a pot with even walls, they should perfect the lip, making sure it is a circle of even thickness when seen from the top and at eye level from the side.

Children should cut their pots in half with a wire to check how even the walls really are. Of course, cutting destroys the pot; but children can accept the loss if you stress the value of striving for the skill of control in making craft objects. In the case of pinched pots, regular walls should be a minimum standard of good craftsmanship.

Slab construction in clay is relatively easy to master if children work on cloth with a $\frac{3}{8}$-inch or $\frac{1}{2}$-inch frame and a rolling pin. Joints are made by scoring the surfaces of clay to be joined and brushing them with *slip*, a soupy mixture of clay and water. The slip and scratch marks create a bond between the clay surfaces. The joint can be strengthened by trailing thick slip into the interior curves or by adding a tiny coil of clay to make a transition. Children can understand the need to use slip in welding their joints if an analogy is made to holding bricks together with mortar or holding wood together with nails or glue.

The *coil method* of fashioning clay objects can be managed well by children in the second and third grades, especially if they have had some practice in joining slabs. Each coil should be at least $\frac{3}{8}$-inch thick and carefully joined with slip to the slab base and to each successive coil. The spiral forms of coils can be either maintained for decorative effect or smoothed together.

Wheel throwing can be undertaken by children in the first and second grades if the clay is fist-sized and extra soft. It is best to use an electric table-top wheel because it can be placed on a low table or raised on blocks depending on the height of the child using it. Most children in the lower grades work best if they are standing and the wheel is slightly below waist level. Beginning in the third and fourth grades, children can begin to use a stand-up kick wheel or an adjustable kick wheel with a seat. All work should be done on a plaster batt so that the piece can be removed from the wheel, stored, and trimmed.

After learning to center the clay, children should be shown how to open the clay, slowly draw the clay up to make the walls even, set the lip, and judge when the clay is ready to receive surface textures, if any are desired. Setting the foot, or lower edge, of the cylinder will also require demonstration and practice. After children have gained skill in making cylindrical forms with even walls, they should be shown

CRAFTS AND PRODUCT DESIGN

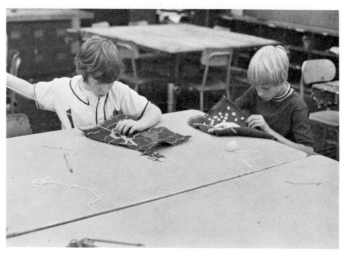

how to fashion bowls and bottles, and how to add parts like handles and lid tops.

Surface decoration on clay can be done by pressing textured forms into soft clay to leave an impression or by shallow carving into hard clay. *Sgraffito*—brushing englobe into the impressions and scraping away the excess after it dries—creates contrasting colors and accentuates the texture. After the pieces are bisque-fired, glazes can be applied to all or part of the final piece by brushing, dipping, or pouring. Some form of glaze—transparent, opaque, glossy, or matte—is essential in order to make a clay container watertight. (All glazes should be lead-free in order to avoid risk of lead poisoning.)

Children can work with sheet metal, wire, or thin foil as an introduction to metal working (Figure 15-6). Sheet metal (preferably tin) can be scored, cut, crimped, joined with interlocking folds, pop-riveted, or soldered. A steel, T-shaped beam about $\frac{1}{8}$-inch thick and 2-inches wide can be mounted on a table and used to bend the metal so that it has even, square edges.

A sandbag, an anvil, and ball-peen hammers will permit children to hammer sheet aluminum or copper into rounded forms. When the metal becomes too hard to hammer, it should be re-softened or annealed by heating it in a small enameling kiln until it is red hot. Allow it to cool on an asbestos pad at room temperature.

Beginning in the junior high years, children can learn to work with silver or copper to fashion

small containers or jewelry. Using a jeweler's saw to cut metal and a small, portable propane torch to solder, children can make links from wire and join them into chains. They can also learn to bend wire into filigree patterns. With proper equipment, they can hammer silver or copper into small, curved containers or solder flat sheets to make cubic forms.

Enameling, the process of fusing ground glass to metal, can be introduced in the upper elementary grades. Enamels, like glazes, are available in many colors and in several forms—matte and glossy, transparent and opaque. Copper is the most suitable base metal for beginners. Small shapes of copper are suitable for jewelry and shallow containers. Precut geometric shapes are available from many craft suppliers; children can learn to cut other shapes with a jeweler's saw. The copper is first cleaned with a solution of vinegar and salt. Enamel powders are carefully sifted onto the surface of the metal. The metal is placed on a tray and then fired in a small enameling kiln. When the powdered enamel melts and becomes molten glass, the piece is removed from the kiln and allowed to cool. The back of the metal is cleaned. Jewelry findings (cuff links, earring holders) can then be soldered to the piece.

Textile arts include weaving, stitchery, crocheting, and knotting (Figure 15-7). Virtually any flexible, fiberlike material can be woven—yarn of cotton, linen, wool, or synthetic materi-

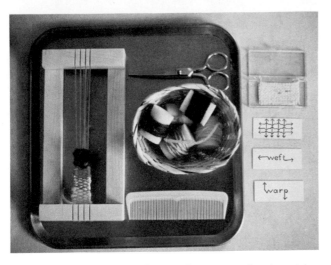

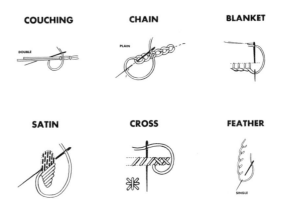

als; reed, wood slats, and grasses; soft wire, strips of plastic and metal foil.

Weaving is done most efficiently when a frame or loom is used to support some of the fibers, called the *warp* threads, so that the cross-threads, called *weft* fibers, can be woven into the warp. Wooden-frame looms are easy for children of all ages to use (Figure 15-8). And if a harness to lift alternate threads is added to the frame, the weft can be passed between the separated yarns very quickly. Children are able to create more elaborate patterns and develop more rhythmic movements if they work on a two- or four-harness table loom rather than on a simple frame loom. Rhythmic movements are an important part of the weaving experience; they contribute to the perfection of the craft, especially as seen in the evenness of the weave and in the straightness of the edges.

Stitchery includes embroidery, appliqué, quilting, and hooking. These techniques can be used separately or can be combined in one piece of work. The cloth to be embroidered, appliquéd, hooked, or quilted should be stretched on a frame so that the work will be flat when it is finished. Small loop frames, which tighten the cloth in the area where the stitchery is being done, are suitable for small pieces of embroidery. Embroidery stitches are limited only by the imagination of the creator. Some of the more common basic stitches are shown in Figure 15-9.

Embroidery can be combined with appliqué. In *appliqué work*, pieces of cloth are carefully sewn (sometimes using embroidery stitches) to the base cloth to make broad shapes, sometimes overlapping, that often resemble informal quilting or a collage in cloth. *Quilting* is a more formal version of appliqué. The quilter stitches pieces of cloth next to each other as though fitting together parts of a puzzle. Quilting is frequently planned so that both sides of the base cloth are patterned and the quilt is reversible.

In *rug hooking*, yarns are drawn through the mesh of canvas and knotted to make a carpetlike pile (Figure 15-10). A special hooking needle makes it possible to adjust the length of the yarn loop. Although the work is easier if a special rug-hooking needle is used, the loops can be made with a crochet hook.

Macramé is an elaborate form of knot tying originally intended as decoration for the fringes of weaving but now used for a variety of products from clothing to wall dividers. Some of the basic knots for macramé are shown in Figure 15-11. For small articles, a starter frame of wire, wood, or another stable material is desirable. The frame often serves as a useful or decorative part of the design—for example, as a buckle on a belt or as a means of suspending the work.

Because mastery of a medium is essential to expression in crafts, children should be encouraged to concentrate their efforts on a single craft

15-8 (*opposite, left*) A teaching aid to build an understanding of weaving.

15-9 (*opposite, right*) Basic embroidery stitches.

15-10 (*top, right*) Rug-hooking can be as satisfying and as colorful as painting.

as soon as their affinity for one of the media becomes apparent. After being introduced to basic techniques in working with wood, clay, fiber, and metal, most children will have a basis for choosing a medium in which to develop their skills. Without sustained yet varied experience in using a single medium, the child's involvement in the crafts is likely to be little more than a constant adaptation to new materials or processes, at the expense of expressive development. Thus, the pursuit of varied technique without corresponding attention to expressive content should be avoided.

Motivation

When a child has had sufficient introductory experience in each medium—wood, clay, metal, textiles—to exhibit a preference for one of them, encourage the use of expressive images, motifs, and purposes as the basis for making objects.

As in other art forms, ideas for expressive images and motifs in the crafts can come from nature. A snowfall may serve as an impetus to weave a scarf or to hook a rug; the colors of yarn might echo the shades of snow or be reminiscent of things that are warm, like the sun and fire (Figure 15-12). Textures and shapes of clay containers, which could be used for living plants or dried arrangements, might be inspired by natu-

15-11 Basic macramé knots.

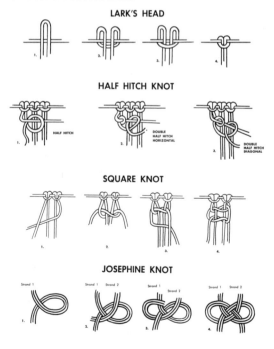

ral forms like shells, melons, nuts, or honey-combs. Patterns for jewelry might be suggested by flowers, vines, or insect contours. Containers or holders made of wood might be fashioned to reveal the beauty of the wood grain itself, heightening nature's own patterns.

Thematic explorations are also appropriate in the crafts. With a medium like yarn, for example, the theme of "play" might lead to an exploration of ideas for stuffed toys, pillows to sit on for quiet games, doll clothes, a carrying case for small treasures, or a giant macramé rope gym. In wood, the theme might suggest making whistles, chess figures, or a miniature village (Figure 15-13). Beyond discussing objects to make, explore the theme to reveal various moods that can be captured in a single kind of object. Clay containers, for example, can be created so that they are round and dumpy, tall and stalwart, aloof and closed, or mysterious and a bit threatening. In metal, a single form like bookends or a spoon might be explored in a comparable manner.

Imagination clearly offers another source of motivation for work in crafts, not only in the kinds of objects that might be made but also in the imagery of the form and the function that it might have. Consider the idea of making a container that holds only empty space, or one that instantly dispenses anything put into it. Might a knife, fork, and spoon all be combined in one utensil? Solutions to these and similar creative problems can be nurtured by helping youngsters think of opposites, unusual combinations, and absurd extensions of ordinary ideas, things, or events (Figure 15-14).

Quite often ideas for expressive images and motifs for the crafts cannot be separated from the intended use of the object. For example, the design of something made for the child's own use or enjoyment might differ from that of an object that will be given to someone else. Similarly, a clay container that is intended to hold flowers might have a shape different from one that is designed to hold cookies. Sometimes, the place in which a handcrafted object will be enjoyed and used provides clues to how it might be designed. A hooked rug for a kitchen might differ in imagery and motif from one designed for a nursery.

Guidance

Sketches and models are important in achieving expression in the crafts. As children work in wood, clay, metal, and fabric, encourage them to develop variations on forms, colors, textures, and shapes to see how the variations might enhance or change the expressiveness of their idea. Quick sketches of form possibilities in wood or metal can be made with pencil or felt-tip marker. Clay is sufficiently pliable for children to work on several variations at the same time; they can

CRAFTS AND PRODUCT DESIGN

15-12 (*opposite, left*) Wall hanging. Grade 8.

15-13 (*opposite, right*) Castle toy. Grade 6.

15-14 (*top, right*) Found-object jewelry. Grade 4.

15-15 (*center, right*) Working from a pattern to achieve a controlled composition.

15-16 (*bottom, right*) Baskets. Grade 8.

"sketch" directly in the medium. In weaving, small samplers (about 2-inch square) can be made to test color, texture, and pattern relationships. The warp for the sampler can be wrapped around a piece of cardboard, and the weft can be woven into the warp with a large needle. For stitchery, appliqué, or hooking, children can make preliminary sketches in crayon, felt-tip markers, and cut paper (Figure 15-15).

It is occasionally helpful for students to alter their customary habits of work in order to gain flexibility in technique and inspiration for new ideas. If a student prefers wood carving, encourage experimentation in wood construction. In clay, a student might shift from the geometric forms easily made by slab construction to methods that lend themselves to curvilinear forms, such as coil or pinch construction. In working with fabrics, children might temporarily switch from using very smooth and subtle combinations of yarns or cloth to exploring the expressive potential of rough and highly contrasting combinations of yarn or cloth. Notice that in all of these examples, the shift is made within a single medium so that maximum skill and flexibility in that medium can be developed (Figure 15-16).

Explore symbols and associations with children to heighten expressive meaning in their works. Symbolic connotations can be examined as they relate to the medium, color, form, texture, or motifs in the work (Figure 15-17). Con-

sider, for example, literary clichés that allude to the symbolism of metal—nerves of steel, heart of gold, wiry build, iron-fisted. Ask children to think of analogies and metaphors that are more subtle and personal than these clichés. Explore how symbolic associations like warm colors, rugged textures, and active shapes can be used to suggest expressive qualities. Encourage children to consider personalized motifs and images for their work rather than clichés and stereotypes.

Finally, help children relate the design of an object to the context in which it will be seen or used. Is the object for everyday use or for special occasions? If the object is for one or several special people, how could it be designed to show that it is meant only for them? Might the object echo or contrast with the colors, shapes, or textures of the place in which it will be seen or used? If the object is meant to be held, is it easy and pleasant to hold?

The artistic heritage

Developments in the crafts and product design during this century should be emphasized in teaching the artistic heritage. There has been a postindustrial renaissance in the handcrafts, and contemporary product design at its best is a translation into the industrial world of values associated with handcrafts.

The crafts are usually defined by media rather than by product or form. Wood, metal, clay, glass, fiber (yarn), and plastic are among the media most favored by contemporary craftsworkers. They are also using leather, paper, enamel, and combinations of media.

One of the most significant features of twentieth-century craftwork is that it is so vital and innovative in a society that honors efficient production of goods for a mass market. Handcrafted objects are not made efficiently, at least not in comparison with the speed of industrial processes. Neither are the crafts mass-produced by anonymous workers: they are fashioned by individuals who have personal control over the entire process of creation. In this sense, the handcrafts are an anachronism.

The contemporary craftsworker, like the traditional artisan, is strongly oriented toward nature not only as a source of materials and a wellspring of ideas but also as a standard for judging the appropriateness of choices of colors, textures, and shapes (Figure 15-18). When a craftsworker speaks of respecting the nature of the materials, there are several levels of meaning in the statement. The first is that each material—clay, wood, stone, metal—has inherent properties that the craftsworker honors and works with (not against), thereby collaborating with nature. For example, since clay is pliable and earth colored, craftsworkers might strive for forms that heighten the feeling of plasticity in

CRAFTS AND PRODUCT DESIGN

15-17 (*opposite, left*) Ceramic vase. Grade 6.

15-18 (*opposite, center*) Beverly Semmens, *Winter Sun: Dakota* (1975).

15-19 (*opposite, right*) Beverly Semmens, cast sterling silver pin (1976).

15-20 (*right*) Wendell Castle, oak sofa.

clay and use earth-colored glazes to finish their work.

Second, many craftsworkers have a deep respect, even reverence, for the natural forces that provide them with the basic material for their work. Woodworkers are conscious of the history of the growing trees that produce their wood. Grain patterns and annual growth rings indicate seasonal changes, stresses on cell structures, the flow of nutrients from the soil; woodworkers are aware of these forces when they choose and shape their material.

Finally, many craftsworkers believe that natural forms of order—rhythm, unity in diversity, equilibrium, evolutionary change, functional adaptation—are models to be emulated in designing objects (Figure 15-19). They seek out and create forms that echo or heighten our awareness of the larger dynamic forces at work in our world.

Although handcrafted objects are generally regarded as useful, they are also a means of expressing imaginative and fanciful concepts (Figure 15-20). Many contemporary craftsworkers are interested in transmuting familiar images and media so that they seem unfamiliar yet paradoxically real. For example, a tray containing a hot dog and potato chips seems unexceptional until we realize that each piece is superbly crafted in blown glass; a miniature couch is covered with a landscape showing cows in a field, yet the whole work is made of ceramic clay. Such

juxtapositions challenge our customary assumptions about reality.

Some craftsworkers prefer to explore the expressive potentials of pure form. The craftsworker's sense of classic form is apparent in works that are based on geometric shapes, smooth surfaces, and subtle transitions in contour and color. The quest for perfection in using a medium is often realized in forms that bear few traces of the processes by which the object was made.

Expressive possibilities for design in the crafts are sometimes established by the intended use of the object. For example, in designing a chalice or a kiddush cup, the artisan will necessarily think of the symbolic and ritual meanings of the container. A stained-glass window for a church or synagogue requires similar attention to the way in which light transmitted through glass may heighten the spiritual significance of worship. In addition to designing objects to be used in orthodox religious settings, craftsworkers are reexamining the meanings of totems, amulets, fetishes, and masks as expressions of personal spiritual insight (Figure 15-21).

Although contemporary craftsworkers are interested in creating one-of-a-kind items, an economy geared to mass production and mass marketing of goods also depends on artists who are willing to forgo the satisfaction of shaping materials by hand in favor of producing plans for objects that can be made by machines.

The product, or industrial, designer creates models and draws plans for home products, tools, and furniture and may design package and display units, vehicles and street "furniture"—waste containers, telephone booths, and lighting fixtures (Figure 15-22).

The product designer for industry is midway between the artisan and the skilled worker who participates in the manufacture of goods. The product designer's role is creative in the same sense that the graphic designer's is. A good product designer meets the needs of the consumer as well as the needs of the manufacturer and the technical requirements for mass-producing an object (Figure 15-23). The product designer is concerned about the safety, convenience, cost, and utility of a product as well as its aesthetic quality and expressive meanings.

In guiding children to look at and think about contemporary crafts and product design, point out contrasts between objects created by hand and objects created by machine—the way parts are fitted together, the edges of and finishes on surfaces, the choice and subtlety of colors. Sensitivity to skilled artisanship and expressive form in both handmade and industrial products should be developed.

Activities such as the following will help teach children about the sensuous and technical qualities of materials associated with the crafts and mass-produced objects:

15-22 (*below*) The industrial designer considers both the function and the form of products.

CRAFTS AND PRODUCT DESIGN

15-23 The development of automobile prototypes requires the talent of industrial designers and engineers.

Obtain duplicate examples of varieties of wood from a lumberyard or a cabinetmaker's shop. Make sure that the samples are the same size and thickness. Have children try to identify the woods by odor, sight, and sound (tapping each piece with a pencil). If possible, obtain examples of wood with the bark in place so that children can comprehend the relationship between finished lumber and its original form.[1]

Obtain duplicate 2-inch square samples of the same kind of wood. Leave two pieces untouched, and finish each of the others with wax, lacquer, varnish, linseed oil, orange shellac, or white shellac. Compare these samples to wood-grain patterns in contact paper or Formica. Invite children to match and sort the pieces.

Ask a parent or a local cabinetmaker to prepare small duplicate examples of varieties of wood joints—dado, mortise and tenon, rabbet, miter, and lap. Invite children to find examples of such joints in the classroom furniture or cabinets. Make schematic drawings of the joints and have children match the schematic version with the real one.

Find examples of poorly crafted wood articles. Point out misplaced hammer marks, rough edges, excess glue, bent nails, gaps between joints, drips from too much finish. Compare these with superbly crafted examples.

Develop a file of poetic metaphors and literary references to wood. Invite children to express in literary form their own feelings about the qualities of wood.

Obtain duplicate 2-inch square samples of different metals of the same gauge. Have children match and sort them by weight, color, and the sound they make when they are lightly tapped.

Find samples of the same metal in a variety of manufactured forms—sheet, wire, solid rod, and tubing. Have children find examples of articles made from these basic forms.

Contrast objects sprayed with silver, gold, bronze, aluminum, and copper paint with objects made of genuine metals.

Obtain examples of metal forms that have been cast, raised with a hammer, turned on a lathe, and machine-lathed. Find other examples showing joints made with rivets and by welding, soldering, threading, and bolting. Ask children to find examples of each forming and joining process in the classroom, school, or neighborhood.

Have children sort different types of the same color yarn into ordered arrays from rough to smooth, flexible to stiff, thin to wide. Have children examine the yarn with magnifying glasses to notice differences in the density and twist of the fibers.

Obtain duplicate swatches of white cloth made of the same fiber but of different weaves—tabby, herringbone, twill. Invite chil-

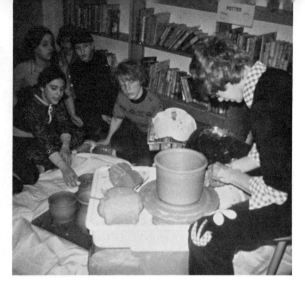

15-24 A potter visits a school and demonstrates the art of throwing clay on a wheel.

dren to match the samples and study them with magnifying glasses. Then have children carefully and slowly pull away threads from the edges of the cloth to discover how the threads are interlocked.

Compare fabric printed to resemble a quilt with a handmade quilt and a machinemade quilt. Compare real burlap with contact paper or wallpaper printed to resemble burlap. Find other examples of authentic and simulated materials for comparison.

Obtain real or photographic examples of woven items other than cloth—wood baskets, screen wire, chair caning, hair-styling with braiding, wood interleafed fences, cable wire, chain-wire screens. Point out the way fiberlike materials are interwoven in each example.

Develop a file of poetic metaphors and literary references to weaving, spinning, cloth, yarn, and the like. Ask children to speculate about the origin of expressions like smooth as silk, spin a yarn, fabric of life, wool gathering, knotty problem, string along. Invite children to write their own poems or metaphors characterizing qualities of yarn and cloth.

Have children imagine how it would feel to sleep on a pillow covered with silk, with velvet, with burlap, with lace, or with wool. Discuss the ways in which clothes made of different materials affect how their wearers feel and act.

Arrange live demonstrations or show films of craftsworkers creating objects in metal, wood,

clay, glass, and fiber (Figure 15-24). Ask artisans to share their sources of ideas, methods of working, and reasons for using their chosen materials. Local and state crafts organizations can be helpful in arranging exhibits and in identifying speakers skilled in giving demonstrations in schools. Invite craftsworkers, parents, or other residents of the community who are skilled in a traditional craft to display their work and demonstrate their techniques. If possible, ask them to spend a week or two working in the school and arrange times for children to visit the temporary studio to see work in progress.

As a follow-up to such introductory activities, provide children with separate schematic drawings or photographs of stages in the development of a craft object. Have children arrange the pictures sequentially. One set of cards, for example, might show the six stages involved in making a pot—obtaining clay, wedging it, hand-shaping it into a pot, firing it, glazing it, and refiring it.

Visit the nearest museum to see collections of artifacts. Have children make sketches of specific objects and later find real or photographic examples of contemporary objects that resemble the museum pieces in some way—tools made by early settlers and tools available in hardware stores today; an Egyptian cosmetics jar and its contemporary counterpart.

Arrange a trip to the design or model- or mold-making studios of local companies engaged

15-25 The products children admire are often patterned on adult models.

in metal or plastic manufacturing. Talk with product designers and model or mold makers and see the manufacturing processes carried on in the plant. Or invite industrial model or mold makers or product designers to visit the school to discuss their work.

Ask children to characterize objects of the same type as if the objects had a personality, could actually speak, and had a favorite place to be. Have the children relate the character of line, shape, weight, and texture of the object to the personality that they assign to the object. For example, "This heavy, fat spoon with the textured handle looks as if it might want to be in the kitchen stirring things up."

Invite children to make judgments about several handcrafted or mass-produced objects of the same type. Build a discussion around the systems of criteria noted in Chapter 4 to illustrate that each object has qualities that might be valued, depending on the context in which the object is seen and used.

Art in society

In preindustrial cultures, household products, tools, and ritual objects usually were made for personal use; persons skilled in fashioning certain items might have been asked to make them for others. In exchange for their service, the

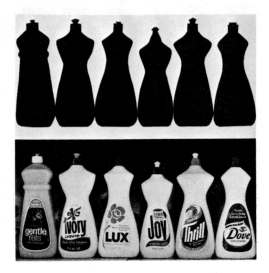

15-26 (*left*) The forms of liquid-soap containers are sculptured for appearance and ease in handling.

15-27 (*opposite*) The problem of containing and distributing goods should lend itself to more creative solutions.

artisans would receive some other valued commodity. In any case, people could see the methods by which goods were produced; the source of raw materials was known, the labor in shaping them was apparent, the reasons for making and caring for tools or utensils were readily appreciated. The personal skill and style of the creator was clearly tied, in memory, to the daily use of the object and to its spiritual or social meaning.

The Industrial Revolution did more than change the process of production and increase the diversity of goods available to people. It altered attitudes about the relative worth of handmade and manufactured products; it removed from each product the personal mark of the maker and replaced it with a brand name or trademark. The magnitude of the loss of our sense of a product's worth (a result of our estrangement from the production process) is reflected in our apparent inability to create meaningful environments from the thousands of products available to us and in our willingness to throw away useful items because they are out of style or need repair. In order to restore a sense of the social importance of objects, we must develop greater awareness of the way in which handcrafted and machinemade products express the beliefs of people and influence their conduct (Figure 15-25).

Encourage children to notice how things are made, why certain objects are part of the school or home environment, what kind of care they require, and whether, in fact, the objects have been cared for at all. Direct attention to the way some objects use shapes, colors, forms, and materials symbolically to make us feel or act a particular way.

If there are restored historical homes in the community or if a nearby museum has period rooms, arrange a class visit. Notice whether the rooms seem to have been for the very rich, the very poor, or middle-class people. Within each room, look for items that go together and discuss why they seem related (shapes in table and in chair legs, motifs in drapes and in rugs). Invite children to imagine how it would feel to live in the house or the rooms.

In studying the artifacts of cultural or national groups, point out how people use materials native to their area and how they use imported or rare materials. When possible, compare items made for important events with objects used in everyday life. As children study various cultural groups and historical periods, direct their attention to the household and ritual objects through which beliefs are expressed. Notice recognizable motifs like animals and plants, as well as symbolic uses of shapes, colors, and materials in pottery, weaving, clothes, furniture, and the like.

Other activities to increase children's awareness of the social importance of objects follow.

Plan certain days when a given piece of furniture or a certain utensil is not used at all. At the end of the day, have children summarize their feelings about the difference that object makes in their lives.

Invite children to personalize their classroom by adding unusual objects, such as a couch, or by customizing objects, such as putting cushions on their chairs.

Compare very simple and very elaborate versions of the same object—an embroidered or lace tablecloth and a cotton cloth or vinyl cover. Have children describe different occasions when each version might be used, how people using the object might feel, how the person owning the object might care for it. In the same way, compare traditional forms of an object with unusual or innovative forms of the same kind of object.

Collect empty containers whose shapes play an important role in identifying and selling the product. Remove the printed labels and paint the containers white. Ask children to describe the customer appeal of the shape of each container.

Visit a nearby drugstore, supermarket, or variety store to see how products are contained—plastic bubble pack, boxes, jars, aluminum cans, reusable plastic containers. Notice the sizes in which the same product is available. Is a given product packaged in the same way by various companies (Figure 15-26)? Which containers seem to attract attention and make consumers want to buy them? Discuss the advantages and disadvantages of packaging to the consumers, manufacturers, and distributors of products.

Develop collections of the same kind of object in disposable and permanent forms. Compare, for example, dinner plates made of fine china, unbreakable plastic, styrofoam, and paper. Discuss the advantages and disadvantages of each variation from the standpoint of use, care, storage, and disposal.

Suggest that children collect and classify the litter (not in waste containers) that they find in a one-square-block area near the school. Have them write a news editorial on their collection or invite a television station to report on their activity (Figure 15-27).

Have children perform a simple act like brushing their teeth and imagine how many different gadgets might be used for the task— toothbrush holder, toothbrush, toothpaste tube, key to roll up toothpaste tube, automatic toothpaste dispenser, electric toothbrush, sink with adjustable cold and hot faucets, dial-your-own-flavor toothpaste dispenser.

Compare life in our gadget-oriented society with frontier life or life on an uninhabited island. How would the need for tooth brushing be met if one did not live in a gadgetland?

Note

[1] My appreciation of the value of duplicate collections such as these has been increased by the work of Georgie Gross, director of the Children's Studio, Cincinnati, Ohio.

Suggested Readings

Editors of *Life* Magazine. *America's Arts and Skills*. New York: E. P. Dutton, 1957.

Faulkner, Ray et al. *Art Today*. 5th ed. New York: Holt, Rinehart and Winston, 1969.

Gardi, René. *African Crafts and Craftsmen*. New York: Reinhold, 1970.

Mattel, Edward L. *Meaning in Crafts*. 3rd ed. Englewood Cliffs, N.J.: Prentice-Hall, 1971.

Moseley, Spencer; Johnson, Pauline; and Koenig, Hazel. *Crafts Design*. Belmont, Calif.: Wadsworth, 1966.

Mumford, Lewis. *Art and Technics*. New York: Columbia University Press, 1952.

Nordness, Lee. *Objects: U.S.A.* New York: Viking Press, 1970.

Pevsner, Nikolaus. *Pioneers of Modern Design*. New York: Horizon Press, 1961.

Architecture
and
environmental
design

16

Architecture and environmental design affect everyone's life. Architecture has evolved as an extension of our quest for shelters that fulfill our physical and psychological needs. Environmental design is the art of combining community resources to enhance the physical environment. The physical environment, in turn, can reinforce, alter, or enhance people's life styles.

Personal expression

Children enjoy covering tables with blankets to construct makeshift tents, crawling into tents, building forts and tree houses, digging holes and constructing lean-tos. Regardless of the kind of home or neighborhood in which they live, children find cozy corners, favorite hangouts, and hiding places from which they can derive a measure of privacy and psychological warmth. These experiences serve as a background from which further sensitivity to architecture and the environment can be developed.

Media and processes

Early experiences with architecture and environmental design should focus on creating structures for personal use and enjoyment.

Young children can pack and carve wet sand in a sandbox or sandtable, creating buildings, land contours, and small model cities as

their first experience in learning about the sculptural qualities of architecture and the land (Figure 16-1). Twigs, small blocks of wood, dowels, toy cars, and similar objects can be added to the landscape to suggest the purpose of the constructed environment. Although a sandbox or a sandtable is usually considered preschool equipment, it is a versatile unit for every classroom. For example, a sandtable can also be used for sand castings in plaster, as a surface on which metal casting can be done, and as a container (with the sand removed and sawdust added) for cleaning intaglio plates.

Table-top models of architectural forms and environments can be made with building blocks made of wood, styrofoam, plastic, sponge rubber, and with found objects like empty thread spools, milk cartons, dowels, hair curlers, paper cups, and discarded packaging materials. These components should be painted white so that they will easily show the patterns of light and shadow on geometric forms (Figure 16-2). If details like windows, doors, signs, and human figures are desired, children can cut these from narrow strips of contact paper and apply them to the forms. Such table-top models should be created on $\frac{1}{2}$-inch styrofoam or on double-thick corrugated cardboard (refrigerator or heavy appliance boxes) so that they can be moved and stored. The bases can be punctured in order to add features like telephone and light poles or trees made of sticks or of wires with sponge tops.

Commercial modular building toys are also excellent for constructing architectural and environmental forms (Figure 16-3).

Architectural models can also be made from plasticene or ceramic clays. Plasticene can be warmed in the sun or on top of a radiator, then rolled out on oilcloth, wax paper, or plastic wrap with a damp rolling pin so that the clay will not stick to the surface. Roll out ceramic clay on a cloth with a rolling pin so that slabs can be cut, lifted, and placed without sticking to the table. Both ceramic clay and plasticene can be textured (preferably before assembling the units) to suggest brick, wood, concrete, or other exterior surfaces of buildings. For environmental studies, a supporting board of $\frac{1}{8}$-inch masonite about 14-inches square can be covered with about 1 inch of clay, which can be added to or carved away to show land contours, clusters of buildings, roads, lakes, and rivers. Details made of scrap materials can be added to give the scene a sense of scale and proportion.

Construct table-top studies of interior spaces from cardboard. Walls—straight, curved, or zigzag—should be built as independent units from stiff cardboard so that they can be pressed into a plasticene or styrofoam base (at least $\frac{3}{4}$-inch thick) and be self-supporting (Figure 16-4). This method of construction permits children to alter single walls and to easily change the shape and proportions of rooms. The cardboard walls can be painted or covered with cloth, con-

ARCHITECTURE AND ENVIRONMENTAL DESIGN

16-1 (*opposite, left*) Clean, wet sand is an excellent medium for exploring architectural forms.

16-2 (*opposite, right*) Building blocks are arranged with dramatic lighting to suggest Stonehenge.

16-3 (*top right*) The geometry of architectural forms can be introduced in the early elementary grades. A child uses straws threaded with string to create a geometric form.

16-4 (*center right, top*) A styrofoam base with ½-inch grooves for the insertion of cardboard provides flexibility in arranging planes to suggest architectural forms.

16-5 (*center right, bottom*) These styrofoam furniture models can be covered with cloth for simple interior-design studies.

16-6 (*bottom right*) Large pieces of cardboard can be assembled to make walk-in spaces.

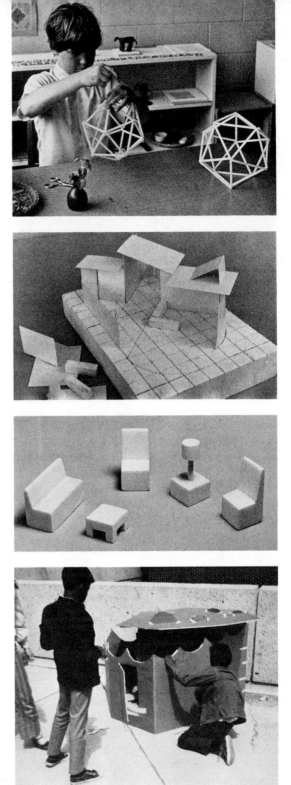

tact paper, or other materials to indicate color schemes and textural surfaces. Window and door placements can be shown with cut-paper drawings glued in place.

Table-top interior models are not complete without some attention to color and furniture placement. Younger children should work with simple precut styrofoam units (Figure 16-5); some pieces can be covered with cloth scraps to suggest colors in furniture. If children are working on a 14-inch square board, the furniture scale for a single room might be 1 inch = 1 foot. If they are working on two adjoining rooms, the scale should be reduced to ½ inch = 1 foot.

Mini-environments can be created with lightweight materials like cardboard packing from heavy appliances, corrugated packing paper in rolls, styrofoam insulation board, and heavy cardboard tubes (Figure 16-6). Space dividers on rollers, which are used in many new open-classroom schools, can serve as walls defining a floor space. Structural supports for foam core or cardboard can be made of wood strips attached with wing nuts and bolts. Other structural supports can be made by folding cardboard into columns, beams, or self-supporting walls. Ridgepoles with tension wires and weights or fixed wall hooks with tension wires can be used to support tent-like structures.

Full-scale temporary changes in the classroom (or another space in the school) can be made by rearranging or removing furniture from

16-7 (*left*) The Space Place, a project of the Central Midwestern Regional Educational Laboratory, is assembled from pieces of grommeted fabric connected by elastic ropes with S hooks on each end. Simple tentlike structures provide an excellent means of studying and creating spaces.

16-8 (*opposite, left*) A model of a park tower. Grade 7.

16-9 (*opposite, right*) Four junior high classes worked on these 4 x 8 foot models that offer proposals for change in a community shopping center.

the classroom or by trading furniture with other classrooms. Normal light sources can be altered or supplemented with special lights. Temporary subdivisions within the total space can be made with room dividers and the other lightweight structural units mentioned earlier (Figure 16-7). Surfaces of walls and floors can be changed by using selective lighting, scrap carpeting, bubble packing, yarn, cloth, and the like. Floor elevations can be altered with borrowed gymnasium mats, stage risers, wood ramps, or tunnels of large cardboard tubing, which can be carpet-covered on the inside.

Full-scale permanent changes within the school or on the grounds will usually require the teacher's receiving approval from school officials (to assure compliance with fire, safety, and other codes), but projects can still be designed and executed in whole or in part by students. Among the possibilities are an interior court with plantings, a gallery, a student or visitors' lounge, and an exterior landscaping and playground design. In making permanent environmental changes, the teacher should draw on the skills of parents, industrial-arts teachers, vocational-education students, and local trade unions. Trade unions and local businesses can be requested to participate in projects as a community service providing an educational activity for youngsters. Normally, permanent changes in or around buildings cannot be made without competitive bidding and payment of union wages.

Architecture and environmental design are best approached as three-dimensional problems. Graphic representation of these art forms should be reserved for the middle and upper elementary grades. Architectural drawing with rulers on $\frac{1}{4}$-inch grid paper (to establish a scale) can be introduced in the fourth and fifth grades. Other forms of representing the environment include cartography, quick sketches, photography, and painting.

Motivation

Nature is an obvious source of inspiration for architecture and environmental design. Children can study birds' nests, animals' burrows, and insects' nests and hills to discover relationships between the structural form of a habitat and the purposes the habitat serves. Relationships between natural and fabricated structures are of vital importance in environmental design. Children might examine the physical geography of their area as a source of inspiration for the form and materials of their own model buildings. The problem of establishing a better balance between developed areas and natural open spaces in urban environments can be an impetus for building models and mini-environments (Figure 16-8).

Imagination is another source of inspiration for architecture and environmental design. Chil-

ARCHITECTURE AND ENVIRONMENTAL DESIGN

dren can learn to examine ordinary objects like furniture, toys, and appliances as if they were to be transformed into houses or cities of the future. Specific ideas might stem from images of a floating city, an orbiting satellite community, an inflatable school, a walking city or house, or a city under the sea. Ideas might be generated by literary references to castles in the sky, the old woman who lived in a shoe, or Robinson Crusoe. Inverted or absurd relationships in the use of building materials can be explored—marshmallow walls, foam-rubber sidewalks, fur-lined kitchens. Environments for real or hypothetical creatures can be imagined—a rapid-transit system for turtles or a house for people who can walk upside down.

Broad themes are well suited to ideas about architecture and the environment, especially in the upper elementary grades. Themes may be projected from different concepts of "the good life" or "the bad life." For example, architectural structures or communities might be designed for a life style in which the most dominant values are personal luxury, immediate access to entertainment, a surfeit of goods and services, and instant mobility. A contrasting set of values might be shown in structures reflecting a concern for public welfare, a quiet, stable, reflective life with goods and services provided only by personal effort and with careful attention to shared human needs. Other viewpoints about architecture and environmental design

might come from role playing. What kind of architecture and community planning would be best for people who value close family ties? for people who do not care about having families? for people who care only about youth? for people who revere the aged?

Children's immediate environments can also be a source of ideas. The home, school, neighborhood, and community are case material for practical and hypothetical problem solving. Even though children have little or no personal control over where they live, play, study, and grow up, they can still be educated to comprehend the difference between the way things are and the way they might or should be (Figure 16-9). Children can explore rearrangements within their homes that might increase their play areas or private spaces, or facilitate traffic flow. Comparable explorations can be made in the school, both in the classroom and in shared spaces like the cafeteria. If the teacher becomes an advocate of reasonable proposals, children will be encouraged to make actual changes.

In the upper elementary grades, children can be inspired to initiate or respond to proposals for community improvement. They might meet with owners of local businesses, city planners, or redevelopment experts to become familiar with efforts to solve problems in their own community. Often a serious problem is brought to the public's attention by a tragic event. Questions of health, safety, and pride in one's com-

Plaza Centered

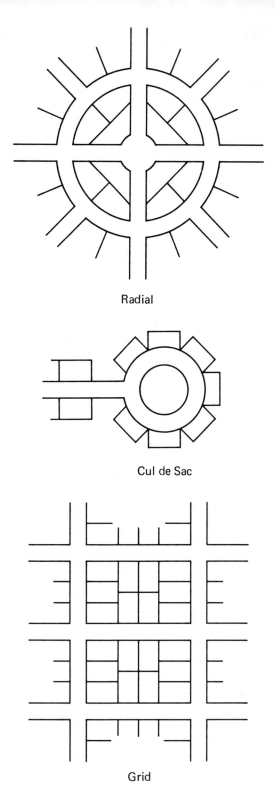

Radial

Cul de Sac

Grid

munity are occasions for thoughtful exploration of the relationship between human behavior and the physical form of the environment.

Guidance

Sketches and models are an essential means of children's comprehension of architecture and environmental design as art forms for personal expression. Children cannot construct a house, school, factory, church, or city; but they can begin to grasp the practical and artistic factors that determine the expressive qualities of these full-scale forms. They can do so, in part, by creating and studying small-scale versions.

Children in preschool and the primary grades can be introduced to a range of architectural and environmental concepts in an informal manner:

Build sandbox communities based on a grid, strip, or radial pattern; create a downtown city, a rural landscape with trees, animals, and lakes; construct imaginary cities, castles, forts.

Drape cloth over tables and chairs to make enclosed spaces, or string rope across the room to form tentlike or tunnellike structures. Create a "light" environment by projecting slides on the cloth; add mood music.

Make temporary changes in the arrangement of furniture. Push furniture into one cor-

Strip

ner of the room, make a circle of chairs, line up tables and chairs in rows. Notice the differences in floor space that each arrangement provides.

Invite children to plant and care for a flower garden, rake the schoolyard, pick up waste paper, repaint trash receptacles.

Beginning in the second and third grades, children can study particular variables that influence expressive form:

City Planning. Use half-pint milk cartons to represent single-dwelling houses, and a 5 × 7-inch square of green paper to represent lawn space. This establishes a rough scale of 1 inch = 10 feet—that is, a house 30 feet × 30 feet and a lot size of 50 feet × 70 feet—a scale not unlike that of many tract developments. Provide two houses and plots for each child. Find ample floor space and ask children to create a community by arranging their houses and plots. Add larger boxes and strips of paper to represent travel arteries, shopping areas, civic buildings, parks, and business districts. Analyze the arrangements children create. Are they strip developments? grid designs? plaza-centered solutions? How might the houses be individualized? Invite children to construct different communities based on other plans that are radial, cul-de-sac, or of functional clusters (Figure 16-10).

Provide children with color-coded blocks of two different sizes. Designate a color to represent *residential* buildings, with the smallest

blocks for single-family dwellings and larger blocks for apartment buildings. Assign a different color, respectively, to blocks that will represent manufacturing (small blocks for light industry, large blocks for big factories), business (from small stores to large department or discount stores), and public service facilities (hospitals, churches, schools, courthouses, fire and police stations). On brown paper prepare three or four hypothetical city sites, showing a river with a bridge, a railroad system, and two major expressways. Divide children into teams and give each team a set of blocks (one color per team) to place on the map. Have children take turns placing buildings as if they were (1) settling the community and gradually building it in a progression: starting with residences and adding manufacturing, business and service facilities; (2) planning the community and building it all at once (determining primary locations for industry, business, residences, and so on). Photograph the models and discuss the advantages of each result.

Site and Materials. Divide children into groups of three or four. Provide each group with a single kit, each including a 1-foot square masonite board, 1 pound of plasticene for developing a geographic setting, and an instruction card describing the climate and terrain of a site on which they must create a house from a few simple materials. Examples of house-building materials for each kit are:

16-11 (*left*) Third grade children work on a building model based on the structural principles used in the Parthenon.

16-12 (*opposite*) Lighting a model permits the study of its form.

1. ceramic clay, twigs
2. soda straws, paper cups
3. corrugated cardboard, wood toothpicks
4. ½-inch cubes of styrofoam, plastic toothpicks
5. tongue depressors, reed or vine
6. thin cloth, stovepipe wire, string
7. aluminum foil, paper clips
8. thin cloth scraps, split-end dowels, string

Students invent a house that accommodates the climate and terrain cards in their kits. Provide glue, staples, scissors, tacks, and related supplies for joining kit materials.

Structural Principles. Provide children with schematic drawings of architectural structures. Have them make several models in different materials (Figure 16-11). For example, make a *truss* of balsa wood, of thin strips of clay, of cardboard, of construction-set parts, of string. Make a *pointed arch* (with keystone) from small blocks of cement (grease an ice cube tray and pour cement into it for blocks), from clay, from styrofoam. Make a series of *post and lintel* or *cantilever* studies in varied media. Discuss how the weight and strength of different materials influence the distance that these structures can span.

Light. Provide students with shoe boxes. Have them cut a ½-inch square hole in one end

and additional holes (about 1 inch × 2 inches) on the other three sides of the box. Then cover each hole with a flap of paper taped in place. Have children study where light falls in the box under different conditions: when the flaps are open or closed, when the box is under different kinds of light, when something is in it, when colored cellophane is placed over the openings. Compare these lighting conditions to those of everyday situations.

When children have made a model of an interior space, have them cut out holes to represent the windows. Then put a temporary roof over the model and illuminate the space by moving a flashlight around it to simulate the sun (Figure 16-12). Vary this kind of study by cutting small or large holes in the roof to represent ceiling lights or a skylight in the actual room.

Form. Provide children with a variety of geometric forms that can be combined to create more complex building structures. (The forms should be painted white to eliminate distracting elements.) Inexpensive geometric forms are cardboard boxes; paper or plastic cups in different sizes; narrow blocks of wood in different lengths; old, hollow rubber balls cut in half, hair curlers, vacuum-pack plastic and styrofoam shapes from small packages. Have children select two forms to combine into a structure, then add a third, a fourth, and so on. Discuss the problems that are created by adding on to the basic

structure too many different forms rather than by adding similar forms of different sizes.

Traffic Circulation. For interior studies, children cut out shapes of contact paper representing a bird's-eye view of types of furniture. They arrange the contact-paper furniture into different patterns within a floor space represented by a sheet of cardboard (also covered with contact paper). After placing the shapes in position and indicating windows and doors, children use a grease marker to trace the traffic pattern of a person who, for example, enters the living room, sits on the couch, gets up and turns on the television, moves to a chair next to the table, opens a window, sits down on the sofa again, turns off the television, and leaves the room. By peeling off the contact paper shapes and rearranging them, children can explore how traffic patterns are influenced by furniture placement. With young children, play sets that provide pressure-sensitive punch-out shapes and a board on which to arrange them can be used for the same purpose.

Space. Children tend to think of an architectural model as a static, positive form that is intended to be seen from only the front view. Place small models on a turntable in front of a projector light so that shadows are projected onto the wall. The increased scale of the work, as a shadow, clarifies its form. Shape relationships that occur when the turntable is slowly rotated reveal the importance of planning all sides of the model. Children can tape paper to the wall and sketch the contours of the model in different positions.

Space and Movement. Architectural and environmental spaces are defined by our movement around them and through them and by the flow of movement that the forms themselves suggest. Ask children to quickly create clay models of buildings that are tall and reach up to the sky, of buildings that are low and play hide-and-seek with the surrounding land. Have them compose interior building spaces (models or mini-environments) so that there is an arrowlike movement through the space. Then suggest that they create other arrangements with gently curving movements through the space, with abrupt angular shifts, with reversed intersecting semicircles. Have children imaginatively or physically move around each arrangement to see how it looks and feels when *they* are in motion.

Symbolism. The symbolic and expressive power of architecture and the environment should be explored with children as they plan and execute their own work. For example, a house can be designed as an efficient machine for living or as a comfortable nest, it can be designed to invite people in or to keep people out; it can be simple or luxurious. Buildings can be explicitly symbolic. A church may be fish- or ark-shaped; a seafood restaurant may have a

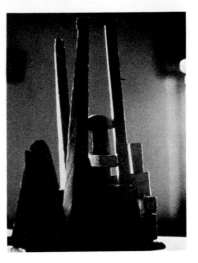

16-13 A towerlike structure. Grade 6.

wharflike entrance. Some cities are brooding, threatening, and cavelike; others are open, inviting, and active (Figure 16-13).

Details. The environment and architecture are animated by the interplay of major forms and small details. Fire hydrants, telephone poles, newsstands, mailboxes, signs, landscapes, shifts in surface texture—all act as small punctuation marks telling us to pause and notice the multiplicity of our world. Although they are difficult for children to incorporate into small environments and models, details can be suggested in a general way. Twigs or torn foam rubber attached to toothpicks can symbolize trees or plants; a match stick, pipe cleaner, or split piece of paper can represent a person; signs can be indicated by cut paper glued onto small sticks. Textural differences in buildings can be shown by the impressions made by pressing small tools into clay or by drawing on cardboard or paper or by using textured paper.

Time and Context. Architecture and the environment are experienced in time—in all seasons, in all kinds of weather, and at all times of day. People, animals, birds, and vehicles enliven space. Thus, the child's architectural models are, in this sense, fairly sterile objects in the fixed environment of the classroom. To suggest the effects of the weather, light, seasonal changes, and movement patterns is difficult and necessarily artificial. However, it is worthwhile

to allude to these influences, if only by painting display backgrounds, adding details to suggest different kinds of weather or the seasons, or lighting the model to suggest times of day. If possible, it is instructive to obtain films of the weather, seasonal changes, times of day, and city movements and to project them directly onto a group of models or mini-environments.

The artistic heritage

In terms of daily lifelong impact on the quality of living, architecture and environmental design are among the most important art forms to be considered in the education of children. Yet, many teachers feel handicapped in presenting architectural and environmental concepts to children. This section presents background information for the teacher as well as activities for children.

As a general rule, architecture and environmental design are collaborative art forms. Architects and designers create structures for a client, who plays an important role in determining what the architect or designer creates. Collaboration also occurs during construction of buildings and in the modification of the environment. Let us examine the roles of the collaborators in more detail.

ARCHITECTURE AND ENVIRONMENTAL DESIGN

Client. A person or group with access to money to spend on a building or an environmental project. The clients of environmental designers are often the citizens of a community, whose views are represented by a smaller group of elected officials. Many large-scale environmental projects are designed and executed by professionals employed by a local governing body, including civil-service workers in planning offices, on zoning boards, and those who enforce fire, safety, and related laws.

Architect and Designer. A person who is specifically trained and licensed to design buildings or to prepare plans for community development. Architects usually work for a flat fee or for a percentage fee based on the total cost of the building. If a building costs $500,000, a 10 percent fee of $50,000, would not be unusual. An architectural firm is usually incorporated so that it can provide comprehensive and efficient service to the client. In addition to having several architects, the firm may employ specialists in drawing plans and in engineering the mechanics of a building. Environmental designers may work on a similar percentage basis or bill for service on an hourly or daily rate, plus expenses. Like the architect, the designer works on a project with other experts in the building field. The architect and the designer earn their fees by planning a structure in advance so that it is safe, physically and psychologically responsive to the present and anticipated needs of the client, and within the budget limitations of the project.

Consulting Engineer. A person with expertise in the technical aspects of planning safe and serviceable buildings and environments. The consulting engineer makes sure that the site for the project is properly surveyed; that the structures can be supported by the underlying earth; that materials for the structure are strong enough to bear weight, span distances, and resist other stresses like wind, fire, water, and extreme changes in temperature. Other engineers specialize in electricity, mechanical devices, transportation, sanitation, and related technological fields.

Construction or Contracting Firm. A company organized to build structures and environments in accordance with the blueprints that are provided by the architect or designer. The construction company employs skilled workers like carpenters, plumbers, and bricklayers to complete the job, purchasing materials and organizing the work force so that the job can be completed efficiently, safely, and on time. Health, safety, and work regulations for the construction workers are usually spelled out in labor-union contracts, as well as in local, state, or federal legislation. Subcontractors often complete a portion of a building, such as electrical or plumbing work, for the client and the main contractor.

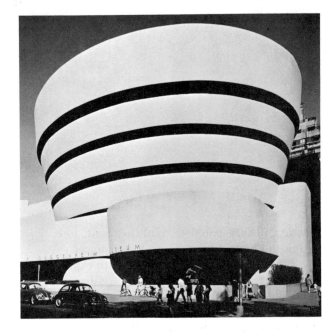

16-14 (*above and below*) Frank Lloyd Wright, Solomon R. Guggenheim Museum, New York (1959).

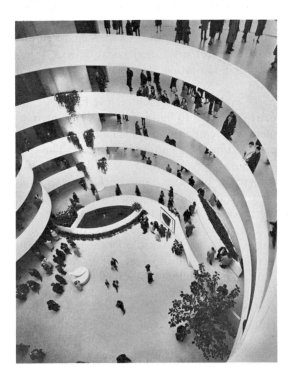

16-15 (*opposite, left*) R. Buckminster Fuller, *Geodesic Dome for Manhattan* (1962).

16-16 (*opposite, right*) Ludwig Mies van der Rohe, Apartments, Chicago (1951).

Zoning, Health, Building, and Safety Commissions. Zoning boards are empowered (by citizens) to approve or reject certain forms of building in particular neighborhoods or districts. For example, a high-rise apartment building usually requires a zoning variance in order to be built in a neighborhood of single-family dwellings. Health, safety, and building commissions are empowered to prevent construction of buildings that are unsafe or inadequately planned for the health and welfare of their users. Such boards approve new plans and inspect existing buildings for compliance with local codes; they can also condemn unsafe buildings.

Architects' and planners' vision, sense of good design, and sensitivity to materials distinguish their efforts from those of the building contractor, structural engineer, and skilled construction worker. In order to appreciate the artistry of architecture and environmental design, children need to understand the creative side of these fields, not merely the technical side.[1]

Many architects, urban planners, and interior designers use nature as the basis for design in their work. Frank Lloyd Wright often tried to integrate constructed forms with the natural landscape. Natural forms may serve as decorative or structural motifs, as seen in the shell-like form of the Guggenheim Museum (Figure 16-14). Paolo Soleri's work strives for massive

ARCHITECTURE AND ENVIRONMENTAL DESIGN

organic form on the scale of a city, but through methods that respond to evolutionary changes in technology and human interests. The vision of Frederick Olmstead, who pioneered the development of our national parks and designed many city parks, is carried forward today in the philosophy of ecological designers like Lawrence Halprin, whose plans include an analysis of the impact of *people* on natural environments.

Architectural proposals that seem highly imaginative and purely speculative today may be quite practical by the year 2000. Among architects whose proposals are based on futuristic thinking are R. Buckminster Fuller, whose book *Operating Manual for Spaceship Earth* invites us to take a planetary view of human relationships and to make technology serve people on a worldwide basis. Archigram, a group of London planners, has proposed collapsible, walking, inflatable, and plug-in cities. Utopie, a French group, has pioneered inflated and disposable architecture on the premise that permanent buildings so rapidly become obsolete that they are wasteful. When we realize that most of the children we are teaching in this decade will be thirty-five to forty years old in the year 2000, these speculative proposals seem less remote as projections, more imminent as possibilities in children's adult lives (Figure 16-15).

The search for formal and logical beauty that we associate with classical architecture is evident today in the International Style of ar-

chitecture and in efforts to plan extensive environmental changes by completely rational methods. Foremost among architects of this persuasion is Le Corbusier, who pioneered the skeleton frame with nonsupporting wall and reenergized the concept of mathematical proportions in architecture. Ludwig Mies van der Rohe's jewellike structures helped set the stage for the many clean-lined, glass-enclosed, efficient-looking office buildings in large cities (Figure 16-16). Also associated with the International Style is Walter Gropius, founder of the Bauhaus and influential educator of architects. In Japan, Kenzo Tange has produced a plan for the expansion of Tokyo into the greater part of Tokyo Bay, thereby housing and providing services to ten million people.

Although the history of architecture is known to us primarily through civic buildings and structures for the very rich and powerful, a number of architects and environmental designers want to serve a broader audience, including the poor (Figure 16-17). The concept of advocacy planning, developed by Paul Davidoff, encourages urban planners and architects to help economically disadvantaged groups prepare their own plans for community change so that they can gain greater control over the design of their own environment. Robert Venturi has shown that architecture can express pluralistic values by integrating familiar images and forms directly into buildings without sacrificing archi-

16-17 James Stirling, Previ Low Cost Mass Housing Project, Lima, Peru. A basic service core, four apartments, and room to add extra bedrooms or small shops.

tectural elegance. Yona Friedman offers a do-it-yourself system for composing an ideal environment from a range of ready-made structural parts and for seeing, on paper, its hypothetical implications. Charles Eames has demonstrated how existing ready-made building materials can be used to make one's own customized house.

Clearly, these several approaches to contemporary architecture and urban design are neither comprehensive nor exhaustive, but they do illustrate that the sources of ideas discussed in relation to more personal art forms also enter into public and collaborative efforts. Similar parallels can be found in the factors that architects and designers may consider while creating plans for structures.

Many architects seek an integration of formal relationships with symbolic or functional meanings. Eero Saarinen's design for the Trans World Airlines Terminal in New York incorporates structural curves that echo the contours of airplanes, bird wings, arrows, wind-swept dunes, and other forms shaped by air currents (Figure 16-18). Symbolic meanings within buildings and in the larger environment are also captured by the size and placement of spaces. For example, in a high-rise building, executive offices are usually placed on the perimeter of upper floors, where the view is spectacular, and light is pervasive. Within a city, particular roads, hillsides, or developments create choice vistas or pleasureable travel to and from the site. Structures built

in such locations acquire a kind of prestige that cannot be matched by any other means.

The choice of materials is critical in architecture and interior and environmental design. A building of red brick has a warm glow that is never found in the cool gray of poured concrete. Concrete seems warmer if the wood pattern from the original concrete molds is visible, or if aggregate concrete (with pebbles) is used. A shag rug has a more obvious texture than indoor-outdoor carpeting, and both are softer and more sound-absorbent than cement or terrazzo. Through their choice of materials, designers can shape an environment that profoundly affects how people feel, think, and behave.

Symbolic meanings are also influenced by the structural properties of materials. Reinforced concrete can be used to span a vast space and to create awe-inspiring interior vistas unlike those outdoors (Figure 16-19). Tall, free-standing buildings that reach upward in towering splendor can be created with steel girders. The height, span, openness, and flow of movement that we experience in architecture are just as important to the expressiveness of a building as are the site and choice of materials.

Every community, whether urban, suburban, or rural, is case material for acquainting children with architecture and environmental design. In larger communities, teachers can draw on resources from local historical archives, preservation societies, or professional organizations

ARCHITECTURE AND ENVIRONMENTAL DESIGN

for architects, interior designers, and urban planners. City and metropolitan governments often have a planning agency through which teachers can obtain copies of maps, zoning laws, redevelopment plans, and models, as well as names of guest speakers. Students and faculty in local colleges may be tapped for their knowledge of additional local resources.

Many of the activities that involve children in creating models and mini-environments also teach children the importance of planned spaces. Nevertheless, in few other art forms is the problem of encouraging awareness so acute or the need for thoughtful response greater. Most of us take for granted our environment and the structures within it and do not really understand how they affect our behavior. There are many ways to overcome our habitual responses to architectural forms and the environment. Here are some introductory activities for the very young child:

Notice elementary parts of buildings—windows, doors, floors, ceilings, walls—and basic units of the neighborhood—walkways, streets, stores, houses. How is a house different from an apartment, a school, a church, a garage? Discuss which parts of a building are put in first, second, and so on.

Create body movements that show a tall building stretching upward, a telephone pole holding up lines, a traffic light blinking, an old house, a new house. Speculate on what keeps a

16-18 (*above, left*) Eero Saarinen, TWA Terminal, New York (1962).

16-19 (*above, right*) The interior of TWA Terminal.

16-20 (*below*) First and second grade children use cardboard tubes to create an arched corridor.

building from getting tired and falling down (Figure 16-20).

Notice visual clues showing that people care for things they own—fresh paint, gardens, objects in rows or neatly grouped together. Look for opposite visual hints, and discuss how we feel and act when nobody takes care of anything. Discuss the prettiest place that children have seen, the ugliest, the scariest. Talk about children's favorite places to visit and why they want to be there.

Beginning in the first grade, children can be introduced to activities that focus on more particular phenomena:

Have children physically assume positions that echo architectural structures (Figure 16-21). Let them stretch out on a table and have their legs or arms cantilever over the edge. Form two rows of children to make a series of arches through which each child, in turn, walks. Two children lean toward each other with stiff arms and palms together; they ask other students to help them become more stable by supporting their legs, backs, or arms. Compare the stability felt when standing with feet together, with feet apart, with one hand on the floor, with both hands on the floor.

Have children create imaginary space bubbles around themselves and then pretend to expand or contract the bubbles to show how large the bubbles might be in order to surround activities like holding a conversation with two

people, playing a game with four people, standing in a cafeteria line, playing charades with six or eight people.

In the early elementary grades these active experiences should be supplemented with objective study. Children should have access to numerous photographs of both interior and exterior architectural forms. Some photographs may be from the local community; others should encompass an international range of structural examples. Photographs should be dry mounted on mat board (with narrow edging) to facilitate matching, sorting, and display.

Children can make schematic studies on top of photographs using a grease pencil, clear acetate notebook covers, and paper tissues. The acetate is placed over the photograph to protect it. Children may then locate particular features in an array of photographs, and trace basic geometric shapes, varieties of doors, windows, roof lines, columns, and so on. The acetate sketches can then be displayed with the photographs.

Photographs taken of architectural details in the classroom, school, and immediate neighborhood are especially valuable for building perceptual awareness. Take photographs of lighting systems, flooring, walls, windows, doors, stairs, signs, building façades, roof silhouettes, and fences. Develop these into 5 × 7-inch (black-and-white) prints. Before children take a walk through the building or neighborhood, pass out photographs that have been taken of details

16-21 (*opposite, left*) First graders shape their bodies to follow different roof lines on buildings. (*opposite, right*) Kindergarten children imagine what it feels like to be a column.

16-22 (*right*) Preschool children learn how frame buildings are constructed.

that they can recognize during the walk. Ask them to try to find the clues in their photographs while they are taking the walk. Within the classroom, post photographs and invite children to guess where the photographs were taken.

Blueprints and maps, together with architectural and topological models, should be available for children to see and discuss (Figure 16-22). Point out the relationship of the plan, elevation, and section drawings to the model. Try to obtain drafting tools, model-making materials, and architectural catalogs so that children can inspect them and learn about their use in the planning process.

Introduce children to an appropriate vocabulary for discussing the environment and provide the experiential basis for understanding these terms. For large-scale environments, a vocabulary (slightly modified) proposed by Kevin Lynch in *The Image of the City*[2] is excellent:

Paths or Transportation Networks. The lines along which people and goods are moved. Walkways, roads, transit lines, railways, rivers, and canals are examples. Every city tends to be organized around these paths. Ask children to identify paths or transportation networks in their neighborhood. Take a brief walk to see which paths may have been overlooked—alleys, walkways to homes. Older children might color-code a city map to show major paths.

Edges or Borders. Breaks in the continuity of an environment; they define areas, help us differentiate one area from another, and tell us where we are in a lateral sense. For example, when we say we are at the edge of the city, in the center of town, near a business district, or looking across a lake at a row of skyscrapers, we are aware of edges and borders. Have children identify borders in their own neighborhood, noticing changes in building heights or in terrain and shifts from open, grassy areas to clusters of buildings.

Districts or Regions. The areas within a city that have features with easily recognizable similar characteristics. The common traits might be associated with the type, use, or condition of buildings; the width, lighting, or straightness of streets; the implied or actual monetary value of buildings; and the social status of residents. Districts are often defined by edges or borders and are frequently related to major paths or transportation networks. Many neighborhoods are subdistricts within a larger region. Children's sense of the scale and distribution of regions in their city (or rural environment) can be enhanced by bus trips outside of it or by walks that are planned to show contrasts in districts. Photographs of buildings from different regions within the city might be taken, sorted into look-alike groups, and then checked against city maps to see if particular types of buildings do cluster in certain districts. Using the same photographs, children can establish hypothetical districts based on similarities in the photo-

graphed buildings. Maps can be color-coded to show districts.

Node, Core, or Hub of Activity. A center of concentrated activity involving people, goods, and services. Within a neighborhood, the corner drugstore may be the hub of activity; in a suburb, a shopping center may be the distinguishing node of activity; in a rural district, the nearest freeway entrance or closest farmhouse may be the core of activity. Ask children to identify places in their community that they and their families go to or from very often. Identify hubs of activity within the home or school, or for shopping, entertainment, or watching other people.

Landmarks. Structures that stand out; they attract our attention in an environment. A landmark can be a tall tower, a historic monument, a freshly painted building in a row of weatherbeaten structures, a lighted billboard, an outdoor stadium, a central plaza or park. Landmarks are sometimes very small. Even desk tops at school have landmarks that make them distinguishable from one another.

In order to teach children to interrelate these environmental concepts in a personal way, invite them to discuss the experience of being lost and finally finding the way. Point out the value of clearly defined paths, nodes, districts, and landmarks—the special appearance of a place—in helping people locate themselves in an environment. Discuss how people learn to find their way when they move from one community to another.

Special attention should be given to observing common elements and materials in the environment. Environments are composed of natural and constructed materials. Sun, air, water, flora, and fauna are all integral parts of the larger landscape. Even if the remaining evidence of nature within the city seems to be little more than weathered buildings, a flock of pigeons, potted plants on fire escapes, and ourselves, the natural elements in any environment should be examined and noted in some detail. Take neighborhood walks to look at and distinguish among surfaces of wood, metal, concrete, brick, glass, and asphalt. Notice the varieties of forms in which each material appears.

To make children aware of their own values concerning their environment, suggest that they write a free-verse group poem. Take the children to a neighborhood site. Have them carefully observe it and then write their feelings about the site. On returning to the classroom, arrange the slips to show similar or contrasting observations. Type the slips into a poemlike survey of student concerns and observations.

A related technique is posted poems. Using a thesaurus, pick out synonymous adjectives, adverbs, nouns, and verbs, and write one word on each of a number of index cards. Students search for words that seem to describe particular parts of their environment. They then post the cards in the environment for a short time.

Explore with children the poetic imagery of cities and the children's own ability to see the urban landscape as if it were alive. Collect poems, stories, paintings, and music that characterize cities. Read aloud or listen to contrasting images and descriptive passages. Carl Sandburg's poems and passages from Charles Dickens' *A Tale of Two Cities* are good. Popular songs about Paris, London, San Francisco, Chicago, and New York also contain phrases that reveal difference among these cities. Afterward, ask children to portray the personality of their own neighborhood or city in a painting, a poem, a story.

Art in society

The social implications of architecture and environmental design should be explored with children and youth. It is of utmost importance that teachers cultivate their own understanding of relationships between the physical form of the

environment and the life styles of people within it. This requires a willingness to encounter and understand people whose values, beliefs, and ways of life are different from one's own. When teaching children about the interrelationship of life styles and environmental design, the teacher must serve as an interpreter of values, not as a judge of others' beliefs and conduct. Value clarification is the governing principle in this area of teaching, not value judgment.

Children should learn that the kind of environmental order that people create depends on their beliefs and values. Changes in the environment are records of changes in beliefs. Consider attitudes about the relationship of humankind to nature. In some cultures, people live in awe of nature. They conserve the land to the fullest extent, even to the point of sacrificing personal comforts to ensure the preservation of the land. If people believe that they should live in harmony with nature, their structures are likely to protect natural land formations and judiciously utilize available natural resources. If people believe nature must be conquered and controlled, they will create structures that are superimposed on the land, often not sparing it at all.

A sense of time and history also influences the construction and preservation of environments. If people honor the past, traditional or permanent structures are considered relevant and are cared for even if they are old. If the present is all that counts, structures are likely to be temporary, innovative, quickly dated by changing taste, and uncared for. There are a number of ways to show children how beliefs, values, and concepts of time affect architecture.

Find examples in the school or in community buildings that show that people care about the way their environment looks and are willing to take good care of it. Find examples that show that people do not care how their surroundings look and abuse them. Help children find a place in which they can make a positive change in the appearance and care given to things. Arrange time and resources for them to create the change. Take "before," "during," and "after" photographs of the location and display them next to the location. Have children maintain their improvements.

Obtain historical and contemporary photographs of interiors of houses. Invite the children to imagine what it would feel like to use the furniture, to have friends in to play or visit, to help with the cleaning and dusting. Focus on what they would enjoy about the space and what they would not like. Ask them to imagine why other people might like to live in the house, even if they themselves would not like to.

Take a walk in the neighborhood through alleys or along paths that permit children to look at the backs of buildings. Discuss the difference between the use, care, and appearance of the fronts and backs of buildings. Ask children to think about why the backs of buildings are often quite different from their fronts. Ask them to think of examples of buildings that have indistinguishable fronts and back (for example, a stadium or a department store that extends an entire square block).

Find out how many local businesses or factories offer tours for school groups. After checking the locations, arrange two field trips offering maximum contrast—for example, to a business oriented toward service to people and then to a business that mass-produces hard goods; to a huge production or warehouse operation and then to a smaller customized enterprise. Contrast the feelings workers might have about their jobs because of the physical environment in which they work and the nature of the tasks they perform.

Obtain a large city map. Have children color-code parks in green; bodies of water in blue; streets in two shades of red (light pink for streets, bright red for main arteries); civic buildings like hospitals, schools, and police and fire stations in yellow. Then take imaginary trips (leisurely, normal, emergency) to and from various destinations on the map. Notice locations

on the map that look as if buildings are crowded together or as if there is a lot of open space. Have children find out how many important places they could or could not travel to by public transportation if they lived in any randomly selected part of town. (To make a random selection, a child should be blindfolded and told to point to a spot on the map.)

Photograph newer buildings in the community (or have older children photograph them) that show borrowed architectural motifs—Greek columns, English Tudor apartments, Spanish tile and stucco, German row houses (Figure 16-23). Discuss why people may want to construct or live in buildings that look historical. Visit community locations (or obtain photographs of them) to study eclectic art forms, such as fast-food restaurants that look like barns, English cottages, Mexican haciendas, or Chinese temples. Sketch the specific motifs and shapes that make people regard the building as part of a tradition. Compare these structures with photographs of authentic versions.

Ask children to list places that they recommend to visitors who could spend only one day in the neighborhood or city. Invite children to explain why those locations would be the nicest to visit. Then have them identify places that they would not want visitors to see. Discuss why people might be proud or embarrassed to show visitors certain parts of their neighborhood or city (Figure 16-24).

Provide children with a wide range of colored paper, scissors, and paste. Ask each child to cut out a shape that is unusual—not like any other person's shape. Have each child use crayons to make the shape into an unusual building and paste this shape anywhere he or she wishes on a large sheet of paper, contributing to a group picture of a community. Make a contrasting group picture with more limited choices. For example, use only three colors of paper and three basic shapes. Have each child cut out a shape within these limitations, add details to make it look like a building, and paste it on the large sheet. Compare the sense of order in each of the two composite pictures. Relate this exercise to the way in which a town or a neighborhood may be created—out of individual choices with no restrictions or out of individual choices with some restrictions. What kind of order seems to be most effective?

Take children on a walking tour or a bus tour of the city to look at landmarks—buildings, parks, sculptural monuments, bridges. Discuss why people like to build and live in distinctive structures. Arrange a contrasting tour through housing projects, suburban developments, and neighborhoods where many buildings look alike. Discuss why people build similar or identical housing structures.

Walk through a neighborhood to look for evidence of uniformity in architecture and the environment. Assign specific things to focus on,

16-23 American architecture with borrowed motifs. (*opposite, left*) A well-manicured "English" manor house. (*opposite, right*) A midwestern American "pub."

16-24 (*right*) Two faces of a metropolitan area, within a few blocks of each other.

such as signs, shapes of windows, building materials, street lights. As an alternative, take photographs of architectural details, structures, and materials in advance and give one photograph to each child. During the walk, have children record the number of times that they can identify the same structure recorded in their photographs.

In the upper elementary and junior high grades, role playing is an effective technique for teaching the architect's or designer's relationship to a client. Role playing can also be used to introduce children to the process of reconciling different opinions about good community design. After one or two role-playing exercises, children can begin to invent their own situations and roles for class members to assume.

Here is one example of a role-playing activity:

PROBLEM:
Design a pocket park for a city lot that is 25-feet wide × 75-feet deep.

DATA:
1. The lot is cleared. A budget of $800 is available for supplies and materials.
2. Community residents are of many ages.
3. Families live in apartments that face the street. There is no other open space in the neighborhood.
4. The crime rate in the district is high.

5. Interviews with local residents have shown that they want the park but fear it may be unsafe.

ROLES:
1. Architectural team (three or four students). Your job is to design the park. To do this, you must find out what people in the community want. Different people may have different ideas about the type of facilities they prefer. Your job is to get the residents to agree on the purposes of the park and on whom it should serve.

2. Neighborhood Consulting Board (ten members of class):
 a. *Teenager 1.* You and your friends want a basketball court, poles for a volleyball net, and a drinking fountain.
 b. *Teenager 2.* You and your friends want a place to hang around and talk after school. You do not care about active sports. You are card players and people watchers.
 c. *Parent 1.* You have three children, ages two, three, and four. You want a safe outdoor place for them to play under your watchful eye.
 d. *Parent 2.* You have three children, ages six, eight, and ten. You want a safe outdoor place for them to play after school. The ten-year-old usually watches out for the younger children.

TABLE 16-1

PROGRAM PLANNING FOR DESIGN

Participants	Environment	Objectives	Activities	Design Requirements*
Boy, age thirteen Friends of the same age.	Bedroom (recently added)	Physical comfort	Sleeping Dressing	_____Provide comfortable place for sleeping _____Provide place for dressing
Parents and older members of family		Security, storage of personal possessions	Storing clothes and other possessions	_____Provide storage space for clothes and possessions
		Expression of interests and tastes of user	Making models Studying Entertaining three or four people	_____Provide work and display areas for models _____Provide for choice of client in color and furnishings _____Provide place for study _____Provide area for individual and small-group activity

*Design requirements can now be used as a checklist for evaluating the adequacy of a proposed physical plan.

e. *Parent 3.* Your teenagers, ages fifteen and seventeen, have been in trouble with the law. You do not care what the park is like as long as youngsters do not get into trouble there.

f. *Older Resident 1.* You are seventy-five years old and live alone with your dog. You would like a quiet place to sit in the sun and walk your dog.

g. *Older Resident 2.* You and your friends are single. You want a place to sit and talk or have a quiet picnic on a rainy day. You would also like the park lighted so that you can enjoy it in the evening.

h. *Older Resident 3.* You work at night and need to sleep during the day. Your apartment overlooks the lot, and you want the users of the park to be quiet.

i. *Shop Owner.* You have a variety store opposite the lot. You do not want anything going on in the park that would hurt your business. You want the park lighted.

j. *Police Officer.* You are concerned about safety. You do not want youngsters chasing balls into the street or ganging up on older people or younger children.

RESOURCES:

Catalogs showing dimensions of park furniture. Area requirements and specifications for indoor and outdoor sports and games. Technical advice on water, electricity, and the like.

Children should be divided into two independent planning groups, each group working on the same problems and with the same roles so that the solution found by both groups can be compared. When the members of both groups reach an agreement on the purposes of the park, they list the purposes on paper or on the blackboard. The architects then draft two or three different

plans for the lot (meeting these purposes) to submit to the Neighborhood Consulting Board for approval by two-thirds of the members. (Funds are not distributed until the plans have been approved by the clients—that is, the Neighborhood Consulting Board.)

Program planning—developing an inventory of needs for an architect, a designer or a planner—can also be introduced in the upper elementary grades. In the example shown in Table 16-1, a bedroom is to be added to a home. The chart of requirements is developed through group discussion of the elements (the categories at the top of each column) that must be considered when designing a room. (The teacher should lead the discussion, at least initially.) Although the group can begin with any element, the participants, the environment, and the activities are easily established. The objectives are important because they condition the character of the activities. For example, the inhabitant of a room will not feel comfortable, warm, and secure if he or she must sleep on a canvas cot on the floor or on a hard slab suspended from the ceiling. Using the design-requirements list, the architect begins the creative task, speculating on alternative ways of meeting each of the requirements and taking into account costs and the most efficient use of space.

Notes

[1]Charles Jencks, *Architecture 2000: Predictions and Methods* (New York: Praeger, 1971).

[2]Kevin Lynch, *The Image of the City* (Cambridge, Mass.: M.I.T. Press, 1960).

Suggested Readings

Baumgart, Fritz. *A History of Architectural Styles.* New York: Praeger, 1970.

Blake, Peter. *God's Own Junkyard: The Planned Deterioration of America's Landscape.* New York: Holt, Rinehart and Winston, 1964.

Group for Environmental Education. *Our Man-Made Environment: Book Seven.* Philadelphia: Gee!, 1971.

Jencks, Charles. *Architecture 2000: Predictions and Methods.* New York: Praeger, 1971.

Lynch, Kevin. *The Image of the City.* Cambridge, Mass.: M.I.T. Press, 1960.

Mumford, Lewis. *The City in History.* New York: Harcourt Brace Jovanovich, 1961.

Rapoport, Amos. *House Form and Culture.* Englewood Cliffs, N.J.: Prentice-Hall, 1969.

Rasmussen, Steen E. *Experiencing Architecture.* Cambridge, Mass.: M.I.T. Press, 1962.

Rudofsky, Bernard. *Architecture Without Architects.* Garden City, N.Y.: Doubleday, 1964.

Ceremonial and holiday arts

The purpose of a ceremony or celebration is to make an experience more vivid and memorable. When children are participating in or creating celebrations, they have to consider the meaning of the event that is being commemorated. The expressive purpose of the event should determine what the participants do, which objects are involved in the ceremony, and what the setting will be. The aim is to choreograph all elements of the event, orchestrating them into a vital and uncommon experience for all the participants.

Personal expression

Many children are introduced to ceremonies and celebrations in the home, in school, or in connection with their religious education. They also become acquainted with holiday festivities

through television and commercial displays in stores.

Media and processes

The principal media for ceremonial expression are people, objects, and settings.

The attitudes and behavior of people are clearly important to the overall expressiveness of a ceremony. Children may take either an active role in creating the ceremony or a more passive but complementary role as participant-observers of the event. In either role, the evocative power of the event will depend on the children's understanding of the ceremony and of the forms of behavior appropriate to it.

The colors, forms, and motifs of objects used in a ceremony or celebration are important in establishing the mood of the event. Among

348

the objects that might be involved in ceremonies and celebrations are the following:

Gifts

Banners, bunting, balloons

Costumes, hats, jewelry, masks

Trophies, plaques, certificates

Mementos

Special music, dances, gestures

Special food, drinks, table settings

Special plays, poems, puppet shows, performances

Permanent objects or changes in the environment

Floats, replicas

Displays, exhibitions, demonstrations

Settings for celebrations or ceremonies can be defined in several ways: by location, by time of year and time of day, or by overall duration of the event. Most school-related celebrations and ceremonies are likely to be held in or near the school or at locations to which groups of children can be transported. Here are some examples of possible locations:

Classroom

Corridors

Cafeteria, gymnasium, auditorium

Playground

Sidewalks around school

Streets for special parades

Public parks, plazas

Stadiums or other public buildings

Hospitals, homes for the aged

Timing can be considered in a number of ways. Here are some examples of factors that might be considered:

Time of year—seasonal events

Time of month—to coincide with a specific day

Time of day—morning, afternoon, evening

Length of time—several days, all or part of a day, an hour, less than an hour

Length of planning period—arranged in advance, totally spontaneous

Gift giving is one way of marking an important event. The nature of the gift, the way it is wrapped, the message or greeting that accompanies it, the time and place of delivery—all are important to the meaning of the gesture. Handcrafted gifts can be made expressly for the recipient (Figure 17-1). For example, a holiday candle might be decorated with carvings that refer to "Grandmother's kitchen." It might be presented in a handmade wrapping paper that narrates a

17-1 (*top, left*) This sixth grader is making a wood toy.

17-2 (*center, left*) Musical instruments contribute to the festive mood of a celebration.

17-3 (*bottom, left*) Fourth graders made these costumes for a play.

story about grandmother's goodies. Personal gifts need not be elaborate; they can be simple tokens of feeling that, in the context of the total act of giving, are more important as symbols than as objects with material value.[1]

Children enjoy watching parades and participating in them. Costumes, banners, balloons, music or chants, rhythmic body movements, simple or elaborate floats—all are part of the magic of parades (Figure 17-2). Simple costumes with special hats, musical instruments, jewelry, staffs, and banners can be made from paper, found objects, or cloth; masks, elaborate head decorations, and large temporary sculptures can be made from cardboard boxes or papier-mâché.

Parades may set the stage for a main event or cap a series of events. For the spectator, watching a parade is a bit like watching an ongoing series of different displays, acts, or events. For the participant, taking part in a parade offers a continuous experience of being on stage before an ever-changing audience.

Because plays and other live performances are presented before an audience, they are usually well planned; they can also be improvised. Costumes, props, and simple stage sets help create the necessary mood and communicate the narrative content (Figure 17-3). Puppets and marionettes are excellent vehicles for live performances.

Exhibitions and the school environment are not usually regarded as ceremonial or commem-

CEREMONIAL AND HOLIDAY ARTS

17-4 (*top, right*) The classroom environment can be enlivened by changing displays and furniture arrangements.

17-5 (*center, right and bottom, right*) A ceramic clay mural. Grades 1 through 6.

orative art forms, but their ultimate meaning and expressive intent is to celebrate learning. The value of viewing the school in this way will be seen in the attitude and behavior of children who look forward to coming to school and who sense that learning is a joyful enterprise. The personalization of classroom spaces through furnishings, plants and animals, displays, and flexible room arrangement can humanize the child's learning environment and offset the sterile character of many school buildings (Figure 17-4).

To the fullest extent possible, children should be involved in deciding what to display, what to take down, how to arrange furnishings, and the like. Most classroom exhibits will attract children's interest for about two or three weeks. Old or familiar material will be seen with a fresh eye if it is relocated or juxtaposed with new material.

Large-scale collaborative projects—murals, outdoor sculpture, and school or community improvements—are means of building a spirit of sharing and a feeling of group identity.

Mural making can be done indoors or outdoors (Figure 17-5). Indoor murals should be integrated with the surrounding architecture. Some murals are narrative; others are decorative surfaces that seem to animate the experience of walking into or through a space. Interior murals can be painted directly on a wall with tempera or latex paint, composed out of clay tiles (slabs painted with underglaze) that are put into place

PERSONAL EXPRESSION

17-6 (*top, left*) A sidewalk mural in chalk. Grades 4 through 8.

17-7 (*center, left*) A celebration of self and the wide world of nature.

17-8 (*bottom, left*) Eighth graders effect a temporary transformation of self through face-painting.

by a professional tile setter, or constructed from assorted materials firmly mounted on wood or masonite and permanently installed on a wall. Outdoor murals can be created on asphalt or concrete surfaces that surround areas where there is heavy foot traffic (Figure 17-6). Temporary works can be drawn with large lecture-size chalk; permanent works can be made with exterior latex paint or enamel. If there is a suitable location, garden murals with plantings can be developed.

Large sculptures can be created with assistance from adults. A fresh snowfall provides a good opportunity to make sculpture. Snow can be solidified and then painted with diluted food coloring. Particular materials or industrial resources available in the community can also be considered as media for sculpture: brick and lumber can be used for large sculpture; sand and clay can be cast in concrete and assembled with mortar into larger forms; a helium tank and heat-seal plastic can be made into large inflated sculptures; helium-filled weather balloons can be used to support floating banners or lightweight mobiles of cloth, cardboard, and paper.

Motivation

Nature is a wonderful source of ideas for celebrations and ceremonies (Figure 17-7). The arrival of winter or spring, the show of autumn

CEREMONIAL AND HOLIDAY ARTS

17-9 A "Class of 76" mural made of plaster life masks. (*top, right and center, right*) Making the masks. (*bottom, right*) The mural.

foliage, a fantastically beautiful day or a threatening stormy day—all can be occasions to celebrate the beauty and power of nature. In addition to being motivated by seasonal or weather changes, ceremonial events might be inspired by the basic elements of air, fire, earth, and water; or by creatures of the air, sea, and land; or by the sun, moon, and stars.

There should also be room for the fanciful and the funny in celebrations. Even activities that seem pointless can be totally refreshing simply because they are not governed by that overriding sense of purpose that pervades so much of life in school (Figure 17-8). For example, on one day, every child in class may wear a red dot on the left cheek simply to see if anyone notices and asks why. For no special reason except as a pleasant surprise, children might create whimsical decorations for the cafeteria. Imaginative celebrations might be originated by questioning the traditional symbols associated with familiar holidays. Might there be more appropriate symbols for George Washington's birthday than an axe and a bunch of cherries? Indeed, are not these motifs remarkably inappropriate to capture the significance of the first president's role in our nation's history? Familiar or original fairy tales, legends, and adventure stories can also be tapped as sources of inspiration for plays, dances, and puppet shows.

Ceremonies at the beginning of each school day can be planned to provide children with the

17-10 The display of artwork is a way of recognizing both effort and accomplishment.

continuity of experience afforded by rituals and with the variety of experience inherent in celebrations. For example, the pledge of allegiance to the flag might be enhanced by adding short poems, messages, or songs about the lives of famous Americans. Comparable programs and activities might focus on local citizens or on children and teachers who have made a special contribution of time or effort worthy of school-wide recognition (Figure 17-9).

Ceremonies recognizing special achievements offer an excellent opportunity for children to learn that excellence can take many forms. Contests and competitions in art should be avoided. However, several students might be recognized as outstanding in a particular art form; others might be recognized for achievement in representational art or in imaginative work. Recognition should also extend to children who are skilled in doing research in, writing about, or discussing art. By broadening the definition of art to include varieties of excellence, you will demonstrate that achievement is within the reach of many students and through a multiplicity of channels.

The timing and pacing of special recognition of students' work should be as close as possible to the performance itself (Figure 17-10). For example, if one or several children have completed unusually fine prints, display the prints outside of the classroom accompanied by photographs of the artists and little cards ex-

plaining the nature of the students' achievement. In general, teachers do not pay enough attention to the positive value of special citations in defining children's self-images and in building their feelings of self-worth. Clearly, every child, at some time, should have the ego-building experience of having his or her competence in a particular area acknowledged in a public arena.

Ceremonies should not be limited to giving special recognition for schoolwork. Children can be encouraged to recognize adults whose efforts are important in their lives—the school crossing guards, the cafeteria staff, the custodian. They might recognize the special courage and effort required of a child who has been seriously ill or who is handicapped. In addition to these opportunities for appreciative concern, there are many informal ways to build a caring atmosphere —a surprise note inside the desk of a child who has been absent, a welcoming note on the blackboard for a visitor, an early-morning, secret delivery to each classroom of a fresh flower.

Dedication and commemoration ceremonies are also opportunities for personal expression. During the school year, there are a number of occasions that might be observed with appropriate ceremonies—Thanksgiving, President's Day, Martin Luther King Day, and Memorial Day. Such occasions call for thoughtful consideration of the reasons for commemorating people and events. Children also might devise ways

to recognize heroes, heroines, or special events that are important in their own experience or community. For example, although many schools are named for individuals who have made contributions to a community, state, or to the nation, children may not know why their own school is named after a particular person. By planning a rededication or commemorative ceremony, children can rediscover the contributions of their school's namesake.

Guidance

For most performance ceremonies, adequate planning time and rehearsals for the event are essential. In the lower elementary grades, one or two full rehearsals are sufficient for most performances that will be staged in front of an audience. Upper elementary children's own standards are higher, and they will usually want to have three or four full rehearsals to feel confident about their roles.

Ceremonies and performances that require props, costumes, or special decorations also need planning. Rough full-scale patterns or models for costumes and props can be made in paper to check their overall effectiveness. Sketches are also of value in designing banners, stage sets, and room arrangements.

Nothing is more important in planning ceremonies and celebrations than considering the meanings of the event and how those meanings can best be translated into the words, music, visual forms, patterns of motion, and timing and ordering of parts of the event. An event to honor the memory of Martin Luther King might be solemn to convey a sense of mourning at his premature death or optimistic and joyful in reflecting Dr. King's own message, "I Have a Dream." The event might well combine both moods and end with one or the other more dominant. Consideration might be given to actions that would best keep alive the ideals of Dr. King. Rather than limit the observance to a school assembly that might involve slides showing Dr. King's life and recordings of his voice, suggest that each child do something for another person that would reaffirm the ideas for which Dr. King stood.

Valentine's Day is an opportunity for people to express their loving relationships with others. However, there are many forms of love—love of mother is not the same as love of country. Love can be tender, charitable, infatuated, coy, reverent, rapturous, passionate. Similarly, if the idea is to send a message of love, there are many means of doing so; the traditional greeting card is only one way. Poems, music, gifts, and kind deeds are other options. By exploring the meanings of love with children, we can help them discover images and ideas that will communicate their feelings to others. By imagining forms of communication that are

17-11 Holidays should be celebrated with relevant and meaningful images.
(*top*) Alexander Gardner, *Portrait of Abraham Lincoln,* photograph (1863).
(*center*) Mathew B. Brady or A. Burgess, *Portrait of Lincoln and Tad,* photograph (1864).
(*bottom*) Lincoln Memorial.

different from conventional means, children may increase the effectiveness of their message.

While the celebration of many events should retain traditional images and symbols, it is sometimes valuable to reinvest tradition with fresh meaning. This might be done by shifting expected color relationships, by developing new symbols, or by inventing different ways of observing an occasion. Halloween, for example, is usually associated with orange and black, two highly contrasting colors that have shock value. Explore other color combinations that have shock value—purple and chartreuse, black and yellow, yellow and purple. Similarly, many alternatives to Lincoln's silhouetted profile can be found to commemorate his birthday—displays made of Mathew Brady photographs, enlargements of Lincoln's signature, photographs of the Lincoln Memorial, or poetry about Lincoln by Carl Sandburg (Figure 17-11).

The location of an event helps define its meaning and importance. For example, the symbolic meaning of an observance of Washington's Birthday might be heightened by holding it on a street or in a park or school named for Washington. Similarly, cards sent to a home for the elderly may have less meaning than a visit to the home for direct communication through a performance or the presentation of cards or gifts. Children tend to regard any celebration held outside of their own classroom as more important than one held inside it. Events planned for

CEREMONIAL AND HOLIDAY ARTS

others to observe usually have greater importance to children than events planned just for classmates.

The artistic heritage

Many artists have created works in honor of people, places, and events. Virtually every portrait can be considered a tribute to the character, achievement, or suffering of an individual. Landscape paintings celebrate the wonders of light, air, and massive land forms, or the delicate tracery of trees, flowers, and fields. Even still-life arrangements may seem to celebrate the beauty and profound symbolic meanings of a simple loaf of bread, a basket of apples, or a bouquet of flowers.

While looking at a portrait, children can imagine that they are the person in the portrait. Have them assume the body position of that person; feel the weight and pull of the clothes; imagine the wrinkles of the eyebrows, the twist of the head, the gentle curve of the lips, the direction of the eyes and what they might be watching. Have children act out the series of movements that they might have made before becoming still in that position. Ask the children to imagine what the person might say if suddenly he or she were to come to life. Is the person like anyone they know? What would children like to find out about the person if they could meet him or her in real life? Why might the person have had the portrait painted?

Help children see landscapes as works that celebrate the power, gentleness, rugged beauty, or violence of nature. Invite children to imagine that they can climb into the landscape and feel themselves walking carefully, running hard, climbing hand-over-foot across rocks, sitting quietly under a tree. Help them imagine breathing the air and feeling the heat or the wind. Treat city scapes in a comparable way to build personal identification with the place, time of day, and possible reasons the artist had for sharing his or her experience through a special work of art.

While they are looking at still lifes, ask children to pretend they are the objects portrayed in the work—the elegant, tall vase filled with fresh water, which is gently holding up the bouquet of flowers; the old books resting quietly on the table. Invite children (as the books) to feel their worn edges, to imagine all the people who have opened their pages, to remember the messages they have communicated to their readers. In viewing some still lifes, children might pretend that they are detectives searching for clues, looking with amazement at all the things people have left in place, standing up tall or crouching low to see every detail in each thing.

Following visual explorations like this, discuss with children their own experiences with

objects like those in the still life. Invite children to recall places in which they have seen similar arrangements and why it is that they can even remember seeing such an arrangement. Explore the variety of meanings of the objects in the still life and decide if all of the meanings are related in some way. Invite the children to consider why the artist might have re-created the composition of objects in a still life and why it was made in just that way.

Some contemporary artists are working directly with ceremonies, rituals, and celebrations as art forms (Figure 17-12). Allan Kaprow pioneered the art of happenings—a performance of events that is loosely staged with a scenario suggesting how people might create an aesthetic experience without being told in detail how to respond or act. Ann Halprin, a choreographer, has developed formats for people to revitalize their experience of the environment. For example, by following a prepared score of locations to visit and things to do at each site, participants can restore their sense of time, place, and identity within a familiar environment.[2]

Iain Baxter, a Canadian artist who asserts that anything is a work of art if people simply claim it is, has formed a company called N. E. Thing Co., to photograph familiar but generally ignored objects that may be regarded as art. Invite children to locate objects or settings that they would like others to recognize as so beautiful, special, or imaginative that the objects or settings should be called *art*. Photograph these discovered works of art and present the photographs as an art exhibit (Figure 17-13).

It is important to teach children that individual objects used in a ritual are not as important to the celebration as is the dynamic interplay of feelings created by the full experience of the moment. You might involve children in creating events based on celebrative formats pioneered by such contemporary artists as Iain Baxter, Allan Kaprow, and Ann Halprin.

You might invite older children to learn about Allan Kaprow's happenings or Ann Halprin's scores. After they have learned about the work of these artists, invite the children to stage a happening or to prepare a score on a theme like "soft stuff," "saving and collecting," "a celebration of nothing in particular." Ask children to think of experiences they have had that, in retrospect, could be considered happenings. Invite them to create scores as records of those events.

The elements of earth, air, fire, and water are being explored as media for celebrative and ceremonial expression, even in a world that is coming to rely more and more on machines (Figure 17-14). Some of today's artists, born into a technological world and reared in a manufactured environment, seem to be seeking the kind of intimate and mysterious connection with nature once experienced by all people whose survival depended primarily, if not totally, on the earth's bounty.

CEREMONIAL AND HOLIDAY ARTS

After studying contemporary artists' interest in earth works, water works, air works, or think works,[3] children may wish to create their own projects expressing something about these forces.

Other contemporary artists are interested in commenting on the superficiality of our responses to heroic deeds. Edward Kienholz, in his work *The Portable War Memorial*, irreverently suggests that people in our time display mock patriotism toward public images, while showing their true patriotism by searching for personal gratification. Equally iconoclastic are Claes Oldenburg's proposals for contemporary public monuments that are shaped like food—a gigantic Good Humor bar to be erected in Manhattan, replacing the Pan American Building. Christo has alluded to a future of mummified and stored relics from the present by wrapping entire buildings, including art museums in Chicago and Bern, Switzerland, in polyethylene and rope.

Some artists work from a more optimistic frame of reference, hoping to reaffirm that joy, peacefulness, and the contemplation of elegant forms need not be alien to everyday life (Figure 17-16). We see this spirit captured in the monumental sculpture of Alexander Calder, Henry Moore, and George Rickey.

Many works of art actually portray ceremonies or are created to commemorate important events. Thematic studies—for example, Ameri-

17-15 (*below*) Christo, *Valley Curtain* (1971).

17-16 (*bottom*) Alexander Calder, *Black, White, and Ten Red* (1957).

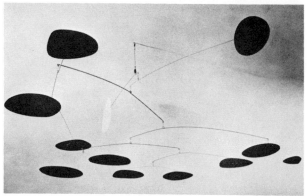

can military history as depicted in portraits of generals, battle scenes, and monuments to known and unknown soldiers—are particularly instructive in helping children appreciate the artist's interest in giving visual form to significant moments in life. Much of what we know about the old West has been chronicled in photographs, sculpture, drawings, and paintings.

Religious works and artifacts might be studied in order to learn how artists contribute to important life events. You might arrange an exhibition of ceremonial objects created by contemporary artists and craftsworkers for churches and synagogues—banners, clerical robes, murals, stained-glass windows, statuary, furniture, and doorways. Marc Chagall and Henri Matisse are among the many artists who have created works for direct sacramental use in religious ceremonies.

Art in society

Much of the world's art can be understood as having a commemorative purpose. The cave paintings found at Lascaux in France are believed to have functioned as symbolic means of rehearsing for a hunt—by painting the animals, the hunter-artist subjected them to his power. Much of Egyptian, Greek, and Roman art was probably intended to preserve and transmit the

memory of important persons, to retell legends, or to recall military victories. Medieval and Renaissance art not only glorified the power of the church but also explained religious doctrine to illiterate people. The courtly baroque and rococo arts and later revolutionary images of the common man reflected the intellectual and moral values of the time. Even twentieth-century art—which often seems introverted and obscure—celebrates the farther reaches of the mind, the human capacity for delight in pure form, and a world marked by rapid innovation.

Both public and personal art forms help commemorate and celebrate important events. The latter forms capture moments in time, inviting us to reconstruct the circumstances under which we acquired the objects and reminding us of people, places, and things that matter to us. They are relics that define our own histories (Figure 17-17).

The following activities will introduce children and youth to ceremonial and commemorative events in which visual forms have an important private or public expressive function:

Develop a photograph collection of commemorative buildings, statues, plaques, and tombstones in the community. Invite children to find out about the people or events that these forms honor.

Research the symbolic meaning of the Washington, Lincoln, and Jefferson memorials; for example, identify the symbolic meaning of

17-17 (*opposite*) Souvenirs, such as the bottle and the Florida shells at left, may be valued as memorabilia.

17-18 (*right*) Visual clues to group identity, rank, and occupation.

the overall form and style of each structure, the materials used for its construction, the placement and style of sculpture and lettering.

Invite children to find out how commemorative stamps are designed and selected by the United States Postal Service. Have children create an exhibit of commemorative stamps and write brief stories about the people or events being commemorated.

Collect photographs of official government ceremonies from around the world. Old *National Geographic* magazines are a good source. Ask children to explain how they know that the event and people involved are important—the use of special flags, jewelry, and clothing; the presence of guards or military officers; the relative location of people in the center of a stage or on a podium (Figure 17-18). Ask children to imagine how it might feel to be in the position of selected persons in the photographs.

Obtain photographs of trophies and plaques that are currently awarded for various kinds of achievement. Ask children to consider the meaning of trophies and awards from the standpoint of the giver, the recipient, the person who almost won, the person who was not a contender for the prize.

Invite children to create an appropriate award for one of their present (preferably living) heroes or heroines in sports, entertainment, politics, or art. Have them consider the qualities that they most admire in the person as the basis

for designing the award. After the work is completed, suggest that children send the award to the person for whom it is designed, enclosing a letter that explains the reasons for its creation.

Acquaint children with the work of archaeologists and anthropologists. Ask children to pretend that they are archaeologists or anthropologists and take them on a walk through the neighborhood to look for evidence of rituals and ritual objects associated with food (and eating), dress, transport, and communication in our society. On another occasion, children might look for evidence of gods and goddesses in the form of motifs and images that are prevalent in the environment. Invite children to share their findings, through an exhibit of ritual objects and relics that they have collected or of photographs and drawings of the objects.

Have children display one or several of their own favorite mementos or any other reminders they have of important events, engaging them in a discussion of their reasons for wanting to save the objects.

Invite someone in the community to explain and demonstrate the Japanese tea ceremony, to explain the meaning of the bow as a form of greeting, or to focus on other customs that are quite different from our own. Invite other people from foreign countries to explain and demonstrate forms of etiquette and to discuss special ceremonies or festivals that are observed in their countries.

17-19 An effort to acknowledge the Fourth of July.

17-20 A holiday becomes an occasion for a display of popular iconography.

Ask children to develop pantomime skits that contrast good and bad manners in various situations, such as dining in a fancy restaurant, listening to a speaker in an auditorium, attending a dance, visiting a sick friend. Focus on the reasons certain forms of behavior are more appropriate than others in situations like these. The pantomime format reveals how much we rely on vision to read the actions and feelings of people.

Plan a dress-up day at school. Invite children to notice how a change in appearance makes everyone feel and act differently. Ask children to identify those occasions on which they do dress up and to discuss how they feel and act when they are wearing their best clothes.

Teach children flag etiquette and hold a demonstration for the rest of the school, explaining the symbolism of the design of the flag, why the flag is sometimes flown at half-mast, when the flag may be draped over a casket, and other symbolic uses of the flag (Figure 17-19). Explore other customs and forms of etiquette associated with eating, going through doors, greeting visitors, saying goodbye. Call attention to variations in customs and forms of etiquette that stem from cultural or ethnic differences.

Provide resources for children to study various customs and festivals associated with birth, puberty, marriage, and death. Cross-cultural studies of rites and of celebrations about nature

CEREMONIAL AND HOLIDAY ARTS

are particularly valuable in making children aware of their own customs.

Invite children to watch televised pageants, parades, or special holiday services and imagine themselves in the role of producer or director of the event and therefore responsible for organizing all parts of it. Have them list the variety of details they would need to think about in planning such an event.

Discuss the commercialization of holidays and ceremonies (Figure 17-20). Ask children to consider why there are pageants to judge beautiful bodies, and why a town would like to host the Rose Bowl Parade or comparable big events. Ask them to consider whether commercialized celebrations are, necessarily, better than smaller, more personal versions.

Notes

[1] This view of gift giving in an art program was introduced to me by Helen Donnell, art teacher in the Dade County Schools, Miami, Florida.

[2] Lawrence Halprin, *The RSVP Cycles: Creative Processes in the Human Environment* (New York: George Braziller, 1970).

[3] Thomas M. Messer and David L. Shirey, "Impossible Art," *Art in America* (May/June 1969): 30–47.

Suggested Readings

Batchelder, Majorie. *The Puppet Theater Handbook.* New York: Harper & Row, 1956.

Harper, Howard V. *Days and Customs of All Faiths.* New York: Fleet Press, 1957.

Helfman, Elizabeth S. *Celebrating Nature: Rites and Ceremonies Around the World.* New York: Seabury Press, 1969.

Hunt, C., and Carlson, B. W. *Masks and Maskmakers.* New York: Abingdon Press, 1961.

Kaprow, Allan. *Assemblage, Environments and Happenings.* New York: Abrams, 1966.

Laliberte, Norman, and Jones, Maureen. *Banners and Hangings: Design and Construction.* New York: Reinhold, 1966.

IV

program planning
and evaluation

Planning the art program

18

Planning is the thought process that makes it possible for you to enter the classroom with confidence and flexibility. This chapter illustrates how the curriculum framework outlined in Chapter 6 and the suggested activities presented in Chapters 11 through 17 can be used as tools for creating art programs that are responsive to a variety of settings.

Levels of planning

Activities can be planned at different levels of detail and comprehensiveness. A plan might describe a single *activity*; a *lesson* that includes several activities; a *unit* that includes a number of related lessons; a *year* of instruction; or a span of *several years*. It is helpful to begin planning at the most comprehensive level so that you can anticipate the larger relationships within the program. You can then develop more detailed plans for each year, unit, and lesson.

Components of a plan

The components of a plan reveal the priorities that the planner believes it important to plan *for*. Because the components listed below reflect the major variables on which teachers must make decisions, it is important to keep these components in mind when planning.

Goals

Goals indicate what we intend to help children learn. The curriculum framework presented in Chapter 6 outlines a number of subgoals that are more specific versions of the major goals.

Approaches to study

Goals can be reached by many paths. Which paths are consistent with our concept of art? Which are appropriate for children and, at the

same time, important in extending children's understanding of the world of art and the role of art in people's everyday lives? Such questions concerning criteria help us test whether approaches are educationally sound, potent, and worthwhile. Chapter 6 outlined some approaches that meet these criteria. Using the same criteria, you might want to develop your own versions of approaches to study.

Content possibilities

Content possibilities indicate the sorts of qualities, objects, images, or ideas that can serve as vehicles for study. For example, if "observing nature and the constructed environment" is an approach to generating ideas for art, what kind of observations are likely to be of interest if you teach on an Indian reservation in the desert? if you teach in an inner-city school? Are there some natural and environmental phenomena that can be seen no matter where you live or teach?

The content of art is not a rigid body of facts and skills; it is a fluid body of options through which one can begin to experience and comprehend the significance of art. Content possibilities are more or less timely and well-substantiated particulars for study that give specificity to the approaches and suggest the kinds of teaching resources you will need.

Teaching activities and resources

Resources may range from such givens as the ever-changing view from the classroom window to the more conventional art media and audio-visual aids. A detailed plan should describe significant teacher activities, such as demonstrations, short presentations, question-and-answer sessions, reviews, and individual guidance.

Student activities and resources

Sometimes the students and the teacher use the same resources. Often, however, students are asked to use resources other than those that serve as aids for the teacher. Descriptions of student activities will differ in detail, depending on the number of choices open to the students.

Desirable outcomes

This section of the plan is really a double-check for your own reference. If you have developed your plan in a fairly consistent manner, your expected outcomes are little more than restatements of the goals. Most teachers are interested in additional outcomes that are not directly stated as goals, but are positive concomitant learning experiences. For example, even if stu-

TABLE 18-1

MAJOR COMPONENTS IN PLANNING

WHY————————————|————WHAT————————————|————————HOW——————————|— TO WHAT EXTENT

Goal	Approach to Study	Content Possibilities	Teaching Materials and Activities	Student Materials and Activities	Desirable Outcomes
To help children learn to generate their own ideas for personal expression.	Observing nature and the constructed environment.	Children's direct perception of land, sea, sky, the seasons, the weather, or structural forms in nature; and of buildings, roads, signs, walkways.	Techniques to heighten children's perception—discrimination of lines, colors, shapes; multisensory awareness; perception of symbolic aspects and contexts or purposes.	Means of recording and interpreting perceptions: cameras, sketches, diary, or tape recorder; direct work in a medium.	Children generate ideas for personal expression from their observations of nature and the constructed environment.

dents are learning to generate their own ideas for art, they may complain about doing so. Evidence that students enjoy getting their own ideas is a desirable outcome, but not necessarily an expected one, especially if students are accustomed to being given ready-made ideas.

It is useful to note desirable outcomes other than those planned for, especially if you are trying to work with the class on solving a pervasive problem, such as increasing students' self-confidence or willingness to participate in cleanup.

Table 18-1 charts the logical relationships among the major planning components. The thought process involved in planning is illustrated with one goal and one approach to study.

PLANNING THE ART PROGRAM

Organizing the program

Excellent and effective art programs are not carbon copies of a perfect model. They are designed by teachers with a view to incorporating the particular strengths of their schools and communities. Nevertheless, a few general concerns merit attention in every program—balance, continuity, variety, and individualization.

Balance in program goals

Goals for personal fulfillment in art should be the central part of the art program in all grades. In a program that spans the preschool through the junior high years, the emphasis should be on the child's personal development as a creator of art and a perceptive respondent to the world. However, studies of the artistic heritage and art in society should be given proportionate attention by planning activities for personal development so that they are linked with the artistic heritage or with the role of art in society. This rule of thumb may seem arbitrary, but it is both educationally sound and responsive to the realities of art education.

For educational reasons, it is important to provide children with evidence that their own artistic efforts in school are relevant to the larger world of art outside of school. For example, in planning an activity such as mask making at Halloween, encourage children to notice that masks are a form of art found in many cultures.

For practical reasons, it is important to stress the relationship between the child's work and the artistic heritage beginning in the preschool years. In most school systems, students (about 80 percent) study art only until the age of thirteen or fourteen. Unless the artistic heritage and the role of art in society are emphasized in the early years, the majority of children will have little or no experience with these aspects of art.

Balance in approaches to study

Art programs should be neither single-minded nor narrowly defined. Rather, programs should be systematically eclectic so that children can both appreciate varieties of art and find their own reasons for continued study of the subject.

The approaches to study presented in the curriculum framework (Chapter 6) complement one another. Some approaches call for control, precision, and analytical thought; others call for fluency, flexibility, and speculative thinking. Some focus on ideas and meanings; others on concrete objects and practical action. Within a preschool to junior high program, children should have options for studying art comparable to those that have been suggested for each goal.

Children should be continually exposed to many options in every grade. Some preschool children show a remarkable interest in precision and control; a preschool program biased toward fluency and flexibility could thwart that interest. At every level, children should be able to develop their interests and preferences. At the same time, they should be challenged to expand their knowledge beyond the easy and familiar.

Clearly, the principle of continual multiple exposure to various approaches does not mean that you and your students must pay attention to everything at every moment. It does mean that choices are open to children, and that the openness is planned. Examples of planning for choice are presented later in this chapter. In general, an art program spanning the preschool through the junior high years should offer choices among approaches to study, and the choices should reveal the complementary values among the approaches.

Continuity from year to year

If you teach in a community where most children attend the same school or remain in the same school system for many years, the art program should be planned so that children reencounter certain art forms in an organized pattern from one grade to the next.

Sequential plans are not effective if there is a high rate of mobility, absenteeism, or yearly turnover in enrollment. The average national mobility rate for 25 percent of the population is one change in residence every four years. In some schools, the absentee rate on any given day may be as high as 40 percent of the children technically enrolled. In communities with a large migrant-labor population or a tourist industry, an 80 percent turnover in enrollment may occur in a single year. Thus, a substantial number of children may never benefit from sequential programs, especially those that are based on a rigid set of prerequisites.

Continuity in learning can be achieved without relying on a predetermined sequential program. Unlike a sequential program, which usually aims for cumulative learning of whole concepts based on mastery of simpler parts, a program designed for continuity is built around a few central concerns that are given recurrent attention each year.

There are several ways to achieve continuity in children's art experiences from year to year. The first derives from the concept of goals that focus on children's ability to become independent in art. Perceiving, interpreting, judging, generating ideas, refining ideas, and using media—these are the constants from which children can build their own competence in art, understand the work of professionals, and grasp the signifi-

cance of art in society. These general goals apply to all grade levels.

Another way to achieve continuity is based on the overlapping relationships among approaches to study. For example, over a span of years, children should have many opportunities to see that selection, adaptation, experimentation, and control, in relation to media, are important considerations not only in the children's own art-work but in the work of professional artists and in the art of social groups and cultures as well. Similarly, children should be presented with many occasions to learn the importance of using different criteria to judge their own art experiences, the significance of works of art, and art forms as they influence life styles.

Continuity within a year through unit planning

Art programs traditionally have been regarded as a series of short-term activities involving radical shifts in medium and subject. As a consequence, children develop the expectation that the art lesson is an occasion to make something new and different, to produce quick results, and to achieve easy success. The justifications for this approach are varied: the interest span of children is said to be short; children enjoy new experiences; parents and teachers expect a varied program; scheduling patterns make it difficult to follow through on activities.

Classroom teachers know that it is possible to arrange time so that children can study a single topic in science or social studies for a period of several weeks. The emphasis may shift during this time; individual or group projects might be initiated; a core collection of resources may be gathered for class reference.

Art can and should be taught in a continuing way. That is, units of study should be developed, resource materials gathered, and activities planned for individual and group work over a period of time. For example, a second grade teacher developed a unit on the topic "What is architecture?" At the end of six weeks, the students were still eager to continue their studies. They had made a scale drawing of the floor plan of their classroom, had read and spelled words like *architecture*, and had learned that basic geometric solids can be detected in the forms of buildings. They met local architects and construction workers and visited a number of well-designed buildings in their community. Parental interest was generated. A committee was established to develop a picture file for the entire school, and several architectural models were donated to the school's newly formed permanent collection.

If this project was unusually successful, it is nevertheless possible to develop a more modest

TABLE 18-2

PLANNING: BIWEEKLY ACTIVITIES
UNIT THEME: THE CITY

Date	September 8	September 22	October 6, 20*	November 3	November 11
Medium	Colored crayon	Colored tissue paper	Clay or boxes	Soft pencil	Varied drawing materials
Subject	*City Moods*	*City Moods*	*City Forms*	*City Details*	*People in the Environment*
Design	Color for mood	Color for mood	Density of structures	Edges of form	Proportion overlap
Art Form	Painterly	Collage	Small sculpture	Drawings as sketches	Finished drawings
Function	Expression	Expression	Expression	Representation	Representation

NOTES

Develop slide collections; identify supplementary poems and music for classroom teachers. Note relationship to "growth of cities" topic in social studies. Get examples of Ashcan School, Soyer, Marin, etc.			*Two weeks. Emphasize city as source of ideas for sculpture.	Use view from cafeteria windows.	Check gym classes; get permission to use gym area for drawing.

version of units of study, even under the most severe limitations in scheduling. In the following example, art teachers were available for instruction in elementary classrooms for only half an hour every two weeks. They provided in-service education for the classroom teacher by initiating activities that could be continued by the classroom teacher. The art teachers developed simple planning notes to chart points of continuity in the program. Because the art teachers had a tight schedule and had to order supplies for a large number of classes, they planned most of the art activities well in advance. Table 18-2 shows the planning format they used for a sixth grade class.

Notice in Table 18-2 that the art teachers have planned several points of continuity from one class session to another. As a source of ideas for art, the subject of the city is carried through several activities. The design element of color for mood is treated in relation to the medium of crayon or colored tissue paper; the art form of drawing, although modified slightly, is used in three activities. Prior to use in the classroom,

these notes were developed to chart goals and approaches in more detail. Some activities were linked with the artistic heritage, others with art in society. In this plan, the date of the activity is noted. Classroom teachers were later supplied with more detailed suggestions for preparation and follow-up of the activity.

When the amount of time available and scheduling pattern for art are arbitrary, the quality of education necessarily suffers. Serious and creative inquiry cannot be turned on and off at the stroke of a clock. If time allocations and scheduling patterns are restricted, it is imperative that teachers inform parents and administrators that the education of children is being compromised.

Variety from year to year

As children mature, their interests and concerns change. They are able to undertake more complex, abstract, and demanding activities. They can study the same ideas in greater depth and

can understand relationships among ideas more readily. Variety in art programs can thus be accomplished in two major ways: by changing the illustrative media, art forms, aspects of design, styles, and themes that children encounter, and by increasing the interrelationships and subtleties within children's studies.

Clay, for example, might be used in every grade. In the lower grades, some of the more direct techniques for shaping clay would be appropriate; in the upper grades, more indirect and complex techniques like underglazing could be taught. Similarly, nature can be introduced in every grade as a source of inspiration, with variation achieved by timely and individual attention to such things as landscape, animals, plant life, and the seasons. Although knowledge of child growth and development offers some guidance for determining year-to-year program variations, it cannot and should not substitute for more spontaneous judgments that seem appropriate on a particular day. For example, if a dog follows one of the children to school, you should certainly take advantage of the opportunity to draw or model the animal from life.

Accommodating individual differences

No two schools are alike, no two teachers are alike, and no two students are alike. In this sense, individual differences are a given in any educational enterprise. Yet, individualizing an art program can mean several things depending on the conception of education to which one subscribes.

Individualizing a program sometimes means that specialized activities are offered to children on the basis of their particular economic background, ethnic or racial heritage, aspirations in life, and so on. Nevertheless, the goal of general education in art, like the goal of general education in reading or science, is that it reach *all* students, not just the talented, the white mid-

dle-class, the rich or the poor. In our desire to remedy educational inequities, we can easily fall prey to a new parochialism in education that reinforces class consciousness and racial and ethnic pride at the cost of weakening sensitivity to the achievements and the foibles shared by humankind. Teachers must give attention to both individual differences and the common traits of human experience.

An art program is not really individualized by allowing students to progress through a predetermined sequence of activities at their own pace. Children will learn at their own pace in any case. A program *is* individualized if children elect activities from many options; but it is very difficult to respond to thirty or more children if each, at the same time, is involved in a totally different activity. Most teachers increase the level of individualized instruction as the school year progresses, when everyone knows each other better.

Beyond these considerations, teachers prefer to work in different ways. Some begin with total group instruction and then move to teaching small groups. After developing this shared background of experience, they concentrate on working with individual students. Other teachers feel more comfortable trying an activity with one or two children and letting others join in at a rate that allows the early starters to help those who follow. Through experience, most art and classroom teachers soon acquire enough expertise to offer at least several optional activities at the same time, especially if work centers are available for small-group and individual activities (see Chapter 20).

Individualizing a program may mean that teachers affect each student's life. Effective communication with children is always based on empathy with how each child sees, thinks, feels, and acts—trying to understand things from each child's viewpoint. But, at the same time, teachers should not merely reinforce the status quo but extend, enrich, and sharpen each child's awareness of what life has to offer. Few subjects so

vividly engage the child in examining the affect-ive aspects of life as art does. The basis for meaningful teaching and learning is communi-cation—a sharing of experience that both ac-knowledges and transcends differences in the particular circumstances of our lives and the lives of children.

Planning units of instruction

Planning for a year or a span of years is simpli-fied by developing units of instruction organized around a topic, a question, a problem, or an area of inquiry. A unit, in turn, is composed of related subtopics or questions that are the basis of lessons and specific activities.

Although scheduling patterns and class-room arrangements will influence the way you plan, this discussion of unit planning assumes that your program will combine total-group, small-group, and individual instruction, and that art is taught to all children for a recommended one and a half to two hours per week with an additional one to three hours per week set aside for children to work on their own. (At mini-mum, children should have ninety hours of art instruction per year.)

In general, from four to six core units (con-sisting of from ten to twenty hours of instruction each) should be developed for every year. At least an equal number of optional core units should be available. Thus, at any given point, children should be able to choose a direction of study from at least two alternatives. Teachers who organize their classrooms around work cen-ters can readily accommodate more options than this suggested minimum.

Deciding on the focus of units

A cohesive learning experience occurs when there is a central focus or an organizing principle behind particular activities.[1] Every unit requires attention to goals, approaches to study, and such features of art as media, subjects or themes, and aspects of design. Units may be built around any one of these organizing principles, and the other factors would then play a supportive role.

GOAL CLUSTERS AS A FOCUS FOR UNITS. You might plan units around groups of related goals. Units might deal with "Understanding How We See," "Where Does Art Come From?" "Problems in Judging Art," or "Unlocking the Meanings of Art." Units that focus on goal clusters tend to feature *fundamental questions and issues* in understanding or creating art. Par-ticular art forms, media, themes, and so on are selected to illustrate these issues. Units orga-

nized in this way should combine goals for personal fulfillment with related goals and activities on the artistic heritage or art in society.

APPROACHES TO STUDY AS A FOCUS FOR UNITS.

You might plan units around related or complementary approaches to study. Units might focus on "Symbolism in Art," "Imagination and Fantasy in Art," or "Innovations in Art." Contrasts might be the focus of a single unit—"The Real and the Imaginary" or "The Art of Individuals and Groups." Units that focus on approaches to study tend to feature *thought processes* that lead to or account for varieties of art expression. Appropriate goals and exemplary media and art forms are not ignored, but are determined after the unit theme is set.

ART FORMS AS A FOCUS FOR UNITS.

You might plan units around art forms—"Painting and Drawing" or "Sculpture." Units organized in this way tend to feature the *unique expressive potential* of the scale, dimensionality, and functions of particular artifacts. Such units draw attention to the varieties of media and processes that can be used in creating an art form. Units planned around art forms can also make children conscious of the *pervasiveness of selected forms* within their own and other cultures.

SUBJECTS AND THEMES AS A FOCUS FOR UNITS.

You might want to organize units around particular subjects and themes such as "People," "Places," "Things," or "Nature." Other possibilities are suggested by themes like "Parents and Children," "Friends and Enemies," or "The Rich and the Poor." Units that focus on subjects and themes illuminate the variety of personal and social *meanings* that can be captured in different art forms and media.

DESIGN AS A FOCUS FOR UNITS.

Design elements and principles have little meaning for children unless they are demonstrated to be relevant to expression in particular art forms. For this reason, no unit should be planned around color, line, or texture in the abstract, theoretical sense. Instead, units should feature design elements in combination with an expressive problem and an art form. The *effects of planned relationships* are to be emphasized in units of this kind. For example, a unit might focus on "Making Things Look Real Through Color and Light" and invite students to explore the realities that can be presented through color and light in painting and photography. Similarly, a unit might be planned around "Lines Can Make Us Laugh and Cry" with the aim of exploring the expressive potential of line in drawing and printmaking.

TABLE 18-3
A STARTER LIST FOR UNIT IDEAS

Emphasis on Issues
(Focus on Goal Clusters)
 Why Art is Made
 How Art is Made
 Varieties of Art
 More Than Meets the Eye
 How to Study a Work of Art
 Problems in Judging Art

Emphasis on Thought Processes
(Focus on Approaches to Study)
 The Real and the Fanciful in Art
 Art in Everyday Living
 New Art and Old
 Communication Through Art
 The Search for Beauty

Emphasis on Unique Expressive Potential
and Pervasiveness of Selected Forms
(Focus on Art Forms)
 Drawing and Painting
 Sculpture
 Printmaking
 Architecture
 Film Making and Photography

Emphasis on Human Meanings
(Focus on Subjects and Themes)
 Love and Hate
 Beauty and the Beast
 People
 Landscape
 Still Life

Emphasis on Effects of Planned Relationships
(Focus on Design)
 How Colors Affect Our Feelings
 How Spaces Make Us Act
 Why the Texture of Things Matters
 Illusions in Art
 Our Sense of Scale and Proportion

Emphasis on Physical Means of Expression
(Focus on Media and Processes)
 The Warmth of Wood
 Precious Metals and Stones
 Weaving Things and Ideas
 The Permanence of Stone
 Carving and Casting

Emphasis on the Uses of Art
(Focus on Purposes)
 Art and Politics
 Commercial Art
 Religious Art
 Humor and Satire in Art

MEDIA AND PROCESS AS A FOCUS FOR UNITS. Although teachers often plan lessons around media or processes, there is always a risk that children will regard the medium as the reason for creating art rather than as the *physical means of expression*. In order to teach art, of course, you cannot ignore the influence of the medium on expression. If you choose to organize a unit around a particular medium or process, be sure to relate the creative means to an expressive problem or an art form. For example, you might plan units like "Weaving Useful Things" or "Paper for Decoration and Celebration."

PURPOSES OF ART AS A FOCUS FOR UNITS. Units might be organized to feature various purposes of art, such as decoration, inspiration, entertainment, information, personal expression, or the building of group identity. Because art is part of life, you might want to plan units that show how science, mathematics, and technology have influenced art (and the reverse). Similarly, one purpose of art is to commemorate heroes or important events. You may want to show how people use music, dance, theater, and literature, as well as the visual and plastic arts, to commemorate events. The *utility*

PLANNING THE ART PROGRAM

TABLE 18-4
DEVELOPING IDEAS FOR UNITS

1. Check which of the following organizing principles you will use to plan the unit. (Example: Approaches to Study)

2. Enter the unit title next to the principle that will serve to organize the unit. Then decide how you might plan for the unit in relation to the other components.

_____**Goal Clusters:** Symbolism in choosing media, perceiving and describing symbolism, understanding how others perceive symbols, how symbols express personal and social beliefs.

__X__**Approaches to Study:** "Symbolism in Art"

_____**Specific Features of Art:**
Medium: varied, symbolism of wood, clay, and so on
Art Form: varied, symbolism of sculpture, photographs
Design: symbolism of geometric-organic forms
Subject or Theme: sun, lion, eagle, others
Purpose: signals, signs, storytelling

TABLE 18-5
TYPICAL GROUPINGS OF ART FORMS

	Usually Two-Dimensional	Usually Three-Dimensional	Studio-Oriented Expression	Functional Design and Communication
Drawing	X		X	
Painting	X		X	
Printmaking	X		X	
Graphic Design	X			X
Photography	X		X	X
Film (Time)		X	X	X
Television (Time)		X	X	X
Sculpture		X	X	
Crafts (surface-oriented)	X		X	
Crafts (volumetric)		X	X	
Crafts (as body adornment)	X		X	X
Crafts (utilitarian)		X		X
Product Design		X		X
Architecture		X		X
Environmental Design		X		X
Ceremonial Arts		X		X

of art is emphasized in units organized in this way.

It is important to remember that in one way or another, all of the organizing principles function in every unit. The decision to concentrate on an art form does not preempt consideration of goals, approaches to study, subjects, purposes, and the like. Rather, these other aspects of art should be discussed in relation to that art form.

As a planning procedure, you might want to use a starter list like that in Table 18-3 to develop possibilities for units. If you cannot think of examples of goals and approaches to study, refer to Chapter 6 for ideas. You can also return to Chapters 11 through 17 in order to find examples of art forms, media, subjects, aspects of design, and purposes. After you develop unit ideas, try to expand on their possibilities in the way outlined in Table 18-4.

Scope of the art program

Because there are many options for planning an art program, the problem of determining the scope of the program is a critical one. Rules of

TABLE 18-6
DECISION POINTS IN PLANNING THE SCOPE
OF THE ART PROGRAM FOR A YEAR

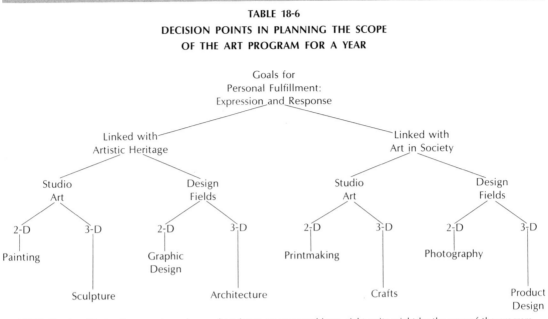

NOTE: If units of instruction are planned around art forms, as suggested here, eight units might be the core of the program for a year. While these art forms meet the criteria for adequate scope, they by no means illustrate every possibility.

thumb rather than rigid standards are most appropriate for making choices. Whatever the organizing principles of your units—goals, approaches to study, or a specific feature of art like subjects, media, aspects of design, art forms, or functions of art—the units taught during the year should be roughly balanced in the following ways:

First, balance activities that center on expression in art with activities that center on response to art. Studio or design activities are always enhanced by significant and concurrent attention to goals for responding to visual forms.

Second, in deciding the art forms to introduce or use as illustrative content in any grade level, try for a balance between (1) two- and three-dimensional forms and (2) the studio arts and the design and communication fields. Table 18-5 charts the usual status of art forms in relation to these factors. If you are able to achieve this balance, there will be sufficient representation of different art forms to sustain the interest

of children and to acquaint them with varieties of art.

Third, consider your resources when deciding which art forms to introduce. Many schools are not presently equipped to offer children experiences of the kind recommended in Chapters 11 through 17. Even with adequate financial support, several years might be required to develop the resources needed for a comprehensive school art program. In addition, both classroom and art teachers have different talents and interests. Within the guidelines previously suggested, build the program to tap and extend present strengths; then develop resources to overcome weak spots.

Finally, plan the art program so that it has its own integrity and vitality. This need not exclude attention to other subjects in the curriculum. Indeed, other subject areas should contribute to and be informed by the child's understanding and appreciation of art. For example, if architecture is introduced as an area of study in

Medium	Art Form	Subject	Design	Function	Artistic Heritage	Art in Society
papier-mâché	masks	Halloween	color; symbolism	disguise; fantasy		*
tempera	paintings	self-portraits	proportion; detail	expression	*	

art, children should be engaged in reading about architecture; in learning a vocabulary with which to talk about architecture; in inquiring into the relevance of science, mathematics, and social studies to the study of architecture; and so on. If other studies are integrated with art, art will be integral to other studies.

Table 18-6 presents the recommended decision points in determining the scope of the art program.

Planning lessons

Creative and critical thinking should govern the process of planning lessons and larger units of study. The curriculum framework introduced in Chapter 6 and the examples of activities presented in Chapters 11 through 17 can serve as basic ideas for planning, but they are not organized in a teachable form.

Lesson planning is a means of organizing your ideas so that you feel better prepared for teaching. Because lesson plans are a kind of mental rehearsal for classroom action, the amount of detail in a plan should be no greater than what you feel you need to be adequately prepared. Several lesson-planning formats follow.

Using the organizing principles to outline possible lessons

The basic organizing principles of media, art form, subject, design, and function enter into lesson planning in several ways. First, they can be used to review content possibilities. Teachers

and students alike can benefit from deciding on those media that should be explored in greater depth and those art forms, design factors, and subjects that are neglected or overworked in a present program.

Second, the organizing concepts can be used to determine appropriate goals and approaches to study. For example, if you want third graders to make papier-mâché Halloween masks, the medium is likely to be so difficult that children will be distracted by problems of controlling it. If you want the third graders to explore the symbolism of Halloween but still make masks, you might have them use a simpler medium like cut paper, so that the subject and symbolism can be explored more readily. A chart format can be used to organize rough notes of possible activities (see above).

Using this scheme, you can quickly chart a number of ideas for art activities. An asterisk indicates whether the activity might best be linked to the artistic heritage or to art in society. After charting activities in this brief form, you can easily develop more extended plans, taking into account goals and approaches to study. Table 18-7 illustrates how the notes can be expanded into lesson ideas.

Considering goals and approaches to study

In day-to-day teaching, only several of the core goals—perceiving, interpreting, judging, generating ideas, refining ideas, and using media—will serve as the dominant concerns for lessons. Similarly, only a few approaches to study can usually be stressed in a lesson. Neither you nor your

TABLE 18-7
PLANNING LESSONS

ROUGH NOTES

Medium	Art Form	Subject	Design	Function	Artistic Heritage	Art in Society
plastic, metal neon, paint	graphic design (signs)	messages and symbolism in signs	color, size placement	advertisement information		*

EXTENDED PLANNING NOTES

UNIT THEME: Graphic Design

Goals: Perceiving Subtle and Obvious Qualities; Interpreting Meanings

Approaches to Study: Exploring Symbolism; Becoming Aware of Contexts; Speculation

Content Possibilities: Advertising signs in various media; Symbolism conveyed by motifs, colors, size, placement patterns

Teaching Material: Neighborhood shopping area

Possible Activities:

1. Establish a vantage point for looking.

2. Look for largest and smallest signs (reasons for size differences).

 Look for highest and lowest signs (reasons for height placement).

 Look for lightest and darkest signs (reasons for light-dark dominance).

3. Count signs with different colors. Note which are lighted. Examine reasons for most dominant or least dominant colors (might be done in teams.)

4. Look for examples of plastic, metal, and wood signs. Examine reasons for using different materials—permanence, scale, message, prestige.

5. Look for examples of signs with pictures, symbols, motifs. Explore bearing of image on product or service advertised.

students can pay attention to everything at one time.

There are innumerable possibilities for emphasizing one or another goal or approach to study, not only within a single class period but also across several class periods. Suppose that you have tentatively planned a mask-making activity for fifth or sixth graders at Halloween. How might you motivate children to deal with the problem of generating creative ideas for the subject of Halloween? You might encourage children to *contemplate* the meaning of Halloween, not only to themselves but also as a universal expression of fear of the unknown and of death, which was the holiday's original intention. They might *observe* how people express and disguise their fears in real life by changing their facial expressions, appearance, and mannerisms. They might *imagine* situations that have frightened people in the distant past or that will frighten people in the future. They might try to *invent* a new system of colors and art forms that express Halloween.

If you feel that most of the children are reluctant to depart from conventional Halloween stereotypes, you might want to help them explore all these (and other) possibilities for getting a fresh perspective on Halloween. If the children are accustomed to a rigid structure and, as yet, are unable to handle options, you might focus their attention on one option and help them explore ideas that can be developed into mask form.

Additional decisions about introducing approaches to study should be considered in light of your particular school and students. Consider the idea that children should learn that media can be selected, controlled, adapted, and treated experimentally. Some children function best when alternative approaches are open to them; others do better with fewer initial choices. A teacher might respond to this fact tutorially, that is, by suggesting a specific approach for some children (learning to control paint so it does not drip) while offering several possibilities for others (working with the problem of choosing media, experimenting, or adapting ideas to media or media to ideas).

Although tutorial relationships are desirable, they are not always feasible in light of the classroom situation or suited to the special strengths of teachers. Some teachers are most effective if they introduce relatively few options at one time but explore them in depth. Sometimes scheduling demands make it psychologically untenable for teachers to extend as many options as they might prefer to have available were there less pressure. Under these circumstances, the teacher might emphasize one approach at a time.

Pacing activities

When teachers work with groups of children under inflexible schedules, they have to antici-

TABLE 18-8

LESSON PLAN WITH APPROXIMATE TIMES INDICATED

UNIT FOCUS: The Real and the Fanciful

Lesson: Imaginary Environments

Goals and Approaches to Study	Activities for three class periods
	First class
Perceiving (Basic discrimination)	Look for qualities of line, color, shape within the classroom.
Interpreting (Symbolism)	Consider symbolism of line, color, shape in everyday life.
Generating Ideas (Imagining)	Imagine an environment with reverse symbolism, for example, *red* means "go."
Using Media (Selecting)	Consider media that might best be used to show an environment with, for instance, furry, soft, rounded houses and streets that are like cloud trails.
	Second class
Understanding (Ways artists have selected media)	Study examples like Giacometti's *Palace at 4 A.M.*, Ron Herron's *Walking City*, Banham and Dallegret's *Un-house*. Relate to previous class activities.
Using Media (Experimenting)	Figure out how to assemble diverse materials to achieve reverse symbolism desired. Work period.
	Third class
Judging (What did I learn? What was special?)	Work period and evaluation. Consider learning gained from activity and special character of the experience in relation to generating ideas, symbolism and fantasy, selecting media.

Resources: Slides and prints. Boxes of found materials and clay. Thick cardboards for bases. Cutting and joining tools and materials: scissors, tape, glue, stapler, hammer, and nails.

pate the pace and flow of activities from one class period to another. Table 18-8 illustrates a simple form of lesson planning that encompasses three class periods.

Amount of planning

Ideally, teachers should not have to rely on detailed lesson plans such as those presented in Table 18-8. Yet, no teacher can be the very model of all things to all children at all times. If you grasp the general curriculum framework and the key concepts, you can use them intuitively.[2]

Teachers rely on planning to different degrees. Experienced teachers may plan by making short memos to themselves; they can often teach effectively without explicit plans. Other teachers prefer to plan activities in a fairly detailed way. Many school systems are now adopting cost-

PLANNING THE ART PROGRAM

accounting programs, which require teachers to keep detailed records. Ways of coping with evaluation and record keeping are considered in the next chapter.

Notes

[1] Hilda Taba, *Curriculum Development: Theory and Practice* (New York: Harcourt Brace Jovanovich, 1962).

[2] Having taught in public schools, I am acutely aware of the distance between goals and accomplishments. I often relied on the general curriculum structure outlined in Chapter 6 together with the organizing principles to get through a difficult Monday morning or a bad Friday afternoon.

Suggested Readings

Sawyer, John R., and DeFrancesco, Italo L. *Elementary School Art for Classroom Teachers.* New York: Harper & Row, 1971. Chapters 9 and 10.

Tyler, Ralph W. *Basic Principles of Curriculum and Instruction.* Chicago: University of Chicago Press, 1950.

Evaluation of learning in art

Evaluation is an integral part of day-to-day teaching. It occurs when you ask children something as simple as "How are you doing?" The many personal impressions teachers gain from daily contact with students are much more vivid and detailed than the formal written evaluations typically required by school systems.

Many states now have laws that require school systems to report on pupil learning in measurable terms. Although there are a number of reasons for this requirement, the most common justification is that citizens can better understand how much learning the schools are producing if accurate and detailed records of educational progress are published. As citizens, we can appreciate the value of knowing how our taxes are being spent. As educators, however, we are also keenly aware of the difficulties in measuring those subtle changes in behavior that reflect learning.

In spite of this trend toward formal quantification of learning in all subjects, including art, evaluation is not the same as measurement, or grading. Measurement is a process of developing a numerical or letter code to represent an individual or a group achievement. Evaluation is a process of examining a situation in order to determine its worth or quality. The word *evaluate* literally means "to draw value from." The difference between measurement and evaluation is succinctly captured in this excerpt from a poem by Stephen Vincent Benét

You can weigh John Brown's body well enough,
But how and in what balance weigh John Brown?[1]

The basic issue in evaluation is determining *which values the school and the art program should pursue*. Only when basic questions of value are resolved can we determine whether,

and to what degree, the desired values *are* being developed through the school environment and activities.

Evaluation of the curriculum

Whether we view the curriculum as a written plan or as the living experience of children, we should evaluate the adequacy of program goals, means of engaging children in art experiences, and resources.

Evaluation of program goals

An art program is effective if children are achieving the goals that have been outlined for them. However, it is essential to examine whether the stated goals of the program are, in themselves, sound and appropriate. Here are several criteria that may be used to evaluate the adequacy of program goals of art in general education.

1. *Are the goals intellectually sound?* The concept of art implied in the goals of the program should be based on a substantial body of scholarship about the nature and practice of art. The concept of art should be broad enough to encompass a range of socially and aesthetically important artifacts within our own and other cultures. The concept of artistic practice for general education should also be pluralistic rather than narrow and elitist.

2. *Are the goals consistent with the aims of general public education in a democratic society?* Unlike technical or vocational education, which trains people for specific jobs and careers, general education develops broad understandings, patterns of behavior, and attitudes that prepare youngsters for lifelong, self-directed learning. General education is intended for all children, not just the select few who may have the talent and interest to pursue a career in art. Goals should be framed for general education, not specifically for particular careers, or jobs, or the development of prevocational skills in art.

3. *Do the goals focus on general patterns of behavior that will enable youngsters to comprehend a wide range of experiences and situations?* Although much of the recent literature in education emphasizes specificity in stating goals, it is neither possible nor desirable to teach children each skill or every item of factual knowledge that they may need in order to find fulfillment in life. We have said that education, as distinct from training, is designed to build attitudes, dispositions, and broad patterns of behavior that facilitate self-directed inquiry.

4. *Are the goals capable of being achieved by educational processes and the resources of*

the school? Some patterns of behavior depend on the physical maturation of the child and cannot be accelerated by formal education. For example, no art teacher can significantly alter the rate of physiological growth on which eye–hand coordination initially depends. Only after physiological growth is complete can coordination be refined and developed.

There are other limitations on what school art programs can be expected to accomplish. Experiences in the school environment cannot reasonably be expected to substitute for experiences in the home or with other institutions that shape the attitudes and values of children. Goals should at least hold the promise of being attainable within the framework of formal schooling.

5. *Is formal education essential for most children to achieve the goal?* This is the criterion of necessity. There seems little point in operating a system of public schools, employing teachers, and asking children to leave their homes for six or seven hours a day unless the process of formal education is essential to the development of children. For example, if we believe that children are naturally capable of drawing, painting, and responding fully to visual forms, we might well ask, "Why bother to teach art?" Although there are many ways of justifying an art program, the most general argument for its inclusion in the school curriculum is based on the fact that few children in our culture pro-duce, appreciate, and comprehend the significance of art without formal instruction.

Evaluation of proposed means

Another step in curriculum evaluation is to examine the proposed means for achieving goals. Means include classroom activities and approaches to the study of art.

Any goal can probably be achieved by a variety of means. For example, heightened perceptual awareness might be achieved by engaging children in matching and sorting activities, by providing time and encouragement for children to see and feel things, or by discussing visual, spatial, and tactual qualities of forms. However, it is also possible to heighten perceptual awareness by taking psychedelic drugs, by creating moderate amounts of hunger or anxiety, by administering shock treatments, or by meditating. If we were interested in achieving only a result, it would not matter to us how we achieve the result; the end, we could say, justifies the means.

How can we determine whether the relationship between goals and means is an appropriate one? Several criteria may be stated.

1. *Are the proposed means related to the behavior described in the goal?* If we want to increase children's ability to interpret art, we

must give children opportunities to do just that. Similarly, if the approach to interpretation is through empathic response, children must be provided with models of empathic response and a supportive environment for expressing their feelings.

2. *Are the proposed means related to the content described in the goal?* If our goal is to sharpen children's sensory discriminations, the stimuli presented to children must have characteristics that permit well-defined discriminations. Texture, for example, is difficult to discern visually if it is confounded with shifts in pattern, color, and shape. Similarly, if children are to use media expressively, the media available to them must have a high potential for expressive use and must be appropriate to the expressive intent of the children who use them.

3. *Are the proposed means likely to serve more than one goal?* This is the criterion of inclusiveness. If an activity builds control only in using media, it is less inclusive—less general— than an activity that also develops skills in choosing media or skills in adapting ideas to media and media to ideas. An activity that nurtures only perceptual skills is less potent educationally than an activity that involves the child in perceiving, interpreting, and judging. To the extent that we match a specific activity to a specific goal, we are engaged in training, not education. Training procedures deny the complexity of art experience and falsely equate learning with following directions.

Evaluation of resources

Goals can be achieved only if adequate resources are available. Resources may be broadly classified as ideological, psychological, financial, and physical.

1. *Are the ideological resources for effective art instruction visible and appropriate?* Published statements about the school program should assert the essential role of art in the curriculum. Such statements have value precisely because they are public, explicit, and they allow citizens to evaluate the degree to which educational goals are fulfilled. The content of such statements should be examined carefully. If art is really an important part of the curriculum, then written or verbal statements should not construe art as little more than a leisure-time activity or an enrichment to life that can, in hard times, be eliminated.

Art and classroom teachers should assume a position of leadership in finding ways to have administrators, principals, parent groups, and colleagues publish position statements that assert that art is an essential part of the curriculum for all children.

2. *Are the psychological resources for effective art instruction visible and appropriate?* Most teachers can endure less-than-ideal conditions for their work if they have concrete evidence of progress toward the ideal. Psychological support of the art program can take many forms: when schedules for art are not determined exclusively by scheduling patterns for reading, writing, and arithmetic; when time allocations for art are flexible enough to avoid excessive anxiety about bells and clocks; when custodians, principals, colleagues, parents, and children offer their help for routine jobs as well as for special art activities.

Art teachers also enjoy some psychological support when principals and other administrators take the time to visit classes and inquire about what might be done to enhance the artistic experiences of children. When the art teacher is asked to report on the art program to a P.T.A. group or is requested to serve on a committee to improve the appearance of the school or is sought out for advice on relating art to other subjects, he or she will appreciate these actions as evidence of attention to aesthetic and artistic concerns.

Psychological support is even apparent in what art and classroom teachers are *not* repeatedly asked to do, such as making posters and decorations or creating drawings for school bulletins. Teachers should not feel obligated to provide services of this kind as a matter of course, but only when clear educational values accrue from the activity. Psychological support is most apparent in the nature of requests made of teachers and in the solicitation of their time and effort.

3. *Are the financial resources of the art program adequate and appropriately allocated?* Although patterns of funding for art programs are varied, budgets should be at least proportionate to the amount of time allocated for art instruction. Suppose that the total amount of money for expendable instructional supplies per pupil is $100 (Expendable supplies are those that either are not reusable or that last less than three years.) Suppose further, that 6 percent of all curriculum time is allocated for art instruction. Proportionately, then, $6 per pupil ought to be available for art. In an art program serving three hundred youngsters, $1800 ought to be available for expendable supplies for the art program, not including library books, films, and other equipment with a useful life beyond three years. Major equipment, furniture, and improvements in classroom space are usually handled in a separate budget account. Budget priorities in a single school are often determined by the principal and an advisory committee of teachers. The allocation of funds for supplies, equipment, and the like should not be made without consulting the art teacher to determine the immediate and long-range needs of the art program.

Every school should encourage the establishment of a committee of parents whose primary mission is to solicit additional funds, gifts, and bequests in order to purchase original works of art and pay honoraria to visiting artists. Most public school systems can be endowed, and this form of investment by local citizens builds a personal interest in the art program that cannot be duplicated by simple payment of school taxes. The precedent for such endowments may be found in parental booster clubs for sports as well as in P.T.A. fund-raising events for special projects.

4. *Are the physical resources adequate and appropriate?* Although teachers work with the givens of a classroom space, the character of that space should not be viewed as unalterable (except as alterations may be limited by health, building, or fire codes). The classroom is an environment for learning, and it should reflect the joy and excitement of the learning process.

When art instruction takes place in a self-contained classroom, centers for art learning should be available every day for no less than six children. The learning centers might be established on a fairly permanent basis or changed to accommodate selected activities of special interest. Display, storage, and quiet gallery-study space should be ample and inviting.

In schools with a special art room, the same kind of gallery-workshop atmosphere should be apparent. Located within or near the classroom should be a gallery space that children can use as a resource for their studio work and as a laboratory for learning to see and think about art. Within the gallery and studio area, learning centers should be established so that children can choose among art forms they wish to study.

The institutional character of the entire school building can be modified by displaying original works of art, carpets or small rugs, plants, collections of natural or constructed forms, and examples of children's work, both finished and in progress.

Evaluation of teaching

Questions that deal with curriculum evaluation do not touch directly on day-to-day events in the classroom, but center on conditions that shape the quality of classroom teaching and learning. If the art program is defined in fundamentally sound terms and if adequate resources are available, the teacher should be able to communicate concepts about art that are intellectually sound and factually accurate; to nurture growth in all students, not just those who are talented in art; to encourage general patterns of behavior that enable students to become their own best teachers; to discern what is essential and what is

peripheral in fostering student growth; to teach for multiple goals.

1. *Does the teacher communicate concepts about art that are fundamentally sound and accurate?* The teacher's own intellectual curiosity and desire for learning about art should be apparent to students. Art teachers cannot, of course, know everything there is to know about art; no teacher can be an authority on every subject. But teachers must be knowledgeable about whatever they present as concept or fact so that children can properly regard their teacher as an expert on that topic. And teachers should reveal to students their own uncertainty about and desire to learn about less familiar concepts.

2. *Does the teacher treat each student as an individual whose worth is not exclusively defined by excellent performance in art?* Although every teacher enjoys working with students who are talented, teachers must show their concern for the total being and becoming of *each* child. Motivation in art is keenest when children perceive that what they are asked to do is authentic, relevant to life, and personally intriguing. Children's sense of well-being and individual identity is enhanced by their personal rapport with the *content* that they encounter in art instruction and by the feeling of *self-worth*

that their peers and teachers communicate to them in other ways. Both are essential in establishing that kind of gentle classroom magic that makes teaching and learning memorable, loving, and dynamic.

3. *Does the teacher encourage patterns of behavior that lead to self-directed, lifelong learning in art?* Growth is here defined as progress toward self-directed, lifelong learning in art. When teachers act as if they were the ultimate authority on all matters, they create a pattern of dependence on a teacher for everything children need to know, and they reinforce the attitude that teachers are to blame for everything children do not know. If teachers are criticized for failing to do an adequate job, the reason may be that we have lost sight of the purpose of formal education as preparation for lifelong learning. When we focus on objectives that are particular, immediate, and tightly sequenced to produce mastery of school work, we can become so preoccupied with achievement that we forget the immediate joy of learning and its ultimate purpose in life.

4. *Does the teacher demonstrate an ability to discern what is essential and what is peripheral in fostering student growth?* Teaching is a demanding profession, and many institutional factors—time, money, and appearance—cause

teachers to forget the priority that must be placed on student growth.

As a culture, we are exceedingly conscious of time that is irretrievably lost if it is not used wisely. We hate to see children wasting time, and we tend to equate wasting time with not working.

In addition to our concern with saving time, we want to save money. Here, too, we can be penny wise and pound foolish. We tend to equate quantity and diversity in the artistic products of children with the quality and breadth of children's experience. We are more inclined to order twelve large jars of tempera paint and four hundred sheets of construction paper than twenty-four large tubes of acrylic paint and one large roll of wide canvas, even though the costs are almost identical. If children are to be engaged in painting as a self-searching, expressive activity, the acrylics and canvas are far better investments than the tempera paint and construction paper. Children would create fewer works, but children would probably value their products more highly, work on them longer, and comprehend more fully the human effort required to produce expressive art.

Culturally, we are also preoccupied with appearances, particularly the appearance of neatness and cleanliness. Although a reasonable degree of order is essential for productive work, classrooms cannot be used thoroughly and en-thusiastically and still remain case material for a home-decorating magazine.

5. *Does the teacher exhibit skill in teaching for multiple goals?* When teachers approach their students with a broad perspective on goals to be reached, flexibility should be the hallmark of their teaching. Unexpected events can be transformed into opportunities for learning, and casual comments can be used to expand awareness and find connections with other topics. When teachers have tunnel vision, they are more likely to treat extemporaneous events as unwelcome disruptions.

The quality of children's learning in art cannot be separated from the quality of instruction that they receive. Nevertheless, judgments about teacher effectiveness cannot be limited to their students' mastery of artistic skills and concepts. Accordingly, we can add one further criterion for evaluating teachers.

6. *Does the teacher behave humanistically?* The teacher is foremost a human being, and that essential humanity should be made apparent to children. Among the qualities that should be evident are optimism, wit, a willingness to talk about life, and a sensitivity to things that both bother and delight children. Humanistic teachers respond to the flow of classroom events. They are sensitive to the "personality" of

19-1 A portfolio of two-dimensional work.

the whole class, to small groups within it, and to particular individuals.

Evaluation of learning

Ideally, evaluation of student learning is an inseparable part of the instruction process; it should not be added on as a special formal exercise to be carried out ritualistically. Whether formal or informal, there are several factors to consider in evaluating student learning: obtaining a record of performance, interpreting the record, and reporting it to others.

Obtaining a record

One of the problems facing teachers in evaluating student growth is that teachers can easily generate more information than they can record, interpret, or report. Because teachers work at different grade levels and under various conditions, they will wish to keep or be able to obtain different kinds of records. A variety of record-keeping formats is presented below.

PORTFOLIOS OF TWO-DIMENSIONAL WORK. Each child's artwork might be kept in a separate folio (Figure 19-1). All work, includ-

ing unfinished or poor efforts, should be retained and dated. Children can become aware of their achievements by periodically examining their own work. A checklist for evaluating work, filled in by the student or the teacher (or both), can help the child become aware of his or her strengths. The same checklist can be used to inform parents of the child's achievements.

PHOTOGRAPHS OF THREE-DIMENSIONAL WORK. Either black-and-white or color polaroid photographs or slides of the child's three-dimensional work might be kept. In the upper grades, a student might take the photographs; parents interested in photography are often willing to do this. A special photo area can be set up to facilitate the process. Photographs might also be taken as children work on their projects in order to record each child's progress in handling three-dimensional media. Photographs should be dated, filed, and used for periodic evaluations.

DIARIES. Beginning at the fourth or fifth grade level, students may be encouraged to keep diaries of their art experiences. Entries might be completely open-ended, structured around specific questions, or a combination of both types. The forms can vary from simple notebooks to 3 × 5-inch cards in a folio or box. Students who

are unsure about their writing ability might keep a visual diary. It is important for students to understand that their diaries are records of what they see, think, feel, and have accomplished in art. Their efforts can be related to the notebooks of Leonardo da Vinci or to the diaries that many creative people keep (Figure 19–2).

TAPE RECORDINGS. Students can be asked to talk about their experiences in creating and viewing art in a small group, with a leader. A group of older children might decide in advance the questions they want to answer on tape. Young children might be interviewed by the teacher or by an assistant teacher. Playback of the tape can serve as a point of review for students and as an opportunity for the teacher to evaluate attitudes and understandings.

MOVIES AND VIDEOTAPES. Films or videotapes of students working or discussing their work offer another means of evaluating learning. If portable videotape equipment is available, short tapes can be made, immediately replayed, and filmed again if desired. This technique encourages students to improve their studio skills or verbal performance. New 8mm films permit a similar approach, except that the time required to develop the film makes it less efficient than videotape.

GAMELIKE FORMATS. Sorting and matching games offer another means of evaluation, especially of discrimination and recognition skills. Games can be combined with record sheets, on which children note their arrays and check reasons for their grouping of items (Tables 19-1 and 19-2).

SIGN-UP SHEETS. Children can help keep daily records of their activities by using a sign-up sheet or a card check-out system for media, materials, and special projects (Table 19-3). This approach is especially useful in schools with open schedules and individualized instruction.

INTERVIEW AND OBSERVATION SCHEDULES. These techniques are especially valuable for evaluating the work of preschool children, but can also be used in the upper grades. An interview schedule is a list of questions designed to elicit responses from a pupil (Table 19-4). An observation schedule is a form that a teacher may use unobtrusively to record a child's behavior (Table 19-5). It is most useful in the preschool and primary grades, when the child's verbal expressions are not well developed. In preschool and in first grade, an interview schedule can be combined with a gamelike problem to ascertain how a child thinks, feels, and sees things.

TABLE 19-1

A GAMELIKE ASSESSMENT

GOAL: Perceiving and Describing Visual Qualities

Instructions

Use at least sixteen postcard reproductions of works with similar subjects; for example, landscapes, figures, still lifes. Number the postcards from 1 to 16.

1. Sort the cards into two piles of eight prints each. The prints in each pile should look alike. Write the numbers of the prints in the squares under *Sort 1*. In the space to the right of the squares, list the qualities of the prints that make them look alike.

2. Take one of the piles from *Sort 1* and sort them into two groups of four prints each. Record the numbers of the prints and why they look alike.

3. Repeat the process described in Step 3, using the other pile of eight prints.

4. Continue the subdivision of piles, listing the numbers of the prints and the reasons they look alike, as shown for *Sort 3*.

 (The greater the consistency between the visual qualities in the prints and the reasons listed, the more evidence of skill in perceiving and describing visual qualities.)

MATCH AND BRANCH

SORT 1 SORT 2 SORT 3

TABLE 19-2

A GAMELIKE ASSESSMENT

GOAL: Learning How Artists Use Media and Processes

Cut out the following pictures. Paste them on another sheet of paper in the correct order. Under each picture, briefly describe what the artist is doing.

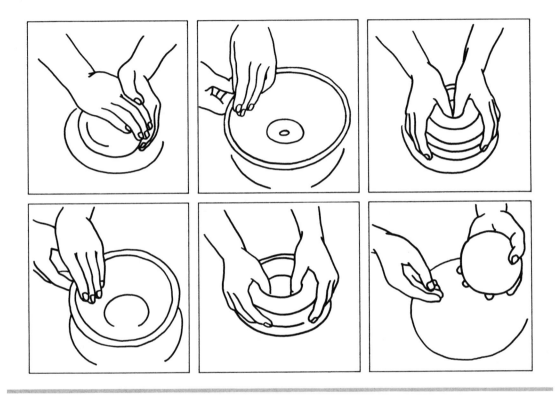

ANECDOTAL RECORDS. Anecdotal records capture the essential details of a situation in which the child's behavior was particularly memorable. Teachers may wish to compile anecdotal records either on sheets of paper or on file cards. Entries can be as simple as a sentence or as detailed as a short paragraph (Table 19-6). In order to assure adequate sampling of students over a period of time, the teacher can record the behavior of four or five students during each class period. In this way, brief comments on each student may be obtained every fifth or sixth class period.

CHECKLISTS. Prepared checklists permit teachers to sample upper elementary children's attitudes and knowledge without making children feel as if they are taking a test. This technique can be an unobtrusive kind of evaluation if it is used on a fairly regular basis; it is also a useful diagnostic aid (Table 19-7).

SUMMARY REPORTS. One of the most efficient methods of keeping a record is a summary sheet, on which periodic judgments are made of student growth. Ideally, the judgments are

TABLE 19-3
SIGN-UP SHEET

Date_____ Class_____

Name	Reason for Choice	Ceramics	Painting	Architecture	Printing	Sculpture	Other
Patty Smith							
Mary Tate							
Bill Jones							
Donald Mack							

Write in reason* before you go to a work center. If the work center is full, choose another.

*Examples of reasons: Continue working. Finish up today. Begin new work. Decide if I want to do this.

TABLE 19-4
INTERVIEW SCHEDULE

GOAL: Personal Fulfillment in Creating Art

	Yes	No	Comments
1. Did you know what you wanted to do before you began working? What was it?	___	___	
2. Did you change your way of thinking while you were working? Why?	___	___	
3. When things went right did you know why?	___	___	
4. When things did not go right, did you know why?	___	___	
5. Did you discover anything unusual or special while you were working?	___	___	
6. Did you enjoy working on this even if you did not solve all your problems?	___	___	
7. Would you like to do something like this again?	___	___	
8. Now that you are finished, how do you feel about what you have done?	___	___	

Questions are based on an analysis of John Dewey, *Art as Experience*, Chapter 3, "Having an Experience." Related questions for older students may be found in Albert D. Mazarella, "The Curricular Implications of Students' and Teachers' Perceptions of the Objectives in Secondary Art Education Programs," (M.A. thesis, Ohio State University, 1969).

TABLE 19-5
OBSERVATION SCHEDULE

This form might be used to record a child's response to a collection of works of art.

Name_____ Grade_____ Date_____

	Sculpture		Painting		Weaving	
	A	B	A	B	A	B
1. Touches lightly						
2. Explores surfaces						
3. Picks up, holds						
4. Glances briefly						
5. Studies thoroughly						
6. Comments to self						
7. Comments to others						
8. Asks questions about						
Other						

Tactual-Kinesthetic: Items 1, 2, 3. Visual: Items 4, 5. Verbal: Items 6, 7, 8.

TABLE 19-6
ANECDOTAL RECORD

Name: **Tillie Ann Marine** Grade: **Kdg.** Year **75–76**

Date	Incident	Comments
11-28-75	Tillie reported she and parents went to art museum and saw a lion and a woman and ate in the cafeteria.	First voluntary reference to art experience outside of school.
2-14-76	Wanted to work at easel but was afraid to get dress dirty.	Gave her an old shirt. She painted for one-half hour, made three snowmen on blue paper with white paint.
2-16-76	Chose clay for the first time. Worked for about ten minutes. Made a baby and a bed. Then rolled up clay and put it away.	Seemed to be pleased with herself but was also anxious to clean up.

TABLE 19-7
INTEREST CHECKLIST

Which do you like to do best?

Draw _____

Cut paper _____

Paint _____

Make prints _____

Make jewelry _____

Make models of things _____

Make useful things _____

Don't care _____

Other_____

I want my work to look:

Nicely designed _____

Carefully made _____

Like the thing I saw _____

Useful to someone _____

Like a special feeling _____

Don't care _____

Other_____

I want to learn more about:

Being neat _____

Getting ideas _____

Drawing _____

Looking at art _____

Don't care _____

Other_____

I want help in drawing:

Portraits (faces) _____

Landscapes (trees, houses) _____

People doing things _____

Airplanes, cars _____

Machinery _____

Don't care _____

Other_____

I would like to work with:

Paint _____

Pencil _____

Chalk _____

Clay _____

Wood _____

Plaster _____

Don't care _____

Other_____

I would like my art teacher to:

What I don't like about art is:

TABLE 19-8
SUMMARY REPORT

Name_____ Grade_____ Year 19_____

Personal Development in Art

Is learning to:

___ find own ideas for art

___ refine, modify ideas for art

___ use media effectively

___ perceive, respond to art forms

___ interpret art experience

___ judge the value of art experience

Learning About the Artistic Heritage

Is learning how and why:

___ artists find ideas for their work

___ artists refine, modify their ideas

___ artists use media

___ experts respond to art

___ experts interpret art

___ experts judge art

Learning About Art and Society

Is learning how and why:

___ people** create art

___ people change their art forms

___ people use media for expression

___ people respond to art forms

___ people interpret art forms

___ people judge art forms

Evaluation Key

* = See note on back for additional comments

G = Is making good progress

V = Enjoys trying

		Evaluation		
1	2	3	4	

**First term: [Eskimos, American Indians, early settlers]
Second term: [People in the community, classmates]

jointly made by the teacher and the student every four to six weeks. Two judgments should be made: satisfactory performance and satisfaction *in* performance (Table 19-8). Because the summary sheet is keyed to general goals, it is reasonably easy to use. At the same time it permits judgments based on an overall impression rather than on isolated behavior. The summary report is the single most efficient type of comprehensive written record for the curriculum proposed in this book.

TESTS. Tests are designed to examine the child's recall of factual knowledge or the child's ability to recognize, interpret, and apply con-

cepts in a hypothetical (paper and pencil) situation (Table 19-9). At best, tests are a way for teachers to assess mental preparation. However, the preparation should not just be for the test; it should be preparation for additional learning experiences.

BEHAVIORAL OBJECTIVES. This approach to evaluation has been adopted by many school systems. A behavioral objective describes observable behavior, the conditions under which that behavior should occur, and a criterion, or standard, for satisfactory performance. Examples of behavioral objectives in art are shown in Table 19-10.

TABLE 19-9
PENCIL AND PAPER TESTS

ARCHITECTURE (SEVENTH GRADE)

1. Match A B C D E

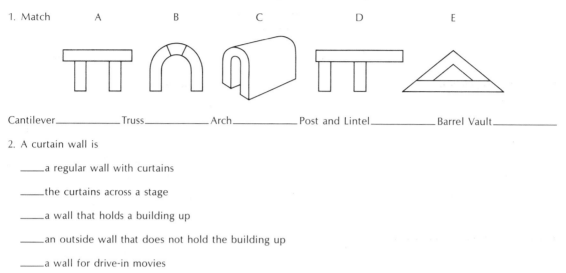

Cantilever_____ Truss_____ Arch_____ Post and Lintel_____ Barrel Vault_____

2. A curtain wall is

_____a regular wall with curtains

_____the curtains across a stage

_____a wall that holds a building up

_____an outside wall that does not hold the building up

_____a wall for drive-in movies

3. Using a ruler, determine the dimensions of *the living room* in the plan below. The scale is $\frac{1}{16}$ inch = 1 foot.

Answer:_____ × _____.

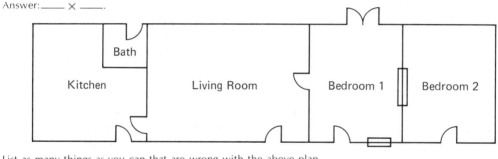

4. List as many things as you can that are *wrong* with the above plan.

Descriptions like these are, in effect, individual test items. If a prepared test were available, a behavioral objective might take this form: "Given the 'Xandu Art Test,' 75 percent of all fourth graders will score 50 or better."

A number of assumptions undergird behavioral objectives. Because the objectives are phrased in terms of conditions, behavior, and criteria, there is a complete separation of means from ends. In other words, the evaluation process does not account for *how* students learn to achieve the objective. Behavioral objectives also assume that learning is a sequential accumulation of specified knowledge, skills, and attitudes. Unexpected insights are simply not counted as part of the learning process. There is little opportunity to account for different combinations of strengths in individuals. Finally, reasons for

TABLE 19-10
BEHAVIORAL OBJECTIVES IN ART

Conditions	Observable Behavior	Criterion
Given five colors of tempera paint (red, yellow, blue, black, and white), a ½-inch bristle brush, a 9 × 12-inch piece of manila paper, water, a paper towel, and one-half hour to work;	the student will mix paints to produce patches of color showing	orange, green, violet, pink, maroon, light blue, dark blue, light yellow, dark yellow.
Given photographs of Wright's "Falling Water" and the instructions to judge it in a short essay according to the criterion of organic form;	75 percent of all seventh grade students will write an essay in which	at least three examples of appropriate evidence for the criterion are given, and judgments are linked to both the criterion and the evidence.

behavior are of little interest. An objective such as "20 percent of the students enrolled in junior high art classes will voluntarily join the art club" does not tell us *why* they will join.

As currently used, behavioral objectives provide a record of different *rates* of achievement but not of different *kinds* of achievement. If we define a single set of objectives for a school or a grade or a class, we are saying that *all* students within that group will meet the objectives to some degree. Students who do not measure up are judged to be behind the group in their rate of development. There is no practical way of indicating the qualitative difference in those students' performances.

The concept of education that underlies the behavioral approach to measurement has substantial public and professional support. However, behavioral objectives require us to view education as a business, whose end product is learning. Production levels can be determined by counting the units of learning produced by the workers (students) in a given time period (school year). Using these analogies, we can use standard business techniques to actually determine the cost of producing a certain level of learning. Costs in teacher salaries, time, supplies, overhead on facilities, and so on can be calcu-

lated and compared with pupil productivity, or the learning outputs of the system. Quality control is assured by periodic sampling of products and by adjustment of the system to improve the efficiency, accuracy, and completeness of the total operation.

Clearly, the behavioral-objective movement has its major drawbacks. This record-keeping technique, like tests, encourages us to think of education in quantitative rather than qualitative terms. Nevertheless, many teachers work in districts that require such reporting, and to offer them help in record keeping, key-punch cards are recommended as a data-gathering form.

KEY-PUNCH CARDS. Key-punch cards are a convenient way of noting achievement when objectives have been specified in advance and a large number of students are to be evaluated (Figure 19-3). The marginal tabs are coded and notched to permit easy access to a set of cards for each class and to alphabetical entries within a class. Other tabs are notched as students achieve a satisfactory level of performance on a specific behavioral objective. A single notch might indicate "effort without success": a double notch "satisfactory achievement." The students

19-3 Key-punch cards and index.

The first card (Master Index - Art Objectives):

```
1-10  Media Skills
11-20 Design Skills
21-30 Idea Sources          MASTER INDEX
31-40 Perception                 ART
41-50 Judgment              OBJECTIVES
51-60 Finished Works
61-70 Elective Works
71-80 Attitudes/Habits

←——Alphabetical, Last Name
```

The second card:

```
WORK HABITS: ( Notch the number if performance is satisfactory)
71, 76  Given instructions for clean-up, does so efficiently
        90% of the time.
72, 77  Given instructions to name and date work, does so 95%
        of the time.
73, 78  Except for excused illness, attended 90% of all classes.
74, 77  Has volunteered to assist others in clean-up on at least
        five occasions.
75, 80  Completes works started at least 75% of the time.

Entries for 71-75 due on January.    OBJECTIVES FOR
Entries for 76-80 due in May.          WORK HABITS
```

The third card:

```
Bertril, Shirley   Grade 4   H.R. 5  Ms. Wigget
Absences
                                Notes
2-2                    #7  Good control with 2D media
2-4   out with measles #21 Prefers working from memory
2-10                   #31 Notices things others miss
2-12                   #43 Beginning to understand that
                           criteria make a difference.
                       #75, 80 Plays too much
```

who need special help can be quickly identified by "needling" the deck. Their cards will not drop off the needle because no notches have been made to indicate effort or achievement.

Interpreting the records

The purpose of interpreting records is to obtain a summary of information. Records of student growth can be interpreted in several ways:

COMPARISON WITH STUDENT'S EARLIER PERFORMANCE. This is the growth criterion. Growth is reflected in a student's progress toward self-directed inquiry. The record of growth is based on accumulated information about the student. The teacher can make four basic interpretations of the comparative information: extensive growth, intensive growth, evolutionary growth, or no growth.

Extensive growth is demonstrated when students expand both their range of satisfactory performances and their satisfaction with their performances. New goals and approaches to study are undertaken; students are trying different ways of becoming engaged in art. Growth is lateral, or in breadth of experience.

Intensive growth is shown when students persist in satisfactory performances and in their

satisfaction with their performances. Closely related goals and approaches to study are pursued for an extended period. Students are intensifying the depth of their experience by continuing to undertake related challenges. They might investigate relationships by concentrating on the artistic heritage or on studio art, or by cutting across several types of goals but centering, for example, on symbolism in art.

Evolutionary growth is apparent when students persist in certain forms of inquiry while expanding their studies into other areas. The total pattern of involvement is cohesive but not stable. New directions in thought and work are attempted, and some of the newer methods are assimilated and gradually replace familiar ways of approaching art.

No growth, or *regression,* is apparent when students are not performing satisfactorily or are not satisfied with their performances, even if the performances are judged satisfactory by others.

Most teachers are familiar with students who perform satisfactorily but constantly express dissatisfaction with their accomplishments. Either the students are unwilling to acknowledge that they are doing well or they are unable to believe their efforts are worthy of commendation. In some cases, students are excessively humble or self-critical. Insecurity is often the reason for self-degrading comments, which are sometimes made in order to elicit reassurance from adults or peers. But occasionally students are genuinely dissatisfied and not insecure. For example, a student who prefers to work in a detailed, careful manner may succeed in working more spontaneously but may not find satisfaction in the fact that he or she is able to make the shift. In either of these cases, growth would be evidenced by children's increasing ability to acknowledge the value of their accomplishments and to express satisfaction with them.

Sometimes children express satisfaction with their performances when, by more objective judgment, they are not satisfactory. The students may be unwilling to acknowledge that their performances are unsatisfactory or they may not understand why their work is unsatisfactory. In some cases, children are excessively defensive; they are quick to rationalize what they have done as satisfactory by saying, "I wanted to do it that way," or "You said it was right." Insecurity is again the problem. The children's comments protect them from criticism by blaming the teacher for the lack of success. In other cases, students do not really understand the difference between what they have done and what was called for by the learning encounter. For example, students may believe they have succeeded in describing a work of art when, in fact, they have merely expressed their likes or dislikes about it. In either case, growth would be apparent in children's increasing ability to understand why their own judg-

ments of success may be inappropriate, to acknowledge that their performances need improvement, and to express satisfaction when their work does improve.

We can also identify children who rarely do satisfactory work. Some children freely acknowledge that they are dissatisfied with their performances. These children are in need of special remedial help and will benefit from it. They are psychologically ready to learn and need patient tutorial assistance. Their growth may be less rapid than other children's, but, in the long run, it can be just as profound. Occasionally, teachers have students who seem to take pride in proving that they cannot do anything right; they seem to enjoy their ability to predict their own failure and make the prediction come true. Such children have become failure prone. Nevertheless, outside of school they may exhibit exceptional competence in sports or a hobby or a job. In order to reverse the failure-prone syndrome, teachers will have to find links between art and the areas of competence.

In rare cases, the child's whole self-image seems to be built around failure, so that success is a threatening experience for the child. Children who are afraid of success have an emotional disturbance and should be receiving professional psychological help. This premature syndrome of the negative self-fulfilling prophesy is sometimes the result of a family environment in which the child is given attention only *because* he or she is

a problem. The teacher should avoid reinforcing this behavior pattern. Showing personal affection and respect for the child as a person, irrespective of his or her performance in art, is essential.

COMPARISON WITH AGE OR GRADE GROUP. Age or grade comparisons are useful to teachers who want to become aware of typical and atypical performance within a class. Comparisons of this kind assume that the age or grade of children is a critical factor in determining their maturity and achievement. This assumption is not always warranted because prior experience can also be an important consideration in children's performances. In addition, interpretations based on the limited information obtained from one class or grade can lead teachers to equate growth with "normal" class performance instead of honoring the distinct value of different types and rates of growth achieved by each child.

COMPARISON WITH ABSOLUTE STANDARDS. Absolute standards can be applied to any subject in which correct performance can be defined with certainty. However, little of the significant content in art lends itself to judgments based on absolute standards. In assessing students' performances in reading, writing, mathematics, and science, the teacher can fairly easily determine when students have achieved abso-

EVALUATION OF LEARNING IN ART

lute mastery of parts of the subject. Norms, or typical scores for ages and grades, can be calculated and used as a basis for judging individual achievement. Indeed, there are numerous standardized achievement tests in subjects in which correct and incorrect answers to questions can be calculated and norms established. Behavioral objectives serve the same purpose as standardized tests. They are written so that responses can easily be scored as right or wrong, all or nothing, mastered or not mastered. The use of behavioral objectives should be restricted to subjects that are factual and absolute; they should not be developed for subjects in which alternative kinds of responses might be equally appropriate, expressive, or valuable.

While the study of art does involve some factual knowledge and adherence to well-defined procedures, teachers cannot assess significant growth if art learning is considered only a matter of mastery. There are no absolute standards for judging sensitivity, flexibility, empathy, and risk taking—all of which are vital in art experience.

Sharing the evaluation with others

Sharing information with others is an important part of the whole process of evaluation. The form and purpose of evaluative reports should suit the interests of the audience.

TEACHER-CHILD REPORTS. Although teachers informally communicate their evaluations to their students every day, teachers might set up more formal evaluation sessions at periodic intervals. Evaluation with children should be conducted as a dialogue, in which the teacher listens and learns as much as the child does. In the middle and upper elementary grades and in junior high, the teacher and student should discuss and record appropriate entries on a summary evaluation form similar to that shown in Table 19-8.

REPORTS TO PARENTS. Some parents ask their children what they learned in school almost every day. Sometimes children volunteer information about school to their parents, especially when something unusual or vivid occurred. Even if report cards or other forms of evaluation are sent home, teachers need not restrict their communication with parents to this format. Short notes might accompany completed works the child takes home. The teacher might write a note to the parents about some insight the child displayed. Occasionally, parents might be invited to observe or participate in the child's class.

In addition to these occasions for reporting to individual parents, there are numerous channels for communicating with groups of parents. Among these are the open house usually held early in the school year, P.T.A. meetings, and special school-community events, including art

exhibits, gallery openings, and guest-artist demonstrations and talks. Through channels of communication such as these, parents not only see and hear about the values of the school art program but also become participants who contribute to its vitality.

REPORTS TO PRINCIPALS AND FELLOW TEACHERS.

It is easy to assume that the principal, fellow teachers, and other professionals understand the activities and values of the art program. But this is not always true. Teachers have to take the initiative in communicating to their colleagues the purposes, accomplishments, and deficiencies of the art program. Faculty meetings provide one forum. Other opportunities to share information include informal discussions in the teachers' lounge, bulletins, exhibition openings, library displays, after-school workshops, and special in-service programs. It is often helpful to invite local art experts—artists, museum personnel, university art educators—to participate in discussions with the principal and colleagues about the values of the art program.

REPORTS TO SCHOOL ADMINISTRATORS AND POLICYMAKERS.

Teachers are primarily oriented toward their own school and community. Nevertheless, administrators, supervisors, and school-board members should receive evaluative reports *even when they are not requested.* Many art programs suffer from benign administrative neglect because administrators lack information about the purposes, needs, and accomplishments of the program. Develop opportunities to communicate program values and needs to this highly influential audience.

REPORTS TO THE LARGER COMMUNITY.

The support given to any art program is influenced by the community's attitude toward art education in the schools. Teachers have to recognize that channels for reporting extend well beyond their own immediate school, parental groups, and administrative system. Television, radio, newspapers, magazines, and direct mail are effective means of developing public consciousness of art as a vital part of the school program. Many community newspapers and radio and television stations regularly allocate time for reports on school activities. These media are highly receptive to feature reports and news releases that are sent to them. Teachers should become familiar with such channels of communication and use them regularly; both the principal and parents should become involved in facilitating preparation of materials for the mass media.

More fundamentally, teachers of the arts—music, dance, theater, literature, and the visual arts—should collaborate with local art institutions and concerned citizens to advocate basic changes in the kind and amount of news coverage given to the arts. Many local newspa-

pers regularly allocate two or three full pages to high school athletes. In all media, proportionately more attention is given to sports on a daily basis than to all cultural events in a community. Citizens can help alter this practice. Radio and television licenses, for example, are subject to review by the FCC, and stations must present evidence that they are responsive to the communities they serve. Although newspapers are not subject to formal controls, they are influenced by community sentiment.

REPORTS TO LEGISLATIVE GROUPS. City, state, and federal legislation bearing on the arts and education has a profound effect on school programs. It is essential for teachers to become active communicators to elected officials of needs and accomplishments. Whatever else might be said about government bureaucracies, they are sensitive to citizen concerns and are dependent on expert opinion in formulating laws.

In 1975, there were 250 federal and quasi-federal programs that had potential for assisting the arts. Federal laws influence wages and work conditions for federally assisted art programs; tax exemptions for artists, collectors, and organizations; and the distribution of funds for the arts and art education. Teachers can become better informed about state and federal legislation by communicating with their state arts council, by consulting the *Cultural Directory*, published by the Associated Councils for the Arts, or by calling their local Federal Information Center.

Communicating with a wide range of audiences is both a means of sharing information and a remedy for the neglect of art within school programs. Art education cannot be restricted to the classroom and to children alone; it must extend to parents, colleagues, administrators, and the larger community. In short, there is as great a need for adult art education as there is for the art education of children.

Note

[1]Stephen Vincent Benét, "John Brown's Body," from *Selected Works by Stephen Vincent Benét* (New York: Rinehart, 1959). Reprinted by permission of Brandt & Brandt.

Suggested Readings

Associated Councils for the Arts. *Cultural Directory.* New York: Associated Councils for the Arts, 1975.

"Evaluating the Total School Art Program." Papers read at the National Art Education Study Institute, San Diego, California. New York: The JDR 3rd Fund, Arts in Education Program, 1973.

Stake, Robert, ed. *Evaluating the Arts in Education: A Responsive Approach.* Columbus, Ohio: Charles E. Merrill, 1975.

Resources
for
teaching

29

This chapter offers suggestions for developing both physical and human resources for effective art programs.

Physical resources

Rooms and spaces

Any concept of an ideal room or space for art instruction depends on the goals we set for art education and the character of the activities we envision happening there. Many older schools offer little space for display, storage, and cleanup for studio-art activities. Under these conditions, teachers and students must rely on ingenuity

and patience. In newer schools, special art rooms or regular classrooms with sinks and substantial storage and display areas are more typical. Even so, it is often difficult for children to work on large-scale projects or to have privacy for quiet, independent work. Blackout curtains, adequate electrical outlets, library-research space, a gallery for two- and three-dimensional work, and storage for works of art, models, slides, reproductions—all are necessities often overlooked in the planning of new art facilities, primarily because art programs are conceived of exclusively in terms of laboratory-studio activities. In short, relatively few spaces and rooms for art are so well designed that some modification of them will not be required or desired.

An example of the arrangement of a typical self-contained elementary classroom is shown in Figure 20-1. A typical modern art room in a junior high school is shown in Figure 20-2. Portable resource units of the kind shown in Figure 20-3 can solve many of the space problems teachers at all levels encounter. The units might be located in the central resource room or in the school library when it is not in use.

Budgets

Budgeting patterns are so varied that relatively few generalizations can be made. Most schools have separate budgets for equipment—any item that has a useful life of five years or more—and for supply items that are used up. (Small tools that are not likely to withstand three years of use—such as rulers and linoleum-cutting tools—are considered supplies.) Large school systems may have a central warehouse from which many supplies can be ordered and charged to the art budget. Items stocked in a school warehouse are purchased in large quantities at very low per-unit prices. Local merchants may offer discounts on purchases made by schools; an official form may be required for teachers to qualify for the discount. Competitive bids are usually necessary for any item that costs more than twenty or thirty dollars.

In some systems, the budget for art is determined by enrollments in art and thus varies from year to year. Other districts allocate to the school a general fund for supplies and equipment. These moneys are reallocated to various teachers or programs, including art. In some districts, students are assessed special fees to cover the cost of art materials. Most districts permit supplementary funding through booster clubs, student clubs, and special projects.

Supplies and equipment

The quality of physical resources should always be as high as possible, even if quantity is reduced by the greater expense of superior materials.

STUDIO SUPPLIES. Recommended studio supplies can be determined from Chapters 11 through 17. In order to estimate quantities for purchase, you will have to become familiar with the units of measurement commonly used by local suppliers of each item. For estimating quantities of expendable supplies, you can best proceed by guessing the amount of the material one child would typically use to complete one activity with the material. Multiply that by the estimated number of occasions when that activity, or one like it, might be undertaken during

20-1 (*top, left*) An accessible work space with open shelving.

20-2 (*center, left*) A well-planned art room.

20-3 (*bottom, left*) A movable storage unit for materials and teaching aids.

the year. Then multiply the quantity by the number of children who are likely to use that material. Here is an example:

Ceramic clay (nonreusable)

Minimum amount one child uses per activity	1 pound (moist)
Number of occasions per year	× 3 activities
	3 pounds per child
Total number of children	×30 (one class)

Order: 90 to 100 pounds (minimum)

When you order studio supplies, remember to make bulk purchases. A ream of paper (five hundred sheets) will cost you less per sheet than five hundred sheets purchased in five packages of one hundred sheets each. The smaller and more expensive the package, the more you are paying for just the package. Classroom teachers should always pool their orders to take advantage of discounts available with larger purchases.

SMALL TOOLS. The quality of small tools like brushes, scissors, saws, hammers, staples, and carving tools can influence the degree of skill

410

20-4 A tool storage cabinet.

that children show in using them. The sense of craft and caring about the quality of one's tools is undermined by the use of inexpensive inferior tools. In order to determine the number of small tools to purchase, estimate the number of children who, at any given time, must have access to the same tool. If your classroom is arranged with work centers for small groups, you can order fewer (and better quality) tools than if you have to teach the same activity to a total group of twenty-five to thirty children (Figure 20-4).

STUDIO EQUIPMENT AND FURNITURE. There are many excellent sources of specialized studio equipment like printing presses, looms, ceramic wheels, kilns, easels, tool racks or cabinets, and work benches. If your school does not have a room designated for studio work, equipment of this kind can be mounted on dollies (with casters that lock) so that it can be moved from one room to another and stored when it is not in use. Large kilns, however, must be permanently installed for safety and for access to 220-volt outlets (Figure 20-5).

DISPLAY SPACE AND FURNITURE. Display areas in the school should accommodate both two- and three-dimensional work of various sizes.

Portable display walls for two-dimensional work may be purchased or made to be used in

20-5 A well-designed pottery area and kiln room.

20-6 A portable display area.

any of the ways shown in Figure 20-6. In schools with brick or concrete walls, it is helpful to firmly attach two strips of 2 × 2-inch or 2 × 4-inch wood to the wall with expansion bolts or molly screws as shown in Figure 20-7. Larger panels of beaverboard, upson board, or shallow display boxes can then be nailed or screwed into the wood strips.

Many schools already have built-in or standing display units for three-dimensional work. In addition to these units, sculpture stands of various heights and widths should be available for classroom, hall, lobby, and office displays.

DISPLAY SUPPLIES. For the purpose of exhibition, final drawings, prints, watercolors, and surface collages should be matted and, if possible, framed under plexiglass (which is safer than glass). Mats can be purchased or cut to fit each work; old mats can be sprayed lightly with flat acrylic enamel to make them look fresh. Framing systems that are easy to assemble are now available in modular sizes and are well worth the investment.

Paintings in oil or acrylic can be framed with a simple wood strip or may be carefully taped around the edges. Photographs should be dry mounted on stiff cardboard. They may be framed if desired.

Access to works of art

Children must have access to original works of art and cultural artifacts. There are several means of obtaining access to such works.

ORIGINAL WORKS OF ART. Donations of original works of art to a school or districtwide collection should be sought (Figure 20-8). It is *not* recommended that artists be asked to donate their work; rather, a patron should first purchase the work so that the artist is fully reimbursed for it. The patron may then donate the work to the school. (In 1976, patrons could deduct the market value of the work from their income taxes. The artist, however, could deduct only the cost of materials used in the work.) Works of art might also be leased or rented from local artists, but should not be contracted for unless full insurance can be provided as well.

Architectural models, product mock-ups, and original art for commercial publications may be solicited as donations. If the client has already paid for the services involved in creating these works, the designer or architect may be willing to contribute the works without charge.

Works in a school or district collection should be cataloged by a competent art historian or curator so that an adequate record may be kept of the nature of the work, its value, its

20-7 (*top, right*) A solution to the problem of creating display space on concrete block walls.

20-8 (*center, right*) Original works of art should be available for display and discussion.

20-9 (*bottom, right*) Many museums now offer active tours like this second grade encounter at the Philadelphia Museum of Art.

physical characteristics, its use, and its condition at the end of each year.

CIRCULATING EXHIBITIONS ON LOAN.
Local and state arts councils are beginning to make available to schools and community centers excellent exhibitions for temporary display. Low-cost traveling exhibitions of art may sometimes be obtained from such national sources as the Smithsonian Institution, the National Gallery of Art, the American Council for the Arts, and the American Institute of Architects. Write directly to these organizations for information on costs, available exhibits, and current scheduling policies.

CULTURAL ARTIFACTS.
Collections of contemporary and historical cultural artifacts should be acquired for school or districtwide collections. Artifacts from our own culture and from others should be represented in such collections. These works should be cataloged in the same way original works of art are cataloged.

FIELD-TRIP ARRANGEMENTS.
Your school principal can give you information on exactly what is required to arrange a field trip. Spontaneous field trips, however desirable, are unwise

PHYSICAL RESOURCES

20-10 The overhead projector is a versatile teaching aid.

and may be illegal. Any trip away from the property line of the school, including brief neighborhood walks, must be fully cleared in advance with the principal and with parents; do not be naive about your personal liability in supervising or transporting children. However, do not avoid field trips simply because they do require planning; most of the pretrip red tape will allow you and the children to enjoy the trip fully.

Visits to art museums, galleries, and studios should be planned at least two weeks in advance. Museums, in particular, often rely on volunteer help and must carefully schedule tours to accommodate their resources and to prevent unpleasant crowding. After you have become familiar with the museum, you will probably want to avoid the standard orientation tours and use the museum as a learning laboratory (Figure 20-9). The director of educational activities will help you learn how to make good use of the collection, while staying within the boundaries of the museum's responsibility for the safety and effective presentation of its holdings.

Audio-visual media

Because we live in an age of technology we are teaching children who, to an increasing degree, are dependent on visual and audio sources for information. Some of the most common audio-

visual formats for teaching are briefly noted below.

AUDIO AIDS. Audio cassette tapes can be valuable in teaching art. Articulate local historians, art critics, and artists might be asked to tape discussions of works of art. Children's vocabulary and interpretive skills can be developed by recording discussions of their own and others' works. Older children may wish to interview people, using the tape recorder as a research tool.

Live audio interviews can sometimes be arranged through your local telephone company. Special telephone amplifiers are temporarily installed for the "tele-interview" so that children can hear the telephone guest. Children's questions are asked of the guest by the teacher, who speaks into a standard telephone. If the speaker can provide slides of himself or herself in conversation or at work, the sense of the guest's presence is enhanced.

Audio cassette tapes and records that are synchronized with slides or filmstrips are available from several sources (see Bibliography). Such materials are well suited to independent study and small-group work. (Students can use earphones to reduce distraction.)

FILMS, SLIDES, AND FILMSTRIPS. Films can be rented or purchased. The cost of 8mm films

20-11 Postcard reproductions are especially useful for matching and sorting activities.

and film loops (cassettes) is less than the cost of 16mm films. Color and sound films are likewise more expensive than black-and-white or silent films. Informational films about artists and their works are to be distinguished from films as works of art in their own right. Projection equipment for 16mm and 8mm film is usually available in the school or district resource center.

Filmstrips, films, and slides are valuable teaching aids, but children should understand that they are only substitutes for the original works of art. Filmstrips, unlike slides, present images in a fixed order. Most filmstrips are published with a guide to each frame and may be accompanied by a narrative audiotape cassette or record. Slides can be arranged so that the sequence of images suits your purpose. Slide sets may have a guide, and some are published with sound narratives on tapes or records. Slides, films, and filmstrips should be handled by the edges to avoid staining them with fingerprints.

Overhead transparencies are useful for presenting schematic relationships and for illustrating optical illusions, color phenomena, and silhouettes (Figure 20-10). Thermofax transparencies of children's pencil drawings can be enlarged for mural work by placing the transparencies on the overhead projector.

Opaque projectors are designed for original flat work, such as books, prints, and papers. To be most effective, this projector must be used in a very dark room. It has a very hot light source.

TELEVISION. Several excellent television series on art have been produced for in-school use. Arrangements for broadcasts can be made through the nearest public-educational television station or state department of education. In addition, call children's and parents' attention to special television programs about art or cultural groups. Local television stations, both commercial and educational, should be requested to inform teachers well in advance of programs of educational value.

Do not overlook the value of community-service television time as a vehicle for making the community more aware of its artistic heritage and cultural resources. Local stations that have production teams might be persuaded to create programs around your needs.

Printed media

Various printed and photographic resources have value in the teaching of art. Among these are reproductions, photographs, and books.

REPRODUCTIONS. Printed reproductions of works of art can be obtained from publishing companies or local distributors (Figure 20-11). Postcard-size prints are sold in many museum and stationery shops; they are very useful for matching, sorting, and recognition games. (They

20-12 Vocabulary development plays an important part in artistic growth.

will last longer if covered with transparent contact paper or clear mylar.) Poster-size prints should be dry mounted on stiff cardboard and, if possible, covered with a nonglossy, clear surface like mylar or heat-seal plastic. Metal eyelets placed in holes cut in corners reduce wear and tear in hanging the prints.

CHARTS AND FLASHCARDS. Large charts and handmade posters can provide useful technical information that otherwise may be difficult for children to remember. When steps or processes in creating an object are crucial to its successful completion, it is wise to illustrate each step and post the illustrations so that children do not have to wait and ask you for further directions. Flashcards may be used effectively to develop basic recognition and vocabulary skills (Figure 20-12).

PHOTOGRAPHS. Try to build collections of colored and black-and-white photographs of details in the environment, sections of paintings, the same object from different viewpoints, complex processes, before and after changes in the environment, and so on. Use smaller prints (5 × 7 inches or smaller) for matching and sorting activities. Make larger prints for display or study. Cultivate your own skills in photography and

seek out photo buffs among students, parents, colleagues, and friends to help develop these resources.

BOOKS. In cooperation with local public and school librarians, develop collections of books about art for children to browse through or read. School libraries should also order children's books that are superb examples of graphic design and the art of illustration. Among these might be winners of the Randolph Caldecott Medal, which is awarded annually for outstanding illustration in a children's book.

Other tangible aids

Objects that can be touched or manipulated should be available for children's art activities.

MODELS AND REPLICAS. Some plastic and paper models can be used effectively as teaching aids (Figure 20-13). Models of houses and miniature villages can be used for some activities in the study of environmental design. Models of the human skull and skeleton can be valuable aids in teaching older children the physical structure of the human form.

20-13 (*top, right and center, right*) Small models and replicas can be effective in teaching children about form.

20-14 (*bottom, right*) A sampler of Navaho weaving technique.

Museum gift shops both provide information about and sell exact-scale replicas of small sculpture and jewelry. The surfaces and forms of museum replicas are generally more faithful to the original works than are replicas sold in souvenir shops and dime stores.

SAMPLERS. Samples of various media, forming processes, and geometric or natural structures permit children to see, touch, match, and sort items that, in many cases, they would not otherwise experience so directly (Figure 20-14). Examples of desirable samplers have been suggested in Chapters 11 through 17.

REAL OBJECTS. Collect real objects like smooth stones, birds' nests, weathered bones, lichen, and shells for visual study and inspiration. A collection of props suitable for figure drawing, still life, and improvisational media events is also helpful.

COMMERCIAL GAMES AND TOYS. A number of commercial games and toys are suitable for teaching art: building blocks of various types, Montessori apparatus, microscopes, prisms, simple printing sets with rubber stamps, puzzles, and magnetic boards (Figure 20-15).

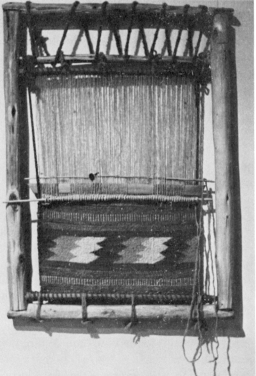

20-15 An invitation to make discoveries about printing.

Human resources

Human resources are too often overlooked in planning an art program. A vital program depends on a wide range of people who care about children and art.

Teachers

The question of who can and should teach art can be answered in only one way. Ideally, every elementary and junior high school should have trained art teachers. Realistically, there are still many districts in which classroom teachers have the full responsibility for teaching art.

THE CLASSROOM TEACHER. Elementary school classroom teachers have a number of advantages in teaching art. In a self-contained class, the teacher has continuing contact with the same group of children for most of the day. Art activities can be coordinated with student interests and continued on an individual or a group basis depending on enthusiasm (Figure 20-16). Art can easily be related to other subjects, and fairly large projects can be undertaken within the classroom. Classroom teachers can arrange field trips to museums and studios more readily than art teachers, whose schedules often involve five to seven classes a day. In addition,

the elementary school teacher is often very skilled in helping children learn about art in the same way they learn about other subjects— through reading, creative writing, research projects, and discussion.

THE ART TEACHER. The elementary school art teacher has two roles: art consultant and art instructor. As art consultant, the teacher does little direct classroom teaching but concentrates on helping elementary school teachers plan and carry out activities. In this capacity, the art teacher may serve up to sixty-five classroom teachers. Direct teaching is usually limited to demonstration lessons that will help the elementary school teacher learn a new or technical aspect of art. In addition, the art consultant often coordinates supply orders, builds resources for teaching art, and offers workshops to assist classroom teachers.

As art instructor, the teacher works directly with children. Art teachers often work under conditions that are far from ideal. Some teachers are assigned to teach in more than fifty classrooms within a two-week period. Clearly, no art teacher can give individual guidance when the pupil–teacher ratio is 1500 to 1. A reasonable ratio of 300 to 1 would permit the art teacher to meet children at least twice a week. Other more reasonable schedules might be planned in which direct teaching is restricted to certain grades,

20-16 An arrangement that permits individual and small-group activity.

rotated among grades at midyear, or combined with consultant time. It is vital that classroom and art teachers assume the initiative and argue for improved scheduling and assignment patterns in art.

Even when special instruction in art is available in the elementary school, the classroom teacher should always build on the understandings children acquire in art, extend this knowledge to other subjects, and feel free to ask the art teacher for guidance in art activities that children may wish to initiate. If the art teacher works in a special room, the classroom teacher should feel free to join the class as an observer or unobtrusive participant. If the art teacher travels from one classroom to another, the classroom teacher should prepare any materials that may be requested by the art teacher and should otherwise be ready for the lesson. It is often essential and always advisable for the classroom teacher to remain in the room to assist the art teacher and to conduct any follow-up that may be necessary.

According to most scheduling patterns, art is an elective after the seventh or eighth grade. In junior high schools, art may be required for as little as half a year, or approximately ninety hours of instructional time. In middle school programs, scheduling patterns are usually similar to those of regular elementary schools for grades five and six, with a concentrated block of time for instruction in the seventh or eighth grade.

These scheduling patterns usually reflect minimum standards for art instruction.

Scheduling patterns for art are becoming more diversified and require art teachers to be flexible, but not uncritically so. In elementary and middle schools based on the open-classroom concept, the art teacher is usually available in an area designed as an art-work center. Various scheduling systems provide for individual, small-group, or full-class instruction. Totally open, or unscheduled, blocks of time are also available to children. In some open classrooms, children maintain records of the dates and times that they use the work center. The art teacher may review these entries periodically in order to identify children who have not used the center and then encourage greater interest in it.

In nongraded elementary and junior high school programs, children are often grouped temporarily according to their levels of performance in reading and mathematics. There are no classes designated as first grade, second grade, and so on. The aim is to individualize instruction so that children can learn at their own rates. Art schedules tend to be a byproduct of the immediate grouping patterns for reading and mathematics, so that art classes are composed of children of various ages who are at the same level of ability in reading and mathematics. As a result, some children may move from one art class to another several times during a year, while others remain in the same class. Unfortu-

nately, the nonmovers soon decide if they are in a "bright" or "dull" group, and their attitudes toward schoolwork may be good or poor. Nevertheless, the practice of homogeneous grouping based on reading and mathematics persists, and you will find that radically different approaches to the same art activities are often necessary.

Some nongraded or otherwise individualized programs in middle or junior high schools use a system of contracts. In art, a student might be given a notebook full of suggested art activities with elaborate descriptions for completing the projects. These activity descriptions might be coded by art areas and levels of difficulty. The student would be asked to prepare a contract to complete a certain number of activities, with a balance between art areas and levels of difficulty. This system is intended to make children responsible for setting their own goals and meeting them.

Programs based on mini-courses are also being developed in middle and junior high schools. These programs aim to increase the choices available to children and offer children opportunities for success in specific areas so that total failures are avoided. A mini-course is offered within a specified period of time; it might be as short as one week or as long as six weeks. The course usually centers on a single topic or theme, such as "Understanding clay," "Art in our time," or "Meet the artist." Students who are experts on a topic may offer a mini-course to their peers. Scheduling is similar to college work, with required courses and open electives balanced throughout the year.

GUEST TEACHERS. If you wish to arrange school visits by members of the community who have something special to offer children, keep these points in mind:

If the guest is a professional in any aspect of art, and if the guest is not regularly employed to make school visits, you should expect to pay the guest for time, services, and expenses. Among such professionals are artists, designers, art critics, historians, and architects. If you offer payment and the guest declines it, that is up to the guest. The offer should be made in every case. Confirm by letter the time, date, place, nature of activity, and payment you have agreed on. Keep one copy of the letter for your file and give one to the principal.

Many other talented people, including professionals in art, are willing to serve as paid guest teachers or as volunteers. They welcome the opportunity to share their knowledge of the community or to demonstrate their special skills in a trade or craft (Figure 20-17). Local residents who have traveled extensively or who are not natives of this country can offer valuable first-hand insights into the relationship of art to life

20-17 Many community residents have talents they are willing to share with youngsters.

in other cultures. Some communities have a volunteer clearinghouse, which lists the names of people who want to share their time and talent with others. In many schools, the P.T.A. can be of great help in locating special volunteer teachers.

With the assistance of federal funds, artists-in-residence programs have been established in many communities. Originally designed to employ artists, a typical residency might provide the artist with a studio within the school for one year, a budget for materials to create art, and a modest salary. In exchange, the school might receive one or more works created by the artist, while the children have many opportunities during the year to visit the studio, to see work in progress, and to talk or work with the artist. Although an artist-in-residence program is never a substitute for a full art program, artist-in-residence programs can be highly successful if the artist is interested in teaching and enjoys children.

An alternative to the one-year artist-in-residence program is to allocate a comparable sum of money for resource collections, field trips to museums and to the work spaces of artists, and short-term school visits from guest teachers—including studio artists, designers, architects, art critics, collectors, and art historians. Another alternative is to arrange a one-year team-teaching assignment by employing a second art

teacher to carry on the comprehensive art program while providing the regularly employed art teacher with the same privileges and schedule that might be given to an artist-in-residence.

Community volunteers

Not every person who wants to help improve the school can best do so by serving as a guest teacher. Contributions of services and supplies are just as valuable. Local industries, businesses, labor unions, and social and fraternal organizations are often willing to help finance and to assist in implementing special projects. Industrial scrap and waste material (wood, metal, leather, paint, paper) can be picked up on a regular basis at the district level and recycled for school use. Be alert to these and other opportunities for community involvement in school art programs.

Supporting staff and services

Most large school districts employ an art supervisor. The art supervisor is responsible for improving the quality of art instruction, for building supportive attitudes toward art among administrators and community groups, and for encouraging innovations. The supervisor assumes a leadership role in developing the art curriculum and in securing better resources,

budgets, and scheduling patterns for art. The supervisor is in a key position to facilitate communication among art teachers and to coordinate districtwide activities. Problems in teaching art that cannot be solved at the school level are often mediated with the help of the art supervisor.

Almost every state has a department of education with a person designated as director of art education, or specialist in art. This person's job is to help improve local art instruction in a number of ways. The state director is in charge of reviewing programs to ensure that minimum state standards for art are being met. As a representative of the state agency that is legally responsible for the quality of education, the director is called on to assume a position of leadership in informing art supervisors and teachers of resources, innovations, and programs within the state. The director coordinates the activities of committees that develop new state curriculum guides, art-teacher certification requirements, and minimum standards for facilities and scheduling. The director also serves as a liaison between the schools and the state department of education, teacher associations, art agencies, and, in some cases, special legislative committees on education and art.

Within most school districts or regions of a state there are organizations through which art teachers share ideas and solve problems that are of mutual concern. Statewide organizations of

art teachers usually meet in conference for several days once a year. Well run school systems reimburse teachers for attending professional conferences that familiarize teachers with recent trends, new resources, and innovative program directions. National organizations of teachers in each of the arts—music, dance, literature, theater, and the visual arts—are seeking ways of acquiring greater recognition for all the arts, not only in the schools but also in public life. Individually and collectively, these organizations respond to the views of their members; they serve as advocates for art, as information channels, and as sponsors of special publications and conferences.

Every state has an arts council through which federal funds from the National Endowment for the Arts are channeled. The arts council also plays an important role in developing a supportive attitude toward the arts within the state. Sometimes the council can help finance special programs in art education at the local level. Cooperative programs involving museums, local art organizations, and schools are encouraged. Some arts councils have helped develop traveling exhibitions of art for use in schools.

Suggested Readings

Ascheim, Skip, ed. *Materials for the Open Classroom.* New York: Dell, 1973.

Brand, Stewart, ed. *The Last Whole Earth Catalog: Access to Tools.* Menlo Park, Calif.: Portola Institute, 1971.

Shrank, Jeffrey. *The Seed Catalog: A Guide to Teaching/Learning Materials.* Boston: Beacon Press, 1974.

Wurman, Richard Saul. *Yellow Pages of Learning Resources.* Cambridge, Mass.: M.I.T. Press, 1971.

Appendix

BIBLIOGRAPHY

The following entries supplement the "Suggested Readings" at the end of each chapter of the book.

BOOKS FOR TEACHERS

Alschuler, Rose, and Hattwick, LaBerta Weiss. *Painting and Personality: A Study of Young Children*. 2 vols. Chicago:University of Chicago Press, 1947 (rev. and abr. 1969).

Anderson, Yvonne. *Teaching Film Animation to Children*. New York: Van Nostrand Reinhold, 1971.

Arts, Americans and Education Panel. *Coming to Our Senses: The Significance of the Arts for American Education*. New York: McGraw-Hill, 1977.

Arts and the Handicapped. New York: Educational Facilities Laboratories, 1975.

Associated Councils on the Arts. *Americans and the Arts: Highlights from a Survey of Public Opinion*. New York: Publishing Center for Cultural Resources, 1974.

Barkan, Manuel, and Chapman, Laura H. *Guidelines for Art Instruction Through Television for the Elementary Schools*. Bloomington, Ind.: National Center for School and College Television, 1967.

Barron, Frank X. *Artists in the Making*. New York: Academic Press, 1972.

Bassett, Richard, ed. *The Open Eye in Learning: The Role of Art in General Education*. Cambridge, Mass.: M.I.T. Press, 1969.

Bay, Ann. *Museum Programs for Young People*. Washington, D.C.: Smithsonian Institution, 1973.

Bland, Jane C. *Art of the Young Child: Understanding and Encouraging Creative Growth in Children Three to Five*. rev. ed. New York: Museum of Modern Art, 1968.

The Book of Art. 10 vols. New York: Grolier Educational Corp., 1966.

Brandwein, Paul F. et al. *Self Expression and Conduct: The Humanities*. New York: Harcourt Brace Jovanovich, 1974.

Brittain, W. Lambert, ed. *Creativity and Art Education*. Washington, D.C.: National Art Education Association, 1964.

Churchill, Angiola R. *Art for Preadolescents*. New York: McGraw-Hill, 1971.

Conant, Howard, and Randall, Arne. *Art in Education*. Peoria, Ill.: Charles A. Bennett, 1963.

Conrad, George. *The Process of Art Education in the Elementary School*. Englewood Cliffs, N.J.: Prentice-Hall, 1964.

D'Amico, Victor. *Creative Teaching in Art*. rev. ed. Scranton, Pa.: International Textbook, 1966.

De Francesco, Italo. *Art Education: Its Means and Ends*. New York: Harper & Row, 1958.

Dewey, John. *Art As Experience*. New York: Minton, Balch, 1934.

Diamant, Lincoln, ed. *The Anatomy of a Television Commercial*. New York: Hastings House, 1970.

Dimondstein, Geraldine. *Exploring the Arts with Children*. New York: Macmillan, 1974.

Dorn, Charles, ed. *Report of the Commission on Art Education*. Reston, Va.: National Art Education Association, 1977.

Eisner, Elliot W. *Educating Artistic Vision*. New York: Macmillan, 1972.

———— and Ecker, David W., eds. *Readings in Art Education: A Primary Source Book*. New York: John Wiley, 1966.

Gaitskell, Charles D., and Gaitskell, M. R. *Art Education in the Kindergarten*. Peoria, Ill.: Charles A. Bennett, 1952 (5th ed., Toronto: Ryerson, 1968).

————. *Art Education for Slow Learners*. Peoria, Ill.: Charles A. Bennett, 1953 (new ed., Toronto: Ryerson, 1964).

———— and Hurwitz, Al. *Children and Their Art*. 3rd ed. New York: Harcourt Brace Jovanovich, 1975.

Golumb, Claire. *Young Children's Sculpture and Drawing: A Study in Representational Development*. Cambridge, Mass.: Harvard University Press, 1974.

Gowan, John C.; Demos, George D.; and Torrance, E. Paul. *Creativity: Its Educational Implications*. New York: John Wiley, 1974.

Greenberg, Pearl, ed. *Art Education: Elementary*. Washington, D.C.: National Art Education Association, 1972.

Grove, Richard. *The Arts and the Gifted*. Reston, Va.: The Council for Exceptional Children, 1975.

Halprin, Lawrence. *The RSVP Cycles: Creative Processes in the Human Environment*. New York: George Braziller, 1970.

Hardiman, George, and Zernich, Theodore. *Curricular Considerations for Visual Arts Education*. Champaign, Ill.: Stipes, 1974.

Harrison, Elizabeth. *Self-Expression Through Art*. Toronto: Gage, 1951.

Hastie, W. Reid, ed. *Art Education. Sixty-fourth Yearbook of the National Society for the Study of Education*. Chicago: University of Chicago Press, 1965.

Herberholz, Barbara. *Early Childhood Art*. Dubuque, Ia.: William C. Brown, 1974.

Herberholz, Donald W., and Herberholz, Barbara. *A Child's Pursuit of Art*. Dubuque, Ia.: William C. Brown, 1967.

Horn, George F. *Experiencing Art in Kindergarten*. Worcester, Mass.: Davis Publications, 1971.

Hubbard, Guy, and Rouse, Mary. *Art 1–6: Meaning, Method and Media*. 6 vols. Westchester, Ill.: Benefic Press, 1973.

Hurwitz, Al, ed. *Programs of Promise: Art in the Schools*. New York: Harcourt Brace Jovanovich, 1972.

—— and Madeja, Stanley. *The Joyous Vision: Art Appreciation for the Elementary School*. New York: Van Nostrand Reinhold, 1976.

Jackson, Philip W. *Life in Classrooms*. New York: Holt, Rinehart and Winston, 1968.

Jameson, Kenneth. *Art and the Young Child*. New York: Viking Press, 1969.

——. *Primary School Art*. New York: Van Nostrand Reinhold, 1971.

Jefferson, Blanche. *Teaching Art to Children: Content and Viewpoint*. 3rd ed. Boston: Allyn & Bacon, 1969.

Kaufman, Irving. *Art and Education in Contemporary Culture*. New York: Macmillan, 1966.

Kellogg, Rhoda. *Analyzing Children's Art*. Palo Alto, Calif.: Mayfield, 1970.

—— and O'Dell, Scott. *Psychology of Children's Art*. Del Mar, Calif.: CRM Books, 1967.

Knudsen, Estelle S. *Children's Art Education*. Peoria, Ill.: Charles A. Bennett, 1971.

Kuhns, William. *Exploring Television*. Chicago: Loyola University Press, 1975.

Lanier, Vincent. *Essays in Art Education: The Development of One Point of View*. 2nd ed. New York: MSS Educational Publishing, 1976.

Lewis, Hilda Present, ed. *Art for the Preprimary Child*. Washington, D.C.: National Art Education Association, 1972.

——. *Child Art: The Beginnings of Self-Affirmation*. rev. ed. Berkeley, Calif.: Diablo, 1973.

Lidstone, John, and McIntosh, Don. *Children as Film Makers*. New York: Van Nostrand Reinhold, 1970.

Linderman, Earl W. *Invitation to Vision*. Dubuque, Ia.: William C. Brown, 1967.

—— and Herberholz, Donald W. *Developing Artistic and Perceptual Awareness*. 3rd ed. Dubuque, Ia.: William C. Brown, 1974.

Lindstrom, Miriam. *Children's Art: A Study of Normal Development in Children's Modes of Visualization*. Berkeley, Calif.: University of California Press, 1957.

Manzella, David. *Educationists and the Evisceration of the Visual Arts*. Scranton, Pa.: International Textbook, 1963.

Mattil, Edward L., project director. *A Seminar in Art Education for Research and Curriculum Development*. U.S. Office of Education Cooperative Research Project V-002. University Park: Pennsylvania State University Press, 1966.

Maynard, Richard. *The Celluloid Curriculum: How to Use Movies in the Classroom*. Rochelle Park, N.J.: Hayden Book Company, 1971.

McFee, June King, and Degge, Rogena M. *Art, Culture, and Environment: A Catalyst for Teaching*. Belmont, Calif.: Wadsworth, 1977.

McKim, Robert H. *Experiences in Visual Thinking*. Monterey, Calif.: Brooks/Cole, 1972.

Melzi, Kay, and Palmer, William. *Art in the Primary School*. Oxford, Eng.: Blackwell, 1967.

Mendelowitz, Daniel M. *Children Are Artists: An Introduction to Children's Art for Teachers and Parents*. rev. ed. Stanford, Calif.: Stanford University Press, 1963.

Montgomery, Chandler. *Art for Teachers of Children*. 2nd ed. Columbus, Ohio: Charles E. Merrill, 1973.

National Assessment of Educational Progress. *Design and Drawing Skills: Selected Results From the First National Assessment of Art*. Report 06-A-01. Denver, Colo.: Education Commission of the States, 1977.

Pappas, George. *Concepts in Art and Education: An Anthology of Current Issues*. New York: Macmillan, 1970.

Pickering, John M. *Visual Education in the Primary School*. New York: Watson-Guptill, 1971.

Plummer, Gordon S. *Children's Art Judgment: A Curriculum for Elementary Art Appreciation*. Dubuque, Ia.: William C. Brown, 1974.

Read, Herbert. *Education Through Art*. rev. ed. New York: Pantheon, 1958.

Richardson, Marion. *Art and the Child*. Peoria, Ill.: Charles A. Bennett, 1952.

Rosenberg, Bernard, and White, David Manning, eds. *Mass Culture: The Popular Arts in America*. New York: The Free Press, 1965.

Rueschhoff, Phil H., and Swartz, M. Evelyn. *Teaching Art in the Elementary School: Enhancing Visual Perception*. New York: Ronald Press, 1969.

Saunders, Robert. *Relating Art and Humanities to the Classroom*. Dubuque, Ia.: William C. Brown, 1977.

Schwartz, Fred R. *Structure and Potential in Art Education*. Lexington, Mass.: Ginn-Blaisdell, 1970.

Shorr, Jon, and Ferguson, Roy. *Visual Communication: Activities for Elementary Schools*. New York: William H. Sadlier, 1977.

Smith, Ralph, ed. *Aesthetic Education Today: Problems and Prospects*. Columbus, Ohio: Ohio State University, 1973.

Sommer, Robert. *Personal Space: The Behavioral Basis of Design*. Englewood Cliffs, N.J.: Prentice-Hall, 1969.

Steveni, Michael. *Art and Education*. London: Batsford, 1968.

Toffler, Alvin. *The Culture Consumers*. New York: Random House, 1973.

Tomlinson, R. R., and Mills, John Fitzmarrice. *The Growth of Child Art*. London: University of London Press, 1966.

Torrance, E. Paul. *Rewarding Creative Behavior: Experiments in Classroom Creativity*. Englewood Cliffs, N.J.: Prentice-Hall, 1965.

Voelker, Francis H., and Voelker, Ludmila A., eds. *Mass Media: Forces in Our Society.* 3rd ed. New York: Harcourt Brace Jovanovich, 1978.

Wachowiak, Frank, and Ramsay, Theodore. *Emphasis Art: A Qualitative Art Program for the Elementary School.* 2nd ed. Scranton, Pa.: International Textbook, 1971.

Weitz, Morris. *Problems in Aesthetics: An Introductory Book of Readings.* 2nd ed. New York: Macmillan, 1970.

BOOKS FOR YOUNG READERS

Abisch, Roz, and Kaplan, Boche. *Art Is for You.* New York: David McKay, 1967.

About Us: The 1973 Childcraft Annual. Chicago: Field Enterprises Educational Corporation, 1973.

Adler, Irving. *Color in Your Life.* New York: John Day, 1962.

Aitchison, Dorothy. *Great Artists Series.* Loughborough, Eng.: Wells and Hepworth, 1970. (*Rubens, Rembrandt, Vermeer, Leonardo, Raphael, Michelangelo,* and others)

Alden, Caralla. *From Early American Paintbrushes: Colony to New Nation.* New York: Parents' Magazine Press, 1971.

————. *Sunrise Island: A Story of Japan and Its Arts.* New York: Parents' Magazine Press, 1971.

Anderson, Yvonne. *Make Your Own Animated Movies: Yellow Ball Workshop Film Techniques.* Boston: Little, Brown, 1970.

Andrews, Michael F. *Creative Printmaking.* Englewood Cliffs, N.J.: Prentice-Hall, 1963.

Atwood, Ann. *New Moon Cove.* New York: Scribner's, 1969.

Ayer, Margaret. *Made in Thailand.* New York: Alfred A. Knopf, 1964.

Bahti, Tom. *Southwestern Indian Tribes.* Las Vegas, Nev.: K. C. Publications, 1968.

Baird, Bil. *The Art of the Puppet.* New York: Macmillan, 1966.

Baldwin, Gordon C. *Strange People and Stranger Customs.* New York: Norton, 1967.

Ballinger, Louise B., and Vroman, Thomas F. *Design: Source and Resources.* New York: Van Nostrand Reinhold, 1964.

Bardi, P. M. *Architecture: The World We Build.* New York: Franklin Watts, 1972.

Barr, Alfred H., Jr. *What Is Modern Painting?* rev. ed. New York: Museum of Modern Art, 1966.

Barren, Beryl. *Wonders, Warriors, and Beasts Abounding.* Garden City, N.Y.: Doubleday, 1967.

Barry, Sir Gerald. *The Arts—Man's Creative Imagination.* New York: Doubleday, 1965.

Bate, Norman. *When Cave Men Painted.* New York: Scribner's, 1963.

Baumann, Hans. *The Caves of the Great Hunters.* rev. ed. New York: Pantheon, 1962.

Baylor, Byrd. *Before You Came This Way.* New York: E. P. Dutton, 1969.

Beaumont, Cyril. *Puppets and Puppetry.* New York: Viking Press, 1958.

Belves, Pierre, and Mathey, François. *Enjoying the World of Art.* New York: Lion Books, 1966.

————. *How Artists Work: An Introduction to Techniques of Art.* Trans. Alice Bach. New York: Lion Books, 1968.

Bendick, Jeanne, and Bendick, Robert. *Filming Works Like This.* New York: McGraw-Hill, 1971.

Berger, René. *Discovery of Painting.* New York: Viking Press, 1963.

Bergere, Thea, and Bergere, Richard. *From Stones to Skyscrapers.* New York: Dodd, Mead, 1960.

Berry, Anna M. *First Book of Paintings.* New York: Franklin Watts, 1960.

Bethers, Ray. *Composition in Pictures.* 2nd ed. New York: Pitman, 1962.

————. *How Paintings Happen.* New York: Norton, 1951.

Bodor, John J. *Rubbings and Textures.* New York: Van Nostrand Reinhold, 1968.

Bonner, Mary Graham. *Made in Canada.* New York: Alfred A. Knopf, 1943.

Borreson, Mary Jo. *Let's Go To An Art Museum.* New York: G. P. Putnam, 1960.

Borton, Helen. *Do You See What I See?* New York: Abelard-Schuman, 1969.

————. *A Picture Has a Special Look.* New York: Abelard-Schuman, 1961.

Brown, Margaret Wise. *The Dead Bird.* New York: E. M. Hale, 1958.

————. *The House of a Hundred Windows.* New York: Harper & Row, 1945.

Browner, Richard. *Look Again.* New York: Atheneum, 1962.

Brustlein, Daniel [Alain]. *The Magic Stones.* New York: McGraw-Hill, 1957.

Cady, Arthur. *The Art Buff's Book: What Artists Do and How They Do It.* Washington, D.C.: Robert B. Luce, 1965.

Campbell, Ann. *Paintings: How to Look at Great Art.* New York: Franklin Watts, 1970.

Campbell, Elizabeth. *Fins and Tails.* Boston: Little, Brown, 1963.

Candy, Robert. *Nature Notebook.* Boston: Houghton Mifflin, 1962.

Carter, Katharine. *My Book of Color.* Pikesville, Md.: Ottenheimer, 1961.

Celender, Donald. *Musical Instruments in Art.* Minneapolis: Lerner, 1966.

Chase, Alice Elizabeth. *Famous Paintings.* New York: Platt & Munk, 1964.

————. *Looking at Art.* New York: Thomas Y. Crowell, 1966.

Chase, Judith. *Afro-American Art and Crafts.* New York: Van Nostrand Reinhold, 1971.

Childcraft Annual: Look Again. Chicago: Field Enterprises Educational Corporation, 1968.

Coen, Rena Neumann. *American History in Art*. Minneapolis: Lerner, 1966.

———. *Kings and Queens in Art*. Minneapolis: Lerner, 1965.

Cooke, Robert W. *Designing with Light on Paper and Film*. Worcester, Mass.: Davis Publications, 1969.

Cornelius, Sue, and Cornelius, Chase. *The City in Art*. Minneapolis: Lerner, 1966.

Cultural Exchange Center. *Prints by American Negro Artists*. Los Angeles Cultural Exchange Center: 1965.

Daniel, Greta. *Useful Objects Today*. New York: Museum of Modern Art, 1954.

De Borhegyi, Suzanne. *Museums: A Book to Begin On*. New York: Holt, Rinehart and Winston, 1962.

Devlin, Harry. *What Kind of a House Is That?* New York: Parents' Magazine Press, 1969.

Discovering Art Series. New York: McGraw-Hill. (*Nineteenth Century Art, Chinese and Oriental Art, Greek and Roman Art, Seventeenth and Eighteenth Century Art, Art of the Early Renaissance, Art of the High Renaissance, Prehistoric Art,* and *Ancient Art of the Near East*)

Douglas, Frederic, and D'Harnoncourt, René. *Indian Art of the United States*. New York: Museum of Modern Art, 1941.

Dover, Cedric. *American Negro Art*. Greenwich, Conn.: New York Graphic Society, 1969.

Downer, Marion. *Children in the World's Art*. New York: Lothrop, Lee & Shepard, 1970.

———. *Discovering Design*. New York: Lothrop, Lee & Shepard, 1947.

———. *Roofs Over America*. New York: Lothrop, Lee & Shepard, 1967.

———. *The Story of Design*. New York: Lothrop, Lee & Shepard, 1963.

Drexler, Arthur, and Daniel, Greta. *Introduction to Twentieth Century Design*. New York: Museum of Modern Art, 1959.

Emberley, Ed. *The Wing on a Flea: A Book About Shapes*. Boston: Little, Brown, 1961.

Epstein, Samuel, and De Armand, David. *How to Develop, Print and Enlarge Pictures*. New York: Grosset & Dunlap, 1970.

Fine, Elsa H. *The Afro-American Artist*. New York: Holt, Rinehart and Winston, 1973.

Fisher, Leonard E. *Colonial Americans Series*. New York: Franklin Watts. (*The Weavers, The Cabinetmakers, The Architects, Glassmakers, Papermakers, Potters, Silversmiths*)

Forte, Nancy. *The Warrior in Art*. Minneapolis: Lerner, 1966.

Franc, Helen M. *An Invitation to See: 125 Paintings from the Museum of Modern Art*. New York: Museum of Modern Art, 1973.

Fraser, Kathleen. *Stilts, Somersaults, and Headstands: Game Poems Based on a Painting by Pieter Bruegel*. New York: Atheneum, 1968.

Freedgood, Lillian. *Great Artists of America*. New York: Thomas Y. Crowell, 1963.

Gettings, Fred. *The Meaning and Wonder of Art*. New York: Western Publishing, 1963.

———. *You Are an Artist: A Practical Approach to Art*. Middlesex, Eng.: Paul Hamlyn, 1965.

Gill, Bob. *What Color Is Your World?* New York: Astor-Honor, 1963.

Glubok, Shirley. *The Art of Ancient Egypt*. New York: Atheneum, 1962.

———. *The Art of Ancient Greece*. New York: Atheneum, 1963.

———. *The Art of Ancient Rome*. New York: Harper & Row, 1965.

———. *The Art of the Eskimo*. New York: Harper & Row, 1964.

———. *The Art of Lands in the Bible*. New York: Atheneum, 1963.

———. *The Art of the North American Indian*. New York: Harper & Row, 1964.

Golden, Grace. *Made in Iceland*. New York: Alfred A. Knopf, 1958.

Gorbaty, Norman. *Printmaking with a Spoon*. New York: Van Nostrand Reinhold, 1960.

Gracza, Margaret Young. *The Bird in Art*. Minneapolis: Lerner, 1966.

———. *The Ship and the Sea in Art*. Minneapolis: Lerner, 1965.

Gregor, Arthur S. *How the World's First Cities Began*. New York: E. P. Dutton, 1967.

Group For Environmental Education. *Our Man-Made Environment: Book Seven*. Philadelphia: GEE, 1971.

———. *The Process of Choice*. Cambridge, Mass.: M.I.T. Press, 1974.

Haftmann, Werner. *Painting in the Twentieth Century*. 2 vols. New York: Praeger, 1965.

Hammond, Penny, and Thomas, Katrina. *My Skyscraper City*. New York: Doubleday, 1963.

Harkonen, Helen B. *Circuses and Fairs in Art*. Minneapolis: Lerner, 1965.

———. *Farms and Farmers in Art*. Minneapolis: Lerner, 1965.

Hart, Tony. *The Young Designer*. New York: Frederick Warne, 1968.

Hayes, Bartlett H., and Rathburn, Mary. *A Layman's Guide to Modern Art*. New York: Oxford University Press, 1948.

Helfman, Elizabeth S. *Celebrating Nature: Rites and Ceremonies Around the World*. New York: The Seabury Press, 1969.

Hiller, Carl E. *Caves to Cathedrals: Architecture of the World's Religions*. Boston: Little, Brown, 1974.

———. *From Tepees to Towers: A Photographic History of American Architecture*. Boston: Little, Brown, 1967.

Hillyer, V. M., and Huey, E. G. *A Child's History of Art*. New York: Appleton-Century-Crofts, 1951.

Hoag, Edwin. *American Houses: Colonial, Classic, and Contemporary.* Philadelphia: Lippincott, 1964.

Hollmann, Clide. *Five Artists of the Old West.* New York: Hastings House, 1965.

Holm, Bill. *Crooked Beak of Heaven: Masks and Other Ceremonial Art of the Northwest Coast.* Seattle, Wash.: University of Washington Press, 1972.

Holme, Bryan, ed. *Drawings to Live With.* New York: Viking Press, 1966.

———. *Pictures to Live With.* New York: Viking Press, 1960.

Holter, Patra. *Photography Without a Camera.* New York: Van Nostrand Reinhold, 1972.

Horn, George F. *Posters: Designing, Making, Reproducing.* Worcester, Mass.: Davis, 1964.

Hunt, Kari, and Carlson, Bernice W. *Masks and Mask Makers.* New York: Abingdon Press, 1961.

Janson, Horst W., and Janson, Dora J. *The Story of Painting for Young People.* New York: Abrams, 1962.

Janson, Horst W., and Cauman, Samuel. *History of Art for Young People.* New York: Harry N. Abrams, 1971.

Johnson, Nicholas. *How to Talk Back to Your Television Set.* Boston: Little, Brown, 1970.

Kablo, Martin. *World of Color.* New York: McGraw-Hill, 1963.

Kahane, P. P. *Ancient and Classical Art.* New York: Dell Publishing Co., 1969.

Kahn, Ely J. *A Building Goes Up.* New York: Simon & Schuster, 1969.

Kainz, Luise C., and Riley, Olive L. *Understanding Art: Portraits, Personalities, and Ideas.* New York: Harry N. Abrams, 1967.

Kaufmann, Edgar. *What Is Modern Interior Design?* New York: Museum of Modern Art, 1958.

Keisler, Leonard. *Art Is Everywhere: A Child's Guide to Drawing and Painting.* New York: Dodd, Mead, 1958.

———. *What's in a Line.* New York: Dodd, Mead, 1962.

———. *The Worm, The Bird, and You.* New York: William R. Scott, 1961.

Kielty, Bernardine. *Masters of Painting: Their Works, Their Lives, Their Times.* New York: Doubleday, 1964.

Kipling, Rudyard. *Jungle Books.* New York: Macmillan, 1964.

Kirn, Ann. *Full of Wonder.* Cleveland: World, 1959.

Kohn, Bernice. *Everything Has a Shape and Everything Has a Size.* Englewood Cliffs, N.J.: Prentice-Hall, Inc., 1966.

La Farge, Oliver. *The American Indian.* Special Edition for Young Readers. New York: Golden Press, 1973.

Larrick, Nancy, ed. *Poetry for Holidays.* Champaign, Ill.: Garrard, 1966.

Larson, Rodger, and Meade, Ellen. *Young Filmmakers.* New York: E. P. Dutton, 1969.

Lear, Edward. *The Dong with a Luminous Nose.* New York: Addison-Wesley, 1969.

Lerner, Sharon. *The Self-Portrait in Art.* Minneapolis: Lerner, 1965.

LIFE Magazine editors. *America's Arts and Skills.* New York: E. P. Dutton, 1957.

Lionni, Leo. *Little Blue and Little Yellow.* New York: Astor-Honor, 1959.

Lovoos, Janice. *Design Is a Dandelion.* Chicago: Children's Press, 1966.

Low, Joseph. *Adam's Book of Odd Creatures.* New York: Atheneum, 1962.

Lynch, John. *How to Make Mobiles.* New York: Viking Press, 1953.

———. *Mobile Design.* New York: Viking Press, 1955.

———. *Mobile Sculpture.* New York: Viking Press, 1957.

MacAgy, Douglas, and MacAgy, Elizabeth. *Going for a Walk with a Line: A Step into the World of Modern Art.* New York: Doubleday, 1959.

Madian, Jon. *Beautiful Junk: A Story of the Watts Towers.* Boston: Little, Brown, 1968.

Manley, Seon. *Adventures in Making: The Romance of Crafts Around the World.* New York: Vanguard, 1959.

Medlin, Faith. *Centuries of Owls in Art and the Written Word.* Norwalk, Conn.: Silvermine, 1967.

Moore, Jane Gaylor. *The Many Ways of Seeing: An Introduction to the Pleasures of Art.* Cleveland and New York: Collins-World, 1969.

Moore, Lamont. *The First Book of Architecture.* New York: Franklin Watts, 1961.

———. *The First Book of Paintings.* New York: Franklin Watts, 1960.

Morman, Jean M. *Wonder Under Your Feet: Making the World of Art Your Own.* New York: Harper & Row, 1973.

Munro, Eleanor C. *The Golden Encyclopedia of Art.* New York: McGraw-Hill, 1967.

Nash, Ogden. *Custard the Dragon.* Boston: Little, Brown, 1961.

Neal, Charles D. *Exploring Light and Color.* Chicago: Children's Press, 1964.

O'Neill, Mary. *Hailstones and Halibut Bones: Adventures in Color.* New York: Doubleday, 1961.

Paine, J. *Looking at Sculpture.* New York: Lothrop, Lee & Shepard, 1968.

Paine, Roberta M. *Looking at Architecture.* New York: Lothrop, Lee & Shepard, 1974.

Parks, Gordon. *A Poet and His Camera.* New York: Viking Press, 1968.

Paschel, Herbert D. *The First Book of Color.* New York: Franklin Watts, 1959.

Paul, Louis. *The Way Art Happens.* New York: Ives Washburn, 1963.

Peare, Catherine O. *Rosa Bonheur: Her Life.* New York: Henry Holt, 1956.

Praeger Encyclopedia of Art. New York: Praeger, 1971.

Preble, Duane. *We Create Art Creates Us.* San Francisco: Canfield Press, 1976.

Price, Christine. *Made in Ancient Greece.* New York: E. P. Dutton, 1967.

⸺. *Made in the Middle Ages*. New York: E. P. Dutton, 1961.

Raboff, Ernest. *Art for Children Series*. 12 vols. Garden City, N.Y.: Doubleday, 1968–71.

Rasmussen, Steen E. *Experiencing Architecture*. 2nd ed. Cambridge, Mass.: M.I.T. Press, 1962.

Ravielli, Anthony. *An Adventure in Geometry*. New York: Viking, 1957.

Riley, Olive. *Masks and Magic*. New York: Viking Press, 1955.

Ripley, Elizabeth. *Botticelli: A Biography*. New York: Lippincott, 1960.

⸺. *Durer*. Philadelphia: Lippincott, 1958.

⸺. *Goya*. New York: Walck, 1956.

⸺. *Leonardo da Vinci*. New York: Walck, 1952.

⸺. *Rembrandt*. New York: Walck, 1955.

⸺. *Rubens*. New York: Walck, 1957.

Robbin, Irving. *Caves to Skyscrapers*. How and Why Wonder Books Series. New York: Grosset & Dunlop, 1963.

Rogers, L. R. *Relief Sculpture*. The Appreciation of the Arts Series. New York: Oxford University Press, 1974.

Ross, Patricia Fent. *Made in Mexico: The Story of a Country's Arts and Crafts*. New York: Alfred A. Knopf, 1952.

Rudofsky, Bernard. *Architecture Without Architects: A Short Introduction to Non-Pedigreed Architecture*. Garden City, N.Y.: Doubleday, 1969.

Ruskin, Ariane. *Story of Art for Young People*. New York: Pantheon, 1964.

Sanoff, Henry. *Seeing the Environment: An Advocacy Approach*. Raleigh, N.C.: Learning Environments, 1975.

Schlein, Meriam. *Shapes*. Addison-Wesley, 1952.

Schwartz, Alvin. *Old Cities and New Towns: The Changing Face of the Nation*. New York: E. P. Dutton, 1968.

Scott, N. H. *Sam*. New York: McGraw-Hill, 1967.

Seidelman, James E. *The Rub Book*. New York: Macmillan, 1968.

Sendak, Maurice. *Where the Wild Things Are*. New York: Harper & Row, 1963.

Shay, Rieger. *Gargoyles, Monsters, and Other Beasts*. New York: Lothrop, Lee & Shepard, 1972.

Shissler, Barbara. *Sports and Games in Art*. Minneapolis: Lerner, 1966.

Skorpen, Liesel Moak. *That Mean Man*. New York: Harper & Row, 1968.

Smith, Bradley. *Mexico: A History in Art*. Garden City, N.Y.: Doubleday, 1971.

Smith, William Jay. *What Did I See*. New York: Macmillan, 1962.

Sommer, Robert. *Personal Space: The Behavioral Basis of Design*. Englewood Cliffs, N.J.: Prentice-Hall, 1969.

Spencer, Cornelia. *How Art and Music Speak to Us*. New York: John Day, 1963, rev. ed., 1968.

⸺. *Made in China*. New York: Alfred A. Knopf, 1952.

⸺. *Made in India*. New York: Alfred A. Knopf, 1953.

⸺. *Made in Japan*. New York: Alfred A. Knopf, 1963.

⸺. *Made in the Renaissance*. New York: E. P. Dutton, 1963.

Spilka, Arnold. *Paint All Kinds of Pictures*. New York: Walck, 1963.

Sternberg, Harry. *Woodcut*. New York: Pitman, 1962.

Strache, Wolf. *Forms and Patterns in Nature*. New York: Pantheon, 1973.

Sullivan, George. *Understanding Architecture*. New York: Warne, 1971.

⸺. *Understanding Photography*. New York: Warne, 1972.

Szarkowski, John. *Looking at Photographs: One Hundred Pictures from the Collection of the Museum of Modern Art*. New York: Museum of Modern Art, 1973.

Taylor, Barbara Howland. *Mexico: Her Daily and Festive Breads*. Claremont, Calif.: Creative Press, 1969.

Tison, Annette, and Taylor, Talus. *The Adventures of Three Colors*. New York and Cleveland: Collins-World, 1971.

Toor, Frances. *Made in Italy*. New York: Alfred A. Knopf, 1957.

Weisgard, Leonard. *Treasures to See: A Museum Picture-Book*. New York: Harcourt Brace Jovanovich, 1956.

Weiss, Harvey. *The Beginning Artist's Library Series*. New York: William R. Scott, 1956–71. (*Ceramics: From Clay to Kiln; Clay, Wood and Wire; Paint, Brush and Palette; Paper, Ink and Roller; Pencil, Pen and Brush; Sticks, Spoons and Feathers; Lens and Shutter*.)

Wentz, Bud. *Paper Movie Machines*. San Francisco: Troubador Press, 1975.

Willard, Charlotte. *Famous Modern Artists from Cezanne to Pop Art*. New York: Platt & Munk, 1971.

Wilson, Forrest. *Architecture: Book of Projects for Young Adults*. New York: Van Nostrand Reinhold, 1968.

Wolf, Thomas H. *The Magic of Color*. New York: Odyssey Press, 1964.

Wolff, Janet, and Owett, Bernard. *Let's Imagine Colors*. New York: E. P. Dutton, 1963.

Zuelke, Ruth. *The Horse in Art*. Minneapolis: Lerner, 1965.

RESOURCES

CEMREL Aesthetic Education Kits are available from Viking Press, 625 Madison Avenue, New York, N.Y. 10022; information about the CEMREL Aesthetic Education Project can be obtained from the Central Midwestern Regional Education Laboratory, 3120 59th St., St. Louis, Mo. 63139.

Scholastic Magazines, Inc., 50 West 44th St., New York, N.Y. 10036, publishes *Art and Man*, a bimonthly, general-interest art magazine.

Below is a listing of distributors of resources that may be of interest to art teachers.

FILMS

ACI Productions 35 West 45th St., New York, N.Y. 10036

American Crafts Council, Research and Education Department 29 West 53rd St., New York, N.Y. 10019

American Federation of Arts 41 East 65th St., New York, N.Y. 10021

Arthur Barr Films, Inc. 3490 East Foothill Boulevard, Pasadena, Calif. 91107

Audio Brandon Films 34 MacQuesten Parkway South, Mount Vernon, N.Y. 10550

Audio Film Center 2138 East 75th St., Mount Vernon, N.Y. 10550

BFA Educational Media 2211 Michigan Avenue, Santa Monica, Calif. 90404

British Information Services 845 Third Avenue, New York, N.Y. 10022

Center for Mass Communications (Columbia University Press) 562 West 113th St., New York, N.Y. 10025

Churchill Films 662 North Robertson Boulevard, Los Angeles, Calif. 90069

Coast Visual Education 5620 Hollywood Boulevard, Los Angeles, Calif. 90028

Contemporary McGraw-Hill Films 1221 Avenue of the Americas, New York, N.Y. 10020

Coronet Instructional Media 65 E. South Water St., Chicago, Ill. 60601

Doubleday Multimedia Box 11607, 1371 Reynolds Avenue, Santa Ana, Calif. 92705

Educational Audio Visual, Inc. Pleasantville, N.Y. 10570

Encyclopaedia Britannica Educational Corporation 425 North Michigan Avenue, Chicago, Ill. 60611

Film Classics Exchange 1926 South Vermont Avenue, Los Angeles, Calif. 90007

Francis Thompson 231 East 51st St., New York, N.Y. 10022

General Electric Educational Films Corporation Park, Building 705, Scotia, N.Y. 12302

Harcourt Brace Jovanovich, Inc. 757 Third Avenue, New York, N.Y. 10017

Harmon Foundation 598 Madison Avenue, New York, N.Y. 10022

Homer Groening 301 Executive Building, Portland, Ore. 97204

Indiana University Audio Visual Center Bloomington, Ind. 47405

International Film Bureau 332 South Michigan Avenue, Chicago, Ill. 60604

Janus Films 745 Fifth Avenue, New York, N.Y. 10022

Jeff Dell Film Service, Inc. 10 East 53rd St., New York, N.Y. 10022

Monument Film Corporation 34 West 13th St., New York, N.Y. 10011

Museum of Modern Art 11 West 53rd St., New York, N.Y. 10019

National Film Board of Canada 1251 Avenue of the Americas, New York, N.Y. 10020

Northern Illinois University, Division of Communications Services DeKalb, Ill. 60115

Pictura Films Distribution 111 Eighth Avenue, New York, N.Y. 10011

Portafilms 4180 Dixie Highway, Drayton Plains, Mich. 48020

Sears-Roebuck Foundation, Audio Visual Department 303 East Ohio St., Chicago, Ill. 60611

Sigma Educational Films P.O. Box 1235, 11717 Ventura Boulevard, Studio City, Calif. 91604

Sterling Educational Films 241 East 34th St., New York, N.Y. 10016

Tiger Films, Inc. 3559 Cody Road, Sherman Oaks, Calif. 91403

University of Southern California, Audio-Visual Services, Department of Cinema 3518 University Avenue, Los Angeles, Calif. 90007

Weston Woods Studios Weston, Conn. 06880

Yellow Ball Workshop and Newton Mini Films 62 Tarbell Avenue, Lexington, Mass. 02173

FILM CARTRIDGES AND LOOPS

Films Incorporated 1144 Wilmette Avenue, Wilmette, Ill. 60091

Harry Hester and Associates 11422 Harry Hines Boulevard, Dallas, Tex. 75229

Visual Education, Inc. 4546 Via Maria, Santa Barbara, Calif. 93105

Warren Schloat Productions 150 White Plains Road, Tarrytown, N.Y. 10591

FILMSTRIPS

American Crafts Council, Research and Education Department 29 West 53rd St., New York, N.Y. 10019

Art Council Aids Box 641, Beverly Hills, Calif. 90213

Bailey-Film Associates 11559 Santa Monica Boulevard, Los Angeles, Calif. 90025

Dr. Block Color Productions 1309 North Genessee Avenue, Los Angeles, Calif. 90046

Educational Audio Visual, Inc. Pleasantville, N.Y. 10570

Educational Dimensions Corporation Box 146, Great Neck, N.Y. 11023

Grolier Enterprises 845 Third Avenue, New York, N.Y. 10022

Harry Hester and Associates 11422 Harry Hines Boulevard, Dallas, Tex. 75229

Indiana University Audio Visual Center Bloomington, Ind. 47405

International Film Bureau 332 South Michigan Avenue, Chicago, Ill. 60604

Life Filmstrips Time & Life Building, New York, N.Y. 10020

Miller-Brody Productions, Inc. 342 Madison Avenue, New York, N.Y. 10017

Museum of Modern Art 11 West 53rd St., New York, N.Y. 10019

National Gallery of Art, Extension Service Constitution Avenue and 6th St., N.W., Washington, D.C. 20566

Prothmann Associates, Inc. 2795 Milburn Avenue, Baldwin, N.Y. 11510

Sandak, Inc. 180 Harvard Avenue, Stamford, Conn. 06902

Society for Visual Education 1345 Diversey Parkway, Chicago, Ill. 60614

Thorne Films, Inc. 1229 University Avenue, Boulder, Colo. 80302

University Prints 15 Brattle St., Harvard Square, Cambridge, Mass. 02138

Visual Media for the Arts and Humanities Box 137, Cherry Hill, N.J. 08003

Warren Schloat Productions 150 White Plains Road, Tarrytown, N.Y. 10591

SLIDES

American Library Color Slide Collection 222 West 23rd St., New York, N.Y. 10011

Art Council Aids Box 641, Beverly Hills, Calif. 90213

Bailey-Film Associates 11559 Santa Monica Boulevard, Los Angeles, Calif. 90025

Dr. Block Color Productions 1309 North Genessee Avenue, Los Angeles, Calif. 90046

Center for Humanities, Inc. 2 Holland Avenue, White Plains, N.Y. 10603

Colonial Williamsburg Foundation, Film Distribution Section Box C, Williamsburg, Va. 23185

Department of the Interior, Bureau of Indian Affairs P.O. Box 345, Brigham City, Utah 84302

Educational Audio Visual, Inc. Pleasantville, N.Y. 10570

Grolier Enterprises 845 Third Avenue, New York, N.Y. 10022

Life Filmstrips Time & Life Building, New York, N.Y. 10020

Museum of Modern Art 11 West 53rd St., New York, N.Y. 10019

National Gallery of Art, Extension Service Constitution Avenue and 6th St., N.W. Washington, D.C. 20566

Prothmann Associates, Inc. 2795 Milburn Avenue, Baldwin, N.Y. 11510

Sandak, Inc. 180 Harvard Avenue, Stamford, Conn. 06902

Society for Visual Education 1345 Diversey Parkway, Chicago, Ill. 60614

Thorne Films, Inc. 1229 University Avenue, Boulder, Colo. 80302

University Prints 15 Brattle St., Harvard Square, Cambridge, Mass. 02138

Van Nostrand Reinhold 450 West 33rd St., New York, N.Y. 10001

Visual Media for the Arts and Humanities Box 137, Cherry Hill, N.J. 08003

OVERHEAD TRANSPARENCIES

Educational Audio Visual, Inc. Pleasantville, N.Y. 10570

VIDEO TAPES AND RECORDINGS

Agency for Instructional Television Box A, Bloomington, Ind. 47401

Center for Cassette Studies 8110 Webb Avenue, North Hollywood, Calif. 91605

Center for Mass Communications (Columbia University Press) 562 West 113th St., New York, N.Y. 10025

Educational Audio Visual, Inc. Pleasantville, N.Y. 10570

Harry Hester and Associates 11422 Harry Hines Boulevard, Dallas, Tex. 75229

Miller-Brody Productions, Inc. 342 Madison Avenue, New York, N.Y. 10017

COLOR REPRODUCTIONS

American Book Company 450 West 33rd St., New York, N.Y. 10001

American Federation of Arts 41 East 65th St., New York, N.Y. 10021

Art Education, Inc. Blauvelt, N.Y. 10913

Artext Prints, Inc. Westport, Conn. 06880

Associated American Artists, Inc. 663 Fifth Avenue, New York, N.Y. 10022

Harry N. Abrams 110 East 59th St., New York, N.Y. 10022

Metropolitan Museum of Art Fifth Avenue and 82nd St., New York, N.Y. 10028

Museum of Modern Art 11 West 53rd St., New York, N.Y. 10019

My Weekly Reader, Art Gallery Education Center, Columbus, Ohio 43216

New York Graphic Society 140 Greenwich Avenue, Greenwich, Conn. 06830

Penn Prints 31 West 46th St., New York, N.Y. 10036

Prothmann Associates, Inc. 2795 Milburn Avenue, Baldwin, N.Y. 11510

Raymond and Raymond, Inc. 1071 Madison Avenue, New York, N.Y. 10028

Reinhold Publishing Company 600 Summer, Stamford, Conn. 06901

Shorewood Reproductions, Inc. 475 Tenth Avenue, New York, N.Y. 10018

Skira Art Books distributed by Collins + World, 2080 West 117th St., Cleveland, Ohio 44111

UNESCO Publications Center 650 First Avenue, New York, N.Y. 10016

University Prints 15 Brattle St., Harvard Square, Cambridge, Mass. 02138

Van Nostrand Reinhold 450 West 33rd St., New York, N.Y. 10001

E. Weyhe 794 Lexington Avenue, New York, N.Y. 10021

REPLICAS

Alva Museum Replicas 30–30 Northern Boulevard, Long Island City, N.Y. 11101

Index

Page	Fig.	Credit
		Museum of Modern Art, New York. Given anonymously
43	2-18D	Oil on composition board, 34″ × 47 7/8″. Collection, The Museum of Modern Art, New York. Mrs. Simon Guggenheim Fund
44		Marjorie Pickens from *Beginning Experiences in Architecture* by George E. Trogler, Van Nostrand Reinhold Co., 1972
47	3-1	Gernsheim Collection/Humanities Research Center/The University of Texas at Austin
48 top	3-2	Kent Anderson, Art Department, Milwaukee Public Schools, Milwaukee, Wisconsin
48 bottom	3-3	Lockheed Missiles and Space Co., Inc.
49 top	3-4	Lindy Demyan-Lehr
49 bottom	3-5	Denise René Gallerie
51 top	3-6	Arnelle A. Dow, Cincinnati Public Schools
52	3-8	Arnelle A. Dow, Cincinnati Public Schools
53	3-9	Nelson Gallery-Atkins Museum, Kansas City, Missouri (Nelson Fund)
54	3-10	Lindy Demyan-Lehr
55	3-11	Collection of Mrs. John Wintersteen, photos courtesy of The Philadelphia Museum of Art
56 top	3-12	Etching on zinc, printed in black, plate 18 3/16″ × 14 13/16″. Collection, The Museum of Modern Art, New York. Gift of Abby Aldrich Rockefeller
56 bottom	3-13	Laura H. Chapman
57	3-14	Steuben Glass
58	3-15	Arnelle A. Dow, Cincinnati Public Schools
58 right	3-16	Courtesy of The American Museum of Natural History
59	3-17	Allen Caucutt, Instructor/Director, Maple Dale Indian Hill Schools, Fox Point, Wisconsin
60	3-18	Sandak, Inc.
61	3-19	Kent Anderson, Art Department, Milwaukee Public Schools, Milwaukee, Wisconsin
64		Marjorie Pickens from *Beginning Experiences in Architecture* by George E. Trogler, Van Nostrand Reinhold Co., 1972
66 top	4-1	Oil on canvas, 29″ × 36 1/4″. Collection, The Museum of Modern Art, New York. Acquired through the Lillie P. Bliss Bequest
66 bottom	4-2	The Cleveland Museum of Art, Dudley P. Allen Fund
68	4-3	Georgie Ann Grosse, Children's House, Cincinnati, Ohio
70	4-4	Royal Collection, Windsor
71	4-5	Oil on canvas, 11′ 5 1/2″ × 25′ 5 3/4″. On extended loan to The Museum of Modern Art, New York, from the artist's estate
72	4-6	Laura H. Chapman
73	4-7	Courtesy of Thomas A. Nasrallah, Akron, Ohio
74 top	4-8	Duco on wood, 48″ × 36″. Collection, The Museum of Modern Art, New York. Gift of Edward M. M. Warburg
74 bottom	4-9	Joseph A. Helman, New York, photo by Leo Castelli Gallery
75	4-10	The National Gallery of Canada, Ottawa
78 left	4-11A	Crown copyright, Victoria and Albert Museum
78 right	4-11B	Courtesy Museum of Fine Arts, Boston, gift by contribution
79 left	4-11C	Bapistry, Florence
79 right	4-11D	Courtesy Mr. and Mrs. Lawrence J. Cohen
80, 82, 83,85	4-12	Hedrich-Blessing
92 top		George Gardner
92 bottom		Laura H. Chapman
94 top	5-1	George Gardner
94 bottom	5-2	Sandak, Inc.
95	5-3	Hollis Dayton
96 top	5-4	Laura H. Chapman
96 bottom	5-5	Laura H. Chapman
97	5-6	Laura H. Chapman
99 top	5-7	Laura H. Chapman
99 bottom	5-8	Laura H. Chapman
102	5-9	Elliott Erwitt, Magnum
103	5-10	Laura H. Chapman
104 top	5-11	Laura H. Chapman
105 bottom	5-12	Laura H. Chapman
107	5-13	George Gardner
108 left	5-14	Sandak, Inc.
108 right	5-14	Harbrace photo by Glyn Cloyd
109 top, center, and bottom	5-14	Wide World
110	5-15	Laura H. Chapman
111 left	5-15	Sandak, Inc.
111 right	5-15	Sandak, Inc.
112 top	5-16	Bloomingdales
112 bottom	5-16	Courtesy, The Henry Francis du Pont Winterthur Museum
113 left	5-17	Robert A. Isaacs
113 right	5-17	Laura H. Chapman
117 top		Laura H. Chapman
117 bottom		Oil on canvas, 24″ × 29″. Collection, The Museum of Modern Art, New York. Given anonymously
140		Laura H. Chapman
142–43		Sarah, Lucy, and Evan J. Kern
144 left	7-1	Sarah, Lucy, and Evan J. Kern
144 right	7-2	Sarah, Lucy, and Evan J. Kern
145 top	7-3	Sarah, Lucy, and Evan J. Kern
145 bottom	7-4	Sarah, Lucy, and Evan J. Kern
146	7-5	Sarah, Lucy, and Evan J. Kern
147 left	7-6	Kent Anderson, Art Department, Milwaukee Public Schools, Milwaukee, Wisconsin
147 center	7-7	Kent Anderson, Art Department, Milwaukee Public Schools, Milwaukee, Wisconsin
147 right	7-8	Sarah, Lucy, and Evan J. Kern
148	7-9	Robert A. Daniel, Martha M. Burnell Laboratory School, Bridgewater State College, Massachusetts
149	7-10	Robert A. Daniel, Martha M. Burnell Laboratory School, Bridgewater State College, Massachusetts
150 top	7-11	Eleese V. Brown
150 bottom	7-12	Bruce Anspach from Editorial Photocolor Archives
151 left	7-13	Georgie Ann Grosse, Children's House, Cincinnati, Ohio
151 right	7-13	Georgie Ann Grosse, Children's House, Cincinnati, Ohio
152	7-14	Laura H. Chapman
153 left	7-15	Laura H. Chapman
153 right	7-16	Laura H. Chapman
154	7-17	Laura H. Chapman
155	7-18	Laura H. Chapman

156	7-19	Laura H. Chapman
157	7-20	Laura H. Chapman
159	7-21	Laura H. Chapman
161	7-22	Ken Karp
164–65		Sarah, Lucy, and Evan J. Kern
166	8-1	Betty Dayton, Finneytown Elementary Schools, Finneytown, Ohio
167 *left*	8-2	Betty Dayton, Finneytown Elementary Schools, Finneytown, Ohio
167 *top right*	8-3	Miriam Richner Ford
167 *bottom right*	8-4	Betty Dayton, Finneytown Elementary Schools, Finneytown, Ohio
168 *left*	8-5	Laura H. Chapman
168 *right*	8-6	Ron Stewart, Demonstration Art Workshop, University of Cincinnati
169 *left*	8-7	Suzanne Senti
169 *right*	8-8	Laura H. Chapman
170	8-9	Eleese V. Brown
171 *left*	8-10	Gene A. Mittler, Department of Art Education, Indiana University
171 *center*	8-11	Photo by Cemrel, Inc.
171 *right*	8-12	Kent Anderson, Art Department, Milwaukee Public Schools, Milwaukee, Wisconsin
172	8-13	Robert A. Daniel, Martha M. Burnell Laboratory School, Bridgewater State College, Massachusetts
173	8-14	Georgie Ann Grosse, Children's House, Cincinnati, Ohio
174	8-15	Laura H. Chapman
176	8-16	Laura H. Chapman
177 *left*	8-17	Philadelphia Museum of Art
177 *right*	8-18	Photo by Cemrel, Inc.
178	8-19	Ken Karp
179 *top*	8-20	James R. Sikler, Beachwood Board of Education, Beachwood, Ohio
179 *bottom*	8-21	Elliot W. Eisner and Stephen M. Dobbs, Kettering Project (1968–71) Stanford University, School of Education
180	8-22	Laura H. Chapman
181	8-23	Laura H. Chapman
184–185		Sarah, Lucy, and Evan J. Kern
186	9-1	Arnelle A. Dow, Cincinnati Public Schools
187 *left*	9-2	Arnelle A. Dow, Cincinnati Public Schools
187 *right*	9-3	Arnelle A. Dow, Cincinnati Public Schools
188 *top*	9-4	Betty Dayton, Finneytown Elementary Schools, Finneytown, Ohio
188 *center*	9-5	Betty Dayton, Finneytown Elementary Schools, Finneytown, Ohio
188 *bottom*	9-6	Miriam Richner Ford
189 *top*	9-7	Miriam Richner Ford
189 *center*	9-8	Lindy Demyan-Lehr
189 *bottom*	9-9	Allen Caucutt, Instructor/Director, Maple Dale Indian Hill Schools, Fox Point, Wisconsin
190–91	9-10	Eleese V. Brown
192 *left*	9-11	Marilyn Arn
192 *right*	9-12	Marilyn Arn
193	9-13	Laura H. Chapman
195	9-14	Colin McRae, University Art Museum, Berkeley, California
196	9-15	James R. Sikler, Beachwood Board of Education, Beachwood, Ohio
197 *left*	9-16	Colin McRae, University Art Museum, Berkeley, California
197 *right*	9-17	Laura H. Chapman
198	9-18	Laura H. Chapman
199 *left*	9-19	Laura H. Chapman
199 *right*	9-20	Laura H. Chapman
200 *left*	9-21	Marilyn Arn
200 *right*	9-22	Laura H. Chapman
202		Sarah, Lucy, and Evan J. Kern
204 *top*	10-1	Brian G. Lillie
204 *bottom*	10-2	Leona Nalle
205 *left*	10-3	Laura H. Chapman
205 *right*	10-3	Laura H. Chapman
205 *bottom*	10-4	Thomas and Kristen Bartushintz
206	10-5	Allen Caucutt, Instructor/Director, Maple Dale Indian Hill Schools, Fox Point, Wisconsin
207 *top*	10-6	Laura H. Chapman
207 *center*	10-7	Brian G. Lillie
207 *bottom*	10-8	Annette Rada
208	10-9	Ron Stewart, Demonstration Art Workshop, University of Cincinnati
209 *top left*	10-10	Thomas and Kristen Bartushintz
209 *top right*	10-11	Leona Nalle
209 *bottom*	10-12	Laura H. Chapman
210–11	10-13	Laura H. Chapman
211 *right*	10-14	Annette Rada
212 *left*	10-15	Joan Staggenborn
212 *right*	10-16	Laura H. Chapman
213	10-17	Lindy Demyan-Lehr
214 *top*	10-18	Gouache on paper, 28 ¾" × 20 ½". Collection of Whitney Museum of American Art
214 *bottom*	10-19	Oil on canvas, 6' 3 ⅞" × 58". Collection, The Museum of Modern Art, New York. Purchase.
216 *left*	10-20	Annette Rada
216 *right*	10-21	Philadelphia Museum of Art
217	10-22	Laura H. Chapman
218	10-23	Laura H. Chapman
219	10-24	Laura H. Chapman
220 *top*	10-25A	Editorial Photocolor Archives
220 *bottom*	10-25B	Laura H. Chapman
222	10-26	Laura H. Chapman
224		Miriam Richner Ford
226		Laura H. Chapman
228 *top*	11-1	Georgie Ann Grosse, Children's House, Cincinnati, Ohio
228 *bottom*	11-2	Madelaine Shellaby, University Art Museum, Berkeley, California
229 *left*	11-3	Georgie Ann Grosse, Children's House, Cincinnati, Ohio
229 *top right*	11-4	Benjamin Holland
229 *bottom right*	11-5	Georgie Ann Grosse, Children's House, Cincinnati, Ohio
230	11-6	Laura H. Chapman, drawing by Vladimir Yevtikhiev
231	11-7	Rita Wasserman, St. Bernard Schools, Cincinnati, Ohio
232 *top*	11-8	Collection of Helen Faye
232 *center*	11-9	Betty Dayton, Finneytown Elementary Schools, Finneytown, Ohio
232 *bottom*	11-10	Laura H. Chapman
234	11-11	Laura H. Chapman
235	11-12	Arnelle A. Dow, Cincinnati Public Schools
236 *left*	11-13	Kent Anderson, Art Department, Milwaukee Public Schools, Milwaukee, Wisconsin
236 *right*	11-13	Laura H. Chapman

Page	Figure	Credit
316 *left*	15-17	Rita Wasserman, St. Bernard Public Schools, Cincinnati, Ohio
316 *center*	15-18	Beverly J. Semmens
316 *right*	15-19	Beverly J. Semmens
317	15-20	Collection of Mr. Lee Nordness, New York
318 *top*	15-21	The Aldrich Museum of Contemporary Art, Ridgefield, Connecticut, photo by Geoffrey Clements
318 *bottom*	15-22	Courtesy of American Telephone and Telegraph Co.
319	15-23	Ford Motor Company
320	15-24	James R. Sikler, Beachwood Board of Education, Beachwood, Ohio
321 *top*	15-25	Laura H. Chapman
321 *center*	15-25	M. R. Greene
321 *bottom*	15-25	Laura H. Chapman
322	15-26	Laura H. Chapman
323	15-27	Laura H. Chapman
325		Laura H. Chapman
326 *left*	16-1	Madelaine Shellaby, University Art Museum, Berkeley, California
326 *right*	16-2	Laura H. Chapman
327 *top*	16-3	Georgie Ann Grosse, Children's House, Cincinnati, Ohio
327 *top center*	16-4	Laura H. Chapman
327 *bottom center*	16-5	Laura H. Chapman, HBJ Photo
327 *bottom*	16-6	Ron Stewart, Demonstration Art Workshop, University of Cincinnati
328	16-7	Photo by Cemrel, Inc.
329 *left*	16-8	Allen Caucutt, Instructor/Director, Maple Dale Indian Hill Schools, Fox Point, Wisconsin
329 *right*	16-9	Allen Caucutt, Instructor/Director, Maple Dale Indian Hill Schools, Fox Point, Wisconsin
330–31	16-10	Laura H. Chapman, drawing by Vladimir Yevtikhiev
332	16-11	Laura H. Chapman
333	16-12	Ron Stewart, Demonstration Art Workshop, University of Cincinnati
334	16-13	Ron Stewart, Demonstration Art Workshop, University of Cincinnati
336	16-14	The Solomon R. Guggenheim Museum, New York
337 *left*	16-15	Buckminster Fuller Archives
337 *right*	16-16	Hedrich-Blessing
338	16-17	James Stirling
339 *left*	16-18	Trans World Airlines Photo
339 *right*	16-19	Trans World Airlines Photo
340 *left*	16-20	Laura H. Chapman
340 *right*	16-21	Philadelphia Museum of Art
341	16-22	Laura H. Chapman
344	16-23	Laura H. Chapman
345	16-24	Laura H. Chapman
348		Thomas and Kristen Bartushintz
350 *top*	17-1	Miriam Richner Ford
350 *center*	17-2	Laura H. Chapman
350 *bottom*	17-3	Kent Anderson, Art Department, Milwaukee Public Schools, Milwaukee, Wisconsin
351 *top*	17-4	Kent Anderson, Art Department, Milwaukee Public Schools, Milwaukee, Wisconsin
351 *center and bottom*	17-5	Randall Harris, St. Charles Elementary School, Bloomington, Indiana
352 *top*	17-6	Laura H. Chapman
352 *center*	17-7	Wayne Miller, Magnum
352 *bottom*	17-8	Allen Caucutt, Instructor/Director, Maple Dale Indian Hill Schools, Fox Point, Wisconsin
353	17-9	Randall Harris, St. Charles Elementary School, Bloomington, Indiana
354	17-10	Laura De Wyngaert, Thorne Junior High School, Middletown Township, New Jersey
356 *top*	17-11	Library of Congress
356 *center*	17-11	Library of Congress
356 *bottom*	17-11	Trans World Airlines Photo
358	17-12	Robert R. McElroy
359 *top left*	17-13	Mike Corbin
359 *top right*	17-14	Laura H. Chapman
359 *center*	17-15	United Press International
359 *bottom*	17-16	Perls Galleries, New York
360	17-17	Laura H. Chapman
361	17-18	Laura H. Chapman
362 *top*	17-19	Laura H. Chapman
362 *bottom*	17-20	Laura H. Chapman
364		Daina Vipulis
366		Laura H. Chapman
384		Laura H. Chapman
392	19-1	Laura H. Chapman
393	19-2	Laura H. Chapman
395	Table 19-2	Laura H. Chapman, drawing by Vladimir Yevtikhiev
400	Table 19-9	Laura H. Chapman, drawing by Vladimir Yevtikhiev
408		Georgie Ann Grosse, Children's House, Cincinnati, Ohio
410 *top*	20-1	Georgie Ann Grosse, Children's House, Cincinnati, Ohio
410 *center*	20-2	Allen Caucutt, Instructor/Director, Maple Dale Indian Hill Schools, Fox Point, Wisconsin
410 *bottom*	20-3	Laura H. Chapman, drawing by Vladimir Yevtikhiev
411 *top*	20-4	Allen Caucutt, Instructor/Director, Maple Dale Indian Hill Schools, Fox Point, Wisconsin
411 *bottom*	20-5	Allen Caucutt, Instructor/Director, Maple Dale Indian Hill Schools, Fox Point, Wisconsin
412	20-6	Laura H. Chapman
413 *top*	20-7	Laura H. Chapman
413 *center*	20-8	Elliot W. Eisner and Stephen M. Dobbs, Kettering Project (1968–71) Stanford University, School of Education
413 *bottom*	20-9	Philadelphia Museum of Art
414	20-10	Georgie Ann Grosse, Children's House, Cincinnati, Ohio
415	20-11	Laura H. Chapman, HBJ Photo
416	20-12	Georgie Ann Grosse, Children's House, Cincinnati, Ohio
417 *top and center*	20-13	Laura H. Chapman
417 *bottom*	20-14	Laura H. Chapman
418	20-15	Georgie Ann Grosse, Children's House, Cincinnati, Ohio
419	20-16	Georgie Ann Grosse, Children's House, Cincinnati, Ohio
421 *top*	20-17	Janet Smith
421 *bottom*	20-17	Laura H. Chapman